**French Painters and Paintings
from the Fourteenth Century
to Post-Impressionism**

A Library of Art Criticism

FREDERICK UNGAR PUBLISHING CO.
NEW YORK

French Painters and Paintings from the Fourteenth Century to Post-Impressionism

Compiled and Edited, with an Introduction, by

Gerd Muehsam

Assistant Professor and Art Bibliographer
Queens College of The City University of New York

With 158 illustrations

To the memory of my mother

Contents

Contents

List
of Illustrations

NOTE: Size, medium, and location are here given only for paintings not
discussed in detail in the text.

Note
and Acknowledgments

The purpose of this book is to introduce the reader to French painters and their works through commentaries and critical writings assembled and excerpted from a wide range of sources. The contributions of scholars and art historians, together with the rich legacy of art criticism from poets and men of letters, form the main body of the work; a few selections from poetry and fiction, as well as quotations from the writings of artists, have also been included. Little known or inaccessible material appears alongside criticism taken from standard works. Most of the foreign language excerpts have been translated here for the first time, or specially retranslated for this volume.

The decision as to which artists were to be included was often a difficult one. For reasons of balance and space most of the so-called academic painters of the eighteenth and nineteenth century were omitted. For our purposes French painters are artists born in France or of French nationality; painters such as the Dutchman Vincent van Gogh, who is sometimes considered a member of the French school, are therefore excluded. An exception was made for Francesco Primaticcio, an Italian active in France for forty years, who succeeded in radically altering the course of sixteenth-century French art.

In a text drawn from almost one thousand sources some stylistic inconsistencies are unavoidable. In selections quoted from previously published works in English the original spelling and punctuation are retained. Variations in the names of artists and the titles of paintings are noted wherever necessary. The present location of paintings is specified in many cases.

In order to place the selections in their proper historical perspective the bibliographical citation for each excerpt provides the date of writing or of first publication in parentheses should the date differ from that of the edition quoted. Authors' footnotes are indicated by the use of authors' initials; I have provided all other footnotes.

Note and Acknowledgments

I would like to express my gratitude to the many individuals who have so generously rendered advice, assistance, and support in the preparation of this book. I am particularly grateful to Sir Anthony Blunt and Dr. Anita Brookner of the Courtauld Institute of the University of London for reading parts of the work and for their words of encouragement. I am indebted to Mr. Benedict Nicolson, editor of *The Burlington Magazine,* for his suggestions and for permitting me to quote liberally from that invaluable tool for the study of French painting. My sincere thanks go to Mr. Howard Marston of French Reproduction Rights, Inc., for his guidance with regard to the quotations translated from French publications. Professor Robert Goldwater of the Institute of Fine Arts of New York University and Professor Robert L. Herbert of Yale University provided helpful suggestions.

I much appreciate the cooperation extended to me by my fellow-librarians of the Cooper-Hewitt Museum of Design, The New York Public Library, The Metropolitan Museum of Art, the French Institute in the U.S., and Queens College. My thanks also go to Mrs. Juliane Biro, Miss Marylin Harris, and Miss Diane Phelan, who contributed to the translations from the French; to Miss Janet Blue who prepared the index, and to Mrs. Ursula Schlochauer who rendered secretarial assistance.

Ultimately, my expressions of deep gratitude go to Mr. Frederick Ungar, without whose encouragement and patience this book would not have been possible, and to his dedicated staff; to Miss Anita Duncan who designed the book; and above all to Mrs. Jean I. Henrickson for her enthusiasm and care in preparing this complex manuscript for publication.

Introduction

Regardons, regardons longtemps,
sentons, et jugeons.
—Diderot

The classical country of art criticism is France—it was the French who created this special branch of criticism as we know it today. Half literature and half journalism, midway between professionalism and connoisseurship, between art history and art theory, it praises, castigates, or exhorts the artist, mirrors public taste or guides it, informs, interprets, and evaluates. In translating the visual language of shapes, lines, and colors into the medium of words, art criticism forms a link—and sometimes a barrier—between the artist and his public.

The French have often been called a nation of critics. Nowhere has the cult of the written word been carried farther than in France. It was the avowed aim of the Académie Française, founded in 1635, to develop the French language into a tool with which to express, "eloquently and with purity," the concepts of the arts and sciences. Since the eighteenth century the most brilliant minds of France have written about art—the long list of distinguished names includes Diderot, Stendhal, Baudelaire, the Goncourts, Zola, Marcel Proust, Paul Valéry, André Gide, André Maurois, and André Malraux.

The emergence of art criticism, however, is not to be attributed solely to the "critical temper" of the French, to their special gift for fine articulating and verbalizing. Nor was art criticism born out of the great friendships between artists and writers that have enriched French art and thought to this day. Rather, art criticism came into being because of a unique historical constellation that created, in the seventeenth and eighteenth centuries, a totally state-sponsored and state-organized system in the fine arts.

This system, of which art exhibitions and critiques were to become an important part, was the outcome of the absolutistic, tightly controlled power

complex created by Louis XIV and his shrewd and energetic finance minister, Jean-Baptiste Colbert, who committed all of France's national resources and economic wealth to the greater glory of the king and the monarchy. Throughout the seventeenth and eighteenth century and even after the Revolution and far into the nineteenth century, state sponsorship and state patronage of the arts were to remain powerful influences in France, leaving their imprint on the artistic life of the nation. This led to a fierce confrontation between the official tastemakers and the creative personality that was to characterize the French art world in the nineteenth century.

In the Middle Ages artists in France, as elsewhere in Europe, organized themselves into guilds (*Confréries des Maîtres Peintres, Sculpteurs, Doreurs et Vitriers,* sometimes simply called *Maîtrises*). The guilds made no distinction between artist and artisan: painters and sculptors belonged to them, as did metalworkers, glaziers, and cabinetmakers. The guilds regulated such matters as the duration of apprenticeship, the type of work an artist was permitted to do, and the trading involved. In the course of the centuries, the rule of the guilds had become oppressive. The court painters, on the other hand, enjoyed greater freedom and special privileges. Attached to the royal household (hence the title *peintre et valet de chambre du roi*), they were exempt from taxes and certain guild restrictions. The disparity between the privileged court artists and artists subject to guild rule caused friction and jealousy, especially in Paris where the *Maîtrise* succeeded in obtaining legal confirmation of its restrictive rules as late as 1639.

From Renaissance Italy arose a new concept: that the dignity and individuality of the artist were to be recognized and that a distinction was to be made between the craftsman—the manual worker—and the painter, sculptor, or architect—a learned man equal to the poet and intellectually on a par with the philosopher and the scholar. The revival of the ancient Greek academies by the Italian humanists of the fifteenth and sixteenth centuries set the stage for the social and intellectual emancipation of the artist, which eventually asserted itself in the establishment of the two leading academies of fine arts—the Accademia del Disegno in Florence, founded in 1563 by Giorgio Vasari and Cosimo de' Medici, and the Accademia di San Luca in Rome, founded in 1593.

Since Italian artists worked in France and Italian influence dominated French art in the sixteenth and early seventeenth centuries, it was natural that the struggle of the Italian artist for higher social status and for independence from the shackles of the medieval guilds was to find a fertile soil also in France.

When Charles Le Brun, who had observed the Italian academies in action, returned from Italy in 1646, he immediately set to work to reform the social position of the French artist. The time was ripe. The Académie Française had been founded in 1635. Cardinal Mazarin, regent for Louis XIV, was

favorably disposed toward the establishment of an academy of art. A petition submitted to the ten-year-old King by the Councillor de Charmois was granted and the Royal Academy of Painting and Sculpture (Académie Royale de Peinture et de Sculpture) opened its doors on February 1, 1648 with twenty-eight members. Among its founding artists were Charles Le Brun, Eustache Le Sueur, Laurent de La Hyre, and Sébastien Bourdon. Modeled on the academies of Florence and Rome, its organization was simple. Twelve founding artists (*anciens*), selected from the membership, had monthly rotating duties as teachers. The students were recruited from the pupils who were being trained in the studios of the member artists. Instruction at the Academy consisted of lectures (*conférences*) dealing with anatomy, geometry, and perspective, and of drawing and life-classes.

The apprenticeship system, on the other hand, continued to be conducted in the traditional manner. The aspiring young artists—the apprentices—continued to live in the houses of their masters, assisting them in the *ateliers,* grinding the colors or preparing the blocks for carving, and ultimately being trained to paint, carve, or model.

In opposition to the Royal Academy of Painting and Sculpture, the Parisian *Maîtrise,* which rightly felt its existence to be threatened, founded, in 1649, its own academy—the Academy of St. Luke (Académie de Saint-Luc). St. Luke's first director was Simon Vouet who, however, died the year St. Luke's was founded. By a decree of 1651 St. Luke's was merged with the Royal Academy, only to be separated again in 1655.

The transformation of France into a centralized autocracy, begun by the Cardinals Richelieu and Mazarin and completed by Colbert after Mazarin's death in 1661, suppressed any remaining individualism and particularism in the life of the nation for the sake of a complete unity of goals and purposes. In this program the arts became an all-important instrument of governmental power and the outward symbol of the King's might and grandeur.

The Gobelins *manufacture* was established in 1662 to produce the furnishings for the royal palace at Versailles. New academies were formed: the Academy of the Dance (1661), the Académie des Inscriptions et Belles Lettres (1663), the Academy of Science (1666), of Music (1669), and of Architecture (1671).

The Royal Academy of Painting and Sculpture was reorganized to formulate and teach the state-approved artistic doctrines and principles. Colbert himself, with Le Brun as his right-hand man, took a leading part in this reorganization, which turned the Academy, originally a free association of artists, into a rigidly organized bureaucracy. Completed in 1663 and legalized in 1664, the reorganization clearly separated the Academy's administrative and teaching functions. High state officials—Colbert, followed by others—held the positions of Protector and Vice-Protector; the remaining administrative officers were drawn from the academicians themselves: a chancellor, six

councillors, a secretary (who was also the historian), and a treasurer. The teaching hierarchy was headed by the director, four rectors, and twelve professors (formerly the *anciens*). Two adjunct rectors and eight adjunct professors completed the formal roster of Academy officials.

Membership in the Academy was open to all qualified painters and sculptors, and the number of academicians without teaching or administrative functions was unlimited. Any artist who had completed his training and wished to establish himself in Paris could apply for admission to the Academy. For this purpose he was required to present a diploma piece; if it was accepted he became an associate or provisional member (*agréé*) until, after a certain number of years, usually seven, he submitted another work for admission to full membership.

The Academy had the right to grant pensions and to allow privileged artists to occupy studios, and even living quarters, in the Louvre. Above all, the 1663–64 reorganization of the Academy was aimed at strengthening its educational function, especially the training of artists. Instruction became thoroughly regulated and students were spurred on by competitions for various prizes and medals.

Most coveted among these was the newly established Rome Prize (*Prix de Rome*) which was, in effect, a four- or five-year scholarship for study in Rome. In 1666 the French Academy in Rome was created to train and house the Rome scholars. Poussin, designated as its first director, died in 1665, however, before he could be officially appointed.

Seventeenth-century Rome was the mecca of the art world. The rich artistic heritage of the city and the presence of artists from many countries offered the Rome scholar the most stimulating environment to be found anywhere. He had come primarily to study the monuments of antiquity and of the Renaissance, but was also in a position to observe and be influenced by the works of contemporary artists. He was required to make copies of antique and Renaissance *objets d'art,* which were then sent back to France to serve as models in the royal workshops. Young artists did not relish this part of their official assignment, but the sojourn in Rome and the carefree student life at the French Academy there made up for these tedious tasks.

For students who pursued the course of study at the Royal Academy of Painting and Sculpture in Paris instruction still focused on drawing and lectures. The 1663–64 statutes had granted the monopoly for teaching drawing to the Royal Academy. This forced its erstwhile competitor, the guild-sponsored Academy of St. Luke, into obscurity until 1705 when St. Luke's succeeded in obtaining teaching privileges once more. Drawing at the Royal Academy was taught in three steps: drawing from drawings, drawing from casts, and drawing from the living model.

The lectures, which covered general topics (see pp. 119, 164–65) as well as analyses of individual paintings (pp. 106–8), were often followed by

discussions. The academicians were expected to be proficient lecturers; attendance at lectures was compulsory for academicians and students alike. Considerable emphasis was placed on these lectures; while they were intended to train artists in the intellectual comprehension and rational interpretation of works of art, their overall purpose, apart from their instructiveness, was to set standards and to establish aesthetic canons.

It was André Félibien (1619–95), the friend of Poussin and, briefly, historian of the Royal Academy of Painting and Sculpture, who most clearly formulated the official doctrines of art which, though derived from Italian art theory, were to represent an almost immutable standard of academic taste in France for the next two hundred years.

The imitation of nature was considered the aim of painting; reason and "good taste" was to prevail in the choice of subjects, as well as in the manner of execution. Only "noble" subjects were worthy of being extracted from nature; the representation of "ignoble," or lowly, subjects was to be avoided.

Drawing was the most important element of painting, because it appealed to the mind; color, which appealed to the senses, that is, to the eye, was secondary. The classical unities of time, place, and action were to be observed in painting, as Corneille and Racine had observed them in drama. All elements of a composition were to attain classical balance. In the grouping of figures the distribution was to proceed according to the rank of the figures portrayed: kings and rulers were to have the most prominent place and receive the best light in a painting. The emotions of the personages depicted were to be rendered with clearly delineated gestures and appropriate facial expressions. (An example was set by the philosopher René Descartes who, in his treatise *Les Passions de l'âme* (1649), had cataloged and categorized the "passions" or states of mind by relating them to physical appearance, gesture, expression, and action.)

This being the age of reason, it was held possible to explain rationally all phenomena and to establish universally valid fundamental principles. Accordingly, the artist was admonished to aspire toward the ideals of absolute beauty—the antique, the works of Raphael, and the paintings of the Carracci, Domenichino, and Poussin. By thus codifying the canons of perfection it was hoped that the artists would create works of supreme beauty. Instead, they produced only rigidly classicist paintings.

Appropriateness of subject matter was a major concern of academic discussion from the early days of the Academy. The classification and grading of paintings according to the subjects represented affected not only the esteem in which works of art were held but also the standing of the artist in the academic hierarchy.

History painting (*peinture d'histoire*)—the representation of religious, historical, or mythological events, was noblest in character, hence ranked highest in the Academy. The history painter excelled not only in the science

with which he was able to arrange the figures in his composition, but he was also erudite, for his subject matter required the study of the classical authors or the Scriptures. Genre paintings ranked lower, because they depicted persons of the lower classes; portraits still lower, because they were less complex, representing only a single figure. Animal painters and landscapists were inferior to the figure painters, while flower- and still-life painters were at the bottom of the list. This classification reflected a religious-anthropocentric attitude, an attitude which regarded man as the most perfect specimen of Creation, to whom all other species were subordinate. The representation of man, especially man in heroic moments, was, therefore, the artist's worthiest subject.

In the 1663–64 statutes of the Royal Academy of Painting and Sculpture provision was made for exhibitions, which were then envisaged as a purely private matter for the benefit of the academicians and their pupils and as demonstrations of academic taste and doctrines. The first such exhibition took place in 1665 and was followed, in the next ten years, by several others, to which the nobility was probably invited. Although intended to be biennial, only two additional exhibitions, in 1699 and 1704, were held during the reign of Louis XIV. While the earlier exhibitions had been held in various quarters for lack of adequate space, those of 1699 and 1704 took place in the Grande Galerie of the Louvre and turned out to be rather spectacular affairs.

Financial difficulties and political unrest caused a reduction in the activities of the Royal Academy and a suspension of exhibitions from 1704 to 1737. The only event close to an Academy exhibition was a competition in 1727 (see p. 208), in which twelve academicians participated.

During this time the outdoor Youth Exhibition (Exposition de la Jeunesse) became important as the only vehicle where artists could show their work. Held every year on the day of Corpus Christi in the Place Dauphine near the Pont Neuf (see p. 210), it was open free of charge to all artists, young and old, academician or nonacademician.

With the year 1737 a new era of exhibitions began. The exhibition of 1737 was held in the Salon Carré and the adjacent Galerie d'Apollon in the Louvre, an event which once and for all established the term "Salon" for the great official art exhibitions in Paris. Hereafter, until 1848, the Salons were held regularly in the Louvre at yearly or two-year intervals.

The Salons, in which only academicians and associates were permitted to exhibit, quickly developed into glittering artistic and social events of far-reaching consequence. They became an integral part of the Parisian cultural scene and were fostered by the State to increase the prestige of the nation. All the world was beginning to look to Paris for its pronouncements on things cultural. Paris was becoming the magnet that attracted the best artists from the far corners of France; for the next two centuries it was to be the artistic center of Europe, if not of the world.

For the exhibiting artist the Salon was to become more than just a proving ground. It was to become the place at which he could mingle with the intellectuals, connoisseurs, wealthy patrons, and collectors, thereby laying the groundwork for later purchases and commissions. It was to become the public forum at which ideas about art could be exchanged and critical discussions pursued. Printed exhibition catalogues (*livrets*) listing the works being shown were issued by the Academy, sometimes with brief explanatory notes. A new breed of critics was about to appear on the scene to guide the up and coming middle-class, eager to acquire culture and refinement, through the complexities of the Salon.

Even the Academy of St. Luke began to participate in the surging exhibition activities. In 1751 it sponsored its first public exhibition in competition with the official Salon. Open to any artist upon payment of a small fee, the exhibitions of St. Luke's were popular with academicians and nonacademicians alike. The end of the Academy of St. Luke came in 1776 with the suppression of all guilds.

The modern art exhibition was thus born in the eighteenth century. Historical exhibitions and retrospectives, however, were infrequent before the nineteenth century.

After André Félibien, a number of writers, notably Roger de Piles (1635–1709) and the Abbé J.-B. Du Bos (1670–1742), were concerned with art theory in the latter part of the seventeenth and early eighteenth century. In 1668 Roger de Piles translated a didactic poem by C. A. Dufresnoy, *De arte graphica,* from Latin into French, to which he added a commentary praising the color of the Venetian painters and of Rubens and Van Dyck—artists proscribed by the Academy. In two later essays, *Dialogue sur le coloris* (1673) and *Conversations sur la connaissance de la peinture* (1677), de Piles went so far as to condemn Poussin in order to extol Rubens. This opinion marked the beginning of the Quarrel of Drawing versus Color in the Academy, a quarrel which was to divide its members into two opposing groups: the conservative "Poussinistes," led by Le Brun, who continued to advocate the supremacy of drawing, classicism, and the grand manner, and the progressive "Rubenistes," led by Roger de Piles, who championed color and artistic truth.

De Piles not only defied the official doctrine but also challenged the right of the Academy to be the sole judge in matters of art, and claimed the layman's right to develop and express critique. By 1699, however, de Piles himself entered the Academy as *conseiller-amateur,* a kind of honorary member, and the Rubenistes won the upper hand.

A further step beyond the rule of the Academy was taken by the Abbé Du Bos in his *Réflexions sur la poésie et sur la peinture* (1719). Whereas Félibien stated that the highest aim of painting was to *instruct* and de Piles held that painting was primarily the *representation of objects,* Du Bos main-

tained that the function of painting—as of poetry—was to *produce emotion*. Du Bos moreover, considered natural sentiment, rather than knowledge, the prime factor enabling the public to express judgments on art.

The artists of the Academy, who had jealously guarded their monopoly on expertise in art, fought a losing battle against the idea of the connoisseur and the public as arbiters of taste. As the popularity of the Salons grew, pamphlets and brochures about them also became more numerous. For the most part they were adulatory, regardless of the distinction of the works shown. (It was rumored that the writers were sometimes secretly bribed by the artists themselves.)

In spite of the praise lavished upon the artists in these brochures, there was a general feeling that the quality of the works shown in the Salon was deteriorating steadily and that the artists were exhibiting too many inferior works.

By 1746 the *Mercure de France* felt impelled to publish an open letter addressed to Maurice-Quentin de La Tour, the leading artist of the day, in which a "judicious examination" of the works shown in the Salon was demanded. A year later La Font de Saint-Yenne, an otherwise little-known writer, published his epochmaking essay, the full title of which read *Reflections on Some Causes of the Present State of Painting in France, with an Examination of the Principal Works Exhibited in the Louvre in August 1746*. It was the first time that an essay had been written for the express purpose of reviewing current works of art on exhibition—it was the first genuine piece of art criticism. La Font began his essay with a statement that may today seem like a commonplace. How radical it indeed was when first made cannot be overemphasized. La Font declared that a picture placed on exhibition was like a published book or a play performed on the stage. The right to judge a book or a play was generally accepted—by the same token everyone had the right to judge a painting.

While La Font's critique itself (see p. 212) was cautious and his style pedestrian, it nonetheless marked the birth of a new literary genre that only a little more than a decade later was to find its first master in Denis Diderot.

The public reacted favorably to this new kind of Salon critique, which was immediately imitated by other writers. Among the artists themselves, however, such adverse criticism was considered a personal insult, and La Font's essay raised a storm of protest. The government responded by instituting a Salon jury, composed of elected and ex officio members of the Academy. When the Salons of 1747 and 1748 evoked more of this unaccustomed art criticism, the artists resorted to their ultimate weapon—they "went on strike." To the amazement of the Parisians there was no Salon in 1749. Yet neither the Academy nor the artists themselves could forego the advantages of the highly popular Salon exhibitions for long, and so the Salon opened as usual in 1750, although after 1751 Salons were held only every other year, in

order to give artists more working time between exhibitions. Critique had become a fact of life and has flourished ever since.

In 1759 the Baron Friedrich (or Frédéric, as he was known in France) Melchior Grimm, a German expatriate living in Paris, engaged the philosopher and encyclopedist Denis Diderot (1713–84) to write reviews of the Salons for the *Correspondance Littéraire, Philosophique et Critique*. Grimm had been issuing this subscription gazette since 1753; it reported on the literary and artistic scene in Paris. It appeared in handwritten copies only; censorship prohibited its publication and distribution in France—it frequently contained condemnations of the monarchy—although occasionally copies were secretly circulated in Paris. Its subscribers included the politically enlightened rulers of Europe, among them Catherine the Great of Russia and Frederick the Great of Prussia.

Although Diderot had, in 1752, written a philosophical essay on the beautiful—*Beau*—for the second volume of his great *Encyclopédie*, his knowledge of art was no more than that of an enthusiastic layman. The way in which he acquitted himself as a *salonnier* (Salon reporter) is remarkable in view of the circumstances surrounding the *Correspondance Littéraire* and in view of the fact that he wrote for readers hundreds of miles away who would never see the works he was describing.

Diderot wrote nine *Salons* between 1759 and 1781. The *Salon of 1759*, his first, was somewhat tentative and perfunctory, though much livelier in tone than those of other *salonniers*. By 1761 Diderot's interest was beginning to deepen. He visited studios, observed artists at work, and listened to them as they discussed their métier. He valued particularly the judgment of Chardin, who escorted him through the Salons and whose guidance in matters of art he freely acknowledged. By the *Salon of 1763* he had fully mastered his role as art critic. His next two *Salons,* those of 1765 and 1767, are masterpieces. In 1765 he confided to his friend Sophie Volland that the *Salon* in hand was the best piece of writing he had ever done. The *Salon of 1767* transcends the limits of a Salon review. The works on exhibit seem only pretexts for long philosophical discourses, including a satirical dialogue with his patron Grimm on the influence of luxury on the fine arts and the description of a fictitious, dreamlike stroll to seven sites depicted in landscapes by Joseph Vernet. After 1767 Diderot had, to quote himself, "emptied his bag." He had said all he had to say; his last *Salons* were but lusterless echoes of former glories.

As Sainte-Beuve, a great critic himself, remarked, Diderot was the creator of a critique that was "sensitive, zealous, and eloquent." His style was spontaneous and conversational, tempered with warmth and enthusiasm. He gave himself fully to the impression of the moment, even to the point of occasionally contradicting himself. He was skillful in utilizing every literary form and device to hold the reader's attention and keep him entertained—his comments burst forth in a constant flow of description, contemplation, and judg-

ment, and are spiced with amusing anecdotes and witty *aperçus*. He pours out his opinions prodigally, and the variety of his thoughts is seemingly inexhaustible. He is in turn gay and tearful, lyrical and tragic, sentimental and caustic, romantic, ironic, naughty and moralistic—the entire spectrum of moods and temperaments files past in glittering prose.

As modern as Diderot appears to us in his style and manner, his opinions on art still reveal him largely as a man of the eighteenth century. Diderot always upheld naturalness and simplicity—nature, not the antique, was for him the ideal model: painting must not simply imitate but must translate or re-create nature. He deplored the artificiality, emptiness, and frivolity of his time, the "moral corruption" of Boucher the man and the "unbearable clutter" of his paintings (pp. 225–26), but he fully accepted the hierarchy of subjects preached in the Academy. He preferred the multifigured landscapes of Joseph Vernet to those of Claude Lorrain (pp. 244–45), because to him Vernet's landscapes attained the level of history paintings. In the same vein, he declared that Chardin was a great man but not a history painter and that, all things being equal, a portrait by La Tour must be valued higher than a "mere" still life by Chardin.

Diderot was charmed by the lascivious sentimentality of Greuze's not-so-innocent young maidens and moved to tears by their misfortunes, be they dead canaries (pp. 252–53), broken pitchers, or cracked mirrors—Diderot even finds this suggestiveness "subtle." Diderot may well have exalted Greuze, but this must be viewed in historical context and understood in terms of the didactic role Diderot assigned to painting. The stress placed by Diderot on the narrative element of Greuze's paintings was typical of the approach to art at the time. The theatricality of Greuze's figures, which today strikes us as false, appealed particularly to Diderot the dramatist, because the paintings told a story or spelled out a message very much as does a play. The moral they point, the domestic virtues they expound, the "common man" they portray, must be considered as the reaction against the *peinture des seins et des culs* (painting of bosoms and buttocks) of the Rococo, which aimed only at the erotic titillation of a jaded, decadent aristocracy.

As an art critic Diderot became influential only after his *Salons* gradually appeared in print (between 1795 and 1857). Every critic from Stendhal to Baudelaire was affected by his writings. For Diderot had infused art criticism with the stamp and sparkle of his personality, the versatility of his thought, and the wealth of his ideas. His great contribution was to raise art criticism from ephemeral and mediocre journalism to the quality of enduring literature.

In the history of ideas the pendulum swings back and forth between the concept of "art for art's sake" and art as a social instrument. Plato was the first to postulate that art should serve political and educational objectives. During the Middle Ages the Church took a similar position when it made

art the handmaiden of religion. In the Renaissance the aesthetic attitude changed. A hundred years later Poussin's view that the end of art was "delectation" still reflected the Renaissance spirit of art for art's sake—a strange contrast to Poussin's otherwise stern ideology and the prevailing doctrines of the Royal Academy in France. The art of the Rococo was the last phase of this hedonistic view of art.

With the Age of Enlightenment the reaction set in. Diderot, who viewed art as a means of advancing morality and virtue, died in 1784, a year before Jacques-Louis David's *Oath of the Horatii* was to be exhibited in Paris. Had Diderot lived, he might have saluted David as the "moral" painter. For in 1781, when David made his debut with *Belisarius*, Diderot—tired, old, exhausted—noted in his last *Salon* that "this young man paints in the grand manner, . . . he has soul."

While Greuze had been merely an opportunist who was cashing in on a prevailing trend, David may be considered the first truly committed artist in the modern sense. The generation that separated him from Greuze made the difference. David was a political artist and a Jacobin who embraced the Revolution. Although he himself was a member of the Royal Academy of Painting and Sculpture, he formed, in 1790, the Commune Générale des Arts, an association of revolutionary artists whose purpose was to overthrow the Academy and its rigid rule. The government made a concession in liberalizing the Salon of 1791, which was thrown open to all artists who wished to enter paintings, waiving membership requirements and the judgment of the jury. There was no Salon in 1792. In 1793 all academies in France were dissolved (the French Academy in Rome was apparently not affected). At the same time the Louvre was established as a national museum open to all for visiting and studying— a pioneering move. (A network of national museums in the provinces was later created by Napoleon.) In 1795 the old academies were reorganized into a single body—the Institute (Institut de France).

The Institute comprised five subdivisions, one of which was the Fine Arts section, named Académie des Beaux-Arts (Academy of Fine Arts) following its reorganization in 1816. At its inception in 1795, the total contingent of painters among the Institute's 144 members was only six; under Napoleon it was raised to ten; and after 1816 to its present number of fourteen. Throughout the nineteenth century most of the painter members were history painters. In addition to the chairs for painting, there were eight chairs for sculpture, eight chairs for architecture, four for engraving, and six for music. (Today, the Académie des Beaux-Arts has ten additional, nonvoting members—*membres libres*.) Membership is for life. The Institute, and every subdivision thereof, is self-perpetuating, vacancies occurring by death only.

It is one of the ironies of history that the academies of fine arts, which had originally been created to free artists from the restrictions of the medieval guild system, were in the course of time to become obstacles to freedom and

were in turn to be abolished in the name of liberty. The Institute and its fine arts section, arising out of the Revolution, was to guarantee freedom for artists once more. But it, too, became fossilized and rigid in maintaining the status quo in the arts.

In the earlier part of the nineteenth century the Institute—through its Académie des Beaux-Arts—reigned supreme in the arts. It controlled the professorial appointments to the newly established École des Beaux-Arts, which was placed under the general supervision of the Ministry of Education. It took charge of the competitions for the Rome Prize and administered the French Academy in Rome. It made recommendations to the government for commissioning the decorations of public buildings and for purchasing works by living artists for the national museums. It selected from its members the juries which were to admit or reject works submitted for exhibition in the Salons—a formidable hurdle to be passed by aspiring artists. (After the Revolution of 1848 the Salon jury was broadened to include nonmembers and special government appointees.) In a complex relationship with the Institute, the government, chiefly through its Fine Arts Ministry, continued to be involved in every phase of the artist's career and remained a strong factor in determining public taste.

Before the Revolution it was comparatively easy to gain admittance to the Royal Academy, and the relatively large number of academicians (about 150 in the 1760's) provided a fair base from which the officers could be chosen. The Académie des Beaux-Arts, which was always limited to forty members, was, on the other hand, a "hierarchy without its base"—a remote, exclusive club of older men that persisted in preaching the classicist gospel for the next hundred years, notwithstanding the advent, in succession, of the romantic movement, realism, Impressionism, and symbolism.

It must be stated, however, that in the beginning the Academy was in tune with the times. Following David, the painters Prudhon, Gros, Girodet, and Gérard all held chairs at the Institute. Ingres, once derided, became a member in 1825. But Delacroix was elected only in 1857, thirty-two years after Ingres and thirty-five years after his debut in the Salon—a belated recognition of the fact that he, too, was part of the tradition. He was the last of the great painters to achieve membership. From Géricault to the Impressionists and Post-Impressionists, the innovators were excluded and the mediocre and artistically sterile eclecticists won the honors.

The concept of the independent artist, which was sparked by the Revolution and the romantic movement, caused an ever-widening gap between "tradition," *l'école*, the official art fostered by the Academy of Fine Arts, and the increasingly personal expression of the nonacademic artist. Closely related to the romantic concept of genius, this view stresses the growing alienation of the artist from an increasingly materialistic society. The artist is seen as standing outside society, different from the rest of the world, unable to produce

works on demand in an artistic language that is commonly understood or to enjoy the patronage of sponsors or wealthy collectors who assure him of a comfortable existence. His work is the product of inspiration, he aims at originality, and he is understood only by a small circle of like-minded friends. Like the poet and the composer, the painter pursues his individual vision, a vision that the public, the critics, and the establishment no longer shares and understands.

Balzac's novella *The Unknown Masterpiece*, dating from 1831, prophetically sketched the artist's isolation from his environment: the old master Frenhofer, in his quest for utmost perfection, labored for ten years over the creation of a "living" masterpiece, which he has kept hidden from the world. He reluctantly revealed it to his pupil Porbus and the young Poussin. Though full of anticipation and eagerness to absorb it, they were unable to see anything but a maze of unintelligible lines and colors.

By the middle of the nineteenth century, Balzac's visionary fantasy became a reality. The Revolution of 1848 and the gradual rise of the realist movement completed the breach between the independent painter and official art. The conventional critic, standing between the painter and a public unsure of its own mind and its artistic judgment, voiced the official, academic point of view. When in the second quarter of the century critics pitted Delacroix the colorist against Ingres the draftsman, the respective merits of line versus color (reminiscent of the seventeenth-century quarrel in the Royal Academy) became the point of departure for an ideological confrontation between classicists and romanticists.

First applied to Delacroix, who was never fully accepted by the contemporary public, the critics' verdict "he doesn't know how to draw or paint" became an ever-recurring motif of Salon reviews. Courbet, who also "doesn't know how to paint," was the "apostle of the ugly"; Millet "glorifies idiocy"; the Impressionists "slap a few haphazard lines on a piece of canvas and call it a masterpiece"—"a child of seven can do better."—Such are the statements that many of the maligned artists of the century had to endure. Even some of the more enlightened critics were unable to come to grips with the intent and purpose of these artists. They continued to examine works in terms of the worn-out concepts of classicism and academism, blaming artists for anatomical inaccuracy, incorrect modeling, "false" coloring, and inappropriate subject matter, while these painters were seeking or experimenting with altogether different objectives.

When in 1863 Napoleon III personally demanded that the works rejected by the Salon jury be publicly shown in a "Salon of the Rejected Artists"—the famous Salon des Refusés—these works, which included paintings by Manet, Pissarro, Fantin-Latour, Cézanne, and Whistler, were indiscriminately ridiculed by most critics. This served only to reconfirm the "soundness" of the jury's judgment in rejecting "inferior" works.

But the nonacademic painters were not wholly at the mercy of a hostile critique. The literary avant-garde of France joined forces with them. The great friendships that existed or developed between artists and poets and men of letters, their encounters in the studios and in the literary and artistic cafés of Paris, stimulated debate and exchange of ideas about art. Thus was created that singular artistic and intellectual climate that was the magic of Paris in the nineteenth century. As the Irish novelist George Moore, the friend of Manet and Degas, was to write in his *Confessions of a Young Man* of 1888: "I did not go to either Oxford or Cambridge, but I went to the Nouvelle Athènes, . . . a café on the Place Pigalle, [whose influence] is inveterate in the artistic thought of the nineteenth century."

With the rise of a wealthy bourgeoisie during the second half of the nineteenth century, art itself proliferated. The Salons became huge exhibitions of several thousand works, compared to the showing of a few hundred in the eighteenth century. Alert art dealers, who observed that artists once ridiculed often became subsequently accepted and even successful, began buying up the works of living nonacademic artists in the hope of a future high return on their investments. New literary and art journals were springing up, newspapers carried art notices and reviews. For some writers art criticism was no longer an occasional activity but a professional occupation. This was also the time in which professional art historians were beginning to come to the fore.

Thus art criticism took on a lively and varied pattern, offering the literary, journalistic, or art historical approach and reflecting all shades of political and artistic opinion, from the ultraconservative to the liberal-progressive and the avant-garde.

The first of the great literary figures who followed Diderot in his concern for the art of his time was the revolutionary poet André Chénier (1762–94), whose brief life ended on the guillotine. His single piece of art criticism was a defense of history painting, culminating in an eloquent tribute to Jacques-Louis David (see pp. 269–70).

Stendhal (1783–1842), who, like Chénier, knew David personally albeit long after the Revolution, understood David's historical role and saw clearly that the taste for the antique was on the wane. Though he deplored Ingres' coldness and demanded feeling and passion in art, he was unable to embrace romantic painting and the work of Delacroix.

Heinrich Heine (1797–1856), the German poet, came to Paris in 1831 as a correspondent for German newspapers and was to remain for the rest of his life. The *Salon of 1831*, the first report he sent to Germany, was a witty piece of political innuendo rather than art criticism in the strictest sense. In matters of artistic philosophy he called himself a "supernaturalist," (a term that was to become dear to Baudelaire)—believing that art must go beyond the mere imitation of nature. Heine denounced the critic who told an artist what he

should do rather than investigated what he *intended* to do. A truly original artist, Heine said, must be judged not by rules and definitions, but by the artist's own aesthetic objectives.

The novelist Théophile Gautier (1810–82) was one of the "men of 1830," a romanticist who had worn the red vest of rebellion in his youth, but who had later remained aloof from the seething political struggles of his age. He had the distinction of having been called "an impeccable poet, a perfect magician in French letters" by Charles Baudelaire, who dedicated *Les Fleurs du mal* to him. Gautier, for a time editor of *L'Artiste* and contributor to important Parisian journals, wrote a considerable amount of art criticism. As the chief protagonist of the "art for art's sake" aesthetic in the nineteenth century, Gautier admired Ingres. Loath to condemn any artist, he found praise also for Delacroix, but could find no redeeming feature in Manet's *Olympia* (see pp. 440–41). For the most part, however, Gautier's taste was rather catholic. His narrative gift dazzled his contemporaries and was the reason for the high regard in which his poetic descriptions of paintings were held. Yet Delacroix for one took a sober view of Gautier as a critic: he noted in his *Journal* of June 17, 1855, that Gautier "takes a painting, describes it in his own way and makes another—charming—work of it, but this is not a true critique."

The notable contribution of Edmond de Goncourt (1822–96) and his brother Jules (1830–70) was essentially to art history. Their studies of the eighteenth century still represent the best introduction to this period, and their critical evaluation of the artists discussed in *L'Art du XVIII^e siècle* remains basically unchallenged. The Goncourts were among the first to collect and promote Japanese prints in Europe (Edmond de Goncourt wrote books on Hokusai and Utamaro), which were to influence Degas, Toulouse-Lautrec, and the Art Nouveau style.

Whereas the Goncourts were realists in their fiction, as critics they adhered to the doctrine of "art for art's sake" and abhorred realism because of its "ugly" subject matter. Their aesthetic sensibilities were in key with the eighteenth century. Although their novel *Manette Salomon* (1867) was the story of Parisian art life in the Second Empire and its central figure, Coriolis, was a "painter of modern life," they were not as discerning in their judgment of living artists. They rated Paul Gavarni, the printmaker to whom they devoted a monograph, above Daumier. Mediocre artists, including Jean François Raffaëlli and Giuseppe de Nittis, who were friends of Edmond de Goncourt after his brother's death, were showered with praise. Except for one visit to Degas' studio by Edmond in 1874, the brothers had no personal contact with either the Impressionists or Manet. It has been noted that in their voluminous journals Manet, Monet, and Renoir are granted only an occasional passing reference, while Cézanne, Van Gogh, Pissarro, Berthe Morisot, and Sisley are not mentioned at all.

In a famous passage in *Mon cœur mis à nu*, Charles Baudelaire (1821–

67) laid down his poetic aims and his affinity for visual forms—"to glorify the cult of images (my great, my unique, my genuine passion)." He perhaps unwittingly described himself when, in 1861, he said that "all great poets naturally, fatally, turn critics." Earlier, in his *Salon of 1846*, he told his readers that criticism, in order to be "right," must be "partial, passionate, and purposeful" (*"partiale, passionnée, politique"*) and that he considered the best criticism that which is also "entertaining and poetic." Baudelaire's critical writings excel in all these qualities.

Baudelaire's prose differed essentially from the freedom and ease characteristic of Diderot's style. At once cerebral, philosophical, and intensely personal, Baudelaire's writing is darkly brilliant, multihued, and poetic; its cogency haunts the reader. In its consummate artistry Baudelaire's art criticism represents the unsurpassed summit of this genre in France, the perfect correlation of thought, form, and expression.

Baudelaire's originality as an art critic developed very rapidly. His *Salon of 1845*, written at the age of twenty-four, is arranged in the traditional academic order—history painting, portraits, genre paintings, and landscape paintings, with the customary brief comments on the exhibiting artists. The *Salon of 1846*, however, is completely unorthodox in its approach, organization, and contents. To illustrate, after a brief introduction "To the Bourgeois," we find the following thought-provoking chapters, all of which lead up to a discussion of Baudelaire's hero, Delacroix: "What Is the Good of Criticism?" "What Is Romanticism?" and "Of Color." Yet Baudelaire was not the creator of a new aesthetic in the sense that he developed entirely new theories of art, neither was he a prophet who saw the coming of Impressionism. His ideas can be traced to many sources, among them Diderot, Stendhal, E. T. A. Hoffmann, and Edgar Allan Poe. But as a poet he was able to see the synthesis of things. With his extraordinary sensitivity and profound insight he came close to explaining the inexplicable kernel of genius and creativity. He extolled Imagination, the "Queen of Faculties," which has "taught man the moral meaning of color, line, sounds, and scent," which is the princple of creation and artistic re-creation, and the means by which the universal *correspondances* and analogies between the physical and spiritual world may be experienced.

To Baudelaire Delacroix was the embodiment of genius, a man who possessed the quality of imagination to the highest degree. Thus Delacroix and his art dominate Baudelaire's thought. As an art critic Baudelaire's most inspired writing is that devoted to Delacroix, but his essay on Constantin Guys, *Le Peintre de la vie moderne*, is probably his most poetic.

In contrast to the aristocratic idler Baudelaire, the dandy who smoked hashish, the inhabitant of "artificial paradises" permeated with sensuality and melancholy, there existed a group of nineteenth-century critics of an altogether different character. These were democrats in an era of political repres-

sion, ardent in their belief in humanitarianism and social progress. These critics rallied around Courbet as the exponent of their ideals.

Champfleury (1828–89), a gifted novelist who championed realism in literature and the fine arts, was an early defender of both Balzac and Courbet. It was probably he who drafted Courbet's Realist Manifesto of 1855, which proclaimed it the duty of the artist to be the interpreter of his own time rather than of the past. In 1857 Champfleury published a key study of his theory of realism entitled *Le Réalisme*. Along with Baudelaire he was one of the first to understand the significance of Daumier. In his researches into art history he rediscovered the Le Nain brothers, *peintres de la réalité* of the seventeenth century, whose work had remained unacknowledged for many years.

The socialist philosopher Pierre Joseph Proudhon (1809–65), who said "property is theft," took Courbet's painting *The Return from the Conference* as his point of departure in *Du principe de l'art et de sa destination sociale*. This is a strictly dogmatic book, for Proudhon claimed no knowledge of art as such. In his view the aims of art were primarily utilitarian and social; art should be a mirror of contemporary society with all its virtues and vices. This concept of art is in sharp opposition to Baudelaire's vision of "modernity" in the latter's *Peintre de la vie moderne*, where the *flâneur* in the streets of the metropolis finds his inspiration in the ephemeral and the fugitive—in the artifice of makeup rather than in prosaic truthfulness to nature.

Théophile Thoré (1807–69) was not only a critic but also a revolutionary. His activities brought him imprisonment under King Louis Philippe, and, after directing an assault on the Parisian authorities in 1849, he received a death sentence which was not carried out. He escaped to Belgium where he became interested in art history and rediscovered the long-forgotten Jan Vermeer of Delft. In his *Salons*, written before and after his exile, he combined his political ideology with aesthetic principles, calling for an art understood by all men rather than by the select few. He rejected Ingres in particular as an ivory-tower artist (see pp. 302–3) and postulated that the doctrine of "art for art's sake" be replaced by an "art for the sake of man."

Jules Antoine Castagnary (1830–88), the chief exponent of naturalism in art, was another of the progressive critics who shared Thoré's antiacademism and opposition to history painting. He asserted the artist's right to paint subjects taken from everyday life or of social significance, as he saw fit. But Castagnary was unable to grasp the simplification of visual forms, such as that practiced by Puvis de Chavannes (p. 410).

Whether they were advocating "art for art's sake" or art in the service of mankind, the critics of the 1860's continued to debate subject matter, just as the artists of the Royal Academy had done two hundred years before. However, it was no longer a question of aesthetics but of moral issues. Critics such as Thoré and Castagnary did, in fact, oppose the old established academic hierarchies, only to replace them with another set of priorities. These

critics did not concern themselves much with formal problems or strictly pic-
torial values in painting; they rarely attached much importance to questions
of style.

It was left for Émile Zola (1840–1902) to concern himself with ques-
tions of style and form. It was he who formulated the new aesthetic, the con-
cept of "pure painting" which he had recognized in Manet's genius. Although
at one point Baudelaire had come close to conceiving of "pure painting,"
when he stated that Delacroix was able to evoke "the invisible, the impal-
pable, the dream . . . with no other means but color and line," the art of his
friend Manet had remained incomprehensible to Baudelaire. It was Zola who
took up the critic's pen where Baudelaire left off.

In 1866 the young Zola, whose interest in art had begun early through his
friendship with Cézanne, asked to be assigned to write a series of articles on
the current Salon for a Parisian daily, *L'Événement,* on which he was the
literary critic. The seven ensuing articles, entitled *Mon Salon* and signed with
the pseudonym Claude, were a devastating indictment of the archaic art es-
tablishment—the jury of the Salon—and a flaming defense of the work of
Manet. It was, as it were, Zola's *J'accuse* as an art critic—presaging his ring-
ing *J'accuse* of 1898 in the Dreyfus case, which was to shake the conscience
of the world. (*Mon Salon* of 1866 and a subsequent study of Manet were later
published in book form, in a much milder version, under the title *Mes haines.*)

In the 1866 *Mon Salon* Zola not only pilloried the jury for systematically
trying to suppress and deliberately silence the young independent painters.
He also singled out the jurors one by one, commenting sarcastically on their
artistic qualifications, their attitudes, and their voting habits. All this was
omitted in *Mes haines.* Daubigny was the only juror who found favor in
his eyes.

Zola stated his artistic creed lucidly and brilliantly, contrasting his own
views on art with the subject-bound attitude of the public. For the public a
painting is only (as we would express it today) the picture of an object or
the illustration of a story to which the viewer responds either positively or
negatively. For Zola a work of art is the expression of a unique personality,
a "temperament." The work of art, according to Zola, consists of two ele-
ments: the invariable element—nature—and the infinitely variable element—
the artist. There is no absolute beauty in art; if it were not for the individual
artistic vision all painting would simply be photographic. And to his outraged
readers, Zola asserted prophetically that Manet's place would be in the
Louvre.

Mon Salon, presented with all the verve of a courtroom argument, pro-
voked a clamor from the readers of *L'Événement;* it was the third artistic
scandal surrounding Manet within three years. (In 1863 there had been the
adverse public reaction to his *Déjeuner sur l'herbe* shown in the Salon des
Refusés, and, in 1965, to his *Olympia* exhibited in the official Salon.) The

readers' outburst was so vociferous that Zola concluded his series abruptly with a "Farewell of an Art Critic" and resigned from the journal.

In 1867 Zola defined Manet's originality even more clearly in a second study on Manet, which was published over an editorial disclaimer in the *Revue du XIX^e siècle*. It coincided with Manet's one-man show at the Place de l'Alma near the grounds of the Universal Exhibition of 1867. In a statement prefacing the catalogue of this show Manet, like Courbet before him, appealed directly to the public to judge his works as "sincere efforts" to "render his personal impression." He proclaimed the artist's unassailable right and need to exhibit, "the *sine qua non* for the artist," yet he "did not wish to protest."

Zola's analysis of Manet's art put into words what the public, to its shocked disgust, had already perceived in Manet's paintings—that the once indisputable academic laws had been irrevocably broken. Zola explained that subject matter was irrelevant and merely a vehicle—the "pretext" for a work of art; that spontaneity, directness of vision, and painting in broad areas of color directly on the canvas was as valid artistically as careful modeling, once the alpha and omega of painting. While the public remained unconvinced, Zola formulated the modern artist's prerogative—to paint paintings, rather than pictures of objects—which ultimately paved the way for the understanding of nonobjective art.

Whereas in his *Salons* of 1866 and 1868 Zola praised the early works of the artists of Batignolles—the future Impressionists—he remained silent in 1874 when the Société Anonyme des Artistes Peintres, Sculpteurs et Graveurs, etc. held its first epochmaking group show in the gallery of the photographer Nadar in Paris. Granted, Zola's reputation as art critic was so thoroughly discredited that any efforts on his part to get another similar assignment may have been doomed to failure. The Impressionists, however, who had first hoped to enlist his support, found other champions for their art: Théodore Duret (1838–1927) and Louis Duranty (1833–80) were followed by J.-K. Huysmans (1848–1907), Octave Mirbeau (1848–1917), George Moore (1852–1933), Gustave Geffroy (1855–1926), and the editor of four issues of *L'Impressionnisme* in 1877, Georges Rivière.

So much has been written about the Impressionists, their early vilification and ridicule and their subsequent rise to glory, that their story has become legend. The name Impressionists, originally devised in mockery of their works, was derived from Monet's painting *Impression: Sunrise*, which was exhibited in that famous show of 1874. While Monet's choice of the word Impression in the title of a painting may well have been an innovation, the term impression as descriptive of a sensation to be rendered pictorially was certainly in the air. In 1851 Millet had written to his friend and biographer Alfred Sensier that he wanted to paint nothing other than an "impression from nature." Théodore Rousseau, who died in 1867, was called a "seeker of new impres-

sions" by Eugène Fromentin. Théophile Thoré, in 1864, wrote of Corot's *Souvenir of Mortefontaine* that "the impression" was there.

The eight Impressionist exhibitions (1874, 1876, 1877, 1879, 1880, 1881, 1882, and 1886) revealed not only the brilliant pictorial discoveries made by the Impressionists, but also had far-reaching consequences for the artistic life in France. Courbet's one-man shows of 1855 and 1867 and that of Manet in 1867 had set precedents for independent exhibitions, but these were isolated efforts that did not prove feasible under prevailing conditions. Lacking financial support, they had been possible only by virtue of enormous financial sacrifices on the part of the two artists, and resulted in nothing but contempt and jeers from the public and the press.

Independent exhibitions by organized groups such as the Impressionists, however, had a better chance of success because artists within a group were able to absorb more easily the shock of malicious critique. Indeed, the Impressionists quickly became notorious. The vehement pros and cons of Impressionist critique stirred up a greater public reaction than the routine of prizes and medals being awarded to mediocre works year after year in the Salon. The second Impressionist group show of 1876, which was artistically bolder but also more violently attacked by the critics, had already received the backing of the enterprising art dealer Paul Durand-Ruel, in whose gallery it was held. Subsequently Durand-Ruel, whose name is indelibly linked with the rise of the Impressionists, also gave the leading artists of the group one-man shows in his gallery.

Guided by the precedent of the Impressionists, other "radical" or innovative artists formed independent groups and held group exhibitions. The originality of the works seen in the independent shows, such as those put on by the Société des Artistes Indépendants (founded 1884), attracted the attention of the avant-garde critics, while the official Salons, which continued to reject innovative works, gradually became artistically stagnant.

When in 1881 the Minister of Fine Arts declared that henceforth the government would cease to intervene in the conduct of the Salon, the official Salon could not regain its status. Artistic leadership had once and for all passed from the Salon and officialdom to the independent artists. Although the operation of the Salon was transferred to the Société des Artistes Français, which was designated as the officially recognized artists' association in France, it remained nevertheless an institution that was slow to abandon the old established academic teachings.

While the artist thereafter was no longer at the mercy of a conservative art establishment, he was to become dependent on the fluctuations of a free market and had to maintain his objectives in an increasingly competitive society. The critic's role as the interpreter of art became more demanding as the artist, in his search for new modes of expression, arrived at ever more uncommon solutions.

Art criticism in France—the critique of works of art by contemporaries of the artists—has come a long way since its emergence in the seventeenth century. The first critics were the artists themselves who, sanctioned by the government, advanced the artistic doctrines that coincided with the interests of the State. The eighteenth century saw the advent of lay criticism. Critique was fully in step with the art of the time, and, after an initial debate, the critic's position with relation to the artist, the government, and the public was firmly established.

The fragmentation of society in the nineteenth century brought about a split in the arts between academic art and independent art. Government and officialdom aligned themselves with the traditionalists, but critical opinion was as divided as art itself.

The conservative critic, unable to comprehend the aims of the independent painters—the avant-garde—proclaimed the sanctity of official art, whereas the avant-garde critics sided with the independents. But a generation later the previously unintelligible art forms of the avant-garde came to be generally understood and a new avant-garde made its appearance. Broadly speaking, all the uproar surrounding Delacroix, Courbet, Manet, the Impressionists, and the Post-Impressionists in turn arose from this cycle of events, a cycle caused by the simultaneous existence of different levels of art and the clash between the old and the new, the academic artist and the independent artist, the tradition and the avant-garde.

The role of the writers—the intellectual elite of France—in this play of forces had no parallel elsewhere. As active participants in the new movements, as incisive commentators on the artistic scene, as articulate defenders of the innovators, they strengthened the artists in their resolve to assert themselves in the face of a hostile present and to pursue the pictorial realization of their vision.*

* In addition to the relevant titles listed in the bibliography, the following works have also provided useful information for this essay: A. Dresdner, *Die Kunstkritik* (Munich, 1915); R. Janssens, "Les Maîtres de la critique d'art" (*Beaux-Arts* IV, 1934); and C. H. Stranahan, *A History of French Painting* (New York, 1888).

Portrait of King John the Good of France

ca. 1360 tempera on plaster and canvas on panel 23¼" x 14¼" Paris, Louvre

This royal portrait is at the present time the earliest painting of its kind known in Europe. It is . . . the work of an artisan painter. The artist attached a rather thin linen canvas to a wood panel. On this canvas he spread a mastic base of considerable thickness to which the gold background was applied. On this brilliant background he drew the profile with a brush and then created the modeling of the facial features with various colors mixed with a binding medium, perhaps with egg. Once the work was finished, the artist pounded hollow impressions into the surrounding gold ground by means of small tools similar to the kind still used by bookbinders. This painting is an excellent example of the type of work done by the guilds of painter artisans whose statutes had been established in Paris since the middle of the thirteenth century. The technique used by the painter of the portrait of King John was also common in France from the middle of the thirteenth century for painted works applied to furniture and to panels. This is the origin of independent painting. The portrait discussed here is at present the most important of these early movable paintings.

Henri Bouchot. *L'Exposition des primitifs français.*
Paris, 1904, p. 1.

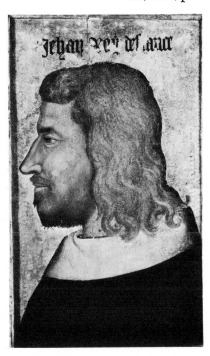

Portrait of King John the Good of France.

1

The idea of reproducing the actual face of an important personality is certainly an ancient one. Donors, clearly recognizable by their contemporaries, and saints given the features of a prince or of a great noble, appeared frequently in stained-glass windows and in miniatures. These were homages stipulated almost always in the contract. From there only one step leads to the isolation of the portrait, to no longer include it with protagonists of religious scenes, and, in short, to create a painting which has no other purpose than to immortalize the traits of a secular personality. But this step is crucial and has immeasurable importance. The appearance of the portrait is a sign of the times. It is indicative of the changing taste of a more or less princely public no longer interested solely in devotional works but also in *man*, in his character, and in his personality. In this monumental bust of the King, painted with large brush strokes and in broad planes, we see the portrait of a man as we imagine him from what we know about the conduct of his life: a man who lives well, a handsome man at the same time sluggish, bold, weak, and insouciant. . . . This is how the portrait bust was born.

Pierre Francastel. *Histoire de la peinture française.*
2 vols. Brussels, 1955, I, 10.

Parement de Narbonne

ca. 1375 brush drawing in grisaille on white silk hanging 30½ʺ x 112½ʺ
Paris, Louvre

This is one of the most interesting French works of art of the fourteenth century which has come down to us. It is neither a miniature nor a painting, but an intermediary work by one of those rather modest artists for whom no task was too small. The man who drew the scenes of the Passion cycle with brush and ink on this piece of silk three meters wide was a master who could have composed a cartoon for a tapestry with life-size figures as well as the exceedingly small miniatures of a manuscript. . . . Various graphic qualities of this work allow us to identify this master as a Parisian artist, or at least as a painter working under the influence of artists of the Île-de-France. The very frail cross of Christ, the halos, the trefoil architectural motifs, the two-headed eagle used to designate the Romans at the time of Pontius Pilate, and the figure of *True Faith* found one hundred years earlier in the sketchbooks of Villard d'Honnecourt, leave no doubt about the Parisian origins of the artist. . . . The supple, curved folds of the drapery are characteristic of the style of Parisian painters of the Île-de-France. They are similar to the drapery found on engraved slab tombs from the same region and the same period.

Henri Bouchot. *L'Exposition des primitifs français.*
Paris, 1904, p. 4.

JEAN MALOUEL

Coming to Paris from the Netherlands province of Gelders, Malouel is documented in 1396 as a painter to Isabeau de Bavière. From 1397 on, he was court painter to the Dukes of Burgundy in Dijon, where he painted altarpieces for the Chartreuse de Champmol. He died in Paris in 1415. The principal work attributed to him is the *Pietà* in the Louvre. The *Martyrdom of St. Denis* may have been begun by Malouel and completed by Henri Bellechose. Around these two works the following paintings have been grouped: a *Lamentation* and an *Entombment* in the Louvre, another *Lamentation* in the Museum of Troyes, and a third formerly in the Berstle Collection, a *Crucifixion* in the Chalandon Collection, and a *Coronation of the Virgin* in Berlin.

HENRI BELLECHOSE

A native of Brabant, Henri Bellechose was active in Burgundy, mostly in Dijon. In 1415 he succeeded Jean Malouel as court painter to the Dukes of Burgundy, working for John the Fearless and Philip the Good at the Chartreuse de Champmol, near Dijon, and the ducal palace of Dijon between 1416 and 1425. Traditionally, it has been thought that he completed Malouel's *Martyrdom of St. Denis* after the latter's death. But in the Louvre catalogue of 1965 this painting is attributed exclusively to Bellechose.

Pietà: The Holy Trinity with the Virgin and St. John

ca. 1400–10 egg tempera on wood 25¼" diameter Paris, Louvre

If we compare the very beautiful *Pietà* with the *Martyrdom of St. Denis* we can easily understand why it has been attributed to Malouel. The relationship between the *Pietà*, the *Martyrdom of St. Denis*, and certain illuminations of the Bibliothèque de l'Arsénal (mss. 623) in Paris has not yet been noted. The idea that certain works of the Chartreuse de Champmol might have been executed in Paris and sent to the Duke of Burgundy stems from the fact that the reverse of the *Pietà* shows the arms of the Duke; this would be superfluous if the picture had been executed in Dijon by Jean Malouel. . . .

Characteristic of the artist to whom we owe the principal works of this group is the exaggeration of the bleeding wounds of Christ, the thinness of the veil covering the nudity of the Saviour, and a certain affectation in the pointed noses and slanting eyes.

Ibid., p. 9.

3

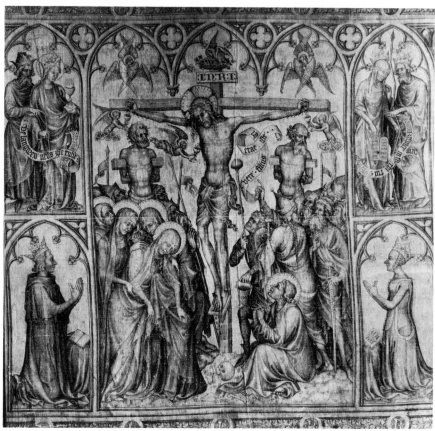

Parement de Narbonne (detail).

The Last Communion and Martyrdom of St. Denis

ca. 1416 panel transferred to canvas 63½" x 82½" Paris, Louvre

This picture is of great importance, for it is the oldest easel painting of which we have objective documentary evidence. We know that Philip the Bold, Duke of Burgundy, commissioned it from Jean Malouel in 1398 for the Chartreuse of Champmol; it formed part of a group of five altarpieces. According to another document published by B. Prost, Henri Bellechose, who had succeeded Jean Malouel as court painter to the Duke of Burgundy, bought "from Jean Lescot, spice merchant in Dijon, the necessary colors to finish a picture of the life of St. Denis." Begun by Jean Malouel, it would thus have been completed by Henri Bellechose. . . . Its composition, utilizing the same decor for two different scenes, is conceived in the ancient manner of the Parisian miniaturists; it could be called a magnified illumination. Here and

4

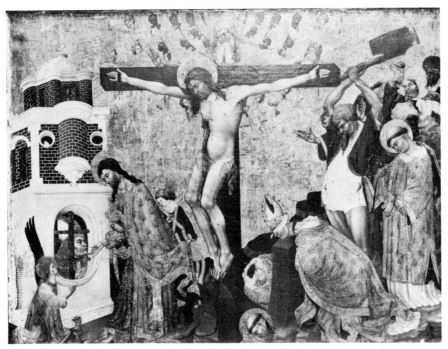

The Last Communion and Martyrdom of St. Denis. *Malouel and Bellechose*

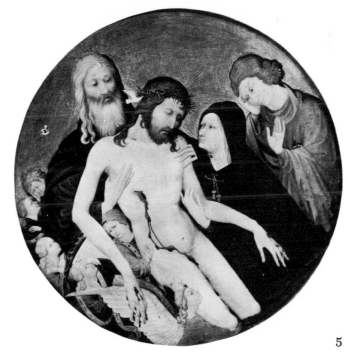

Pietà. *Malouel*

5

there we find Italianate reminiscences in the ornaments of the vestments and in the Lombard architecture of the Saint's prison, but they are of too little significance to accord the work a character other than French. Its design and color may be compared with certain manuscript illuminations for the Duke de Berry: Christ, for example, resembles the figure in the *Très Riches Heures*. The crucifixion in the center is in the tradition of the *Parement de Narbonne*, and we find in the attitudes of the figures a trace of the elegance which had characterized the Parisian school of the mid-fourteenth century.

P. A. Lemoisne in *La Peinture au Musée du Louvre*, vol. I: *École française*. Paris, 1929, fascicle 1, p. 8 ff.

A curious combination of cult image and historical narrative, it shows in the center the crucified Christ and God the Father in a glory of angels. On the left, Christ, clad in the same blue, gold-embroidered pluvial as are the three martyrs, visits St. Denis in the Prison de Glaucin . . . to administer the Last Sacrament in person; and on the right is shown the Martyrdom itself: St. Denis, his head half severed by the "blunted axe," on the block, St. Rusticus lying beheaded on the ground, and St. Eleutherius awaiting execution. The general scheme of this somewhat archaic composition, still faithful to the Byzantine and Italo-Byzantine habit of making the central motif emerge from two symmetrically descending diagonals, is well in keeping with the date of 1398 and with the presumable style of a mature master who had spent most of his adult life in Paris. There is a decorative, almost heraldic spirit in the emphasis on embroidered and brocaded designs, flat areas of bright, clear color, and undulating borders some of which bear ornamental "Kufic" inscriptions—an orientalizing fad of the Sienese which began to make headway in the North about 1400. . . . The movements and expression of the Martyrs and the Saviour are gently restrained and the body of the crucified Christ, remarkable though it is for anatomical insight and for skill in handling the Italian technique of shading flesh with green, is modeled with delicacy rather than vigor. All this, however, is at variance with the savage power and naturalistic directness that can be felt in the upper portions of the picture, especially in the somber figure of God the Father, in the magnificent brute of an executioner, and in the fantastic yet amazingly real group of pagans behind him. Here, I think, we can indeed discern the hand of another artist—a younger man and one who had not undergone the mellowing influence of the Paris tradition and had instead been plunged from his native Brabant into the orbit of Claus Sluter.

It might be objected that the stylistic contrast within the *Martyrdom of St. Denis* can be accounted for by the familiar custom . . . of indicating social or moral inferiority by more naturalistic treatment. The executioner and the onlookers behind him may be thought to differ from the other figures, not because they were painted by a different hand but because they are evil-doers and pagans. There would be, however, no justification in making a

stylistic difference between the First and Second Persons of the Trinity; and no such difference exists in another picture commonly ascribed to Malouel but executed without the participation of a second artist. This picture is the beautiful *tondo*, one of the earliest panel paintings of circular form. . . . It represents the Trinity according to the new, *Pietà*-like form in which God the Father holds the broken Body instead of the Crucifix, and it has been attributed to Malouel, first, because its back bears the arms of France and Burgundy, and second, because it agrees with the *Martyrdom of St. Denis* in several stylistic peculiarities. The childlike, soft-chinned angels' heads are very similar in both pictures, and the dead Saviour in the *tondo*, though even more delicate, is much akin to the crucified Christ in the *Martyrdom of St. Denis*. However, the more convincing these parallels between the two paintings, the more striking is their difference with regard to the depiction of God the Father. In the *Martyrdom of St. Denis*, He looks like a Sluterian prophet with a mighty round skull, ample hair, low forehead and a thick beard depicted as a woolly mass. In the *tondo*, He is a gentle, sad aristocrat with a long, narrow-browed face, sparse undulating locks, and much less abundant beard in which the strands of hair are treated in linear fashion. Both documentary and stylistic evidence thus seem to support the attribution of both pictures to Malouel, provided that we date the *tondo* a little earlier than the *Martyrdom of St. Denis* and that we accept the hypothesis that the latter was finished by Henri Bellechose.

<div align="right">

Erwin Panofsky. *Early Netherlandish Painting.* 2 vols.
Cambridge, Mass., 1953, I, 84 ff.

</div>

MASTER OF THE AIX ANNUNCIATION

The identity of the Master of the Aix Annunciation is still a mystery. Hulin de Loo (1902) believed him to be a Fleming influenced by the Swiss Conrad Witz. Charles de Tolnay traced his style to the Master of Flémalle. Lionello Venturi (*L'Arte*, 1908) related him to Antonello da Messina. Carlo Aru (*Dedalo*, 1931) attributed the Aix *Annunciation* to Colantonio, the Neapolitan who was Antonello's teacher. Jean Boyer (1948 and 1960) has sought to identify him with a painter of stained glass, Guillaume Dombet, and with Jean Chapus, a native Provençal painter who worked for King René of Anjou at Aix. Although art historians now tend to see the Aix *Annunciation* as a French work painted by an artist in King René's entourage, its superior quality would indicate that it was painted by someone other than a local artisan.

This triptych is the only work credited to the Master of the Aix Annunciation. Commissioned by the will of a draper, Pierre Corpici, dated 1442, it was completed in 1445. The center panel, *The Annunciation*, is in the Church of Ste. Marie Madeleine at Aix. The right wing (St. Jerome, with still life above) is in the Musées

The Annunciation (central panel). *Master of the Aix Annunciation*

Royaux, Brussels. The left wing (Prophet Isaiah, with bookshelves above) has been cut in two: the lower part, representing the prophet, is in the Boymans-Van Beuningen Museum, Rotterdam. The still life with books is in the Louvre, on extended loan from the Rijksmuseum, Amsterdam.

The Annunciation

1443 Egg tempera on plaster on wood 61" x 69¼ " (central panel)
Aix-en-Provence, Church of Ste. Marie Madeleine

Shortly before Fouquet reached his maturity, an equally important artist was working in the south of France. This anonymous painter, who produced the altarpiece of *The Annunciation* around 1443, almost certainly came from Burgundy. He began his early training there, influenced by the sculpture of Sluter and by the painting of both Van Eyck and the Master of Flémalle. From the latter he derived the strong sculptural quality of his figures; from the former, the brilliant coloring and interest in *trompe l'œil.* But he is basically different from these Flemish artists in his feeling for the monumental quality

of his form. He is closer to their followers, who worked in Provence. He does not use lighting as a soft encompassing medium, but rather to emphasize the separate volumes and to move the observer throughout the composition in a direct, penetrating manner. His carnations are more firmly modeled than those of the Flemish painters, but the surface of the skin is treated with a richer softness than we find in Italian paintings. His still lifes, the most beautiful of the fifteenth century, combine with a similar originality the architectonic quality of the Tuscan artists with the Eyckian interest in the objects themselves. Like Fouquet, he sees things in a more synthetic way than the northern painters, but more sensuously than the Italians. His vision is thus specifically French.

<div align="right">Charles Sterling. Les Peintres primitifs.
Paris, 1949, p. 64 ff.</div>

The soft glow and subtle translucencies of the colors in the figures of the Angel of the Annunciation and the Virgin, who is wearing a sumptuous mantle of gold brocade (in the French style), are typically Eyckian; the forms, however, are fuller, more roundly modeled. Particularly striking is the way in which this artist has humanized his effigies of prophets, abandoning the old tradition of painting them, in grisailles, as statues set in niches. Standing on pedestals and portrayed in color, these prophets have the look, not of stone figures, but of living beings—an effect enhanced by still lifes of common domestic objects placed on shelves, pots and pans and boxes, books piled up in disorder: details obviously stemming from Van Eyck. Thus we have here a painter who learnt much from the Flemings—though, unlike them, he painted not on oak but on deal—and who most probably had practised at Dijon and there seen Sluter's work. At some time he must have come in touch with Conrad Witz, perhaps at the Council of Basel. . . . He may well have been a Frenchman, and there are several facts pointing in this direction—for example the fact that Mass is being celebrated on an altar adorned with fleur-de-lys. . . .

Though we have no wish to exaggerate their importance, . . . mention should be made of some peculiarities in this artist's treatment of his subject. The fact that he has inserted in the ray of light leading from God the Father to the Virgin a tiny, fully formed babe, the Infant Jesus, may not have the heretical intention that some have read into it (this naïve symbolism had had a precedent in the Mérode altarpiece), but it is odd, to say the least, that a small carved monkey should surmount the reading-desk in front of which prays the Virgin; that a bat and a small demon should figure on the trefoil arch above the Angel of the Annunciation; and that the window at the back is similarly adorned with the heads of devils. Some have thought to detect alongside the traditional lily various malefic flowers such as aconite, belladonna and basil, and in the angel's wings the plumage of that bird of ill omen, the owl. (One

cannot help being reminded of the somewhat sacrilegious flavor of Fouquet's depiction of the Virgin. . . .) Whatever be the explanation of these "eccentricities," one thing is certain: only a painter in high favor with King René or (if the suggestion does not seem too far-fetched) the royal artist himself would have dared to include such background material in his work. It must not be forgotten in this context that King René's writings teem with intricate symbols and bold flights of fancy—in one of his illuminated manuscripts he had himself portrayed as a crowned skeleton! Anyhow it seems hardly credible that the creator of the Aix *Annunciation* was some humble local craftsman, however gifted.

> Jacques Lassaigne and G. C. Argan. *The Fifteenth Century*. Geneva, 1955, p. 69 ff.

JEAN FOUQUET

Jean Fouquet, also spelled Jehan Foucquet, was the foremost French painter of the fifteenth century. He was born at Tours circa 1420. Between 1443 and 1447 he was in Rome, where he painted a portrait of Pope Eugene IV (now lost). On his return to Tours in 1448 he married. He worked for King Charles VII and King Louis XI, who appointed him *peintre du roi* in 1475. Fouquet died in Tours about 1481. His only documented work is the miniatures of the *Antiquités judaïques* by Flavius Josephus (Paris, Bibliothèque Nationale). The *Portrait of Charles VII* (Louvre), *Melun Diptych* (Antwerp and Berlin), the *Self-Portrait* (Louvre), the *Portrait of Jouvenel des Ursins* (Louvre), and the *Pietà of Nouans* (Nouans, Church) are the principal paintings attributed to him.

> There was a very good [master] called Jan van Eyck. He, too, is dead. I think there is a master Roger [van der Weyden] who is very good. There is also a Jean Fouquet; if he is alive he is a good master, especially for doing portraits from life. He did [a portrait] in Rome of Pope Eugene and two of his retainers that seemed to be really alive. He painted this on linen and it was placed in the Sacristy of the Minerva. I say this because he painted it in my time.
>
> Filarete. *Treatise on Architecture* (ca. 1460). 2 vols. New Haven, 1965, I, 120.

> We have said that [the portraits of Fouquet] have the weight and the impenetrability of stone. Their silence of painted figures is more mute than any other silence. No disquiet inhabits their largeness, their authority, their aplomb; no fever makes them tremble. They are like blocks cut in a hard-grained stone with an admirable justness of proportion and plane, and then lightly covered over with the pale colors of life, as if Jean Fouquet, painter royal, had, for some funeral cere-

mony, still continued to color a "persona" made of a heavier and prouder matter than the wax and plaster of a mask. This is what opposes them to the portraits of Van Eyck. The latter is obsessed by the extreme particularly of the unique example and he has at his command an analytical power which makes a sort of magnifying glass of his eye, and almost a graver's burin of his brush. For him, every detail reveals some internal geography, and he envelops them all in a line of silhouette which is no mere floating net, but a deduction calculated from all the accidents of the visage. Thus every face becomes a profile, I mean that its contour outlined against the background becomes an island, isolated in the universe, resembling no other. Each element of the structure thus acquires an astonishing expressive value: the way the eye is inserted in the socket; the drawing, the relief and the formation of the ear, whose auricle, like some strange shell, adds the ornamental excrescence of its own profile to the profile of the head. Here we see the reasons why the *Man with the Wine Glass,* brother to the *Man with the Pink* [by Jan van Eyck], cannot be attributed to Fouquet; and at the same time we become aware of all that separates the analytical portrait (as we may call it) from the monumental portrait.

> Henri Focillon. "Le Style monumental
> dans l'art de Jean Fouquet."
> *Gazette des Beaux-Arts,* January 1936, p. 28.

It is comparatively easy to show the part Fouquet played in the artistic development of his own country. He took a step which proved to be decisive for the French art of the following centuries; for he was the first French artist to bring his country into touch with the Italian Renaissance. In fact, he inaugurated that far-reaching transformation of France from a Gothic to a Latin country. In Fouquet's youth two epoch-making movements had started—in Flanders with the van Eycks and in Italy with the Florentines of the early Renaissance. Fouquet took up both these movements, one after another, in quick succession. No sooner had he adopted the new vision of the van Eycks than he went to Italy (c. 1443–47). He is, in fact, at the head of that long line of Northern artists who went to Rome. . . . Like Jan van Eyck or the Master of Flémalle, Fouquet describes in his portraits individual characteristics with great perspicacity. . . . But in contrast to Flemish portraiture the rendering of individual character is neither the whole content nor the essence of Fouquet's portraits. . . . [Fouquet's drawing of Jouvenel des Ursins] is one of the most searching studies of a human face. . . . The enormous volume of the head fills the whole sheet while the bust is only slightly indicated. . . . In Fouquet's finished portrait of Jouvenel, however, the head loses much of its pre-

dominance and importance. The trunk which is dressed in a volumi-
nous doublet is as conspicuous as the head. The heavy pompous dress
determines the whole pose of the sitter leaving the impression that
his character is formed to a considerable degree by his social rank
and position. The finished portrait of Jouvenel shows that this man
did not really exist apart from his social function; we are confronted
by an individual representative of a certain class of society. This qual-
ity in the portrait is further emphasized by the design of the back-
ground, which is a much more intricate part of the composition than
in a portrait by van Eyck. . . . Curtains, brocades, marble columns and
panels, the familiar *décor* of the courtly world, are all brought to-
gether to give an appropriate setting. . . .

Fouquet has an original contribution to make to the development
of European portrait painting. The portraiture of the fifteenth century,
both in Flanders and in Italy, was chiefly concerned, first with the
microcosm of human physiognomy and secondly with the private
and personal character of the sitter. The strength of Fouquet's por-
traits, however, does not lie here. His men do not stand out as indi-
vidual personalities, they appear merely as part and parcel of their
social environment. This idea of portraying an individual as a repre-
sentative of a specific social group was only generally taken up in
the 16th century with the spreading of Mannerism. Fouquet fore-
shadows and anticipates an art which flourished in the portraits of
Clouet, Holbein, Pontormo, Bronzino and Parmigianino.

Otto Pächt. "Jean Fouquet." *Journal of the Warburg and
Courtauld Institutes*, IV, 1941, p. 86 ff.

Fouquet's art was courtly art; not only was it intended for
courtly patrons and persons of high rank but it served to epitomize the
spirit of the court. It surveyed the world from a height, from the point
of view of the mighty, just as François Villon, the penniless vagabond,
saw it from the depths of his poverty. . . .

Like Jan van Eyck, Dirk Bouts and Hugo van der Goes, like
Pisanello, Fra Angelico, Piero della Francesca, like Conrad Witz,
Stephan Lochner and all his famous predecessors and contemporar-
ies, exponents of the new style of painting, Fouquet, with the precision
of a miniaturist in his care for detail, portrays the world with truthful
clarity. . . .

How much Fouquet combined French mentality with French
feeling for style, how much of his work, like that of all painters of
genius, was prophetic of the future, modern in its appeal, was appar-

ent at the great exhibitions of French art in London in 1932 and in Paris in 1937. Fouquet's Antwerp Madonna with the features of Agnès Sorel is the prototype of such paintings as François Clouet's *Maîtresse au bain,* or the *Gabrielle d'Estrées au bain* and *Sabina Poppaea* of the time of Henri IV, of Pierre Mignard's *Marie Mancini* and Nattier's *Mademoiselle de Clermont,* as well as Fragonard's *Mademoiselle Colombe* and finally David's *Madame Récamier* and Ingres' *Belle Zélie.* The rational, realistic and at the same time idealistic outlines of the art which united him and his followers . . . formed an almost unbroken sequence till the end of the *ancien régime* and even till the Classical Revival. . . . His first known work, the so-called *Diptych of Melun,* reaches a very high level of creative power. . . . The plastic strength of the modelling, the accomplished simplification and the big sweep of outline, the clearcut brilliance and the delicacy of the colour harmonies, and finally the commanding portraiture are all in evidence. The Antwerp Madonna, in view of its monumental strength . . . , can be compared only with the Madonnas of Piero della Francesca. The poetic conception of the Angels of Day and Night, with their brilliant, effective colour, has scarcely ever been so impressively represented. . . .

In the portrait of the donor, Étienne Chevalier, as well as in the portrait of Charles VII and of his chancellor Guillaume Juvénal des Ursins, Fouquet proves himself to be a profound psychologist, unsurpassed by any of the great portrait painters of the 15th century, the century rightly celebrated for the discovery of the human countenance. . . . As one can see in the portrait of Charles VII, whose personality is best known to us, Fouquet depicts not only one side of the sitter but all the different sides of his character, his whole complex nature. An unsurpassed master of theatrical production, he enhances these invisible characteristics with an appropriate setting, . . . the unfathomable monarch who keeps shyly to himself is placed between the half-drawn curtains of his box in church, his hands clasped on a velvet cushion, near, yet inaccessible, separated from mankind by his majesty; the ostentatious chancellor, on the other hand, is posed before a Renaissance background, richly decorated with gilded ornaments. . . .

The self-portrait of Fouquet, painted in grisaille on an enamelled medallion, . . . is the first known self-portrait of a French master and it is the first product of its kind as far as the technique of the enamelling is concerned, a technique which soon afterwards rose to great importance through its use by the School of Limoges.

Paul Wescher. *Jean Fouquet and His Time.* New York, 1947, p. 16 ff.

The Melun Diptych

ca. 1450 oil on wood *left wing:* Étienne Chevalier Presented by St. Stephen
37¾" x 34⅝" Berlin–Dahlem, Museum
right wing: Virgin and Child 37½" x 34" Antwerp, Musée Royal

In said church [of Melun], behind the choir . . . two medium-sized pictures can be seen on rare occasions, painted on wood and closing one into the other. One of the pictures represents the Virgin Mary wearing a white veil on her head and a crown with high fleurons of pearls above. One breast is bared, and she lowers her eyes on a little Infant standing upright on his' feet [*sic*]. Some mean to say that this image represents the features of Agnès Sorel, mistress of Charles VII. The other picture depicts the kneeling figure of said Étienne Chevalier, part of whose name is written in large gilt Gothic letters beside him. He is clothed in a fur-lined red velvet robe and bareheaded; his hands are joined in prayer. Next to him stands St. Stephen . . . who presents him to said Virgin.

The borders of said painting are covered with blue velvet, decorated and enriched all around with regularly spaced, large love knots in the ancient manner, embroidered with gold and silver thread. On each side of the love knots is a large "E," also in the ancient manner, all covered with fine little pearls. Medium-sized medals of silver gilt are set between the love knots. They represent episodes from sacred history, the figures of which are admirably painted.

Denis Godefroy (1661). Quoted in Pierre Champion.
La Dame de beauté, Agnès Sorel. Paris, 1931, p. 140 ff.

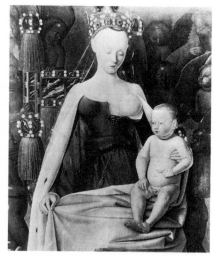

The Melun Diptych: Étienne Chevalier Presented by St. Stephen (left wing). Virgin and Child (right wing). *Fouquet*

All life was saturated with religion to such an extent that the people were in constant danger of losing sight of the distinction between things spiritual and things temporal. . . . In the Middle Ages the demarcation of the sphere of religious thought and that of worldly concerns was nearly obliterated. . . .

The step from familiarity to irreverence is taken when religious terms are applied to erotic relations. . . . No instance of this dangerous association of religious with amatory sentiments could be more striking than the Madonna ascribed to Foucquet, making part of a diptych which was formerly preserved at Melun and is now partly at Antwerp and partly at Berlin. . . . In the seventeenth century Denis Godefroy noted down a tradition, then already old, according to which the Madonna had the features of Agnès Sorel, the royal mistress, for whom Chevalier felt a passion that he did not trouble to conceal. However this may be, the Madonna is, in fact, represented here according to the canons of contemporary fashion: there is the bulging shaven forehead, the rounded breasts, placed high and wide apart, the high and slender waist. The bizarre inscrutable expression of the Madonna's face, the red and blue cherubim surrounding her, all contribute to give this painting an air of decadent impiety in spite of the stalwart figure of the donor. Godefroy observed on the large frame of blue velvet E's done in pearls linked by love-knots of gold and silver thread. There is a flavour of blasphemous boldness about the whole, unsurpassed by any artist of the Renaissance.

<div align="right">

J. Huizinga. *The Waning of the Middle Ages* (1924).
Garden City, N.Y., 1956, p. 156 ff.

</div>

The Melun Diptych—and particularly the section at Antwerp—may be considered as the highest point which our artist reached in those examples of portraiture which may, with reason, be attributed to him. The calm, sophisticated beauty of the Antwerp Virgin is unforgettable in its matchless delicacy and sensibility, and the entire work has an imaginative quality which brings it into line with the greatest pictures of all time.

<div align="right">

Trenchard Cox. *Jehan Foucquet.* London, 1931, p. 54.

</div>

ENGUERRAND QUARTON

Known also as Enguerrand Charonton, Quarton was born (date unknown) in the diocese of Laon. It has been documented that he lived in Provence from 1444 to 1466. Two works have come down to us: the *Virgin of Mercy* (1452; Musée Condé, Chantilly), painted in collaboration with an otherwise unknown artist, Pierre Villatte, and *The Coronation of the Virgin,* painted 1453–54 in fulfillment of a contract discovered and published in 1889 by the Abbé Requin. This altarpiece, one of the most important surviving fifteenth-century French paintings, was first noticed in 1835 by the novelist Prosper Mérimée, who was then Inspector-General of Historical Monuments in France.

The Coronation of the Virgin

1453–54 egg tempera on panel 72″ x 86½″ Villeneuve-lès-Avignon, Hospice

First: There should be the form of Paradise, and in that Paradise should be the Holy Trinity, and there should not be any difference between the Father and the Son; and the Holy Ghost in the form of a dove; and Our Lady in front as it will seem best to Master Enguerrand; the Holy Trinity will place the crown on the head of Our Lady. . . .

Item: The vestments should be very rich; . . . and surrounding the Holy Trinity should be cherubim and seraphim.

Item: At the side of Our Lady should be the Angel Gabriel with a certain number of angels, and on the other side, Saint Michael, also with a certain number of angels, as it will seem best to Master Enguerrand.

Item: On the other side, Saint John the Baptist with other patriarchs and prophets according to the judgement of Master Enguerrand. . . .

Item: In paradise below should be all the estates of the world arranged by said Master Enguerrand.

Item: Below the said paradise, there should be the heavens. . . .

Item: After the heavens, the world in which should be shown a part of the city of Rome.

Item: On the side of the setting sun should be the form of the church of Saint Peter of Rome, and, before said church at an exit, one cone of pine in copper, and . . . a large stairway to a large square leading to the bridge of Sant' Angelo. . . .

Item: Outside Rome, the Tiber will be shown entering the sea, and on the sea will be a certain number of galleys and ships.

Item: On the other side of the sea, will be a part of Jerusalem. . . .

Item: On the right part will be Purgatory. . . .

Item: On the left side will be Hell, . . . and from the part of Purgatory below the mountain will be an angel comforting the souls of Purgatory; and from the part of Hell will be a very disfigured devil turning his back to the angel and throwing certain souls into Hell, given him by other devils.

Item: In Purgatory and Hell will be all the estates according to the judgement of said Master Enguerrand.

Item: Said altarpiece shall be made in fine oil colors. . . .

Item: Said Master Enguerrand will show all his knowledge and skill in the Holy Trinity and in the Blessed Virgin Mary, and will be governed by his conscience.

<div align="right">

Quarton's contract of April 25, 1453, in Elizabeth G. Holt, ed.
A Documentary History of Art. 2 vols. Garden City, N.Y., 1957–58,
I, 298 ff.

</div>

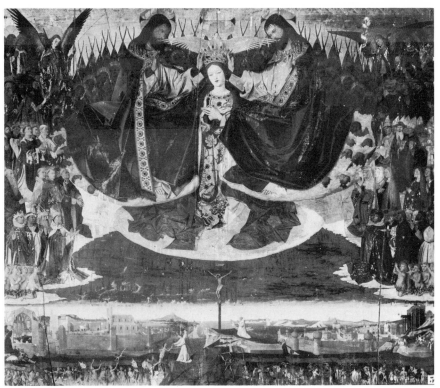

The Coronation of the Virgin. *Quarton*

The hospital of the town [Villeneuve-lès-Avignon] possesses another most remarkable picture of the fifteenth century, representing the Last Judgment. The Father and the Son, in long dark-red robes, occupy the upper part of the composition. Their heads are of the highest beauty. One could not choose a better model to render kindness coupled with majesty. Between them hovers the Holy Ghost with spread-out wings of which the outer edges lightly touch the mouths of God the Father and Son, forming a connecting link. This reminds me of the Eros in Girodet's *Endymion.* Below is the Virgin draped in blue and half wrapped in the cloaks of the two principal personages of the Trinity. A mass of saints and prophets is grouped around the Trinity, not to mention a battalion of red, green, and blue angels and cherubim. This variety of colors among the inhabitants of the heavens is an ancient idea borrowed, I believe, from Mohammed.

It has been said that the painter has bestowed on several of the saints the features of King René's friends, namely of those who remained faithful to

17

him in his misfortune.* Nonetheless, he is placed at the bottom of the picture, among the damned carried away by the devils. . . .

The draftsmanship, though very dry, is admirable, and all the heads, even the smallest, are executed with an amazing perfection. The colors have changed very little, and even the glazes have lost nothing of their brilliance.

<div align="right">

Prosper Mérimée. *Notes d'un voyage dans le Midi de la France.*
Paris, 1835, p. 163 ff.

</div>

The arrangement of the panel recalls the "tympanon" of French Cathedrals, and it has been observed that it is nearer to the romanesque than to the gothic type of tympanon.† There is a striking discrepancy between the upper and lower parts of the picture. The upper part, representing Heaven and Paradise, is carefully elaborated, its large figures solidly built; it is composed symmetrically in a traditional hieratic way. . . . The lower parts—Earth, Purgatory and Hell—are surprisingly unorthodox and original, and it is these parts which make the picture remarkable. Like Hieronymus Bosch, Charonton seems more at home in Hell than in Heaven. The theme sets his imagination free. . . . The composition becomes loose, the execution quick, bold, cursory, sketchy. The colours are set up in short strokes and dots in an almost pointillist manner. The small figures on Earth and in Hell are two-dimensional, without much weight and substance, the tiny souls flying in the dark-blue sky above the Earth, perfectly diaphanous; Christ on the Cross a vision, the donor nearly more ghostlike than the figures of the artist's invention. The most extraordinary feature, however, is the landscape which envelops figures and buildings, the great "Latin" landscape of Provence with the classical silhouettes of its mountains, including the "Montagne Sainte-Victoire," meanwhile immortalized.

<div align="right">

Grete Ring. *A Century of French Painting, 1400–1500.*
London, 1949, p. 31.

</div>

The Coronation of the Virgin is a veritable *summa* expressing the medieval concept of the universe according to French thought. Quarton's vision of Paradise, seat of a proud chatelaine with finely chiseled features and fingers of spun glass, lacks the lyrical, heavenly bliss of a Fra Angelico. It is a multitude of saints and the elect; all classes of society are known to each other, animated by simple expressions of devotion. Purgatory and Hell show man plunged into suffering, but not irretrievably dishonored. The penitents await without haste the time of their deliverance; even the damned are not tortured, grotesquely disfigured creatures; the devils are debonair. Earth, with

* King René I (1409–80) survived the death of two sons and two grandsons, who were murdered.

† See Henri Focillon: *The Art of the West,* 1963, vol. II, p. 185.

the cities of Rome and Jerusalem composed of the streets of Villeneuve-lès-Avignon, has as its background the white rocks and azure sea of Provence. The comings and goings of everyday life enliven the squares, the shops and gray and rose houses, sleepy in the peaceful heat of the Midi. A serene harmony extends over this mystical epoch of man, this Divine Comedy as it is understood in the French civilization of the fifteenth century.

Charles Sterling. *Les Peintres primitifs.* Paris, 1949,
p. 65 ff.

SCHOOL OF AVIGNON (?)

After the departure of the Popes from Avignon in 1377 and the waning of Sienese influence, Avignon became the center of a fifteenth-century Provençal school of painters, among whom were the unknown Master of the Aix Annunciation, Enguerrand Quarton, Nicolas Froment, and the painter of the *Pietà* from Villeneuve-lès-Avignon. This masterpiece, originally the center panel of a large retable, was first shown in the great exhibition of French primitives held at the Louvre in 1904. Attempts have been made to link it with other Provençal artists; Catalan, Portuguese, and Italian characteristics have been seen in its poignancy of expression. Charles Sterling, in an article of 1959, attributed the *Pietà* to Quarton, and the work is thus listed in the Louvre catalogue of 1965.

Pietà from Villeneuve-lès-Avignon

ca. 1460 egg tempera and oil on panel 64" x 86" Paris, Louvre

The highly original composition is perhaps one of the most important factors in establishing the aesthetic value of the picture. Semi-voluminous planes are irregularly balanced on either side of the central mass made by the figures of the Madonna and Christ; there are two figures on the left and only one on the right, but the place of the missing figure is filled by the legs of Christ. The composition flows gracefully from left to right, comes to a perfect equilibrium, and is tied together by the body of Christ. The horizontal sweep of the body is repeated in the enframing curvilinear movement of the other figures and is counterbalanced in the lower section of the picture by the upward curves of the draperies. The design is a compact arrangement of planes in very shallow space, and at first sight the picture appears to be flat. Figures seem reduced to scarcely rounded masses made of large areas of color which are repeated in the smaller planes of the distant buildings and the vaguely perceptible fields and hills. When the picture is viewed from a distance the voluminous character of the figures and the spatial intervals take on greater

19

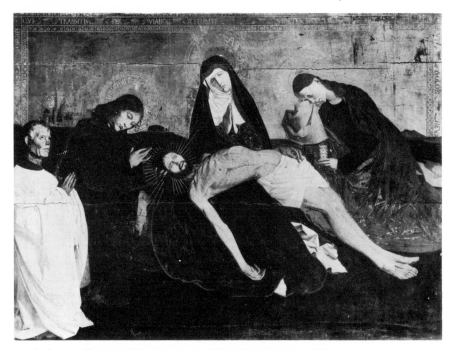

Pietà from Villeneuve-lès-Avignon. *School of Avignon (?)*

emphasis, and the composition extends rhythmically in deep space as well as from side to side. In this movement of alternating masses and intervals, the color, line and light fuse in a unity which conveys vividly the idea of procession.

> Albert C. Barnes and Violette de Mazia. *The French Primitives
> and Their Forms.* Merion, Pa., 1931, p. 252 ff.

The *Pietà* from Villeneuve-lès-Avignon does not fit easily into any history of late medieval art. It is of such a mystifyingly high quality in comparison with the efforts of contemporaries that the world is ready to acknowledge the hand of a genius who so surpassed his age that he hardly seems to have been a part of it. He is joined to that exclusive company of great artists apparently born out of their time, of which Nicholas of Verdun or the Naumburg Master are two other noteworthy members. . . .

In the case of the Avignon *Pietà*, the supreme difficulty in any approach to understanding is found in the absolute lack of documentation. . . . In fact, so completely unattached is it to time or place that any opinion must receive an audience; and only by a localization through iconography and relationships of style can its present unsettled position finally be stabilized. In part this already has been done, notably by Conrad de Mandach in a discussion in the

Monuments Piot of 1909. The article which follows purposes to supplement these earlier findings, re-examining the position of the Avignon *Pietà* in the whole corpus of Provençal painting. Finally the examination of its genesis will be completed by an association stylistically with a little-known but great artist, the Portuguese painter Nuno Gonçalves, author of the two triptychs of St. Vincent now in the Museum, Lisbon. . . .

The stylistic similarities between the Avignon *Pietà* and the two triptychs by Nuno Gonçalves are so conspicuous that the latter work must be taken seriously into a consideration of the problem of the origin of the great *Pietà*. . . .

It is rather in the handling of the heads that the most striking similarities are apparent. One may compare the head of the donor in the *Pietà* with any of the numerous male portraits in the triptych and find not only the same formal peculiarities but also a similar intense psychic feeling. . . .

The Iberian quality of the Avignon *Pietà* has often been noted in contrast to the rather spiritless productions of the rest of Provence. . . . Specific factors in this opinion are: the gold background, the Hispano-Moresque cup, the oriental city in the offing, and the intensity of the religious expression. The first two items may reflect Spanish influence; but at the same time the gold background was regularly employed in Provençal and Niçois *Pietàs*, as the Tarascon panel and the Brea altar of 1475 witness. The Hispano-Moresque ware appears frequently in Provençal works. . . . More difficult to explain is the oriental city in the background at the left. The conception is definitely reminiscent of a Moorish city and must have been based on actual knowledge of such architecture. Such knowledge was easily obtained by anyone who had lived in southern Spain or Portugal. . . .

Lastly, the Iberian intensity cannot be matched in Provence. It stands quite within the realm of possibility that a Spanish or Portuguese master painted the *Pietà;* and, spiritually, the triptychs of St. Vincent are conceived on as high a level of religious expression. . . .

There are, then, no physical difficulties confronting the theory that Nuno Gonçalves is to be closely related to the Avignon *Pietà*. Of a more positive nature is the internal evidence, the very close similarity in portraiture, both in the general impression and the delineation of detail, the profound religious spirit which both exhibit, the markedly Iberian strain tangibly apparent in each, and the numerous minor similarities that the two share, which, when amassed, form a substantial body of evidence in favor of the theory. Whether Nuno's participation was immediate, or whether through some pupil or follower the gleam of his powerful style is seen, remains a question impossible of present answer. We feel sure, however, that the answer will not come through the study of French painting alone: the solution will follow only after a more thorough investigation of the rich possibilities of Portuguese painting.

J. B. Ford and G. S. Vickers. "The Relation of Nuno Gonçalves to the Pietà from Avignon." *Art Bulletin*, XXI, March 1939, p. 5 ff.

The greatest French work of the fifteenth century is also the most mysterious as to authorship and date, the latter ranging in critical opinion from the first half of the fifteenth century to its end. This is the *Pietà* from Villeneuve-lès-Avignon in the Louvre, the finest rendering of the theme in art, not even excepting Michelangelo's great group in St. Peter's at Rome. The beautifully chiseled face of the donor kneeling at the left gives us no clue to the picture's origin; he is not a high ecclesiastic, wearing only the white surplice of a priest. The white of this surplice and of the loincloth of the Crucified and the Virgin's wimple are used in the scene as by Roger van der Weyden to intensify its poignancy, and this together with the gold background and its tooling would indicate a date as early as the middle of the century. Some exotic experience must have suggested the Moslem domes and minarets that contribute, on the horizon, the slight suggestion of a landscape. Some north Italian element in the faces and the picture's silver tone, a symptom of Spain in the incisive thrust of painful accents, the conservative clinging to the neutral field—these mark the work as part of the international "coastal" style that reached from Valencia and Barcelona to Naples. Despite its realism, the theme is pitched in a lofty key: death and sorrow are ennobled, the shocking corpse is transfigured as a symbol, and the final effect is one of serenity and grandeur.

Gothic painting here attains a universal note without the aid of landscape, without resort to abstraction as in Italy, and with no relaxation of its hold on concrete and poignant reality. The picture is in fact an early example of what French writers call the *Détente*—the "relaxation" of the Gothic tight and too promiscuous detail, seeking a broader and more simple style to express a content of more profound significance. It is peculiarly French phenomenon, the resurgence of the *rationale* that organized the variety of High Gothic into the artistic counterpart of St. Thomas's *Summa*.

C. R. Morey. *Medieval Art.* New York, 1942, p. 384 ff.

SIMON MARMION

Active in Amiens, where he is mentioned as having lived between 1449 and 1454, Simon Marmion died in Valenciennes in 1489. Marmion was a miniature painter; the chief easel painting credited to him is the altarpiece of St. Omer.

Altarpiece of St. Omer: The Life of St. Bertin

ca. 1455–59 oil on panel 22" x 58" each panel (right and left wings)
Berlin, Stiftung Preussischer Kulturbesitz

For a long time, and for no apparent reason, these paintings were attributed to Memling. Canon Dehaisnes, who has been able to prove that the

altarpiece, ordered by Abbot Guillaume Fillastre, was executed in Valenciennes between 1455 and 1459, proposes to assign the work to Simon Marmion, an Amiens painter who was already famous at the time when the order was given, and was in Valenciennes at the time of the execution of this altarpiece. At all events the picture is extremely interesting and shows that its author was subject to Flemish influence, but tempered by French tradition. In the arrangement of the picture, in the clarity of the composition, in the simplicity of the physiognomies, and also in the phantasy of certain details, we find certain elements which are clearly French. These could be easily explained by the fact that Marmion was born at Amiens, which had always been directly subject to Parisian influences before the Burgundian occupation. The distribution of the scenes in numerous compartments would lead us to suppose that their author was both a painter and a miniaturist; and this was actually the case with Marmion, to whom, if we admit that he was the author of the altarpiece, must be attributed the illuminations in the "Grandes Chroniques de St-Denis" now preserved at Leningrad. . . . To the same painter we must also attribute another work, the *Invention of the Holy Cross,* in the Louvre. . . .

A very secular freedom is noticeable in this picture, but does not detract from the atmosphere of respect created by the miracle. Fine qualities of naturalness, nobility and grace may be noticed in it, and the sumptuous materials, velvets, brocades and silks, with their brilliant and harmonious colouring, add to the attraction of the painting. . . . M. Édouard Michel,* in a very interesting article, has mentioned other works which it is possible to attribute to Marmion, namely, the *Crucifixion* and the *St. Jerome with Donor,* in the Johnson Collection [now part of the Philadelphia Museum of Art] . . . the *Descent from the Cross* in the Lehman Collection at New York, the *Mother of Suffering* and the *Pietà* in the Museum at Strasbourg.

P. A. Lemoisne. *Gothic Painting in France.* Florence, 1932, p. 97.

NICOLAS FROMENT

Born at Uzès in Languedoc, Froment is mentioned in documents extending from 1450 to 1490. He probably worked in Avignon between 1468 and 1472, and as painter to King René of Anjou after 1475. His documented works are two altarpieces—the *Resurrection of Lazarus* (1461; Uffizi, Florence), and *The Burning Bush* (in Aix-en-Provence).

* "À propos de Simon Marmion." *Gazette des Beaux-Arts,* September–October, 1927.

Triptych: The Burning Bush

1476 oil on wood 161″ x 120″ Aix-en-Provence, Cathedral
center: Virgin Mary
left wing: King René d'Anjou with Sts. Mary Magdalen, Anthony, and Maurice
right wing: Queen Jeanne de Laval with Sts. John, Catherine, and Nicholas
outer wings: Annunciation, in grisaille

This representation of the burning bush, which departs from the text of the Bible and from traditional accounts, was supposedly inspired by King René, "canon of Saint-Victor of Marseilles," according to the formula of the Victorines.* It is obviously a noble thought to symbolize the Virgin Mary as the bush which burns without being consumed. Another artist might have found a mystical subject in this theme in order to put the emphasis on the other-worldly life and aspirations. An artist such as Mathias Grünewald at the beginning of the sixteenth century was able to redeem Christ's body from its earthly existence and to spiritualize it in a supernatural light in the *Resurrection*. But Froment did not have an outlook on life compatible with mysticism. He was too much attached to reality. His Virgin and Child are two creatures who are as close to us as possible. The angel is a handsome adolescent with colorful wings and a magnificent costume. He is similar to the angels Froment saw on stages where the mystery plays of the Redemption were performed and on the platforms decorating town streets during the joyous entrances of kings, governors, and other illustrious personalities.

Froment was even more committed to exactitude in the painting of the wings of this altarpiece. It is impossible to find faces more strikingly realistic, more real in their faults and imperfections, less flattering in their facial expressions. These are certainly exact likenesses of King René and of his wife Jeanne de Laval. . . .

The quality of this triptych is superior to that of the *Resurrection of Lazarus*. Nicolas Froment proves to be one of the best painters of Provence in the fifteenth century, and one whose art did not decline with old age. He remained faithful to Burgundian and Flemish influences. . . .

We should not leave this work without comparing the portraits of the King and Queen to those in the little Matheron diptych in the Louvre. Those in the Louvre diptych are smaller, but their posture and physiognomy are exactly the same as in this altarpiece. The only difference is in the clothes, which are less elaborate and more ordinary. I think it is quite possible to consider the little panels in the Louvre as life studies for the wings of *The*

* The Abbey of Saint-Victor in Marseilles was originally a monastery under Benedictine rule and later a community of secular canons. The Victorines were a religious order that adopted a symbolist view of the universe derived from the teachings of St. Augustine.

Burning Bush altarpiece. There is no doubt that they reveal the same style and that they were executed by the same artist.

<div align="right">

L.-H. Labande. "Notes sur quelques primitifs de Provence."
Gazette des Beaux-Arts, February, 1933, p. 85 ff.

</div>

In the third chapter of Exodus it is narrated that the Angel of the Lord appeared to Moses "in a flame of fire out of the midst of a bush: and he looked, and, behold, the bush burned with fire, and the bush was not consumed." According to mediaeval typology the "Burning Bush" is a symbol of the Virginity of Mary. The miracle of the bush which burned but was not consumed by the flames is likened to the Virgin who conceived by the Holy Ghost without being consumed by the flames of concupiscence.

Literary analogies of the "Burning Bush" with the Immaculate Conception are . . . an ever recurring subject of ecclesiastical poetry. . . . It is only natural, therefore, that it should also appear in the popular typological works of the late Middle Ages: the *Biblia Pauperum* and the *Speculum Humanae Salvationis.* . . .

Nicolas Froment's triptych in the Cathedral of Aix-en-Provence has long been known to belong to this mystical tradition. But an unusual and rather puzzling feature is here introduced: instead of the figure of God or His angel, the Virgin herself with the child appears in the burning bush, while God the Father is shown, as a half-figure, surrounded by angels, in a curved panel above the central scene. From the first, there cannot be any doubt that this is an "emblematic" picture in which not a single detail is accidental. . . .

That the thorny bush of Moses is replaced by a burning rose bush is due to the fact that the rose is again a symbol of Virginity which as such acquired greatest prominence in the cult of Mary in the late Middle Ages. The type of Froment's Madonna sitting amidst a garden of roses is closely related to the well known representations of the "Madonna im Rosenhag." A justification for the use of this type in our context can also be found in ecclesiastical literature. Rabanus Maurus, for instance, compares the immaculate birth of Christ to the growth of a rose on a bush. . . . Yet . . . neither the liturgy, nor the ecclesiastical writers, nor the pictorial examples which we have quoted, give the slightest hint of the appearance of the Virgin on top of the tree. On the other hand this idea is unlikely to be the free invention of a painter—it bears clearly the traits of poetical imagery.

In Guillaume de Deguilleville's romance *Le Pèlerinage de l'âme*, written before 1350, . . . Mary appears . . . in the branches of the mystic apple tree as the symbol of Virginity. Christ himself is the mystic apple. This scene is represented in a number of manuscripts. We may safely say that they furnished the prototype of Froment's picture. In the new context the apple tree was replaced

<div align="right">25</div>

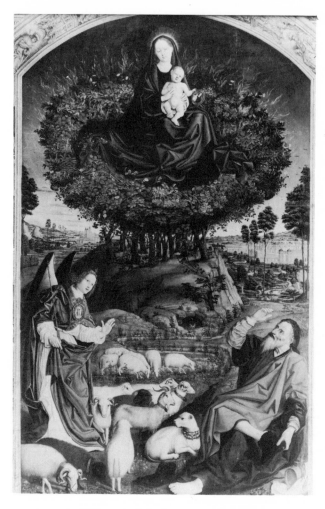

Triptych:
The Burning Bush
(central panel).
Froment

by the burning rose bush, and the female figure of Justice by Moses, the representative of the Old Law. . . .

Enriqueta Harris. "Mary in the Burning Bush."
Journal of the Warburg Institute, I, April 1938, p. 281 ff.

MASTER OF MOULINS

Together with the Master of the Aix Annunciation and the painter of the *Pietà* from Villeneuve-lès-Avignon, the Master of Moulins is the third great anonymous artist of fifteenth-century French painting. In 1902, Hulin de Loo identified him

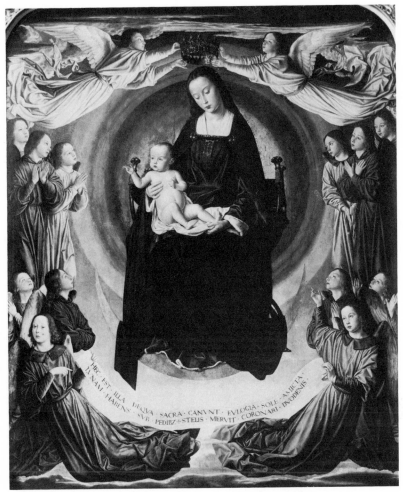

The Moulins Triptych (central panel). *Master of Moulins*

with Jean Perréal, a theory widely accepted for some time but abandoned today. More recently (1946), Paul Dupieux sought to identify him with the stained-glass painter Jean Prévost, a pupil of Perréal. This theory has found much support. Dissent has been voiced by Charles Sterling and Madeleine Huillet d'Istria. *The Moulins Triptych* is his principal work. A number of other paintings have been grouped around it, notably the *Nativity* (Autun), *Donor Presented by St. Maurice* (Glasgow), *Meeting at the Golden Gate* (National Gallery, London), *Virgin and Child* (Brussels), *Portrait of Charles, Cardinal of Bourbon* (Munich), *Portrait of Princess Suzanne* (New York, Lehman Collection), and the portraits of the Duke and Duchess of Bourbon (1488), *Mary Magdalen and a Female Donor,* and *Portrait of a Child* (latter four in the Louvre).

27

At the time of the exhibition of the Flemish primitives in 1902 and of the French primitives in 1904, the art historians classified some related paintings from the end of the fifteenth century into a group and provisionally attributed them to the Master of Moulins, from the name of the triptych in the Cathedral of Moulins. He was then also known as the Painter of the Bourbons, because some of his works had been commissioned by this family at the time of the regency of Anne de Beaujeu and after.

It was supposed that the Master of Moulins must have been Jean Perréal, who was celebrated by the poets of his time but whose works were not known. . . . The proposed arguments were never completely convincing, and one fact could not be explained: there are no paintings of the Master of Moulins dated after 1504, while Jean Perréal was active until 1530.

This hypothesis has been abandoned today, but there is another proposed by M. Dupieux, archivist from the *département* of Allier, . . . which deserves to be considered. He proposes to attribute the triptych of Moulins to Jean Prévost, painter and stained-glass worker in the church of Lyons.

The unity of the works grouped together under the name of the Master of Moulins is now well-established on the basis of a scientific examination. The x-ray photographs of the main works published here by Mme. Hours* add an objective basis to all the earlier, merely subjective studies. This had been neglected up to now: the study of the painter's actual technique as revealed by x-rays. This technique is so exceptional in its precision, so characteristic, so uniform in the course of a career of twenty years, that it alone verifies the grounds for attributing the corpus to the Master of Moulins.

No other painter of the second half of the fifteenth century yields, to our present knowledge, similar x-ray images. Mme. Hours has verified this in the laboratory of the Louvre by examining quite a large number of paintings contemporary with those of the Master of Moulins. We are compelled to admit that the *Nativity* of the Autun Museum, and the paintings of the Louvre—the wings of the Duke and Duchess of Bourbon of 1488, *Mary Magdalen and a Female Donor,* and the *Portrait of a Child,* said to be the second son of Charles VIII†—are to be attributed to the artist who painted the center panel and wings of *The Moulins Triptych.* . . .

The Moulins Triptych, also known as the *Virgin in Glory,* and the

* M. Hours, "Le Maître de Moulins: étude radiographique." *Art de France,* vol. III, 1963, p. 62 ff.
† Also believed to be a portrait of Princess Suzanne de Bourbon.

Portrait of Suzanne are the last known works of the Master of Moulins, dated around 1503. It is just at this time that Jean Prévost died, in 1504.

According to the documents, Jean Prévost was a painter who also worked with stained glass. It is thus tempting to determine whether his style also prevailed in the Collegiate Church [now the Cathedral at Moulins] which is so rich in beautiful late fifteenth and early sixteenth-century windows. . . . Despite the disappearance of some of the grisaille parts, the female portraits in particular are of the same family as the *Mary Magdalen and a Female Donor* in the Louvre.

For us, the unity of the work of the Master of Moulins, confirmed by the x-ray investigation, is to be accepted as a fact from now on. The proposed chronology seems to correspond largely to the evolution of his style from 1480 to 1503. As for the identification with Jean Prévost, it is the most plausible according to the present state of our knowledge, and better founded than the attribution to Perréal. The only evidence lacking are the documents which would formally establish for us that Jean Prévost is indeed the Master of Moulins as we believe.

<div style="text-align: right">

Jacques Dupont. "Jean Prévost, peintre de la cour de Moulins." *Art de France*, III, 1963, p. 78 ff.

</div>

This study disputes the existence of the Master of Moulins and proposes to divide his works among several new masters and various local schools—those of Tours, Moulins, Lyons, and Autun. . . .

For half a century the mysterious Master of Moulins has resisted all attempts at identification, because no one has thought of seeing in him a combination of several French schools related to one another only by their specific late fifteenth-century style, just as is the case with all the sculptured Virgins of the thirteenth or fourteenth centuries.

Henceforth we can no longer assume that all the best French paintings extant from the late fifteenth century are by a single artist, the unknown painter called the Master of Moulins. Nor can we believe that through an inexplicable accident we possess twelve or fourteen works by him, whereas nothing has been preserved by the other great masters mentioned in the documents. . . .

<div style="text-align: right">

Madeleine Huillet d'Istria. *Le Maître de Moulins.* Paris, 1961, pp. 7, 96.

</div>

The appearance of the first monograph on the Master of Moulins[*] ought to be an occasion for rejoicing. . . .

[*] By Madeleine Huillet d'Istria. See above.

But those of us who genuinely love the Master of Moulins . . . will meet only with the greatest surprise and disappointment: they will learn that the Master of Moulins does not exist! More than twelve painters, it seems, are the authors of his works: Jean Bourdichon is responsible for the central part of *The Moulins Triptych* and the *Portrait of Charles Orland;* Jean Prévost for the *Portrait of the Cardinal of Bourbon;* Jean Richier or Jean d'Orléans for the shutters of *The Moulins Triptych;* . . . an artist from Autun for the Cardinal Rolin *Nativity;* . . . three artists from Eastern France and the Lyons district for the Brussels *Virgin and Child*, the Chicago *Annunciation* and the London *Meeting at the Golden Gate.* . . . In short, with the exception of Bourdichon, who is thought capable of having produced two of these works (dissimilar though they are), every painting reveals, according to the author, the hand of a different master.

A bewildering analytical method is used in scrutinizing each work in all its details—a method which, by emphasizing and exaggerating the importance of these details, can only lead to the conclusion that each is independent of every other. . . . The attempt at dismemberment of the *œuvre* of the Master of Moulins is not likely to distress many readers for long. His existence was long ago established through the judicious investigations of a number of art historians. . . . It is clear from an analysis of Mlle. Huillet d'Istria's reasoning that her thesis rests essentially on the splitting up of the panels of *The Moulins Triptych* between two artists. But the concrete arguments brought forward in support of this theory are extremely tenuous.

. . . Undoubtedly the figures on the shutters have received a more realistic treatment than those in the central panel, but the author refuses to recognize in this a desire to effect a contrast between the celestial and terrestrial spheres. How then can she justify her attitude when the inner and outer sides of each shutter reveal a similar contrast? . . . In short, it is the attempt to express two very different worlds which accounts for the slight difference in style between the two elements of the triptych.

Now if one admits the unity and single authorship of *The Moulins Triptych*, the *œuvre* of the master can easily be reconstructed. . . .

In these circumstances, the most convincing hypothesis is still that which identifies the Master of Moulins with the stained-glass artist, Jean Prévost. Originally advanced by M. Paul Dupieux—who, regrettably, coupled it with the first attempt at splitting up the *œuvre* —the theory has since been reiterated on numerous occasions by M. Jacques Dupont. . . .

In 1471 Jean Prévost succeeded his father-in-law, Laurent Girardin, in the appointment of stained-glass artist to the cathedral of

Lyons. In 1498 he relinquished his post to Pierre de Paix, but in the succeeding years his name again appears in account-books, notably in 1502 in Moulins, where he had previously worked in 1490. He died in about 1504. Hence his recorded activity will be seen to encompass fairly adequately the period of the Master of Moulins' *œuvre*, and his qualities as a glass artist could explain certain stylistic affinities between the paintings and some of the stained-glass windows. . . .

Thus it is that Jean Prévost, long known as a glass painter, but studied by relatively few scholars, can perhaps be identified within a reasonable degree of probability with that distinguished artist known as the Master of Moulins. This would in no way diminish the stature of this Master, and it is merely playful speculation to attribute his *œuvre* to ten or more executants. His work shows all the forcefulness of a great creative artist who has succeeded in integrating foreign elements into a style whose originality and continuity are all too clearly manifest.

Albert Châtelet. "A Plea for the Master of Moulins."
Burlington Magazine, December 1962, p. 517 ff.

The Moulins Triptych
[Madonna and Child Surrounded by Angels and Donors (Virgin in Glory)]

ca. 1498–99 oil on wood 61⅞″ x 111⅜″ Moulins, Cathedral
center: Madonna and Child *left wing:* Pierre de Bourbon presented by St. Peter
right wing: Anne de France and her daughter Suzanne presented by St. Anne
outer wings: The Annunciation, in grisaille

This masterpiece of the Master of Moulins is his most characteristically French work. It is composed according to the traditional formula for royal triptychs of the time of John the Good, known to us through copies: the donors and their patron saints are placed against a background of drapery, behind curtains which are symmetrically parted. The composition is monumental, while the color has a decorative effect. It would be difficult to find similar angels in Flemish painting or this touch of aristocratic melancholy expressed in the faces and in the gestures. . . . The combination of elegance and sobriety, which is so French, is characteristic of this painter's style. The patron saints have simple, statuesque stances; there are few other figures in contemporary painting whose natural nobility compares with that of the *Donor Presented by St. Maurice* or *St. Anne* of *The Moulins Triptych.* . . .

Little remains of the art of Hugo van der Goes in this French picture. Already, in the *Nativity* of Autun, the figure types borrowed from Van der Goes lack his robustness. Their fingers are elegant and refined, their skin is smooth and polished. The Flemish master was particularly sensitive to monumental grandeur and often developed his compositions only in one plane in

31

space. However, the composition of the figures in the paintings of the French masters is even more simplified and flattened in depth. The landscape is less weighty and given more space by the clarity of its construction. The folds of the drapery are rigorously logical. The painter of the *Portinari Altarpiece* seems to have borrowed his bold drawing, flowing from a decorative pattern, from the Italian pictures he might have seen at Ghent. However, the Master of Moulins transforms this pattern into a handwriting that is more receptive to the subtle modulations of life. But at the same time he is unable to avoid the elegance of outline completely, and sometimes even gives the impression of a sober, academic approach that makes us think involuntarily of Ingres' purism. A tendency toward roundness of form is perhaps the aspect of the Master of Moulins' style that reveals to us most clearly that he has latinized and softened the northern components of Flemish art.

The Master of Moulins was educated in an artistic tradition very different from that of Fouquet. But he reveals to us with the same authentic evidence the French aesthetic sensibility at the end of the fifteenth century, as the Master of Tours had done for the preceding generation. In the context of a half urban, half courtly civilization, the Master of Moulins brings to an art which is essentially Gothic, and still predisposed to an excess of sensitivity and a rather mundane realism, a spontaneous feeling for life. Yet this is instinctively controlled, and only charm and the most noble refinement emanate from his art.

<div style="text-align:right">

Charles Sterling. *La Peinture française: les peintres du moyen age.* Paris, 1942, p. 45.

</div>

JEAN BOURDICHON

Jean Bourdichon was born 1457 in Tours. He worked for King Louis XI and was appointed *peintre et valet de chambre du roi* in 1484 during the regency of Anne de Beaujeu. Bourdichon worked subsequently under Charles VIII, Louis XII, and Francis I. He died in his native city in 1521. The illuminations of the *Hours of Anne of Brittany* (Paris, Bibliothèque Nationale) are his chief documented work.

Jean Bourdichon was completely unknown until the middle of the nineteenth century. The *Hours of Anne of Brittany* were admired, but they were attributed to Jean Povet, a miniaturist of Tours, who was somewhat famous in his lifetime. In 1868, some old documents were discovered in Lyons proving without doubt that the artist of this masterpiece was not Jean Povet, but Jean Bourdichon. This was an order of payment signed by the Queen and worded as follows: "To our dear and esteemed Jean Bourdichon, painter and *valet de chambre*

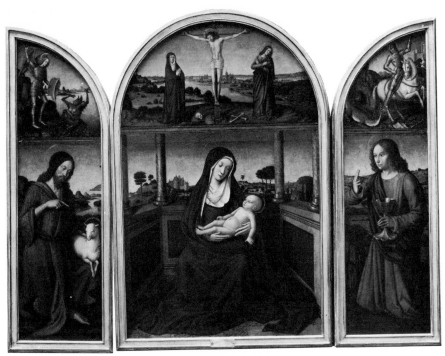

Triptych: Virgin and Child. *Bourdichon*

to the King, the sum of one thousand fifty pounds of Tours and six hundred *écus* of gold . . . for a magnificently and sumptuously illustrated and ornamented large Book of Hours for our use."

Thus this *Book of Hours of Anne of Brittany* was to become the starting point for research to attribute other manuscripts to the same master. . . . I published all these results in the *Gazette des Beaux-Arts* in 1902 and 1904.

At the same time the archives revealed new aspects of Bourdichon's activity. . . . He was also commissioned to create a plan for the town of Caudebec, to make a death mask of St. Francis of Paula, to produce a model for new money for Nantes, to design a reliquary and candelabra for the Sainte Chapelle of Bourbon-l'Archambault, and finally to design banners. But it was not forgotten that he was above all a painter. He received commissions for paintings. He painted a Virgin seated under a canopy carried by angels. In another painting he represented King Charles VIII listening to a sermon by his favorite preacher, Brother Jean Bourgeois. He also painted the portraits of Charles VIII and of Anne of Brittany. Have all the paintings of Bourdichon disappeared? A portrait of the dauphin Charles in the Beiste-

gui collection has been attributed to him, not without reason. . . . A portrait of his younger brother in the Louvre may also be by the same hand. A painting in the church of St. Antoine of Loches depicting the Passion has been attributed to Bourdichon. It has been suggested that some of the facial traits are those of relatives of the master and also that the three letters F I B would signify *fecit* Jean Bourdichon. But these propositions are not very convincing, and we still need a critical examination of the Loches *Passion*. . . .

A rather recent discovery should be mentioned here. M. Jacques Dupont has published in the *Monuments et Mémoires de la Fondation Piot*, vol. XXXVII, a triptych by Bourdichon which is in the Naples Museum. The attribution is certain. Would Bourdichon have gone to Naples? M. Dupont does not think so, and I agree with him. Perhaps the painting was sent from France to Frederick of Aragon to show him the artist's talent. Perhaps the King had asked him to illustrate his book of hours and Bourdichon had sent the illuminations from Tours.

<div style="text-align:right">

Émile Mâle. "Jean Bourdichon." *Verve*, IV, nos. 14–15, 1946, p. 9 ff.

</div>

JEAN PERRÉAL

Born about 1455, Jean Perréal, or Jean de Paris, was a resident of Lyons in 1483 and court painter to the Bourbon family. After 1496 he was in the service of three kings—Charles VIII, Louis XII, and Francis I. Throughout his life he prepared the triumphal entries of kings and rulers into Lyons. Three times Perréal accompanied Louis XII to Italy, where he met Leonardo da Vinci, who mentioned him in his *Notebooks*. In 1501–2 he designed the tombs for Francis II of Brittany and his wife, parents of Anne of Brittany, but the relationship between his designs and the sculptures executed by Michel Colombe remains obscure. After the death of Anne of Brittany, whose funeral he directed in 1514, he was sent to England to supervise the wedding preparations of Mary Tudor, who was to become the bride of King Louis XII. In 1515 he was in charge of the King's funeral. During the 1520's he worked on new fortifications for the city of Lyons. His last documented assignment was to supervise the repair of the castle of Melun. Perréal died in 1530. For a long time art historians identified him with the Master of Moulins, but now the principal painting attributed to him is the portrait of Louis XII in Windsor Castle.

On a superficial reading the biography appears to provide the perfect record of a successful court painter's career. And yet, reading the documents carefully, . . . one cannot help noticing a strange discrepancy between Perréal's privileged social position and the comparatively

humble tasks he was almost always called on to perform. Great artists of the past had fulfilled still humbler tasks; they had coloured and gilded statues and death masks, painted shields and banners, invented patterns for metal ornaments, with the same assiduity and pride which they applied to the creation of their great altarpieces. But the time of the Gothic artisan had gone, and Perréal, the friend of the humanists Jean Lemaire and Cornelius Agrippa, was a child of a new age. . . . He expounded the Renaissance man's ambitions and ideals, emphasising his belief in the importance of the artist's mission. Perréal aimed as high as his transalpine colleagues, some of whom he met when accompanying his royal master to Italy. Perréal's letters and his entries in the archives are, in fact, one interminable complaint that he was insufficiently understood and appreciated, and, of course, not well enough paid. He emerges as an early example of the "frustrated artist," full of bitterness and unrealised aspirations. The greatest task that had ever come his way, to design and supervise the tombs of Brou for Margaret of Austria, miscarried after a short period of apparently satisfactory collaboration. Already in 1512, eighteen years before his death, Margaret informed the artist that his services were no longer required. Perréal persisted in ignoring his dismissal. . . .

It seems indeed unreasonable to imagine that the "Maître de Moulins" could have suffered a rebuke of the kind which Perréal had experienced. . . . *The Moulins Triptych*, as well as the other works attributed to the great anonymous artist, convey the impression of a singularly well-balanced mind, capable of realising his visions to his own and to others' complete satisfaction. It is senseless to identify this artist, the model of harmony and poise and, if anything, rather too unproblematic, with the writer of Perréal's notes and letters.

<div style="text-align:right">

Grete Ring. "An Attempt to Reconstruct Perréal."
Burlington Magazine, September 1950, p. 256 ff.

</div>

King Louis XII

1514 wood 12″ x 9″ Windsor Castle, England

The King of France is here represented not as the successful military leader . . . but as a prince worn with years. Wrinkles have marked his features and hardened his expression. The lower part of the face is heavy, the chin double, the eyes baggy. The long hair frames in a mask which seems stiffened from illness. The long nose, the slightly pinched mouth, and above all the peculiar formation of the join between the top of the nose and the eyebrows are all characteristic of Louis XII's features. The face is pale under the black cap with its gold medal, but is livened by the steely grey, piercing eyes. The gold chain of St. Michael hangs over a richly brocaded dress.

King Louis XII. *Perréal*

In its simplicity and its deliberate harshness this portrait is true to the tradition of French painters, whose habit was to depict their sovereigns not with pomp and a display of attributes but with a disarming and intimate sincerity. Jeaṅ le Bon, as he was painted, it is said by Girard d'Orleans . . . Charles VII, . . . as seen by Jean Fouquet, Louis XI, as he appears in the profile of the Friedsam collection, New York—all these sovereigns are treated without flattery by their portraitists. . . .

The portrait of Louis XII differs in one important respect from those of his predecessors. The artist no longer uses light in the manner of the primitives but models his forms in terms of subtle shadows, as did the painters of Milan. Naturalism of conception and Italianism of execution are therefore the particular characteristics which distinguish the Windsor portrait of Louis XII. . . .

Jean Perréal, called Jean de Paris, remains one of the most irritating puzzles of French art at the end of the fifteenth century. Official painter to three Kings, . . . praised by contemporary poets as the equal of Jan van Eyck, Fouquet, Rogier van der Weyden, Gentile Bellini, and Leonardo da Vinci, an admirable letter writer, a lover of intrigue, on terms of familiarity with the great, a dabbler in alchemy, Perréal was the type of the Renaissance man of culture. But of his work in painting, so often mentioned and so often praised, we know nothing. . . .

Jacques Dupont. "A Portrait of Louis XII Attributed to Jean Perréal."
Burlington Magazine, September 1947, p. 236.

JEAN CLOUET

The origin of Jean Clouet, also called Janet or Jehannet, is uncertain; he probably came to France from the Low Countries. He is first mentioned in 1516 as one of the painters to Francis I. After the deaths of Jean Bourdichon and Jean Perréal, he became, in 1533, *peintre et valet de chambre du roi*, the highest rank accorded a painter at the French court. Clouet, who was active in Paris and Tours, died in 1540. No signed works have come down to us, but about 130 chalk portrait drawings made between 1515 and 1540, now in the Musée Condé at Chantilly, are traditionally attributed to him. These form the basis for the few paintings assigned to him, notably *Guillaume Budé* (New York, Metropolitan Museum), *Man with a Volume of Petrarch* (Windsor Castle), *Francis II as a Child* (Musée Royal, Antwerp), and the *Portrait of Madame de Canaples* (National Gallery, Edinburgh). The well-known *Portrait of Francis I* (Louvre) has been attributed to him since the seventeenth century, but the attribution is now considered doubtful.

There was also Janet, who was an excellent portrait painter. His portraits of Francis I and Francis II can be seen at Fontainebleau. In the library of M. le Président de Thou* were several portraits of the principal nobles who lived at that time. He [Janet] painted equally well in oil as in miniature.

> André Félibien. *Entretiens sur les vies et sur les ouvrages des plus excellens peintres.* 2 vols. Paris, 1685–88, I, 706.

In the eyes of the historian of art, the great abundance of portraits is the original and interesting feature of this period of the accession of François I. Nothing like it had been known before, and we must wait till the year 1515 to see the very extraordinary development of this branch of the art. Paintings innumerable and drawings by the thousand have survived from that age, to hand on to the remotest posterity the features and the form of all the noteworthy people of the time, in the state as well as at court. In spite of widespread destruction, still further increased by the revolution of 1789, the quantity that remains is surprising. . . . Not all these specimens dated back to the time of François I.; but this vast number was a result of the fashion which came then into vogue and was destined to last throughout the whole century.

The result of this rage for portraits was that people were not content with the necessarily limited number of originals. The works of

* Thou, who died in 1544, was President of the Parliament of Paris. However, the owner of the celebrated library was his grandson, the historian Jacques Auguste de Thou (1553–1617). The library was dispersed in 1679.

37

the masters of the time were copied and recopied a hundred times, often by unskillful . . . hands. This was the case not only with the portraits of kings and queens, which have been multiplied thus in all ages, but with those of any one at court—a feature which is peculiar to the period under consideration. Not even the number of painted portraits and painted copies was enough: there was a demand for quicker and cheaper satisfaction. The original chalk-drawings were copied, in the same medium, an infinite number of times, far oftener, indeed, than the paintings; and these drawings were commonly bound into albums and preserved as family treasures.

The manner in which this kind of work was carried on is now proved. Janet used to visit all these sitters in their own houses and draw portraits of this nature with the greatest care in coloured chalks. That finished, the model had sat for the last time. The oil-portrait was executed in the studio, working from the drawing only; manuscript notes used sometimes to direct the choice of colours. During this part of the work new accessories were added at need, and this fact prevents our regarding these drawings as portraits commissioned for their own sake or as anything more than preparatory studies. In addition to these changes the painter would add, in the studio, the hands, a book, or some drapery.

<div style="text-align:right">Louis Dimier. French Painting in the Sixteenth Century. London, 1904, p. 27 ff.</div>

The Clouets are, one may say, quite a recent discovery. Less than eighty years ago it was still thought that there was but one Clouet. . . . All portraits between the years of 1500 and 1620 were ascribed to François Clouet irrespective of style. . . .

It was not until 1852 when M. de Laborde published his *La Renaissance à la Cour de France* that the Clouets were differentiated, and their separate lives placed in some semblance of order. Since then much new information has been gained, notably by Jal, Bouchot, Dimier and Moreau-Nélaton. But it is still to Laborde that we must turn for the bulk of our knowledge, which even now is of an extreme paucity when we consider in what a prominent position, and at what an important artistic period both Jehannet and François lived. . . .

It is indeed wonderful that Jehannet should so clearly have maintained his position, when we consider how widely different is the spirit of his work and style from that of the exciting movement which was spreading over France from Italy. . . .

François, . . . though not so vital an artist as his father, became so popular that the old Janet was entirely forgotten in the new. He was certainly a more able draughtsman than Jehannet, but it was the abil-

ity of a recipe well learned. He knew beforehand what he was going to say, and consequently drew his sitters more as he thought they should be than as they really were. Jehannet, on the other hand, had to start afresh with each new sitter, taking his idea and composition from the inspiration of the moment, thus arriving at a more life-like portraiture.

H. S. Ede. "Authenticated Information Concerning Jehannet and François Clouet."
Burlington Magazine, March 1923, p. 111 ff.

Man with a Volume of Petrarch (Claude d'Urfé)

Oil on wood 14¾″ x 12¾″ Windsor Castle, England

The *Claude d'Urfé, Seigneur de Châteauneuf*, is Jean Clouet's finest work. Its design and technique is based on Holbein, who is the outstanding influence on father and son. It can be described better as coloured drawing than as painting, for the head and hands are modelled with grey black shading, in the manner of a drawing, and coloured over evenly with pink: the dress is entirely black, and the background is filled in last with some thick resinous medium coloured a uniform blue, not the brilliant azurite of Holbein, but an opaque colour imposing only by its contrast with the rich black of the dress. The features are treated with so unusual a breadth that they arrest and astonish the observer. Here is one of the most poetical of small portraits. It is the same

Man with a Volume of Petrarch
(Claude d'Urfé).
Jean Clouet

with the composition as a whole: the handling is timid and clumsy, but the design is broad and bold. It thus has a decorative success which is typical of this whole school of portraiture and makes up in its gay assurance for all manner of crudities to be found in the minor artists and in the Clouets themselves.

<div align="right">

Philip Hendy. "French Painting in the Sixteenth Century." *Apollo*, III, 1926, p. 50.

</div>

FRANÇOIS CLOUET

Son of Jean Clouet, François Clouet was born in Tours about 1510. He is first mentioned in 1541, as succeeding his father as *peintre et valet de chambre du roi*. He was in the service of four kings—Francis I, Henry II, Francis II, and Charles IX. Since father and son were both known by the name Janet, and since François, moreover, is believed to have directed a large workshop, attributions of works to either artist have varied. François Clouet's *oeuvre* is now based on three uncontested paintings—the portraits of *Charles IX* (Vienna) and *Pierre Quthe* (1562; Louvre), and the *Lady in Her Bath* (Washington, D.C., formerly Cook Collection). François Clouet died in 1572.

> I bear her portrait in my heart,
> Her smiling face, her graceful stance,
> Her hair, her eyes, her lips apart,
> Her kindly words, her tender glance.
>
> Only Janet, the glory of our France,
> Could draw her better with his art
> Than Cupid draws his bow and plants
> His piercing arrows in my heart.*

<div align="right">

Pierre de Ronsard.† "Livre des amours (1552)." *Œuvres complètes*. Paris, 1923, p. 226 ff.

</div>

* *Je sens portrait dedans ma souvenance,*
Ses longs cheveux, et sa bouche et ses yeux,
Son doux regard, son parler gracieux,
Son doux maintien, sa douce contenance.

Un seul Janet, honneur de nostre France,
De ses crayons ne la portrairoit mieux,
Que d'un Archer le trait ingénieux
M'a peint au cœur sa vive remembrance....

† Ronsard also composed a long poem entitled *Élégie à Janet, Peintre du Roy* which describes a nude as painted by François Clouet.

"I bear her portrait"—no painter in the world could portray his beloved so well; as we say, to carry a portrait in one's heart. "Only Janet"—Janet, painter to the King, undisputedly the foremost master in his art.

<div style="text-align: right">

Marc-Antoine de Muret. Commentary on the above poem
in the 1553 edition of Ronsard's "Livre des amours."

</div>

The Clouets had neither a Vasari, nor a Karel van Mander.* They lived in France at a time when French painters were no prophets in their own country; we must reconstruct their lives and works from fragments. Jean Clouet and his rival in Lyons, Corneille, came from Flanders. The Flemish procedures which they brought with them produced, when combined with the French tradition, a very special art. This was the representation of the human face—the art of portraiture.

It was François Clouet who brought this art to its apogee in France, even though he had lost, to some extent, the naïveté and freedom of his predecessors. To use a metaphor—the earlier masters retained their foreign accents while speaking the language of their adopted country, whereas François Clouet spoke French in all its purity.

<div style="text-align: right">

Henri Bouchot. *Les Clouet et Corneille de Lyon.*
Paris, 1892, p. 3.

</div>

François Clouet was essentially a court painter. He had all the qualities and defects of one, the flexibility, virtuosity, eclecticism, and also, at times, the superficiality and slightness. . . . François Clouet was the contemporary of the great Italians of Fontainebleau, having known them at an early age. (His father Janet's art, on the other hand, was fully formed by the time Rosso and Primaticcio dominated the court.) Clouet caught some of the reflections of their Italianism, and the last traces of his heritage from Flemish art and Fouquet were extinguished.

The younger Clouet was a man of another generation, another epoch. He belonged to the school of Fontainebleau and we can justly attribute to him the anonymous *Bath of Diana,* in the Museum of Rouen, a painting characteristic of that moment in the history of French art when Flemish painters came to Fontainebleau to work side by side with the Italians. François Clouet lived to see the deaths of Rosso and Primaticcio; he was familiar with the landscapes of

* Flemish painter (1548–1606) and author of the *Schilderboek* (1604), the best early source on Northern painters.

Niccolò dell'Abbate. His technique thrived on all the styles of painting he saw practised around him—the style of the Florentines, still tinged with mannerism, the *maniera grande* of the Romans, the dramatic realism of the painters of the Low Countries under Italy's tutelage. The skill bequeathed to him by his father, the sturdy medieval honesty, and the simplicity of the local tradition which he had learned from Fouquet, were enriched by his further acquisitions. . . .

The Clouet of the royal portraits, the Clouet of the chalk drawings, was a man completely free from any Italian or Flemish influence. . . . His painted portraits show no trace of Gothic timidity or of Flemish absorption with detail, tendencies still retained by his father, Janet. He harmoniously combined realism with a grand manner which, though failing to attain the monumentality of Fouquet, is on a level with the finest Italian contemporary portraits. This is particularly true of his portrait of the humanist Pierre Quthe, where the powerful and restrained coloring and quiet grandeur produced a work of exceptional beauty. . . .

Clouet, in painting his friend Quthe, was able to free himself from the restrictions that normally inhibited the court painter. He was at liberty . . . to surround his model with an air of intimacy—impossible in the frigid atmosphere of official portraits. . . . It was not merely because he knew the botanist more intimately that he could better express the spirituality of the sitter, but also because this learned citizen was a man with no official function; in state portraits, on the other hand, the "function" of the sitter covered the face like a mask, stylizing and idealizing it, as is ultimately seen in the amazing *Francis I on Horseback*, in the Uffizi, certainly the masterpiece of Renaissance state portraits. . . . We can understand the vast difference which separates this portrait, where the subject has been idealized to an extreme so as to give full expression to the glamor of the royal myth, from the portrait of Quthe, where the only concern is to render *truth.*

<div align="right">

Marcel Brion. *Lumière de la Renaissance.*
Paris, 1948, p. 153 ff.

</div>

The general admiration that the Clouets have enjoyed for the last fifty years is directed toward the gallery of faces rather than the artists themselves. . . . To tell the truth, the chalk drawings of the Clouets are less admirable when compared with their antecedents than when seen in relation to the works of their contemporaries in the same medium. There exist magnificent, never equaled portraits by Van Eyck. . . . Fouquet has left some chalk drawings which far surpass those of Clouet. . . . Holbein and Dürer . . . both created works of superior stylistic quality in this medium. Clouet as an artist does not

come near that level; his technique is workmanlike, he lacks the bold sweep which imposes the artist's vision and style on the spectator. The drawings of Holbein and Dürer are minor masterpieces, appreciated by the limited circle of the artists' admirers or their sitters' friends. Clouet's portraits produced, in a society at the point of organizing itself into a modern state, the spread of a certain physical ideal linked with certain moral qualities. Clouet's greatness lies less in his art than in his role as the interpreter of a living society. . . . He preserved the image of the fashions of the French court, cast in a stylized form, as did his rival Corneille. From the reign of Francis I the French *gentilhomme* has become one of the typical characters of his era.

Pierre Francastel. *Histoire de la peinture française*. 2 vols. Brussels, 1955, I, 66 ff.

A Lady in Her Bath
[Diane de Poitiers]*

oil on wood 36¼" x 32"
Washington, D.C., National Gallery of Art, Samuel H. Kress Collection

She is seated in the bath, along the rim and across the end of which is a white cloth; a dish of fruit stands on a board laid across the bath; on it she rests her right hand holding the stalk of a carnation. She is nude to the waist, her body turned to the left, her face looking out at the spectator. Dark green cap, lined with white silk, the edge of which is trimmed with gold. A jewel is in the middle of her forehead, an earring in her right ear. The child, whose head and hands only are seen, clutches at the fruit. Near by, towards the left of the composition, is a woman nursing her swaddled child. In the centre of the background a maid-servant, wearing a low-cut blue dress with red corsage, clasps a large jug. By her side a chairback worked with the design of a unicorn dormant under a tree on a red field. A framed picture hangs on the wall, and a "landscape" is let into the overmantel. Branches of a tree seen through the open window on the left. A rich red curtain is looped up on either side of the front part of the picture to reveal the figures beyond.

M. W. Brockwell in Herbert Cook. *A Catalogue of the Paintings at Doughty House, Richmond.* 3 vols. London, 1915, III, 44.

One of the most important works belonging to the French School of the sixteenth century is Sir Frederick Cook's so-called *Portrait of Diane de Poitiers.*

* Traditionally identified as a portrait of Diane de Poitiers, the favorite of Henry II, it is more likely to represent Marie Touchet, the mistress of Charles IX. (Cf. Anthony Blunt. *Art and Architecture in France, 1500 to 1700.* Baltimore, 1954, p. 69.)

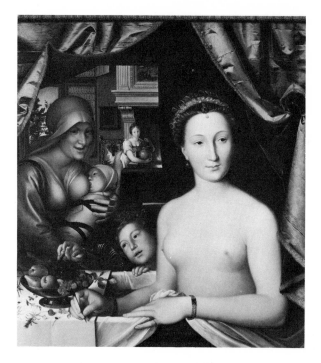

A Lady in Her Bath.
François Clouet

This is superbly signed "FR. JANETII OPUS"—*i.e.*, the work of François Janet (or Clouet). All the same, it is not until the recent discovery of a signed and dated portrait of the botanist Pierre Quthe . . . that the authenticity of this wonderfully finished piece, unique of its kind and certainly the original of countless repetitions and adaptations, has been completely established. Hitherto we have not known François Clouet as an Italianising painter . . . and what is more, we are compelled to doubt if the most masterly and charming of all "Clouets"—the *Elizabeth d'Autriche* of the Louvre—can be by the same hand. Though the painter of this "Diane de Poitiers" is the reverse of imaginative or profound, we may and must admire the extraordinary neatness and clearness of his execution, and the singular elegance, the perfect taste, with which he has depicted this figure of an *élégante* of the later French Renaissance, elaborately *coiffée* but completely undraped. The question obtrudes itself: Does this *Lady in the Bath* really represent the ever-fresh and, even in late maturity, still beautiful mistress of Henri II, Diane, Duchesse de Valentinois? She would have been about fifty at the time when Clouet painted this fantastic piece, and the slender, perfectly shaped *Lady in the Bath* cannot have counted more than twenty-five summers at the utmost. Does flattery so far go? Moreover, the best authenticated among the fair Diane's portraits, the marble Diana, by Jean Goujon . . . now in the Louvre, does not agree particularly well with the exquisite bather portrayed in the panel which comes to us

44

from Richmond. All that can be said is that both divinities depend entirely for adornment on their ingenious and imaginative *coiffeurs*, and owe absolutely nothing either to ladies' tailor or even to *chemisier*.

<div align="right">

Claude Phillips (1911) in *ibid.*, III, 45.

</div>

CORNEILLE DE LYON

Corneille "of Lyons" was born in The Hague and became a resident of Lyons before 1534. In 1541 he was recorded as court painter to the dauphin, the future King Henry II, and in 1551 as *peintre et valet de chambre du roi*. He was naturalized in 1547 and lived in Lyons until his death about 1574. The portraits ascribed to him are based on works (now in the Louvre and at Versailles) collected in the seventeenth century by Roger de Gaignières, who still knew them as painted by Corneille. They are small half-length portraits of members of the French court, mostly on green backgrounds, painted on wood with thin, clear colors. Corneille de Lyon is mentioned in several sixteenth-century sources. The best-known of these is the episode (see below) described by the French chronicler Brantôme (1540–1614), which took place about 1564.

> I remember that one day [in June 1564] at Lyons she [Queen Catherine de' Medici] went to see a painter named Corneille, who had painted in a large room all the great seigneurs, princes, cavaliers, queens, princesses, ladies of the Court, and damoiselles. Being in the said room of these portraits we saw there our queen, painted very well in all her beauty and perfection, apparelled *à la Française* in a cap and her great pearls, and a gown with wide sleeves of silver tissue furred with lynx,—the whole so well represented to the life that only speech was lacking; her three fine daughters were beside her.[*] She took great pleasure at the sight, and all the company there present did the same, praising and admiring her beauty above all. She herself was so ravished by the contemplation that she could not take her eyes from the picture until M. de Nemours came to her and said: "Madame, I think you are there so well portrayed that nothing more can be said; and it seems to me that your daughters do you proper honour, for they do not go before you or surpass you." To this she answered: "My cousin, I think you can remember the time, the age, and the dress of this picture; so that you can judge better than any of this company, for you saw me like that, whether I was estimated such as you say, and whether I ever was as I there appear." There was not one in the company that did not praise and estimate that beauty highly, and say

[*] The painting described here is lost.

that the mother was worthy of the daughters, and the daughters of
the mother.

Pierre de Brantôme. *The Book of the Ladies* (after 1584).
Boston, 1899, p. 51 ff.

The origins of the history of the portrait in France escape us
altogether. The mystery is not limited to Jean Clouet alone. While
Clouet was flourishing in Paris . . . another painter from the Low Coun-
tries, also devoted to the art of portraiture, appeared suddenly in
Lyons, also seeking his fortune in France. We know neither for what
reasons he settled there, nor what his beginnings were in that city. . . .

It is not known whose pupil Corneille was. According to the pres-
ent state of our knowledge he appears fully trained in his genre, and
without antecedents. His paintings are small, lightly painted, and
rather monotonous. Timidity, thinness, and an aura of minute and frail
industry are their most striking features. There is nothing of Jean
Clouet's heritage, nor did Clouet's example contribute anything to
Corneille's works. . . .

It is noteworthy that Corneille hardly ever painted a personality
of Lyonese society, although he was, after all, established there. Cor-
neille's work is not at all provincial—his sitters are ladies and gentle-
men of the court. . . . The persons he painted are the same as those
painted by the Clouets, and it is not the least puzzling factor of the
history of portrait painting that the same persons appear in parallel
groups of pictures so different in style.

The difference extends even to the method. No preparatory chalk
drawings by Corneille de Lyon are known to exist. . . . The custom,
in speaking of the Clouets, to mention the chalk drawing together
with the painting, is absolutely meaningless in the case of Corneille.
The picture stands alone, without accompanying drawing. But this
should not lead to the conclusion that these portraits were painted
from nature. . . . As with the Clouets, neither Corneille's color scheme
nor his brushwork indicate the presence of a sitter. . . . It may well
be that Corneille made his painting directly from his drawing, per-
haps even over the drawing. This is plausible, because several of
these pictures do not seem to be painted in oil, but with watercolor on
paper. In some places one can even discern the aquarelle under the
varnish.

Another result of this practice would be that none of the portraits
by Corneille were copied in a secondary medium, and hardly any exist
as miniatures, or have served as models for enamels. No chalk draw-
ings were available, from which such secondary works could have
been derived. Thus the paintings of Corneille, in contrast to those of

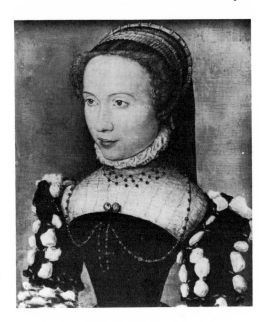

Presumed Portrait
of Gabrielle Rochechouart.
Corneille de Lyon

his fellow portraitists, exist isolated from any other works of the above-mentioned type. . . .

Another question must be raised. How is it possible that Corneille, living far from Paris, where most nobles resided . . . could continue to fill his workshop with portraits of these persons? The most natural answer is that, having once painted their faces, the artist could then make innumerable copies at his leisure; this is also borne out by his extant works. Moreover, let us not forget that the court . . . moved from one end of France to the other. Fontainebleau was the only place where the court stayed for some time. . . . Thus even Lyons offered occasions for an industrious court painter to exercise his art. . . .

[In spite of the high reputation Corneille enjoyed in his own time] it cannot be concealed that his true talents did not quite live up to this reputation. . . . The artist achieves some sort of perfection with a formula learned by heart and easily repeated. It is the three-quarter view of a face with foreshortened cheek, eye, and . . . lips. . . . There is no variation of this arrangement, nor do we find any freedom in the handling of this device. . . . Even in Corneille's best paintings everything except the face is extremely weak. The drawing of bust and shoulders is elementary. . . .

His handling of color is the most pleasant aspect of his art. It is delicate, limpid, and of incomparable freshness. The execution of

jewels is sometimes delightful. The overall effect is pleasing, if monotonous. The end result, though of little merit, is achieved with much adroitness.

<div align="right">

Louis Dimier. *Histoire de la peinture de portrait en France au XVI^e siècle.* 3 vols. Paris, 1924–26, I, 32 ff.

</div>

DUMOUSTIER

This was the family name of a group of portrait painters and draughtsmen, which also appears as Dumoûtier and Dumonstier. Geoffroy, who died 1573, had three sons: Étienne II, (died 1603), Pierre the Uncle (born circa 1540), and Côme (died 1605). Étienne II had a son, Pierre the Younger (1585–1656). Côme's son was Daniel Dumoustier (1574–1646), who was the father of Étienne III, born in 1604.

François Clouet died in 1572, and Corneille de Lyon followed a little later, after 1574. Yet the French portrait was not doomed; it followed a new course because of the activities of two artists bearing a celebrated name. They were Étienne and Pierre Dumoustier, sons of Geoffroy Dumoustier. The former became *peintre et valet de chambre* to Catherine de' Medici in 1569, the latter in 1586. . . .

Only chalk drawings survive of their work. All evidence points to the assumption that they practiced this genre more than oil painting. . . . This was the period in which, probably because of a new and more advanced technique, chalk drawing gradually became more common, outranking oil painting in its popularity. Previously the portraits were drawn in black chalk and sanguine only; now artists began to apply an infinite variety of nuances, including blue for the half-tints. It is possible that the Dumoustiers, witnesses of the process, were even its initiators. We have samples of this type in large numbers from the hand of Pierre, and those by Étienne—the portrait of Mayenne (Paris, Cabinet des Estampes), two portraits (one unverified) of the Duchesse de Joyeuse . . . and that of an old man, in the Louvre—are the masterpieces of the genre.

Étienne Dumoustier had a son named Pierre after his uncle. He, together with Daniel, son of Côme, forms a second generation. This new generation prolonged the renown of the family to the point that posterity never quite forgot it. In contrast, the fame of the Quesnel brothers, [another contemporary group of portraitists] once great, perished very suddenly with their death.

<div align="right">

Louis Dimier. *Histoire de la peinture française des origines à la mort de Lebrun.* 3 vols. Paris, 1925–27, I, 72.

</div>

JEAN COUSIN THE ELDER

For a long time art historians knew of only one Jean Cousin, although there were actually two, father and son. Jean Cousin the Elder was born in 1490 near Sens. He became an apprentice glassmaker of the cathedral of Sens between 1512 and 1515. In 1526 he was land surveyor for the district of Sens. Thereafter he was commissioned to paint altarpieces for two chapels of the Sens cathedral. About 1540 he moved to Paris, where he acquired land and erected a large mansion in which he maintained an engraver's school. He prepared the decorations for the triumphal entries into Paris of the Emperor Charles V in 1540 and of King Henry II of France in 1549. For this occasion Cousin designed a triumphal arch with the inscription *Lutetia Nova Pandora*. To Jean Cousin the Elder are also attributed the cartoons for eight tapestries of the *Legend of St. Mammas* in the cathedral of Langres (1543), and a stained-glass window in the choir of the church of St. Gervais in Paris (1551). Jean Cousin the Elder died in Paris in 1561. His best-known work is *Eva Prima Pandora* (Louvre). His treatise on perspective (1560) is mentioned by Vasari. Older sources state that Cousin was also active as a sculptor, but this is now considered doubtful.

Eva Prima Pandora

ca. 1550 oil on panel 38″ x 58⅞″ Paris, Louvre

One of the most remarkable French painters of the time was Jean Cousin, whose present reputation is no longer what it deserves to be. One of his finest pictures is the *Last Judgment** in the Sacristy of the Minims in the Bois de Vincennes, engraved by Pierre de Jode [the Elder]. In this picture alone we see the quality of his drawing and a wealth of great thoughts and noble expressions. A councillor of the government of Sens possesses a painting by this master, representing a reclining nude. One arm rests on a skull and the other arm, a snake coiled around it, reaches toward a vase. The woman is in a grotto that has two openings. One of them looks out on the sea, the other on a forest. An inscription *Eva Prima Pandora* is across the picture. . . . In all of Cousin's work we note the ease of his execution, . . . correct drawing, and exact observation of perspective and all other aspects of art.

> André Félibien. *Entretiens sur les vies et sur les ouvrages des plus excellens peintres.* 2 vols. Paris, 1685–88, I, 706 ff.

In sixteenth-century France the decorations and spectacles that solemnized the visits of kings to their principal cities acquired the character of Roman triumphs: the *entrée joyeuse* of the fifteenth century became an *entrée solennelle et triomphale*. The processions, *tableaux vivants*, theatricals, and,

* This painting, now in the Louvre, is actually by Jean Cousin the Younger. Félibien does not distinguish between father and son.

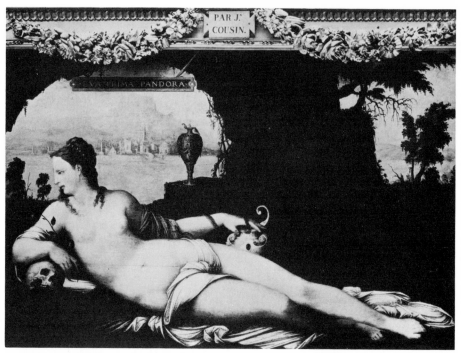

Eva Prima Pandora. *Cousin the Elder*

above all, triumphal arches devised for these occasions teemed with classical gods, heroes, and personifications. . . . Dorat explicitly instructed his pupils in the art of "properly hiding and concealing the classical fables and of disguising the truth of things with an imaginative cloak so as to immortalize the men whom the poet wishes to exalt and to praise."

When the king entered a town, this town—acting as hostess, so to speak—had to be represented after the fashion of classical city personifications. And when Henry II entered Paris in 1549, the role of Paris was played by Pandora. The triumphal arch erected for the occasion exhibited in its very center a figure portraying Lutetia [i.e., Paris] in the guise of "La nouvelle Pandore vestue en nymphe" [the new Pandora clad as a nymph]. . . . And above this enticing figure was a simulated relief on which was painted LUTETIA NOVA PANDORA.

We happen to know that the artist entrusted with the execution of this triumphal arch was Jean Cousin. And at about the same time—certainly not, as has been suggested, before 1538—the same Jean Cousin produced a famous and enigmatical picture, now in the Louvre, in which an analogous subject is treated. It shows a beautiful nude reclining in front of shrubs, trees, and ruined masonry, which, forming a kind of arch, disclose the prospect of a

river and an ancient city; and a tablet suspended across this arch bears the inscription: EVA PRIMA PANDORA.

The posture of this figure is patterned after that of Cellini's *Nymph of Fontainebleau,* now also in the Louvre, so much so that it has justifiably been called a "transposition en peinture" of this famous relief. The city in the background, however, boasting a pyramid and a spiralized column, evokes the memory of Rome. This lends great probability to a hypothesis, advanced by Maurice Roy, according to which an iconographical connection may exist between the *Eva Prima Pandora* in the Louvre and the *Lutetia Nova Pandora* in the triumphal arch of 1549, and it is even possible, we think, . . . that the woman represented in the painting was originally intended to be a *Roma* Prima Pandora rather than an *Eva* Prima Pandora . . . ; but since a *Roma* Prima Pandora made sense only as the counterpart of *Lutetia* Nova Pandora, he preferred to change the subject in favor of an *Eva* Prima Pandora that could stand by itself. In doing so he lent visual expression to that patristic comparison which, like so much else about Pandora, had fallen into oblivion during the Middle Ages but re-emerged when the Renaissance revived Origen as well as Hesiod. No one needs to be told that the parallel between Pandora and Eve was a favorite motif of Milton's and the popularity it had gained during the sixteenth century can be gauged by the fact that Karel van Mander, writing before 1603, thought it necessary explicitly to disassociate himself from what he considered an improper fusion of the sacred and the profane.

<div style="text-align:right">

Dora and Erwin Panofsky. *Pandora's Box.*
New York, 1956, p. 159 ff.

</div>

In France itself, a certain current persisted apart from Primaticcio and his direct disciples. The most marked personality among these more or less conscious champions of French independence is that of Jean Cousin the Elder, whom we find working at Sens from 1526, i.e., before Rosso and Primaticcio made their appearance at the court of Francis I, . . . and whose style is a very personal mixture of charm and gravity. In spite of its worn condition, *Eve the First Pandora* deserves to have our respectful attention. It marks an important date in French painting. It is the first large French composition of the feminine nude conceived in the spirit of the Renaissance. It clearly owes its origin to the Reclining Venuses of Italy. But though she is far from achieving that fullness and that perfection of form which we admire in the work of the Italian masters, this Eve has her own very personal and unmistakably French beauty and poetry, grave and calm as she is, much closer to the antique than her Italian sisters, more classical too, perhaps, obedient to the formula which we can regard as one of the most constant pass-words of the French spirit. . . . It is the first of a long series of works which, in spite of the differences in period

and in their authors, maintain an analogous inspiration right up to Manet, painter of *Olympia,* and to the most recent generations.

<div align="right">Paul Jamot. "French Painting I." *Burlington Magazine,* December 1931, p. 314.</div>

FRANCESCO PRIMATICCIO

Architect, painter, sculptor and designer, Primaticcio was the head of the first school of Fontainebleau and, although Italian, the most influential artist in sixteenth-century France. He was born in 1504 in Bologna. He was working under Giulio Romano for the duke of Mantua in the Palazzo del Tè, when in 1532 he was called to Fontainebleau by King Francis I. Rosso Fiorentino was in charge of the workshops there, and a rivalry developed between the two men. In 1540, while Primaticcio was in Italy to purchase antiquities for the King, Rosso died. On his return to France in 1542, Primaticcio took over direction and control of the ateliers at Fontainebleau, aided by Niccolò dell'Abbate and other, lesser, Italian and French artists.

His most ambitious project at Fontainebleau was the painted and stucco relief decorations of the Galerie d'Ulysse. These were destroyed in the eighteenth century but have recently been partially restored. Except for several trips to his native Italy, Primaticcio lived in France for almost forty years, until his death in 1570. In addition to his teacher, Giulio Romano, he was influenced by Correggio and Parmigianino. Of Primaticcio's original work little survives apart from numerous drawings. *Ulysses and Penelope* in the Toledo (Ohio) Museum of Art has been attributed to him.

He thus acquired such favour with the duke that when King Francis of France, hearing of the palace, wrote asking that a youth might be sent to him who could paint and do stucco, the duke sent Francesco in 1531. The year before Rosso had been sent to serve the king, and had done many things, notably the *Bacchus and Venus,* and *Cupid and Psyche.* However, it is said that Francesco did the first stucco and frescoes of any account in France, decorating many rooms and loggias for the king, who, liking his style, sent him to Rome in 1540 to procure marble antiquities. . . .

Meanwhile the death of Rosso took place in France, and as he left a long gallery unfinished Primaticcio was recalled. Packing his marble treasures and moulds he returned to France, and began by making casts of a great number of the antique figures, to be placed in the queen's garden at Fontainebleau, to the delight of the king, who there established a sort of new Rome, for they looked like original antiques. . . . Primaticcio was next employed to finish the gallery begun by Rosso, and this he soon did, making more stucco and paintings than

are contained in any other place. The king, being well pleased with his eight years' service, appointed him to be one of his chamberlains and soon afterwards, in 1544, made him abbot of St. Martin's. Yet Francesco never ceased to produce paintings and stucco for the king and others. . . .

But of all Primaticcio's assistants none has done him more honour than Niccolò da Modena, who surpassed all the others in skill. From the abbot's designs he decorated the ball-room with an almost countless number of figures. . . . In the great gallery he next did sixty scenes from the abbot's designs of the exploits of Ulysses. . . . The vaulting of the gallery is all decorated with stucco and paintings of the artists mentioned above and other youths, from the abbot's designs. . . .

In design Primaticcio is excellent, as we see by a sheet of his in our book representing the heavens. He sent it to me himself, and I value it highly for his sake and its own excellence. . . . The abbot has in his last years excelled in every branch of art, and has been employed by his patrons not only on buildings, painting and stucco, but in devising festivities and masquerades.

> Giorgio Vasari. *The Lives of the Painters, Sculptors and Architects* (1568). 4 vols. London, 1927, IV, 192 ff.

Rosso was responsible for the style of decoration which we connect with the school of Fontainebleau, but it was Primaticcio who created the manner of figure drawing that was to become the most recognizable characteristic of French painting for the rest of the sixteenth century. . . .

Rosso sometimes elongates his figures, but he does so in order to give them a sort of spiritual intensity, and the elongation is combined with an angular disposition of the limbs which heightens this effect. With Parmigianino and Primaticcio the forms are long and delicate, and are disposed with the utmost ease, never with abruptness. The figures in the Chambre de la Duchesse d'Étampes [in the Fontainebleau palace] were the first examples of this formula, which was to have such success in France and was to be imitated by other countries during the later sixteenth and early seventeenth centuries.

The most important examples of this style were the two galleries at Fontainebleau which occupied the later part of Primaticcio's career, the Galerie Henri II or Ballroom, and the Galerie d'Ulysse. . . .

The Galerie d'Ulysse was far more complex [than the Ballroom] and took many years to complete. . . . The walls were decorated with a series of paintings illustrating the story of Ulysses which, as far as we can judge from the drawings and engravings, show Primaticcio as a master of academic design in a style more affected than previously

by Michelangelesque influence, particularly in the scenes of violent action. In the gentler subjects, however, the style of Parmigianino dominates, and we can form some idea of what they must have been like from an oil painting of Ulysses and Penelope, probably by Primaticcio himself, which is based on one of the panels. A striking feature here is the group of small figures in conversation in the background, their lean silhouettes forming with the foreground group a contrast which in its dramatic quality recalls Rosso.

Anthony Blunt. *Art and Architecture in France, 1500 to 1700.*
Baltimore, 1954, p. 58 ff.

Ulysses and Penelope

ca. 1560 oil on canvas 44¾″ x 48¾″ Toledo (Ohio) Museum of Art

This rare example of Primaticcio's oil painting, formerly at Castle Howard [Yorkshire, England], is a repetition of the left side of his fresco *Ulysses Relating His Adventures to Penelope,* which was destroyed in 1738. We know the

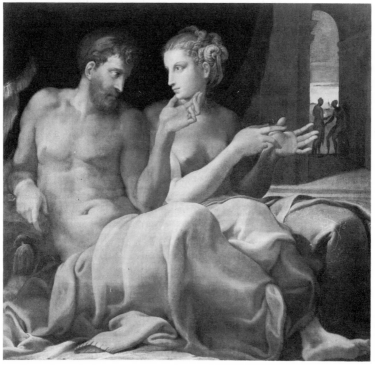

Ulysses and Penelope. *Primaticcio*

composition of the fresco from a seventeenth-century engraving by van Thul-
den and from an anonymous sixteenth-century drawing that is now in the
museum at Princeton: Ulysses and Penelope are seated to the left, above and
to the right is a spacious and severely classical architectural setting with a
group of six figures moving off to the right in the middle distance. In the oil
painting Primaticcio retains the life-like presentation of the two monumental
forms, but the epic scene becomes one of a poetic, almost secretive, intimacy,
in which the protagonists are set against a sliver of ambiguously distant archi-
tecture framing two small figures in silhouette. Niccolò dell'Abbate, Prima-
ticcio's contemporary, used this composition for his *Eros and Psyche* [in the
Detroit Institute of Arts].

<div style="text-align: right">

Irene Gordon, ed., in *The Italian Heritage: an Exhibition*
(Wildenstein & Company). New York, 1967 [no. 41].

</div>

SCHOOL OF FONTAINEBLEAU

With the accession to the throne of Francis I, an enthusiast of
Italian art, the Italians were beginning to triumph at the French court.
Francis was no longer content with his French painters, Perréal and
Bourdichon, though they remained in favor. Leonardo da Vinci, An-
drea del Sarto, Rosso in 1531, and Primaticcio in the following year,
were summoned to France. The two latter artists, working on the
decorations of the Palace of Fontainebleau, formed the school bearing
the name of this palace. Their art was remarkable for its elaborate
and sumptuous decorative character, for its great elegance of form,
and, in the case of Primaticcio, for its beautiful style.

From the reign of Francis I to the end of the sixteenth century
France was altogether infatuated with this new school, which over-
threw the traditions of veracity, simplicity, one might almost say,
bonhomie, of the old Gothic masters. The accomplishment of Rosso,
Primaticcio, and Niccolò dell'Abbate, the most important artists of
this group, was indeed considerable. Aided by their Italian compan-
ions and also by French artists influenced by their teachings, these
three artists created a new style that differed not only from the earlier
French tradition but also from the contemporary works in Italy it-
self. Like the Flemish artists of the fourteenth century attached to
the court of the first Valois, Primaticcio and his associates were tem-
pered by their French environment. . . . Had Primaticcio remained in
Italy, his work would have taken a different direction. Even though
he spread Italian influence and the precepts of Italian art, his work
must, to some extent, be credited to French genius.

The influence of the school of Fontainebleau did not cease with the deaths of Primaticcio and Niccolò dell'Abbate, in 1570–71; it extended to the beginning of the seventeenth century. During the reign of Henry III a new generation of painters appeared, justly called the second school of Fontainebleau by Louis Dimier. They were either French, like Dubreuil, Fréminet, and Jean Cousin the Younger, or Flemings like Dubois, who became naturalized, to name but the principal artists. Formed by the principles of the first school of Fontainebleau, they strove to continue its efforts. But even though they had the same taste for sumptuous decoration and for mythological or legendary subjects, they inherited neither the elegant refinement or bravura of Primaticcio or Niccolò dell'Abbate, and their work is sometimes rather heavy. It suffices to look at *Diana as Huntress** [School of Fontainebleau, ca. 1550], the *Baptism of Clorinda* by A. Dubois, or *Mercury Orders Aeneas to Abandon Dido* by Fréminet, to realize the difference. These pictures suffer in comparison with the *Continence of Scipio* by Niccolò dell'Abbate, or with *Eva Prima Pandora* by Cousin the Elder, who both belong to the first school of Fontainebleau. On the other hand, the *Ancient Sacrifice* by Dubreuil demonstrates more nobility and ease.

P. A. Lemoisne in *La Peinture au Musée du Louvre*, vol. I: *École française.* Paris, 1929, fascicle 1, p. xiii.

The Birth of Cupid

ca. 1540–60 oil on wood 42½″ x 51⅜″ New York, Metropolitan Museum of Art

This painting was formerly known as *Venus and Cupid with Attendants*, but its subject is more accurately *The Birth of Cupid*. Venus is shown attended by the Four Hours, one of whom anoints the head of the new-born child, and by the Three Graces, who push back the curtains and scatter flowers. She lies on an elaborate couch strewn with a haphazard multitude of flowers, including roses and myrtle, which ancient writers say were especially sacred to Venus. . . . The picture is a highly characteristic example of the school of Fontainebleau. . . .

The painter of our panel reveals the most strikingly curious features of Rosso's manneristic style in his relief-like composition, elongated bodies with exceedingly small hands and feet, nacreous flesh tones, elaborate coiffures with stiff curls, the varying colors of shot silk, and the sort of ornament that

* This painting and the following five are in the Louvre.

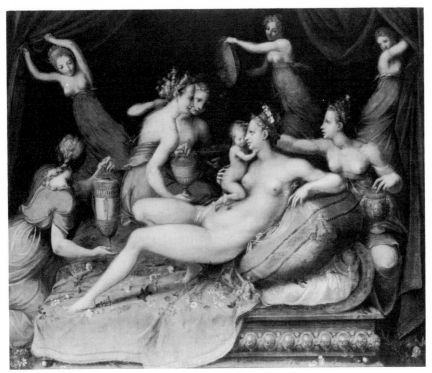

The Birth of Cupid. *School of Fontainebleau*

decorates the couch and vase. However, the influences of Parmigianino intro-
duced by Primaticcio are also noticeable, in the precious delicacy of the entire
composition and in such details as the use of transparent veils. Accordingly
our artist seems to have been affected primarily by Rosso, but somewhat
also by Primaticcio, who for some time worked on at Fontainebleau after Rosso
died in 1540, exerting a continuing influence. Indeed, in style the panel strongly
resembles another Fontainebleau picture, the *Flora and Zephyr* in the Al-
benas collection at Montpellier, which must be later than 1540 because it
shows unmistakable borrowings from Bronzino's *Venus, Cupid, Folly, and
Time* in the National Gallery in London, which did not enter the collection of
Francis I at Fontainebleau until after 1540. The execution of our picture,
therefore, must be placed after 1540 but before 1560, because about 1560
Rosso's influence was replaced by that of Niccolò dell'Abbate, and nothing of
Niccolò's picturesque style is reflected in our painting.

Charles Sterling in New York Metropolitan Museum of Art.
A Catalogue of French Paintings. 3 vols.
Cambridge, Mass., 1955–67, I, 47 ff.

ANTOINE CARON

Antoine Caron was born about 1527 at Beauvais. Between 1540 and 1560 he worked at Fontainebleau under Primaticcio and Niccolò dell'Abbate. He later went to Paris and participated in the great court festivals. In 1569 he supervised the decorations for the triumphal entry of Charles IX; in 1572 he was involved in the festivities connected with the marriage of Margaret of Valois to the King of Navarre, the future Henry IV. In 1573 he collaborated with the Pleiade poet Dorat and the sculptor Germain Pilon in preparing the triumphal entry of Henry III. Caron was also active as a book illustrator. Numerous drawings and tapestry cartoons by him survive, notably the *History of Artemisia* (symbolizing Catherine de' Medici's widowhood) and the *History of the Kings of France*, both woven at the Gobelins in the seventeenth century. Caron, who died in Paris in 1599, was forgotten until his rediscovery by Gustave Lebel in the 1930's.

Only fifteen years ago, Antoine Caron was considered a rather obscure artist, associated with some remarkable drawings and book-illustrations, but with only one painting. Since that time, thanks largely to the scholarly and often brilliant researches of Gustave Lebel and Jean Ehrmann, some dozen paintings have been attributed, with more or less certainty, to Caron. . . . Today, . . . this artist emerges, almost unexpectedly, as one of the most important figures in the generally chaotic history of sixteenth-century French painting. For Caron, perhaps even more than Clouet or the unnamed French satellites of Italian mannerism at Fontainebleau, reflects the story of France's enthusiastic reception and assimilation of Italian and classical influences, and, most significantly, in his particular interpretation of the new art from the South, points the way to the grand style of the seventeenth century. . . . From the style and subject of Caron's paintings, an approximate chronology can be suggested, one which would indicate the artist's growing understanding and increasingly skillful manipulation of the sixteenth-century Northerner's imported discoveries—the antique world, schematic perspective, and the Italian Renaissance style. . . . The art of Caron, in fact, touches on almost every aspect of the French Renaissance; it is the way in which he translated these new cultural phenomena into French terms which will interest us here.

We have, unfortunately, only one signed and dated work of Caron, the 1566 *Massacres of the Triumvirate*, a relatively early painting. . . . This painting, now in the Louvre, is crucial in a study of Caron . . . because it expresses clearly for the first time his artistic personality and indicates, however tentatively, the direction his art was to take.

Robert Rosenblum. "The Paintings of Antoine Caron." *Marsyas*, VI, 1950–53, p. 1 ff.

... Caron's place may not be of the first rank, but he still holds a very special position in the development of sixteenth-century French art.

He is a decorative artist particularly in view of the grace and attractiveness of his compositions, but he is also a very skillful narrator and, in a certain way, a realist. By disguising the horror of massacres and civil war under the cloak of antiquity, he makes us feel the violent upheavals of his own century, whose passions he shared. If he depicts a scene of martyrs, he will introduce, next to the Roman warriors, groups of contemporary characters. If he represents a mystery drawn from legend, or if the seasons file past, the occasion of such diverse presentations will always be some court festival which he had witnessed or of which he had been in charge. Although he does not give us an exact reproduction of reality, but, rather, transposes it to the level of decoration and fantasy, his work nevertheless has a lively documentary interest.

It seems to us that consequently we may consider Caron the most faithful recorder of the tempestuous society of the sixteenth century, in which intellectual pleasures and the spectacles of festivals and court games form a striking contrast with the unleashed passions of politics and religion.

> Gustave Lebel. "Notes sur Antoine Caron
> et son œuvre." *Bulletin de la Société de l'Histoire
> de l'Art Français*, 1940, p. 33 ff.

Augustus and the Sibyl of Tibur

ca. 1580 oil on canvas 50″ x 66⅞″ Paris, Louvre

What is probably Caron's best-known work, the *Tiburtine Sibyl* . . . is, in fact, one of the most polished and elegant French court paintings of the century. The unusually complex scene depicts a dramatic presentation at the Valois court of a mystery play, *Le Mystère de l'Incarnation et Nativité de Notre Sauveur et Rédempteur Jésus Christ,* which we know was given at Paris in 1575 and 1580 (a fact which, together with the costumes of the spectators behind the balustrade, suggests a date ca. 1580). The dramatic action, typical in its blend of antique and Christian themes, takes place on the foreground platform where the Tiburtine Sibyl announces to Octavian the coming of Christ, of which proof is to be seen in the heavenly vision above and in the miracle of the Roman fountain below which gives off oil instead of water. Many other events associated with the court festivities are presented simultaneously—the houndkeeper leading his dogs at the right, the tournament in the background, the galleys on the Seine, the crowd of spectators behind the balustrade—and yet, unlike the earlier works, our attention is clearly

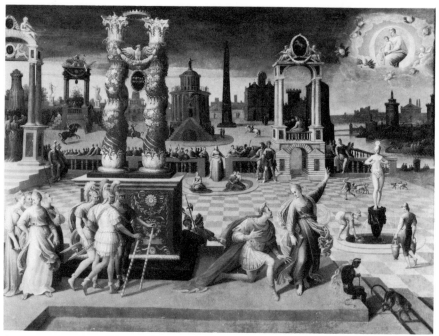

Augustus and the Sibyl of Tibur. *Caron*

focused upon the central theme of the dramatic presentation, to which all other narrative elements are subordinate. Caron's penchant for lucid formal groupings, revealed already by the rigorous symmetry of the massacre scenes and the continued formal experimentation in the *Astronomers*, is still more skillfully and pleasingly exploited here. The fantastic architectural *décor*, characteristic of the pseudo-classical arches actually designed for Valois pageants (and it must be remembered that Caron . . . often participated in the designing and organization of these festivals), measures out pictorial space, and its repeated, though always varied, arch motif leads our eye from front to back in a circuitous and complex route. The figures, too, participate in the formal order. The strict pairing already noticed in the balustrade figures of the *Astronomers* seems to be Caron's characteristic method of attaining formal unity, and the dual rhythm of the arches' coupled columns is reiterated throughout the painting. . . .

 The figure style, now clearly Italianate, again betrays the influence of dell'Abbate. If one compares, for example, the female prophets at the left of the *Tiburtine Sibyl* with the female figure at the right of dell'Abbate's *Continence of Scipio* (Louvre) . . . the debt seems apparent. . . . Caron's style, however, for all its new fluency, is still more linear than its Italian proto- type, its precise, dry contours echoing the abstract elegance of the Fontaine-

bleau nude paintings. One must call attention, though, to the more richly plastic group of Octavian and the Sibyl, for here Caron has succeeded in creating a broad, sweeping movement between the two figures, a pictorial fusion of separate elements which again looks forward to the sevententh century.

Robert Rosenblum. "The Paintings of Antoine Caron." *Marsyas*, VI, 1950–53, p. 5 ff.

TOUSSAINT DUBREUIL

Born about 1561 in Paris, Dubreuil was the pupil of Fréminet the Elder, but was formed primarily at Fontainebleau under the successor to Niccolò dell'Abbate, Ruggiero de Ruggieri, whose relative he married. As court painter to Henry IV, he also worked on the decorations of the Petite Galerie du Louvre and the château of Saint-Germain-en-Laye. Dubreuil died suddenly in 1602, while speeding on horseback from Saint-Germain to Paris. As the most important artist of the second school of Fontainebleau, he represents the transition from mannerism to classicism.

Ancient Sacrifice.
Dubreuil

Very few paintings, some drawings, and four engravings by Dubreuil have come down to us. It is a signal misfortune that all his major works have disappeared. Nothing remains of the *Labors of Hercules* of the Pavillon des Poêles in Fontainebleau. The Galerie d'Ulysse, for which he created the decorative emblems, has vanished. The Petite Galerie du Louvre [now Gallery of Apollon] burned down in 1660. We are hardly more fortunate with respect to the few decorations which remain. The Galerie des Cerfs at Fontainebleau, still in place, has much suffered. Of the decorations at Saint-Germain-en-Laye only some fragments are left. Moreover, Dubreuil's methods are apt to be misleading: like Primaticcio, he painted little himself. . . . He made sketches of his compositions and entrusted their execution to his aides, who for the most part were Flemings. Like Primaticcio we must therefore judge him by his drawings. From a study of these it can be assumed that his paintings were forceful, full of contrasts and fervor. This is also borne out . . . by the remark of Karel van Mander [in his *Schilderboek* of 1604]: "He had often recourse to Flemish artists who executed his works, but he would add the finishing touches, using a vigorous technique and often even pure blacks." . . .

The traces of Dubreuil's decorations at Saint-Germain give us an idea of his decorative talent. . . . It is based on mannerism and the great examples at Fontainebleau—Rosso, Primaticcio, Niccolò dell' Abbate and the entire group of artists working at Fontainebleau at the end of the sixteenth century. Dubreuil's admiration for Michelangelo gave him a taste for the grandiose and for a vigorous plastic form. We also discover a curious sense of realism which is evident in the expressive and grimacing faces, as well as in the humble details of still life. This tendency relates him to the Flemings.

His diversity is striking. Dubreuil composes with ease and without redundancy. His elegant, fully developed forms are set in a space which transcends the limits of the mannerist world. The relationships between figures and landscape begin to take the form which was ultimately developed in the classicist period—the just proportion of planes and the remarkable understanding of relationships.

The gap existing between Dubreuil's sketches and pictures makes attribution difficult. Only a few items have been proposed for the catalogue of his paintings: *Angélique and Médor* (Louvre) and its companion piece *Leda, The Marriage of Cana* (Rennes), and a *Presentation of the Virgin*.

In his life as in his work Dubreuil remains a painter without a face. . . . We know of no anecdote about him, and no painting fully reveals his art; time has obliterated his traces, destroyed the rare

vestiges of his art, and caused his disappearance. . . . An entire generation vanished with him, a generation of which he was undoubtedly the best and which he himself had most strongly influenced.

Sylvie Béguin. "Toussaint Dubreuil." *Art de France*, IV, 1964, p. 89 ff.

JACQUES DE BELLANGE

Very little is known about this important mannerist, compatriot of Jacques Callot. He is recorded as having worked as a portrait painter in Nancy between 1600 and 1617. In the service of Duke Charles III of Lorraine between 1602 and 1611, he painted stage designs and decorated the ducal palace, but only some drawings, engravings, and a few paintings have survived.

Painter to the court of Lorraine between 1600 and 1616, Jacques de Bellange lived in an artistic milieu open to all influences. He was at one time famous; he was copied and imitated; he then fell into oblivion and was rediscovered only in this century. He is now considered to represent mannerism at its peak, on the eve of its decline and

The Stigmatization of St. Francis. *Bellange*

eventual disappearance. He has the defects of this style: difficulties of composition, lack of technique, and a certain casualness. . . . In these respects he is the complete opposite of Callot, who is already a classicist. But Bellange turns his faults into virtues.

His originality can be seen in certain forms which reappear constantly; this repetitiousness gives his work more unity: pointed fingers made to caress or to scratch, narrow, full-mouthed faces, almond-shaped eyes slanted upward toward the temples; all this is linked with an expression in turn virginal or sardonic, peaceable or frenzied, with violent gestures, contrapposto, elaborate costumes and ornaments. The technique of this artist is no less individual. It is difficult to appreciate his paintings, for there are only a few extant, but *The Stigmatization of St. Francis of Assisi* (in the Musée Lorrain at Nancy) with its large copper-colored angels resembling palpitating flames, merits attention. His etchings—there are about fifty—nervously drawn, abound in arabesques, crosshatchings, and reworked lines; they foreshadow Rembrandt. His drawings must be associated with works now lost or with the engravings—some of them fix an impression, others are preparatory studies, while still others constitute variations of an original theme. Persistent research has gradually increased their number; there are now about fifty, the pride of collections and exhibitions, and to this number must be added all those called "School of Bellange." It is not always easy to separate these two groups. . . .

The world of Bellange exalts the artifice of festivals. Imaginatively, as in the theater, he blends details of stunning veracity based on everyday life, with antiquity or even with the kind of exoticism that is found in Eastern Europe or the Mohammedan world. There is always opulence—bizarre details, a profusion of motifs emerging from one another, and heavy, overwhelming figure groups.

[Bellange is] sensuous, proud, elegant, eccentric, extravagant, effusively religious, and anguished. All in all an uncommon personality, consumed by a "divine fire," who discovered unknown effects and novel thrills.

<div align="right">

F.-G. Pariset. "Jacques de Bellange."
L'Œil, September 1962, p. 42 ff.

</div>

JACQUES CALLOT

This prolific etcher was born at Nancy in 1592 or 1593. He grew up at the court of the Duke of Lorraine, but ran away to Italy twice, wanting to become an artist. Between 1608 and 1611 he was in Rome, where he was trained by the French en-

Italian Comedians: Riciulina,
Metzetin (etching).
Callot

graver Philippe Thomassin. From 1611 to 1621 he was attached to the court of
Cosimo II de' Medici in Florence, producing etchings of fairs, festivals, *commedia
dell'arte* characters, and grotesque figures—dwarfs, beggars, and hunchbacks. In
1621 Callot returned to Nancy. He continued to work in the same vein (his
Gypsies dates from 1622), but added religious subjects and siege compositions
to his repertory. Callot's masterpiece, the *Grandes misères de la guerre* (1633),
ranks with Goya's *Disasters of War*. Callot died in Nancy in 1635.

Many writers have been fascinated by Callot. Goethe mentions
him; his great collection of drawings at Weimar included a Callot
study of a beggar. Sir Walter Scott refers to his work in a letter in
Lockhart's biography. The popular German romanticist, E. T. A.
Hoffmann, described his novel, *Prinzessin Brambilla*, as a "Capriccio
in the manner of Callot." He also appropriated eight etchings of the
Balli set for illustrations and called his four volumes of tales *Fantasiestücke in Callot's Manier.*

With the same poetic license and imagination, Gustav Mahler
composed a "Dead March in Callot's Manner" in the fourth movement of his *Symphony in D Major, No. 1.* Perhaps Mahler, in this
ironic, macabre music, had in mind Callot's *Temptation of St. Anthony,* where devils burlesque the playing of many musical instruments.

The number of times Callot has been mentioned in French literature is beyond discovery. A subtle and personal appreciation is that of
Anatole France in *Le Livre de mon Ami,* where he recalls his nightly
visions when put to bed as a child. Fantastic grotesques would march
slowly across the walls of his nursery as he fell asleep: they were
hazy, projected memories of what he had seen during the day in a
printshop next door, with its Callot etchings of dwarfs, vagabonds,
and devils. . . .

Callot's etching needle magically indeed translated both his imaginative and his objective world. Hundreds of his copper plates glisten with his brilliant draftsmanship. They vary in size from Lilliputian banquets which might almost be covered with one's thumbnail to three sets of great sieges, each made up of six sections of folio size. In the complex range and variety of his subjects, he etched landscapes, public squares, and parterres; court festivities, funerals, and carnivals; battles, sieges, and the calamities of war; the life of soldiers, gypsies, and the actors of the Commedia dell'Arte. His subjects include noblemen, beggars, saints for every day of the year, and devils in hell and in a saint's chalice. His many sensitively and minutely etched religious subjects, drawn from the New Testament and from the histories of saints and martyrs, would alone give him a distinguished place among the Little Masters of his time.

Callot etched comprehensively what he felt and saw. From the vast market place of *The Impruneta*, crowded with its busy multitudes, to the microscopic figures of scores of his smallest plates that equally reveal his genius, he interpreted the world about him with acute originality. So generous was his artistic endowment that his gift for creating fantasy, caricature, and the grotesque did not prevent him from recording the actual world with such clarity and originality that he may well be regarded as the pioneer realist of the seventeenth century.

<div style="text-align: right">

Edwin de T. Bechtel. *Jacques Callot.* New York, 1955, p. 6 ff.

</div>

SIMON VOUET

Born in 1590 in Paris and first trained by his father, a sign painter, Vouet was said to be a child prodigy who went to England as an accomplished portrait painter at the age of fourteen. In 1611 he accompanied the French ambassador to Constantinople. From 1612 to 1627, Vouet was in Italy, first in Venice, then in Rome; he also visited Bologna and Genoa. In 1624 he became president of the Roman Academy of St. Luke. Recalled to France by Louis XIII in 1627, he was named *premier peintre du roi* and given lodgings in the Louvre. His return to Paris marked the end of Fontainebleau mannerism and the beginning of classicism in France. Vouet painted altarpieces for churches, designed tapestry cartoons, and decorated palaces for Louis XIII, Cardinal Richelieu, and others; most of these works are lost. Among his many pupils were Charles Le Brun, Mignard, and Le Sueur. His fame was eclipsed by Poussin's arrival in Paris in 1640, which prompted the king's famous *mot: "Voilà Vouet bien attrapé!"* [Now Vouet is getting what is coming to him!] Vouet could not reestablish his old position after Poussin returned to Rome eighteen months later. Richelieu and Louis XIII, his principal patrons, died

in 1642 and 1643 respectively. The Royal Academy of Painting and Sculpture was founded in 1648 without Vouet's participation. He died in 1649.

I must tell you frankly that Vouet had no facile and easy gift of invention. And I have even heard some of his best pupils say that he could not compose a picture without a model. This is not to say that he was unable to group his figures in an agreeable way, for he always sought to imitate Paolo Veronese, but he was not too well versed in the rules of composition, nor in the art of drawing, although in certain respects he was quite correct. He was ignorant of perspective and lacked the knowledge of blending and harmonizing colors. Neither did he understand the combination of light and shade. His greatest merit consisted in the beauty and freshness of his brushwork. This is most evident in the decorations of the Hôtel Séguier [Paris]. . . . His early manner resembled that of Valentin, and the paintings he did in this style are quite forceful. But it is to the greatest glory of this intelligent man that he was an excellent teacher and formed competent students. And we must recognize . . . that in his time the art of painting began to be practiced here in a nobler and more beautiful way than ever before.

André Félibien. *Entretiens sur les vies et sur les ouvrages des plus excellens peintres.* 2 vols. Paris, 1685–88, II, 190.

France is indebted to him, for destroying the insipid and barbarous manner that reign'd then, and for beginning to introduce a good *Goût.*

Roger de Piles. *The Art of Painting and the Lives of the Painters* (1699). London, 1706, p. 341.

As we study in detail the works of Vouet we are constantly impressed by his special refinement and decorative brilliance, but he does not emerge as an artist of unlimited gifts. He can scarcely be called a revolutionary innovator, either in his interpretations or in his stylistic conceptions. His religious paintings fall far short of achieving the penetration to the heart of spiritual ideas seen in the works of Caravaggio and Georges de La Tour. Nor does it seem from his art that Vouet would have been capable of expressing the simple, human understanding of a man like Louis Le Nain. To traditional mythological and allegorical themes Vouet brings a certain light-hearted superficiality which is attractive and charming, but which at the same time stands in direct opposition to the polished intellectual rhetoric of Poussin or Rubens' sensuous coloristic excitement. Sty-

listically Vouet's art is an assimilation of many Italian traditions, rang-
ing from the elegant and courtly mannerism of Primaticcio and Nic-
colò dell'Abbate, to the sumptuous lyricism of Titian and Veronese,
and the more "modern" Italian art of the first decades of the seven-
teenth century, of Caravaggio, the Carracci, Reni, Guercino, and
numerous artists of lesser distinction. Vouet never swore total al-
legiance to any single faction of Italian art past or present, as did
Poussin; in an earlier time Vouet could have been considered a prime
example of the seventeenth-century eclectic artist. He brought back to
France a new complex of Italianism, modified, restrained and in-
tensely refined in its virtuosity. It is this new interpretation of Italian
ideas that gives Vouet's altarpieces and his decorations their special
character, and it was his Italianism that became the accepted and
fashionable artistic idiom in France during the 1630's and 1640's.
Vouet was not an inventor, but an importer of artistic modes.

Perhaps the most serious obstacle to a fair evaluation and appre-
ciation of Vouet's art arises from the fact that he lived in a time that
was so very rich for the history of western painting, an age of the
most superlative genius. Vouet must inevitably suffer from compar-
ison with his more illustrious and gifted contemporaries. He can
hardly be called the equal of such internationally important men as
Caravaggio, Poussin, Rubens, Velazquez, and Rembrandt, but he
must be counted as a leader amongst the many smaller French masters
in the time of Louis XIII and Mazarin. It was artists like Vouet,
Blanchard, Vignon, La Hyre, Bourdon, and Philippe de Champaigne
who, working mainly in Paris, began to create a vigorous and pro-
ductive artistic climate in which the later glories of French painting
could flourish. With Vouet and his fellow artists Paris commenced its
slow ascent toward the leadership of western art. In this context
Vouet appears as a key figure for the formation of the French tradition
of painting.

<div style="text-align: right">

W. R. Crelly. *The Painting of Simon Vouet.*
New Haven, 1962, p. 136 ff.

</div>

The Presentation of Jesus in the Temple

1641 oil on canvas 154¾" x 98½" Paris, Louvre

The Presentation [of Jesus] in the Temple can serve to characterize all
other paintings of the same order and proves that they should be classed as
"decorative" paintings, though at first glance they seem to resist such classifi-
cation. It is a reasonably good picture. Architecture takes a large portion of the
pictorial space; the composition is tightly knit and contains fewer exaggera-

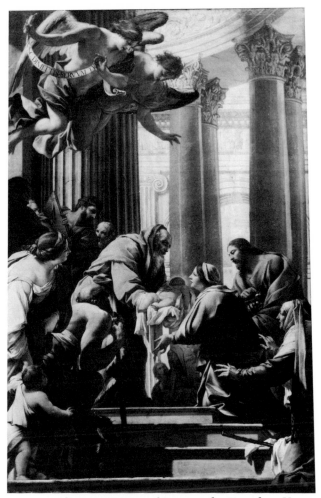

The Presentation of Jesus in the Temple. *Vouet*

tions than Vouet's other paintings. The High Priest, the Virgin, and the Infant
Jesus are placed exactly according to the rules [for formal composition], and
each of them is depicted and clothed in the conventional manner. There is
nothing to offend, but neither are there any of those happy discoveries whereby
an artist recaptures some unexpected gestures seemingly drawn from life
itself, or expresses, in his own personal style, a true emotion. It is a pompous
and glacial painting.

However, this picture has long been considered Vouet's masterpiece, and
almost a masterpiece in its own right. This is understandable, for all church
art, even to the present day, has practically always followed the same stand-
ards. If we examine the religious paintings that fill our cathedrals and muse-

ums we will find the same features everywhere: the same architecture, the same composition, the same figures, costumes, and expressions. . . . This is typical of the work of *academic* artists; for this is the term we must finally use—academic. . . .

What, in the end, is Vouet's art? We could describe him as the most brilliant representative of the limited academic style of the seventeenth century. A man of reason rather than imagination, he took from Italian painting precisely what the French spirit of the time could absorb.

<div style="text-align: right">

Henry Lemonnier. *L'Art français au temps de Richelieu et de Mazarin.* Paris, 1913, p. 270 ff.

</div>

CLAUDE VIGNON

Claude Vignon was born in 1593 in Tours. He probably received his training from Georges Lallemant, who was the leading teacher in Paris before Vouet opened his studio in 1627. About 1616, in Rome, Vignon came under the influence of the followers of Caravaggio, Adam Elsheimer, and Domenico Feti. Vignon returned to France about 1624. In the '30's the paintings of the young Rembrandt and Rubens began to influence his style. Vignon was a prolific artist who was also active as an engraver and book illustrator. He was considered the purest representative of baroque painting in France. A picture dealer and an authority on painting, he traveled to Spain twice and was commercially interested in the work of the young Rembrandt. Vignon was married twice and supposedly had thirty-four children. He died in Paris in 1670.

> . . . He dispatch'd his work so fast that he did an infinite number of pieces. . . . His performances were done with ease, and he had a particular way of using his tints. He plac'd them in the canvas without mixing them, and as he painted, he always added colours, not mingling them by the motion of his pencil [brush], as other painters do. By this means the superficies [surfaces] of his pictures are very rugged. His manner . . . is easy to be known. He seldom consulted Nature, or the Antique. There is nothing extraordinary either in his invention or expression, and therefore his pieces were little sought after by the curious. His chief excellence was in distinguishing the manner of several masters and in setting a price on pictures.
>
> <div style="text-align: right">
>
> Roger de Piles. *The Art of Painting and the Lives of the Painters* (1699). London, 1706, p. 367.
>
> </div>

> Claude Vignon is one of the forgotten minor masters of the first half of the seventeenth century. A careful study of his work brings

new surprises every day and reveals a more vivid picture of this critical period in which a truly independent style of painting developed in France. Vignon's art has so far been discussed only in general works. In one of them, published recently [W. Weisbach: *Französische Malerei des XVII. Jahrhunderts.* 1932], M. Weisbach has properly placed Vignon among the followers of Caravaggio. But the analogies, which relate his paintings to those of the precursors of Rembrandt, have never been sufficiently brought out, for the simple reason that none of the pictures known so far has warranted such a connection. . . .

Do we not find in the two paintings in Grenoble *[Jesus among the Doctors]* and in the Louvre *[Esther before Ahasuerus]* the same use of chiaroscuro combined with a range of subtle colors and a heavy impasto which characterize the paintings of Lievens and Rembrandt between the years 1625 and 1630? And does the face of Esther not foretell the heads of old men and young boys enveloped in soft, poetic shadows, or the type of woman Rembrandt was later to portray in Saskia? . . .

Art historians should give Vignon a place beside Elsheimer, Lastman, Pynas, Bramer, and Feti. Vignon proves that France, too, joined that international group of artists who participated in the new search for pictorial effect and lyrical expression which we consider the essence of baroque art. The independent and conscious efforts of Vouet, Le Sueur, and Poussin turned French artistic genius in the direction of classicism. Thus baroque art in France was relegated to the provinces and reserved for the minor masters. But it is nonetheless interesting to observe how these minor masters were able to respond to the formulas they adopted, and how they were able to give them a specifically French interpretation. Such artists were Bellange amongst the mannerists, Georges de la Tour amongst the followers of Caravaggio, and Claude Vignon amongst the immediate precursors of Rembrandt. Striving for powerful expression, they rejected commonplace realism. Thus breaking away from Dutch influence, they did not slavishly imitate the Italian artists. At a moment when the art of a country becomes conscious of itself, the initial, hesitant attempts of its isolated artists assume particular significance. In the works of its greatest artists national genius becomes exalted to the point where art becomes a means of expressing man's universal aspirations. In the works of the forgotten ones we find the most vivid, most personal statements of these aims.

<div align="right">

Charles Sterling. "Un Précurseur français
de Rembrandt, Claude Vignon."
Gazette des Beaux-Arts, October, 1934, pp. 123–36.

</div>

The Martyrdom of St. Matthew

1617 oil on canvas 56″ x 37¾″ Arras, Musée

The iconographic basis . . . is as follows. Toward the end of his life Matthew succeeded in converting Ethiopia and its ruler to Christianity. But when Hirtacus, successor to the throne, fell in love with the king's daughter Ephigenia and demanded that Matthew approve of his passion, Matthew dared to oppose him because he had received Ephigenia's vow of Christian virginity. Overwhelmed with rage at this refusal, Hirtacus sent his henchman to murder Matthew in his church.

Caravaggio's rendering of this subject [the Contarelli Chapel, S. Luigi de' Francesi, Rome] places the action inside the church, in accordance with written tradition. . . . By varying the postures of the moving figures that surround the main scene, he achieves an effect of motion going in two directions:

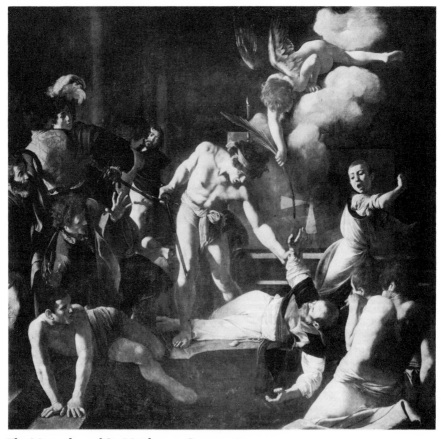

The Martyrdom of St. Matthew. *Caravaggio*

from the right foreground toward the left background, and from the left foreground toward the right background.

Vignon, in his version, focuses his entire attention . . . on the main scene, and therefore limits himself to the three chief protagonists, i.e., Matthew, the henchman, and the angel. The French artist, however, combines the three figures in an entirely different fashion.

While in Caravaggio's version the external drama of the scene corresponds with the inner tension of the henchman, . . . in Vignon's interpretation that same figure loses a measure of motional tension because the pivotal position of the legs is hidden by the pile of books at the extreme right. The figure is thus pushed back into one plane, the surrounding space hardly comes to the fore, and the drama inherent in Caravaggio's version is here drastically spelled out. This tendency becomes even more apparent upon close examination of the details; Caravaggio's henchman is just about to deal the fatal blow,

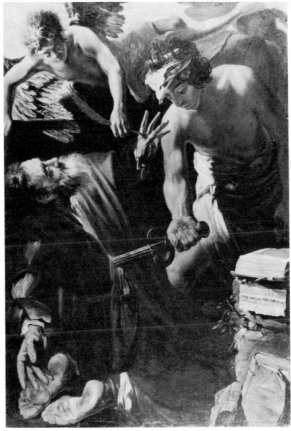

The Martyrdom of St. Matthew. *Vignon*

whereas in Vignon's version he has already stabbed the victim, whose blood gushes forth in thick streams; the angel in the Contarelli Chapel holds the martyr's palm in readiness but hesitates, whereas in our painting he places it directly into the saint's hand. The triangular composition used by Caravaggio to present the scene of martyrdom is also no longer apparent in Vignon's painting. Here the saint kneels before the henchman with arms extended, whereas in Caravaggio's version he lies on the floor awaiting the fatal blow. On the other hand, Vignon adds a Caravaggiesque motif which we do not encounter in the painting in the Contarelli Chapel, but which again shows this tendency to translate dramatic tension into harsh explicitness, namely the motif of the feet, with their dusty soles facing toward the viewer. . . .

In addition to these traits, which generally connect Vignon with the followers of Caravaggio, we believe that we can discern some others that should be attributed to other sources. Vignon fills up almost his entire painting with figures and barely indicates space. We recognize in this *horror vacui* . . . a carry-over from the second school of Fontainebleau. . . .

Another trait that also points away from Caravaggio, and will emerge more strongly later on, is the manner of color application. Even though Vignon limits himself to a few large areas of color in the manner of Caravaggio—the red in the outer cloak of Matthew and the angel's mantle dominates the green-blue used for the saint's habit, while the right half of the painting is completely dominated by white and reddish-brown hues—he loosens the solidity of the colors, especially in his flesh tones, by using lighter, more agile brush strokes.

Wolfgang Fischer. "Claude Vignon." *Nederlands Kunsthistorisch Jaarboek*, XIII, 1962, p. 105 ff.; XIV, 1963, p. 137 ff.

ANTOINE, LOUIS, AND MATHIEU LE NAIN

Although the brothers Le Nain are briefly mentioned by Félibien, our principal early source is a manuscript *L'Histoire de Laon* (1711–23) by the canon Claude L'Eleu, discovered by Champfleury, champion of realism and their first biographer. All three brothers were born in Laon; Antoine probably in 1588, Louis in 1593, and Mathieu in 1607. The question of their training has not yet been solved. Antoine was accepted as master painter at Saint Germain-des-Prés, then outside Paris, in 1629. Louis, who is called "The Roman" in some early sources, may have visited Rome. Mathieu became *peintre ordinaire* of the city of Paris in 1633 and was awarded the title *chevalier*. The three brothers were elected to the Royal Academy of Painting upon its founding in 1648. Antoine and Louis, who died shortly thereafter, were classified as painters of *bambochades,* i.e., of rustic or genre subjects in the manner of the Dutch artist Pieter van Laer, nicknamed in Italy *Il Bamboccio.* Mathieu Le Nain survived his brothers until 1677. None of the three was married. Their signed paintings bear the name "Le Nain" without initials, which has led to

the assumption that the brothers maintained a studio together and painted their pictures collectively; the latter conclusion has now been abandoned. Although principally known for their peasant subjects the brothers also painted portraits and religious and mythological pictures. An exhibition at the Burlington Fine Arts Club (London, 1910) assembled by Robert C. Witt, brought a group of their works together for the first time. Paul Jamot's attempts to establish an *oeuvre* for each of the brothers have in general been accepted. Louis Le Nain is today considered the greatest of the three.

The brothers Le Nain painted portraits and historical pictures, but in a manner of little nobility, often representing plain objects without beauty. "I have seen some of their pictures," Pymandre interrupted, "but I must confess that I would not stop to ponder over these low and often ridiculous subjects." Works in which intelligence has little part, I replied, soon become boring. . . .

André Félibien. *Entretiens sur les vies et sur les ouvrages des plus excellens peintres.* 2 vols. Paris, 1685–88, II, 487.

About that time [1632] three able painters born in the town of Laon began to flourish. They were brothers living in a perfect union and named Antoine, Louis, and Mathieu. They followed their own taste and inclination in painting and were formed in their art by a foreign painter who, for one year, instructed them in the rules of painting at Laon. Thereafter they went to Paris, where they perfected themselves and settled down, all three living in the same house. Their characters differed: Antoine, the eldest . . . excelled in miniatures and small portraits. Louis, the second, was successful with half-length and shoulder portraits. Mathieu, the youngest, painted large pictures such as mysteries, martyrdoms of saints, battles, and the like. All three were master painters to the king and became members of the Royal Academy of Painting the same day. The letters of admission are dated March 1, 1648 and countersigned by M. Le Brun, the famous painter. . . .

Claude L'Eleu (1711–23) in Antony Valabrègue. *Les Frères Le Nain.* Paris, 1904, p. 9 ff.

They painted *bamboches* in the French style, and harmonized so perfectly in their work that it was almost impossible to distinguish the share of each in a picture. For they worked together: no painting left their studio in which both* did not have a hand. They had a fine technique and knew the art of combining colors. Thus they produced

* Mariette speaks of Antoine and Louis. He did not know that Mathieu, to whom he devotes a special paragraph, was their brother.

75

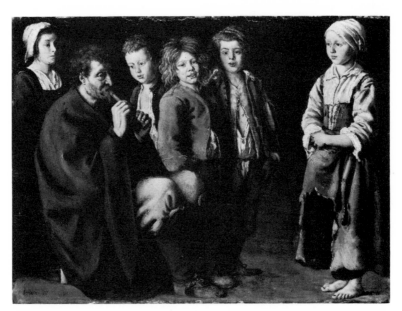

The Village Piper. *Antoine Le Nain*

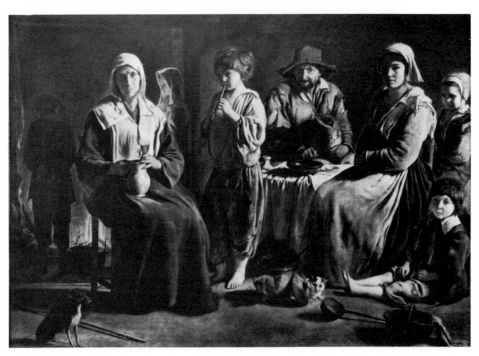

Peasant Family in an Interior. *Louis Le Nain*

76

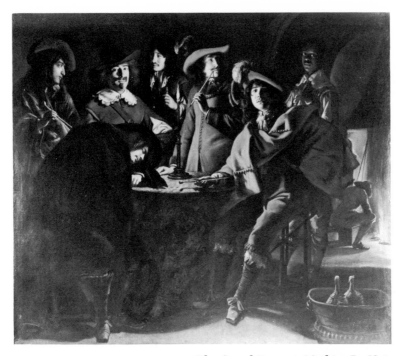

The Guard Room. *Mathieu Le Nain*

pictures which pleased for their workmanship as well as for the sim-
plicity of the characters they introduced.

P. J. Mariette. *Abécédario* (ca. 1750–60). 6 vols.
Paris, 1851–60, III, 136 ff.

It is obvious that their present low reputation stems from the fact
that they renounced life in Paris and at the court in order to live
quietly in the remoteness of the country or a small town. In Paris they
could have been rich and honored. Were they not among the first to
be elected to the Academy of Painting? But the Le Nains were simple
men, artisan-painters, who preferred cabins to palaces. The large
number of peasant interiors they painted proves their love for the
country. The melancholy sadness of their figures is only a reflection
of their own sad and melancholy temperament. . . .

Le Nain's peasants always look as if they are *thinking*. In many
pictures the workmen gaze at the horizon, their heads cupped in their
hands in a way that recalls Albrecht Dürer's *Melencolia*.

Champfleury. *Essai sur la vie et l'œuvre des
Lenain.* Paris, 1850, p. 48 ff.

77

The work of the Le Nain brothers is of a deeply personal character. Painters of the peasantry, painters of real life, they treated subjects scorned by their contemporaries. Yet they bring to mind compositions similar to those in which the artists of the Low Countries excelled. The Le Nains are our own "Flemings." Today they are rightly considered the realists of old France. . . .

The paintings of the Le Nains clash with the classical movement on the eve of its appearance, creating a kind of dissonance with that lofty and learned art which was to develop during the reign of Louis XIV. . . .

Let us now examine [for comparison] the villagers and poverty-stricken people of Callot, the beggars of the fields as etched by the master from Lorraine. Tattered, carrying crutches, they drag themselves along with a pitiful mien, heaving deep sighs. Callot's peasants . . . seem to belong to an oddly accentuated world which is difficult to define and to recognize in its pristine reality. On the other hand we frequently find among them creatures of fantasy, conceivd to demonstrate the artist's *verve*—hidalgos of poverty, charlatans of vice, fake pilgrims, cripples, beggars, and thieves. With their tragicomic poses they seem ready, if need be, to mount the platform at an itinerant fair. . . . Yet beneath their extravagant appearance and their exaggerated gestures some of these people give, nevertheless, an idea of the peasants' misery. . . .

The villagers painted by the Le Nains have obviously nothing in common with Callot's equivocal characters. Their apparent misery is truer to life, because it unfolds within the framework of their very existence and their actual dwellings. We believe their testimony, even though it must be noted that they are usually taciturn and reserved.

<div style="text-align:right">

Antony Valabrègue. *Les Frères Le Nain.*
Paris, 1904, p. 96 ff.

</div>

In attempting to form an estimate of the artistic values of the work of the brothers Le Nain an obvious danger must be faced. The interest attaching to these mysterious and elusive personalities is a temptation to overrate the quality of their painting. Above all, it must be borne in mind that their art is essentially provincial. Of Antoine and Louis this is particularly true. They seem to have held themselves aloof from the traditions and mannerisms of the court of Louis XIV[*]

[*] Actually, the Le Nain brothers did most of their work within the reign of Louis XIII.

and all the influences which gave to the art of the period . . . the character it bears. . . .

There is something almost archaic in much of their early work. . . . [But] there is much, too, which is original in their outlook. . . . In an age of pomposity and elaborate ostentation they were reticent, modest, austere. The influence of Le Brun, which had already begun to dominate the art of France, seems to have had no effect on them. . . . Their art never became grandiose, never pretentious. . . . In their larger canvases a curious intensity and immobility are often prominent. There is a considerable dormant power, but any expression of activity or vitality is rare.

<div align="right">

Robert C. Witt in *Illustrated Catalogue of Pictures
by the Brothers Le Nain*
(Burlington Fine Arts Club).
London, 1910, p. 11, 23 ff.

</div>

The twelve dated and signed paintings show characteristics which are rather diverse and distinct from each other. They fall quite naturally into three groups to which other unsigned and undated works may be added. . . .

The first group is composed of small paintings on wood or copper: *The Family Gathering* (1642, Louvre), *Children's Dance* (1643, formerly in the Butler Collection), and *Portraits in an Interior* (1647, Louvre). . . .

The best qualities of these small paintings are the freedom and vitality of the color, subtlety of observation, and simplicity. However, the composition is somewhat awkward because the artist has redundantly emphasized vertical lines. The rigid figures seem to be placed next to each other without any link.

There are remnants of archaism which lead us to believe that the painter of these pictures is the eldest of the three brothers. . . . This archaism is all the more significant since it is continued up to a date when the other works of the Le Nain brothers no longer show any trace of it. . . .

The second group is that to which the name and glory of the Le Nain brothers remain particularly attached. Here we see an outstanding painter of rustic life, a man animated by a new spirit which was heralded neither by the works of his own brothers nor by those of his contemporaries in France. Six or seven modest, but genuine, masterpieces are the jewels of this group. . . . Those in the Louvre are the *Charette* or *Return from the Harvest* (1641), . . . *The Forge, The Peasants' Repast* (1642), and the *Family of Peasants* which is not dated, but which must have been executed at the same time.

<div align="right">

79

</div>

The artist no longer used wood or copper. He used canvas and was not afraid of larger surfaces. In spite of some awkwardness and a lack of interest in the harmony and brilliance of color, the execution is broad and powerful. Grays and browns predominate, with a note of blue in some places, or pinkish reds and somewhat harsh, chalky whites. The flesh tones are pale with barely a trace of a pink glaze.

The figures, which in some paintings are almost life-size, are calm, solemn people painted, out of preference, at the hour when a meal unites the members of the family in their one room. . . .

The mark of Louis Le Nain's personality is so strongly imprinted on the above works that we can exclude any possibility of collaboration between him and the archaic, meticulous Antoine, or the elegant Mathieu. . . .

Logical reasoning is enough to attribute to Mathieu everything which in the undisputed works of the Le Nain brothers cannot be given to either Antoine or Louis. In dividing this *œuvre* we will concentrate on one principal signed and dated work which offers all the characteristics by which Mathieu is distinguished from his brothers. This painting is the *Corps de Garde* [*The Guard Room;* 1643; Coll. de Berckheim].

The composition is clever and effectively carried out. The artist was less concerned with feeling than with picturesqueness and especially with the truthfulness of the portraits. He was a portraitist; he liked elegance and the ways of a cavalier. . . .

The *Corps de Garde* was painted within a year of *The Peasants' Repast* of the La Caze collection [in the Louvre] and the *Peasant Family.* However, we feel here a more modern accent, a more supple and facile art. . . .

The painter of the *Corps de Garde* practically abandoned scenes of rustic life. His favorite models were not the honest and solemn peasants whose touching portraits were painted by his brother Louis. He rather depicted soldiers, young men wearing plumed hats and lace frills. Any pretext justified their reunion around a table: the pleasures of wine, tobacco, cards, backgammon, or a simple meeting at an inn. . . .

Let us remember what Mariette said about the Le Nain brothers. They painted *bamboches* . . . "in the French style." What a contrast with the peasants of Brueghel, Brouwer, or Teniers; all drunk, bawdy, noisy, and gesticulating. . . . These artists never completely avoided caricature. In the work of the Le Nain brothers we see reality through French eyes. Only in France were humble people painted in this way. These paintings are neither a pastoral, nor a satire, nor unbridled

fantasy. For Louis Le Nain, as later for Chardin and Jean-François Millet, truth, together with some humane sympathy, sufficed to create a masterpiece.

Paul Jamot. *Les Le Nain*. Paris, 1929, *passim*.

The Peasants' Repast of the La Caze collection in the Louvre again places before our eyes the type of landholders we are beginning to recognize, but the artist gives them a stronger sense of plasticity. Everything holds together better, is simplified and broadened. The color scheme is quite chalky, which is not exceptional in Louis Le Nain's work. There are some dark areas which are perhaps excessive, accentuated by the effect of time. They are combined with pale, dull luminosities. The reddish-violet color of the wine in the glasses is sufficient to heighten the flavor, the *bouquet* of the entire canvas. The child who leans on the mantelpiece plays admirably well the role which in other paintings was assigned to the accessory figures. He is the grain of salt, the drop of life which makes the vessel overflow— and also the promise of escape. Similarly, in the most moving versions of the *Card Players*, Cézanne places against the wall in the rear a young boy who observes the game and who also pursues some secret idea. Our wonder, affection, and attention all converge on the oval of his face.

In addition to the stark and solemn *Repast* there is the *Peasant Family*. We find the same tonality, the same gamut of sentiment, and the same overall atmosphere. The composition is free without being arbitrary. . . . Each person has his own character, his own spirit. Nothing in the art of the Le Nain brothers equals the old seated woman with her shriveled face, whose pose is so natural and yet dignified enough to be that of a statue. Her solemn demeanor is enhanced by the contrast between her wrinkled forehead and head seen full-face, well in the light, and the exquisite profile of a little girl in the background, illuminated by the flames of the hearth. Here, Louis Le Nain, without leaving earth, touches the sublime. The young peasant girl to the left appears no less magnificent. She is, as it were, a sister of the figure . . . in *The Forge*, with a round chin, a healthy body and mind. . . . The little flutist has grown up. Everyone listens to him, including the old man who cuts the bread and who resembles the Italian *Bean Eater* [by Annibale Carracci] though possessing neither his sly eyes nor his ferocious hunger.

The family stops briefly and collects their thoughts. Is it the noon "Angelus" which tolls? A more delicate chime rings in the bucolic scenes of Millet. We also think of Corot and his figure paintings . . . of Roman majesty. The work can wait; the meal also—it is now time

for prayer. . . . Paul Jamot remarked that the title *Grace* could apply to a good part of the works of Louis Le Nain. It is the actual title of a beautiful painting with four figures in the National Gallery [London]. It is one of the most soberly harmonious of pictures, with its reddish tonality, its very delicate chiaroscuro, and its subtle gradations from white, olive green, and brown to the darkest black.

Paul Fierens. *Les Le Nain.* Paris, 1933, p. 34 ff.

Antoine, the leader of the school, remained until his death a Primitive: at least so it seems if the dates 1642 and 1647, to be found in the two small pictures painted on copper, preserved in the Louvre, are taken as authentic. . . .

In contrast to Antoine the "naive" we have Mathieu the "clever" who, belonging to another generation, stands up well to the realist painters of the seventeenth century. He has a free and fluid style, which draws him into the orbit of the painters of the Low Countries. . . .

But it is . . . Louis Le Nain, Louis the good, the tender-hearted, who takes his place in the long line of great French painters, and it is the nobility of his work that we wish to emphasize here. To do him justice, we must renounce certain attitudes of mind and ways of seeing due to contact with the painters of the Low Countries: perfect style, beautiful colouring, exquisite use of materials, ingenious lighting— qualities not found among the French *peintres de la réalité*. In the presence of such painting we have to imagine to ourselves a completely different way of seeing, another sense of beauty, in short another æsthetic. . . . It is a hopeless task to speak of his antecedents. Who was the legendary "Flemish" painter to whom Louis and Antoine were apprenticed? Was Louis the "Roman"; did he go to Rome to learn the lesson of Caravaggio? How are we to explain his affinities with Spanish painting, the indication of his mysterious link with Velasquez (in *The Forge*)? There are so many unresolved mysteries of artistic creation.

In any case, the work of Caravaggio and Velasquez created in Europe at the beginning of the seventeenth century a climate favourable to the development of French realism. But whereas a Valentin, a Vouet, of less tough fibre, remained Italianising artists; whereas a Tournier practised a type of baroque which retained academic gestures; whereas a Georges de La Tour, seductive, enigmatical, among the most fascinating of European Caravaggiesques, yet at the same time a little provincial, shut himself up in his ivory tower—Louis Le Nain alone followed the road of French painting that leads direct to Chardin, Corot, Cézanne. And let us say in parenthesis, it was not at all by chance that after Champfleury, the great critic, the author

of the delightful *Violon de faïence,* the friend of Courbet, it was Vala-brègue, the friend of Cézanne, who gave new impetus to the study of the Le Nains.

<div align="right">

Vitale Bloch. "The Tercentenary of Antoine
and Louis Le Nain." *Burlington Magazine,*
December 1948, p. 352 ff.

</div>

The Forge

oil on canvas 27 ½ " x 22 ¾ " Paris, Louvre

The Forge is their masterpiece, and this painting alone would suffice to consecrate their name. . . . It is of small or medium-sized dimensions. We stand in front of the forge. Its blazing furnace lights the background of the picture and is reflected on the faces grouped around it. The blacksmith holds his iron in the fire. He awaits the moment to grasp his hammer, whose handle is within arm's reach, and beat the anvil, barely touched by the gleaming flame. The old-est child blows the bellows, while one of the younger brothers looks on casu-ally, his hands behind his back. The blacksmith's wife, a large peasant woman dressed as is the custom in northern France, is standing with one hand placed

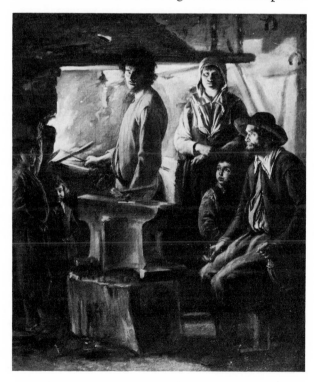

The Forge.
Louis Le Nain

upon the other. She is seen full-face, near her husband, who is shown in three-quarter profile. The father, seated in a corner, holds a gourd in one hand and a glass in the other. These respectable people, with their naïve and expressive faces, have but one fault which is easily forgiven: they are turned toward the spectator. These persons are not posing, but are looking at you. It is as if, seeing you entering their house, all these good people keep their eyes fixed on you without abandoning their calmness or stepping out of character. Furthermore, it seems that there is more than one person coming in, for they do not all look at the same point of the threshold. The blacksmith and his wife and one of the children look straight into your face, but the old father and another child nearby look elsewhere; they seem distracted or preoccupied by someone or something on the side. One of the children, the one who blows the bellows, even looks somewhat astonished. In spite of this slight flaw in the action and compósition, which becomes noticeable only upon analyzing it and thinking it over, the effect of light is so well rendered, so true, so bold, so fully harmonious; the goodness, intelligence, and domestic virtues portrayed (on all these faces) are so perfect and so lifelike that the work holds the attention, delights the eye, calms the heart, and sets our mind dreaming. It would not be extravagant to call it a masterpiece.

C. A. Sainte-Beuve. "Les Frères Le Nain." *Nouveaux lundis,* IV, January 5, 1863. Paris, 1865, p. 122 ff.

GEORGES DE LA TOUR

Georges de La Tour (Latour, de la Tour, Georges Du Mesnil de La Tour), was born in 1593 at Vic-sur-Seille in Lorraine. Nothing is known about his youth and training; some critics assume that he visited Italy and the Low Countries. La Tour went to Lunéville about 1618; from 1636 to 1644 he is not mentioned in the registers of that city—he may have been away while Lorraine was being ravaged by the Thirty Years' War. In 1644, La Tour returned to Lunéville, where he remained until his death in 1652. He was "Painter to the City of Lunéville" and *peintre ordinaire du roi.* The sole contemporary reference to him is one line in the *Livre des peintres et des graveurs,* a didactic poem by the print collector Abbé de Marolles (1673). But engravings and replicas of his works indicate that La Tour was well-known in his own day.

The paintings now assembled under his name had been ascribed to Velazquez, Zurbarán, Vermeer, Le Nain, and others, and his few signed pictures were believed to be by Maurice-Quentin de La Tour, when, in 1915, the painter was rediscovered by the German art historian Hermann Voss. The exhibition *Les Peintres de la réalité,* held in Paris in 1934 at the Musée de l'Orangerie, brought together for the first time twelve paintings by La Tour—all that were then attributed to him—and established him as one of the major seventeenth-century painters. More works have since been added to his *oeuvre,* but attempted chronologies have remained controversial.

Those whom I shall name do honor to Lorraine,
Henri Hubert, Merlin, Nicolas de la Fleur,
And Nicolas de Bar, Courtois full of warmth,
Des Ruez of Nancy, *La Tour* joins without pain.

Abbé Michel de Marolles. *Le Livre des peintres et des graveurs* (1673). Paris, 1872, p. 47.

Claude du Mesnil [*sic*] de La Tour, a native [*sic*] of Lunéville excelled in paintings of night-pieces. He presented to King Louis XIII a picture of this type, representing St. Sebastian at night. This work was of such perfect beauty that the king had all other pictures removed from his chamber and kept only this one. La Tour had previously presented a similar painting to the Duke Charles IV [of Lorraine]. This picture is now in the Château de Houdemont, near Nancy.*

Abbé Dom Calmet. "Bibliothèque lorraine (1751)."
In F.-G. Pariset. *Georges de La Tour*, Paris, 1948, p. 7.

The work of this artist . . . had been practically forgotten, when, in 1915, in *Archiv für Kunstgeschichte,* I attempted to reconstruct his personality on the basis of two signed paintings [*Angel Appearing to St. Joseph Asleep* and *The Denial of St. Peter,* both in the Museum of Nantes] and the available literary material.

Up to the present time only a few authentic pictures by him are known to us, and it is unlikely that their number will be appreciably augmented, as there is every indication that he was an unprolific painter who worked under difficulties.

Du Mesnil spent his life in a remote country town in Lorraine, and his art reflects unmistakably the narrow horizons of his local milieu. His strongly marked personality, however, and his individual and independent approach lend a power and directness to his work which arrests and holds one's attention. . . .

Whether our surmise that Du Mesnil studied in Italy be correct, or whether his knowledge of the Caravaggio School derived from northern sources (Paris? the Netherlands?), it is certain that the genesis of his artistic development lay in Caravaggio and the Caravaggio School. His art, however, cannot be thus summarily dismissed, for it contains two novel and highly individual elements. First, the stern form of his unusual and relief-like composition, almost hard impression, is augmented by a conscious accentuation of straight lines. Second, a severe and individual color scale, in which a powerful vermilion, a glowing lilac and a light sulphur yellow predominate, ap-

* Both works appear to be lost.

plied in broad, very slightly modelled planes. These tones constitute a remarkably daring harmony for which we find no parallel among his contemporaries, although we are reminded of certain very modern experiments.

Another anachronism for seventeenth century France is the combination of a "low," that is naturalistic and thoroughly worldly approach in the treatment of religious themes with a noticeable sternness, even rigidity of style. The brothers Le Nain offer the only contemporary parallel. They are, however, in strong contrast to Du Mesnil in respect to their naturalistic style.

Neither contemporary French art with its strict canonical rules, nor Italian or Flemish painting offer a satisfactory analogy for the problem of Du Mesnil's attitude—with the exception of one single, and somewhat later master—Vermeer of Delft, who pursued similar goals in respect to line and color. . . .

It is unlikely that we can draw any direct connection between Du Mesnil and Vermeer, but it is indisputable that certain stylistic problems in regard to which the great Delft master differed so strikingly from his contemporaries were already foreshadowed by the earlier master from Lorraine.

<div style="text-align:right">Hermann Voss. "Georges du Mesnil de La Tour."

Art in America, December 1928, p. 40 ff.</div>

The art of G. de La Tour, although closely related to the international style of Caravaggio's pupils, has a distinctly original character. He was not a prolific artist, his imagination was relatively limited, and he confined himself to a few figure types (probably members of his family), but La Tour nevertheless set himself serious plastic problems which he resolved in an independent way. . . .

He is first and foremost a stylist, handling the problems of light, form, and color according to the dictates of his vision, never, however, losing contact with reality. His powerful but never harsh lighting delineates the volumes with precision. His range of colors, in which cinnabar recurs frequently, is bold and unusual, but always harmonious and tempered by a light dusky veil. . . . The composition is straightforward and based on very simple geometric patterns; it has none of that baroque spirit which dominates the painting of most of the *tenebrosi.* Simplifying at the same time both form and content, La Tour reduces the latter to its essentials. The calm poetry of his art is emphasized by the unhurried gestures of his figures, by their melancholy isolation. . . . It creates in his religious paintings a deep sense of emotion; the mysterious effect of the chiaroscuro combined with an inspired gesture is sufficient to transform the simple servant

girls of Lorraine into angels *(The Liberation of St. Peter* [now known as *Job and His Wife,* Épinal Museum], . . . *The Angel Appearing to St. Joseph* [Nantes Museum]). This iconographic originality, which was perhaps to some extent the product of the religious spirit peculiar to France at that time, proves La Tour's independence even in the circle of Caravaggio's pupils who were competing among themselves for the representation of intimate Bible scenes. . . .

The chronology of the paintings is uncertain. One of them, *The Denial of St. Peter* in the Museum of Nantes, is dated 1650 and represents the painter's last style. Since the figures, details, costumes, and workshop accessories are often repeated in the twelve principal works known at present to be by La Tour, we must conclude that these paintings were all executed, if not within a short time of each other, at least while the artist was in Lunéville (between 1621 and 1652).

Style and composition alone can guide us in an attempt to date the paintings.

The series of night scenes present essentially different plastic problems from the daylight scenes. . . . In the interior of each of these we notice an evolution in the artist's vision and treatment of form: a progressive development from volumes defined by their sculptural purity to volumes suggested with many subtleties of modeling; a transition from a solid dark background, from which the figures detach themselves clearly, to an airy background, part shadow and part light, which is closely linked up with the figures themselves.

> Charles Sterling in *Peintres de la réalité en France au XVII^e siècle* (Paris, Musée de l'Orangerie). Paris, 1934, p. 60 ff.

His art, like that of de Champaigne, Le Nain and many other minor "painters of reality," contrasts by its bare sobriety with the voluble baroque which Simon Vouet and his school were at that very time trying to acclimatise in France, following the example of the Italians and Flemings. . . . In La Tour's work this austere bareness, which we observe to some extent in Le Nain, becomes asceticism. It is this quality which relates him to Zubarán, so much so that the work of the one is sometimes mistaken for that of the other. Yet the magical, passionate realism of the Spaniard is psychologically far removed from the "inner" realism of the Frenchman.

> Germain Bazin. "The Art of Georges de la Tour."
> *Apollo,* November 1936, p. 290.

Some have said that, like those contemporaries of his who specialized in night-pieces, Latour gave close study to the chemistry of light. But fascinating as is his use of light, it is not, strictly speaking,

correct. . . . No doubt torches play a large part in his compositions, but has a torch ever diffused that even glow which shows up masses and does not bring out accents? The bodies in *St. Sebastian Mourned by St. Irene* [Berlin-Dahlem Museum] cast shadows, but only those the painter requires; and in the foreground of *The Prisoner* there is not a single shadow that is not put there with a purpose. Caravaggio's lighting usually comes from a stray beam of sunshine, often the ray piercing one of those small high-set windows he was so fond of, and it serves both to make his figures come forward from a somber background and to bring out their features. Latour's pale flames serve to unite his figures; his candle is the source of a diffused light (despite the clean-cut rendering of the planes) and this light, far from being realistic, is *timeless* like that of Rembrandt. Great as is the difference between Rembrandt's genius and Latour's, there was much in common in their poetic vision of the world. Neither set out to copy the effects of light, but both artists indicate them with just enough accuracy to secure the spectator's assent, the credibility needed in their evocations. . . . Moreover such elements of reality as Latour employs are often rendered with remarkable precision—the candlelight, for example, glowing through the fingers of the child Jesus in *The Carpenter*—and his light creates an all-pervasive harmony, an atmosphere of other-worldly calm.

This light "that never was" creates relations which likewise are not wholly real between forms. The difference between Latour's daylight scenes and his night-pieces is far greater than we realize at first sight, even when the colors are akin, and even when the pictures are almost replicas, as in the case of the Stockholm and Grenoble *St. Jeromes*. The difference, it may be said, lies merely in the special lighting of the night-pieces. But are Latour's small sources of illumination intended merely to act as lighting? The light in works by Caravaggio and his school serves primarily to isolate figures from a shadowy background. But Latour does not paint shadowy backgrounds; he paints night itself—that darkness mantling the world in which, since the dawn of time, men have found a respite from the mystery of life. And his figures are not isolated from this darkness; rather they are its very emanation. Sometimes it takes form in a little girl whom he calls an angel, sometimes in wraithlike women, sometimes . . . a small light kindles and reveals shepherds gathered round a Child, that Nativity whose humble gleam will spread to the farthest corners of the earth. No other painter, not even Rembrandt, can so well suggest this elemental stillness; Latour alone is the interpreter of the serenity that dwells in the heart of darkness.

<div align="right">

André Malraux. *The Voices of Silence.*
Garden City, N.Y., 1953, p. 190 ff.

</div>

The interrelation between scholarship and contemporary art is dramatically illustrated by a five-star performance in modern research —the rescue of . . . Georges de la Tour, of Lorraine, from total neglect.* La Tour stands today as the peer of Poussin and Claude, a vital link in the sequence running from Fontainebleau mannerism to the rococo. Perhaps not since the 1860's has the French tradition in painting been so greatly strengthened near its core. During that decade, quite appropriately, for it was the era of Courbet's realism and Proudhon's socialism, the brothers Le Nain, contemporaries of La Tour, began to be recognized at their full worth. They began to be known as the superb painters of an elegiac humility, of a genre style in which the peasants of France worked or meditated with a dignity no less remarkable than that of the well-groomed gods and goddesses in Poussin's various Arcadias. On the other hand, the rediscovery of Georges de la Tour waited for a later time, a time when realism interested living painters far less than those geometrical problems of form which are so brilliantly proposed in La Tour's own work. The rediscovery took place . . . in 1914–15 when Hermann Voss published an article identifying as by La Tour three paintings previously ascribed to a fantastic list of other artists.

I suppose no one would argue dogmatically that Voss could not have recognized La Tour's style if he had not been aware of cubism and other advanced developments in modern art. The fact is, however, that he *did* know about these developments, just as Champfleury had known all about Courbet when he extolled the brothers Le Nain in 1862. . . .

During the . . . 1934–35 . . . *"Exposition des peintres de la réalité au XVIIe siècle en France,"* . . . La Tour ran off with the honors, and it was evident that the world had refound one of its finest masters. Meanwhile the intensified search for authentic works had made progress. Until 1931 only nightpieces, lighted by candle or torch, had been known. But in that year a signed daylight scene, *Le Tricheur* [Collection Pierre Landry, Paris] was found in a house on the Quai Bourbon, and it was obvious that La Tour was not merely an extraordinarily inspired member of the *tenebrosi* who followed in Caravaggio's mountainous wake, but also a painter of varied range. Today the scholars disagree as to the number, and in certain cases as to the identity, of indisputable works by La Tour. The strictest of these critics, S.M.M. Furness, lists fourteen pictures as certain; the late Paul Jamot's reissued monograph adds a few more; François-Georges Pariset's huge monograph reproduces twenty as beyond question. We can

* Publication of the three monographs on La Tour by Jamot, Furness, and Pariset. See bibliography.

expect that other paintings will come to light and we can be positive
that La Tour will never again disappear into the shadows which hid
him.

J. T. Soby. *Modern Art and the New Past.*
Norman, Okla., 1957, p. 4 ff.

St. Joseph the Carpenter

oil on canvas 54½″ x 40⅖″ Paris, Louvre

In grandeur of conception and design this picture—certainly one of the
finest of Georges de la Tour's works, and perhaps the most impressive of them
all—accords with the importance given by the Church of the Counter-Refor-
mation to the cult of Joseph. . . .

From one point of view, the picture might almost be called a companion
to the *Éducation de la Vierge.** As the subject there is Mary, . . . so the subject
here is the boy Jesus attendant on his father . . . in the dim carpenter's shop.
On the right of the picture he sits . . . , holding a candle in his right hand and
screening with his left the flame that rises between his face and Joseph's, bent
over his work. He turns his head to look straight at Joseph, to speak to him, it
seems, for his lips are open; and the clear profile is seen against a dusk back-
ground, irradiated with light and contrasted with the black hair that falls
across the brow. . . .

The centre and source of the reddish glow that colours much of the group
is the figure of Jesus. . . . Though there is no considerable area of "cinabre," as
in some of the pictures, an undercurrent of that colour is pervasive, most nota-
bly in the frock of Jesus, which is red-brown in effect but of a unique quality
not to be found in any other of de la Tour's known works. . . .

The full "cinabre" appears only in the two small patches which are all
that is seen of the boy's belt. But the same pigment is used for the fingers of
the left hand, translucent before the candle and for the inside of the right,
behind it, and in touches on Joseph's brow and cheek flushed with toil; there
it is in contrast with the thick creamy pigment which shows with a sharp ac-
cent of light the rugged texture of his skin.

Far different are the smooth skin, soft form, and unlined features of the
boy Jesus, whose face has the radiance with which de la Tour marks the divine
or supra-human. The face of Jesus here is golden white, with a faint red colour
on cheek and brow.

The figure of Joseph is a masterpiece, grand in force and finely expressive.
. . . The whole figure, with its contrasts of brown-red where the light strikes

* There are versions in the Frick Collection, New York, and in the Musée des Beaux-
Arts, Dijon, both of which are considered to be copies; the original is lost.

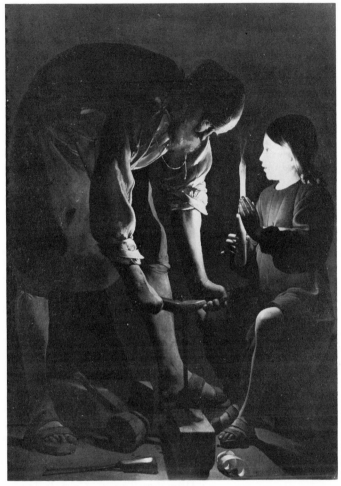

St. Joseph the Carpenter.　*Georges de La Tour*

in front and dark brown in the shadows of the back, stands out in strong relief against the lighter grey-brown of the background and the reddish brown of the floor.

On the ground, collected with de la Tour's supreme economy, are the sheer necessaries of the carpenter's work; part of one great block of wood, squared as for a beam; the smaller one on which he is working with the drill; a wooden mallet, and a chisel; and one curled shaving, itself a little masterpiece of form and light and shade. This group of "still life" can be compared . . . with that of the Louvre *St. Jerome,* and for its geometrical shapes with that of the *Madeleine à la veilleuse* [Louvre].

This picture has relations with two of de la Tour's other pictures, . . .

91

L'Éducation de la Vierge . . . and *L'Ange apparaissant à St. Joseph*, where the connection is through the models, which I believe to be the same in the two pictures. Taking into consideration the difference of angle, the face of the angel in the one picture and of the boy Jesus in the other is surely one and the same, but at different ages.

S. M. M. Furness. *Georges de la Tour of Lorraine.*
London, 1949, p. 108 ff.

The Newborn Child
[The Nativity]
Le Nouveau-né

oil on canvas 30″ x 36″ Rennes, Musée

There is an absolutely sublime Dutch [*sic*] painting, *Le Nouveau-né*, attributed to Le Nain,* depicting two women who look at a little week-old infant, asleep. . . . It is impossible to describe that deep, all-engrossing sleep of the poor little thing, which barely a week ago had still lain in its mother's womb. . . . Its tiny body is tightly wrapped and sheathed in its stiff white swaddling clothes like a mummy. It is impossible to render more poignantly that profound primeval torpor, the still submerged soul. All this is brought into relief by the uncomprehending mien of the mother, and by the simplicity and harshness of the intense red of her garment, which casts a warm reflection on that little round bundle of flesh. . . .

The dominant, all-pervading impression here is that the true painter is simply a maker of bodies. The subject counts for nothing; what matters is how the artist has grasped it, how he has handled it, and how deeply he has understood living, flesh-and-blood colored reality. The more a man is a painter, the more he is unceasingly and eternally committed to seek truth.

Hippolyte Taine. *Carnets de voyage . . . 1863–1865.*
Paris, 1897, p. 51 ff.

So smooth, so caressing is the workmanship, with its grainy impasto and the few visible brush strokes, that the painting seems transformed into a block of marble. The technique is "extremely simplified."† Yet there is nothing rustic here, none of the simplification or awkward harshness characteristic of folk art. Such attention to detail recalls the art of the preceding

* Taine was one of the first modern writers to notice this extraordinary painting, which, in 1915, Hermann Voss linked up with La Tour's two signed works in Nantes —*Angel Appearing to St. Joseph Asleep* and *The Denial of St. Peter.*
† L. Goulinet. "Georges de La Tour." *Le Dessin,* January 1935, p. 36.

The Newborn Child (detail).
Georges de La Tour

century, and unless this patient care served to produce the gradations already implicit in the engraving* we should perhaps place this painting among the early works of the artist. The contrast between the severity of the design and outline and the subtlety of the relief and lighting is indeed striking. "The contours of the red raiment are so smoothly accentuated as to seem polished."† La Tour attenuates the light, but in the penumbra the grain or nap of the fabric catches the last luminous rays. The shadows are shot through with reflections; the face of the Virgin casts a transparent shadow on her breast; St. Anne's hand, although against the light, is gilded and remains alive through the warm reflections from Mary's robe. . . . The flesh tones of the faces are indicated with the same delicacy. These refinements link La Tour as much to the mannerists . . . as to the school of Honthorst, where preference for curved lines becomes a weakness. Like Honthorst, La Tour handles light and form softly, but he preserves the solidity of his structure and his curves retain their precision. . . .

Corresponding to these subtleties of modeling are the modulations of

* It is assumed that La Tour worked from an engraving by Jean Leclerc, an engraver from Nancy.
† G. Gilles de la Tourette. "Georges de La Tour, intimiste." *L'Art et les Artistes,* XXX, 1935, p. 217.

the major and lesser tones which enhance the poetic effect of the painting. Red is the dominating color. Not a dazzling or violent red; not the red which blinds the bull, nor the red of a Matisse; there is no joyful conflagration, but, rather, a vigorous tonality, an overall vibration, caused by the reddish-brown underpainting which combines with the pigments, and by the reflections cast by the cinnabar robe. The robe, like the one worn by the Magdalen with the watch light [Louvre], is full of harmony, and haunting in its purity. Other tones also recall that painting: the somber areas with their reddish browns mixed with bistre, at times almost greenish; the bright areas with their more orange hues and whitish draperies tinged with red and citron, and the lemon yellow of the light itself. Some tones tend more toward violet . . . and assume a great importance. St. Anne's robe is a dove-colored, linen-like grey, very susceptible to light, turning to a rich mauve on her knees, though remaining colorless, light grey, almost white in spots, verging on green in the shadow due to a touch of brown, and finally taking on a warm, vibrant reddish hue when caught up in the reflections. The same tints reappear in other fabrics, but red is always predominant. The carnations have a surprising brick-colored tone as if covered with makeup. Could this be maladroitness? Was the preparation perhaps applied too freely? . . . In fact, this is a tone used lavishly by the followers of Honthorst, and La Tour thus shows that he is still of their school. It is a concession he makes deliberately. . . . He sparingly uses pink, yellow, and mauve patches, and accents of brilliant yellow. It seems possible that fairly late in his career, La Tour saw the works of the Flemish painters as a revelation of color, and was especially influenced by their handling of flesh tones. This in turn contributed to the change in his palette and to the adoption of a warmer tonality.

F.-G. Pariset. *Georges de La Tour.* Paris, 1948, p. 182 ff.

VALENTIN

Valentin, also known as Moïse Valentin or Valentin de Boullogne, was born in 1594 at Coulomniers near Paris. By 1614 he was in Rome, where he lived until his death. He came under the influence of Caravaggio, Vouet, and Bartolommeo Manfredi, and was a friend of Poussin. Little is known about Valentin's life in Rome. He painted large religious and secular compositions for private patrons. Among them was Cardinal Francesco Barberini, who commissioned Valentin's only documented picture, *The Martyrdom of St. Processus and St. Martinianus* (1629–30, Vatican), a companion piece to Poussin's *Martyrdom of St. Erasmus.* Valentin died of a sudden fever in 1632. His style is personal, pictorially rich, and characterized by a pervading melancholy, which distinguishes his genre scenes from those of Manfredi. Cardinal Mazarin and Louis XIV were early collectors of his works in France.

Valentin differs from Manfredi in his stronger, more vigorous draughtsmanship, greater skill in composition, and a psychological refinement that borders on nervousness, but frequently these qualities are rendered less effective by exaggeration and overemphasis. Although he preferred to paint secular genre pieces he was able to progress successfully to more dramatic and important subjects. His use of color is characterized by a somewhat unpleasant flatness and monotony; his flesh tones in particular have a rather lifeless quality. Here and there he attempts to strike stronger chords, but in spite of their intensity the colors appear remarkably cold and are to some extent neutralized by the general preponderance of dull grays, olives, and gray-blues.

<div align="right">

Hermann Voss. *Die Malerei des Barock in Rom.*
Berlin, 1924, p. 453 ff.

</div>

Just as it is impossible to understand the paintings of Toulouse-Lautrec without a knowledge of the *Baraque de la Goulue* and other less disreputable places, so one cannot understand the art of Valentin without a knowledge of the taverns of the Via Margutta. The astonishing artistic ferment in the Rome of these years has often been described, but we forget too easily what intense passions, what violent mores, and what audacities of mind were brought together in this strange world composed of a mixture of all classes and nationalities. Apprentices and gentlemen, merchants and prelates, footmen and whores all rubbed elbows with one another without restraint. . . . This is the world in which Valentin lived and painted. He did not portray it as an indifferent or amused observer, but as an impassioned participant.

No one except perhaps Manfredi in his best paintings has better expressed its poetry. This mixture of gaudy finery and antique ruins, of elegance and vice, of superstition and sensuality, and this taste for art and music, even in debauchery, was not softened by Valentin in order to please. . . .

[There is] nothing of the sort in Valentin's paintings. Not a single smile, not a single unfastened skirt. Rather, a kind of unmitigated sadness emanates from these people. Even the children seem to raise their big, brown eyes to forbidden dreams. . . .

Far from being a simple romantic diversion, as has been believed too often, the art of Valentin is one of the most profound investigations into human nature in the history of painting. In contrast, an artist like Callot always remains an artist; he depicts a spectacle. He portrays the same type of beggar, the same type of gentleman as Valentin, but they are all merely anonymous portraits in a gallery. His com-

passion is concerned with the suffering of his time, while Valentin is interested in each protagonist as a fellow human being. . . .

By chance, two rival representations of *The Judgment of Solomon*, by Poussin and Valentin, have been placed together in the Louvre. . . . Poussin's interpretation resembles nothing less than a tragedy by Corneille. Each element is delicately balanced, especially the various states of emotion which are expressed with precision and nobility. At first they seem simple but soon arouse wonder on the part of the viewer. Poussin, like the dramatist, studies these emotions in semi-abstract personalities who remain bound to their creator. For him they are just actors in a play, while for Valentin this drama consists of the persons themselves. There is no studied scenery, no archaeological properties, no minor figures to point out the background events of the story. Solomon is an impassioned and serious adolescent. The two mothers are young Roman women full of fear. The dead child actually looks like a small, fragile, but weighty body. The episode that has gripped them is less important than their own reality and the unfathomable pity each one, as a sensitive human being, demands and gives in return through his passions and feelings.

<div style="text-align: right">

Jacques Thuillier. "Un Peintre passionné."
L'Œil, November 1958, p. 30 ff.

</div>

The Card Sharper

oil on canvas 37¼″ x 53⅞″ Dresden, Gemäldegalerie

Two young soldiers sit at a rough wooden table in some Roman guard-room (the artist gives no more precise information than this). One man is hiding an extra card behind his back while a third fellow looks over his opponent's shoulder and makes signs to the cheat. A harsh light falls on a patch of red, a patch of yellow, and glints metallically from weapons and coins.

The handsome, careless faces seem familiar; these are the typical *ragazzi* introduced into art by Caravaggio and taken over by Honthorst, Terbrugghen, Michael Sweerts, and—in his youth—Velázquez.

<div style="text-align: right">

Henner Menz. *The Dresden Gallery.* New York, 1962, p. 254.

</div>

This famous painting was formerly attributed to Caravaggio. But while it is indeed derived from a similar subject by that master,* Valentin has typically attempted to intensify it, eliminating the naïve genre qualities in order to create a demoniacal atmosphere. In Valentin's hands the scene retains none of its harmless straightforwardness; in its stead we encounter an undercur-

* *The Card Sharpers*, formerly in the Sciarra Collection, Rome.

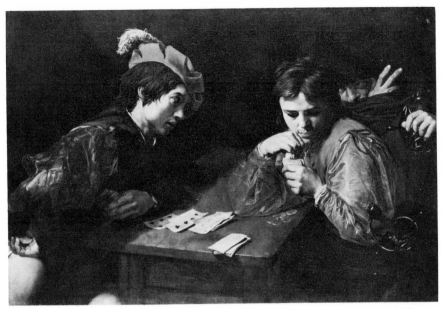

The Card Sharper. *Valentin*

rent of dramatic tension. In addition to the unrest expressed in the faces of the participants, the artist successfully conveys the atmosphere in the sinister, brooding quality of the light and by the intentional crowding of the figures into what appears to be an oppressively enclosed space. Finally, in a particularly effective move, the artist has placed the accomplice, who in Caravaggio's painting appears in the central axis, to the extreme right of the composition, immediately behind the threatened youth, invisible to him and recognizable even to the viewer only after closer scrutiny.

Hermann Voss. *Die Malerei des Barock in Rom.* Berlin, 1924, p. 453 ff.

NICOLAS POUSSIN

Poussin was born of peasant stock at Les Andelys, Normandy, in 1594. He went to Paris in 1612, and there worked with Ferdinand Elle, Philippe de Champaigne, and probably Georges Lallemant. By 1624 he was in Rome. He entered Domenichino's studio but was also influenced by Titian and Raphael as well as by Roman antiquities. Persuaded by Louis XIII, he returned to Paris in 1640 to supervise the decoration of the Long Gallery in the Louvre. Dissatisfaction and intrigues caused Poussin to leave Paris eighteen months later for Rome, where he remained until his death in 1665. Poussin painted only easel pictures. His chief patrons were

Cardinal Francesco Barberini and the *Cavaliere* Cassiano dal Pozzo in Rome, and Paul Fréart de Chantelou and the banker Pointel in Paris. The correspondence he maintained with his patrons forms a valuable source of information. After Poussin's death, in the 1670's, his art was pitted against that of Rubens in the Quarrel of Color versus Drawing at the Royal Academy of Painting, which paralleled the Quarrel of the Ancients and the Moderns in the literary world. The conservative supporters of Poussin, led by Le Brun, regarded drawing and composition as essential, and color merely as an accessory, whereas the progressive Rubenists, led by the critic Roger de Piles, claimed the superiority of color and admired the Venetian painters and Rubens' naturalism. As France's foremost classical painter, Poussin's influence was nevertheless far-reaching. In 1960 a comprehensive exhibition of Poussin's paintings and drawings at the Louvre revived a discussion of his art and brought about some revisions in the catalogue of his works.

> My temperament compels me to look for and take pleasure in well-ordered things. I avoid confusion, which is contrary and opposed to my nature, just as light is opposed to the darkness of night.
>
> Nicolas Poussin. Letter to Fréart de Chantelou,
> April 7, 1642. *Lettres*, ed. P. Du Colombier.
> Paris, 1929, p. 71 ff.

Nicolas Poussin was tall and well-proportioned in every part. . . . He had a slightly olive complexion, his hair was black and had mostly fallen out with age. Something celestial shone in his eyes; his pointed nose and wide brow ennobled his modest face.

He maintained a very regulated way of life. . . . He was in the habit of getting up early, taking some exercise for an hour or two, walking almost always on the mountain of the *Trinità* (Mount Pincio) not far from his house. . . . He carried on unusual and learned conversations with his friends; when he returned home, he would paint without interruption until the middle of the day. Then he would refresh himself and paint again for a few hours. . . . At night he would go out once more and walk about the square at the foot of the mountain, among the crowd of foreigners who habitually flock there. . . . His remarks were very serious and were received with attention. He spoke very often of art and expressed himself with such perfect clarity that not only painters but cultivated men of every sort came to learn the deepest secrets of painting from him. He did not teach with any purpose, but just talked on the inspiration of the moment. Having read and observed much, he spoke of nothing that he did not thoroughly understand. His words and ideas were so apt that they did not seem random, offhand remarks, but the fruit of long study and meditation. All of this was due to his wide reading, not only in history,

mythology, and learned works, in which he surpassed everyone, but also in the other liberal arts and in philosophy.

> G. P. Bellori. *Le Vite de' pittori, scultori et architetti moderni* (1672). Rome, 1931, pp. 440, 435 ff.

Poussin unceasingly studied all essential aspects of his art. He never began a painting without first thinking about the position of each individual figure, which he then drew very carefully. . . . Next he would put little models on a table, which he then draped with garments in order to judge the effect and arrangement of all the figures as a group. He tried so hard to imitate nature at all times that I even saw him examining stones, lumps of earth, and pieces of wood, in order to paint rocks, terraces, and tree trunks with exactitude. He painted with exceptional neatness and in a very particular way. He would arrange his paints on the palette so carefully that he never made any useless brush strokes and never overworked his colors. It is true that his shaky hands did not allow him to paint with the same ease as other artists, but his genius and superior judgment compensated for the physical weakness of his hands. . . .

Poussin . . . did not imitate any other painters and trained no pupils. He always worked alone in his studio and undertook no large works. He needed no one to assist him; therefore there are no paintings which are not entirely by his hand.

> André Félibien. *Entretiens sur les vies et sur les ouvrages des plus excellens peintres.* 2 vols. Paris, 1685–88, II, 436 ff.

I have often admired Poussin's great dedication to perfection in his art. Old as he was, I frequently saw him among the ruins of ancient Rome, out in the Campagna, or along the banks of the Tiber, sketching a scene that had pleased him; and often I met him, his handkerchief full of stones, moss, or flowers, which he carried home, in order to copy them exactly from nature. One day I asked him how he had attained this degree of perfection, which had won him so high a rank among the great painters of Italy. He answered modestly: "I have neglected nothing."

> Bonaventure d'Argonne (1699–1700).
> Quoted in Centre National de la Recherche Scientifique.
> Colloques internationaux: *Nicolas Poussin,* ed. André Chastel.
> 2 vols. Paris, 1960, II, 237.

He [Poussin] neglected Colouring. We may perceive by his Works in general, that he knew nothing of Local Colours, or the *Claro*

Oscuro: For which Reason almost all his Pictures have a certain *grey* predominant in them, that has neither force nor effect. Some of the pieces of his first Manner, and some of his second, may however be excepted. . . . Where any of his Colouring is good, he is indebted for it what he remembered of that part of his Art, in the Pictures he copy'd after Titian, and was not the effect of any intelligence of the Venetian Painter's Principles. In a word, 'tis plain Poussin had a very mean Opinion of Colours. In his Life written by Bellori and Félibien there is a sincere Confession that he did not understand them, and had as it were abandon'd them: an undeniable proof that he never was Master of the Theory of Colouring.

> Roger de Piles. *The Art of Painting and the Lives of the Painters* (1699). London, 1706, p. 350.

. . . Then the *Cavaliere* Bernini looked at M. Poussin's great land-scape, *The Death of Phocion* [Louvre] and found it beautiful. Of its companion piece, *The Ashes of Phocion,* he said, after having examined it for a long time: "*Il Signor Poussin è un pittore che lavora di là!*" [Signor Poussin is a painter who works from here!], pointing at his forehead. I told him that he worked from his mind, because he had always had weak hands. The *Cavaliere* then saw *The Virgin in Egypt* [1657; Leningrad, Hermitage] which, I explained, was among his last works. After having viewed it, he said that one should stop working at a certain age, for all people decline with age. . . .

M. Colbert asked me whether the *Cavaliere* had seen my picture collection and what he had said about it. I told him that the *Cavaliere* had seen my pictures and had praised them exaggeratedly, deigning them to be as good as those of any painter. M. Colbert replied that he was much relieved to hear that the *Cavaliere* had found at least something to his liking in France. It had been rumored, he added, that the *Cavaliere* did not like the paintings of M. Poussin, nor M. Poussin the works of the *Cavaliere*.

> Paul Fréart de Chantelou. *Journal du voyage du Cavalier Bernin en France.* Entries of August 10 and July 29, 1665. Quoted in Centre National de la Recherche Scientifique . . . *Nicolas Poussin*, II, 1960, pp. 126–7.

Poussin's only guides were his own genius and some engravings of Raphael which fell into his hands. A desire to study the perfect forms of classical antiquity led him to Rome, even though his extreme poverty was an obstacle to travel. In Rome he painted many masterpieces which he sold for only seven crowns apiece. Summoned

to France by the secretary of state, Desnoyers, he returned and established correct taste in painting there; but envy and persecution drove him back to Rome, where he died, a very famous but still poor man. He usually sacrificed color to the other aspects of painting. For example, his *Sacraments* [Collection of the Earl of Ellesmere, Scotland] are too gray. However, there is an *Ecstasy of St. Paul* in the collection of the Duke of Orléans [now in the John and Mable Ringling Museum, Sarasota], which is quite strong in its colors. It is hung next to *The Vision of Ezekiel* by Raphael and is not at all adversely affected by being compared with Raphael; in fact, the observer can look at both with equal pleasure.

> Voltaire. *Le Temple du goût* (1733). *Œuvres complètes,*
> vol. XII, Paris, 1785, p. 173.

Opposed to this florid, careless, loose, and inaccurate style [of Rubens], that of the simple, careful, pure, and correct style of Poussin seems to be a complete contrast. Yet, however opposite their characters, in one thing they agreed; both of them always preserving a perfect correspondence between all the parts of their respective manners....

Poussin lived and conversed with the ancient statues so long, that he may be said to have been better acquainted with them than with the people who were about him. I have often thought that he carried his veneration for them so far as to wish to give his works the air of Ancient Paintings. It is certain he copied some of the Antique Paintings, particularly the *Marriage* in the Aldobrandini Palace at Rome....

No works of any modern have so much of the air of Antique Painting as those of Poussin. His best performances have a remarkable dryness of manner, which though by no means to be recommended for imitation, yet seems perfectly correspondent to that ancient simplicity which distinguishes his style.

> Joshua Reynolds. "Fifth Discourse (1772)."
> *Discourses Delivered to the Students*
> *of the Royal Academy.* New York, 1905, p. 128 ff.

Poussin's landscapes set our minds dreaming. We feel transported to those lofty, far-off lands where we find the bliss which escapes us in the real world.

> Stendhal. *Histoire de la peinture en Italie* (1816).
> Paris, 1892, p. 106.

He was the first and only one to imprint *style* on nature as seen in the Italian countryside. . . . This is true to such an extent that in looking at a beautiful view we are right in saying that it is *Poussin-esque*.

J. A. D. Ingres (undated). *Écrits sur l'art.*
Paris, 1947, p. 50.

Just imagine Poussin entirely done over again from nature—that is classicism as I understand it. What I cannot accept is the kind of classicism which restricts us. The contact with a master should make us more aware of ourselves. Whenever I have studied Poussin I know better who I am.

Paul Cézanne (undated). Quoted in Joachim Gasquet.
Cézanne. Paris, 1926, p. 192.

Those who have repeatedly characterized Poussin as the most classical of painters will be surprised to see him treated in this essay as one of the boldest innovators in the history of painting. When he began to paint, the then flourishing mannerist schools were stressing the technical rather than the intellectual aspect of art. Poussin rejected all this falseness because of his own nature rather than from any bias he may have had against these artists. But the fact that he was a reformer should not lead to the conclusion that he had an extensive influence on his contemporaries.

. . . When Poussin appeared in the midst of the highly favored Carracci followers, he was as though isolated among them, in spite of the approval he finally obtained. It seems that the influence of these decadent painters even eclipsed his own—the French painters who came after him were still thoroughly Italianate in their style. Although Le Brun studied Poussin's art, and his work showed a regularity borrowed from Poussin's severe style, the spirit of the Italian academies was still dominant in him and was the main inspiration for the next generation of artists in France. . . .

Poussin did not imitate [ancient] bas-reliefs and statues in order to merely recapture their outward appearances, as is done nowadays;* in other words he did not pay scrupulous attention to costume or to other purely external incidentals. He did not pretend to be a purist by trying to copy the actual forms of a fold, a piece of furniture, or a hair style. This is the art of the antiquarian, not of an artist: the artist must interpret the spiritual content of the sculpture. He is studying man by means of the antique, and rather than congratulating himself

* This is a sly reference to Ingres' paintings.

on reviving the *peplum* or the *chlamys* he must resurrect, as it were, the manly genius of the ancients through the representation of human forms and human passions. Such is the imitation of Poussin.

. . . Poussin incontestably found ideal beauty; but this beauty does not have the irresistible attraction and charm of Raphael's works. Poussin's figures of gods and goddesses, saints and Madonnas, have much nobility, but this nobility is due to a somewhat cold and monotonous correctness. He paints neither modest, blushing Virgins, nor ecstatic, pale saints and martyrs; he does not have that penetrating unctuousness of the Virgins of Murillo, nor the sweet languor and tender complexion of Correggio's Madonnas. Unlike these two masters, he does not submerge his Madonnas in resplendent halos, nor does he show them transfigured amid all the glories and millions of archangels, their glances rising up to God.

But, on the other hand, what superiority lies in his representation of historical subjects! What eminence, what vigor in those Romans! They are true men! How far they are from those theatrical heroes who only wear the costumes of heroes! What superb Greeks are Phocion, Eudamidas, and Achilles! . . . Like the great Corneille with whom he has more than one thing in common, Poussin prefers to choose his subjects from periods of history calling for the representation of noble actions and intense emotions. We might be tempted to take his characters for heroes from Plutarch, brought to life again. Poussin, contemptuous of low and vulgar subjects, is at ease only in the heroic sphere.

<div style="text-align:right">

Eugène Delacroix. "Le Poussin (1853)." *Œuvres littéraires.* 2 vols. Paris, 1923, II, 58 ff.

</div>

The other characteristic master of classical landscape is Nicolo Poussin. . . .

It would take considerable time to enter into accurate analysis of Poussin's strong but degraded mind; and bring us no reward, because whatever he has done has been done better by Titian. His peculiarities are, without exception, weaknesses, induced in a highly intellectual and inventive mind by being fed on medals, books, and bassi-relievi instead of nature, and by the want of any deep sensibility. His best works are his Bacchanalian revels, always brightly wanton and wild, full of frisk and fire; but they are coarser than Titian's, and infinitely less beautiful. . . . His battle pieces are cold and feeble; his religious subjects wholly nugatory, they do not excite him enough to develop even his ordinary powers of invention. Neither does he put much power into his landscape when it becomes principal; the best pieces of it occur in fragments behind his figures. Beautiful vege-

tation, more or less ornamental in character, occurs in nearly all his mythological subjects, but his pure landscape is notable only for its dignified reserve; the great squareness and horizontality of its masses, with lowness of tone, giving it a deeply meditative character. His *Deluge* might be much depreciated, under this head of ideas of relation, but it is so uncharacteristic of him that I pass it by.

<div style="text-align: right">

John Ruskin. *Modern Painters* (1843–60). 5 vols.
London, 1929–35, V, 322 ff.

</div>

The influence of Poussin extended well beyond the classical period. We can easily find unquestionable traces of this influence in the works of David. Ingres did not conceal how much he owed to the Master of the Pincio, and in Corot's landscapes with dancing nymphs we see the strict order, luminosity, and poetry of Poussinesque nature....

An extraordinary integrity of craftsmanship prevailed in his work. He left nothing unfinished. All of his authentic canvases impress by their definitive quality. Whether history, mythology, the Scriptures, or legend furnished the subject, there is a unity of execution equal to the loftiness of inspiration....

Founded on an exceptional knowledge of composition, a subtle sense of order, clarity, and simplicity, and a vigorous mastery of drawing, his paintings create a feeling of complete harmony. This harmonious feeling results from the fact that everything contributes to the expression of the central idea. The landscapes and architectural settings are exactly adapted to the scenes they frame. The arrangement of the figures, their costumes, positions, gestures, and expressions are calculated with particular care. The colors are applied according to the variations of light and shade, of which the artist had made a special study, and form a discreet and exquisite harmony. The perspectives, handled with a thorough knowledge of optics, open up vast horizons.

<div style="text-align: right">

Émile Magne. *Nicolas Poussin.*
Brussels, 1914, p. 190 ff.

</div>

Nicolas Poussin was and is the most conscious of painters, and on that account, too, he is the most French: "E un pittore che lavora di là," Bernini said of him, touching his forehead. Thought presides at the birth of each one of his pictures.

But just as Mallarmé (the most intellectual of our poets before Valéry) used to say that it was not with thoughts that poems were made but with words, so Poussin teaches us that pictures are made, not with thoughts, but with lines and colours. Nevertheless, thought

dwells in his pictures, subordinates in them colours and lines, and co-ordinates the whole into a single harmony.

Like Ingres, he may seem more of a draughtsman than a painter; and a picture often seems to him nothing but a way of putting volumes into colour, for even his drawing always revolves itself into orderly arrangement and composition. The eye's sensuality may sometimes no doubt guide him, but will never rule him as an absolute mistress; a sovereign reason will always keep it in control. Domenichino, the only contemporary painter Poussin did not disdain and whom he consented to listen to, used to say to his pupils (and Poussin liked to repeat it after him): "No line should come from a painter's hand which has not first been formed in his mind."

André Gide. "The Lesson of Poussin."
The Arts, no. 2, 1946, p. 64.

The reason why the chronology of Poussin's work is so important, why such an effort is made to establish an exact list of his canvases, is that the evolution of his style traces a spiritual journey. From 1630 on, working with unusual independence, free from the shackles of official commissions, never having submitted (like his contemporary Velasquez) to the exigencies of portraiture, giving little thought to dedicating his art to official religion, Poussin made painting an instrument of a prolonged meditation on the human condition.

The earliest paintings and drawings we possess offer a double image of man torn between pleasure and suffering, divided between the cruelty of destiny and his joy in living. Bacchanales intermingle with battles and martyrs. The same lyrical exaltation is evoked in the painter by the horrors of bloodshed and the massacre of innocents as by Armida's emotion on discovering Rinaldo, or the springtime joy of the *Triumph of Flora* where apple branches blossom against a blue sky.

As he reached the age of forty, more and more involved in ancient and sacred history, Poussin made an attempt to master destiny, to oppose the will of the hero against the double human fate. His style turns colder, greater pathos informs the subject matter, attitudes become more virile, there develops an evident stoical philosophy—directly related to intellectual currents of the day, as Sir Anthony Blunt has shown. But stoicism soon dissolved in an atmosphere of relaxed tensions. More and more, Poussin turned to the landscape and seemed to find in it a peace and universal consciousness. The Hermitage's *Polyphemus* evokes none of the tragedy of the loves of Acis and Galatea; there remain only the embraces of cheerful nymphs, the bucolic calm of shepherds watching their flocks. A Vergilian felicity pervades

the Louvre's *Four Seasons*, in which Winter, seen in the Deluge itself, is reminiscent less of divine anger against the sins of man than simply the mindless cruelty of natural cycles. The aging painter, tortured by illness and close to death, experienced a sort of release verging on pantheism which is close to the gentle irony of the old Montaigne, with a touch of peasant tenderness thrown in.

It would be inaccurate to say that Poussin's force for us is now only in terms of his ideas rather than in his paintings themselves. . . . For a long time we saw in his paintings an art of order and measure, admired by Cézanne, and invoked as precedents by Seurat and the Cubists. But in 1944, when Picasso felt the need to copy (or rather translate) a Poussin *Bacchanale*, it was certainly less for its deliberate structure than for that exuberant gaiety which later clued his own Antibes pastorals, *The Joy of Living* and *The Faun and the Centaur.*

Jacques Thuillier. "Poussin." *Art News Annual,* XXX, 1965, p. 188 ff.

Rebecca and Eliezer

1648 oil on canvas 46½″ x 77½″ Paris, Louvre

The excerpt below is the partial record of a conference held at the Royal Academy of Painting and Sculpture in 1668. The participants were Jean-Baptiste de Champaigne* (nephew of Philippe de Champaigne), Le Brun, Noël Coypel, and Colbert (the statesman and financier under Louis XIV). The minutes were reread by Guillet de Saint-Georges, the Academy's secretary, in 1682. This is an example of the hairsplitting type of art criticism practiced by the seventeenth-century academicians.

After praising M. Poussin, as he certainly deserved, M. de Champaigne . . . said that it seemed to him M. Poussin had not treated the subject of his painting with complete historical accuracy, since he had omitted the representation of the camels which the Scriptures mention . . . ; this was well worth noting, in order to prove the exactness and the accuracy of the painter in treating a historical subject. . . .

M. Le Brun took the floor again and asked M. de Champaigne if he thought M. Poussin had not known the story of Rebecca. Thereupon M. de Champaigne agreed with the assembly that M. Poussin had too much knowledge and too much erudition to have been unaware of this point of sacred history. This led M. Le Brun to say that the camels had not been eliminated from this painting without solid reflection; that M. Poussin, who endeavored always to purify and disencumber his subjects and to make the principal

* Cf. Centre National de la Recherche Scientifique. Colloques internationaux: *Nicolas Poussin.* II, 1960, p. 143.

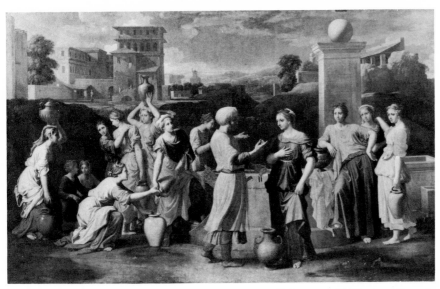

Rebecca and Eliezer. *Poussin*

action which he treated pleasing to the eye, had rejected the bizarre objects which might corrupt the eye of the spectator and divert him with minutiae; that the picture space was destined only for essential figures and for those capable of ingenious and pleasing expression.* Thus, he did not have to deal with a procession of camels, equally thankless, in view of the labor required to paint them, as encumbering in their number; for the Book of Genesis mentions ten camels, and if he had been bound to treat the subject with the fidelity and exactness the critics require, he would have had to actually put ten of them in the picture and form a complete caravan. M. Poussin, he continued, often reflected on such an incompatible mixture and said, as a maxim, that painting as well as music had its particular modes . . . each mode having its own rules which in no way could be combined with the other; that following this example, M. Poussin, once he had considered the particularities of the subjects he was treating, would omit objects which, by virtue of being dissimilar, would have been disharmonious; he considered them insignificant, and, by omitting them, he did not distort history in any way. . . .

Although these reasons had satisfied the greater part of the assembly, some partisans of M. de Champaigne persisted stubbornly in maintaining that the story of Rebecca would have been more intelligible with the representation of at least three or four camels. . . . But M. Le Brun turned the arguments of these censors against themselves. . . .

* Le Brun apparently did not know that Poussin had painted another version of this picture (Anthony Blunt Collection) in which one camel is depicted.

Entreated to state his opinion on this matter, M. Colbert protested against doing so for a long time, and said that these discussions were absolutely the domain of the academicians. At this moment, one member (M. Coypel) offered an example in opposition to that of M. Poussin, and said that Carracci, in a painting depicting the Nativity, had seen fit to place in the foreground of this painting an ox and a donkey which took up almost the entire width of the picture; this relegated the principal figures to the background and the sides. One member of the assembly (M. Le Brun) retorted that Carracci was no longer worthy of esteem or imitation. On the contrary, he had erred against the rules of composition which do not permit the lowliest objects of a painting to smother or dominate the nobler ones, even if both should be equally necessary for the delineation of the subject. . . . When this dispute had forced M. Colbert to take the floor, he said that, without intending to make any decision on this matter, it was his opinion that the painter must consult common sense and remain free to omit in a painting the least important incidents of the subject, provided the principal ones are sufficiently delineated.

> Guillet de Saint-Georges (1682) in *Mémoires inédits . . .*
> *de l'Académie Royale de Peinture et de Sculpture.*
> 2 vols. Paris, 1854, I, 252 ff.

Shepherds in Arcadia
[Et in Arcadia ego]

oil on canvas 33½" x 47⅝" Paris, Louvre

The dating of this important painting is controversial. Grautoff, Friedlaender, and Jamot date it between 1638 and 1640; A. Blunt places it circa 1650. (For a full discussion of this problem, see Denis Mahon's "Poussiniana," in *Gazette des Beaux-Arts,* July–August 1962.) Poussin painted an earlier version of the subject, which is now in the Devonshire Collection, Chatsworth, England.

The picture represents the memory of death in the midst of the prosperity of life. Poussin has painted a shepherd, who, one knee on the ground, points to the following words engraved on a tomb: *Et in Arcadia ego.* Arcadia is a region poets have spoken of as a land of delight; but this inscription means that the person buried in the tomb has lived in Arcadia and that death is often met amid the greatest happiness.

> André Félibien. *Entretiens sur les vies et sur les ouvrages*
> *des plus excellens peintres.* 2 vols. Paris, 1685–88, II, 379.

If the version at Chatsworth is poetic, that in the Louvre is philosophic. An absolute calm has replaced the movement of the first version. Poussin

has abandoned the sumptuous tones he liked in his youth in favor of a silvery, almost gray color; though not equally seductive, it harmonizes perfectly with the contemplative spirit of the picture.

> Anthony Blunt in *Exposition Nicolas Poussin* (Paris,
> Musée National du Louvre). Paris, 1960, p. 126.

For us, the formula *Et in Arcadia ego* has come to be synonymous with . . . what Mrs. Felicia Hemans expressed in the immortal words: "I, too, shepherds, in Arcadia dwelt." They conjure up the retrospective vision of an unsurpassable happiness, enjoyed in the past, unattainable ever after, yet enduringly alive in the memory: a bygone happiness ended by death; and not . . . a present happiness menaced by death.

I shall try to show that . . . "Death is even in Arcadia" represents a grammatically correct, in fact, the only grammatically correct, interpretation of the Latin phrase *Et in Arcadia ego*, and that our modern reading of its message—"I, too, was born, or lived, in Arcady"—is in reality a mistranslation. Then I shall try to show that this mistranslation, indefensible though it is from a philological point of view, yet did not come about by "pure ignorance" but, on the contrary, expressed and sanctioned, at the expense of grammar but in the interest of truth, a basic change in interpretation. Finally, I shall try to fix the ultimate responsibility for this change, which was of paramount importance for modern literature, not on a man of letters but on a great painter. . . . [In Poussin's earlier *Et in Arcadia ego* composition at Chatsworth] the phrase *Et in Arcadia ego* can still be understood to be voiced by Death personified, and can still be translated as "Even in Arcady I, Death, hold sway," without being out of harmony with what is visible in the painting itself. . . .

[In Poussin's] second and final version of the *Et in Arcadia ego* theme, the famous picture in the Louvre—no longer a *memento mori* in classical garb—we can observe a radical break with the mediaeval, moralizing tradition. The element of drama and surprise has disappeared . . . and the death's-head is eliminated altogether.

Here, then, we have a basic change in interpretation. The Arcadians are not so much warned of an implacable future as they are immersed in mellow meditation on a beautiful past. . . . Poussin's Louvre picture no longer shows a dramatic encounter with Death but a contemplative absorption in the idea of mortality. We are confronted with a change from thinly veiled moralism to undisguised elegiac sentiment.

When read according to the rules of Latin grammar ("Even in Arcady, there am I"), the phrase had been consistent and easily intelligible as long as the words could be attributed to a death's-head and as long as the shepherds were suddenly and frighteningly interrupted in their walk. . . .

When facing the Louvre painting, however, the beholder finds it difficult to accept the inscription in its literal, grammatically correct, significance.

109

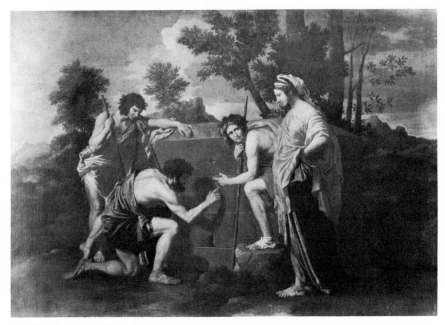

Shepherds in Arcadia. *Poussin*

Thus Poussin himself, while making no verbal change in the inscription, invites, almost compels, the beholder to mistranslate it. . . . The development of his pictorial vision had outgrown the significance of the literary formula, and we may say that those who, under the impact of the Louvre picture, decided to render the phrase *Et in Arcadia ego* as "I, too, lived in Arcady," rather than as "Even in Arcady, there am I," did violence to Latin grammar but justice to the new meaning of Poussin's composition.

This *felix culpa* can, in fact, be shown to have been committed in Poussin's own circle [by Bellori and Félibien. . . .] The final touch, it seems, was put by the great Diderot, who in 1758, firmly attached the *et* to the *ego* and rendered it by *aussi:* "Je vivais aussi dans la délicieuse Arcadie," "I, too, lived in delightful Arcady." His translation must thus be considered as the literary source of all the later variations now in use, down to Jacques Delille, Johann Georg Jacobi, Goethe, Schiller, and Mrs. Felicia Hemans.

<div align="right">

Erwin Panofsky. *"Et in Arcadia ego:*
Poussin and the Elegiac Tradition (1936)."
Meaning in the Visual Arts.
Garden City, N.Y., 1955, p. 295 ff.

</div>

Self-Portrait

1650 oil on canvas 38½″ x 29″ Paris, Louvre

The conception of the Chantelou and Pointel portraits* has no direct parallel in painting. The pose of the head in the Pointel version recalls the self-portrait of Giorgione in Brunswick, which Poussin may have known from copies or engravings, but the background in both versions is a pure and happy invention of Poussin. The . . . putti . . . in the background of the Pointel picture probably had some special significance for Poussin which escapes us. . . . In the Chantelou version he replaces them by a background of framed canvases and a door, which pattern out the composition in a series of simple rectangles strictly in accordance with Poussin's rigidly mathematical principles of composition at this period. At the same time they present a sort of abstraction of the artist's studio, which is Poussin's equivalent for the glimpses of studio properties which are common in self-portraits of the seventeenth century. On one of the canvases we can see the head and shoulders of a woman, wearing a diadem with an eye in the centre, and with the two hands of an invisible figure clasping her shoulders. Bellori tells us that the woman is painting, and the two clasping hands represent love of painting and friendship, a delicate reference to the two qualities which the artist recognised in the patron for whom the portrait was executed.

<div style="text-align:right">

Anthony Blunt. "Poussin Studies I: Self-Portraits."
Burlington Magazine, August 1947, p. 225 ff.

</div>

Poussin has represented himself here in a significant moment of his life—at the peak of his career. . . . Behind him lies his past—gayer and more colorful; before him, unavoidable decline and death await him. . . .

This idea of a balance-sheet of life is commented upon by the paintings in the background. (*Note*: Paintings represented in pictures are always, according to a tradition going back to the end of the Middle Ages, glosses on the major theme.) . . . The representation of the nuptials of Hera and Zeus probably has here, an autobiographical significance; it is the symbol of the artist's marriage, to which the engagement ring and wedding ring on his finger also allude.

Would it not, then, be permissible to assume that the two other paintings behind the figure, might have a similar meaning and, . . . with the Hera painting, could represent the three phases of the artist's life? That at the back,

* The Poussin self-portrait painted for Paul Fréart de Chantelou is that in the Louvre. The earlier portrait, painted for Pointel in 1649, is in the Gemäldegalerie of the Staatliche Museen, East Berlin. Since it was cleaned after World War II, it has been regarded as the original, and a version in the collection of Gimpel Brothers, London, a copy.

Self-Portrait. *Poussin*

whose frame appears on the right, is exactly at the level of the artist's eyes; it could thus represent the sensual period, that is to say, Poussin's youth. The Hera painting which follows and has a wider frame, partly hiding the first painting, levels at exactly the height of the forehead; it could therefore be a symbol of the acme of his life, the phase of carefully thought-out creativeness. On top of these two canvases is a third one with the frame coming below the artist's eyes. This canvas has not yet been worked on; its gray-beige surface is blank, except for the inscription in golden letters on the right; it could therefore be the period ahead—the unwritten chapter of old age.

Thus this *Self-Portrait* appears as a résumé of Poussin's character and life —a "history of the soul" of the artist, and at the same time a picture of the typical stages in the life of any man.

Charles de Tolnay. "The Self-Portrait of Poussin in the Louvre Museum." *Gazette des Beaux-Arts*, September 1952, p. 140 ff.

The Blind Orion Searching for the Rising Sun

1658 oil on canvas 46⅞" x 72" New York, Metropolitan Museum of Art

Orion, the subject of this landscape, was the classical Nimrod; and is called by Homer, "a hunter of shadows, himself a shade." He was the son of Neptune; and having lost an eye in some affray between the Gods and men,

was told that if he would go to meet the rising sun, he would recover his sight. He is represented setting out on his journey, with men on his shoulders to guide him, a bow in his hand, and Diana in the clouds greeting him. He stalks along, a giant upon earth, and reels and falters in his gait, as if just awaked out of sleep, or uncertain of his way;—you see his blindness, though his back is turned. Mists rise around him, and veil the sides of the green forests; earth is dank and fresh with dews, the "grey dawn and the Pleiades before him dance," and in the distance are seen the blue hills and sullen ocean. Nothing was ever more finely conceived or done. It breathes the spirit of the morning; its moisture, its repose, its obscurity, waiting the miracle of light to kindle it into smiles: the whole is, like the principal figure in it, "a forerunner of the dawn." The same atmosphere tinges and imbues every object, the same dull light "shadowy sets off" the face of nature: one feeling of vastness, of strangeness, and of primeval forms pervades the painter's canvas, and we are thrown back upon the first integrity of things. This great and learned man might be said to see nature through the glass of time: he alone has a right to be considered as the painter of classical antiquity. Sir Joshua has done him [Poussin] justice in this respect. He could give to the scenery of his heroic fables that unimpaired look of original nature, full, solid, large, luxuriant, teeming with life and power; or deck it with all the pomp of art, with temples and towers, and mythologic groves. His pictures "denote a foregone conclusion." . . . Like his own Orion, he overlooks the surrounding scene, appears to "take up the isles as

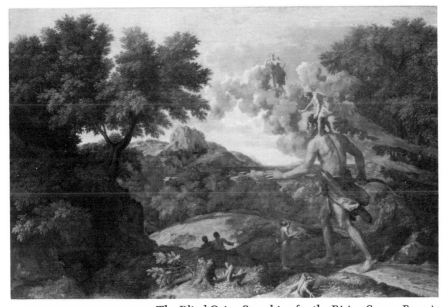

The Blind Orion Searching for the Rising Sun. *Poussin*

113

a very little thing, and to lay the earth in a balance." With a laborious and mighty grasp, he put nature into the mould of the ideal and antique; and was among painters (more than any one else) what Milton was among poets. There is in both something of the same pedantry, the same stiffness, the same elevation, the same grandeur, the same mixture of art and nature, the same richness of borrowed materials, the same unity of character. . . .

Poussin was, of all painters, the most poetical. He was the painter of ideas. No one ever told a story half so well; nor so well knew what was capable of being told by the pencil. He seized on, and struck off with grace and precision, just that point of view which would be likely to catch the reader's fancy. There is a significance, a consciousness in whatever he does (sometimes a vice, but oftener a virtue) beyond any other painter. His Giants sitting on the tops of craggy mountains, as huge themselves, and playing idly on their Pan's-pipes, seem to have been seated there these three thousand years, and to know the beginning and the end of their own story.

William Hazlitt. "On a Landscape of Nicolas Poussin (1821–22)." *Complete Works*, vol. VIII, London, 1931, p. 168 ff.

The Four Seasons: Winter
[The Deluge]

1660–64 oil on canvas 46½" x 63" Paris, Louvre

Poussin symbolized the four seasons by four subjects from the Old Testament, perhaps with a hidden allegorical connotation (*cf.* W. Sauerländer's "Die Jahreszeiten," *Münchner Jahrbuch*, vol. III, 1956). *Spring* is represented by the Garden of Eden and the world *ante legem* (i.e., before the Ten Commandments). *Summer* is shown as the meeting of Ruth and Boaz, the ancestors of Christ, representing the world *sub gratia* (i.e., in a state of grace). *Autumn* depicts the return of the messengers from the Promised Land and symbolizes the world *sub lege* (i.e., under the law of the Old Testament). *Winter,* the work under discussion here, is represented by the Deluge, symbolic of the Last Judgment and ultimate redemption.

We had gathered in the house of the Duke of Richelieu [to admire *The Four Seasons*, which Poussin had just painted for the Duke]. All the leading connoisseurs of Paris were present. The speeches were long and learned. M. Bourdon and M. Le Brun led the discussion and said many fine things. I, too, spoke and declared myself for *The Deluge*. M. Passart agreed. M. Le Brun, who appreciated *Spring* and *Autumn* very little, praised

Summer most highly. But M. Bourdon gave the palm to the *Earthly Paradise* [Spring] and did not waver in his opinion.

L. H. Loménie de Brienne. "Discours sur les ouvrages des plus excellens peintres anciens et nouveaux (1693–95)." Quoted in Centre National de la Recherche Scientifique . . . *Nicolas Poussin*, II, 1960, 222.

It is a remarkable and often discussed phenomenon that great artists develop in the last years of their lives a sublime style which differs symptomatically from the style of their youth and maturity. The works of the late or "old age" style of Titian, Rubens, Rembrandt and others display a deepening and broadening of imagination in form and idea, that compensates for the natural uncertainty of vision caused by the decay of bodily forces. It seems that in their late works aged artists strive for totality of impression while they are less concerned with the delineation of detail. Frequently their works are filled with a new and moving lyricism, a revival from youth, but in a different, often elegiac tone which contrasts with the clear and vigorously expressed narration or action of their mature works.

These deficiencies and virtues of old age are observable also in Nicolas Poussin and his work. . . .

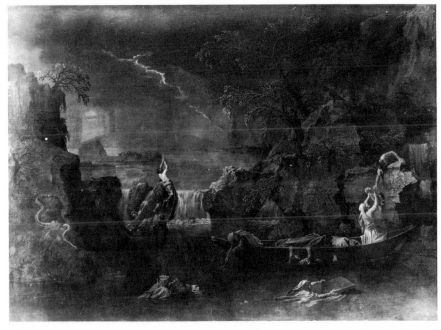

The Four Seasons: Winter. *Poussin*

Only in a few very late mythological and landscape paintings Poussin . . . reveals his personal and passionate feeling, so that the figures appear as symbols for his transcendental meditations. The paintings in which a new and very different sense is manifested are: the *Orion* of 1658 . . . , *The Birth of Bacchus* of 1657 in the Fogg Museum, and his very last work, the Louvre *Apollo and Daphne* fantasy. To these have to be added the incomparable and enigmatic cycle of *The Four Seasons*. . . .

Some people have wondered why the last of Poussin's *Four Seasons, Winter,* was not rendered in the normal way as a snow landscape. One explanation may be that Poussin aimed at giving, as far as possible, correct local color to Old Testament stories, and that he knew winter in the Levant to be characterized not by snow, but by torrential rain. But this rationalization, stated already in the French Academy, is only half true. For *Winter,* Poussin chose tempest and death as a palpable and necessary contrast to the blooming life of spring and the exuberant fullness of summer and fall. In accord with the religious content invested in the other seasons, Poussin equated winter with the almost complete destruction of mankind, the Deluge . . . it is the cosmic aspect of terror and catastrophe itself which he depicts.

For the setting of *The Deluge,* Poussin could go back to Michelangelo's grandiose fresco on the ceiling of the Sistine Chapel. And he was probably also aware of the surprising composition . . . of *The Deluge* which the youngest of the Carracci, Antonio, made in the Quirinale about 1616. In Poussin's painting, as in Antonio's, two great rock masses enclose the expanse of water in which hopeless men and women struggle without avail against the rushing tides. A great snake, which Poussin in his late years used often as a personification of evil, winds itself from a rock and adds still more horror to the scene. The waters are divided into two regions by a foaming cataract. Above, the water is calm, the sun is breaking through the clouds, and in the background is the only note of hope, the Ark of Noah, the symbol of the Church.

<div style="text-align: right">Walter Friedlaender. "Poussin's Old Age." *Gazette des Beaux-Arts,* July–August, 1962, p. 249 ff.</div>

CLAUDE LORRAIN

Claude's real name was Claude Gellée. He was born in 1600 at Chamagne, near Nancy in Lorraine; hence the surname "Lorrain" or "Lorraine." At the age of about thirteen Claude went to Italy as a pastry cook, but, while in the service of the landscape painter Agostino Tassi, he turned painter. Except for a journey to Lorraine in 1626–27, Claude lived in Rome until his death in 1682. Influenced by Paul Bril and Adam Elsheimer, Claude was one of the creators of the ideal landscape. By the end of the 1630's he was already a very popular landscape painter; his mature style developed after 1650, when he was concerned with the effects

of light in the sky and on water. Presumably to protect himself from fraudulent imitations, he created his *Liber veritatis* (Book of Truth), now in the British Museum, which is a collection of 195 drawings made from his paintings. This still forms the basis for the identification of his work. (It was engraved by Richard Earlom, London, 1777–1819.) Claude's influence extends over two centuries, leading up to the landscapes of Corot. His principal early biographers are the German painter Joachim von Sandrart (1606–88), who was in Rome from 1628 to 1635, and the Italian art historian Filippo Baldinucci (circa 1624–96).

He was thrifty and studied his art with great seriousness and application: he tried by every means to penetrate nature, lying in the fields before the break of day and until night in order to learn to represent very exactly the red morning-sky, sunrise and sunset and the evening hours. When he had well contemplated one or the other in the fields, he immediately prepared his colours accordingly, returned home and applied them to the work he had in mind with much greater naturalness than anyone had ever done. This hard and burdensome way of learning he pursued for many years, walking daily into the fields and the long way back again, until he finally met me, with the brush in my hands, in Tivoli, in the wild rocks at the famous cascade, where he found me painting from life and saw that I painted many works from nature itself, making nothing from imagination; this pleased him so much that he applied himself eagerly to adopting the same method; thanks to great laboriousness and continuous exercise he attained such naturalness that his landscapes were [or: are] demanded by amateurs from everywhere, eagerly bought and sent to various places; and in spite of having been little appreciated at the beginning, they were afterwards held in esteem and sold for a hundred and even more gold crowns, so that even though he always worked diligently he could nevertheless not make enough of them.

As a master of perspective, he knew how to break the hard quality of the colours and to mix them so that they no longer resembled those colours but what he wished to represent; he was also very assiduous and by long persistence brought out all that his rich memory, as it were, had sucked out of nature and life; thus he was soon followed by all landscape painters, and his manner was remarked, praised, and honoured. In his manner of life he was no great courtier, but good-hearted and pious; he searched for no other pleasure beside his profession, for which we loved each other very much and lived for a long time together in Rome, often also painting together from life in the field. But while I was only looking for good rocks, trunks, trees, cascades, buildings, and ruins which were great and suited me as fillers for history paintings, he on the other hand

117

only painted, on a small scale, the view from the middle to the greatest distance, fading away towards the horizon and the sky, a type in which he was a master. . . .

> Joachim von Sandrart. *Teutsche Academie* (1675).
> Quoted in Marcel Röthlisberger. *Claude Lorrain.*
> 2 vols. New Haven, 1961, I, 47 ff.

He was working for the King [Philip IV of Spain] on the said pictures, to which indeed he had scarcely begun to give some shape, when certain envious men, eager for dishonest gains, not only stole the compositions but even imitated the manner, and their copies were sold in Rome as originals from his brush; this brought discredit to the master, disserved the person for whom the pictures were made, and defrauded the buyers to whom the copies were presented as originals. But the trouble did not end there, because whatever he did, the same thing happened. The unhappy Claudio, a man of innocent behaviour, did not know against whom to guard himself among the many who frequented his studio, or to which side to turn; finding every day that similar paintings were being brought to him so that he might ascertain whether they were from his own hand, he decided to put together a book which he himself showed me at his house in Rome, to my great delight and admiration; into this book he began to copy the composition of all the works which he sent out, transcribing them with a truly masterly touch, every detail down to the most minute of the painting in question, noting even the name of the person for whom it had been made and, if my memory serves, the price which he had received; to which book he gave the name of "Libro d'Invenzioni" or "Libro di Verità"; and from that time onwards, whenever he was brought pictures for inspection—his or not his—without further words he would show the book, saying: I never send out a work from here which, after having completely finished it, I have not copied with my own hand in this book. Now I wish you yourselves to settle our doubts, therefore look here and see if you recognize your picture; and in this manner, since whoever stole the composition was unable to render precisely all the details, the difference was immediately apparent to the eyes of everyone, and the deception was exposed. And if sometimes, frightened by the rumour already current that there were scoundrels in Rome who gave out their landscapes as originals, even those who had bought his pictures and did not understand more than what the works of art showed them had him look at them again, he made them see unequivocally from the book, in addition to his own testimony, that theirs were indeed his originals.

> Filippo Baldinucci. *Notizie dei professori del disegno,*
> vol. IV (1728). Quoted in *ibid.,* I, 59.

Allow me to mention another landscape painter whom I knew in Rome long ago and who painted the effects of the rising sun so well— I mean Claude Lorrain. His paintings are perfect representations of nature; the sun glistens in them. But this is particularly admirable about them and entirely his own: The sun shines through a haze, a light mist not yet wholly dissipated by its rays. This moderates the brightness of the sun's luminosity, thereby lending his pictures a delightful freshness.

> Sébastien Bourdon. "Conférence
> sur la lumière (1670)." In Henry Jouin, ed. *Conférences*
> *de l'Académie Royale de Peinture et de Sculpture.*
> Paris, 1883, p. 129.

The sky always gradates one way or other, and the rising or setting sun exhibits it in great perfection, the imitating of which was Claude de Lorrain's peculiar excellence. . . .

> William Hogarth. *The Analysis of Beauty* (1753).
> Oxford, 1955, p. 110.

[Benjamin] West [the American painter] observed that Claude had so continued his lights that the eye always settled upon the distance & the Center of the picture,—as the eye naturally does in viewing the scenes of nature.—He remarked how carefully Claude had avoided sharp & decided forms in the distance, gradually *defining* the parts as He came nearer to the foreground.—He thinks that Claude began his pictures by laying in simple gradations of flat colours from the Horizon to the top of the sky,—and from the Horizon to the foreground, witht. putting clouds into the sky or specific forms into the landscape till He had fully settled those gradations.—When He had satisfied himself in this respect, He painted in his forms, by that means securing a due gradation,—from the Horizontal line to the top of his Sky,— and from the Horizontal line to the foreground.—[Robert] Smirke remarked how entirely all *positive* colour was avoided, even to the draperies of the figures.—[William] Turner said He was both pleased & unhappy while He viewed it,—it seemed to be beyond the power of imitation.

> Joseph Farington. *The Farington Diary.* 8 vols.
> London, 1923–28, I, 269. Entry for May 8, 1799.

The name of Claude has alone something in it that softens and harmonises the mind. It touches a magic chord. Oh! matchless scenes, oh! orient skies, bright with purple and gold; ye opening glades and distant sunny vales, glittering with fleecy flocks, pour all your en-

chantment into my soul, let it reflect your chastened image, and forget all meaner things!

<div align="right">

William Hazlitt. "Sketches of the Principal Picture
Galleries in England (1824)."
Complete Works, vol. X, London, 1932, p. 66.

</div>

Claude Lorraine pours the spirit of air over all objects, and new-creates them of light and sun-shine. In several of his master-pieces . . . the vessels, the trees, the temples and middle distances glimmer between air and solid substance, and seem moulded of a new element in nature. No words can do justice to their softness, their precision, their sparkling effect. But they do not lead the mind out of their own magic circle. They repose on their own beauty; they fascinate with faultless elegance. Poussin's landscapes are more properly pictures of time than of place. They have a fine *moral* perspective, not inferior to Claude's aërial one.

<div align="right">

William Hazlitt. "Notes of a Journey
Through France and Italy (1826)." *Ibid.* p. 108.

</div>

Goethe placed before me a volume of Claude Lorrain's landscapes.

"There you can see for once a human being of perfection," said Goethe. "His thinking and feeling was concerned with beauty. He saw a world with his inner eyes as is not readily encountered anywhere outside. His pictures are of the highest truth, yet contain no trace of actuality. Claude Lorrain knew the real world by heart, down to its minute details. He utilized it as a means of expressing the harmonious universe of his soul. This is true idealism: To employ the means of reality so that the resulting truth produces the illusion of being real."

<div align="right">

Johann Wolfgang von Goethe (April 10, 1829).
Quoted in J. P. Eckermann. *Gespräche mit Goethe.*
2 vols. Berlin, n.d., II, 115.

</div>

. . . Mr. Ellison did much toward solving what has always seemed to me an enigma:—I mean the fact (which none but the ignorant dispute) that no such combination of scenery exists in nature as the painter of genius may produce. No such paradises are to be found in reality as have glowed on the canvas of Claude. While the component parts may defy, individually, the highest skill of the artist, the arrangement of these parts will always be susceptible of improvement.

<div align="right">

Edgar Allan Poe. "The Domain of Arnheim (1847)."
Works, vol. II, Chicago, 1894?, p. 98.

</div>

He had a fine feeling for beauty of form and considerable tenderness of perception. His aërial effects are unequalled. Their character appears to me to arise rather from a delicacy of bodily constitution in Claude, than from any mental sensibility; such as they are, they give a kind of feminine charm to his work, which partly accounts for its wide influence. . . .

He had sincerity of purpose. . . . Very few of his sketches, and none of his pictures, show evidence of interest in other natural phenomena than the quiet afternoon sunshine which would fall methodically into a composition. One would suppose he had never seen scarlet in a morning cloud, nor a storm burst on the Apennines. But he enjoys a quiet misty afternoon in a ruminant sort of way, yet truly; and strives for the likeness of it, therein differing from Salvator, who never attempts to be truthful, but only to be impressive.

His seas are the most beautiful in old art. For he studied tame waves, as he did tame skies, with great sincerity, and some affection. . . .

He first set the pictorial sun in the pictorial heaven. We will give him the credit of this, with no drawbacks.

He had hardly any knowledge of physical science, and shows a peculiar incapacity of understanding the main point of a matter. Connected with which incapacity is his want of harmony in expression. . . .

Such were the principal qualities of the leading painter of classical landscape.

> John Ruskin. *Modern Painters* (1843–60). 5 vols.
> London, 1929–35, V, 318 ff.

Claude is the most ardent worshipper that ever was of the *genius loci*. Of his landscapes one always feels that "some god is in this place." Never, it is true, one of the greater gods: no mysterious and fearful Pan, no soul-stirring Bacchus or all-embracing Demeter . . . but some mild local deity, the inhabitant of a rustic shrine whose presence only heightens the glamour of the scene.

It is the sincerity of this worship, and the purity and directness of its expression, which makes the lover of landscape turn with such constant affection to Claude, and the chief means by which he communicates it is the unity and perfection of his general design; it is not by form considered in itself, but by the planning of his tone divisions, that he appeals, and here, at least, he is a past master. This splendid architecture of the tone masses is, indeed, the really great quality in his pictures; its perfection and solidity are what enables them to bear the weight of so meticulous and, to our minds, tiresome an elaboration of detail without loss of unity, and enables us even to accept the enam-

elled hardness and tightness of his surface. But many people of to-day, accustomed to our more elliptical and quick-witted modes of expression, are so impatient of these qualities that they can only appreciate Claude's greatness through the medium of his drawings, where the general skeleton of the design is seen without its adornments, and in a medium which he used with perfect ease and undeniable beauty. Thus to reject the pictures is, I think, an error. . . . But in the drawings, at all events, Claude's great powers of design are readily seen, and the study of the drawings has this advantage also, that through them we come to know of a Claude whose existence we could never have suspected by examining only his finished pictures. . . .

> Roger Fry. "Claude (1907)." *Vision and Design.*
> New York, 1947, p. 147 ff.

Claude Gellée, the true heir to the poetry of Giorgione, was fully appreciated in his own lifetime, and has been the object of much devotion ever since; but he does not offer an easy target for the critic, and no great artist has inspired so little literature. Roger Fry, whose essay on Claude in *Vision and Design* remains the best criticism of his painting since Hazlitt, regarded him as a sort of simpleton who arrived at his felicities by accident, and this view would probably have been corroborated by Poussin, who lived in Rome at the same time as Claude for almost forty years and never mentions him, although we know from Sandrart that they went painting together. But the inspired-idiot theory of a great artist is practically never correct; and when we look at the enormous range of Claude's drawings and the quantity of delicately observed fact which they contain, and then consider that he was able to use all this material in subordination to a poetic conception of landscape almost as ideal in its own way as Poussin's, we realise that Claude, however inarticulate, was not lacking in intelligence.

Anyone who looks at [his pictures] in a receptive frame of mind must surely be touched by their exquisite poetry. They are a perfect example of what old writers on art used to call Keeping. Everything is in Keeping: there is never a false note. Claude could subordinate all his powers of perception and knowledge of natural appearances to the poetic feeling of the whole. The world of his imagination is so clear and consistent that nothing obtrudes, nothing is commonplace, nothing (least of all) is done for effect. . . . Claude nearly always conformed to an underlying scheme of composition. This involved a dark *coulisse* on one side (hardly ever on two), the shadow of which extended across the first plane of the foreground, a middle plane with a large central feature, usually a group of trees, and finally two planes,

one behind the other, the second being that luminous distance for which he has always been famous, and which he painted direct from nature. Much art was necessary to lead the eye from one plane to the next, and Claude employed bridges, rivers, cattle fording a stream and similar devices; but these are less important than his sure sense of tone, which allowed him to achieve an effect of recession even in pictures where every plane is parallel. Naturally he used many variants of this compositional scheme.

Kenneth Clark. *Landscape into Art* (1949).
Boston, 1961, p. 62 ff.

Seaport with the Embarkation of St. Ursula

1641 oil on canvas 44½" x 58½" London, National Gallery

He [Claude] carried landscape . . . to perfection, that is, *human perfection.* . . .

When we speak of the perfection of art, we must recollect what the materials are with which a painter contends with nature. For the light of the sun he has but patent yellow and white lead,—for the darkest shade, umber or soot.

Brightness was the characteristic excellence of Claude; brightness, independent on colour, for what colour is there here? (holding up a glass of water.)

The *St. Ursula*, in the National Gallery, is probably the finest picture of *middle tint* in the world. The sun is rising through a thin mist, which, like the effect of a gauze blind in a room, diffuses the light equally. There are no large dark masses. The darks are in the local colours of the foreground figures, and in small spots; yet as a whole, it is perfect in breadth. There is no evasion in any part of this admirable work, every object is fairly painted in a firm style of execution, yet in no other picture have I seen the evanescent character of light so well expressed. . . .

Though it is the fashion to find fault with his figures indiscriminately, yet in his best time they are so far from being objectionable, that we cannot easily imagine any thing else according so well with his scenes;—as objects of colour, they seem indispensable.

John Constable. "Notes of six lectures on landscape painting
(1836)." In C. R. Leslie. *Memoirs of the Life of John Constable.*
London, 1845, p. 338 ff.

Lorrain's harbor scenes are always filled with the same kind of monumental Roman structures that suggest the same kind of historic setting, whether they frame the "Arrival of the Queen of Sheba," the "Landing of Cleopatra," or the "Embarkation of St. Ursula." In the St. Ursula scene, the sunlight dropping

Seaport with the Embarkation of St. Ursula. *Claude Lorrain*

through tranquil air, gilds each little wave crest, models the columned porticoes, and illuminates trees, masts, and human figures with the calm unchanging radiance that softens the rigidity of the underlying linear composition.

Paul Zucker. *Styles in Painting* (1950).
New York, 1963, p. 205.

Coast View with Acis and Galatea

1657 oil on canvas 39½″ x 53″ Dresden, Gemäldegalerie

"In the gallery at Dresden there is a picture by Claude Lorraine, called in the catalogue *Acis and Galatea*, but I used to call it 'The Golden Age,' I don't know why. . . . I dreamed of this picture, but not as a picture, but, as it were, a reality. . . . It was just as in the picture, a corner of the Grecian Archipelago, and time seemed to have gone back three thousand years; blue smiling waves, isles and rocks, a flowery shore, a view like fairyland in the distance, a setting

Coast View with Acis and Galatea. *Claude Lorrain*

sun that seemed calling to me—there's no putting it into words. It seemed a memory of the cradle of Europe. . . . Here was the earthly paradise of man: the gods came down from the skies, and were of one kin with men. . . . Oh, here lived a splendid race! they rose up and lay down to sleep happy and innocent; the woods and meadows were filled with their songs and merry voices. Their wealth of untouched strength was spent on simple-hearted joy and love. The sun bathed them in warmth and light, rejoicing in her splendid children. . . . Marvellous dream, lofty error of mankind! The Golden Age is the most unlikely of all the dreams that have been. . . . Rocks and sea, and the slanting rays of the setting sun—all this I seemed still to see when I woke up and opened my eyes, literally wet with tears. . . . A sensation of happiness I had never known before thrilled my heart till it ached; it was the love of all humanity."

Feodor Dostoyevsky.* *A Raw Youth* (1875).
New York, 1961, p. 505 ff.

* Dostoyevsky's vision of the Golden Age as inspired by Claude's *Acis and Galatea* occurs also in the suppressed chapter of *The Possessed* entitled "Stavrogin's Confession," and in his short novel *A Funny Man's Dream.*

Landscape with Psyche and the Palace of Amor
[The Enchanted Castle]

ca. 1664 oil on canvas 34¼ " x 59½ " Collection of C. L. Loyd, Wantage, England

... You know, I am sure, Claude's *Enchanted Castle*,* and I wish you may be pleased with my remembrance of it. ...

> Dear Reynolds, as last night I lay in bed,
> There came before my eyes that wonted thread
> Of Shapes, and Shadows and Remembrances,
> That every other minute vex and please:
>
>
>
> You know the Enchanted Castle, it doth stand
> Upon a Rock on the Border of a Lake
> Nested in Trees, which all do seem to shake
> From some old Magic like Urganda's sword.
> O Phœbus that I had thy sacred word
> To shew this Castle in fair dreaming wise
> Unto my friend, while sick and ill he lies.
>
> You know it well enough, where it doth seem
> A mossy place, a Merlin's Hall, a dream.

Landscape with Psyche and the Palace of Amor. *Claude Lorrain*

* Keats probably knew only the engraving by Vivarès and Woollett (1782), and not the original painting.

126

You know the clear Lake, and the little Isles,
The Mountains blue, and cold near neighbour rills—

. . . .

O that our dreamings all of sleep or wake
Would all their colours from the Sunset take:

. . . .

John Keats. Letter to J. H. Reynolds, March 25, 1818.
Letters. London, 1895, p. 109 ff.

JACQUES BLANCHARD

Born in 1600 in Paris, Blanchard was the pupil of his uncle Nicolas Bollery and, later, of Horace Le Blanc of Lyons. In 1624 he went to Rome and then to Venice. Five years later he returned to Paris, where he died in 1638. A member of the Guild of St. Luke, he was active as a decorator of Parisian palaces and mansions, but most of this work is lost. He also painted religious, mythological, and allegorical pictures, combining French mannerism with the influence of the Venetian painters and Rubens.

[Jacques Blanchard] the artist of whom I speak has distinguished himself particularly as a colorist. His color is so beautiful, so fresh, and so natural that he is commonly called the Giorgione or the Titian of France. His knowledge of drawing follows this precious gift of color closely. Although he died young he painted many fine pictures cherished by the connoisseurs.

Charles Perrault, *Les Hommes illustres*. 2 vols.
Paris, 1696–1700, II, 91.

He liked very much to paint female nudes, and he had such great facility in rendering them well that he could be seen painting an entire life-size figure in two or three hours.

André Félibien. *Entretiens sur les vies et sur les
ouvrages des plus excellens peintres*. 2 vols.
Paris, 1685–88, II, 181.

Jacques Blanchard has a very special place in the history of French painting of the time of Louis XIII. He was the representative of that group of artists who became known as the "colorists." He was the first French painter, from the time that contact was established with Italian art in the reign of Francis I, who was profoundly influenced by the Venetian School. Of course, Vouet preceded him to Venice and derived his grand decorative style and his florid range of

127

colors from Venetian art. . . . But when we compare the paintings of Blanchard to those of Vouet, we see the great difference between the two artists. Blanchard's colors are ravishing. He subtly meshed together cold and warm tones with a rich, rough-textured brushwork. In contrast, Vouet almost always used a cool range of colors which are clear, stridently sharp, and distinctly separated from each other. The colors are applied with smooth brush strokes, rarely overloaded with paint. Seeing the paintings of Blanchard and Vouet side by side, we can fully comprehend d'Argenville's praise of Blanchard: "He understood better than anyone else the technique of mixing colors, what Pliny called *commixtura et transitus colorum.**" D'Argenville added a revealing statement about the historical position of the two artists. As a critic still in the grip of the quarrel between the supporters of Rubens and those of Poussin, his appraisal was correct though oversimplified. He said: "One cannot dispute the fact that Blanchard established a new taste for color in France just as Vouet had restored the correct way of drawing."

But Blanchard did not quite establish this new interest in color in his own lifetime. He encountered the powerful opposition of Vouet and of his students, in other words of almost the entire French school. For those painters, color was not completely ignored, far from that, but it was given a secondary, decorative role. They used a range of bright and cool colors which were clearly differentiated from one another, in contrast to the Venetians who painted with harmonies of rich colors. However, Blanchard set the stage for a new attitude. By the intermediary of his pupil Louis Boullogne the Elder, and of his son Gabriel Blanchard (through his theories rather than his paintings, which were weak) Blanchard's teachings were followed, and the "colorists" were finally able to triumph at the end of the century. This was Blanchard's true historical importance.

<div style="text-align:right">

Charles Sterling. "Les Peintres Jean et Jacques Blanchard." *Art de France*, I, 1961, p. 117.

</div>

Angelica and Medor

ca. 1628–30 oil on canvas 47⅞″ x 69¼″
New York, Metropolitan Museum of Art

Angelica and Medor illustrates the episode from Ariosto's *Orlando Furioso* in which the two lovers engrave their names on the bark of a tree. The female figure, a nude seen from the rear with her face turned away from the spectator, reclines on a white sheet, over which a light red cloak is spread. The pose is

* The blending and gradation of colors.

Angelica and Medor. *Blanchard*

not completely free from the artificiality of a model. The gracefulness of the body differs considerably from the more robust, vibrant female nudes of the Venetian Cinquecento. The formal problem is the same as that which Velazquez was to set himself later when he painted his *Rokeby Venus*. We must admit that Blanchard does not fare badly with his solution, which reveals good taste as well as an appropriate sentiment.

Werner Weisbach. *Französische Malerei des XVII. Jahrhunderts.* Berlin, 1932, p. 58.

PHILIPPE DE CHAMPAIGNE

Philippe de Champaigne (also spelled Champagne) was born in 1602 in Brussels, where he received his early training under Fouquières, one of Rubens' assistants. He came to Paris at the age of nineteen in 1621 and worked with various painters, among whom was the mannerist Georges Lallemant. Together with the young Poussin he worked on the decorations of the Luxembourg Palace under the direction of Nicolas Duchesne, whom he succeeded as painter to the Queen Mother Marie de' Medici. As a painter of portraits and religious scenes he also enjoyed the patronage of Louis XIII, Queen Anne of Austria, and Cardinal Richelieu, whose portrait he painted several times. In his earlier work he was subject

to the influence of Rubens and Van Dyck. About 1643 he came into contact with the austere Jansenist doctrines and the convent of Port-Royal. Severity and sobriety characterize his paintings for the remainder of his life. He died in Paris in 1674.

The abbeys and churches in which he [de Champaigne] worked have mostly been demolished, the Luxembourg and the Palais Royal have been gutted. One half of his life's work has thus practically disappeared; but it is a mistake to ignore its influence or to forget that, while it existed, it was the outstanding example of adherence to Rubens and the connecting link between the great Flemish artist and the Frenchmen of the other end of the century who revolted in his favor against Le Brun. . . . De Champaigne's earlier decorations are entirely in the manner of the great Fleming's Luxembourg paintings. . . .

Yet de Champaigne was by no means out of sympathy with contemporary life in France. . . . The intellectual and moral movement which was going on . . . rallied round the Jansenists in their effort to combat the laxity of contemporary doctrines. . . . Jansen himself was a Fleming who achieved no great fame until, after his death, his strict exposition of rigid Augustinian doctrine was transformed in France into a fiery standard to be borne against the Jesuits. . . . As the sins of the Court appeared to be condoned by the Jesuits, so the more thoughtful . . . were attracted to the [convent of] Port-Royal . . . living as "solitaries" in the utmost simplicity. Thinkers like Pascal turned a dogmatic and sectarian agitation into a great intellectual movement. . . .

There is a keenly polished austerity in de Champaigne's face, as he himself depicted it, which makes it clear that he would prefer Port-Royal to the palace. The Jansenist point of view came to dominate his art, and one cannot fully understand the paintings of the second part of his career without some knowledge of the moral and intellectual ideals which dominated his mind. . . .

De Champaigne was an austere man by nature, but the Jansenist view of religion appears finally to have frozen up the natural exuberance which was his Flemish birthright.

> Philip Hendy. "Philippe de Champaigne."
> *Apollo*, V, 1927, p. 166 ff.

He painted agreeably and with ease, and was a good colorist. His draftsmanship was rather precise; one could hardly execute a portrait head more successfully. His portraits were always excellent likenesses; he was also a proficient landscapist. On the other hand, he remained a slave to the object he depicted, representing it too literally, and being unable to somehow rise above it. His talent, which was lacking in fire, did not permit him to apply imagination. Furthermore, because of his

zealous piety (for he led a very religious life) or simply because he recognized his own limitations, he rarely painted anything but devotional themes, which do not lend themselves to the representation of the passions or agitated emotions, as do subjects drawn from history or legend. This type of work, and the portraits to which he had dedicated himself, as well as his modesty, righteous morality, and almost unprecedented disinterestedness won a place for him among all the virtuous persons of his century.

> P. J. Mariette. *Abécédario* (ca. 1750) 6 vols.
> Paris, 1851–60, I, 351.

Philippe de Champaigne is more famous than he is known, as is the case with so many of his contemporaries. . . . Up until now there has been no scholarly study of his art, nor has there been a comprehensive exhibition of his works. Thus . . . he is ordinarily only considered as the portraitist of Richelieu and of Port-Royal, a severe, stilted, religious artist, who is wrongly placed as the intermediary between the painters of reality and the champions of classicism and, indeed, of academic painting. . . .

But Philippe de Champaigne has a more varied talent than one would think. He did not only create religious paintings and portraits. Outside of genre painting, which was too earthbound for his grave personality, and outside of mythology, which annoyed his sense of morality, his subject matter included the themes customary in his time.

Unfortunately his still lifes are only known through engravings. . . . As a sought-after decorator, he executed commissions for Marie de' Medici at the Luxembourg Palace; for Richelieu at Bois-le-Vicomte, Rueil, Richelieu, the Cardinal's Palace, and the Sorbonne; and for Louis XIV at Vincennes and the Tuileries. However, none of these decorations have been preserved except for some vestiges of the Gallery of Famous Men, the jewel of the Parisian residence of His Eminence, and the entire decoration of the church of the Sorbonne, the only ensemble that has remained in its original place.

Philippe de Champaigne painted easel pictures of allegorical subjects, as well as designed such compositions for use in tapestries and other large decorations. Only one easel painting survives, a *Charity* in the Museum of Nancy. . . .

Philippe de Champaigne was also one of the most remarkable landscape painters of his time. Unfortunately only the four landscapes that once embellished the Val-de-Grâce are preserved. His technical mastery is striking, and so is the originality of his compositions. Here the decorative eloquence derived from his master, Fouquières, his classical severity, and his tendency to construct are com-

131

bined with the style of the contemporary French historical landscape. At the same time there is a note of realism with a simple religious accent.

What diversity can be found in the areas which are really his domain! Philippe de Champaigne as a religious painter executed vast altarpieces for parish churches and rich convents, as well as easel paintings whose severe quality is in accord with their restricted format. He is equally at home in the pompous compositions destined to be used for tapestries as well as in the grave canvases commissioned by strict, pious orders such as the Jansenists and the Carthusians.

His state portraits, where kings, ministers, prelates, and the nobility of the robe and of the sword are revived in all their proud splendor and desire for power, did not, however, prevent him from painting also the sober effigies of the solitary worshippers and nuns of Port-Royal. While Philippe de Champaigne excelled in re-creating a unique personality in the limited space of an individual portrait, he was equally proficient in arranging the many figures of a group. He was thus neither a painter of one genre, nor a man with a one-sided personality. He was more versatile than any of his contemporaries, not excluding Vouet and Poussin, and for this reason he has special significance in the history of art. More than that of any one of his equals, his art expresses the spirit of his time.

<div style="text-align: right">Bernard Dorival in Philippe de Champaigne (Paris, Musée de l'Orangerie). Paris, 1952, p. 11 ff.</div>

Portrait of Armand Jean du Plessis, Cardinal de Richelieu

ca. 1635 oil on canvas 87½" x 61" Paris, Louvre

The figure is seen at full length, standing in front of a rich backdrop, and arrayed in the *capa magna*, with the ribbon of the Order of the Holy Ghost round his neck, a red skullcap on his head, and his biretta in his right hand.

This is undoubtedly the most famous of de Champaigne's works and deservedly so, for it is a most remarkable example of the master's ability to preserve in a state portrait both the essence of the man and the dignity of his office. Moreover, he successfully fuses the one with the other. This work has often been called "Portrait of a Robe," since it is the robe which defines the social being. Furthermore, the painter has given this robe an almost unprecedented importance by placing himself in a position below the model on the dais. However, the face reveals that this effigy is also the portrait of a man, and the device of viewing the face from a diminishing angle lends it added emphasis. In this way the strangeness of the proportions and the contrast between the robe and the figure serve to bring out the personality of the sitter

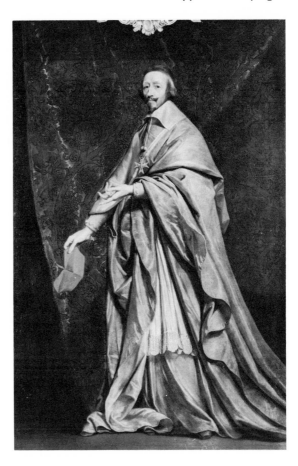

Portrait of Armand Jean
du Plessis,
Cardinal de Richelieu.
Champaigne

more clearly. He is further defined by the willful and well-bred hands, the imperious bearing and proud countenance. De Champaigne has here used with particular felicity those same elements which he employed in his other portraits of Richelieu.

Bernard Dorival in *ibid.*, p. 39 ff.

Two Nuns of Port-Royal

1662 oil on canvas 65″ x 91″ Paris, Louvre

If it is permissible to include Philippe de Champaigne among the painters of our own country, it might be said that the most truly religious works that have appeared since the end of the Italian Renaissance are French. The religious paintings of Le Sueur greatly surpass anything of this type done outside of France; and the *Nuns of Port-Royal*, by Philippe de Champaigne, are a miracle of devotional persuasiveness, of simplicity, and of a profound depth

133

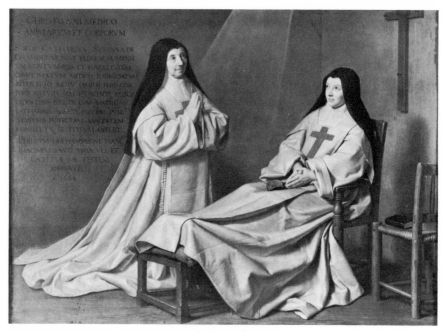

Two Nuns of Port-Royal. *Champaigne*

of expression beneath a calm exterior for which no equivalent can be found elsewhere. And what admirable truth is there in his portraits! What resourcefulness of the painter before nature, what sincerity, what great faith!

<div align="right">J. A. D. Ingres (undated). Écrits sur l'art. Paris, 1947, p. 51.</div>

. . . Under the stress of personal emotion [de Champaigne] has created a work unique in ardor of aspiration as in quiet intensity of pathos. The personages represented are the Mother Superior of Port-Royal, Cathérine-Agnès Arnauld, and the painter's own daughter, Sister Cathérine-Suzanne de Champaigne. The Sister had suffered during fourteen months from a malignant fever;[*] and . . . had been cured through the persistent and untiring prayer of the Mother Superior. Philippe de Champaigne, . . . in order to express his gratitude and to commemorate this wonder, painted, in 1662, the picture. . . . Of the two nuns represented we have the absolutely veracious, the wholly unflattered, portraits; yet the ardor of their devotion, the austere joy of their thanksgiving, transfigures the homeliness of their features. . . . There is here indefinably, yet none the less surely suggested, the Calvinistic severity of Jansenism, the rigid banishment of voluptuous ecstasy from the purified aspiration of faith. . . .

<div align="right">Claude Phillips. "Dramatic Portraiture." Burlington Magazine,
February 1906, p. 313 ff.</div>

[*] Both her legs were paralyzed.

Philippe de Champaigne has painted the masterpiece which expresses the religious spirit of seventeenth-century France. Sister Cathérine de Sainte-Suzanne and Mother Agnès are praying in a cell which is poor and bare, yet filled with a mysterious presence. They are awaiting a miracle. Nothing could be simpler, more modest and gentle than the recumbent young nun, with her hands clasped, her gaze fixed upon God Whom she seems to see but Who does not even fill her with wonder, so accustomed is she to living in His presence.

<div align="right">

Émile Mâle. *L'Art religieux après le Concile de Trente.*
Paris, 1932, p. 200.

</div>

LAURENT DE LA HYRE

Laurent de La Hyre (also spelled de la Hire) was a native Parisian, born in 1606. He studied first with his father and later with the mannerist Georges Lallemant. Although he probably did not visit Italy, his early work was baroque in character, showing the influence of Caravaggio and the Bolognese painters. An example is *Pope Nicholas V Before the Body of St. Francis* (1630; Louvre). After 1640, La Hyre adopted Poussin's classicism. Like Poussin, he did only easel paintings, mainly of religious and allegorical subjects. Toward the end of his life he also painted small landscapes. In his paintings La Hyre liked to use architectural settings or to include architectural elements in scientifically delineated perspective. He was one of the twelve founders of the Royal Academy of Painting in 1648 and died in Paris in 1656.

Laurent de La Hyre was a contemporary of Vouet. Since the latter was the artist with the highest reputation at that time, it was he who trained most of the young painters in his style, and it became a kind of necessity to paint and draw like him, if a painter wanted to be successful. This was the reason for the popularity of Vouet's studio. De La Hyre was almost the only artist who resisted the tide. His style was quite different—he was unable to compose on as large a scale as Vouet; nor was he as elaborate as Vouet in his drawing—but he, too, had his admirers. It might even be said that he lacked the knowledge of giving movement to his figures; they seem a little stiff. But he painted agreeably and with much care. His subjects were placed in a landscape or architectural setting, which he treated with perfection according to all the rules of perspective, of which he had made a special study. Thus his works were in demand, and he himself was held in high esteem.

<div align="right">

Philippe de La Hyre. "Mémoire pour servir à la vie de
Laurent de La Hyre (before 1695)." In P. J. Mariette.
Abécédario (ca. 1750). Paris, 1851–60, III, 49.

</div>

Because of the abstract quality of his style, the sculptural clarity of his figures, and his almost "Ingresque" line, his art is as remote from the expansive baroque lyricism of Vouet as from the sensual and elegiac quality of Blanchard. At the same time, his subtle colors and regard for an elegance combined with realistic details prevent us from considering La Hyre's art merely as an echo of the "classicism" of Poussin. We are forced to recognize the originality of this Parisian art of the *Régence*. In the midst of the disorder and anxiety caused by the Fronde, La Hyre, contemporary of Jordaens and Rembrandt, Bernini and Ribera, was able to combine nobility, simplicity, and stylization with ease. Only Le Sueur in some late paintings, such as the *Sainte Scholastique* in the Louvre, produces anything comparable. We must wait some one hundred and fifty years for the art of Canova and the Empire to find a similar refinement, elegance, and restraint.

However, the name of La Hyre does not evoke much recognition now, and if it does at all, it is only from a few specialists of the seventeenth century. Why do we find this indifference on the part of the public and historians as well? A methodical man, La Hyre was careful to sign and date his principal paintings in fine capital letters so that his work has not completely vanished as has that of Testelin and Errard. An excellent engraver, he produced about forty etchings which have never ceased to be admired by collectors. These etchings are also important because they reveal La Hyre's style to us. A happy family man, he left children who were devoted to preserving his memory. His eldest son Philippe, a notorious personality in Paris, compiled a résumé of his father's life and works for the biographers of his time: Félibien, Guillet de Saint-Georges, and Roger de Piles. However, this did not prevent La Hyre from becoming the victim of the vicissitudes of taste. Even his virtues hurt him. The unobtrusive quality of his paintings concealed their craftsmanship. The simplicity of his life, which reveals no dramatic episode or amorous anecdote, also added to the neglect of an artist who was revered in his lifetime and who should be considered one of the original talents in the totality of European painting. It now requires a considerable effort to bring together the scattered remains of a productive career and to redefine La Hyre's true personality as it lies beneath all the incorrect attributions and bold assertions. . . .

It would be well to show someday how, in the France and Italy of 1640, following a period of excessive lyricism, a need arose for intellectual clarity. . . . One will then note that La Hyre, to have so keenly affirmed this reaction . . . had the boldness of a true innovator.

Thérèse Augarde and Jacques Thuillier. "La Hyre."

L'Œil, April 1962, p. 16 ff.

Allegory of Geometry

1649 oil on canvas 40″ x 62½″ Toledo (Ohio) Museum of Art

By its recent reappearance, out of a Swiss private collection, this previously unpublished and unexhibited *Allegory of Geometry* brings to an extant total of five different subjects the set of allegories of the Seven Liberal Arts that La Hyre is recorded to have painted between 1648 and 1650 as decorations for the house of a M. Tallemant in the Marais quarter of Paris. One, representing *Music,* has been since 1950 in the Metropolitan Museum, New York. . . . The *Allegory of Geometry* . . . testifies to a feeling that seems, in several respects, to reach back to Italy beyond Poussin. Such subjects as series of the Arts had first originated in quattrocento Italy, where they were chiefly painted by masters working at the highly intellectualized court of Urbino and also were worked in the trompe-l'œil *intarsiate* (mosaics of inlaid wood) characteristic of this school and period. Whether La Hyre was ever in Italy is doubtful, yet he may have seen engravings of such fifteenth- or sixteenth-century series. The source seems probable when we note the widespread presence in this painting of a considerable variety of symbols, ranging, left to right, as follows: at the extreme left edge, almost cut by the frame, is seen the corner of an easel-mounted panel incised, then painted, with geometric squares and diagonals for spatial or perspectival measurement; then, a globe to which clings a serpent of the type usually depicted in association with a Cleopatra—perhaps only a form to balance the Sphinx at the right, or simply

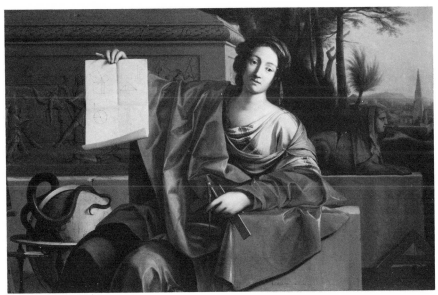

Allegory of Geometry. *La Hyre*

an allusion to Egypt as a purported source of dimensional calculations; then, a sheet of geometrical drawings being held up by the allegorical figure herself —which includes a plan of the Golden Section representing a moderately advanced concept for a French painter of the time; then, held in the hands of the allegorical female are compass and T-square, probably meant as geometric symbols of time and place. To the right of this figure appears a Sphinx, with a geometric triangle affixed to its base; she is, notably, a Roman, not an Egyptian, Sphinx. Roman, too, is the pyramid attenuated almost into a characteristic Roman obelisk. The trees are typical Roman flora just as is the remaining architecture, including bridge and wall as well as the landscape of the Campagna....

So the nature of the background here, with its landscape, buildings and other elements, makes this Allegory considerably more interesting than the other paintings known to have come from the original series. It shows us an aspect of painting under Louis XIV which is as deliberately Italianate and hyper-Classical as the Franco-Classical architecture of the Marais, at the east end of Paris, where this painting originally had its home.

Alfred Frankfurter. "Museum Evaluations II: Toledo."
Art News, January 1965, p. 24 ff.

PIERRE MIGNARD

Born at Troyes in 1612, Mignard was first trained at Bourges and at Fontainebleau and later joined Vouet's studio in Paris. In 1636 he was in Rome, where he became a successful portrait painter. Ordered back to Paris by Louis XIV in 1657, he fell ill en route and remained for some time with his brother Nicolas in Avignon, where he met Molière. In Paris he continued to paint portraits while receiving other commissions from the court. For the Queen Mother Anne of Austria he painted the dome of the Val-de-Grâce church in fresco (1663), and for *Monsieur*, the king's brother, he executed decorations (since destroyed) in the château of Saint-Cloud. Mignard was the lifelong rival of Charles Le Brun. Since he was the protégé of Colbert's successor, Louvois, his star was in the ascendancy as Louvois rose to power. But he had no part in the founding nor was he a member of the Academy until Le Brun's death in 1690, at which time he was named *premier peintre du roi*, and in a single session at the Academy was awarded all degrees from associate to academician, professor, rector, director, and chancellor. Mignard died in Paris in 1695.

M. Mignard may be regarded as one of the great painters of his time. He had the full command of his craft. Knowing the deficiencies of his teacher [Vouet], he went to Italy to rid himself of these weaknesses, and he succeeded.

His color scheme followed the manner of [Francesco] Albani, and his style was graceful. He painted large decorative works as well as small easel pictures and excelled particularly as a portraitist. He painted very fine portrait heads, among them three Popes and ten portraits of King Louis XIV. Sitting for his last portrait, the King said to him: "You find me looking older."—"It is true, *Sire*," Mignard replied, "I see several additional campaigns traced on Your Majesty's forehead."

M. Mignard was hard-working. He often said that he regarded lazy people as dead people. Consequently, he painted innumerable pictures. His integrity, wit, gentleness, and pleasant dealings with his patrons won him many friends. . . . Since his pictures were in great demand and he was painting for seventy-three years, he died very wealthy.

> Bernard Lépicié. "Vie de M. Mignard, lue à l'assemblée du 3 août 1743." In *Mémoires inédits . . . de l'Académie Royale de Peinture et de Sculpture*. 2 vols. Paris, 1854, II, 96 ff.

Mignard made no original contribution to the art of his time; his allegories were narrow in outlook, and as decorator of the Val-de-Grâce and Les Invalides he is remembered more for the banality of his execution than for the strength of his ideas. As a religious painter he produced a number of sugary, affected Virgins for the oratories of various public buildings and for the chapels of churches and convents; none of these paintings betray the slightest religious fervor, and they are, moreover, rather childish in sentiment. His reputation was most solidly founded on his abilities as a portraitist, and it was in this field that he succeeded best. Nearly all the important personalities of his day sat for him; although Poussin [in his letter of August 2, 1648, to Fréart de Chantelou] found the figures "frigid, rouged, and without aptitude or vigor" they are good, solid portraits, lifelike and true —once they have been stripped of the trappings of state or of mythology, which contemporary standards required them to don.

> Pierre Marcel in *La Peinture au Musée du Louvre*, vol. I. Paris, 1929, fascicle 2, p. ix ff.

Mignard's name is popular. The reverberations of his fame seem to announce a major talent. Yet if we consider the circumstances of his renown, we realize that it was based only on the clamor he had made himself, for the appreciation of his merits did not survive him. After his death no one investigated his works, and few writers praised him with sincerity. . . .

For Mignard was successful. He won the favors of *courtisanes*

as well as men of letters. Mme. de Sévigné gives evidence of it, La Bruyère calls him the only master of his art, and Molière dedicates a long poem to him. . . .

"I was in Mignard's studio just now [writes Mme. de Sévigné in a letter of September 6, 1675] to see his portrait of Mme. de Louvigny, which is a striking resemblance. But I did not see Mignard himself. He was painting Mme. de Fontevrault, whom I watched through the keyhole." He painted an equestrian portrait of Turenne, which Mme. de Sévigné also went to see and which was "the most beautiful thing in the world."

Alas—we judge him differently. What remains for us of these portraits is dull, drawn without warmth, and crude in color; we see arms that are too softly rounded . . . , ultramarine-colored cushions which lack the feel of the material, and excessive paraphernalia of curtains and adornments. . . . In short, we see simply bad painting of the kind which we find most disgusting.

> Louis Dimier. *Histoire de la peinture française des origines à la mort de Lebrun.* 3 vols. Paris, 1925–27, III, 65.

Praised to the skies in his own time, as well as in the eighteenth and nineteenth centuries, Mignard's talent seems to be excessively belittled today. An author like Louis Dimier makes out of Mignard a schemer who skillfully managed to establish his fame on very thin grounds.

Where lies the truth, and by what paintings is he being judged? The name Mignard is a catch-all for an immense amount of oddly-assorted articles. Because of his celebrity, thousands of portraits have been attributed to him unduly, portraits of incredibly uneven value and by visibly different hands, replicas and copies of which museums and châteaux are full. Almost all the originals of the portraits known through engravings are lost. In an exhibition of 1955 by the Museum of Troyes only eight portraits could be grouped as certain works along with some "attributed" ones; a few more in foreign collections could be added. This makes a total of only twenty or thirty portraits which, with one exception, all belong to his French period, in other words to the second phase of his career.

We must admit that they elicit hardly any enthusiasm on our part. Conventional poses, heavy impasto, softness of drawing seem to justify Dimier's opinion. Let us note, however, that these faults are particularly obvious in female portraits, subject as they are to prevailing fashions. As much as can be deduced from the engravings, the male portraits must have shown more character.

But one might think that the undisputed portraits known today

were identified as by Mignard because they conform to the "Mignard type," whereas many others could have eluded the art historians because of their originality.

How can we be sure that Mignard did not do his best work in Italy, in the stimulating artistic ambiance of seventeenth-century Rome, or under the influence of Venetian color?

This could be demonstrated by an admirable portrait, supposedly a self-portrait by Mignard [now in the Prague National Gallery], which figured in the 1937 exhibition of the *Chefs-d'œuvre de l'art français.* . . . No one would have thought of attributing it to Mignard, were it not for an old inscription on the back of the canvas "P. Mignard pinxit, Venetia 1654." The correctness of the date, which is, indeed, that of the artist's sojourn in Venice (as we know from [his biographer] Monville), gives the inscription the character of authenticity which lets us presume the authenticity of the artist's name. Once this is put forward the attribution seems plausible, if not certain. This portrait shows French characteristics, though the model is not, as has been believed, the artist himself. . . . The mastery of this portrait impresses itself on our memory. . . . If indeed it is by Mignard, as the inscription has us believe, the artist will rise to the rank of one of the masters of seventeenth-century portraiture. . . .

<div align="right">

Jacques Wilhelm.
"Quelques portraits peints par Pierre Mignard."
Revue du Louvre, XII, no. 4, 1962, p. 166 ff.

</div>

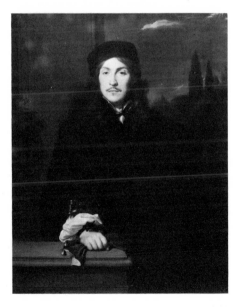

Portrait of a Man Painted in 1654.
Mignard

GASPARD DUGHET

Gaspard Dughet, also known as Gaspard Poussin and Le Guaspre, was born in 1615 in Rome though his father was French. He married Poussin's sister and subsequently adopted the name of his famous brother-in-law. He was probably a pupil of Nicolas Poussin from 1630 to 1633, but the style of his early work is more reminiscent of Salvator Rosa (1615–73). Beginning in the late forties, Gaspard's paintings combined Poussin's calmness and order with Claude's effects of light. Gaspard died in 1675. His "ideal landscapes" were immensely popular and influenced eighteenth-century English and nineteenth-century French landscape painters.

Gaspard Dughet is an artist who in our time has been admired rather than studied. The reason for this is not hard to find. The very charm of his pictures means that we are inclined to take them for granted and in doing so we tend to overlook his originality and to underestimate his historical significance. Thus we are apt to forget that our own view of the Roman landscape has been somewhat coloured by his interpretation. . . . He introduces us to a romantic and mysterious world of waterfalls, small lakes and unexplained classical buildings. The site selected may be Ariccia or Tivoli but the scene that greets the eye is not so much particularised as transposed into a gentle and lyrical vision and one that echoes an antique civilisation, where some Roman poet—a Horace, a Tibullus, or a Virgil, perhaps—could have found his inspiration.

Small wonder then that Gaspard's pictures were so favoured by eighteenth-century English collectors with their nostalgic affection for the classical past. His language not only pleased these cultivated amateurs but influenced painters like Wootton, Wilson, and Gainsborough and counted for much in the elaboration of the picturesque garden. The result of the Englishman's ambition to create in his native land a Roman landscape, complete with temples and a lake, are nowhere better seen than in the Gaspardesque setting of the pleasure gardens at Stourhead in Wiltshire—a true image of one of this painter's characteristic pictures. . . .

Inevitably Gaspard's contribution has been somewhat dwarfed by the outstanding achievement of his famous brother-in-law, Nicolas Poussin, whose name he apparently adopted early in his own career. Notwithstanding this homage, Gaspard possessed his own very decided character both as a man and an artist. He certainly deserves to be studied. . . .

Unfortunately the absence of signed or dated easel paintings renders difficult the charting of Gaspard's development and the reconstruction of its earlier stages in particular must necessarily depend

upon stylistic considerations. Moreover, his artistic personality reveals a temperament quick to appreciate the significance of fresh trends. . . . He had the enviable gift of being able to match his technique and his artistic vocabulary to the task in hand.

Gaspard's ability to assimilate fresh ideas and to synthesize in his painting some of the principal discoveries of his contemporaries is clear. . . .

The artistic consequences of his appreciation of a novel trend may be observed in *The Falls of Tivoli.* . . . This fascinating picture, one of Gaspard's masterpieces, provides an insight into his evolution at a material moment. Whereas the lower portion of the canvas with its

The Falls of Tivoli. *Dughet*

small figures accords well with his customary style of the 1640's, the emphasis upon the lucid solidity of the architecture discernable in the upper part can only stem from a vivid understanding of Poussin's heroic paintings like *The Funeral of Phocion* (Earl of Plymouth Collection) of 1648 in which just this quality is emphasized. Poussin's "noble" style, then, was to act as a spur to Gaspard and to give some of his later works a new and different twist. . . .

Gaspard's role as one of the most personal landscape painters of his generation working in Italy is undeniable. At the start he was attracted by the more open and even rugged aspects of nature. With time, however, his painting became richer and more dramatic in its expression. He more or less abandoned a close observation of naturalistic details in favour of an approach relying upon selectivity and synthesis. Nevertheless, the fundamentally artificial and picturesque conception that resulted, one relying for its effects upon the arrangements of nature in terms of his own imagination, succeeds in achieving a reality all its own. . . . His translation of his findings into an artistic form may lack the cogeny so apparent in Poussin's compositions, but it does reveal a lyrical quality; one that at certain times of the day and in certain moods, can still be experienced . . . by any wanderer over the Campagna or in the Alban Hills.

Denys Sutton. "Gaspard Dughet:
Some Aspects of His Art." *Gazette des Beaux-Arts*,
July–August 1962, p. 269 ff.

Was he a French painter, this Roman who never set foot in France? Or an Italian painter, this son of France who was formed in Poussin's studio? The question matters little, but this ambiguity has foolishly diverted from him the attention of the scholars of the last century. Was he a "classicist"? We would hardly deny this before *Tancred and Herminia* in the Galleria Nazionale in Rome, yet we can imagine him equally well in an exhibition of "romanticism": His evocations of nature seek to render not only calm luminosities and clear panoramas, but also the humidity of plants and leaves, the cascades, the storms, or perhaps the great silence of the heavens above brooding forests. The paintings of Claude . . . seem to take on an indefinable pastoral air when placed next to some of Guaspre's canvases where the precipices break away steeply (*View of Tivoli*, Newcastle-upon-Tyne) and where the foliage harbors no pensive flute player (same subject, Molinari-Pradelli Collection). . . .

One day the drawings—as yet little known—will reveal the course of the artist's creativity more fully. . . .

The great innovators of the seventeenth century escape from the

ready-made categories of the nineteenth century: classic—baroque, romantic—realist, but speaking of Dughet we can use each of them in turn. When the time comes for us to reconstruct the work of this painter, to distinguish his canvases from the enormous output of his imitators—from Crescenzio Onofrio to [Francisque] Millet or Orizzonte, to separate his drawings from those of Poussin and also from the mass of landscapes which are falsely passed off as his, we realize that it is not the man of a specific school or trend which counts, but the complex personality of a master.

Jacques Thuillier. "Gaspard Dughet, le 'Guaspre' Poussin." *Art de France*, III, 1963, p. 247 ff.

SÉBASTIEN BOURDON

Born in 1616 of a Huguenot family in Montpellier, Sébastien Bourdon was sent to Paris as a boy of seven and became apprentice to the painter Barthélemy. At fourteen he moved to Bordeaux and Toulouse, but, unable to earn a living there, he established himself in Rome about 1634. While in the service of a picture dealer he painted pastiches of the leading artists of the day, such as Claude Lorrain, Poussin, Parmigianino, the Carracci, and Pieter van Laer. Following a quarrel with a fellow artist who was about to turn him over to the Inquisition as a heretic, Bourdon hurriedly left Rome. Back in Paris in 1643, he became a historical painter and was one of the founders of the Royal Academy of Painting and Sculpture in 1648. He was a frequent lecturer at the Academy; his lectures on Poussin, Carracci, the study of light, and the antique have been preserved. In 1652 he was called to Sweden as first painter to Queen Christina, whose portrait he painted several times (National Museum, Stockholm, and Prado, Madrid). After her abdication in 1654, he returned to Paris, where he died in 1671.

At the age of eighteen Bourdon went to Rome, where, being penniless, he was forced to work for a picture dealer named Escarpinelle. Endowed with a vivid imagination, an excellent memory, and great dexterity, he could easily copy anything he saw. He thus adopted freely the styles of other artists.

One day he paid a visit to Claude Lorrain, the famous landscape painter. Seigneur Claude showed him a large landscape begun only two weeks ago, which required another two weeks to complete. M. Bourdon, having formed a perfect idea of the picture, went home, took a canvas of equal size and within one week counterfeit the landscape so successfully that, when shown at a festival, it was acclaimed to be the most beautiful picture Seigneur Claude had ever done. The latter was much surprised about the uproar, and learned

145

An Artist in His Studio. *Bourdon*

from the connoisseurs frequenting his studio that M. Bourdon's painting seemed exactly like the one still on his easel. Seigneur Claude could not help wanting to see it and returned extremely angered. M. Bourdon could barely escape violence. . . .

We have gone into such length commenting on the ease with which M. Bourdon could, in his youth, counterfeit a picture, so as to better admire what he did later of his own invention. He treated many different subjects in a most original manner. But we should like to add that while in Rome he also counterfeit the historical paintings of Andrea Sacchi, the battle pictures of Michelangelo delle Battaglie [Cerquozzi], and the small figurative canvases of a Flemish painter nicknamed Bamboccio [Pieter van Laer].

> Guillet de Saint-Georges (ca. 1682)
> in *Mémoires inédits . . . de l'Académie Royale*
> *de Peinture et de Sculpture.* 2 vols.
> Paris, 1854, I, 88 ff.

Few artists had more skill than Sébastien Bourdon. We often find in his work a warmth and suppleness of execution together with several other painterly qualities, but at the same time he lacked personality. . . . He had a remarkable aptitude for speed and an agility which is sometimes astonishing, though nonetheless pleasing; on the other hand he lacked the necessary strength to penetrate to the very heart of things. His painting somewhat resembled the art of the

conversationalist, and, in fact, his lectures at the Academy showed him discoursing readily, with a fine rhetoric, but not devoid of banalities. . . .

The direction which his talent was to take became clear at an early stage. During his stay in Italy he imitated the style of nearly all the masters in vogue . . . and to the end he remained such a painter, dealing with all subjects, borrowing from all styles successively or even concurrently. His work, therefore, is prolific, extremely varied, and, as a whole, very empty. It is curious to note that the pictures by this Calvinist were mainly religious, he even painted Virgins and Saints. . . . At intervals he painted small battle scenes, hunting scenes, and landscapes in the style of the Italianate Flemish artists. Lastly he did a number of portraits, and here he at times excelled.

Henry Lemonnier. *L'Art français au temps de Richelieu et de Mazarin.* Paris, 1913, p. 277 ff.

EUSTACHE LE SUEUR

Le Sueur's life was uneventful; he did not travel. Born in 1616 in Paris, he became Vouet's pupil at the age of fifteen. His first important commission was a series of tapestry cartoons, *The Dream of Poliphilus.* Except for his decorations for the Cabinet de l'Amour (1646–47) and the Cabinet des Muses (1647–49) at the Hôtel Lambert in Paris (now in the Louvre), Le Sueur was chiefly a painter of religious subjects. He is best known for his twenty-two paintings of *The Life of St. Bruno,* executed for the Charterhouse of Paris about 1648, now in the Louvre. Le Sueur's early work was influenced by his teacher Vouet. He later emulated Raphael (whose paintings he knew from the royal collections, from engravings, and from copies made by contemporary artists returning from Italy) and Poussin. Le Sueur was one of the twelve founders of the Royal Academy of Painting and Sculpture, created in 1648. He died in 1655 at the age of thirty-eight.

Although Le Sueur never left France, his paintings were nevertheless in excellent taste. . . . A man truly born to paint will always form concepts of beauty similar to those of the greatest artists of all time. This can be seen in Le Sueur's art. Without having studied in Rome, his work as a painter came near to perfection; he met all the requirements with respect to skill and judgment in the subjects he treated. In the pictures painted for the cloister of the Carthusians in Paris [*The Life of St. Bruno*] we note nobility and naturalness in the composition and expression. His thinking seems appropriate and lofty; nothing is more refined than the arrangement of the figures; their gestures and their actions are simple and natural, and there is life, dignity, and grace in this work. . . . Le Sueur had previously painted

pictures which had established his reputation, but the latter works show his talents even better than anything he had done before.

André Félibien. *Entretiens sur les vies et sur les ouvrages des plus excellens peintres.* 2 vols. Paris, 1685–88, II, 460 ff.

If I had to find one word to . . . characterize the art of Le Sueur, the epithet I would choose would be delicacy. . . . His drawing was delicate in spite of some awkwardness or inability. . . . This was the quality which made Le Sueur worthy of comparison, even if from afar, with the aristocratic Raphael. His color, too, was delicate, as can be seen in the works which have not suffered from time and restorations. The same can be said of the lighting and soft luminosity of his compositions. This delicacy distinguished him from his contemporaries, who were imitators of the Venetian or Bolognese painters or of Caravaggio. Their strength and sensuality was the antithesis of Le Sueur's delicate nature. . . .

In the moral domain we again discover this delicacy which assured a place apart for Le Sueur, and which enabled him to create unforgettable figures of young girls. The purity joined with piety which emanates from his paintings . . . made him a religious painter worthy of the name. . . .

Le Sueur naturally exhibited faults along with his good qualities. His extreme delicacy . . . was sometimes accompanied by certain shortcomings—at times he was weak, feeble, and dull. When he chose to aim for the powerful and majestic, he generally failed. With such a personality, Le Sueur did not command the stature or power which would produce originators of schools of painting, and which would enable a master to maintain a studio and train numerous disciples. He was, rather, the kind of artist who is forgotten after his death and who has no spiritual descendants. . . .

Any influence Le Sueur may have had on his successors was indirect, and was not transmitted through his teachings, but through his paintings alone.

Gabriel Rouchès. *Eustache Le Sueur.* Paris, 1923, p. 130 ff.

The Le Sueur room at the Louvre . . . is always deserted. Visitors are wrong not to tarry here, for Le Sueur as well as Champaigne are leading French artists, ranking with Poussin, Le Nain, and Claude Lorrain. Their work is of basic significance for understanding the French spirit of the 1650's. But there is still another phenomenon that merits attention. The works of these artists . . . only rarely find their way across the French borders. They do not command any prices on

the art market outside of France. All this proves that this type of painting somehow does not have any impact on the non-French world.... Their art has ... national limitations. Whereas the academic doctrine, discipline, and organization emanating from France spread throughout the world, French art based on these principles lacked the power to prevail internationally....

For many years Le Sueur worked on a series of paintings for the Hôtel Lambert, where he was assisted by Herman van Swaneveld, Pierre Patel, François Perrier, and Giov. Francesco Romanelli. Raphael's growing importance for Le Sueur becomes apparent in these works. The spirits floating among clouds, the Muses and the Cupids, show the influence of the Italian master in their proportions, the delineation of their faces, the cast of their eyes, and the shape of their noses. Possibly Poussin also played a part in their conception; at any rate the types derived from antiquity are related to those of Poussin. This leads us to the conclusion that these types transcend the work of the two painters, and correspond to an ideal prevalent in France during that period. Le Sueur's outlines are less defined, his colors less saturated and not as luminous. The pale colors render these paintings less effective....

The Parisian churches that commissioned altarpieces by Le Sueur were Saint-Étienne-du-Mont, Saint-Germain-l'Auxerrois, les Capucins de la rue Saint-Honoré, the Seminary of Saint-Sulpice, and Saint-Gervais. In addition, Le Sueur frequently worked for churches and chapels in the vicinity of Paris. His highest achievement in this genre are the twenty-two paintings on the life of St. Bruno, executed for the Church of the Carthusians in Paris, now in the Louvre.

St. Bruno was a popular saint in the 17th century. In Italy he was extolled in the work of Crespi, Poccetti, and Guercino, and in Spain by Carducho, Ribalta, and Zurbarán. Simon Vouet painted a praying St. Bruno for San Martino in Naples, and Le Sueur popularized the saint in France by his series of paintings. Perrier, Jouvenet, Charles de la Fosse, Jean Bernard Restout, and Le Clerc were to follow his example....

Le Sueur's series, however, is not merely a hagiographic monument. It is, rather, a vital profession of faith on the part of an artist who had made the saint's ethical views of life and the world his own. Le Sueur had little use for immoral excesses; he loved order, simplicity, and seclusion, and for him the life of St. Bruno of Cologne signified the utmost in human perfection. The image of the preacher also corresponded to the French ideal of virtue of the time. Thus Le Sueur was strengthened in the execution of this work by both his personal convictions and the prevailing spirit of his time. That is why he succeeded so well in it.

Here Le Sueur is less dominated by Raphael. The composition is free and loose. The central axis is de-emphasized. . . . The painter has avoided all external pathos. . . . Where he has occasionally depicted a face expressing forceful emotion, as in the death of St. Bruno, it reveals a depth and sincerity comparable to Zurbarán, and the raised arms and outstretched fingers are heavy with emotion; the prostrate figure of the monk is suffused with deep shock. . . . The overall paleness and nonresonant coloring of Le Sueur's paintings makes their enjoyment more difficult. In a single instance, in the death of St. Bruno, he transcends himself in a magical experience of luminosity; but even here we must not think in terms of Rembrandt, which would make Le Sueur appear suddenly small, precious, miniaturelike. . . .

Out of these dialectical antitheses the reader must draw his own conclusions regarding Le Sueur's limitations. But let him not forget that Le Sueur has remained the model for religious painting in France, that David and Ingres called him "divine," that Delacroix admired him, and that all modern French art historians have included Le Sueur among the leading masters of the seventeenth century.

Otto Grautoff in Nikolaus Pevsner and Otto Grautoff.
Barockmalerei in den romanischen Ländern.
Wildpark-Potsdam, 1928, p. 301 ff.

The Death of St. Bruno

ca. 1648 oil on wood transferred to canvas 76" x 51" Paris, Louvre

[Not all of the twenty-two paintings of *The Life of St. Bruno*] are by the master himself . . . but his inspiration is visible in all, and a supreme unity reigns in this gallery of monastic life.

The difference between the monks of Le Sueur and of Zurbarán, between the tender piety of the French painter and the grim faith of the Spaniard, is great indeed. Le Sueur's monks think of heaven, Zurbarán's of hell. . . . Le Sueur stirs up emotion, Zurbarán terror. . . . The French artist clings to the moral aspect of the subject and attenuates its physical horror. Except for the intense ultramarine of the draperies, which immediately stand out, everything is kept in a low key and within a pale, soft range of colors; the ultramarine is the color used also by Philippe de Champaigne, Le Brun, Mignard, and other painters of the period, and is one which has not been subject to gradual alteration. . . . The simplicity of the composition is remarkable, the freedom of details and accessories, the sobriety of the execution, the limited number of tones employed, and especially the humble, fervent, and convincing expression of the faces. . . .

The Death of
St. Bruno.
Le Sueur

Among these paintings . . . is *The Death of St. Bruno*, Le Sueur's master-
piece, and one of the masterpieces of all painting. The saint, on his deathbed,
expires after having made a public confession. A Carthusian monk, crucifix
in hand, mourns with the other monks the loss the order has just sustained.
At the head and at the foot of the body, four brethren chant prayers for the
dead, and another is prostrate on the floor, overcome with grief and devotion.
The light of a single candle casts its pale reflections on the shroudlike white
gowns, the white, tomblike walls, and the bare floor which recalls the planks
of a bier; a deeply felt sorrow wells out of this almost monochromatic painting.
Théophile Gautier. *Guide de l'amateur au Musée du
Louvre* (1867). Paris, 1882, p. 165 ff.

151

CHARLES LE BRUN

Charles Le Brun (also spelled Lebrun), born in Paris in 1619, was a precocious artist who, like most major painters of his time, was trained by Vouet. While still in Vouet's studio he painted his early masterpiece *Hercules and Diomedes* (Nottingham Art Gallery). Sent to Rome in 1642 by the Chancellor Ségnier (whom Le Brun painted in 1661; Louvre), Le Brun came under the influence of Poussin and his Roman contemporaries, especially Pietro da Cortona. On his return to Paris in 1646, he succeeded Vouet in public favor and received important commissions, including the Hôtel Lambert, and the Château de Vaux. He was instrumental in the founding of the Royal Academy of Painting and Sculpture in 1648. Promoted by the financier Fouquet, and after Fouquet's demise by Louis XIV's authoritarian prime minister Colbert, Le Brun became the virtual dictator of the arts after 1661. He was named *premier peintre du roi* (Louis XIV) in 1662, and became director of the Academy and of the Gobelins factory in 1663. During the next twenty years he reorganized the Academy, decorated Versailles, Marly, and other châteaux, and designed tapestry cartoons (the *Months* and the *History of the King*) and *objets d'art* for the king. After Colbert's death in 1683 Le Brun's influence waned, for Colbert's successor, Louvois, favored and advanced Mignard. Le Brun died in Paris in 1690.

On April 4, 1686 M. Le Brun took his painting *Moses and the Daughters of Jethro* [now in the Galleria Estense, Modena] to Versailles. . . . The King received it with much pleasure, and sent for M. le Dauphin and Mme. la Dauphine and the leading personalities of the Court so that they could examine it. . . .

Several of the spectators crowded around M. de Chantelou* and urged him to express his opinion. "M. Le Brun has surpassed the ablest painters of Europe," he said, "but in this work and in *The Raising of the Cross* he has surpassed himself." The entire Court was divided in its opinion: some preferred *The Raising of the Cross* while others favored *Moses and the Daughters of Jethro*. . . . So they all asked M. Le Brun which, in his view, was the better picture. M. Le Brun replied that since the two pictures represented very different subjects he had treated them in a different manner, but that he considered both to be equally successful.

The King then addressed himself to Mme. la Dauphine and said: "After M. Le Brun's death these pictures will be priceless," . . . and turning to M. Le Brun, he added, "You mustn't die just to raise the prices of your other paintings, I esteem them sufficiently even now!" . . .

It had been noticed for some time that M. Louvois and some others had the intention of making known to the King that M. Le Brun had produced all those beautiful works only out of envy of M. Mi-

* Paul Fréart de Chantelou, financier and collector, patron of Poussin.

gnard. This was to justify the plan to have M. Le Brun removed from his position as director of the royal workshops in sculpture and painting, all the more since M. Le Brun had always said that if he had been left to work at his own projects without being occupied with so many other things, he would have accomplished much more than he was able to under the circumstances. At this M. Le Brun very cleverly found the opportunity to retort that if he had applied himself only to his paintings he would not have been in the position to train so many competent pupils. . . ; and he remarked that compared with the great *Battles of Alexander* the two pictures praised so highly now mattered little; yet the *Battles of Alexander* had been completed in a very short time and at a period when he was busier than ever with the direction of the King's workshops.

These were the days when the gallery at Versailles where M. Mignard was working was being opened for inspection, and the King urged M. Le Brun to go and look at it, which M. Le Brun declined to do. But when some of his friends thought he should make it his duty to go, he told them: "If I go and speak well of it, I might authorize some bad work; if I criticize it, I will be accused of jealousy, and if I say nothing I will be pressured into speaking up. I won't have any of these problems if I don't go at all."

Guillet de Saint-Georges (1693) in *Mémoires inédits . . . de
l'Académie Royale de Peinture et de Sculpture.* 2 vols.
Paris, 1854, I, 60 ff.

Le Brun was very zealous to advance the Fine Arts in France. In this he seconded the King's good Intentions, who entrusted Monsieur Colbert with the Execution of his Orders. That Minister did nothing without consulting Le Brun, and this Painter not only undertook the Charge of taking Care of the Performances of things in general, but also, was very careful about his own in particular, finishing his Pictures with the greatest Industry, and informing himself exactly of every thing that related to his Art, either by reading good Authors, or consulting Men of Learning.

His Works at Sceaux, and in several Houses in Paris, spread his Fame all over Europe; but especially what he did for the King, the most considerable of which are his large Pictures, containing the History of Alexander the Great, in the Ceiling of the Gallery of Versailles, and the great Stair-Case there.

When the King made Le Brun his principal Painter, he gave him also the Direction of the Manufactures at the Gobelins, which he minded with such application, that there was nothing done there, that was not after his Designs. . . .

Every thing that came out of his Hands was Masterly, insomuch, that one may in some measure say of him, that the Progress he made in his Art, was not to learn it, since he knew it already, but to render him one of the greatest Painters of his Age.

Roger de Piles. *The Art of Painting and the Lives of the Painters* (1699). London, 1706, p. 382 ff.

Although the direction of the arts and the decoration of the royal palaces seems to have absorbed Le Brun from 1661 on, we can see in *The Jabach Family* (painted ca. 1662; destroyed 1945) that he did not completely abandon portraiture. . . . His drawings and studies show us that he remained rooted in reality; his major decorative schemes never caused him to lose either the taste or the keen sense of it. . . .

Capable of strongly individualistic works, Le Brun imposed his own direction on the entire arts of his time, thus assuring a unity of style. Up to 1683, and even a little beyond this date, nothing was done unless planned according to his designs or at least approved by him. All the major decorative schemes were conceived by him: the Stairway of the Ambassadors (1668–78) and the Gallery of Mirrors (1678–86) [at Versailles], the château of Marly and its *trompe l'œil* façades (1679–86), the sculptures of Versailles, and furthermore the entire production of the Gobelins and Savonnerie workshops after 1664: furniture, art objects, carpets, and tapestries. Since his genius was essentially one of organization, his ideas never hampered the outflow of production. An eclectic artist himself, he chose his collaborators for their own talents, regardless of their doctrines, and he never penalized them for their views. Although he championed the superiority of drawing at the Academy, he surrounded himself with advocates of color, revealing himself to be more Flemish than one would expect in his choice of artists and even in his own paintings. . . .

His role in art was quite similar to that of Boileau in letters. Like Boileau, and like Poussin, he was "passionately reasonable, a theoretician, and a rationalist." Like Boileau, he was also a realist, because he sought for truth. . . . Le Brun, like Boileau, would ask himself the following question: "Is there a Beauty which gives us an absolute standard of taste?" Both would answer: "Yes." Reason creates Beauty and Beauty is identical with Truth. This "naturalism" justifies their admiration for the antique artists who were great because their art was true and patterned after nature. The immortality of their works proves the excellence of their method. . . .

It was not without reason that Le Brun had himself painted by Largillière before two ancient statues, the *Dying Gladiator* and An-

tinous, pointing to them as his models. . . . He wanted to show in this way his veneration for the antique.

This attempt to combine antiquity with the modern style is most noticeable in the Gallery of Mirrors at Versailles. It is modern in terms of the luxury of its mirrors and its French sense of order, but one then wavers between the allegory of Hercules and the realistic representation and contemporary costumes of the events of the reign of Louis XIV. . . . Le Brun ended his career with the Gallery of Mirrors; three years later he died.

> Charles Mauricheau-Beaupré. *L'Art au XVII^e siècle en France.* 2 vols. Paris, 1947, II, 92 ff.

Most of the paintings of Le Brun are lost or have at least disappeared. This is very surprising. We automatically think that only the "painters of reality," those innocent and feeble victims of official art, were persecuted by time and by men. But the paintings . . . of Charles Le Brun, official painter to Louis XIV, exemplar of royal painters, have hardly fared better than those of Valentin or the Le Nains. By a miracle, the decorations of the Hôtel Lambert, Vaux-le-Vicomte, Sceaux, and Versailles are partially preserved. But what remains of the long lists of paintings, cited by Nivelon [Le Brun's first biographer]? Except for the collection of Louis XIV, which was kept together and transferred to the Louvre and to the provincial museums almost intact, only a few have survived. The generations that took pleasure in Watteau, Pater, or Boucher found Le Brun's works dull and cold. The romantics and, even to a greater extent, the realists saw in the founder of the Academy the incarnation of academism. . . . As for our own century, it has decreed Le Brun a boring orator; it is as yet no closer to letting go of this judgment.

> Jacques Thuillier in *Charles Le Brun* [Exposition]. (Versailles, Château). Paris, 1963, p. xvii ff.

The Tent of Darius: The Queens of Persia at the Feet of Alexander

1660–61 oil on canvas 117¼ " x 165" Versailles, Musée National

This is one of five colossal paintings depicting *The Triumphs of Alexander* (also called *The History of Alexander* or *The Battles of Alexander*) owned by the Louvre. *The Tent of Darius* was painted first, but the sequence and dates of the execution of the other four is not certain. The narrative order is as follows: *Crossing the River Granicus, The Tent of Darius, The Battle of Arbela, The Triumphant Entry into Babylon,* and *The Defeat of Porus.*

The Skill of the Workman is to be Admired, in this that Designing to Draw this Interview of Alexander and the Queens, he has Chosen the very Moment when Sysigambis, who was Mistaken in Applying herself to Ephestion, Throws herself at the Feet of Alexander, and Asks his Pardon for the same. For he Represents that Moment after so Elegant a Manner, that he Sheweth in his Picture an Infinite Number of Fine Expressions, which Render it Incomparable. . . .

The Painter was not Satisfied to Express in the Face of Alexander, his Youth, Mildness of his Temper, Courage and all those other Qualifications which History Informs us of that Great Prince, . . . But besides in his Motions we Observe four sorts of Different Actions. The Compassion he has for the Princesses Visibly Appears, both in his Looks and in his Behaviour; His Open'd Hand Shews his Clemency, & Perfectly Expresses the Favour he has for all that Court; His other Hand which he Lays on Ephestion, plainly Shews that he is his Favourite, or rather another Himself; And his Left Leg which he Draws Backward, is a Token of the Civility which he Pays to these Princesses. The Painter has not Drawn him more Inclining, because he Represents him in that Moment that he Accosted these Ladies; that it was not in Use among the Greeks; And besides, that he could not Stoop very much, because that in the Last Battle he had Received a Wound in his Thigh. . . .*

Nevertheless so Great a Variety of Things does not in the Least Hinder the Unity of the Subject; But on the Contrary all those Various Expressions, and all those Different Movements Contribute to Represent one Single Action. . . .

But if the Unity of the Action be Observ'd with so much Knowledge and Judgment, the Unity of the Light and the Unity of the Colours are not Handled with Less Art and Beauty. . . .

<div align="right">André Félibien. *The Tent of Darius Explain'd* (1663).
London, 1703, p. 5 and *passim*.</div>

The most famous of the academic lectures given by Le Brun deals with the subject of the expression of the passions. It is the only lecture of which the integral text has come down to us—only a few notes survive of his treatise on physiognomy which was accompanied by such strange drawings. It has been justly remarked that certain of his formulae and even of his explanations reflect the doctrine of Descartes' *Passions of the Soul*†; but this was far from being the only influence. Le Brun, like all his contemporaries, was greatly indebted to the ancients and to the Italians—especially Lomazzo and Junius. To

* Félibien goes on to describe at length the expressions and "passions" of every principal in this picture.
† This was already noted by Roger de Piles in his *Cours de peinture par principes* (1708).

The Tent of Darius (engraved by Simon Gribelin, reversed).
Charles Le Brun

portray the passions well was basic in all theory of painting and was accepted by everyone: we find it in Dufresnoy, in his translator de Piles, and in Molière honoring Mignard in his poem on the *Glory* of the dome of the Val-de-Grâce....

We do not know the date of Le Brun's first lecture on *General and Particular Expression;* we only know that in January 1678 it was repeated in the presence of Colbert....

If we turn to the painting *The Tent of Darius* we already find represented there a good many of the expressions analyzed in the *Conférence.* The painting immediately became famous and Félibien published in 1663 a detailed appreciation of it.... A whole century before the tender scenes of Greuze and the *Salons* of Diderot, Félibien underlined the pathos of this expressive picture. He pointed out how many different passions appear on the faces and in the gestures of all the persons in the picture. Alexander expresses compassion and mercy, the mother of Darius sadness, respect, and humility, his daughter Statira abandonment and sorrow, and on the face of his youngest sister there are "a thousand things to consider: sorrow, fear, admiration, each with their different effects." ... Félibien also underlined the different kinds of unity which tie this canvas together: unity of subject matter—a single action; unity of light, unity of color....

Charles Perrault's detailed appreciation of this painting is of even greater

interest; he presented it as the perfect fulfillment of modern art, and compared it to a painting by Veronese [*The Pilgrims at Emmaus*, now in the Louvre]. Perrault had already linked himself to Le Brun when in 1688 he extolled the latter's art in his poem *Painting*, which can be considered the counterpart to Molière's poem praising Mignard. It is nonetheless striking to note that in his *Parallel between the Ancients and the Moderns* he returned to this canvas which he judged to be a work surpassing not only the art of the ancient Greeks and Romans, but also the art of the "ancients" of his day, who were in fact the great Italian masters of the preceding century. Perrault also stressed the unities in this painting, and asserted the parallel between painting and poetry which the picture suggested:

"It is a true poem in which all the rules are observed. The unity of action is represented by Alexander entering the tent of Darius. The unity of place is the tent itself in which are gathered only those people who have a right to be there. The unity of time is realized the moment when Alexander says it is not such a grave error to have mistaken Ephestion for him since Ephestion is another version of himself." . . .

We can see that the contemporaries of Poussin and Le Brun, of Corneille and Racine, will not hesitate to juxtapose and compare the different arts. I would even say that we will not be able to reach an adequate understanding of the aesthetics of the classical period if we fail to consider these juxtapositions and comparisons.

> W. McC. Stewart. "Charles Le Brun et Jean Racine."
> *Actes, 5ᵉ Congrès International des Langues et Lit-*
> *tératures Modernes, 1951.* Florence, 1955, p. 216 ff.

The story, which is told in greatest detail by the first-century historian Quintus Curtius, relates that after the Battle of Issus, Darius' family was captured by the Macedonians. When Alexander with his friend Hephestion entered the royal tent, the queens and princesses, mistaking the taller man for Alexander, bowed before Hephestion. Alexander was then pointed out by one of the eunuchs, and Sisigambis, Darius' mother, fell at his feet, begging his pardon. Alexander raised her up and told her, "You are not mistaken, mother, for this man too is Alexander." Then he reassured the women and thereafter treated them with notable clemency.

This story has never been especially popular in the history of art although it was illustrated by a number of artists before Le Brun (but not to my knowledge in France). The two best-known versions, by Sodoma and Veronese respectively, offer different interpretations of the story. Sodoma's *Tent of Darius* is pendant to his *Wedding of Alexander and Roxanne*, and was painted in the Farnesina in Rome about 1512. . . . Veronese's picture, in the London National Gallery, is treated with little regard for historical accuracy. . . .

In the *grand siècle* the story was to be seen in a new light, and the

pictorial accents which Le Brun gave to his picture were unique in the history of the subject. Indeed, the name that the seventeenth century gave to his painting, *The Queens of Persia at the Feet of Alexander,* is in itself indicative of its special connotations. Here . . . the dramatic emphasis of the picture is thus entirely on Alexander's attitude toward the beauteous and despairing women, on his gesture of gallant gentleness. . . .

Sodoma's fresco was for Le Brun a more or less classic model that could be improved upon and surpassed. Although reversing its direction and placing the scene deeper in space Le Brun appropriated the general composition of Sodoma's painting without significant changes, and he adapted a number of pictorial and narrative motifs. . . . But Le Brun strengthened the main lines of Sodoma's composition, "formalized" it we might say, with stately and rather ponderous accents. . . . The composition is enriched and further clarified by the chiaroscuro which cements the individual elements into a relieflike group of large and weighted masses. The expressive rhetoric that animates the figures, who react to the moment with distinctive and suitable expressions, makes the picture read like a psychological drama, and by contrast Sodoma's figures are blandly inexpressive, turning in graceful but meaningless poses. . . .

For the late seventeenth century *The Tent of Darius* was "*un véritable poème,*" which had unity of action, place, and time; a poem which developed with dramatic necessity, where composition, color, chiaroscuro, and expression conspire to a single end. . . .

Le Brun moreover could enrich this unity not only with a polyphony of expressive rhetoric, but also with a wealth of archaeological detail and picturesque costuming. Sodoma's painting seen alone seems richly textured, but it pales before Le Brun's luxuriance of Persian shields and quivers, antique armor, Egyptian headdresses, silks and satins, and naked flesh.

Whether he surpassed his model or not, it is certain that Le Brun gave *The Tent of Darius* a lucid and stately grandeur, an historical and picturesque splendor, and a theatrical gregariousness that suggest nothing quite so much as a spectacle on the grounds of Versailles, a not inappropriate connotation, and one which further elucidates the iconological significance of the picture.

Donald Posner. "Charles Lebrun's Triumphs of Alexander."
Art Bulletin, vol. XLI, no. 3, September 1959, p. 237 ff.

This painting was formerly the most famous of Le Brun's pictures. Today, it is without doubt the most disappointing. . . . Time has taken away most of its prestige. Restorations and cleanings have not left many traces of the quality of its execution, so much admired in the past. Although the colors seem harsh to us, they were once praised for their masterly combination and discreet harmony. We are no longer even remotely receptive to the clever retelling of the plots. . . . In this episode taken from the Life of Alexander . . . we see hardly anything more than the first application of the theme of Alexander to the

glory of Louis XIV. . . . Nevertheless, even if there is practically nothing left to captivate us, the painting is still important historically.

Jacques Thuillier in *Charles Le Brun* [Exposition]. (Versailles, Château). Paris, 1963, p. 71 ff.

JEAN JOUVENET

Jean Jouvenet III, principal member of a large family of artists, was born in 1644 at Rouen and at the age of seventeen entered the Royal Academy of Painting and Sculpture as a pupil of Le Brun, whom he assisted with the decorations at Versailles. An associate of the Academy in 1674 and a full member in 1675, he became a rector in 1707. When, in 1713, his right side was paralyzed Jouvenet continued to paint with his left hand (*The Visitation*, 1716; Louvre). Several of his religious and historical paintings were used as cartoons for tapestries. Jouvenet died in Paris in 1717.

Jean Jouvenet, the greatest religious painter of the period and perhaps the only one who painted ecclesiastical pictures out of inclination if not conviction, never went to Italy; on the contrary, he had a great admiration for Rubens, by whom he was influenced relatively early in his career. In the large *Descent from the Cross* (Louvre),

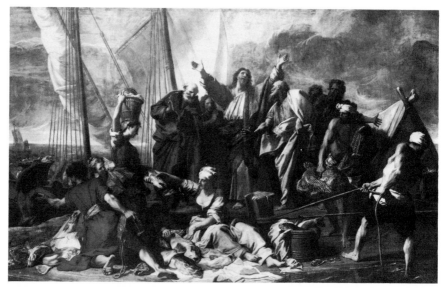

The Miraculous Draught of Fishes. *Jouvenet*

160

painted 1697, he was the first [French artist] who dared to paint a real corpse. The body of Christ is limp—only the arms, which are being removed from the Cross, are still rigid—and his head drops mournfully on his shoulder. How far removed are we already from the traditional idealism and conventionalism! His *Christ in the House of Simon, Resurrection of Lazarus, Christ Driving the Traders out of the Temple,* and *Miraculous Draught of Fishes* (all painted for the church of St. Martin des Champs in 1706, now in the Louvre) are also inspired by realistic tendencies. Jouvenet painted his *Miraculous Draught of Fishes* only after a trip to Dieppe [on the seashore], where, as a biographer tells us, he . . . "made a considerable number of studies, examining with scrupulous attention the tones and beauties of the three elements involved." His religious and artistic sincerity are perhaps even more apparent in a small canvas in the Louvre, the *Mass of the Canon de La Porte* [*View of the High Altar of Notre Dame de Paris*] commissioned . . . in honor of the old priest who had dedicated his life to the beautification of the cathedral. . . . All the personages in this scene exist and pray in a contemplative spirit. No other contemporary of Le Brun would have celebrated the piety and generosity of the old canon without a pompous and complex allegory. Jouvenet, on the other hand, introduces neither angel nor genie, saint nor Virtue into the composition.

<div style="text-align: right">

Pierre Marcel. *La Peinture française au début du XVIIIᵉ siècle.* Paris, 1906, p. 178 ff.

</div>

JEAN-BAPTISTE SANTERRE

Born in 1651 at Magny-en-Vexin, Santerre was a pupil of Lemaire and Bon Boullogne. He became an associate of the Academy of Painting in 1698 and a full member in 1704. His diploma piece was *Susanna in Her Bath* (Louvre). In 1708 he was given residence in the Louvre. Primarily a portrait painter (*Duchess of Burgundy,* Versailles), he later turned to fantasy. His paintings of biblical subjects, most of which are lost, shocked his contemporaries. He died in Paris in 1717.

In religious painting the spirit of the *Régence* was foreshadowed by Jean-Baptiste Santerre, for whom the Bible was no longer edifying reading but a vast repertory of equivocal subject matter. Adam and Eve in the earthly Paradise, Lot and his daughters, Susanna and the Elders became ingenious pretexts for painting piquant nudities.

The majority of Santerre's paintings were religious in name only, and caused scandals. He invented the portrayal of Adam and Eve

<div style="text-align: right">161</div>

without a navel, claiming that this was the state in which God had created them and that according to the best theologians the navel was formed only after the first childbirth.

His *Susanna in Her Bath* . . . is an elegant Parisian girl with a pretty face and slender legs; his model was undoubtedly one of his favorite sultanas of that strange *Académie de jeunes filles* which he had founded in order to "brighten up his philosophy," as d'Argenville° tells us. He taught them art and they served him as models.

When in 1709 his *St. Theresa* was placed in the chapel of Versailles, it stirred up indignant whispers among the pious. Like the sculptor Bernini, Santerre did not distinguish very well between the ecstasies of divine love and the spasms of human love: his voluptuous Carmelite nun was nothing but a less disrobed sister of Io or Danaë. St. Theresa kneels on her prayer-stool, and an angel holding a fiery arrow appears from above in order to pierce her heart, which seems aflame and filled with love. "The expression and the action are so lively," writes d'Argenville, "that in the opinion of scrupulous persons

Susanna in Her Bath. *Santerre*

°Dézallier d'Argenville in his *Abrégé de la vie des plus fameux peintres* (1762).

this picture appears dangerous, and even the clergymen avoid cele-
brating our holy mysteries before the altar of this chapel."

> Louis Réau. *Histoire de la peinture française
> au XVIII^e siècle.* 2 vols. Paris, 1925, I, 4.

NICOLAS DE LARGILLIÈRE

Nicolas de Largillière (also spelled Largillierre) was born in 1656 in Paris, but spent his youth at Antwerp, where he was trained in the Flemish tradition. About 1674 he went to London and entered the studio of Peter Lely as a painter of drapery and still-life accessories. Returning to Paris in 1682, he was received into the Academy in 1684; his diploma piece was his *Portrait of Le Brun,* submitted in 1686 (Louvre). He became one of the most prominent members of the Academy and was, together with Rigaud, the leading portrait painter of his time. He also painted a number of official group portraits of which the *Ex-voto* (painted 1696) for the church of St. Geneviève in Paris (now St. Étienne-du-Mont) survives; it combines portraiture with religious art. Except for another visit to England in 1685, when he painted the portraits of King James II and his second wife, Largil-lière remained in Paris until his death in 1746 at the age of ninety. Largillière's most famous pupil was Jean-Baptiste Oudry. In a lecture on color, delivered at the Academy in 1749, Oudry refers at length to the instruction he had received from his master.

> This painter had few connections with the Court of France. He never applied for commissions. As he told me many times, he preferred to work for private clients—they were less troublesome and the payment was quicker. . . .
> The talent of this uncommon man was apparent in every way. . . . He was active in all branches of painting and his work proves that nothing is outside the sphere of a good painter. His art is characterized by a quality of freshness, a light and sparkling touch, abundant invention, correct drawing, an admirable delineation of heads and hands, and skillfully arranged drapery. The lifelike character of his paintings is even more surprising if we realize that he did everything from direct observation. There were no models, no lay figures. He kept saying that he had studied and looked at Nature for so long that she was ever present in his mind. Yet, looking at his paintings from that point of view, we find that naturalness sometimes escaped him, and he appears mannered. Largillière always made a special point of the fact that he never copied anything. He tossed his ideas on to the canvas without preliminary sketches, except for the heads and hands.

Since he painted very rapidly and never over-charged his colors, they have remained fresh, brilliant, and rich, worthy of a Van Dyck. . . .

Always a gentleman in his attitude towards the ladies whose portraits he painted, Largillière liked to repeat a compliment he had once paid to one of his most charming sitters. "You are so beautiful," he used to say, "that one might take you for a flower."

<div align="right">

A. J. Dézallier d'Argenville. *Abrégé de la vie des plus fameux peintres.* vol. IV. Paris, 1762, p. 298 ff.

</div>

I remember one encounter with that charming man who was the paradigm of a great master and honest man. . . .

Largillière said one morning that he wanted me to paint some flowers. I went to get some immediately. I thought I was doing him a favor by bringing back flowers of all colors. But when he saw them he said to me, "I asked you to do this exercise in order to give you some instruction in color. But do you think that your choice is right for that purpose? Go out," he continued, "and bring back a bunch of flowers that are all white." I obeyed immediately. When I had placed them before me, he took my place, put them against a light background, and began to point out to me that in the areas of shadow the flowers appeared very dark, whereas in the areas of light they stood out against the background in half-tones which were, for the most part, rather light. Then he took white paint from my palette and put it near the light area of these flowers, which was also very white, making me realize that the paint was even whiter than the flowers. Largillière then showed me that the highlights of these flowers, which had to be painted with pure white, were much fewer in number than the half-tones. . . . He made me understand that it was this relationship between highlight and half-tone that created the three-dimensionality of the bouquet; it was on this principle that the three-dimensionality of all other objects depended. Thus in order to produce the appearance of relief one had to emphasize the half-tones and never overdo the highlights.

After this, Largillière made me see the very strong dark areas that were in the center of the shadow and in places devoid of reflections. He continued: "Few painters have dared to produce the effect you see here, although nature reveals this to us at every turn. You must realize that this is one of the great keys to the magic of chiaroscuro. If you want to give brilliance to your object, remember to take advantage of the shadows in order to avoid drowning out the highlights, or overextending them, or overcharging them with color. . . . As a general rule . . . never try to make your objects stand out by applying color thickly,

because on a flat surface this will only ruin your effect in all but a few rare cases."

Having instructed me what to do, Largillière put two or three other white objects on the table next to the flowers to serve as guides for the accuracy of color, and he left. Immediately, I started to carry out his instructions as best I could. My head was brimming over, and, I admit, I was carried away. After I had finished my painting, I was surprised to see the effect. All the flowers seemed stark white, although I had used pure white only in a few places. Since I had used large, broad half-tones, my bouquet of flowers in all its roundness stood out against the background with its shaded, not to say dark, mass. The vigorous strokes I had applied to the shadows gave the bouquet an astonishing strength.

> J.-B. Oudry. "Reflexions sur la manière d'étudier la couleur (1749)." In Henry Jouin, ed. *Conférences de l'Académie Royale de Peinture et de Sculpture.* Paris, 1883, p. 389 ff.

Whether he painted royalty, a city magistrate, an actress, or simply a bunch of fruit, Nicolas de Largillierre proved to be a fine artist and subtle technician. His iridescent palette heralded the great colorists of the eighteenth century: Lemoyne, Boucher, Fragonard, and even Chardin. The dark manner of Le Brun and his academic art was beginning to crumble, conquered by . . . light. This quality of light had certainly not as yet attained the famous rose sheen, sometimes admired, sometimes derided, of Boucher, but was simply a harmonious balance of tones, the joy of painting rich stuffs and beautiful flesh tones. Historically, this is very Flemish and Venetian, but psychologically, very French.

> Camille Gronkowski in *Exposition N. de Largillierre* (Paris, Petit Palais). Paris, 1928, p. 11.

Portrait of the Artist with His Wife and Daughter

ca. 1700 oil on canvas 58⅝″ x 78¾″ Paris, Louvre

This family portrait reflects the whole of Largillierre; in it he gave full rein to his great gifts as a colorist and to his enthusiasm for rendering the bloom of pearly complexions against a bronze-tinted sky. The satiny red of the robe worn by his wife, the white and gold dress of his young daughter, the sparkling gray of the artist's own costume create against the russet colors of the autumn landscape a harmonious and captivating sonority. The happy serenity of the flesh tones he achieved by means of a fine, light impasto gives to the faces of the young singer and her mother a bluish transparency which seems to absorb

Portrait of the Artist with His Wife and Daughter. *Largillierre*

the light; the face of the painter is more pronounced in tone, and in his bright eyes and amost imperceptible smile we find his warm, vital color which renders the glow of radiant health so well. The elegance of the draperies, the beauty of the decor, the bloom of the finely shaped hands, all this is Largillierre at his best, and this family portrait, sparkling with color, feeling, and good humor, is the most eloquent witness to the genius of the painter.

Largillierre's pupil, Oudry, has revealed the secret of his master's vision in his two famous discourses, given at the Academy on June 7, 1749 and December 2, 1752. . . . The first of these, *On the Manner of Studying Color by Comparing Objects with Each Other*, outlined a very perceptive theory concerning correct values, the importance of reflections, and the notation of the atmosphere. . . . Oudry has informed us how carefully Largillierre had observed the way objects exist in the open air under different lights, with a boldness that a modern painter would not disclaim. . . .

In his second discourse on the practice of painting and its principal procedures—sketching, foundation, and retouching—Oudry has revealed the technique of his master: his use of neutral tones only for the underpainting "on which he could build up great masses" and in this way he was "not obliged to put a light color over a dark color or vice versa." All the delicacy of the tonalities had to be obtained by glazing; in this way the danger of a heavy impasto, which was likely to darken or crack later on, was avoided; "a well-executed

sketch should be, in view of the work that has to be done over it, more
or less like a kind of general half-tint which would take light and dark tones,
like the gray or blue paper used for drawing. . . ."

Georges Pascal. *Largillierre*. Paris,
1928, p. 39 ff.

HYACINTHE RIGAUD

Hyacinthe Rigaud (full name: Hyacinthe-François-Honorat-Mathias-Pierre-André
Rigaud y Ros) was of Catalan descent. He was born in 1659 at Perpignan and
studied painting in Montpellier and Lyons before reaching Paris at the age of
twenty-one. In 1682 he won the Rome Prize; however, on the advice of Le Brun
he did not go to Italy but settled as a portrait painter in Paris. Elected to the Royal
Academy in 1700, Rigaud painted, in 1701, the great state portrait of Louis XIV,
which was shown at the Salon* of 1704. Honors were now heaped upon him: he
became a professor at the Academy; the town of Perpignan made him an honor-
ary citizen; Louis XIV ennobled him; Louis XV named him Knight of the Order of
St. Michael. After 1721 his production slackened; he died in 1743. Rigaud kept
an account book (*livre de raison*) in which he noted the names of his sitters and
patrons, and the amount of work done by him and by his assistants. His style,
like that of Largillière, combined the influence of Van Dyck with the standard
requirements for the French state portrait.

> M. Rigaud was one of those extraordinary men whom the Lord
> had created to serve as a guide and model for artists. . . . As a portrait-
> ist he took Van Dyck for his master, whose fine execution had always
> charmed him. . . . He combined the pleasant naïveté and simplicity of
> Van Dyck with a nobility in the poses of his sitters and a graceful con-
> trast, which were all his own. He elaborated and extended, as it were,
> the draperies of Van Dyck, and emphasized the grandeur and magnifi-
> cence characteristic of the majesty of kings and the dignity of high-
> ranking persons, whom he preferred to portray.
>
> No one has gone beyond him in the imitation of nature with respect
> to local color and the texture of stuffs, especially of velvets; no one has

* The official Salons were the only public exhibitions of importance in France up to
the *Salon des Refusés* of 1863. They were originally sponsored by the Royal Acad-
emy and held in the Salon Carré of the Louvre, hence the name. Before 1704
Salons were held only occasionally. Beginning in 1737, they became a regular
function of the Royal Academy. Only academicians and associates were permitted
to exhibit. After the abolishment of the Academy by Jacques-Louis David during
the French Revolution, the *Institute* became the official sponsor of the Salons and
a jury composed of its members selected the works for exhibition.

draped stuffs more elegantly and in better taste. . . . He was opposed to that poor and lowly simplicity, which is not at all that of Van Dyck; down to the smallest details he ennobled his subjects and bestowed charm upon them.

<div align="right">

Hyacinthe Collin de Vermont. "Essai sur la vie de M. Rigaud (1744)." In P. J. Mariette. *Abécédario* (ca. 1760). Paris, 1851–60, vol. IV, p. 396 ff.

</div>

France lost her Van Dyck in the person of Hyacinthe Rigaud. . . .

Rigaud was able to give his portraits such a perfect likeness that viewing them from afar one seemed to enter into conversation with the persons represented; one might say that these portraits hinted more than they expressed: he had set down such definite and well-established rules about physiognomy that he rarely failed to achieve a resemblance. Since he could not oblige all those who were anxious to be painted by him, he put a fairly high price on his portraits, and although he doubled it later on, he never suffered from a lack of clients.

Draperies made up his principal study: he varied them in a hundred different ways and by the ingenious arrangement of the folds made them seem to be all of one piece. If he painted velvet, satin, taffeta, furs, or lace one would have liked to touch them to undeceive oneself; wigs and hair, so difficult to paint, were just child's play for him, and his delineation of hands was divinely beautiful. . . .

Although Rigaud was by nature very attentive to the ladies, he did not like to paint them: "If," he would say, "I paint them as they are, they think they don't look beautiful enough; and if I flatter them too much, the resemblance is lost." One lady who was wearing a great deal of makeup and whose portrait he was painting, complained that the colors he was using were not sufficiently beautiful and she asked him where he had bought them: "I think, Madame," answered Rigaud, "that we both buy them from the same merchant." . . .

Some critics have reproached him for the excessive brilliance of the draperies which divert the mind from the attention rightfully due to the head of a portrait. . . . It must be admitted that these objections are not without foundation; in his later years, Rigaud, under pressure to finish his paintings, gave his contours a rather harsh outline, and his color took on a slightly violet tinge. . . .

<div align="right">

A. J. Dézallier d'Argenville. *Abrégé de la vie des plus fameux peintres.* vol. IV. Paris, 1762, p. 310 ff.

</div>

Du Piles* recommends to us portrait painters, to add grace and dignity to the characters of those, whose pictures we draw: so far he is undoubtedly right; but, unluckily, he descends to particulars, and gives his own idea of grace and dignity: *"If,"* says he, *"you draw persons of high character and dignity, they ought to be drawn in such an attitude, that the portraits must seem to speak to us of themselves, and, as it were, to say to us, 'Stop, take notice of me, I am that invincible King, surrounded by Majesty': 'I am that valiant commander, who struck terror every where': 'I am that great minister, who knew all the springs of politics:' 'I am that magistrate of consummate wisdom and probity.'"* He goes on in this manner, with all the characters he can think on. We may contrast the tumour of this presumptuous loftiness with the natural unaffected air of the portraits of Titian, where dignity, seeming to be natural and inherent, draws spontaneous reverence, and . . . has the appearance of an unalienable adjunct; whereas such pompous and laboured insolence of grandeur is so far from creating respect, that it betrays vulgarity. . . .

The painters, many of them at least, have not been backward in adopting the notions contained in these precepts. The portraits of Rigaud are perfect examples of an implicit observance of these rules of Du Piles; so that, though he was a painter of great merit in many respects, yet that merit is entirely overpowered by a total absence of simplicity in every sense.

Joshua Reynolds. "Eighth Discourse (1778)." *Discourses Delivered to the Students of the Royal Academy.* New York, 1905, p. 233 ff.

Rigaud is the painter who represents the age of Louis XIV the most faithfully, not only by the richness of his accessories and draperies and the majestic poses of his sitters, but also by the number and variety of famous men who served as models for him. He painted six kings, thirty-six princes, both French and foreign, twenty-one marshals, twenty-eight dukes, seven prime ministers and sixty-four cardinals, archbishops, or bishops. He was the painter favored by the great financiers. . . .

Rigaud also painted—and this is not the least interesting part of his work for us—the painters, sculptors, engravers, architects, and poets of his day: Le Brun, Mignard, Bourdon, La Fosse, Desjardins, Coysevox, Simoneau, Boileau, La Fontaine, Fontenelle, and several

* Roger de Piles, in his *Cours de peinture par principes* (Paris, 1708); an English translation, *The Principles of Painting . . .* , was published in London in 1743.

Louis XIV, King of France.
Rigaud

others, whose portraits have, for the most part, been popularized by engravings.

. . . In the beginning his prices were very modest; a head for eleven livres, a bust for twenty-two to thirty-three livres, depending on its dimensions; a half-length or seated portrait from forty-four to eighty-eight livres. . . .

When he became a court painter, earning 26,000 livres for the two large state portraits of Louis XIV and Philip V [of Spain] Rigaud set no limit to his greed. From the year 1700 on a mere head cost 150 livres and a half-length portrait ranged from 400 to 650. Princes of the royal family never expended less than 1,000 livres for their portraits and sometimes even 6,000 to 7,000. . . .

After 1684 Rigaud, as his *Livre de raison* (account book) shows, had copies made in his atelier of many of the portraits he painted, which he would touch up when he deemed it necessary. His accounts prove that he used to give the final brush stroke to the work done by

his pupils; this is easily discernible in many of his paintings, the various parts of which are of a very unequal technical competence.

When Rigaud reached the stage where he was painting forty paintings a year he was obliged to obtain outside help. The painters who worked for him fell into two categories. One group were specialists: Flower painters such as Hulliot, Blain de Fontenay, or Monnoyer, known as Baptiste, painted the bouquets which the elegant ladies held in their hands, the flowers that they picked or that adorned the baskets they carried. Painters of battle scenes, such as Parrocel, embellished the backgrounds of portraits of men of war with cavalry charges or naval battles; and there were landscape painters, like Desportes; and painters of draperies or of ornaments. . . .

The second group of assistants, however, worked constantly in Rigaud's atelier; some of them, such as Nattier and Tournière, became famous in their own right, but the majority of them were unknown. . . .

Rigaud was therefore a contractor of portraits as well as being a great portrait painter himself: his main object was to satisfy his opulent clientele and not keep them waiting too long; for this reason he surrounded himself with collaborators who had taken up his style.

The consequences of this system can easily be imagined. His straightforward portraits have a superb appearance but are lacking in personality and, moreover, the heads are often placed on shoulders for which they are not designed, the hands are always delicate and aristocratic and the same attitudes recur over and over again. . . .

Rigaud was at his best when he derived his inspiration from reality. Those portraits where, alone and without intermediary, he confronts his sitter face to face are almost masterpieces, as the portraits of his mother, of the Abbot of Rance, and of the young Duke of Chevreuse, and still others, bear witness.

<div align="right">J. Roman. "Le 'Livre de raison' d'Hyacinthe Rigaud."

Gazette des Beaux-Arts, April 1914, p. 265 ff.</div>

Toward the end of the Grand Monarch's reign . . . there appears a brilliant group of great portraitists led by Rigaud and Largillière. This revival of portraiture affords us glimpses into the splendor of the century at its close, an image that already hints at decline. To be sure, still powerful social imperatives continue to take precedence over the individual: these pompous, important figures are men of state who exist only in and by their social functions. Rigaud does not paint Louis XIV but the Grand Monarch; not Bossuet but the prince of the Church; not Dangeau but the courtier. He portrays social types wearing their robes of office and posed against backgrounds descriptive of their service to the state. The art of the portrait conquers new territory

in these works, a territory not located within man and not used for communication of his innermost self to others, but located outside man in hangings, pillars, throne room, desk, etc. descriptive of his official function. The individual's personal characteristics have no place here. Man is no longer shown either against a background of nature or alone with himself on a neutral ground. Instead he is shown as a member of society—ceremonial robes and professional gestures placing his exact function within an all-encompassing social entity, the state.

<div align="right">René Huyghe. Art and the Spirit of Man.
New York, 1962, p. 346.</div>

ANTOINE COYPEL

Born in 1661 in Paris, Coypel was the most prominent member of a family of painters. At the age of eleven he accompanied his father Noël Coypel to Rome to study at the French Academy, of which his father had become director. Young Antoine returned to Paris in 1676 and was received into the Royal Academy in 1681; his diploma piece was *Louis XIV Resting after the Peace of Nijmwegen* (Musée Fabre, Montpellier). Coypel began as an eclecticist, but under the influence of his friend Roger de Piles he turned colorist and became an admirer of Rubens (*Democritus,* 1692; Louvre). His *trompe l'œil* ceiling of the chapel of Versailles (1708), modeled after the ceiling of the Gesù church in Rome but painted in its entirety, is the most pronounced example of the baroque in France. Coypel was appointed director of the royal collection of paintings and drawings in 1710 and director of the Royal Academy of Painting and Sculpture in 1714. Patronized especially by the Duke of Orléans, he was named *premier peintre du roi* in 1715, when the duke became Regent for Louis XV. Coypel died in 1722.

The influence of Antoine Coypel, first painter to the King and director of the Royal Academy (1714) must be reckoned on the side of tradition. It was opposed by Jean-François de Troy and François Le Moine. Coypel, standing nearly thirty years nearer to the days of Le Brun than his younger rivals, had come early into contact with Jouvenet, whose remarkable force of expression and powerful effects of light and shade he has striven to emulate in the *"Gloire"* of the chapel of Versailles. Unfortunately, in attempting to rival the strength of his model he has only shown his own weakness. In his hands any attempt at the heroic becomes a mere joke. . . . Coypel executed in the Great Gallery of the Palais Royal (1705) and in a house looking into the gardens (1708), afterwards occupied by cardinal Dubois, his principal works of decoration. His success at the Palais Royal—where he had followed the example set by Mignard, and introduced into

his picture of Olympus portraits of the favorite ladies of the Court—seems to have induced the duc d'Antin to give him employment at Versailles, where his work shows a certain aptitude for voluptuous expression and a practised skill in the arrangement of his composition, which carries off much of that theatricality and exaggeration of action and expression which is insufferable in his easel paintings, such as *Suzanne accusée par les vieillards* [Susanna and the Elders] or *Esther en présence d'Assuérus* [Esther Before Ahasuerus], which are amongst the more favorable specimens of his talent now preserved in the Louvre.

<div align="right">

E. F. Dilke. *French Painters of the XVIIIth Century.*
London, 1899, p. 26 ff.

</div>

If we want to see Coypel in a better light we must thumb through his drawings, which comprise no less than 280 sheets, in the Cabinet des Dessins of the Louvre. These drawings are superior to his paintings. Usually done in three-color crayons on gray paper, they are spirited and free in style and assure Coypel a leading place in the history of French drawing. They anticipate the technique of Watteau, whose

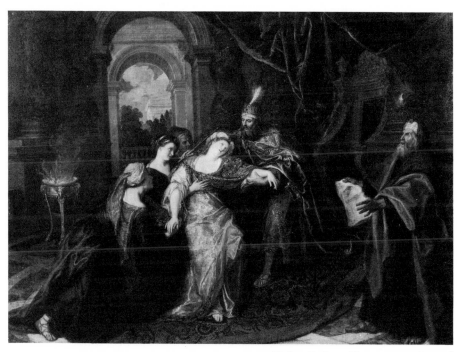

<div align="right">

Esther Before Ahasuerus. *Coypel*

173

</div>

miraculous accomplishments as a draftsman thus become more readily understood.

<div align="right">

Louis Réau. *Histoire de la peinture française au XVIII^e siècle.* 2 vols. Paris, 1925, I, 7 ff.

</div>

ALEXANDRE-FRANÇOIS DESPORTES

Born in 1661, Desportes was a farmer's son from Champigneulles in the Champagne. He went to Paris at the age of thirteen and entered the studio of the Antwerp animal painter Nicasius. He subsequently worked at the Château of Anet and at Versailles. He also did stage designs. During a year's stay in the service of the King of Poland in 1695–96 he painted numerous portraits. On his return to France he was named *peintre de la vénerie du roi* (painter of the king's hunt). Elected to the Academy in 1699, he became councillor in 1704. In 1712 he undertook a trip to England, and in 1735 worked on the restorations of the *tapisseries des Indes* at the Gobelins factory. He died in 1743. His son Charles-François and his nephew Nicolas both painted animals and still lifes with dead game in the manner of the elder Desportes.

Few persons realize all the difficulties inherent in animal painting, the prodigious amount of study it requires, and the effort it takes actually to paint an animal. Did M. Desportes not work from nature in the royal and princely kennels, surrounded by grooms and footmen, people very little appreciative of the art of painting? How he labored in the menagerie of Versailles and at the fairs of Paris in order to paint lions, tigers, and other wild beasts in cages that were neither comfortable nor even well lit! Only a great passion for this art can overcome such obstacles. This was, indeed, the case with our illustrious M. Desportes. . . .

When going to the country he used to take with him, in zinc boxes, his brushes and his palette already loaded with colors. He had a walking stick with a long steel point which could be stuck in the ground; on the handle, which opened, was a little easel of steel hinged with a screw, to which he attached the drawing board and paper. He never visited friends in the country without carrying this little bundle . . . and he never failed to make good use of it. Hence the exceptional veracity of his landscapes. In spite of the large number of studies he made, which he used only whenever he could not work directly from the object, he continually referred to Nature, which always offered him new insights.

<div align="right">

C.-F. Desportes. "La Vie de M. Desportes, peintre d'animaux (1748)." In *Mémoires inédits . . . de l'Académie Royale de Peinture et de Sculpture.* 2 vols. Paris, 1854, II, 108 ff.

</div>

View of Compiègne. *Desportes*

Like Largillière, Desportes owes a great deal to such Flemish artists as Snyders and Fyt. Like him, he helped French painting at the threshold of the eighteenth century get out of the academic rut by turning his back on the "grand manner," and by giving new importance to beautiful color harmonies and subtle experiment with pigments. His big still lifes (Angers, Lyons, Grenoble), his "portraits" of dogs belonging to the King's hunt (Gien), and his big hunting pictures are valuable for their qualities of pictorial sensibility and their decorative elegance, sometimes also for their deep understanding of animal life. Modern taste delights even more in works by Desportes, which had long gone unnoticed, especially his sketches preparatory to large compositions. In his landscapes (Sèvres and Compiègne), free from all constraint, the artist reveals a vision of nature very close to our own.

Jean Vergnet-Ruiz and Michel Laclotte.
*Great French Paintings from the Regional Museums
of France.* New York, 1965, p. 70.

JEAN-BAPTISTE OUDRY

Born in Paris in 1686, he became a pupil of Largillière and joined the Academy of St. Luke at the age of twenty-two. In 1717 he was a professor at St. Luke and was also admitted to the Royal Academy. A successful designer of tapestries since 1726, Oudry became director of the Beauvais tapestry manufacture in 1734. For the Gobelins tapestry works he designed the *Hunts* of Louis XV, a series of

tapestries woven in 1736 that led to his appointment as director of the Gobelins works. As supervisor of the entire tapestry production, he had considerable influence on the decorative arts in France and attracted artists like Boucher and Natoire to tapestry design. Oudry specialized in the painting of hunting scenes, animals, and still life. He maintained a large studio. He also illustrated the *Fables of La Fontaine* and gave two lectures at the Royal Academy—*Reflections on the Manner of Studying Color by Comparing Different Objects* (1749) and *Lecture on the Technique of Painting* (1752). Oudry died at Beauvais in 1755.

He was often called to Versailles. The King [Louis XV] ordered him to paint several dogs in his presence, especially one animal which he wanted to keep for himself. M. Oudry had acquired such a habit of conversing with high-ranking persons and of working in their presence that he painted as calmly at the court as he would in his own studio.

Hunters would send him deer from all over France, and if by accident a rare bird was killed during a royal hunt, the bird was brought to him to be painted, before being passed on to the natural history collection. The same was true of strange animals which died in the menagerie.

There was rarely a more industrious man. He made ten trips to Dieppe [at the seashore] to paint fresh fish. On Sundays and holidays it was his greatest pleasure to go to the forest of St. Germain, to Chantilly, or to the Bois de Boulogne to study the scenery, tree trunks, plants, glades, stormy skies, and vast horizons. He never went to the country without carrying a little tent with him under which he would draw, or even paint, landscapes. From the beginning he made use of the *camera obscura,* but soon recognized that, with its incorrect presentation of light, shade, and perspective, it possessed certain drawbacks.

Before the total destruction of the gardens of Arcueil, he never failed to go and draw there whenever he had a moment's leisure. . . . One could always find people sketching, and everyone eagerly consulted M. Oudry; in these picturesque pastimes he excelled like an instructor in his class. These various landscape drawings most clearly demonstrate the principles he had learned from M. de Largillière about the understanding of the chiaroscuro. It is here that we can find his boldest and most accurate effects. . . .

He was most successful in the representation of hunting scenes, landscapes, animals, fruits, and flowers. He produced the highest degree of illusionism in painted imitations of bas-reliefs. He has been praised for depicting stag's antlers, game, and dead animals, for painting on white backgrounds and even for painting entire groups of

white objects. If he did not achieve universality, he was, no doubt, an accomplished artist in his chosen fields.

<div align="right">

Louis Gougenot. "Vie de M. Oudry . . .
lue à l'Académie le 10 janvier 1761."
In *Mémoires inédits . . . de l'Académie Royale
de Peinture et de Sculpture.*
2 vols. Paris, 1854, II, 377 ff.

</div>

Between 1730 and 1750 the number of Oudry's paintings became so large that the question must be raised as to how he could have done justice to all these works, even though he had prodigious capabilities. His contemporaries, too, were amazed that such an abundant production was possible in the midst of such an active life. Oudry was suspected of sometimes simply signing the works of his pupils. "I like Oudry's paintings provided they are by him," said Desportes.

But it is not very likely that this remark was justified. All Oudry's paintings—portraits, hunting scenes, landscapes, and animals—share the same minor gaucheries and faults caused by his constant concern with light and reflections, which he overemphasized, forced, and used to excess. Sometimes this emphasis leads to the most beautiful effects; then his modeling is incomparable. No French painter before the nineteenth century attained such mastery of the art of the half-tint and the chiaroscuro. . . .

Above all Oudry was the great animal painter. He made animal painting his speciality throughout his life and was the leading artist in this genre. . . . His only rival was Desportes, whom he surpassed by his interest in every kind of beast. As for the painting of dogs, he was really the artist ·most attracted to them, as Largillière had once predicted.*

<div align="right">

Jean Vergnet-Ruiz. "Oudry." In Louis Dimier, ed.
Les Peintres français du XVIIIᵉ siècle.
2 vols. Paris, 1928–30, II, 145.

</div>

The White Duck

1753 oil on canvas 37½ " x 24½ "
London, Collection of the Marchioness of Cholmondeley

Suppose you would like to paint a silver vase on a piece of canvas. The general idea of the color of silver is white. But in order to render this metal

* When the young Oudry had painted a portrait of a hunter with his dog, Largillière, who disliked the rendering of the hunter, told him prophetically: "You will never be anything but a painter of dogs!"

The White Duck. *Oudry*

correctly it is necessary to determine the exact shade of white which would be appropriate. How can this be determined? By putting next to your silver vase several other white objects, such as linen, paper, satin, or porcelain. These different whites will enable you to evaluate the exact tone of white you need for your silver vase, because you will recognize by comparison that the tone of one of these white objects is never the same as that of the others. . . . If you proceed in this manner you will not run the risk of using the wrong shades. This is one of the aspects of technique which the Flemish painters have so well understood and in which they have been most successful. They have always achieved this accuracy of tone which we so greatly admire.

> J.-B. Oudry. "Réflexions sur la manière d'étudier la couleur (1749)." In Henry Jouin, ed. *Conférences de l'Académie Royale* . . . Paris, 1883, p. 386 ff.

As the result of a lecture M. Oudry gave at the Academy [in 1749] he painted a picture representing five or six white objects on a white background.*

* *The White Duck* apparently made a lasting impression on Diderot, who obviously referred to this picture in his essay *De la poésie dramatique* (1758). Comparing the dramatist's need for contrasting characters with the use of different colors in a painting, he wrote: "If the poet does not want to be as cold as a painter who places white objects against a white background, he will always have different states, ages, situations, or interests in mind."

Each of these is of a different white: a white duck, a damask tablecloth, a white porcelain bowl filled with whipped cream, a candle in a silver candlestick, and, high up, a white piece of paper. According to the connoisseurs a high price seems to have been put on this canvas.

F. M. Grimm. *Correspondance littéraire*, September 15, 1753.
16 vols. Paris, 1829–31, I, 59.

It [*The White Duck*] was painted . . . no doubt as an exercise in style, and perhaps to balance a second picture conceived, as a contrast, in a variety of colors. In any case, he produced a masterly work which points up not only his skillful handling of color and light, but also that almost tactile sense of matter which is his most eminent quality in the works he executed unhurriedly.

Albert Châtelet in Jacques Thuillier and Albert Châtelet. *French Painting from Le Nain to Fragonard.* Geneva, 1964, p. 156.

CLAUDE GILLOT

Painter, engraver, and illustrator, Claude Gillot is best known as the teacher of Watteau. He was born in 1673 at Langres and trained by Jean-Baptiste Corneille. The theater, especially the Italian *commedia dell'arte*, was his chief inspiration. After the suppression of the *commedia dell'arte* in France in 1697, Gillot turned to outdoor pantomime and marionette shows as his principal themes. The novelty of his subject matter and a more spontaneous decorative style played a considerable role in freeing French painting and decoration from the classical conventions of the school of Le Brun and foreshadowed the rococo. Gillot died in 1722.

Although he was an ingenious and prolific creator, an adept draftsman, an etcher of fine compositions, the father of the French School of the eighteenth century, and the real inventor of the genre to which Watteau attached his name, Claude Gillot is nevertheless as little known today as his pupil is famous. Only a few collectors possess works by him. Nothing is more unjust than this neglect by the public and especially by the art world. For Gillot was not only an adroit artist who set forth a new trend by proclaiming the independence of the imagination in his striking compositions, he was also a master with a highly individual talent, who established landmarks on a terrain unknown at that time, and who blazed the path that his disciple was to travel so triumphantly.

. . . Gillot is hardly better known or more appreciated in our time than he was in 1857, when Philippe Burty devoted three articles to him in *L'Art du XIX^e siècle* by Théodore Labourieu. These articles are

179

Scene from "The Two Coaches." *Gillot*

remarkable for their date, since they antedate the writings of the
Goncourt brothers. . . .

What is most striking in Gillot's art is the richness and uniqueness
of his talent. . . . He was more than just an original artist. He was an
initiator. . . . He was a man ahead of his time, who was unencumbered
by the prevailing traditions and had only his own imagination for a
guide. He combined the picturesque with religion, humanism with
mythology, and mythology with the theater. He was infatuated with
actual life and impassioned with movement and color. Although not
exactly inventive as a decorator, he was at least on a par with the in-
novator Claude Audran. As a costume designer he surpassed Bérain
and even foreshadowed Boucher. As an illustrator he went beyond
Sébastien Leclerc and was ahead of all the great vignettists of the cen-
tury. As a painter and illustrator of modern subjects he was the guid-
ing spirit of Watteau, whom he met at the decisive moment. . . .

Without doubt he had his great weaknesses. One must not de-
mand deep emotions or far-reaching thoughts from him. He never
rose above the details of everyday reality. His genius was that of a
facile, superficial, and somewhat pedestrian storyteller who only saw

the external and picturesque appearance of things. Sometimes Gillot had the grace of Watteau, but he was incapable of either the soaring imagination and fantasy or the exquisite poetry of the master of *The Embarkation for Cythera*. He lacked Watteau's marvelous gift of transforming everything he touched. . . .

The few paintings extant by Gillot . . . will not make us forget his drawings, faulty though they may have been. Even in the engravings, he did not always seem to be the master of his craft. Great skill is mixed with amazing clumsiness. In short, Gillot was an incomplete artist. His means of expression were never fully in accord with the originality and the richness of his imagination.

But once we have weighed Gillot's strong and weak points, the scale leans in his favor. Even if he had not created his ornaments and his illustrations, and even if he had not revitalized genre painting, he would merit a first place amongst the founders of the French school of the eighteenth century, if only for having introduced the theme of the Italian comedy.

<div align="right">

Émile Dacier. "Gillot." In Louis Dimier, ed.
Les Peintres français du XVIIIᵉ siècle. 2 vols.
Paris, 1928–30, I, 157 ff.

</div>

ANTOINE WATTEAU

The son of a tiler, Watteau was born in 1684 at Valenciennes, and first studied painting with a local artist named Gérin. He went to Paris in 1702 and entered the studio of Gillot about 1704–5. He left Gillot in 1708 and became associated with the ornamentalist Claude III Audran, keeper of the Luxembourg palace. Watteau did decorative figures for Audran and had the opportunity to study Rubens' paintings of Marie de' Medici, then at the Luxembourg. In 1709 Watteau competed for the Rome Prize, but achieved only second place. He became an associate member of the Royal Academy in 1712 and a full member in 1717, submitting as •his diploma piece *The Embarkation for the Island of Cythera** (Louvre; a later version in Berlin). He was accepted as painter of *fêtes galantes,* a new genre created expressly to admit Watteau. These paintings depict an imaginary world combining pastoral and theatrical elements. In 1719, Watteau went to London, perhaps to seek medical advice for the tuberculosis from which he suffered. Greatly weakened, he returned the following year and died in 1721 in the house of his patron Gersaint, at Nogent-sur-Marne, near Paris. Watteau received no commissions from the Court; besides Gersaint, his principal patrons were Pierre Crozat, in whose house he stayed during 1716–17, and Jean de Julienne. The latter

* The traditional title of this painting has been retained here. See below for Michael Levey's analysis of "The Real Theme of Watteau's Embarkation for Cythera."

published two collections of engravings after Watteau's paintings and drawings, *Figures de différents caractères* (1726–28; engraved by Boucher), and *L'Œuvre gravé d'Antoine Watteau* (1735).

The painter of refinement and grace, whose death we announce, was highly distinguished in his profession; his memory will always be dear to the true lovers of art. Nothing furnishes better proof of this than the excessive prices paid today for his work. The only kind of pictures he did were easel paintings of small figures; he painted in the Flemish manner, but his color was very close to Rubens. . . .

We find in his art an agreeable mixture of the serious, the grotesque, and the caprices of old and modern French fashions. . . . His touch and the *vaghezza* of his landscapes are charming. His color is pure and accurate; his figures have all the delicacy and precision that could be desired.

<div align="right">

Antoine de La Roque. "Vie de Watteau (1721)."
In Hélène Adhémar. *Watteau, sa vie—son œuvre.*
Paris, 1950, p. 166.

</div>

Although Watteau's life was very short, the large number of his paintings would lead us to believe that he lived very long, but it only shows that he worked very hard. In fact, even the hours of recreation and of outdoor walks were utilized by him for the study of nature, and he made sketches whenever nature seemed most admirable to him.

<div align="right">

Jean de Julienne. "Abrégé de la vie d'Antoine Watteau
(1726 or 1736)." In *ibid.,* p. 168.*

</div>

Watteau's temperament was restless and changeable; he was self-willed and libertine in spirit but virtuous in his conduct; impatient and timid; cold and embarrassed when approached; discreet and reserved with strangers, but a good though difficult friend; misanthropic, even malicious and caustic in his criticism, always dissatisfied with himself and others, and forgiving with difficulty. He spoke little, but well; he loved to read; this was his only amusement; though he lacked the advantages of an education, his judgment was sound. . . .

As regards his work, one might have wished that he had devoted his early studies to history painting and that he had lived longer. Pre-

* Pierre Champion dates the essay 1736 in his *Notes critiques sur les vies anciennes d'Antoine Watteau* (Paris, 1921), whereas A. Vuaflart, in E. Dacier and A. Vuaflart, *Jean de Julienne et les graveurs de Watteau* (Paris, 1922–29) gives the date as 1726. La Roque's and de Julienne's essays appear also in P. J. Mariette's *Abécédario*, vol. VI.

sumably he would have become one of the greatest painters of France. His pictures suffer from his impatience and the inconstancy of his character. . . . He jumped from one subject to the next and would often begin a composition only to tire of it before it was half completed. In order to rid himself more quickly of a picture he had begun and was obliged to finish, he loaded his brush with thick oil, so as to spread the color more easily. As a result some of his pictures have deteriorated more and more and have completely changed color or darkened irretrievably; yet those free of these faults are admirable and will always hold their own in the greatest collections.

His drawings dating from the best period, that is, after he left M. Crozat, are unsurpassed. Their finesse, grace, lightness, accuracy, facility, and expression leave nothing to be desired. Watteau will always remain one of the greatest and best draftsmen France has ever had.

<div style="text-align:right">

E.-F. Gersaint. "Catalogue de feu M. Quentin de Lorangère (1744)." In *ibid.,* p. 172.

</div>

Enjoying a fine reputation, Watteau had no enemies but himself, and a certain spirit of instability by which he was dominated. No sooner had he taken lodgings anywhere than he became displeased with the place. Time and again he moved, and always on some specious pretext that he had to invent out of a sense of shame at his behavior. . . .

Basically . . . Watteau was an infinitely mannered artist. Although he was gifted with certain talents and his favorite subjects were enchanting, his hands, his heads, and even his landscapes all suffer from his mannerism. Taste and general effect . . . produced, it is true, very pleasing illusions, especially as his color was good and he was very accurate in rendering of stuffs which he delineated in a delightful fashion. It should be added that he hardly ever painted stuffs other than silk, which always falls in small folds. But his draperies were well arranged and correctly rendered, because he always drew from nature and never made use of a lay figure. . . .

In order to increase the speed of effect and execution, Watteau liked to apply his paint thickly. . . . To practice this successfully, elaborate and proper preparations are necessary, but Watteau hardly ever made them. . . . Only rarely did he clean his palette; he sometimes went for several days without doing so. The pot of thick oil, which he used so much, was full of dirt and dust mixed with all sorts of colors which adhered to his brushes as he dipped them into it. How remote was this procedure from the exceptional care that certain Dutch painters took in order to work cleanly! . . .

Ordinarily, Watteau drew without a specific objective. He never made a sketch or noted down an idea . . . for any of his pictures. . . . It was his habit to make his drawings in a bound book, so that he always had a large supply of them at hand. He owned cavalier's and actor's costumes in which, whenever he had the opportunity, he would dress up persons of either sex, who would pose for him. He drew them in their natural attitudes, preferring the simplest ones. When he was in the mood to paint a picture, he resorted to his collection of drawings and chose the figures most suited for the occasion. He arranged them in groups so as to be in harmony with a landscape background which he had already conceived or prepared.

A. C. de Caylus. "La Vie d'Antoine Watteau (1748)."
In Edmond and Jules de Goncourt.
L'Art du XVIIIᵉ siècle. 3 vols. Paris, 1909–10, I, 33 ff.

He was successful in the representation of small figures, which he grouped very well. But he never painted anything in the grand manner; he was incapable of it.

Voltaire. "Le Temple du goût (1733)." *Œuvres complètes.*
vol. XII. Paris, 1785, p. 173.

I prefer boorishness to daintiness, and I would give ten Watteaus for one Teniers.

Denis Diderot. "Pensées détachées
sur la peinture (ca. 1760)." *Œuvres complètes.*
vol. XII. Paris, 1876, p. 75.

Watteau is a master I adore. He unites in his small figures correct drawing, the spirited touch of Velazquez with the coloring of the Venetian School.

Joshua Reynolds (ca. 1780). Quoted in William Whitley.
Artists and Their Friends in England, 1700–1799.
2 vols. London, 1928, I, 110.

Watteau looks . . . as if painted in honey—so tender—so soft and so delicious. . . . This inscrutable and exquisite thing [The *Bal champêtre* at Dulwich] would vulgarise even Rubens and Paul Veronese.

John Constable. Letter to C. R. Leslie, August 1831. *John
Constable's Correspondence*, III, Ipswich, 1965, p. 41.

To compare Watteau with the great masters of art is like placing beside an ancient statue a pretty Meissen figurine.

Alfred de Musset. "Salon de 1836." *Œuvres complètes.*
vol. VIII. Paris, 1909, p. 116.

Watteau: Greatly despised under David, restored to honor at a later time. Admirable execution. . . . He possesses the art of holding a picture together.

> Eugène Delacroix. *Journal.* 3 vols. Paris, 1932, III, 12.
> Entry for January 11, 1857.

Watteau, that carnival where hearts illustrious
Flutter about like butterflies aflame,
A cool and airy stage illumed by lustres,
Whose rays toss folly on this whirling game.*

> Charles Baudelaire. "Les Phares." *Les Fleurs du mal*
> (1857). *Œuvres complètes.* vol. I. Paris, 1886, p. 112.

The great poet of the eighteenth century was Watteau. A world, an entire universe of poetry and fantasy sprung up from his mind and filled his art with the subtlety of a supernatural life. A magic spell, a thousand magic spells, took wings from his imagination, from the humor of his art, from the absolute originality of his genius. . . .

Watteau renewed the quality of grace. It is no longer the grace of antiquity, a firm and solid charm, like the marble perfection of Galatea. . . . The grace of Watteau is grace itself. . . . It is a subtle thing: the smile of a contour, the soul of a form, the spiritual physiognomy of matter. . . .

The Grecian gods are gone, and Rubens, who lives again in this palette of rose and golden flesh tones, wanders, a stranger, through those *fêtes,* where the senses stir no more, through those sparkling visions, which seem to await the magic wand to lose their corporeality and to vanish into the realm of fantasy like a midsummer night's dream. It is Cythera, but it is the Cythera of Watteau. It is love, . . . but poetic love, modern love with all its aspirations and crowning melancholy.

Yes, deep down in Watteau's art there murmurs an undefinable harmony, slow and ambiguous, beneath those smiling expressions; an undefinable musical sadness sweetly permeates those *fêtes galantes.* Like the seductiveness of Venice an undefinable poetry, veiled and sighing, speaks softly to our enchanted minds.

> Edmond and Jules de Goncourt. "Watteau (1860)."
> *L'Art du XVIIIᵉ siècle.* 3 vols. Paris, 1909–10, I, 3 ff.

* *Watteau, ce carnaval où bien des cœurs illustres,*
Comme des papillons, errent en flamboyant,
Décors frais et légers éclairés par des lustres
Qui versent la folie à ce bal tournoyant.

We have had our September Fair in the *Grande Place,* a wonder-stir of sound and colour in the wide, open space beneath our windows. And just where the crowd was busiest young Antony was found . . . sketching the scene to the life, but with a kind of grace—a marvelous tact of omission, as my father pointed out to us, in dealing with the vulgar reality seen from one's own window—which has made trite old Harlequin, Clown, and Columbine, seem like people in some fairyland; or like infinitely clever tragic actors, who, for the humour of the thing, have put on motley for once, and are able to throw a world of serious innuendo into their burlesque looks, with a sort of comedy which shall be but tragedy seen from the other side. . . .

That charming *Noblesse*—can it be really so distinguished to the minutest point, so naturally aristocratic? Half in masquerade, playing the drawing-room or garden comedy of life, these persons have upon them, not less than the landscape he composes, and among the accidents of which they group themselves with such a perfect fittingness, a certain light we should seek for in vain upon anything real. For their framework they have around them a veritable architecture—a tree-architecture—to which those moss-grown balusters, *termes,* statues, fountains, are really but accessories. . . .

Yes! Besides that unreal, imaginary light upon these scenes, these persons, which is pure gift of his, there was a light, a poetry, in those persons and things themselves, close at hand *we* had not seen. He has enabled us to see it: we are so much the better-off thereby. . . .

> Walter Pater. "A Prince of Court Painters." *Imaginary Portraits* (1885). London, 1900, p. 1 ff., 31 ff.

Dusk paints trees and faces with her bluish mantle
Under the yet uncertain mask of day.
On weary lips the dust of kisses lingers,
The haze turns tender, and the near seems far away.
The masquerade, in distant, melancholy hue,
Makes lovers' gestures false and triste and charming,
A poet's whim, or cautious lovers' cue,
Love must be smartly decorated and disarming,
Hence festive raiments, food, and silence,—music, too. *

> Marcel Proust. "Antoine Watteau."
> *Les Plaisirs et les jours* (1896). Paris, 1924, p. 136.

* *Crépuscule grimant les arbres et les faces,*
Avec son manteau bleu, sous son masque incertain:
Poussière de baisers autour de bouches lasses . . .
Le Vague devient tendre et le tout près lointain.
La mascarade, autre lointain mélancolique,

His *fêtes galantes* are the symbols of his own moods, and the philosophy of his art is summed up in one small figure—*L'Indifférent* of the Louvre. That graceful young cavalier is chiefly charming by reason of the lurking ennui back of his debonair abandon, the vague sadness disguised in sprightly silver and rose. And this prevailing mood—though ever so frail and fugitive a thing, seems Watteau's most alluring quality to our appreciative, unimaginative age. In many ways has he influenced modern art. Was he not the first to recognize the prismatic brilliancy of the atmosphere—the first to combine the realistic zeal of Rubens in the study of light and air, with the romantic ardour of Giorgione in the evocation of the personal sentiment? Yet for all his spirited draughtsmanship and vivacious colour, it is the successful *symbolism* of Watteau that makes him most interesting to modernity—his inspired discovery of a peculiarly subtle means of expressing his peculiarly subtle mood. . . . Watteau's spirit has been translated into verse by almost every poet who is any way sensitive to painting. No one has done this quite so perfectly as Verlaine in his *Fêtes galantes*. Arthur Symons sympathetically rendered the lyrics into English. Here is one of them.

> The singers of serenades
> Whisper their faded vows
> Unto fair, listening maids
> Under the swaying boughs.
>
> Tircis, Aminte are there,
> Clitandre is over-long,
> And Damis for many a fair
> Tyrant makes many a song.
>
>
>
> And the mandolines and they
> Faintlier breathing swoon
> Into the rose and gray
> Ecstasy of the moon.

Duncan Phillips.
"Watteau and His Influence on Modern Poetry (1913)."
The Enchantment of Art.
Washington, D.C., 1927, p. 243 ff.

Fait le geste d'aimer plus faux, triste et charmant,
Caprice de poète ou prudence d'amant,
L'Amour ayant besoin d'être orné savammant,
Voici basques, goûters, silences et musique.

187

Watteau's art is musical to the highest degree in form and content; in this respect, too, it is kindred to Giorgione. With the exception of *Gersaint's Signboard* there is hardly a picture which does not show musicians playing. . . . Motifs such as *L'Indifférent* are rhythmic revelations the meaning and value of which cannot be verbalized, but can be measured only in terms of musical sensibilities.

> Edmund Hildebrandt. *Malerei und Plastik des achzehnten Jahrhunderts in Frankreich.* Wildpark-Potsdam, 1924, p. 116.

Watteau was one of the most touching, graceful, and sympathetic painters who ever lived . . . a mellifluous, tragic, and hurried poet.

> Sacheverell Sitwell. *Antoine Watteau.* London, 1925, p. 7.

There may be moments when we think we might embark for Cythera with all those dainty and exquisite companions, as beautifully dressed, as debonair, as deft, as finely tempered for social life as they are, moments when those sunlit distances might tempt us through dappled glades and past splashing fountains. But, if some sober reflections on our qualifications for such an adventure recall us to drab actuality, we need feel no disappointment, we need not go in person— Watteau will take us in our detached and disembodied state and we shall enjoy ourselves all the more. That spiritual experience will not be so poignant nor so profound as when we go with Giorgione, it will retain a stronger flavour of actuality but it will have its rare delights, for we shall be endowed with a finer sense of the *nuances* of social life, a subtler apprehension of the meaning of a gesture, the implications of a smile. It is in that direction that Watteau gives to our earthly Paradise so distinctively French a quality, for it is only in France, perhaps only in eighteenth-century France, that the social temper was brought to so fine a point and so high a polish.

It is tempting to compare Watteau's realization of this material with Mozart's, for they are surely the two great poets of eighteenth-century life. And both belong to this exquisite social milieu. Neither ever strays outside the Park gates. Both find their richest inspiration in a factitious life, though Mozart imparts to it a greater poignancy of feeling, a stronger sense of the menace of fate and the tenderness of human feeling in face of that. That sense of the pathos of human fragility sometimes colours his most reckless gaiety with a heartrending pathos, and Watteau, though the feeling is less intense, is no stranger to this mood. . . .

There have been more penetrating and profound interpreters of

human nature than Watteau, but perhaps none has ever had so keen a sense of human nature in its social aspects, or at least none has ever been able to give to this material so delicately imaginative an interpretation.

<div align="right">Roger Fry. "Characteristics of French Art (1932)."

French, Flemish, and British Art. London, 1951, p. 35 ff.</div>

L'Indifférent

ca. 1716 oil on canvas 10¼ " x 7½ " Paris, Louvre

No, no, he is not indifferent, this mother-of-pearl messenger, this herald of Dawn; let us say rather that he hesitates between soaring and walking; he is not dancing yet, but with one of his arms extended and the other spreading the lyric wing out wide, he holds in suspense an equilibrium whose weight, half exercised, forms only the least important element. He is in a position to depart or to enter; he listens, he awaits the right moment; he seeks it in our eyes; from the trembling tips of his fingers to the extremity of this extended arm, he counts, and the other volatile arm in the full cape gets ready to cooperate with

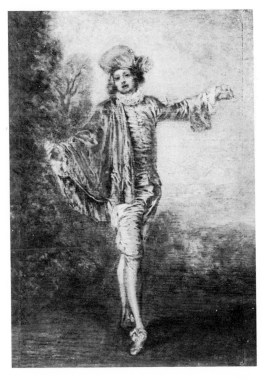

L'Indifférent. *Watteau*

the calf. Half fawn, half bird; half sensibility, half discourse; half taut and half relaxed! Sylph, magic, and dizzy quill preparing the flourish! The bow has already begun that long note on the string, and the whole justification of the figure is in the measured spring he is preparing to take, effaced, destroyed in his own whirlwind. Thus the ambiguous poet, inventor of his own prosody, of whom one never knows whether he is flying or walking, extends his foot, or wing if he wishes to spread it out, to any strange element, whether it be land or air, or fire, or this water, in which we float, that is called ether.

> Paul Claudel. "Watteau: L'Indifférent (1939)."
> *The Eye Listens.* New York, 1950, p. 179.

The Embarkation for the Island of Cythera
Le Pèlerinage à l'isle de Cithère

1717 oil on canvas 50⅜" x 76" Paris, Louvre

"In this masterpiece the action . . . begins in the foreground to the right and ends in the background to the left.

"What you first notice in the front of the picture, in the cool shade, near a sculptured bust of Cypris garlanded with roses, is a group composed of a young woman and her adorer. The man wears a cape embroidered with a pierced heart, gracious symbol of the voyage that he would undertake.

"Kneeling at her side, he ardently beseeches his lady to yield. But she meets his entreaties with an indifference perhaps feigned, and appears absorbed in the study of the decorations on her fan. Close to them is a little cupid, sitting half-naked upon his quiver. He thinks that the young woman delays too long, and he pulls her skirt to induce her to be less hard-hearted. But still the pilgrim's staff and the script of love lie upon the ground. This is the first scene.

"Here is the second: To the left of the group of which I have spoken is another couple. The lady accepts the hand of her lover, who helps her to arise. She has her back to us, and has one of those blonde napes which Watteau painted with such voluptuous grace.

"A little further is the third scene. The lover puts his arm around his mistress's waist to draw her with him. She turns towards her companions, whose lingering confuses her, but she allows herself to be led passively away.

"Now the lovers descend to the shore and all push laughing towards the barque; the men no longer need to entreat, the women cling to their arms.

"Finally the pilgrims help their sweethearts on board the little ship, which, decked with flowers and floating pennons of red silk, rocks like a golden dream upon the water. The sailors, leaning on their oars, are ready to row

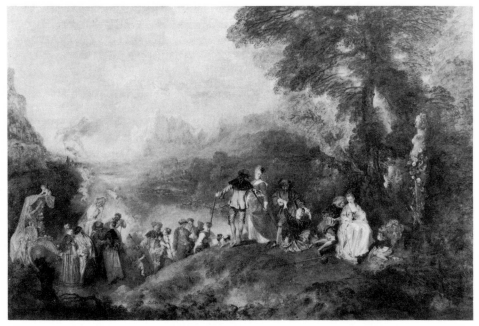

The Embarkation for the Island of Cythera. *Watteau*

away. And already, borne by the breezes, little cupids fly ahead to guide the travellers towards that azure isle which lies upon the horizon."

"I see, Master, that you love this picture, for you have remembered every detail," I said.

"It is a delight that one cannot forget. But have you noted the development of this pantomime? Truly now, is it the stage? or is it painting? One does not know which to say. You see, then, that an artist can, when he pleases, represent not only fleeting gestures, but a long *action,* to employ a term of dramatic art."

<div align="right">

Auguste Rodin. *On Art and Artists* (1911).
New York, 1957, p. 95 ff.

</div>

Most of the prose-poetry which has accumulated about it since the famous pages of the Goncourt [brothers] has emphasized the pilgrim lovers setting out to sail for Cythera, . . . the reluctance of some, the eagerness of others. And along with an autumnal air the Goncourt spoke of, a feeling of sadness has been detected. . . .

As so often happens, these sentiments which seem at first rather subjective are much closer to the picture's real mood and meaning than its common title [*The Embarkation for the Island of Cythera*] would allow. If one looks at the picture with a fresh eye, ignoring everything that has been written about it

. . . the most probable explanation of what one sees is that a pleasure party which has the use of a boat and the companionship of cupids is about to leave a place where stands a term of Venus. Since the partial cleaning of the picture, it can be seen too that the sunset atmosphere is not a matter of discoloured varnish. The time is obviously evening and the setting sun has given its tone to the whole scene.

That love is the central theme is at once too obvious to need argument, and is uncontested. The place is particularly dedicated to love, for a prominent term of Venus stands there. . . . And the statue is freshly garlanded with roses —freshly, one may say because the cupid-pilgrim who sits close by holds a rose in his hand. Not only roses are hung on it but convolvulus also, symbolizing no doubt lovers' bonds. All these are suggestions of a rite accomplished. . . . In that case it would be probable that the pilgrims—for such their costume and their staves and scrips show them to be—had arrived on pilgrimage at the island and were now on the point of departure. . . .

More obviously, the group of the pilgrim helping his partner to get up suggests the end rather than the beginning of a *fête galante*. Cythera seems not to lie amid the misty Claudian peaks of the distance, but to be here and now. And hence the absorption of the whispering lovers, reluctant to leave. Finally, the most conclusive evidence that the scene is in fact a pilgrimage to (*i.e.* on) the island of Cythera is provided by Watteau's own title [*Le Pèlerinage à l'isle de Cithère*]. . . .

This is the reason why an air of transience and sadness has so often been detected in the two pictures, more markedly in the Paris version. A festivity is drawing to a close. A cupid tugs at the skirt of the still seated woman, trying to break her reverie, and down by the water's edge cupids conduct the less tardy lovers on to the boat. It is indeed with *"une certaine tristesse"* that the standing woman turns back to that pair of lovers who are still possessed by love and not yet disturbed by time.

It is Watteau's usual theme. The demand of time is inexorable. A boat is always waiting and there is always a return from the shrine of love. . . .

We may not care to think of Watteau's pictures as requiring to be explained; but it is worth remembering that this attitude is a sentimentality now applied to no other great painter. In the case of the so-called *Embarkation for Cythera* such an attitude is demonstrably wrong.

<div align="right">

Michael Levey. "The Real Theme
of Watteau's Embarkation for Cythera."
Burlington Magazine, May 1961, p. 180 ff.

</div>

Gilles

ca. 1719? oil on canvas 72½ " x 58⅝ " Paris, Louvre

This doltish, round-faced pierrot is standing in a kind of diurnal moonlight. For it is late afternoon, and sun and moon are shining out of opposite

ends of the sky. The slanting sunlight gives the evening its colour of golden sandstone, as if it were a Roman evening, yellow as Tiber or the campagna, with stone pines for shadow. Such is the sunlight; but, all the time, the round-faced full moon has half the heavens to itself and shines above his shoulder.

Gilles is standing immediately in front of us, on purpose, as if he has been told to stand still. His arms hang straight down at his sides. He has shoes tied with ribbons, a white ruff, and a wide hat. Underneath this he wears a nightcap, or perhaps it is the white cap of a pierrot, for his hat is too big for him. So are his clothes. They hang loosely upon him, and look as if they had been borrowed. As for his face, he has dark eyebrows and a full mouth. And his expression tells us he is not certain if he can make us laugh. Mezzetin, il Dottore, and the rest of the company are chattering noisily in the background, low

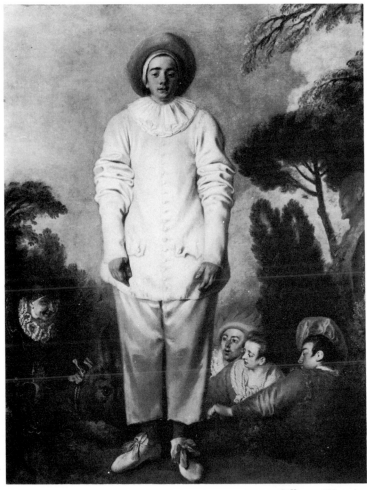

Gilles. *Watteau*

down, at the level of his knees, while a garden term smiles cynically at them from underneath the boughs.

But the figure of Gilles holds all the attention. . . .

His clothes, as we have said, are of moonlight, as if soaked in it. He stands for the artifice of night in this sunset landscape; and, at the same time, not for the darkness of that, but for its contradiction by the lit scene. This may be a pool of moonlight, or the light of candles on the stage. But he is nocturnal man, the creature of the lights; and if one thing is certain it is that he does not appreciate these garish colours of the day, this Roman evening and the resin of the pines. And then we remember that he is not the real Gilles, but a friend in actor's clothes, posing for his portrait. That is why the clothes are ill-fitting. . . . A miraculous emptiness lies upon those moonlit clothes. . . .

The illuminating blankness of his image opens a whole world of conjecture. It is as if the painter has invested his figure with the positive angles of his own spirituality, has given him his own adolescence, not yet turned cynical. It is a portrait of himself in terms of sensibility; not a physical likeness of himself, but an image borrowed from a friend, hung with hired clothes, and given a soul.

<div style="text-align: right">Sacheverell Sitwell. "Entrance of Gilles." The Dance of the Quick and the Dead. London, 1936, p. 66 ff.</div>

Gersaint's Signboard
L'Enseigne de Gersaint

1720 oil on wood 71⅝" x 121⅛" Berlin-Dahlem, Staatliche Museen

On his return to Paris in 1721 [actually in 1720], during the early years of my business, Watteau came to ask me if I would receive him at my house and allow him—these were his words—"to loosen up his fingers" and to paint a signboard which I was to display outside my establishment. I was somewhat reluctant to grant his request, as I would have much preferred to occupy him with something more substantial. But I consented, seeing that this would give him pleasure. The success of this painting is well-known; the entire picture was executed from nature,* and the attitudes were so lifelike and natural, the arrangement so pleasing, and the composition so well conceived that it attracted the attention of the passers-by; even the best painters returned several

* The painting represents Gersaint's shop. On the right Madame Gersaint is showing a picture to a lady client; behind the counter are de Julienne, Crozat, and Count de Caylus. Gersaint, off center, is holding out his hand for payment, while the figure on the far left may be that of Watteau himself.

times to admire it. It had been painted in only eight days, and, furthermore, Watteau worked only in the mornings; his delicate health, or, rather, his weakened condition, did not permit him to paint for a longer span of time. It was the only example of his work that in any way raised his self-respect; he admitted this to me quite openly.

<div style="text-align:right">

E.-F. Gersaint. *"Catalogue de feu M. Quentin de Lorangère* (1744)." In Hélène Adhémar. *Watteau . . .* p. 171.

</div>

When I first saw *Gersaint's Signboard* . . . I was immediately struck by a detail in the painting to which nobody else, to my knowledge, has ever drawn attention, namely that the entire foreground of the painting consists of four rows of large cobblestones, representing the street in front of Gersaint's shop. This area is further emphasized by a bundle of straw to the extreme left and, on the far right, by a dog biting off his fleas, supposedly borrowed from a painting by Rubens. That this should be the foundation for the entire painting is strange. For me it underlines the didactic intention of the painter, the lesson he bequeathes to the future—his manifesto and testament.

A long scene, . . . to which I shall return later, unfolds between the challenge of the paving stones and another challenge which dominates the entire work: the exhibition of paintings in Gersaint's shop, paintings in gilt frames that mount the walls to the right and to the left three and four rows high. . . .

All these paintings differ from one another in subject matter, technique, and school. They range from portraits by Velazquez to rural scenes by Le Nain, from an Italian Nativity to a Flemish still life. . . . How could it have eluded the critics that this diversity of styles, together with the artist's slightly ironic interest in them, must of necessity take on the character of a systematic critique both of painting and of the painters that have preceded Watteau himself. This is also brought out by the fact that he has included, with pointed mockery, one of his own canvases, or rather an allusion to it, chosen precisely because it is the opposite of what Watteau was to mean to posterity, that *Pénitent blanc* of which he correctly assumed that nobody would attribute it to him in the future. If we add to this the irreverent manner in which the most famous portrait of the Sun King, the one by Le Brun, is being packed into a box and is thus seen sideways, (and this only five years after the death of Louis XIV), how can we fail to understand that *Gersaint's Signboard* provided for Watteau the opportunity to criticize contemporary painting or the prevalent concept of painting? . . . And it seems to me that Watteau's satiric intention is obvious when we observe how the two customers in gray and black, shown with their backs toward the viewer, ogle through their pince-nez the large oval picture that Gersaint is showing them. Let me remind you that this oval represents the "modern art" of the time, entirely different in treatment and the use of light, and it shows a composition of nude ladies in a park, which Watteau

<div style="text-align:right">195</div>

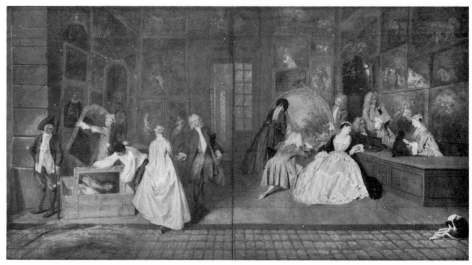

Gersaint's Signboard. *Watteau*

would never have made the object of such rapt attention if he had not meant it to be humorous.

Let us recall that Watteau was the great initiator among the eighteenth-century painters, that it was he who, at the outset of that extraordinary period that would turn the world on its hinges, devised the new themes and the new poetry which were to prevail until the fall of the Bastille. . . . Let us recall that all this "Italian style" comedy, as well as *Cythera*, the *Signboard*, and the *Signature du contrât* . . . signified a break with the academic subjects as they had become frozen under the Sun of Versailles. . . . Thus at the age of thirty-seven, still young but already full of the portents of death, Watteau abandoned the decorative and charming manner at which he had excelled, in order to forge ahead, beyond his own poetry, to the exploration of the actual world through painting. In the depths of the immediate future he sensed, he discovered, the force and the novelty of realism as well as the ambiguities of the bourgeois comedy with its porters standing in the wings, and he painted this picture, which foreshadows Denis Diderot, thirty years before the *Encyclopédie*.

<div align="right">Louis Aragon. L'Enseigne de Gersaint. Geneva, 1946, p. 38 ff.</div>

My first impression of the *Enseigne* is of an interplay of tone and colour so breath-takingly beautiful in its own mysterious domain that to attempt an analysis would be foolish and indelicate. But as I sit enraptured by these areas of shimmering light and shadow I fancy that I can understand some of the principles on which it is constructed. To my astonishment I find myself

thinking of Piero della Francesca's fresco of the Queen of Sheba. There is the same silvery colour, the same processional dance of warm and cool tones, even some of the same detachment.

The individual colours are nameless, and a colour reproduction which pretendes to itemise them misrepresents the whole. The silk dress of the lady on the left, which is the most positive note in the picture, could, I suppose, be described as lavender. But every other large area is not a colour but a mutation of tone. The lavender dress, which is cool, is completed by the warm russet of the man's waistcoat, which then passes into the cool grey of the background. On the right the process is reversed. . . . It is a design as strict as a fugue.

But of course Watteau has not allowed this formality to become apparent. He has introduced subtle variations, and he has disguised the symmetry of tone by a contrast in subject. . . .

The *Enseigne* employs the schematic perspective of fifteenth-century Florence, which had been revived by the Dutch some sixty years earlier. The setting is a box, with walls converging on a central vanishing-point, and with a chequered foreground to lead in the eye. But this box is also a stage; and in the disposition of the figures, which Gersaint found so natural, Watteau has used the arts of the stage director. What a genial piece of stagecraft, to put the farmer's boy, who brought the straw for the packing-case, in front of the proscenium arch. By thus establishing his actors on a stage he has preserved his detachment, in spite of the fact that they are no longer creatures of illusion, but real and familiar. . . .

This formalised setting has allowed him the symmetrical interplay of tone and colour which was the first thing to strike me in the *Enseigne*. But by a stroke of inspiration the walls of his perspective box do not imprison the eye, for they are covered with shadowy promises of escape, the pictures in Gersaint's gallery.

<div style="text-align: right">

Kenneth Clark. *Looking at Pictures.*
New York, 1960, p. 75 ff.

</div>

NICOLAS LANCRET

Lancret, who was born in Paris in 1690, was first trained as an engraver. In 1708 he was admitted to the Royal Academy of Painting and Sculpture as a student, but was expelled for bad behavior. Subsequently he failed as a history painter in the competition for the Rome Prize. He entered the studio of Gillot and met Watteau, under whose influence he gave up history painting for the painting of *fêtes galantes,* for which was received into the Academy in 1719. After the death of Watteau in 1721 and of Gillot in 1722, Lancret was the most successful painter in this genre. Among his patrons were Pierre Crozat, Count Tessin of Sweden,

and Frederick the Great of Prussia, who acquired twenty-six of his works. Lancret also received commissions from the Court and executed decorations at Versailles and Fontainebleau. With his death in 1743, the genre of *fêtes galantes* disappeared.

Lancret was a laborious artist who, throughout his life, painted subjects in the manner of Watteau. But he fell far short of the qualities of the latter. I find him without talent; his compositions are almost always repetitions of his earlier works. His sense of color is poor, his art insipid and unreal. His paintings demonstrate that he is nothing but a technician.

<div align="right">

P. J. Mariette. *Abécédario* (ca. 1750). 6 vols.
Paris, 1851–60, III, 55.

</div>

Lancret has been called the "Art-child of Watteau." Less striking than his master, he was more painstaking, and his execution was more precise. His pictures lack Watteau's golden glow, and he failed to invest his work with the master's airy gracefulness. Although very many of his paintings have been mistaken for Watteau's, close exam-

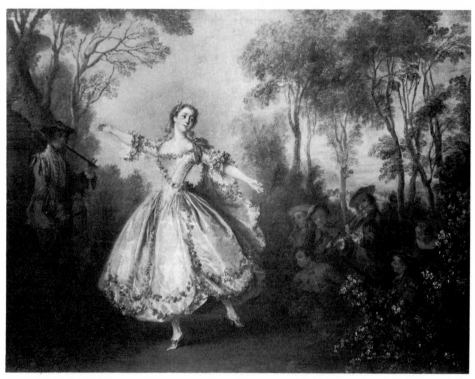

Mademoiselle Camargo Dancing. *Lancret*

ination shows less delicacy of drawing and less brilliant coloring. . . .
If Watteau was the "poet-painter of the eighteenth century," his pupil
was its prose-artist. . . . The games and pastimes of the period fur-
nished him with fruitful inspirations. Whether his subject is blind
man's buff, or skittles; an archer shooting his arrow, or a lady in a
swing; it is full of animation and movement. . . . Quite charming, too,
are his portrayals of the elegant figures of the dance; as in the two
beautiful pictures in the Wallace Collection [London], *Mademoiselle
Camargo Dancing* and *The Revels.*

> Edgcumbe Staley. *Watteau and His School.*
> London, 1902, p. 97 ff.

In the work of Lancret, as in that of Gillot, Watteau, and Pater,
the principal element is the vague and somewhat mysterious *fête
galante.* . . .

For the public the *fête galante* is a combination of rose-colored
powder with such inconsistent and charming evocations as the *Dix-
huitième,* the *Régence,* Camargo, Madame de Pompadour, or Madame
Du Barry, accompanied by maidens and cavaliers.

Some of the art critics see in the *fête galante* the gate opened by
Watteau on the infinity of man's dream, while others consider it the
pictorial expression of a brilliant masquerade, the essence of a cor-
rupt century. At any event, the study of the *fête galante* always brings
to light many historical and psychological factors. . . .

If we examine the works of the masters of the *fêtes galantes* at
close range, we find a rather homogeneous group of pictures. They
represent pleasant meetings of young men and women, usually in a
garden or park. . . . These young people are engaged in talking, play-
ing, flirting, dancing, or making music. . . .

In the pictures of Watteau and Lancret, these people are some-
times attired in contemporary dress, but more frequently they are
disguised in fancy theatrical costumes as shepherds or as actors of the
commedia dell'arte. The theater is the new motif. The innovation
consists in introducing into pastoral scenes theatrical costumes, char-
acters, and situations. . . .

Curiously enough, Lancret's career offers parallels with that of
[the playwright] Marivaux. Lancret was a native Parisian, but Mari-
vaux, Parisian by adoption only, was so fully adapted to Parisian life
that he could not bear to depict anything else; Lancret was rebuffed
as history painter and Marivaux rejected by the Comédie Française
because of the fiasco of his tragedy *Hannibal;* as a result of their fail-
ures, Lancret and Marivaux both discovered their true vocations and
became delineators of the *conversation galante.*

Lancret's role in the genre of *fête galante* was considerable. Having outlived his master as well as his rivals, his influence was more prolonged. . . . Watteau had created a most delicate and refined combination of art and spirit. In his world, reality and dream had been interrelated. . . . Lancret, on the other hand, brought the Muse back to earth. Like Aved and Chardin, he was of the lineage of French realists who needed contact with their native soil. For him the *fête galante* was no mere product of imagination. Under the transparent mask borrowed from contemporary theater his art represented contemporary taste, manners, and characters. . . . The *fête galante* of Watteau went beyond the limits of time and space. For Lancret it was life as it was lived in eighteenth-century France.

Georges Wildenstein. *Lancret.* Paris, 1924, p. 22 ff.

JEAN-BAPTISTE PATER

Pater was born in Valenciennes in 1695. In 1713 and again in 1721 he studied briefly with Watteau; he was Watteau's only pupil. Pater became an associate of the Academy in 1725 and a full member in 1728, painting *fêtes galantes* like his master, but without Watteau's delicacy. He died in 1736.

Like Watteau, Pater came from Valenciennes. His father . . . believed that Watteau, as a compatriot, would aid his son in perfecting his art, and therefore placed him in Watteau's studio. But young Pater found Watteau of too difficult a temperament and too impatient a character to adapt himself to a weak pupil and to encourage him as a student. He had to leave and try to instruct himself alone. However, Watteau, at the end of his life, reproached himself for not having done justice to the natural talent he had recognized in Pater. . . . He asked me [Gersaint, Watteau's patron] to have Pater come to Nogent to make up for the wrong he had committed in neglecting him, so that Pater could still profit from his instruction. Watteau gave the last days of his life to Pater and worked with him. But Pater could profit from this favorable opportunity for only a month. Death took Watteau away too quickly. Pater later confessed to me that everything he knew came from this short period of instruction. He forgot all the angry moments he had endured during his youth and had an unending gratefulness toward Watteau ever since that time. . . .

Pater was born with the sense of color which was so natural to the Flemish painters. He had everything that was necessary to become an excellent artist, but his interest and desire to make money caused

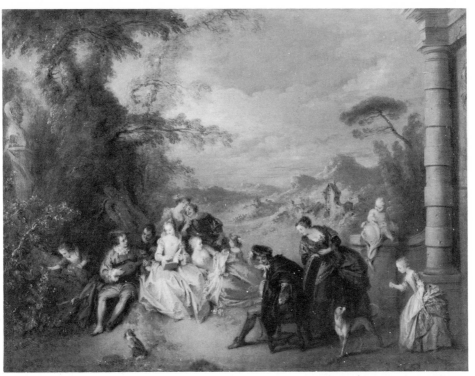

Concert champêtre. *Pater*

him to neglect the most essential part, draftsmanship. . . . Most of his paintings reveal this deficiency. As a result, they are poorly organized and lack the naturalness which is easily recognized in those paintings where the figures were drawn from life.

Pater had a weakness for money. . . . One can even say that . . . he lived frugally in order to die wealthy. In spite of his brief life the ease with which he painted and the quantity of canvases he produced result in the fact that his works are neither rare nor expensive. It is regrettable that this painter abused his gifts, because he had the necessary talent to be a great artist. Lancret and Pater were the only two artists who painted the fashionable and elegant subjects of which Watteau was the inventor and originator. This type of painting ended with their deaths.

<div align="right">E.-F. Gersaint.</div>

<div align="center">"<i>Catalogue de feu M. Quentin de Lorangère</i> (1744)."
In Florence Ingersoll-Smouse. <i>Pater</i>. Paris, 1928, p. 19.</div>

In the history of French eighteenth-century painting the importance of Pater is twofold: He is of interest to us as a painter of *fêtes*

galantes above all because of his close relationship with Watteau, to whom many of his paintings are still attributed, and secondly, because he was an artist in his own right. Although he imitated his master even more than Lancret, he nevertheless preserved his specific artistic personality.

Above all, he was a delightful colorist. His color schemes were derived from Flemish art. His gray and rose harmonies contrasted with the warm colors of Watteau, which, in turn, had stemmed from the Venetian painters and Van Dyck. Pater thus inaugurated the entire tradition of the brightened palette, characteristic of French eighteenth-century painting.

Florence Ingersoll-Smouse. *Ibid.*, p. 1.

JEAN MARC NATTIER

Jean Marc Nattier was the son of the portraitist Marc Nattier and of Marie Courtois, a miniature painter. Born in 1685 in Paris, he studied with his parents. A volume of engravings published in 1710 under the title *La Galerie du palais du Luxembourg, peinte par Rubens, dessinée par le Sieur Nattier et gravée par les plus illustres graveurs du tems,* was made from Nattier's drawings. He subsequently became a portrait painter. He was admitted to the Royal Academy in 1718, and from 1737 on he exhibited regularly at the Salon. Nattier's earlier work represents the type of *portrait historié,* or mythological portrait, depicting his sitters as Greek or Roman deities, but after 1740 he attempted a more straightforward representation. His best-known works are the portraits of the daughters of Louis XV— Adelaide and Henriette de France—and of Marie Leszczynska, all in Versailles. Nattier died in 1766.

There are three kinds of portraits: those which resemble the sitter, but make him uglier; those which depict a perfect likeness neither adding nor subtracting anything from nature, and those which resemble perfectly, but add an almost imperceptible feeling of beauty. ... The palm goes to the third kind which, unfortunately, is extremely rare. But artists who paint in this manner deserve the tremendous fortunes they amass. Such was the famous Nattier, whom I met in Paris in 1750. This great artist was then eighty years old [in reality he was only sixty-five]. In spite of his old age his talent had retained all its freshness. He had portrayed an ugly woman; it had a speaking resemblance, but persons seeing only her portrait found her beautiful. Yet, the most scrupulous examination did not reveal any infidelity: Something imperceptible had bestowed a true and undefinable beauty on the composition. Where did this magic come from? One day, when

he had just painted the ugly *Mesdames de France* [daughters of Louis XV] who on canvas looked like two Aspasias, I asked him that very question. He replied: "This is the magic which the God of Good Taste flashes from my mind to the tip of my brush. It is the Goddess of Beauty, adored by all, defined by none, for no one knows her secret. This demonstrates that the nuance between beauty and ugliness is hairline thin; yet the gap seems wide to those who have no understanding of our art."

<div align="right">

G. G. Casanova. *Memoirs* (written 1791–98).
Quoted in Pierre de Nolhac. *Nattier* (1904).
Paris, 1910, p. 184 ff.

</div>

Some [of Nattier's portraits] are truly admirable and can stand up to comparison with those of his contemporaries, although these could seem rather overpowering. At his best Nattier even rivals the rather surprising English school which owes a great deal to him. This school, in fact, often surpassed Nattier but, nonetheless, they never attained the charm of the more exquisite of his portraits.

Do not expect to find in Nattier the severe style which characterized the work of Hyacinthe Rigaud, nor the naturalness, superior to every other quality, which Chardin expressed with his matchless integrity. Rather will we find a Hebe or an Aurora reclining on the clouds of Olympus, a carefree naiad resting among the reeds. Let us also note the unusual details: a vessel from which eagles drink, a flaming torch held in delicate fingers, a stream of water flowing from a tilted urn. . . .

[The engraver Charles-Nicolas] Cochin, that man of good sense and ironic humor, had already mocked at the caprices of his female contemporaries. . . . Their yearning to be transfigured into goddesses . . . has been perpetuated by Nattier. Thanks to him, a woman's dream, now a century and a half old, lives before our eyes in all its strange fantasy, on a canvas in a slightly faded frame. . . .

His outdated mythologies, however, interest us less than certain more intimate portraits: a young girl in a flower-patterned robe with a simple ribbon in her hair, a lively little bourgeoise from Paris leaning on a well-rounded arm, a worthy queen in a kerchief of black lace, seated on her throne of gilded wood, her favorite book open before her. . . . But since there are too few examples of these straightforward portraits in his work we must, perforce, accept them along with his mythological conventions and his ingenious parodies, where he is without a rival. Also we must take the demands of his age into consideration, forgiving him his shortcomings and tolerating the uni-

formity of his composition which makes all the faces look alike, al-
though less often than has been said. . . .

Nattier's work, therefore, however incomplete it may be, still re-
mains a necessary witness of a society and a way of life now lost.
Reduced to its essentials and freed from the mediocre pieces which
encumber it, his work deserves to be counted among the better paint-
ings of the secondary masters. World art would not suffer from its dis-
appearance, but French art is not rich enough to dispense with it. Our
knowledge of the eighteenth century would be strangely incomplete
without Nattier, for he supplies us with an image of an epoch which
specialized in the cult of certain now forgotten charms. His work is
also the best example of an art form now outdated and not likely to
reappear.

<div style="text-align:right">

Pierre de Nolhac. *Nattier* (1904). Paris, 1910,
p. iii ff.

</div>

One might say that, whereas the seventeenth-century portrait is a
reflection of official life, the eighteenth-century portrait is a reflection
of private life (and the nineteenth-century portrait a reflection of in-
timate life).

Most instructive in this respect are some portraits of Maria Lesz-

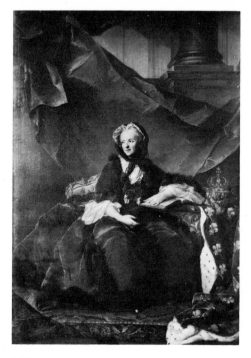

Portrait of Marie Leszczynska.
Nattier

czynska. In 1740, Tocqué represented her in the great Rigaud tradition: draped in an ermine robe adorned with fleurs-de-lis, standing on a marble floor against a background of columns and hangings that tell us that this is the palace of Versailles. Her crown rests on a cushion to which she points in a symbolic gesture. Eight years later, Nattier (Tocqué's father-in-law) painted "the good Queen." This time she is depicted as rather less hemmed in by the official portrait tradition as practiced by a Belle or a Van Loo. The columns are concealed, the drapery less overpowering, and, although the crown is still there, in this portrait the Queen turns her back to it. She is shown seated, one elbow resting casually on an open book. She wears ordinary dress, the lace kerchief over her bonnet loosely knotted at her neck. Nattier's daughter reports that he was not permitted to make more than a simple portrait, the Queen having ordered him to paint her in ordinary dress. In the Versailles museum there is still another version of this portrait, showing the central figure only, with scarcely any décor and no crown at all. In the Salon of 1748, the Queen was also represented in the famous pastel by La Tour as a simple *bourgeoise* of Paris, seated in an armchair, fiddling with her fan, talking, and smiling. In this last portrait, she has escaped all reference to the pomp of her official status. It is as though a mask had been torn off to reveal her as she really was

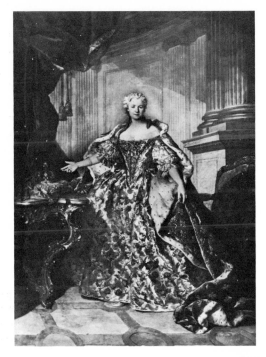

Portrait of Marie Leszczynska.
Tocqué

205

—as her friends must have known her. These few works sum up the whole philosophy of the eighteenth-century portrait.

René Huyghe. *Art and the Spirit of Man.*
New York, 1962, p. 346 ff.

LOUIS TOCQUÉ

Tocqué, a Parisian born in 1696, studied with Nicolas Bertin and his future father-in-law Nattier, with whom he maintained a close relationship throughout his life. He became an associate of the Royal Academy in 1731 and a full member in 1734. During 1757 and 1758 he went to Russia as official court painter to the Empress Elizabeth of Russia. He returned to France by way of Denmark, where he painted portraits of King Frederick V of Denmark and members of the royal family. He made another trip to Denmark in 1769. In 1750 he gave a lecture at the Academy with the title "Reflections on Painting with Particular Respect to Portrait Painting," which was read again in 1763. Tocqué died in 1772.

With the exception of [Maurice Quentin de] La Tour, Tocqué was perhaps the most natural of the eighteenth-century portrait painters. He saw the man beneath the clothes, and he sought to portray an individual, rather than elegance and glamor. He was also a sparkling and charming master, whose color schemes, though a little gaudy at the beginning of his career, later became much softer. None of the painters of his time placed his sitters in simpler or more tasteful settings. . . .

He did not follow the fashion [of the mythological portrait] launched, so to speak, by Nattier. Except for one portrait of the actor Jélyotte as Apollo [1755] he never painted mythological portraits. Even though Tocqué's reputation did not equal that of his father-in-law, it was still solidly established in his time, and his fame transcended the borders of France.

Louis Dumont-Wilden. *Le Portrait en France.*
Brussels, 1909, p. 248.

Portrait of Marie Leszczynska

1740 oil on canvas 110" x 75" Paris, Louvre

The queen rises from her throne and gives audience. The magnificent ermine cloak, fastened at her shoulders, preserves in its fall the spiral sweep of the movement made by the princess as she turns toward the company. The elegant splendor of the decor, the twin columns, and the pilasters supporting

the cornice of the rotunda-shaped room, complete the majesty and dignity of her reception. The glimpse of the satin slipper at the border of her flower-patterned skirt hints at the woman beneath the finery, whose shoulders, emerging from the heavy embroidery of the bodice, carry the smiling head.

This portrait . . . represents one of the most dazzling pages in the history of the French school. As an example of pure painting nothing surpasses the white brocade skirt with its pattern of roses and leaves, the sleeves with their froth of lace, the subdued tone of old gold which radiates from the royal robe. Nothing eludes or obstructs the smooth flow of the brush; the artist could express every nuance without lingering too long over the details, and, without having recourse to the subtleties of Rembrandt or the masterly techniques of Velazquez, he overcame all pictorial problems and is at ease with the realities of life. This is excelled only by the charm of the gentle face; the queen was not pretty but her features were redeemed by her kind expression. When we consider the almost inhuman infantas of Velazquez . . . we will conclude that this Frenchman, although lacking genius, had nevertheless a well directed and natural talent even in his portrayal of solemnity.

> Louis Gillet in *La Peinture au Musée du Louvre*, vol. I: *École française.* Paris, 1929, fascicle 3, p. 12.

FRANÇOIS LE MOYNE

François Le Moyne (also spelled Lemoyne, Le Moine, or Lemoine) was born in Paris in 1688. He won the Rome Prize in 1711 and became an academician in 1718. He did not visit Italy until 1723; while there he was most profoundly influenced by Veronese and Parmigianino. He returned to France a year later and became one of the chief exponents of the Venetian style of painting, which he transmitted to his pupil, Boucher. His ceiling paintings, emulating the Roman baroque, culminated in the ceiling of the Salon d'Hercule at Versailles (1732–36), for which he received the title *premier peintre du roi*. Overambition and excessive work led to his suicide at the age of forty-nine in 1737.

The rivalry which arose between him [François Le Moyne] and Jean-François de Troy is a striking feature of the early years of the eighteenth century, and it is worth attention, if only on account of its influence on the development of the French school of painting at a critical moment. Le Moyne, eight years younger than de Troy, had passed through the schools of the Academy with Lancret, and his sympathies were to a certain extent with the tendencies then developing amongst his own pupils. . . .

Prudent in conduct and of unsleeping ambition, Le Moyne was hard pressed by Jean-François de Troy [1680–1752], a man of greater

natural gifts than himself, who was supported by Coypel and of whom
no less a man than Rigaud had said, that if his capacity for work had
equalled his genius the art of painting had never known a greater
illustration. . . .

The Royal Concours of 1727, whether suggested by the friends
of Le Moyne, or by the partisans of de Troy, had the result of placing
them in direct antagonism. It was . . . expected that Le Moyne would
triumph . . . and . . . it, no doubt, would have been so, had not de Troy
exerted his talent for intrigue; [and in spite of the mediocrity of de
Troy's picture the prize was divided between the two].

In the Museum of Nancy, not far from Le Moyne's *Continence de
Scipion,* there now hangs the rival *Repos de Diane* by Jean-François
de Troy, and as we now look at these two works it seems difficult to
realize all the bitterness of the war that raged about their respective
merits. The de Troy shows great prettiness of color, but the drawing
is slovenly, and, on the whole, it is an uninteresting performance;
whereas the work of Le Moyne—who was said to have none of the
celerity of his rival—strikes one as light but amusing, in virtue of a
certain attractive freedom of touch, coupled with the dawn of that
rayon rose with which he endowed his followers.

<div style="text-align:right">

E. F. Dilke. *French Painters of the XVIIIth
Century.* London, 1899, p. 28 ff.

</div>

François Le Moyne occupies a capital position in French paint-
ing. Although his art was not without faults, no other artist was as
typical of his time, and few have exercised an influence comparable to
his.

In contrast to the reddish tonalities of the seventeenth-century
paintings, he painted in clear harmonies and softened the shadows.
He substituted delicately broken tones for the crude blues and bright
reds used by his predecessors. His models are elegant and youthful,
his palette brings out the sensation of life beneath the pearly skin.
Compared with the earlier masters his paintings are less tightly knit,
more decorative and better suited to compositions on a large scale.
He was the first French painter able to cover large surfaces without in-
dicating architectural subdivisions, and was thus the creator of the
art forms which were taken over almost without change by the eigh-
teenth-century painters, of whom Boucher and Natoire, the most
representative artists, were his actual pupils.

<div style="text-align:right">

Charles Saunier. "Lemoine." In Louis Dimier, ed.
Les Peintres français du XVIIIᵉ siècle. 2 vols.
Paris, 1928–30, I, 61.

</div>

Hercules and Omphale

1724 oil on canvas 72¼" x 59" Paris, Louvre

Le Moyne, the formidable fabricator of ceiling paintings, who stirred up many an Olympus, who turned out countless clouds and apotheoses, and who set the goddesses of Parmigianino flying to the skies of Versailles, was a great painter and one of those masters who would almost certainly have enjoyed a solid reputation and a lasting fame, had he been born into a less frivolous epoch. We need only recall his *Hercules and Omphale* to justify this statement.

Against a strong, deep blue eastern sky, under a brocade canopy entwined among the branches of trees, the couple rises before our eyes, bathed in light, caressed by shadows. . . . The figure of Omphale is a marvel: the divine luminosity of the skin, its moisture, silky radiance, and fruitlike whiteness, the soft, delicate and tender *glory* of a nude female body modelled by light, is admirably rendered in this suave life-study. The body delightfully blends youthfulness with the bloom of maturity in the drawing of these forms, which are slender as well as rounded, in the budlike bosom and those already

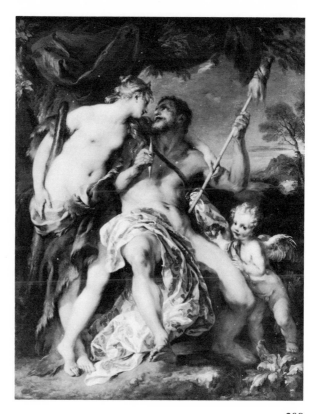

Hercules and Omphale.
Le Moyne

mighty hips. By means of a contrast beloved also by Poussin, the glowing reddish body of the hero-god emphasizes even more strongly Omphale's whiteness, which is slightly tinged with a mother-of-pearl blue in the shadows and delicately heightened with pink at the breasts, elbows, and knees.

The artist who painted this work was predestined to become the teacher of Boucher.

<div style="text-align: right">

Edmond and Jules de Goncourt. "Boucher (1862)."
L'Art du XVIII^e siècle. 3 vols. Paris, 1909–10, I, 197 ff.

</div>

JEAN BAPTISTE SIMÉON CHARDIN

Chardin, born in 1699 as the son of a carpenter, was a Parisian who never left his native city. He studied painting with P. J. Cazes and Noël-Nicolas Coypel, and as an aide to Jean-Baptiste Van Loo he worked on the restoration of Rosso's and Primaticcio's frescoes at Fontainebleau. In 1728 he exhibited his *Skate* (Louvre) at the so-called *Exposition de la Jeunesse,* an annual outdoor show on the Place Dauphine in Paris. Largillière noticed the picture and invited Chardin into the Academy. Chardin was admitted as an associate and a full member in a single day. In 1743 he became a councillor and in 1755 was unanimously elected treasurer. In this capacity he was in charge of hanging the pictures for the biennial Salons, a duty which he performed in exemplary fashion until he resigned, because of old age, in 1774. It was in the course of this activity that Diderot came to know and admire him.

At the beginning of his career Chardin painted only still lifes, but from about 1733 to 1751 he turned to genre painting, taking up still-life painting again after 1751. Between 1771 and 1775 he painted a few portraits in pastel, among which are two self-portraits and one of his second wife, which are masterpieces in this medium. The great demand for his pictures caused him to make frequent replicas. Although he had a studio, he created no school. He was a regular exhibitor at the Salon from its reopening in 1737 until his death in 1779.

<div style="text-align: center">

Painting is an island of which I have skirted the shores.

</div>

<div style="text-align: right">

J. B. S. Chardin (undated).
Quoted in Edmond and Jules de Goncourt. "Chardin (1864)."
L'Art du XVIII^e siècle. 3 vols. Paris, 1909–10, I, 149.

</div>

M. Chardin was active as a still-life painter when an incident caused him to take a step forward in the art of painting. M. Aved, the portraitist, was his friend, as he still is, and they saw each other often. One day a lady came to M. Aved to have her portrait painted. She wanted a three-quarter length portrait but was not willing to pay more than 400 livres. She left without having concluded the deal,

because this offer seemed too modest to M. Aved, although at that
time [about 1737] he was not as busy as he is now. M. Chardin, on
the other hand, insisted that he should not pass up this occasion and
wanted to prove that 400 livres was a good sum for an artist not too
well known. "Yes," said M. Aved, "if a portrait is as easily painted as
a sausage." He was referring to a picture for a fire screen* M. Chardin
was painting at the time, which had a plate with a sausage in it. This
remark impressed M. Chardin greatly. Taking it as a serious state-
ment rather than a joke, he took stock of himself, and the more he
thought about it the more he became convinced that as a still-life
painter he would never advance very much. He was afraid, and per-
haps rightly so, that if he remained a painter of inanimate objects of
little interest the public would soon tire of his works, and if he were
to try his hand at live animals he might not reach the stature of M.
Desportes and M. Oudry, who were already in the forefront with an
established reputation. From this moment on M. Chardin decided to
give up still-life painting.† He had to choose another specialty, and
chance presented him with the opportunity to paint a young man
blowing soap bubbles. . . .‡

M. Chardin's talent is only a renewal of that of the brothers Le
Nain. Like them he chooses the simplest and most naïve subjects. . . .
He represents attitudes and characters very well and does not lack ex-
pression. This, I believe, is the main reason for the current popularity
of his pictures, which merit their place next to Teniers and the other
Flemish genre painters, though there is quite a difference in quality
between their works and his. It must be admitted that M. Chardin's
paintings make the viewer too conscious of hard work and toil. His
touch is heavy and not at all varied. His brush stroke has no fluidity.
He expresses everything in the same style and with a kind of inde-
cision that makes his work too cold. Generally, his color is not accurate
enough, though on the whole it is harmonious. Since M. Chardin is
not well enough grounded in draftsmanship and lacks the ability to
make sketches and preparatory studies on paper, he has to have
the object he is painting continually before his eyes, from the first
sketch to the final brush stroke.§ This takes a long time and would
dishearten anyone else. Likewise, he always says that his work gives

* Probably *The White Tablecloth,* now in the Art Institute of Chicago.
† Chardin resumed still-life painting after 1751.
‡ Versions of this painting exist in the Metropolitan Museum of Art, New York, the
National Gallery, Washington, D.C., and the William Rockhill Nelson Art Gallery,
Kansas City.
§ This remark may explain the rarity of Chardin's drawings.

him no end of trouble—yet even if he did not mention it his work would show it anyway.

<div align="right">

P. J. Mariette. *Abécédario* (1749). 6 vols.
Paris, 1851–60, I, 355 ff.

</div>

I should have spoken of M. Chardin in connection with the original, the composer-painters. He has an admirable talent for representing, with a singularly naïve truthfulness that is all his own, certain moments in life that are really without interest and in themselves undeserving of our attention, and which often are neither worthy of the artist's choice nor of any intrinsic beauty. These have nevertheless spread his reputation here and abroad. Since the artist only paints for his own amusement and consequently very little, a public greedy for his paintings has eagerly sought to compensate with engravings after his works. The two life-size portraits in the Salon are the first that I have seen of this style. Although they are very good, and promise even better things to come, were the artist to make portrait painting his sole concern, the public would despair at seeing him abandon or even neglect an original talent and inventive brush in favor of indulging in a genre that has become too commonplace, and which is not even prompted by need. This year he has entered two small paintings in the Salon, one of which is an old work with some new changes—the well-known *Blessing*, spoken by the child. The new work* represents a pleasant-looking, idling figure of a lady in a modish negligé, whose rather piquant face is enveloped in a white headdress knotted under the chin and concealing the sides of her face. One of her arms rests on her knees and carelessly holds a booklet. Next to her and slightly toward the back is a spinning wheel, placed on a small table. The exactitude of the likeness is to be admired in the subtlety of his brush strokes, both in the figure and in the ingenious rendering of the spinning wheel and the other furnishings of the room.

<div align="right">

La Font de Saint-Yenne. *Réflexions sur quelques causes*
de l'état présent de la peinture en France.
n.p., 1747, p. 109 ff.

</div>

This man is really a painter,† and what a superb colorist!
At the Salon there are several small paintings by Chardin, almost all of them showing fruits together with tableware. It is nature itself

* *The Recreations of Private Life,* now in the Stockholm National Museum.
† In his *Salon of 1761* Diderot had called Chardin one of the "slipshod painters," who had once done a great many things entitling him to a place among artists of the first rank.

that we face here; the objects are of such eye-deceiving reality that they seem to exist outside the canvas.

The painting at the foot of the stairs merits the most attention. On a little table the artist has placed an antique Chinese porcelain vase, two biscuits, a jar filled with olives, a basket of fruit, two glasses half filled with wine, an orange, and a pastry.

In order to look at the paintings of others I have to put on, as it were, a special pair of eyes; but to look at the work of Chardin I need only keep the eyes Nature has given me and use them well. . . .

How this man has grasped the harmony of color and reflection! Oh Chardin, it is not white and red and black you are sprinkling on your palette; it is the very substance of things, air and light itself, that you pick up with the tip of your brush and set down on the canvas. . . .

The subject of *The Skate* [1728; Louvre] is highly unpleasant; we are confronted with the very flesh of the fish, with its skin and its blood. To see the thing itself would affect you in exactly the same way. M. Pierre,* take a good look at this painting when you go to the Academy, and learn, if you can, the secret of saving certain subjects from being revolting, through sheer talent.

It is impossible to fathom this magic. It consists of thick layers of color laid one on top of the other; they seem to shine through one another to create a unique effect. At other times we might say that a mist has been wafted onto the canvas, and then again that a light froth has been sprayed on it. Come closer, and it all breaks up, flattens, disappears; step back and everything falls back into place and creates itself anew.

I have been told that Greuze, coming up to the Salon and catching sight of the painting I have just described, stopped to look at it and then heaved a deep sigh. His tribute is shorter and better than mine.

Who will be able to pay the price for Chardin's paintings when this rare man is no longer alive? You must also know that this artist has common sense and speaks marvelously about art.

Denis Diderot. "Salon de 1763." *Œuvres complètes.*
vol. X, Paris, 1876, p. 194 ff.

There were few paintings which could assert themselves next to those of Chardin, and it was said of him that he was a dangerous neighbor [at the Salon]. His paintings, moreover, had a very rare quality: truth and naïveté of attitude and of composition. Nothing seemed to have been brought in expressly for the sake of the arrange-

* Jean-Baptiste Pierre (1713–89), then first painter to the Duke of Orléans.

ment of effect; yet these very conditions were fully realized with an artistry rendered even more admirable because it was concealed. Aside from the accuracy of his observation and his power as a colorist, his natural simplicity charmed everyone. . . .

Chardin was of short stature, but robust and muscular. He was intelligent and, above all, had a great deal of common sense and excellent judgment. He had a singular ability to convey his ideas and to make them understood, even when discussing aspects of art which cannot easily be explained, such as the magic of color and the various reasons for his light effects.

One day an artist was showing off his methods of perfecting his colors. M. Chardin, impatient of his chatter, said to him, "But who told you that we paint with colors?"—"With what, then?" replied the other, greatly astonished.—"We use colors," said Chardin, "but we paint with our feelings."

> C. N. Cochin. "Essai sur la vie de Chardin (1780)."
> In H. J. N. C. de Rothschild. *Documents sur la vie
> et l'œuvre de Chardin.* Paris, 1931, p. 9 ff.

In general, Chardin worked extremely hard on his paintings; he aimed at a faithful representation of nature. For this reason he painted his pictures over and over again, until he had achieved the broken tones produced by the distance of the object and the reflections of all surrounding objects. His technique of painting appeared rugged to some, but the resulting harmony seemed to have an almost magical effect, so great was the illusion he produced.

Through long practice, profound thinking, and continuous effort he had acquired such perfect theoretical knowledge that, when examining certain paintings lacking unity, he was often able to indicate with one word and without an actual brush stroke what was needed to accomplish the harmony which the artist had failed to realize.

It was his axiom that shadows were all of one kind and that the same tone should serve to break up all others—a fine and great truth which is little known to any but the great colorists. . . .

In Chardin's lifetime his pictures enjoyed great fame; they will continue to do so in the future. . . . Let us not forget that his great reputation spurred on some painters, even history painters, to emulate him. They wanted to try for themselves the genre he had chosen; a minor genre, they said. But it is minor only when treated in a small way.

> J. B. G. Haillet de Couronne. "Éloge de M. Chardin, sur les
> mémoires fournit par M. Cochin (1780)." *Mémoires inédits
> sur la vie et les ouvrages des membres de l'Académie . . .*
> 2 vols. Paris, 1854, II, 436 ff.

Still-life painting was, indeed, the speciality of Chardin's genius. He elevated this secondary genre to the highest level of art. Never, perhaps, has the material fascination of painting been developed so far as by Chardin, who transfigured objects of no intrinsic interest by the sheer magic of their representation. . . . Who has expressed as he did the life of inanimate things? Like a ray of sunshine Chardin seems to enter the beautiful but somber little kitchen of Willem Kalf. Beside Chardin's magic everything else pales: Van Huysum with his herbals and dried flowers, de Heem with his airless fruit, Abraham Mignon with his poor, meager, cut out, and metallic bouquets. . . .

Chardin paints all that he sees. No theme is too humble for his brush. . . .

What, in effect is Chardin's role [as a genre painter]? He is the middle-class painter painting the middle class. It is in the lower middle class that he finds his subjects and his inspiration. His art is confined to that humble world from which he comes and in which lie his habits, thoughts, affections, and the very essence of his personality. He does not search beyond, nor does his vision rise to higher aims. He confines himself to the representation of scenes which are close to him and which touch him. . . .

Look at that small picture, *The Morning Toilet* [Stockholm, National Museum] where the mother, who appears in so many of Chardin's paintings, puts the finishing touches to her little daughter's dress. . . . It is the epitome of Sunday, of a bourgeois Sunday.

We can recall other scenes which have the same glowing gentleness, the same naïve coquettishness, and the same natural setting and penetrating effect of truth. We are attracted, captivated, and charmed by that indefinable sense of purity, peculiar to Chardin and unique in this period of libertine, frivolous painting. . . . We might say that his art has escaped the corruption of the eighteenth century and has preserved something of the sanity and sincerity of bourgeois virtues. . . .

The secret and strength of Chardin, his grace, his rare and intimate poetry, rests in the stillness of things, their unity, harmony, and serene light.

<div style="text-align:right">

Edmond and Jules de Goncourt. "Chardin (1864)."
L'Art du XVIII^e siècle. I, 103 ff.

</div>

The prose of life became poetry in Chardin's hands.

<div style="text-align:right">

Frederick Wedmore.
"Jean-Baptiste-Siméon Chardin (1906)." In J. J. Foster.
French Art from Watteau to Prud'hon.
3 vols. London, 1905–07, II, 80.

</div>

He is a master of discreet tonalities and a draughtsman of the first order. His lighting, more diffused than Rembrandt's, is the chief actor in his scene. With it he accomplishes magical effects, with it he makes beautiful copper caldrons, humble vegetables, leeks, carrots, potatoes, onions, shining rounds of beef, hares, and fish become eloquent witnesses to the fact that there is nothing dead or ugly in nature if the vision that interprets is artistic. It is said that no one ever saw Chardin at work in his atelier, but his method, his *facture*, has been ferreted out though never excelled. He employs the division of tones, his *couches* are fat and his colour is laid on lusciously. His colour is never hot; coolness of tone is his chief allurement. . . . Decamps* later exclaimed in the Louvre: "The whites of Chardin! I don't know how to recapture them." He might have added the silvery grays.

James Huneker. *Promenades of an Impressionist.* New York, 1910, p. 157.

It is significant that Chardin . . . was not, in any way, an intellectual painter. His problems were those of technique. . . . The discoveries which he made and the new fields of vision which he opened up were the results, not of a desire to renew painting, or to make a revolution in current forms of expression, but of a resolution to do ultimate justice to every object, every surface, every shadow.

The quality of Chardin's technique was of constant interest and even surprise to his contemporaries. Critics . . . commented significantly on the fact that few people had ever actually seen him painting. Of even greater interest to us is the fact that they commented on the hardness and violence of his color, a quality which, in all save a few of his paintings, is entirely lost to us through generations of dirt and varnish. Chardin was not the gentle, mild colorist whose canvases glow in an even, gold tonality that time and ill-usage has made him. He was an innovator who used complexity to create unity of color.

Chardin prepared his canvases with size and then laid on a thin coat of oil paint, usually of white and brown mixed. He started the painting with the darker parts, went on to the chiaroscuro and the lighter tones, and then returned to the lights and shadows. The bad condition of many of his works is due very largely to the vast amount of overpainting which he did in his attempts to achieve the utmost perfection and accuracy of light and form. His powers of observation led him almost to complete disbelief in the existence of a pure color unrelieved by reflection or proximity to another. The only thing which kept him from a full realization of the Impressionists' discoveries was

* Alexandre-Gabriel Decamps (1803–60) was a French painter.

that the light which infused his works was not the emphatic light of the outdoor world, but the mild, diffused lighting of the studio.

Bernard Denvir. *Chardin.* New York, 1950, p. 15 ff.

Of all French artists previous to the nineteenth century, Chardin, alongside Poussin and Claude Lorrain, is one who has had the greatest influence on modern painting. Certain researches of Manet and Cézanne are inconceivable without Chardin. It would be hard to imagine anything more "advanced" in the way of layout and pictorial handling than the Edinburgh *Vase of Flowers.* It stands out above anything of the kind painted by Delacroix, Millet, Courbet, Degas and the Impressionists. Only in Cézanne and in post-Cézannian painting can we hope to find so much power in so much simplicity. And before Chardin, Vermeer alone (though apparently he never painted a still life) would have been capable of eliciting a comparable serenity from a few harmonies of white and blue in a milky light.

By virtue of these incidents, Chardin occupies one of the foremost positions in art history. Caravaggio is the first example of a great master who painted independent still life pictures. But Chardin did more: he won recognition as a great master by specializing in what was then considered an inferior branch of art. . . . As for the spiritual significance of his work, not only did it become obvious to all after the Goncourts enthusiastically paid homage to Chardin, but it suddenly revealed all the still life painting of previous centuries in a new light: such artists as Heda and Kalf were now also recognized as masters. With Chardin at last understood, it was realized that they too had enriched the human sensibility with a new fund of experience for which there was no exact equivalent in the other branches of painting.

Charles Sterling. *Still Life Painting from Antiquity to the Present.* New York, 1959, p. 88 ff.

Saying Grace
[The Blessing]
La Bénédicité

1740 oil on canvas 19¼ " x 15⅜" Paris, Louvre

The *Bénédicité* . . . is a tiny comedy of domestic life, almost too slight, too elusive, too trivial for literature with its descriptive analysis. And here we read at once all its subtle implications. The mother, as she helps the children, looks up suddenly to see whether the younger child is saying her grace in the proper spirit of reverence. The girl has just the puzzled, anxious, deprecating gesture of a child who half fears she has got into trouble—the older girl looks

217

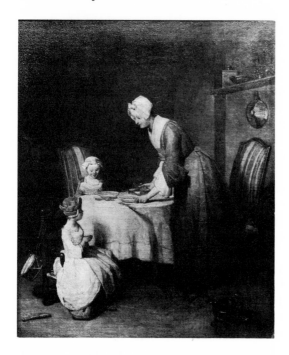

Saying Grace. *Chardin*

down at her with the exact air of self-righteous superiority from which all younger children suffer. The very slightness of the theme makes the miracle of its exact notation all the greater and perhaps Rembrandt is the only artist who could have expressed it with greater intensity but even he, perhaps, would have overshot the mark of playful and tender malice which is so characteristic of French feeling. . . .

Or take again the scene from the series of *Amusements de la vie privée* [*The Recreations of Private Life*] of a lady who sits in her armchair with a book in her lap; what a profound feeling for the slightest overtones of everyday life Chardin's quick sympathetic vision reveals! How happy the discovery of exactly this spacing and composition! Again, it is his sense of the elusive and trivial comedies of bourgeois life that achieves so much out of so little. . . .

Such a picture as this inevitably invites comparison with Terborgh, who is another great master of life's little comedies in a precisely similar bourgeois circle, and who chose frequently a similar relation of figures to space. Nothing could be more acute or more subtle than Terborgh's expression of the psychological situation with all its implied overtones of feeling, but he is more prosaic and literal, his comedy is not coloured with quite the same playful tenderness and intimacy that Chardin gives, nor has Terborgh quite so much feeling for the atmospheric quality which veils and broadens Chardin's effects.

Roger Fry. "Characteristics of French Art (1932)." *French, Flemish, and British Art.* London, 1951, p. 44 ff.

The Brioche

1763 oil on canvas 18½″ x 22″ Paris, Louvre

When the thing represented is, in point of character, absolutely in agreement and one with the manner of representing it, isn't it just that which gives a work of art its quality?

That is why, as far as painting goes, a household loaf is especially good when it is painted by Chardin.

> Vincent van Gogh. Letter to his brother, Theo, June 9, 1889.
> *The Complete Letters of Vincent van Gogh.* 3 vols.
> Greenwich, Conn., 1958, III, 179.

They trudged past acres of canvas, through one room after another, for Lydia had some difficulty in finding her way; but finally she stopped him in front of a small picture that you might easily have missed if you had not been looking for it.

"Chardin," he said. "Yes, I've seen that before."

"But have you ever looked at it?"

"Oh, yes. Chardin wasn't half a bad painter in his way. My mother thinks a lot of him. I've always rather liked his still lifes myself."

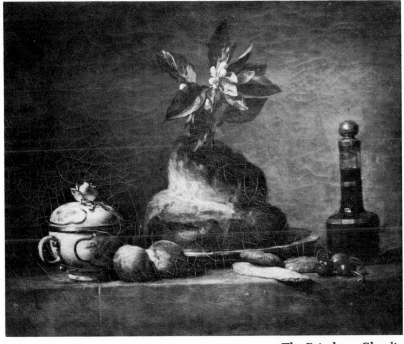

The Brioche. *Chardin*

219

"Is that all it means to you? It breaks my heart."

"That?" cried Charley with astonishment. "A loaf of bread and a flagon of wine? Of course it's very well painted."

"Yes, you're right; it's very well painted; it's painted with pity and love. It's not only a loaf of bread and a flagon of wine; it's the bread of life and the blood of Christ, but not held back from those who starve and thirst for them and doled out by priests on stated occasions; it's the daily fare of suffering men and women. It's so humble, so natural, so friendly; it's the bread and wine of the poor. . . . It's the cry of the despised and rejected. . . . It's the mystery of man's lot on earth, his craving for a little friendship and a little love, the humility of his resignation when he sees that even they must be denied him."

Lydia's voice was tremulous and now the tears flowed from her eyes. She brushed them away impatiently.

"And isn't it wonderful that with those simple objects, with his painter's exquisite sensibility, moved by the charity in his heart, that funny, dear old man should have made something so beautiful that it breaks you? It was as though, unconsciously perhaps, hardly knowing what he was doing, he wanted to show you that if you only have enough love, if you only have enough sympathy, out of pain and distress and unkindness, out of all the evil of the world, you can create beauty."

She was silent and for long stood looking at the little picture. Charley looked at it too, but with perplexity. It was a very good picture, . . . in some odd way it was rather moving; but of course he could never have seen in it all she saw. Strange, unstable woman! It was rather embarrassing that she should cry in a public gallery.

W. Somerset Maugham. *Christmas Holiday.*
New York, 1939, p. 240 ff.

Self-Portrait with Eyeshade

1775 pastel 18" x 15" Paris, Louvre

In the other pastel that Chardin has left of himself, his costume attains the comical eccentricity of an old English tourist. From the eyeshade, firmly set on his brow, to the Masulipatam foulard knotted around his neck, the whole thing makes you want to smile without feeling any need of disguising it from this old character who would be so intelligent, so gently docile about taking a joke—above all, so much the artist. For every detail of this extraordinary, careless undress, all ready for the night, seems quite as much an index of taste as a challenge to convention. If this rose Masulipatam is so old, it is because old rose is softer. When you look at these rose and yellow knots that seem to be reflected

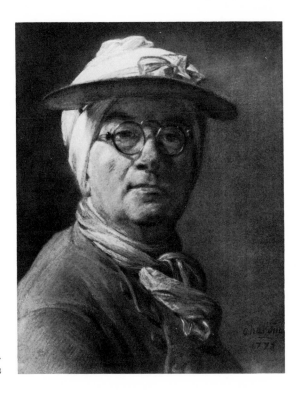

Self-Portrait with Eyeshade.
Chardin

in the jaundiced and reddened skin, when you recognize in the blue border of the eyeshade the somber luster of the steel spectacles, the astonishment that the surprising attire of the old man at first arouses melts into a soft charm; into the aristocratic pleasure, too, of rediscovering in the apparently disorderly undress of an old bourgeois the noble hierarchy of precious colors, the order of the laws of beauty.

But in looking more deeply at Chardin's face in this pastel, you will hesitate, you will be confused by the uncertainty of the expression, daring neither to smile, to justify yourself nor to weep. . . . Is Chardin looking at us here with the braggadocio of an old man who does not take himself seriously? . . . Or has our youth, perhaps, wounded his sense of helplessness, is he revolting in a passionate, useless challenge that is painful for us to see? One might almost believe this, for the intensity of the eyes, the quivering of the lips have a sombre expression. . . .

We have learned from Chardin that a pear is as living as a woman, that an ordinary piece of pottery is as beautiful as a precious stone. The painter has proclaimed the divine equality of all things before the spirit that contemplates them, the light that embellishes them. He has brought us out of a false ideal to penetrate deeply into reality, to find therein everywhere a beauty no

221

longer the feeble prisoner of convention or false taste, but free, strong, universal, opening the world to us.

Marcel Proust. "Chardin: the Essence of Things (ca. 1894–1904)."
Art News, October 1954, p. 38 ff.

A full generation before Jean-Jacques Rousseau, in the midst of a period aiming only at decorative surface values, at elegance and graceful forms, there towers the lone figure of the greatest naturalist and apostle of truth known in the history of European painting before Barbizon and Batignolles. . . .

The self-portrait of the seventy-six-year-old artist and the portrait of his second wife . . . may be considered the crowning glory of French portrait painting. The admiration for the technical feat of this pastel, which surpasses all audacities of Chardin's manner of painting, . . . is overshadowed by the psychological accomplishment. Chardin is the ancestor of Impressionism not only as a colorist. . . . He also removes himself spiritually from his surroundings, thereby transcending all limits of his time and nation. What can La Tour's portraits convey, with all their often admired veracity, compared to the monumentality of those of Chardin? The greatest artistic genius of his day, the respected member of the Academy, presents himself in the deepest *négligé* of his domestic and professional existence, in dressing gown, nightcap, spectacles, eyeshade and scarf, a Jean-Jacques who—quietly—declares war on his century.

Edmund Hildebrandt. *Malerei und Plastik des achzehnten Jahrhunderts in Frankreich.* Wildpark-Potsdam, 1924, p. 161.

JACQUES AVED

The portrait painter Jacques-André-Joseph-Camellot Aved, who was born at Douai in 1702, spent his early youth in Amsterdam and reached Paris at the age of nineteen. In the studio of the portraitist Belle he met Chardin, with whom he developed a lifelong friendship. Chardin's portrait of Aved is now in the Louvre. Aved became an academician in 1734, councillor in 1744, and pensioner in 1762. His portrait of Madame Crozat (1741; Musée Fabre, Montpellier) was long attributed to Chardin. Aved died in Paris in 1766.

In contrast [to Rigaud, Largillière, and François de Troy] Aved rejected effects and accessories [in his portraits] and aimed above all for truth and physical as well as psychological realism. . . . All histories of art state correctly the contribution of Chardin, who resumed the French tradition of straightforward and conscientious representation. But what Chardin accomplished, Aved did, too. A share in the importance that is given to Chardin's role in the development of French art should also be attributed to Aved.

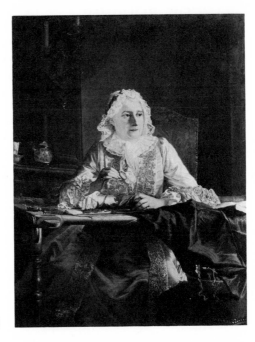

Portrait of Madame Crozat. *Aved*

We certainly do not want to hand out prizes or establish ranks and grades for artists, but we must not underestimate Aved's role. He was able to free himself from the convention of the state portrait which had prevailed for a century; in so doing he brought about the "psychological" portrait. La Tour, who owed nothing to him, but who, chronologically, comes a little after him, pursued the same course. Although Aved's direct influence was probably negligible, since his pupils, Mlle. Bouchot, Mlle. Allet, and Antoine Lebel, hardly left an imprint, Aved indirectly, by the reaction he helped set in motion, did much to advance French art.

If his art was a reaction, he was not conscious of it. Nothing in his life would indicate that he had developed a specific system or a theory. He was just a painter. Philippe de Champaigne, in his own day, had also reacted against certain prevailing tendencies . . . but it seems that the latter's reaction was the result of a deliberate attitude. Not so with Aved, who combined the major artistic characteristics of two schools—French style and Dutch freedom. Although he lacked the spark of genius his art had, nevertheless, forcefulness and charm; it represents the innate penchant for truth, order of composition, and moderation, that is in keeping with his own personality.

Georges Wildenstein. *Le Peintre Aved.* 2 vols.
Paris, 1920, I, 124 ff.

FRANÇOIS BOUCHER

Boucher, whose father was a designer of lace patterns, was born in Paris in 1703. He studied briefly with Le Moyne, whose style he adopted. Later he worked under the engraver J.-F. Cars. Jean de Julienne, Watteau's former patron, commissioned Boucher to engrave Watteau's paintings and drawings, of which Boucher executed 125 under the title *Figures de différents caractères*. He won the Rome Prize in 1723 and went to Italy for the customary four years, but, except for the art of the young Tiepolo, he found little to admire there. Admitted to the Academy in 1734, he designed cartoons for the tapestry works at Beauvais, then under Oudry's direction. He illustrated an edition of Molière and painted stage decorations. When the vogue for Chinoiserie began in the 1740's he adopted Chinese motifs in his decorative designs. In 1746 began Boucher's association with the reigning favorite of the day, Madame de Pompadour, whose protégé and personal friend he remained until her death. In 1756 he took over the Gobelins tapestry works. Louis XV appointed him *premier peintre du roi* in 1765 after the death of Van Loo, and in the same year he was named director of the Academy and given residence in the Louvre. Boucher was by this time the most successful artist of his century. He died in Paris in 1770.

What colors! What variety! What a wealth of objects and ideas! This man has everything but truth. There is not a single element in his works that, considered by itself, does not please the eye; even the composition as a whole is utterly captivating. But where have shepherds ever dressed with such elegance and extravagance? And how, by any stretch of the imagination, could one ever expect to find in the open countryside, under the arches of a bridge and far from any dwelling place, such an unlikely assembly of men, women, children, cows, bulls, sheep, dogs, haystacks, water, fire, a lantern, cooking pots, jugs, and cauldrons? . . . What a proliferation of incongruous objects! The absurdity of it all is glaringly apparent, and yet it is hard to tear oneself away from this painting. There is a magnetism in it; one keeps returning to it; for it is such a pleasurable vice, such an inimitable and rare extravagance! There is so much imagination here, such magic and such ease!

After looking for a long time at a landscape such as we have just described we have the feeling that we have seen it all. But this is a mistake, for in it we may find an infinite number of things of value! . . . No one has mastered the art of light and shade like Boucher. The fashionable crowd as well as the artists are deceived by his virtuosity. Boucher's elegance, his daintiness, his coquettishness and romantic flirtatiousness, his stylishness, his facility, his diversity, his brilliance, his roseate flesh tones, and his lewdness must of necessity captivate the dandies and their ladies, the young, the rich, and the fashionable.

. . . How could they resist the wit, the froth, the glimpses of nudity, the wantonness, and the satire of Boucher? The artists, who perceive to what extent this man has surmounted the difficulties of the craft of painting and to whom the fact that this merit can only be appreciated by fellow artists like themselves is all-important, pay homage to him as though he were their god. Only persons of excellent taste, who appreciate simplicity and the antique, do not pay attention to him.

> Denis Diderot. "Salon de 1761." *Œuvres complètes*, vol. X, Paris, 1876, p. 112 ff.

In the background, imagine an urn on a pedestal crowned by a sheaf of inverted twigs, and beneath it a shepherd asleep, his head on the knees of his shepherdess. Scatter around them a shepherd's staff, a little hat filled with roses, a dog, some sheep, a bit of landscape, and God knows how many other things heaped up one on top of the other. Endow all this with colors of the utmost brilliance, and you have Boucher's *Pastoral*.

What a misuse of talent! What a waste of time! With half the effort he might have achieved twice the effect. Among so many details, all equally well executed, the eye does not know where to rest. There is no air here, no peace. . . . When writing, must you say everything? When painting, must you paint all? For goodness sake, leave something to the imagination. . . . But tell this to a man corrupted by praise and infatuated with his own talent, and he will scornfully shake his head. . . .

When he had just returned from Italy, this man used to paint beautiful things. His colors were strong and true, his compositions were well-ordered though charged with life, his execution was broad and lofty. I know some of his earliest pieces that he now calls *daubs* and that he would gladly buy back in order to burn.

> Denis Diderot. "Salon de 1763." *Ibid.*, p. 172 ff.

I don't know what to say about this man. The corruption of his morals parallels step by step the degradation of his taste, color, and composition, as well as of the expression and drawing of his figures. What would you think that this artist puts on canvas? Whatever fills his mind! And what can be in the mind of a man who spends his life in the company of prostitutes of the lowest order? . . .

I dare to state that this man truly does not know the meaning of grace, that he has never known truth, and that the concepts of refinement, integrity, innocence, and simplicity are well-nigh alien to him. I dare declare that he has never, even for an instant, looked at na-

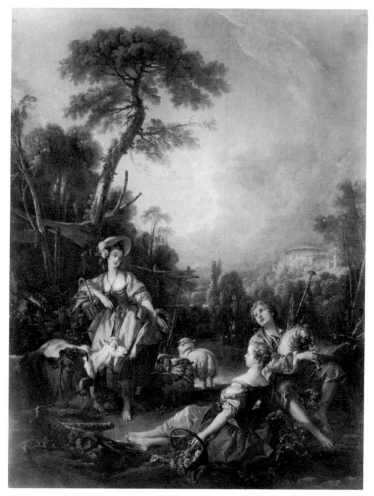

A Summer Pastoral. *Boucher*

ture, at least that aspect of nature that could affect my soul and yours, . . . and I dare to say that he is completely lacking in taste. . . . All his compositions disturb the eye with their unbearable clutter. He is the deadliest enemy of silence I have ever known. . . . There was a time when he was possessed with the idea of painting Madonnas. And what do you think his Virgins were like? They were pretty little flirts, and his angels were nothing but licentious little satyrs. And yet Boucher is no fool. He paints well, but he is a fake artist, just as there are fake intellectuals, and, far from having any real depth in art, he just puts on airs.

Denis Diderot. "Salon de 1765." *Œuvres complètes*, vol. X, Paris, 1876, p. 256 ff.

Boucher had a brilliant imagination, but not much veracity and even less refinement; his encounters with the Graces never had a respectable setting; he painted Venus and the Virgin from the nymphs backstage; and his language, like his pictures, suffered from the manners of his models and the tone in his studio.

> J. F. Marmontel. "Mémoires (1792–95)."
> *Œuvres complètes*, vol. I, Paris, 1818, p. 358.

M. Boucher, first painter to the King and one of the most famous artists of our Academy of Painting, is dead. For a long time he looked like a ghost and had all the inevitable infirmities resulting from a life consumed by work and dissipation. His fecundity was prodigious, hence his works are innumerable. The galleries of our collectors are filled with his pictures, their portfolios bulge with his drawings. He was called the painter of the Graces, but his Graces were mannered. As a teacher he was quite dangerous for the young people. The piquancy and voluptuousness of his pictures carried them away; desiring to imitate him, they became loathsome and false. . . . In spite of these objections voiced against Boucher—and rightly so—by persons of noble and forthright taste, his death, considering the present state of our school, represents a major loss.

> F. M. Grimm. *Correspondance littéraire,*
> June 15, 1770, VI, 481 ff.

But the climax of absurdity to which the art may be carried, when led away from nature by fashion, may be best seen in the work of Boucher. . . . His landscape, of which he was evidently fond, is pastoral; and such pastorality! the pastoral of the Opera house. . . . His scenery is a bewildered dream of the picturesque. From cottages adorned with festoons of ivy, sparrow pots, &c. are seen issuing opera dancers with mops, brooms, milk pails, and guitars; children with cocked hats, queues, bag wigs, and swords,—and cats, poultry, and pigs. The scenery is diversified with winding streams, broken bridges, and water wheels; hedge stakes dancing minuets—and groves bowing and curtsying to each other; the whole leaving the mind in a state of bewilderment and confusion, from which laughter alone can relieve it.*

> John Constable. "Notes of Six Lectures on Landscape Painting
> (1836)." In C. R. Leslie. *Memoirs of the Life of John
> Constable.* London, 1845, p. 343.

* Boucher is Watteau run mad,—bereaved of his taste and his sense. (C. R. Leslie's footnote.)

With his brush and his crayons Boucher untiringly created the mythology of the eighteenth century. His Olympus is neither the Olympus of Homer, nor of Virgil: it is the Olympus of Ovid. How these two painters of decadence, these two masters of sensuality, Ovid and Boucher, resemble one another! One page of Ovid has all the brilliance, the fire, the style, . . . of a canvas of Boucher. . . .

Voluptuousness was the essence and the soul of Boucher's art. . . . His goddesses, his nymphs, nereids, and all his female nudes are women who have undressed; but who knew better how to undress them? The Venus of his dreams, the Venus as he painted her, was only the physical Venus, but he knew her by heart. . . . He devised a tantalizing setting for her. Desire and pleasure were incarnate in that light, volatile, ever-renascent figure. . . .

When Boucher descended Olympus, his imagination found relaxation in the pastoral. But he painted it in the only way then permissible: he banished from his idyls "that certain unbecoming grossness." He represented it in the most chivalrous disguise, in the costumes of a masked ball at the court. . . . [There are] adorable shepherdesses, delightful shepherds, nothing but silks, tassels, crinolines. . . . It is a world tumbling onto the grass out of a pastoral by Guarini, with madrigals on its lips, tufts of roses at its feet! . . .

The critics of the time agreed in their admiration of his rich, ample, and imposing compositions, of his fresh and agreeable color, the tender sweetness of his poses, the felicitous groupings, the picturesqueness of his rustic scenes. . . .

One man alone resisted with energy, even brutality, the intoxication and kind of spell which the painter's talents exerted on his contemporaries; that man was Diderot. . . . There was an important reason for Diderot's unjust treatment of Boucher. We must remember that, if Diderot recognized Chardin, he invented Greuze. Diderot was above all . . . the apostle of a type of art that was to be useful and profitable to mankind. . . .

Boucher no more deserved Diderot's cruel harshness than he did the boundless enthusiasm of the public. He was neither a dauber of fans, nor a "master in all branches of art." He was simply an original and highly gifted painter who lacked one superior quality, . . . distinction. He had manner, but no style. In this respect he was greatly inferior to Watteau with whom he is often named and paired, as if there could be any similarity between Boucher and Watteau, the master who has raised wit to the height of style. Elegant vulgarity is the hallmark of Boucher. . . . To say it bluntly, if we may use a term borrowed from the argot of the studios, . . . he was *canaille*. . . .

Edmond and Jules de Goncourt. "Boucher (1862)." *L'Art du XVIII^e siècle.* 3 vols. Paris, 1909–10, I, 209 ff.

Boucher possessed, in the absence of other gifts as a portraitist, a full understanding of the art of feminine seduction and its piquant charms, together with a knowledge of the correct arrangement of the robes and the appropriate toilet accessories, which for more than an epoch constituted at least half of a woman's beauty. . . . He portrayed Mme. de Pompadour in all kinds of costumes, in all possible poses; he viewed her in the solitude of the parks, on a bench where she lingered in reverie, and in an abandoned attitude on the studio sofa. Her constant companion was a book or sketch stamped with her coat of arms. At a later date Drouais was to paint the political woman . . . but Boucher has immortalized the young mistress who lived only for love and art.

It was natural for Boucher to have chosen to depict the creator of Bellevue, of Crécy, and of the Hermitages of Versailles and Fontainebleau in gardens. . . . The painting in the Wallace collection shows her standing by an orange tree near the sculptured group of an impatient Cupid soliciting Venus; she is wearing a taffeta robe trimmed with gauze and lace, a network of ribbon and bows fastens her bodice which is adorned with a single rose; the same ribbon encircles her collar; she has pearls in her hair, at her neck, and at her wrists; in her hand is a fan and on the bench in front of her sits her favorite pug, which was to reappear in so many other portraits. . . .

The portraits by Boucher of Mme. de Pompadour in an interior setting are no less numerous . . . the most famous one is signed and dated 1757. The favorite is dressed in a robe of blue silk decorated with mauve bows. She is reclining on a couch, a book on her lap, surrounded by those familiar objects characteristic of her concern for the arts and her life at the court; on her left is a little rosewood table at which she has just completed a letter; in the background a mirror reflects her sumptuous library, a detail which is omitted from the partial copy in the Edinburgh National Gallery. This portrait, which belongs to the Adolphe de Rothschild collection, concludes the list of what we consider to be genuine portraits of the marquise by Boucher.

<div align="right">Pierre de Nolhac. François Boucher.
Paris, 1907, p. 55 ff.</div>

He [Boucher] sums up far better than Watteau the taste of the century. . . . He played in his own way a part analogous to Le Brun's. He had an instinct for decoration and an easy sense of elegant and well-balanced composition. He could illustrate a book and make of a fan a charming work of art just as effectively as he could throw a piece of gauze round a gracious goddess, or people the sky or sea with blonde and rosy nudities. His masterpiece in this latter style

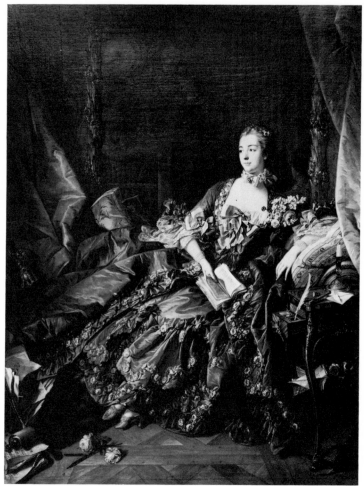

Madame de Pompadour. *Boucher*

is *The Triumph of Venus* in the Stockholm Museum. This master of
the artificial could even at need respect truth: he painted excellent
portraits, though it need hardly be said they are feminine ones. . . .

Why did he fail to be a really great painter? He loved his art
and worked hard. His decorative gifts are hardly inferior to those of
his illustrious contemporary, Tiepolo. His cartoons for tapestries merit
unreserved admiration. . . . What, then, did he need to equal those
whose works have real significance for humanity as a whole? In my
opinion the answer to this question is one of ethics. Boucher's work
expresses nothing but satisfied pleasure. Art, the privileged interpre-

ter of the hopes and passions of puzzled humanity, demands more.
<div style="text-align:right">Paul Jamot. "French Painting II."

Burlington Magazine, January 1932, p. 31.</div>

Boucher is the most important name in connection with the rise
of the rococo formula and the masterly technique which gives the art
of a Fragonard and Guardi that quality of unfailing certainty in the
execution. He is the individually insignificant representative of an ex-
traordinarily significant artistic convention, and he represents this
convention in such a perfect way that he attains an influence unlike
that of any artist since Le Brun. He is the unrivalled master of the
erotic genre, of the genre of painting most sought after by the *fermiers
généraux,* the *nouveaux riches* and the more liberal court circles, and
the creator of that amorous mythology which, next to Watteau's *fêtes
galantes,* provides the most important subject-matter of rococo paint-
ing. He transfers the erotic motifs from painting to the graphic arts
and the whole of industrial art, and makes a national style out of the
peinture des seins et des culs.
<div style="text-align:right">Arnold Hauser. *The Social History of Art.*

2 vols. London, 1951, II, 532.</div>

The Triumph of Venus

1740 oil on canvas 51″ x 63½″ Stockholm, National Museum

The color-scale of brilliant half-tones (sea green, pink, and "summer
blue") characteristic of Boucher, was derived from Le Moyne. . . . It was
also influenced by Rubens . . . and by Albani. . . . In his youth Boucher en-
graved a number of works by Watteau, thus receiving—particularly at the
beginning of his career—many important impulses from that artist.

It is thus possible to discern the influence of many different artists in *The
Triumph of Venus,* but these impulses have been admirably merged into a
wholly individual style. The composition of the picture shows a *fortissimo* of
whirling lines, robust sea gods, delicious female bodies and half transparent
but pregnantly designed draperies, operatic waves, grand-opera scenery and
sky. . . . One admires not only the freshness and the ornamental perfection
of this work, but also the stage management behind it. . . .

Boucher's work is primarily decorative—created for ornamental purposes.
In this work he combines the varied forms—waves, human bodies, draperies—
with inimitable grace and a feeling for the decorative effect. His color scheme
comprises but a few tones, all of which are congruent with the forms they de-
pict, and they are applied on a fairly light ground, which increases their bril-
liancy. The waves form an effective contrast to all the feminine nudity, and the

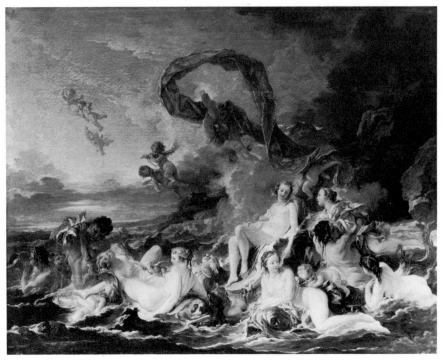

The Triumph of Venus. *Boucher*

whole work, with its fine pictorial effects competing with frivolous details, was a deliberate attempt to capture the interest of the fashionable world.

Sixten Strömbom. *Masterpieces of the Swedish National Museum.* Stockholm, 1951, p. 166.

MAURICE-QUENTIN DE LA TOUR

Maurice-Quentin de La Tour (sometimes spelled de Latour) was born at Saint-Quentin in 1704. At the age of eighteen he went to Paris, but he was unable to establish himself there. He therefore accepted an offer from the English ambassador to go to London, where he became a portrait painter. Returning to Paris in 1724, he turned to pastel painting, for which the Venetian pastelist Rosalba Carriera had started a vogue. In 1737, La Tour was admitted to the Academy. Now eligible to exhibit at the Salon, he did so without interruption from 1737 to 1763. He became one of the most celebrated artists of his time, receiving commissions from the court and from leading personalities in the arts, sciences, and letters. He was greatly interested in technique and experimented with fixatives in the hope of giving pastels the permanence of oils. La Tour never married; the portrait

of his long-time mistress, the singer Marie Fel (1757), is one of his masterpieces; it is in the Musée Lécuyer at Saint-Quentin, which houses the largest collection of La Tour's work. Late in life La Tour founded an art school and several charitable organizations. He became mentally deranged during his last years and had to be confined to his house in Saint-Quentin, where he died in 1788.

> La Tour is self-taught. . . . His color lacks Rosalba's freshness, but he is the better draftsman. His work is finished to the last detail, and he has the precious talent of achieving a perfect resemblance. But his temperament is peculiar; his manner of dealing with a great many people whom he calls his friends and whose portraits he wishes to paint does not do him honor. . . . He is treating his friends like a veritable pirate. There is no end to the stories of his dealings with them, nor of the ridiculous scenes he has made at the Court, which have slowed down the demand for his works. . . . I would forgive him his eccentricities, but not the rashness with which he spoiled the beautiful portrait of Restout, his diploma piece at the Academy. Under some kind of pretext he got hold of it, apparently thinking that he would be able to improve on it. Without realizing how much his art had declined, he reworked and completely ruined it. What a pity!
>
> And here is another trait. He was painting the portrait of Mme. de Pompadour. The King was present, and in the course of the conversation the buildings were mentioned which the King was having erected. La Tour, unasked, began to speak. He had the impudence to say that all this was very well, but that ships would be much more valuable. This was the time when the English had destroyed our fleet, and we had no vessel whatsoever to oppose them.* The King blushed. Everybody considered this foolhardy remark stupid, pointless, and despicable.
>
> <div align="right">P. J. Mariette. <i>Abécédario</i> (ca. 1760).
6 vols. Paris, 1851–60, III, 66 ff.</div>

> He is very painstaking in his work and not easily satisfied, which does great harm to his paintings. He does not know when to stop. He continually seeks to improve what he has done, with the result that by reworking and excessively retouching his pastels he often ruins them. He then becomes disgusted, blots out everything, and begins again; and his second attempt is often inferior to the first. Moreover, he stubbornly uses a fixative which he believes he has invented himself and which frequently spoils everything. It is a great pity. Work in

* La Tour was referring to the French defeat in the French and Indian Wars (1754–63), which led to France's cession of Canada to England. The portrait of Mme. de Pompadour, exhibited at the Salon of 1755, is now in the Louvre.

pastel should not be overdone. Too much effort takes away its bloom, and as a result it tends to become blurred.

Louis de Bachaumont.
"Liste des meilleurs peintres . . . 1750." in J. G. Wille.
Mémoires et journal. Paris, 1857, II, 407.

It is not in the finished pastels, . . . in so many portraits, that the connoisseur finds the great revelation, the fascination of the Museum in Saint-Quentin. The "preparations" [exhibited there] reveal La Tour's genius in its first inspiration and are perhaps superior to his other works. . . . In these sketches technique and medium seem to vanish, and nature is present in all its vividness, without the intermediary of interpretation and translation. . . . It is no longer art, but life itself.

A marvellous spectacle, these faces . . . on blue paper, drawn with a few untidy strokes with bits of pastel, or with broad hatchings of brown chalk! . . .

These faces by La Tour live not only by the veracity of their construction, the realism of drawing, the material illusion of the individual's physical presence, but the painter, this keen observer, is equally accurate in capturing the moral essence of the sitter. . . . His faces think, speak, confess, and reveal their secrets Diderot failed to recognize this important quality of La Tour's talent, when on one occasion [in 1767] he saw in him only the great technician, the "marvellous mechanic." La Tour is more than that. He himself said of his models: "They believe that I render only their physical features, but, unknown to them, I probe into the recesses of their minds and take possession of them in their entirety." . . .

His work is a magic mirror in which the dead return to life. Through his art we see again the men and women of his day. From this gallery of portraits the physiognomy of History itself emerges. . . . Here are the princes, noblemen, great ladies, the dazzling splendors of Versailles, there the men of philosophy, science, and the arts, whom the painter, recognizing genius, . . . had painted with special devotion and enthusiasm. . . . From the dust of his pastel, from this art blown, as it were, from the face powder of the epoch, La Tour has extracted the frail and delicate immortality, the miraculous illusion of survival which his contemporaries deserved. His work is the imposing and charming portrait of the France that was born of the *Régence* and begot the Revolution. La Tour's Museum is the Pantheon of the century of Louis XV, of its spirit, its grace, and its thoughts, of all its talents and its glories.

Edmond and Jules de Goncourt. "La Tour (1867)." *L'Art du XVIIIᵉ siècle.* 3 vols. Paris, 1909–10, I, 357 ff.

Twelve years ago I made the trip to Saint-Quentin just to study La Tour's work. As he is not well represented in the Louvre, I had the impression that I would understand him better in Saint-Quentin. I don't know why, but in the Louvre I had always classed him with Gainsborough. In Saint-Quentin this resemblance vanishes. La Tour is very French and very "Gentilhomme," and if there is a quality I admire in painting it is just that. Of course I am not speaking of the elegance of his models.

It is not the mighty sword of a Bayard but rather the court rapier of a marquis; not the bludgeon of a Michelangelo, but the stiletto of La Tour. The lines are as pure as Raphael's, the composition of the curves always harmonious and significant.

> Paul Gauguin. Letter to A. Fontainas, August 1899.
> *Lettres de Gauguin à sa femme et à ses amis.*
> Paris, 1946, p. 294.

La Tour did not take the trouble . . . to keep a record of the portraits he painted and neither dated nor signed his works. Thus their total number and exact chronology will never be known. It is, furthermore, important to distinguish, whenever possible, between the "definitive" portraits and the "preparations," which La Tour sometimes gratuitously handed over to the sitter, but most frequently kept for himself. It is not excessive to estimate at about 200 the number of portraits created by this artist, of which about 120 were exhibited at the Salons.

> Maurice Tourneux. *La Tour.* Paris, 1904, p. 15.

Never vulgar, never commonplace even when humorous . . . La Tour had that natural distinction which, better than any principles, saves an artist from triviality. He maintained a natural elegance even in his realism.

It cannot be said of him that he was a poet, and he was neither an Epicurean nor a virtuoso. It is in this that he differs essentially from Boucher, Watteau, and Fragonard. Whatever he perceived he rendered without emphasis, without rapture, without imagination, but as a man who knows mankind and paints it as he sees it. La Tour is above all intelligent. He looks, and he registers. He is a quiet analyst, a skillful observer, a spectator beholding the world. He is the portrait painter *par excellence*.

> Albert Besnard. *La Tour.* Paris, 1928, p. 13.

The evolution of the French portrait in the first half of the eighteenth century . . . passed through three stages: the state portrait, the

mythological portrait, and the psychological portrait. This development can be summed up more succinctly by three names: Rigaud, Nattier, and La Tour.

The decorative portraits of Rigaud and the mythological disguises of Nattier's sitters can be explained by the artists' desire to elevate an underrated genre to the level of history painting. When La Tour began to paint the struggle had been won; the portrait no longer needed excuses; it sufficed by virtue of itself. There was no longer any need for theatrical trappings or mythological disguises. The simple human face, accurately delineated, was enough to create a masterpiece.

La Tour added another novelty, this time of a technical nature. He substituted the *pastel,* in other words painting with a dry medium, for painting in oil. With simple colored crayons and a few rapid strokes, with a keen eye and a quick hand, he was able to recapture the flash of lightning in the human physiognomy, which passes and never returns. . . .

In the hands of La Tour and Perronneau the technique of the pastel attained its peak of perfection. In eighteenth-century French art it maintained a position equal to that of the English watercolor.

Louis Réau. *Le Rayonnement de Paris au XVIIIe*
siècle. Paris, 1946, p. 103 ff.

Portrait of Jean-Jacques Rousseau

1753 pastel 17¾″ x 13⅜″ Saint-Quentin, Musée Lécuyer

This great artist has developed the art of pastel so far that he is no longer satisfied with painting a perfect likeness; he knows how to animate his portraits and make them come to life like no one before him. There is at the Salon a large number of portraits of famous men by him, including that of . . . M. Rousseau, citizen of Geneva, for whom M. de Marmontel has written the following lines:

Before these traits, with zeal and friendship drawn,
O wise men, stop, men of the world, move on!

F. M. Grimm. *Correspondance littéraire,*
September 15, 1753. Paris, 1829, I, p. 60.

M. de La Tour, so true, so sublime in his works, has made of M. Rosseau's portrait* a handsome object, rather than the masterpiece he could have cre-

* La Tour painted several portraits of Rousseau. This particular version is known only from an engraving. The painting shown in our illustration appears to be a replica of the portrait described by Rousseau. The contour of a chair is dimly seen on the left.

Portrait of Jean-Jacques Rousseau.
Maurice-Quentin de La Tour

ated. I am looking for the censor of literature, the Cato and Brutus of our age; I expected to see Epictetus, carelessly attired, his wig ruffled, frightening writers, noblemen, and high society with his stern mien; but I find only the author of *Le Devin du village*,* well-dressed, well-combed, well-powdered, and ridiculously seated on a wicker chair. It must be admitted that M. de Marmontel's lines indicate very well who M. Rousseau is and what we ought to find, but search for in vain, in the picture of M. de La Tour.

<div style="text-align:right">

Denis Diderot. "Essai sur la peinture (1766)."
Œuvres complètes, vol. X, Paris, 1876, p. 483.

</div>

Some time after my return to Mont-Louis, M. de La Tour, the painter, came to see me and brought me a portrait in pastel, which he had exhibited at the Salon some years before. He wanted to present it to me, but I did not accept it. Later, however, Mme. d'Épinay, who had given me her portrait and wanted mine, had made me promise to ask him for it. He [de La Tour] had taken his time to touch it up. In the meantime I broke with Madame d' Épinay. I returned her portrait to her, and as there was no longer a question of giving her mine, I hung it up in my room in the little château. M. de Luxembourg saw it there and took a liking to it. I offered it to him; he accepted it, and I sent it to him.

<div style="text-align:right">

Jean-Jacques Rousseau. *Les Confessions.*
Paris, 1849, p. 501. Entry for 1759.

</div>

* *Opera buffa* written and composed by Rousseau. It was first performed in 1753.

Yes, Sir, I accept my second portrait. As you know, I have made of the first a use as honorable to you as to myself, and one very close to my heart. M. le maréchal de Luxembourg has consented to accept it. . . . That monument to your friendship, to your generosity and rare talents, now occupies a place worthy of the hand from which it came. I am reserving for the second a humbler spot, but chosen out of the same sentiment. Your admirable portrait, which somehow makes the original more respectable to me, shall never leave me. I shall have it before my eyes every day of my life; it will speak to me always.

<div style="text-align: right">Jean-Jacques Rousseau. Letter to La Tour, October 14, 1764.

Œuvres complètes, vol. XV, Paris, 1833, p. 332.</div>

The interpretation of this portrait has varied. Some thought that it reflected the all too well-known character of the philosopher, others saw in it the softened expression La Tour had wanted to give him. Thus Bernardin de Saint-Pierre found this physiognomy "amiable, fine, and touching," whereas Maurice Barrès perceived in it "a mixture of jealousy and contempt."

Jean-Jacques himself has expressed the secret of present and future disagreements in the following quatrain:

> Men, in the art of feigning teachers,
> Who lend me airs so sweet in tone,
> You may well wish to paint my features,
> Yet you will paint none but your own.°

. . . Such as it is, the pastel no doubt presents his exact features, and a rather seductive image at that. But its fault lies in its very charm. La Tour, whose crayon was at times forceful to the point of rudeness . . . lacked the proper comprehension or frankness when confronted by Rousseau.

<div style="text-align: right">Henry Lapauze. *Les Pastels de Maurice-Quentin de La

Tour au Musée Lécuyer* . . . Paris, 1919, no paging.</div>

JEAN-BAPTISTE PERRONNEAU

Jean-Baptiste Perronneau was born in Paris in 1715. He studied painting with Natoire and engraving with Laurent Cars. Before 1744 he was active as an engraver and then turned to painting in oil and pastel. His earliest known pastel (*Girl with Cat,* National Gallery, London), dates from 1748. Perronneau became an associate

° *Hommes savants dans l'art de feindre*
 Qui me prêtez des airs si doux
 Vous aurez beau vouloir me peindre,
 Vous ne peindrez jamais que vous.

member of the Academy in 1746 and was admitted to full membership as a portrait painter in 1753; he submitted the portraits of Oudry and of Adam *l'aîné* (both in the Louvre) as his diploma pieces. The year 1750 marked the beginning of his rivalry with Maurice-Quentin de La Tour, the leading portrait painter of his age, whose portrait he painted at La Tour's request, according to Diderot. It is doubtful that this portrait was shown together with a self-portrait by La Tour in the same Salon, as Diderot has claimed. Perronneau exhibited at most of the Salons up to 1779. He died in Amsterdam in 1783.

M. Perronneau is a good portrait painter who works in oil and in pastel; his pastels are superior to his oils. He aims at the manner of the famous Rosalba, but does not reach her stature. His touch is spirited, though perhaps a little mannered, and somewhat removed from nature. One has to see his portraits from a certain distance; his oils especially are more effective from afar.

<div align="right">

Louis de Bachaumont.
"Liste des meilleurs peintres . . . 1750." In J. G. Wille.
Mémoires et journal, vol. II, Paris, 1857, p. 411.

</div>

When the young Perronneau appeared, La Tour became uneasy. He feared that the public could only be made fully aware of the gap separating them by means of a direct comparison. What did he do? He proposed that his rival paint his portrait, which Perronneau refused to do out of modesty. . . . But the innocent artist allowed himself to be persuaded, and while he was working on the portrait, the anxious La Tour for his part set to work on his own self-portrait. The two pictures were completed at the same time and shown in the same Salon;* they demonstrated the difference between the master and the pupil. This scheme is clever, but displeases me. A singular man, but a decent and chivalrous one, La Tour would not do this today. And then, one should have some forbearance for an artist piqued to see himself lowered to the level of a man who does not reach his ankle.

<div align="right">

Denis Diderot. "Salon de 1767." *Œuvres complètes*,
vol. XI, Paris, 1876, p. 151 ff.

</div>

We have just learned that M. Perronneau, the very distinguished portrait painter, died last autumn in Holland. This artist, born in Paris,

* Diderot refers to the Salon of 1750, where Perronneau's portrait of La Tour was exhibited. As to La Tour's exhibits in this Salon, the official catalogue lists only "several heads in pastel." It can therefore not be determined with certainty whether a self-portrait was among them. One of La Tour's self-portraits, now in the Museum of Amiens [see illustration], bears an old date of 1751. Diderot's memory may have deceived him, writing seventeen years after the event.

Self-Portrait.
Maurice-Quentin de La Tour

was first taught drawing by M. Natoire. He then entered the studio of M. Cars with the intention of becoming an engraver. But he was not born for the practice of an art requiring much perseverance and patience. He gave up engraving and began to work in pastel. He made very rapid progress and after a few years was able to win the approval of the most discriminating connoisseurs. No better proof can be cited than the fact that the most celebrated portrait painter of our time, M. de La Tour, wished to have his portrait painted by M. Perronneau and has always expressed his high esteem for M. Perronneau. The drawing of this painter was correct, the poses [of his sitters] nobly chosen, the arrangements of the draperies pleasant, and his execution light and spirited. His color and overall effect were the weakest parts of his talent. He practiced his art throughout most of Europe, and his instability was one of the peculiarities of his life. He would settle down nowhere. . . . Italy, Spain, England, Germany, Russia, Poland, Hamburg, Holland, and all the principal cities of France preserve examples of his visits.

<div style="text-align: right">

Abbé de Fontenay. "Morts remarquables: Perronneau (1784)." Quoted in L. Vaillat and P. Ratouis de Limay. *J.-B. Perronneau.* Paris, 1923, p. 135.

</div>

Portrait of Maurice-Quentin
de La Tour.
Perronneau

Compare Perronneau's sitters with those of La Tour. The latter, erect, always on the alert, are as cunning as La Tour himself. Vitality seems to dart from their eyes; indeed, it is chiefly through their eyes that they come to life. . . . Yet these persons lack the proper atmosphere; they are not placed in relationship to their surroundings. The coloring is arbitrary, little difference can be noted in the complexion of a lady and of that of her consort. The shadow cast by the head is the same as that which models the features. It is not so in nature. . . .

Perronneau, less brilliant, less polished intellectually, yet of a much deeper sensibility, seems to have felt this. His heads and his garments are bathed in a wave of light and reflections. He is aware of the differences between materials: the white of a jabot is not the same as that of powdered hair; the face has one tone and the costume another; the play of light is different upon each of them. He notes the accidental details of dress, such as a spray of faded roses falling from a buttonhole. In short, he paints people as they are, whether their skins are pink, reddish, or yellowish. . . . Though delightful to our modern taste, this could hardly have proved attractive to a society bound by the desire to please and determined to see only the pleasant side of life. Hence Perronneau was misunderstood in his time. . . .

241

The more I study Perronneau's work, the more I see in him a brother of Watteau. . . . Like Titian and Veronese, Perronneau liked black and gray garments . . . because they aid the play of light and shade and give the necessary support to the lighter tones. . . . But Perronneau did not use those tones alone; like Watteau, he was also fond of rose and green, . . . colors which reflect and absorb, and vary in tonality, permitting this divine interplay of nuances. None of his contemporaries had dared to use colors in such a way.

Albert Besnard (1908). Quoted in L. Vaillat and P. Ratouis de Limay. *J.-B. Perronneau.* Paris, 1923, p. 151 ff.

A man of little culture and deep simplicity, so uneducated that he was unable to decide on the spelling of his own name, ignorant of the art of flattery and of showing himself to the best advantage, he could not have been a fashionable portrait painter and a courtier, audacious to the point of insolence, as was La Tour. While the latter, when asked to go to Versailles to paint the portrait of Madame de Pompadour, replied, "Dites à Madame que je ne vais pas peindre en ville,"* and fixed the price of the portrait at 48,000 livres; Perronneau, at the height of his talent, did not dare to ask for more than 1,000 livres for painting the portrait of the Prince de Soubise. . . . Far from the court and deprived of all official favour, although a member of the Royal Academy of Painting and Sculpture, he had to lead a wandering life . . . always looking for the chance to make a few hundred livres by painting a portrait.

He found his models among all classes of society; actors and gentlemen of the court, churchmen and magistrates, writers, artists and collectors, fashionable women and dancers at the Opéra, all posed for him in turn.

He was also the painter of the bourgeoisie. At the Salons of the Louvre in particular he often exhibited portraits of bourgeois. These works attracted very little attention from contemporary critics. . . . Yet the work of Perronneau constitutes one of the most brilliant chapters in the history of the portraiture of the eighteenth century.

Paul Ratouis de Limay. "Jean-Baptiste Perronneau, Painter and Pastelist." *Burlington Magazine,* January 1920, p. 35 ff.

[Perronneau] made, unlike the lordly Latour, no strong personal impact on his contemporaries.

* "Tell *Madame* that I do not go out to paint."

But above all it was the existence and popularity of Latour that then obscured him and to some extent shadows him still. . . . Latour, vivacious, skilful, ready, a specialist in the pastel that dogs oil-painting to such a point that his name is almost a synonym for the art, recorded the "Graces" of his time as the Graces of every time desire to be remembered, and will always have his good place among such recorders or eulogists; but when, a few years ago, the St. Quentin collection came to Paris, a case . . . came up for final appeal, and a single pastel by Perronneau extinguished his supposed master. In the midst of those stereotype heads, always more vivid in reproduction than in reality, and in "preparation" than in completion, the single head of Latour himself by Perronneau, which had slipped in among them, reversed the *proxime accessit* for all time. . . . Perronneau missed his separate niche in the eighteenth-century gallery of the Goncourts, though they were aware of him[*] and had examples; it was left . . . for Albert Besnard to pronounce the painter's panegyric that Perronneau's own century had denied.

<div align="right">D. S. MacColl. "Perronneau." Burlington Magazine,
XLV, 1924, p. 29.</div>

CLAUDE-JOSEPH VERNET

Joseph Vernet, the best-known member of a family of painters, was born in 1714 at Avignon. He was first trained by his father, the decorative painter Antoine Vernet. In 1734 he left France for Italy, where he studied under B. Fergione, an imitator of Salvator Rosa, and A. Manglard, a marine painter. In Italy Vernet painted genre scenes and Roman *vedute* (views of cities or landscapes characterized by topographical accuracy). He was admitted to the French Academy in Rome in 1746. Five years later he returned to France and established himself at Marseilles. Commissioned by Louis XV through the marquis de Marigny in 1753 to paint a series of twenty-four views of French seaports, Vernet worked on these paintings for nine years, traveling all over France to inspect the harbors. He completed fourteen of them (some with the help of assistants), and they remain his most important works. After 1762 he settled in Paris and painted highly successful pictures of storm scenes, shipwrecks, and moonlit night-pieces, which foreshadow romantic landscape painting. He died in 1789.

[*] Discussing the rivalry between La Tour and Perronneau in their chapter on La Tour, in *French XVIII Century Painters*, the Goncourts remark in a footnote: "Perronneau is a better colorist than La Tour. There is something of the luminosity of the English school, of Reynolds, in his pastel style."

Vernet knows how to whip up a storm, to open the floodgates of the sky and inundate the earth; but he also knows, whenever it pleases him, how to quell the tempest and restore tranquillity to the sea. And then all of nature emerges from chaos and brightens up enchantingly, regaining all its charms.

What serenity we find in his daylight scenes, what tranquillity in his night-scenes, what transparency in his seas! It is Vernet who creates the silence, the coolness, and the shade of the forest. He dares to put a sun or a moon in his sky without trepidation. He has stolen Nature's secret; whatever she produces, Vernet can recreate. . . .

His *Port of Rochefort* [Louvre] is very beautiful, and it attracts the attention of artists because of the unattractiveness of the subject.

But his *Port of La Rochelle* [Musée de la Marine, Paris] is much more interesting. Here is something we can really call a sky, here are truly limpid waters, and all the groups compose so many true and characteristic little vignettes of the region. The figures are drawn with absolute correctness. How light and brilliant is his touch! And who understands aerial perspective better than Vernet? . . .

I don't always just look; sometimes I also listen. I heard one viewer of these paintings say to his companion, "To me Claude Lorrain seems still more exciting," and the other replied, "I agree, but he is less true."

This reply did not seem fair to me. By comparison, the two artists

The Port of La Rochelle. *Claude-Joseph Vernet*

ring equally true, but Lorrain has chosen rarer moments and more extraordinary phenomena for his subjects.

But does that mean, you will ask, that I prefer Claude Lorrain to Vernet? For when an artist takes pen or brush in hand, he does not do so to say or show the commonplace.

I agree, but remember that in his large compositions Vernet cannot give his imagination free reign. They are commissions, and he has to show the place as it really is. And note, too, that Vernet's works, with their incredible multitude of activities, objects, and individual scenes, reveal an entirely different conception, another kind of talent from that of Lorrain. One is merely a landscape painter, but the other is a history painter* of the first rank in every aspect of his art.

Denis Diderot. "Salon de 1763." *Œuvres complètes,*
vol. X, Paris, 1876, p. 202 ff.

Twenty-five paintings, my friend, and what paintings! To judge from the speed of execution, they must be by the very Creator, and their veracity seems to stem from nature itself. Any other industrious painter might have spent two years on a single picture, while Vernet painted them all in that span of time. What incredible light effects, what marvellous skies! Look at these waters, that skill in arrangement, the tremendous variety of scenes! Here a child, saved from shipwreck, is being carried on his father's shoulders, and there on the shore lies the body of a woman with her husband grieving over her. The sea roars, the winds whistle, the thunder rumbles, the pale, somber flashes of lightning pierce the clouds, now showing, now concealing the view. . . .

Turn your eyes to another seascape, and here you see tranquillity with all its charms. The calm waters, smooth and placid, lose their transparency almost imperceptibly, and just as imperceptibly brighten at the surface as they spread out before you from the water's edge to the horizon. The vessels are immobile, but the sailors and passengers have every distraction to quell their impatience. When [Vernet] depicts morning, how gossamer are the mists that arise! And in the evening scenes, look how the mountain tops turn golden! Observe the color gradations in these skies, the movement of the clouds, how they change and leave a tint of their own color on the water! . . . Although Vernet is the most prolific of all our painters, he gives me less work than any other. It is impossible to describe his compositions; they must be seen. His night scenes are as moving as his daylight views are

* In according highest rank to the history painter, Diderot reflects the point of view that prevailed at the Academy itself.

beautiful; his imaginary scenes are as stimulating as his harbor views are magnificent. And, what is equally marvellous, . . . no matter whether he depicts day or night, natural or artificial light, his paintings are always harmonious, vigorous, and well ordered. . . . The buildings, the churches, the garments and the gestures, the people and the animals—they all ring true. From close up, his work strikes you; from afar, it impresses you even more. Chardin and Vernet are two great magicians. Of the latter one might say that he begins by creating a place, and that he keeps men, women, and children in store to populate it, just as one might settle a colony. Then he creates the weather for them, and a sky, a season, a fortune or misfortune, as his fancy strikes him. . . . Jupiter calls this ruling the world, and he is wrong; Vernet calls it painting pictures, and he is right.

> Denis Diderot. "Salon de 1765."
> *Ibid.,* p. 310 ff.

From Claude Lorrain he borrowed the always well-balanced arrangement of masses and planes, the convenient device of using trees for contrast or buildings as backdrops, and the effects of aerial perspective. But, what is more important, he anticipates Corot's Italian paintings in his luminous landscapes which he brought back from his long sojourn in Rome, such as the *Ponte Rotto,* mirroring its broken arches in the transparent water rippled with reflections, and the *View of the Bridge and Castle of Sant' Angelo* [both in the Louvre].

Following the Salon of 1753 the marquis de Marigny commissioned from him the series of *Seaports of France* which occupied him during the next decade, up to 1763. The original drawings kept in the Museum of Avignon inform us about his method of work: He began by making sketches in Chinese ink, noting the approximate color effects of mountains and sea in tones of ash gray *(cenerino),* blue *(torchino),* and violet *(pavonazzo).* In the best works of the series (not all of them are entirely by his hand), the *Port of La Rochelle* [Musée de la Marine, Paris], the *Port of Toulon,* and the *Port of Marseilles* [Louvre], we admire his skill in enlivening his canvases with numerous figures; they evoke the picturesque life of old France . . . for Vernet the figure painter was on a par with Vernet the landscapist.

Unfortunately the end of his career was a period of decline. Swamped with commissions from French and foreign collectors, the victim of his own success, Vernet painted innumerable melodramatic storm scenes and sentimental moonlit night-pieces, done mechanically

—one might almost say by the gross. In the end his talent became shipwrecked like his boats.

> Louis Réau. "La Peinture française
> dans la seconde moitié du XVIII^e siècle." In A. Michel.
> *Histoire de l'art,* vol. VII, pt. 2. Paris, 1924, p. 525 ff.

Vernet was the painter of nature as the eighteenth century conceived it; from that point of view he occupies a leading position in the art of his time. . . .

Even though there is much that is artificial and conventional in his art, it must not be forgotten that Joseph Vernet was a very gifted artist. Admirable painter of the sea which he knew and loved, painter of figures which surpass in their delineation and liveliness those of any other landscapist, and a fine colorist, he produced between 1740 and 1760 a large number of pictures which combine the best traits of eighteenth century painting. In his *Views of Rome and Environs* and in his *Pleasure Parties* he left unforgettable visions of the grace and charm of old Rome. His marine landscape, *View of Ponte Rotto* [Louvre] compares favorably with any genre painting of any school. The *Seaports of France* continue in their conception the charming *Pleasure Parties* of his Italian period. His *Morning Mists,* sunsets, and *clairs de lune,* animated by fishermen, bathers, and washerwomen, are the high point of the classical marine landscape.

Even though Joseph Vernet's influence on subsequent marine painting was insignificant, no other painter was as much copied and imitated in his own lifetime. We must therefore be sceptical of any undocumented works attributed to this master beyond his signed and dated works and those paintings whose provenance and artistic quality eliminate any doubt as to their authorship.

> Florence Ingersoll-Smouse. *Joseph Vernet.*
> 2 vols. Paris, 1926, I, 32.

JEAN-BAPTISTE GREUZE

Greuze was born in 1725 at Tournus, Burgundy, and entered the studio of Charles Grandon in Lyons about 1745. In 1750 he left Lyons for Paris, where he attended the Academy irregularly. In 1755 he was admitted to the Academy as an associate. His debut at the Salon of 1755 with *The Bible Reading* (Leningrad, Hermitage) was a triumph. He visited Italy for a year and after his return continued his successful career in Paris. *The Village Bride* (1761; Louvre) and his entries at the Salons of 1763 and 1765 won Diderot's acclaim. In 1767, Greuze was forbidden to

exhibit, because after twelve years as an associate, or provisional, member of the Academy he had failed to present a diploma piece. He then submitted his *Septimius Severus and Caracalla* (1769; Louvre), hoping to be accorded the highest rank of history painter, but he was rebuffed and accepted only in the lower category of genre painter. An open letter published by him in defense of his painting was to no avail; even Diderot no longer supported him. Another disaster was his marriage to his pretty former model, which led to scandals, unsavory documents, and finally a divorce. Following his debacle at the Academy, Greuze withdrew completely from the Salon until after the Revolution, but David was then the rising star and Greuze could not reassert himself as an artist. Impoverished and forgotten, he died in 1805. Greuze's genre scenes and sentimental portrayals of young girls, which had made such an impact on his contemporaries, are now considered inferior to his portraits—as, for example, that of the engraver J. G. Wille (1763; Paris, Musée Jacquemart-André).

Diderot's *Salons* are the liveliest description we have of a society seen through its paintings. Through these descriptions runs the whole current of ideas and passions which excited the society of that time, and it is for this reason that the painters are so sharply focused. It is to these *Salons* that we owe the continuing interest in the paintings of Greuze. It has been said that Greuze was Diderot's pupil and that his painting, *The Bible Reading*, was derived from Diderot's *Essai sur la littérature dramatique*. Although the connection is perhaps not quite so definite, we can be certain that both the painter and the man of letters participated in the same movement. In 1757 Diderot published his *Fils naturel* which quickly became the most widely read and the most talked about book in Paris. . . . Its attempt to portray the manners and customs of real life and of ordinary people seemed at that time a literary revolution. The following year Diderot wrote *Le Père de famille*, which Voltaire described as a sensitive and moral work, praising it for its new literary style. . . . In fact, the *Essai sur la littérature dramatique*, in which the author systematized his new poetics, was published only after *Le Père de famille*. . . . Diderot did not conceal the fact that paintings often provided him with examples and ideas, but at the period when these plays and bourgeois paintings appeared, more general causes were setting the style, and there were more famous literary works to serve as examples. It was now about the twelfth year of Madame de Pompadour's ascendance, the Seven Years' War was still in progress, and still fresh in everyone's mind was the defeat of Rossbach, where the nobility had received such an unexpected setback. . . . Abbé Prévost had written *Manon Lescaut*, and with great success had published [French editions of Samuel Richardson's] *Pamela* and *Clarissa*. . . . Rousseau had published his *Nouvelle Héloïse*. . . . It was now the turn of Greuze. The age had given him a taste for the sentimental novel and the intimate drama of home life,

and the happy originality of his interpretation contributed to the advance of that patriotic and sentimental spirit which was to prevail till the end of the eighteenth century.

Jules Renouvier. *Histoire de l'art pendant la Révolution.* 2 vols. Paris, 1863, I, 507.

Throughout the eighteenth century he [Greuze] was the object of much violent partisanship, while the nineteenth century adopted him as a sort of honorary academician for the appeal of his studies in palpitating virginity. In our day he has been briefly considered as the spear-head of the middle-class revolution which was to triumph with David, an attitude based on only a proportion of his works and one which leaves no room for connoisseurship. It would perhaps be fairer to regard him as the complete expression in painting of an epoch known best to us through its writers—Nivelle de la Chaussée, Diderot, Rousseau, Rétif de la Bretonne; yet even this should not be attempted until the true facts of his life and work have been brought to light. . . .

Anita Brookner. "Jean-Baptiste Greuze." *Burlington Magazine,* May 1956, p. 157.

Greuze is truly a man after my own heart. . . .

To begin with, his genre is to my liking, for Greuze is a painter of morals. What then! Has not the brush been devoted to lewdness and vice long enough? Should we not rejoice that he is competing with dramatic poetry in order to move us, instruct us, and exhort us to virtue? Courage, my friend Greuze, go ahead and moralize with your paintbrush, and always continue in this manner! When you are about to depart from this life there will not be a single painting that you may not recall with pleasure. . . .

Denis Diderot. "Salon de 1763." *Œuvres complètes,* vol. X, Paris, 1876, p. 207 ff.

The Village Bride
[The Wedding]
L'Accordée de village

1761 oil on canvas 36" x 46½" Paris, Louvre

Here is M. Diderot's report* of this year's Salon, which is worthy of exercising his imagination and his pen. . . . During the last ten days of the Salon

* Diderot wrote his *Salons* for Friedrich Melchior Grimm's *Correspondance littéraire.* This is an example of how Grimm introduces his "reporter." Grimm's interpolation appears only in the Seznec-Adhémar edition of the *Salons* (4 vols. Oxford, 1957–67) and is translated from this source (I, 141).

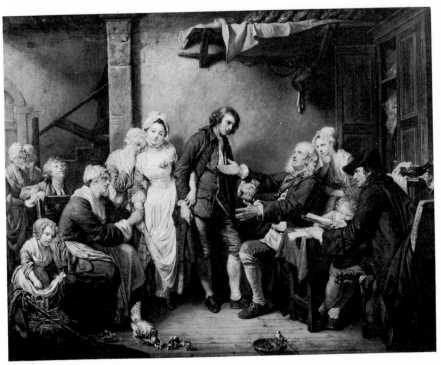

The Village Bride. *Greuze*

M. Greuze exhibited his picture of *The Wedding*, or the moment when the father of the bride hands the dowry over to his son-in-law. This picture is, in my opinion, the most pleasant and most interesting of the Salon. It had a prodigious success. It was almost impossible to get close to it. I hope that it will soon be engraved so that all interested persons can be satisfied. But before I express my own opinion, let me transcribe that of M. Diderot. It is he who now speaks:

At last I have seen this picture by our friend Greuze, but not without difficulty; it continues to attract the crowd. It represents a father who has just paid the dowry for his daughter. The subject is moving, and in looking at it we feel captured by a tender emotion. The composition seems very beautiful to me; it tells the story the way it must have happened. There are twelve persons; every one is placed and acts as he should. How they are all intertwined! How the lines of the composition undulate and form pyramids!

. . . Teniers paints customs perhaps more truthfully, but there is more elegance, more grace, a more pleasant characterization in Greuze. His peasants are neither ruffians like those of our good Fleming, nor chimerical like those of Boucher. . . .

One might reproach Greuze for having repeated the same head in three

different paintings. The head of the father who pays the dowry is the same as the father who reads the Bible and, I believe, also that of *The Paralytic*. Or at least they are three brothers with a great family resemblance.

Another fault: Is this older woman a sister or a servant girl? If she is a servant she should not lean against the back of her master's chair, and I don't know why she envies her mistress her fate so violently. If she is a member of the family, why this lowly appearance, why be dressed in a negligee? Happy or unhappy—she should be properly dressed for her sister's betrothal. . . .

But we really ought to ignore these trifles and show our enthusiasm for a picture which is full of beauty. Greuze has certainly excelled himself. This picture will do him honor as a painter learned in his art and as a man of intelligence and good taste. His composition is sparkling and delicate. His choice of subjects is characterized by sensibility and morality.

<div align="right">

Denis Diderot. "Salon de 1761."
Œuvres complètes, vol. X, Paris, 1876, p. 151 ff.

</div>

The public closed their eyes on the clashing colors, the dissonant tones, . . . the garish lighting, and on all the blemishes and shortcomings in the execution of this masterpiece. They were fascinated, enraptured, and moved by the scene, the idea, and the emotions depicted in the canvas. They saw only the good nature of the old father, the telling gestures of the mother . . . the sadness of the younger sister hiding her tears . . . the bashfulness of the young bride. . . . The public applauded the discreet subtlety of the details, the wit of the trifling little touches the painter had put here and there, the ingeniousness of his allusions, . . . the allegory in the foreground showing a hen with her chickens. . . .

The success of the picture confirmed Greuze in his aims, in his mission to portray the manners and morals of the middle and the lower classes, for which high society had developed a taste, curiosity, and interest. . . .

Greuze became the painter of Virtue. He became the disciple of Diderot— who was at once his master and his flatterer. . . . He aspired to realize the concepts with which Diderot had prefaced his dramatic works. Like Diderot, he wanted to play upon the heartstrings of the public, instilling in them a sense of moral decency. By means of colors and lines he wanted to touch the spectator deeply and intimately and to stir up his emotions, to inspire in him the love of virtue and the hatred of vice. He wanted to create a moral art out of an imitative art. Like the poet, the orator, and the novelist, he hoped to reach the heart of man, to induce morality with his brush, to spread it by means of images —such was the dream of the painter who was destined to found in France the deplorable tradition of literary painting and moralizing art.

<div align="right">

Edmond and Jules de Goncourt. "Greuze (1863)."
L'Art du XVIIIe siècle. 3 vols. Paris, 1909–10, II, 17 ff.

</div>

Girl with Dead Canary
Jeune fille qui pleure son oiseau mort

1765 oil on canvas 20″ x 18½″ (oval) Edinburgh, National Gallery of Scotland

What a lovely elegy! What a beautiful poem! Gessner* would have composed a perfect idyll! . . . The painting is utterly delightful; it is certainly the most charming and perhaps the most interesting of the Salon. The girl is shown full face, her head resting on her left hand; the dead bird lies on the upper shelf of the cage, its head hanging, wings drooping, and its feet in the air. How natural she looks, what a lovely head, how elegant the arrangement of her hair, how expressive her face! Her sorrow is deep, and she abandons herself utterly to her grief. . . . At first sight we think, "How delightful!" And as we linger there or return again to this painting we cannot help repeating, "How delightful, how charming!" Soon we find ourselves talking to that child, consoling her. . . .

Your sorrow seems very great, my dear, and you are so pensive! What does this dreamlike, melancholy air signify? You can't be grieving like that just

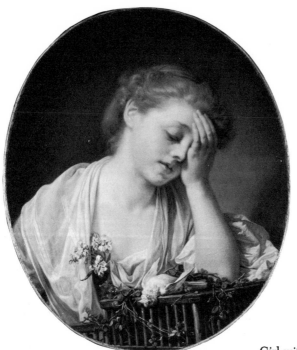

Girl with Dead Canary. *Greuze*

* The Swiss poet and painter Salomon Gessner (1730–88), author of the pastoral prose poems *Idylls* (1756).

for a bird! Open your heart to me, my dear, and tell me the truth; is it really the death of the bird that has made you so sad and introspective? . . . You lower your eyes, you don't answer me. You are close to tears. Come, I'm not your father, and I am neither strict nor indiscreet. . . . Oh well, let me guess. He loves you, he has sworn it, sworn it for such a long time. He was suffering so, and how can we bear to see those suffer whom we love! . . . This morning, unluckily, your mother was away, and he came while you were alone. He was so handsome, so passionate, so tender, so charming! His eyes were full of love, and there was so much sincerity in his face as he told you things that went straight to your heart! And while he was saying them he must have knelt at your feet. He was holding your hand, and from time to time you felt his warm tears as they rolled down your arm. And all the while your mother did not come back. This wasn't your fault, my dear, it was your mother's. . . . Meanwhile, your canary sang in vain, he tried to call you, warn you, flap his wings and complain of your neglect. But you did not see him or hear him, you had other thoughts on your mind. Neither his water nor his seed were replenished, and this morning the bird was no more. . . .

This little poem is so subtle that many people have not understood it; they thought the young girl was grieving only for her canary. . . . Would it not be as foolish to attribute the tears of the young lady of this Salon to the loss of a bird, as it is to assume that a broken mirror could be the cause of grief of the girl of the previous Salon?* This girl weeps for another reason, I tell you. You see, she agrees, and her pensive sorrow reveals the rest. Such grief at her age can't be just for a bird!

<div align="right">Denis Diderot. "Salon de 1765." <i>Œuvres complètes,</i>
vol. X, Paris, 1876, p. 343 ff.</div>

FRANÇOIS HUBERT DROUAIS

Born in Paris in 1727, he was taught by his father (Hubert Drouais), Nonotte, Carle Van Loo, Natoire, and Boucher. In 1754 he became an associate and in 1758 a full member of the Academy. He participated in the Salons from 1755 to 1775. As *premier peintre du roi* he was the painter of royalty and nobility, and did portraits , among others, of Louis XV and Louis XVI (Musée de Picardie, Amiens) and Marie Antoinette (Chantilly). Drouais died in 1775.

M. Drouais paints little children well. He puts life, transparency, and a moist, rich, and floating quality into their eyes. They seem to

* Diderot is referring to Greuze's painting *The Broken Mirror* [1763; Wallace Collection, London].

look and smile at you from close by. But when he wants to paint white and milky flesh tones, they become chalky.

<div align="right">

Denis Diderot. "Salon de 1763." *Œuvres complètes,*
vol. X, Paris, 1876, p. 206.

</div>

As usual the best possible chalk. But tell me, what is that madness? Is it a sickness of the mind, or of the eyes? Imagine faces and hair of whipped cream, old stiff fabrics looking as if they had been put through a mangle, a dog of ebony with eyes of jade, and there you have one of his best pictures.[*]

<div align="right">

Denis Diderot. "Salon de 1767." *Ibid.,*
vol. XI, p. 160.

</div>

François Hubert Drouais is one of the most typical portrait painters of the eighteenth century. Indeed, he manifests their faults rather than their qualities. His work is artificial, conventional, and superficial, having neither the broad, loaded brush stroke, nor the warm color and happy charm of Nattier. Some of his portraits are free from certain

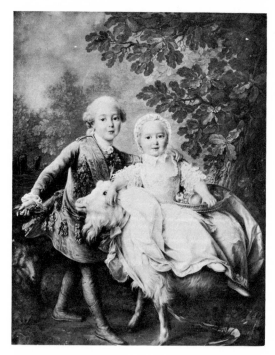

The Count of Artois
and His Sister.
Drouais

[*] Diderot refers perhaps to Drouais's *Portrait of the Countess Brionne with a Black Dog.*

imperfections caused perhaps more by his inability to resist what was fashionable and successful than by any lack of talent; but even in others we cannot deny him artistry of composition, wit, and a charm at once affected and simple, which is entirely his own. Of course we must not expect of Drouais character delineation or the specific indications of the physiognomies of his contemporaries; he will, however, be a marvellous informant about the current fashions. . . .

In his day François Hubert Drouais enjoyed a tremendous popularity, matching that of Nattier. . . . He became the portrayer of elegant, conventionally dressed children. Even when he yields to the taste for the pastoral, which began to establish itself at that time, and places his little gentlemen and gentlewomen in a theatrical costume, pose, and setting, this makes him no less an historian of eighteenth-century manners. Although Diderot, who was annoyed by his chalky color and his artificiality, often criticized his work adversely, Drouais was still universally admired in his time.

Louis Dumont-Wilden. *Le Portrait en France.*
Brussels, 1909, p. 179.

JEAN HONORÉ FRAGONARD

Born in 1732 at Grasse in Provence, Fragonard went to Paris about 1742. He studied briefly with Chardin and the more congenial Boucher and won the Rome Prize in 1752. In preparation for his Roman journey he entered the École Royale des Élèves Protégés under Carle Van Loo. In 1756 he was in Rome, where he made friends with Hubert Robert; they met the Abbé de Saint-Non, a wealthy art patron and collector, who took them on a voyage to southern Italy and Sicily. Fragonard returned to Paris in 1761. He became an associate of the Royal Academy by acclamation in 1765 on presentation of his *High Priest Coresus Sacrificing Himself to Save Callirhoë* (Angers Museum). But he quickly abandoned history painting for the gallant and amorous subjects that made him famous. Although he exhibited only in two Salons, those of 1765 and 1767, and therefore attracted little notice from contemporary critics, he received commissions from wealthy clients, such as the farmer-general Bergeret, with whom he traveled to Italy from 1773 to 1775, and from Madame du Barry. Madame du Barry, however, rejected one of his major works, *The Progress of Love* (now in the Frick Collection, New York), intended for her château at Louveciennes. Fragonard took the paintings with him to Grasse to which he fled in 1790. Returning to Paris the following year he found that the vogue for his art had ended. David, his former pupil, secured a position for him in the newly created Louvre Museum. In 1806, Fragonard, like all other artists, had to give up his apartment in the Louvre. He died the same year in complete obscurity.

His work has all the magic, all the intelligence, and all the necessary pittoresque trappings. The ideas of this artist are sublime. He merely needs a more lifelike color and greater technical perfection, which only time and experience can give him.

Denis Diderot. "Salon de 1765." *Œuvres complètes.*
vol. X, Paris, 1876, p. 406.

The last century had no poets; I do not mean rhymers, verse-makers, or word-setters; I do say poets. Poetry, in the truest and most profound sense of the word, . . . was unknown in eighteenth-century France; her only poets were two painters: Watteau and Fragonard.

Watteau, a child of the North . . . , was the great love poet, whose wistful magic sighed deeply through melancholy autumn woods; he was the *pensieroso* of the *Régence.* Fragonard, on the other hand, was the minor poet of the *ars amatoria* of his age.

Do you remember, in *The Embarkation for Cythera*, that bunch of naughty little naked cupids, almost vanishing into the sky? Where are they going? They are bound for the studio of Fragonard, where they shed the dust from their butterfly wings onto his palette.

Fragonard was the libertine storyteller, the gallant *amoroso*, pagan and playful, whose mischievous wit was Gallic, whose genius was almost Italian, and whose intelligence was French; he was the creator of ceiling mythologies and of frivolous forms of undress, of skies roseate with the reflections from the skin of goddesses, and of alcoves lit by the glow of a woman's body. . . .

Every aspect of Fragonard's art, his palette, his imagination, the bloom of his ideas, sentiments, and colors, was derived from the Midi. Do not all his paintings look as if improvised beneath a blue sky, upon an easel in a garden enveloped in a soft atmosphere, in the breath of summer, surrounded by music and sweet echoes from the fading strains of a troubadour song, a *canzona* by Petrarch, or the last sighs of the Courts of Love mingled with the harmonious splashing of the fountain of Vaucluse? . . .

Fragonard the painter was a sketcher of genius. It is in his sketches that he excels. He is the master of the first inspiration, of the preliminary study, improvising groups of nymphs and Graces whose rippling naked forms emerge from his canvas as if touched in flight. . . .

The memory of Fragonard survives almost exclusively in his works. Behind the painter, the man is barely visible. We know almost nothing about him. The newspapers, reviews, obituaries are silent about this gracious artist who achieved fame without clamor. With him, the biographer is at a loss. . . . Research yields only a few dates,

a few references, the mere glimmers of his personality. . . . Even his features evade us. . . .

Fragonard's drawing is his handwriting: It is his medium of correspondence. . . . It is even more: his drawing is, so to speak, the diary of his creative ideas. All his thoughts are released through his drawings: they are his confessions and the flights of his imagination. A complete collection of his drawings would be the light-hearted and poetic history of his life, his ideas, his tastes, his opinions, and his moods; they would be the memoirs of both the painter and the man. . . . His paintings do not tell us much about him: in his paintings, he was Fragonard; in his drawings, he was both more and less: he was quite simply and intimately, *Frago.*

<div style="text-align: right">

Edmond and Jules de Goncourt. "Fragonard (1865)."
L'Art du XVIII^e siècle. 3 vols.
Paris, 1909–10, III, 241 ff.

</div>

Fragonard worked with a speed which was quite prodigious. It amazed the naïve Bergeret, who noted, in his *Account of the Trip to Italy,* while they were passing through Uzerche in Limousin and he saw the painter toss off a sketch in the twinkling of an eye: "M. Fragonard immediately made a drawing of the site. He never wastes time in what he undertakes. . . . Before you can count to ten his drawing is finished. If you were to count to twelve, you would see his sheet replete with the entire countryside down to its inhabitants and even its animals."

. . . Fragonard triumphs in the quick sketch: there is nothing more delectable, more crisp than the drawings he turned out at a single sitting. However, he too often stopped there. . . . Works on a large scale that require a long gestation intimidated or bored him, and only once in his life did he turn out a *grande machine: The Sacrifice of Callirhoë,* an academic assignment. He abandoned it after passing the examination.

It is a mistake to dismiss Fragonard as a lesser master. . . . He deserves much more than that: he has all the gifts of a great painter.

To a highly developed knowledge of the effects of lighting and of chiaroscuro derived from the school of Rembrandt, Fragonard adds a most brilliant coloring, predominating in chrome yellows and vermilions, which he harmonizes with a superb authority equal to Rubens or Tiepolo. The splendor of these red and gold harmonies is incomparable . . . in his portraits of *Diderot* and *The Abbé de Saint-Non* [Museum of Modern Art, Barcelona]. Along with such bursts of color, however, what delicacy, what an exquisite sense of nuance there

<div style="text-align: right">257</div>

is in his thinly painted canvases "in luminous, pearly, bluish, roseate, iridescent harmonies."

One cannot speak of Fragonard's technique without mentioning his brush stroke—even more resplendent than his palette. It is the animation of his brush that distinguishes him at first glance from his master Boucher. His line is nervous and broken, his folds are angular and in the form of triangles and chevrons, with none of the rounded contours that make Boucher's figures so vapid. Toward the end of his life, under the influence of the lesser Dutch masters and certain collectors who demanded a preciousness of finish, his surfaces tended to become glossy and smooth....

What is it that prevents this fine painter from being a very great artist, an artist of the stature of Poussin and Watteau?

He is not a thinker; painting was never a *cosa mentale* for him. ... We would search in vain for works that move the intelligence or the sensibilities to the same degree as *Shepherds in Arcadia* and *The Embarkation for the Island of Cythera*. He is as exhilarating as the sparkling froth on a glass of champagne; he provides no substantial nourishment for either thought or dream. His art is only skin-deep; it does not generate the deep reverberations of certain of Rembrandt's masterpieces. Herein lies the limit of his genius.

But if the ultimate end of painting is to be above all a "delight to the eye," who then surpasses Fragonard's art, which was conceived, to quote Poussin, as "an unending source of delectation?"

Louis Réau. *Fragonard; sa vie et son œuvre.*
Brussels, 1956, p. 129 ff.

Fragonard is indeed, with Watteau, one of the greatest painters of the eighteenth century, and without doubt one of the very great French painters of all time.

He owes this high position firstly to his subjects, which make him the painter of his age, the recorder of this sensual, voluptuous, charming eighteenth century, and of the age of Louis XV, of the *fermiers généraux*, the tax-farmers, and of the pleasure-loving and passionate *bourgeois* who were soon to overthrow the monarchy. While his master Boucher was amusing himself with allegories and bucolic scenes, while the successors of Watteau lingered in the world of *fêtes galantes*, Fragonard, to the great indignation of the art critics of his time, turned his back on antique and mythological subjects in order to produce what since Courbet has come to be called "living art." Thanks to him, we have a picture of the life of his age, and ever since the eighteenth century this has been one reason for his success. His rather daring subjects, which he painted at the time of his belated

marriage, do not show the mawkish sentimentality of those by Greuze, but remind us that the painter was the contemporary of Beaumarchais (born, like him, in 1732), of Dorat and Restif de la Bretonne (born in 1734) and of Casanova (born in 1735), and that Laclos and de Sade were born only a few years after him. Besides, if he repeated, with evident pleasure, these indelicate pictures and drawings, it was partly to satisfy public taste which was growing more and more eager for them on the eve of 1789. To be sure we are not trying to make out that Fragonard was a moralizer or a spiritual guide, but we must insist that he was always happy in his paintings of family life, of joyful mothers and pretty children, scenes which he depicted in a spirit of realism which has nothing affected about it. He is also, it cannot be said too often, one of our great landscape-painters, the first French artist to capture effects of cloud and storm equal to a Castiglione or a Hobbema. Above all he has revealed, as no-one else, the charm of Roman villas with their tall pines and poplars, and the charm also of the broad landscapes of the Ile-de-France, with flocks of sheep and washerwomen. At the close of his artistic life his amorous allegories make him an ancestor of the romantics in the manner of Sénancour, or rather Chénier. Like the latter, his lovers cry out, "I belong to you, Love, inexorable Love."

<div style="text-align: right">Georges Wildenstein. *The Paintings of Fragonard.*
London, 1960, p. 43.</div>

The Swing
Les Hasards heureux de l'escarpolette

ca. 1767 oil on canvas 30" x 25½" London, Wallace Collection

"Would you believe," said [the painter Gabriel-François] Doyen to me, "that a few days after the exhibition of my picture [*The Miracle of St. Geneviève des Ardents*] in the Salon a gentleman of the Court sent for me to commission a picture. . . ? The gentleman [the Baron de Saint-Julien] was with his mistress in his villa when I went to see him to find out what he wanted. He showered me with courteousness and praise and finally confided to me that he was consumed with desire to have a picture painted of a subject he would outline for me. 'I would like you to paint Madame' (pointing to his mistress) 'on a swing which is being pushed by a bishop. As for me, I would like to be placed somewhere in the painting so that I can have a good view of the legs of this charming girl. . . .' I must confess," said Doyen, "that this proposition, which I could hardly have expected considering the nature of the painting that had prompted the offer, confounded and petrified me at first. I recovered myself sufficiently, however, to be able to reply almost at once: 'Ah, Monsieur, we

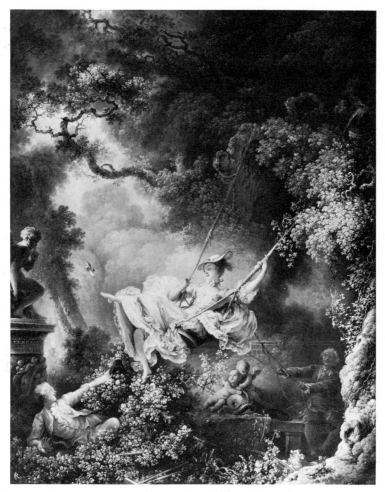

The Swing. *Fragonard*

must elaborate on your idea for this picture by showing Madame's slipper flying up into the air and caught by cupids.' But since I was unwilling to treat such a subject . . . I referred the gentleman to M. Fragonat [*sic*] who agreed to undertake the commission and is in the process of executing this singular work."

Charles Collé. *Journal et mémoires.* 3 vols. Paris, 1868, III, 165. Entry for October 2, 1767.

A small but famous painting, *The Swing*, was, as it were, Fragonard's reception piece into the gallant art, a masterpiece which immediately placed him in the forefront and made him a leader in this genre. The anecdote related

by Doyen to Collé, who revealed it in his memoirs, serves also to illustrate the way in which certain subjects were imposed on artists. . . .

The scene opens in a very pretty setting with contrasting light and shadow, roses growing on the bushes and trelliswork, and a profusion of heavy branches stemming from the great tree with its smooth, unfettered trunk. The execution is judicious, the brush moves in small, measured strokes. The young master has not yet acquired his rich and flowing style; the details are too studied, the drawing too precise; but what a delicious little thing is this fair-haired child enveloped in pale golden light! Like a great pink butterfly she takes wing in a halo of petticoats, flinging out her little satin slipper toward the Cupid who gazes so earnestly at her, then trying to keep hold of it by the sweetest gesture, sending a bright confusion of silken skirts swirling into the air. One finger raised, she chides this plight which places her in such a naughty attitude; she is amused, annoyed, charming; her eyes are fearful but her mouth is smiling. There are flowers everywhere, on the lawn and the trellis; in this exquisite painting of springtime, the charm of execution and the painter's tact have redeemed the indelicacy of the subject. It almost seems as if we are witnessing the birth of a new kind of light-hearted art, to which, more than any other, "Frago" will link his name.

Pierre de Nolhac. *Fragonard*. Paris, 1931, p. 110 ff.

The Festival of Saint-Cloud

oil on canvas 85½ " x 133" Paris, Banque de France

From about 1767 to 1773 we find Fragonard occupied with various decorations, as well as painting for the Baron de Saint Julien the compositions known under the title *La Main chaude* [*A Game of Hot Cockles*] and *Le Cheval fondu* [*A Game of Horse and Rider;* both in the National Gallery of Art, Washington].

Of a brighter, though extremely harmonious tonality is *The Festival of Saint-Cloud*. Its masses of verdure, its play of water, parades, strollers, and marionette theater are sketched in a brilliant manner and bathed in sunshine. On the left, Colombine jests with the motley crowd; in the center are merchants selling trinkets and children busying themselves around a pile of cakes. These groups are dominated by the huge water jet falling in a luminous spray. Great arches rise in the distance, drenched in the moist atmosphere of a bright summer afternoon. Here is the gay representation of the festivals of bygone times. . . . It is a large and beautiful painting, the artist's masterpiece.

Roger Portalis. *Honoré Fragonard, sa vie et son œuvre*.
Paris, 1889, p. 82 ff.

261

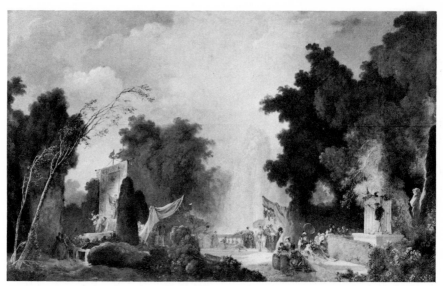

The Festival of Saint-Cloud. *Fragonard*

Here, rather than in any bacchanal or ostentation of nudes, the fastidious voluptuary may find the life of which he dreams and of which he must always be frustrated. Nymphs as witty as they are seductive and kind; youthful gallants to whom these with a wise intuition prefer him; actors and singers to fan or to renew his flame; marionettes to reassure him that life is but a comedy, in case some grave reflection break in for a moment upon his errands. The painter has devised a Nature in gauze and feathers, a millinery of trees, under which to be private, and yet so little removed that the music will drift through the shadows to attend the grateful libation. Nor need one be at the bother of kissing. On these ample lawns those who prefer can indulgently elude the Paphian crew, and abandon themselves to the lazier cult of pretty memories.

Without the melancholy of Watteau, Fragonard yet knows that a touch of sentiment is becoming to the lightest loves; without Boucher's cynicism, Fragonard is just for this reason more masterly in provocation. "Oh, to have lived when frivolity could be thus poetical," sighs the modern rake—but it never was. A junketing at Saint-Cloud, which no doubt could be charming enough, has been turned to a vision of Armida's Garden.

Raymond Mortimer. "The Desirable Life." *The Arts* (London), no. 1, 1946, p. 67.

HUBERT ROBERT

Hubert Robert, a Parisian born in 1733, went to Rome at the age of twenty to study painting at the French Academy, at that time under the direction of Natoire. He met Pannini and Piranesi and adopted their style of romantic representation

of ruins. With his close friend Fragonard he undertook a trip to southern Italy in 1761. Robert returned to Paris in 1765 and was admitted to the Royal Academy the following year. He continued to paint Roman ruins, but added French gardens, palaces, and street scenes to his visual repertory. In 1784 he was named Keeper of the King's Pictures by Louis XVI. During the Revolution, Robert was imprisoned for eight months. Freed after the fall of Robespierre in 1794, he became Curator of the newly established Musée du Louvre in 1795. He died in 1808.

Oh these beautiful, these sublime ruins! What vigor, and at the same time what delicacy, certainty, and facility in the brushwork! If only I knew whose ruins they are, so that I might steal them. . . . It is with amazement and surprise that I view this shattered arch and the masses superimposed upon it. Where are the men who built this monument, what has become of them? In what enormous, dark, and silent depths must my eye lose itself? How tremendously far away is that bit of sky that I glimpse through the opening! The gradations from light to darkness are astonishing! See how the light pales as it comes from the top of the arch and descends along the long columns, how the gloom is hemmed in by contrasting daylight at the entrance and in the background! I never tire of looking at this painting. For those who admire it time seems to stand still. How little time I've had to live, how short was my youth! . . .

I shall tell you my opinion right away, M. Robert. You are an able man and you will excel, indeed, you already excel, in your genre. But study Vernet, learn from him the skills of draughtsmanship, of painting, and how to make your figures interesting. And since you have devoted yourself to painting ruins, take note that this genre has a poetry all its own, a fact of which you seem to be completely oblivious. You ought to search for it. You have the right manner, but you miss the point. Can't you feel that there are too many figures here, that three-fourths of them should go? Only those should remain that add to the feeling of solitude and silence. . . . M. Robert, you still don't understand why ruins give so much pleasure, quite apart from the variety of past incidents they suggest. Let me tell you what comes to my mind on the subject at this very moment:

The thoughts that ruins arouse in me are profound. Everything ends in nothingness, everything perishes, everything passes. Nothing but the world itself remains. Nothing but time itself endures. How old this world is! I walk along between two eternities. . . . What is my short existence in comparison to the settling of this rock, to the gradual deepening of this valley, to the dying of this forest, to the disintegration of these masses of stone suspended above my head? I see marble tombstones crumbling into dust, and I do not want to die! I vainly wish

to guard this frail tissue of flesh and fiber from the universal law to which even bronze is subjected! . . .

If anything remains to be said regarding the poetry of ruins, M. Robert will bring me back to it.

Denis Diderot. "Salon de 1767." *Œuvres complètes,* vol. XI, Paris, 1876, p. 228 ff.

Robert was a gifted and inventive artist. As a friend and follower of Fragonard, Robert learned to see antiquity not through the glasses of the historian, but rather with the eyes of the poet and the painter. While he was never to attain the stature of his mentor, Robert's vigor of conception and the lightness and fluidity of his colors make him appear ever lively and fresh. The early influence of Pannini, whom Robert considered his principal teacher after nature itself, and of whose work he possessed no less than thirty originals, was supplemented by the impact of Piranesi's engravings. But it was his friendship with Fragonard which played the most decisive role in Robert's artistic development. With this kindred spirit Robert spent the happy and productive period in Tivoli and Naples . . . which resulted in the great set of engravings of the Abbé St. Non. . . .* Robert's superiority

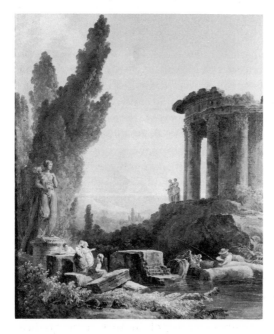

Antique Ruins.
Hubert Robert

* *Différentes vues dessinées d'après nature dans les environs de Rome et de Naples, par Robert et Frago,* 1761–63.

to Vernet becomes evident when we compare his *Pont-du-Gard* at the Louvre with a similar subject, Claude-Joseph Vernet's *The Bathers,* also in the Louvre.

Edmund Hildebrandt. *Malerei und Plastik*
des achzehnten Jahrhunderts in Frankreich.
Wildpark-Potsdam, 1924, p. 157.

Robert des Ruines, as his contemporaries liked to call him, . . . was sent in 1754 to study at Rome, where he spent eleven years. . . . These eleven years were the foundation of his entire art; during them he not only received the inspiration but also made actual sketches which were to serve him as a basis for nearly all his painting after his return to France in 1765.

It was in Rome and the Campagna that he made his extensive studies of Classic architecture and of landscape as well. It was from his Roman master, Pannini, that he learned the style which he, as a pupil, was to surpass and bring to France as the unchanging formula for a lifetime of success.

Yet from his first Parisian successes of 1765 to his death as a still famous painter and as one of the first organizers of the picture gallery at the Louvre, Hubert Robert was far more than an able mannerist and stylist. He caught the spirit of his times in landscape as his friend and colleague Fragonard caught it in subject pictures. His scenes are composed with the precise balance of the architecture of antiquity which they most often depict. His coloring is among the most restrained and appealing of eighteenth century painting, and his draftsmanship is quite as famous for itself, through the great number of his drawings still extant, as are his oils. In some of his pictures, like his views of the destruction of houses along the old Pont-au-Change and of the two great fires at the Opéra, as well as his lovely paintings of the parks of Versailles and other great châteaux, he is one of the most agreeable historians of the eighteenth century as well as one of its most delightful painters.

Alfred M. Frankfurter in *Exhibition*
of Paintings and Drawings by Hubert Robert
(Wildenstein & Co., Inc.) New York, 1935,
no paging.

Like Joseph Vernet, Fragonard, and Louis-Gabriel Moreau, Hubert Robert never represents nature as he sees it. He makes a choice and paints his landscapes from sketches, in the studio. He thus follows a course which eliminates any possibility of realistic representation,

265

but gives him all the freedom to abandon himself to the whims of his imagination.

> Alfred Leroy. *Évolution de la peinture française des origines à nos jours*. Paris, 1943, no paging.

LOUISE ELISABETH VIGÉE-LEBRUN

Vigée-Lebrun (or Le Brun) was born in 1755 in Paris; her father was the pastelist Louis Vigée. She studied painting with him and with Greuze, who was her father's friend. At the age of fifteen she began to be known as a painter and at nineteen she was a member of the Academy of St. Luke. In 1776 she married the picture dealer Pierre Lebrun, whom she later divorced. In 1779 Vigée-Lebrun was called to Versailles to paint the first of her many portraits of Marie Antoinette. She received the official title "Painter to the Queen" and was admitted to the Royal Academy in 1783. As a supporter of the *ancien régime,* Vigée-Lebrun left France at the outbreak of the Revolution and traveled to Italy, Germany, and Russia, where she painted portraits of the nobility and celebrities of these countries. In 1802 she returned to France for a brief period but soon resumed her travels. Returning to France permanently in 1810, she died at Louveciennes in 1842. Her *Memoirs,* originally published 1835–37, appeared also in English translations by Lionel Strachey (New York, 1903) and Gerard Shelley (London, 1926).

It is not too much to say that some of her pictures are amongst the most universal favorites that can be named; one meets with them everywhere; they—and the affected, semi-sensuous, child-women of Greuze from which they are very different—are reproduced in every conceivable form. It must be allowed that, considering the extreme artificiality of her day, she was natural, and whilst she had not . . . "the naïveté of Chardin nor the realism of [Maurice-Quentin de] La Tour," there is grace without affectation, and a charm diffused over her work, which does not interfere with the sincerity of expression. Devoted to her art, in full sympathy with the women of her age—that is, of the circle in which she moved—she yet never produced anything with a spark of divine fire in it. Her art is equally devoid of pathos; it leaves us quite unmoved; the artist never rises to the highest planes of vision, whilst the depth of suffering and passion seem unknown to her. The vicissitudes through which she passed seem to make little or no impression on her art. But it must be owned she possessed no slight ability, rising often to a lifelike charm, which has made some of her pictures of women amongst the most popular which have ever been painted.

> J. J. Foster. "Madame E. Vigée Le Brun (1907)."
> *French Art from Watteau to Prud'hon.* 3 vols.
> London, 1905–07, III, 96.

In taking Vigée-Le Brun as her favorite painter, Queen Marie Antoinette rightly divined that her brush would be supple and flattering enough to capture the proud beauty of her youth, the splendor of her hair, and the glow of her complexion—sufficiently ingenious to temper the rest. The queen, whose disposition was charming but frivolous, devoted her time to the study of her dresses, the arrangement of her coiffure, the flower she held in her hand; Vigée-Le Brun understood her royal model admirably, for she, too, was motivated by the same lively and constant desire to please!

Perhaps the best of her numerous female portraits are those which represent the artist herself, with her pleasant smile and slightly detached, faraway expression. . . . In the pretty, seminude self-portrait in the Louvre she is clasping her wide-eyed young daughter to her heart, her radiant face full of the joy which possesses her. The emotion here is both profound and strongly felt. It is the expression of maternal love which strikes us first, and only later are we able to observe the fine modeling of the arm, the delicately drawn hand, the white shoulder, and the rich color of the fabrics and red bow holding back her hair.

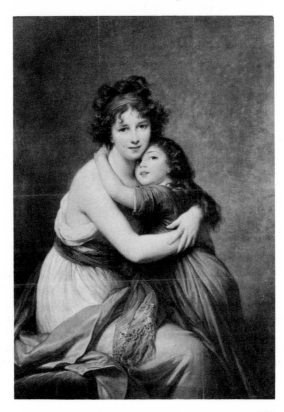

Portrait of the Artist
and Her Daughter.
Vigée-Lebrun

Friendship also played an important role in Mme. Vigée-Le Brun's life, in particular her friendship with certain men, which, although not so profound as the love she felt for her daughter, sometimes enabled her to rise above the usual level of her art. These men, including Vernet, Grétry, and Hubert Robert, represented the image of the intellectual. However, Vigée-Le Brun, the amiable friend of the Count of Vaudreuil, covered too many canvases to allow us to discover more than a few masterpieces among them. She herself has given us a count: six hundred and sixty-two portraits, not to mention the numerous formal paintings and landscapes! A good many of these were painted abroad, for demands to be painted by her came from all over Europe and she accordingly took her brushes to Turin, Rome, Naples, Vienna, St. Petersburg, Berlin, Dresden, and London. Her longest stay was in Russia, where she remained for six years. Throughout this period she used to work every day from morning to night, reserving only Sunday for visitors and for receiving the compliments of the next day's sitters. The authentic lists of her sitters are still preserved and contain names of many of the sovereign rulers and illustrious beauties of that epoch.

> Pierre de Nolhac. *Madame Vigée-Le Brun; peintre de Marie-Antoinette*. Paris, 1912, p. 2 ff.

JACQUES-LOUIS DAVID

The son of an ironmonger, David was born in Paris in 1748 and studied briefly with Boucher; in 1765 he entered the studio of J. M. Vien, then the best-known teacher in Paris. After winning the Rome Prize, he set off for Rome with Vien in 1775. Deeply moved by the ancient statuary he saw and studied in Rome, David renounced his earlier rococo style and adopted the emerging neoclassicism. He was back in Paris in 1781 and became an academician in 1782.

Returning to Rome for another eighteen months, he painted *The Oath of the Horatii* (Louvre), perhaps the most important French neoclassic painting, which was exhibited first in David's Roman studio and then in Paris at the Salon of 1785.

With his subsequent paintings, *The Death of Socrates* (1787; Metropolitan Museum of Art, New York) and *Brutus* ("The Lictors Bringing the Bodies of His Sons to Brutus," 1789; Louvre), David established himself as arbiter of taste and soon assumed virtual control of all the arts in France. During the Revolution he was a delegate to the National Convention and voted for the execution of Louis XVI. He abolished the Academy, thus freeing the artists from its rigid rules, and helped to found the Institute of France, of which he became a member. After the fall of Robespierre, David was imprisoned for several months; in his cell he painted his only landscape, *View of the Luxembourg Gardens* (1794; Louvre). He met Napoleon in 1798 and became his ardent supporter. During the Consulate he painted

The Rape of the Sabines (1799; Louvre); as *premier peintre de l'empereur* he produced a series of huge canvases glorifying Napoleon, among them *The Coronation of Napoleon* (1805–07; Louvre) and *The Distribution of the Eagles* (1810; Versailles). After Napoleon's defeat at Waterloo in 1815, David fled first to Switzerland, then to Belgium. David maintained a large studio—he sometimes had as many as sixty pupils, the most important of whom were Gérard, Girodet, Gros, and Ingres. He died in Brussels in 1825.

I have set out to do something entirely new. I want to restore art to the principles followed by the ancient Greeks. When I painted the *Horatii* and *Brutus* I was still under the Roman influence. But without the Greeks the Romans would have remained barbarians in matters of art. We have to revert to the source; this is exactly what I am about to do. I shall surprise many people. In my picture *[The Rape of the Sabines]* all the figures are nude, and there are horses without reins or bridle. I want to paint in a pure Greek style. I feed my eyes on antique statues, I even intend to imitate some of them. The Greeks had no scruples about copying a composition, a gesture, a type that had already been accepted and used. They fixed all their attention and all their art on the perfection of a previously conceived idea. They thought, and rightly so, that in art the way of rendering an idea, and the manner of expressing it, was much more important than the idea itself. To give a shape and a perfect form to one's thought, this—and only this—is the true meaning of being an artist.

> J.-L. David (1799). Quoted in E. J. Delécluze.
> *Louis David, son école et son temps.*
> Paris, 1855, p. 61 ff.

As for M. David, while it would be a real injustice to humiliate all the other artists before him, it would, in my opinion, be equally unjust to deny him the title of leader of our school, which his talent and his work have already earned for him even abroad. Trained by M. Vien, who had preserved moderation and common sense amid the excesses of Boucher and his contemporaries, he has nurtured and matured the great talents nature has bestowed on him through the constant study of the masterpieces of Italy, among them, above all, the magnificent remains of antique sculpture. . . .

It is not, however, in the antique alone that David finds his great and original ideas—the old Horatius arming his three sons, his five-year-old grandson biting his lip as he looks at this spectacle with a kind of envy; Brutus, alone within his family and exiled, as it were, in his own house, finding shelter only beneath the shadow of the god-

dess to whom he has just made such a tremendous sacrifice*; Socrates continuing his discourse as he stretches out his hand to the peril of the hemlock; *The Oath of the Tennis Court*†, one of the most beautiful compositions engendered by modern art, in which a multitude of figures animated by the same emotion takes part in a single action without either confusion or monotony—all this undoubtedly stems entirely from the soul and genius of the artist. But the elements derived to a great extent from the study of the models we have just mentioned are the grandeur and majesty of his compositions, the delicacy and exquisite truthfulness of the facial expressions, varying in accordance with age and sex, the fidelity of all his details, the beauty we find in his forms, the flowing simplicity of the draperies, his touching and austere naïveté, and the free and noble elegance that belongs to all time and all places.

> André Chénier. "Sur la peinture d'histoire (1792)."
> *Œuvres complètes.* Paris, 1958, p. 286 ff.

We are on the eve of an artistic revolution. The huge pictures composed of thirty nude figures copied after antique marbles, and the ponderous five-act tragedies in verse, are very respectable works, no doubt. But whatever may be said in their favor, they begin to bore. If the painting of the *Sabines* appeared today, we would find that its personages lack feeling, and that anywhere in the world it would be considered absurd to march into combat without clothing. "But this is customary in antique bas-reliefs," say the classical painters, the people who swear by David and cannot utter three words without mentioning the term "style." What do I care about the antique bas-reliefs? Let us paint good modern pictures! The Greeks liked nudity. Nowadays we don't see it any more, and moreover, we find it revolting.

> Stendhal. "Salon de 1824." *Mélanges d'art
> et de littérature.* Paris, 1867, p. 21 ff.

About 1780 the journals, the new books, the intellectuals in their conversation, all the organs of public opinion, continued to extol the paintings of Boucher, [Jean-Baptiste] Pierre, Fragonard, and [Louis Jean François] Lagrenée; yet in spite of this unanimous praise, painting was dull. David understood this. He was aware of the impression

* Lucius Junius Brutus, who expelled King Tarquin the Superb and founded the Roman republic in 509 B.C., condemned his own two sons to death for conspiring with the deposed king.
† This painting was never completed. The drawing, now in the Louvre, was shown at the Salon of 1791.

any of Van Loo's large canvases made on the French public, even though praised to the skies by Diderot. He understood clearly that art had lost its power over the public. It adds to David's glory that his own early attempts in the worn-out and pallid style of 1780 had been crowned with the greatest success. He could have continued to paint in this vein without having to battle the tide of public opinion. . . . He would have been a famous painter like so many others, he would have had his turn at the Academy and at his death a fine eulogy in the *Mercure.* . . . But, fortunately for the fine arts, this kind of success seemed insignificant to the painter of the *Sabines;* his heart beat for higher glory. He had the courage to be an innovator, and for this he will be immortal. He realized that in 1789 the vague and indistinct style of the old school was no longer befitting to the aims of the French people. He painted his masterpieces and was cursed by all those who had a name and an assured existence in art.

From this moment the insipid style of painting was dealt a death blow. What a pity that narrow political considerations do not permit the administration of the Louvre to place beside the pictures of David a sample of the so-called skill of a [Carle] Van Loo, a Fragonard, a Pierre, or of any other illustrious painter of 1780. The public would then have an idea of the *audacity* of David. It would laughingly return the insults which those "great" men, fabricated by Diderot, in all seriousness heaped upon their young rival. . . .

This illustrious man [David] will perhaps be more renowned in posterity for the firmness of his character, which gave him the courage to be an innovator, than for the degree of pictorial beauty with which he endowed his paintings, or for the pleasure the spectator experiences before his pictures. David restored antiquity and consigned to oblivion the ridiculous figures of Boucher's young shepherds with their gold-braided hats.

> Stendhal. "Des beaux-arts et du caractère français; le Salon de 1827 (1828)." *Ibid.,* p. 167.

David's pictures . . . are not romantic or *revolutionary,* but they are completely French; they are in a little, finical manner, without beauty, grandeur, or effect. He has precision of outline and accuracy of costume; but how small a part is this of high history! In a scene like that of *The Oath of the Horatii,* or *The Pass of Thermopylæ* [1814; Louvre], . . . the attempts at expression are meagre and constrained, and the attitudes affected and theatrical. There is, however, a unity of design and an interlacing of shields and limbs, which seems to express one soul in the *Horatii,* to which considerable praise would be due, if they had more the look of heroes, and less that of *petit-maîtres.*

271

I do not wonder David does not like Rubens, for he has none of the Fleming's bold, sweeping outline. He finishes the details very prettily and skillfully, but has no idea of giving magnitude or motion to the whole. His stern Romans and fierce Sabines look like young gentlemen brought up at a dancing or fencing school, and taking lessons in these several elegant exercises. What a fellow has he made of Romulus, standing in the act to strike with all the air of a modern dandy!

William Hazlitt. "Notes of a Journey Through France and Italy (1826)." *Complete Works*, vol. X, London, 1932, p. 133 ff.

All paintings of a particular period have the same special characteristics—they are the painted symbols of the *Zeitgeist*. For example, a canvas of Watteau, Boucher, or Van Loo mirrors the graceful, powdered pastoral play, the rouged coquettish emptiness, the sweet crinolined bliss of the then prevailing Pompadour style; everywhere are light-colored beribboned shepherd's crooks, nowhere a sword.

In contrast, the paintings of David and his pupils are but the colored echo of the period of republican virtue somersaulting into the glory of imperialistic war. We see here a forced enthusiasm for the marble model, an abstract, frosty intoxication with rationalism. The drawing is correct, severe, harsh; the color dim, austere, indigestible; in other words, Spartan soups.

Heinrich Heine. "Lutezia (1843)." *Sämtliche Werke*, vol. V, Philadelphia, 1855, p. 402.

David's particular merit, which assures him an important place among the artists of renown, was to have been the first Frenchman who attempted to put into practice the theories expounded by the intellectuals of his time; furthermore, through the single-mindedness of his studies he was instrumental in establishing a new method of teaching painting, based on the doctrines of the ancients. . . .

The ideas of regeneration in art, adopted by David between 1775 and 1779, were first propounded and developed by Lessing, Heyne, Winckelmann, and Sulzer, then practiced by Mengs and Gessner, and finally readopted by David and applied by him to the art of painting in France.

The influence of these ideas on David did not come directly from Mengs, whose talent David never appreciated, and even less from the antiquarian philologists whose writings he knew only by title or by the engravings contained in their works. Nevertheless, it is easy to see from what has been said of the studies, relationships, and friendships of David during his two sojourns in Rome that this artist participated

in a great intellectual movement although he was not the one to set it in motion.

> E. J. Delécluze. *Louis David, son école et son temps.*
> Paris, 1855, p. 128 ff.

David is the striking example of an admirable artist who needed only to heed his talent in order to produce masterpiece upon masterpiece and who, for a certain period in his life, allowed his beliefs to seduce him into producing works not suited to his gifts. It would seem that David, the portrait painter, the impeccable realist, the possessor of infallible taste, was destined to become the natural link in the history of French art between the eighteenth and the nineteenth century, the forerunner of Ingres, Manet, and Degas, and it is indeed from this point of view and in this role that he remains so great. David himself, on the other hand, believed that it was his mission to bring the ancient Greeks and Romans back to life, to paint *The Oath of the Horatii,* the *Sabines,* and *Leonidas at Thermopylae.* He was so talented that even these *dessus de pendule* have their merits, but like Voltaire, who believed himself immortal because of his *Zaïre* but became so for his *Candide* (which in his eyes was just a simple drawing-room farce), so David touches us much more by the portrait of Madame Sériziat [Louvre] or of Charlotte du Val d'Ognes,* . . . than by his *Distribution of the Eagles.* And yet . . .

And yet, he would perhaps be less representative if he had not so naïvely permitted himself to mirror the ideas, prejudices, and palinodes of his time. Because he was a dogmatic and stubborn French bourgeois who took part in all the passions of his class, which was then clamoring for its rights, he has his place in the history of manners as well as in the history of art. He left his imprint not only on French artists but also on the artisans of France. . . . Both the Directoire and Empire styles owe their existence to his archaeological researches. . . . In his youth, he participated in the last years of eighteenth-century libertine decadence, but around 1785 he became one of the first to respond to the French need for a return to antiquity. He was later to sketch *The Oath of the Tennis Court (Serment du Jeu de Paume),* and to record for posterity the corpses of Marat and Le Peletier de Saint-Fargeau,† as well as the portraits of Saint-Just and Bailly. He also pitilessly sketched Marie Antoinette on her way to the guillotine.

* In the Metropolitan Museum of Art, New York. It is now attributed to Constance Marie Charpentier (1767–1849). See *Metropolitan Museum of Art Bulletin,* January 1951, p. 121 ff.

† This painting of Le Peletier de Saint-Fargeau is lost.

After the fall of Robespierre he enthusiastically espoused the cause of Bonaparte, and his portrait of the first Consul is the most beautiful one we have of Napoleon. He became official painter of the Empire, after he had been, during the Revolution, its master of ceremonies. For the entire duration of this, the most dramatic period in French history, David thus remained, despite his mistakes, despite his changes of allegiance or perhaps even because of them, by sheer force of talent, the universally acclaimed "first painter" of France. His political role would not have made a great artist out of him if he had not also possessed talent, but the epic background against which he depicted his beautiful portraits endow them with a strange and new charm.

André Maurois. *J.-L. David.* Paris, no paging.

For all that David was, until 1794, an *"artiste engagé"*—and probably no earlier artist was so conscious of the social functions and utility of art—he was nonetheless deeply concerned with the pure practice of his art, with creating a vital contemporary pictorial idiom. In this he can be compared with Picasso. . . . All his greatest work was done under the direct inspiration of a new social order in the years 1785–95. And the most mature, most sublime of all is undoubtedly the *Marat Assassiné* (Musée des Beaux-Arts, Brussels), painted at the height of his political activity. Life-like, unidealised, simple, this is a scene which David saw; but by pictorial science he has transformed a moment of horror into an eternity of sublime martyrdom. Neither here nor elsewhere was he tempted to turn propagandist. The effect is purely pictorial: the weird one-sided composition, the head and arm parallel to the surface of the canvas, the light directed from a hidden source on the left, the large empty space filling the upper half of the picture. As a composition it is remarkably daring; in effect, it is deeply religious—it is so to speak the Pietà of the Revolution, and forms part of a devotional trilogy with the lost *Le Peletier de Saint-Fargeau* and *Joseph Bara* (Musée Calvet, Avignon). . . .

The present exhibition* was especially revealing of David's technique, for it contained several unfinished works, all portraits. And one saw how he applied his paint in a series of small brush strokes of different colours. David did not paint with *à-plats*, but obtained a general tone by the juxtaposition of several. He is a most curious forerunner of impressionism. His colour scale was limited and restrained; modelling and shadows were obtained by *frottis*, by rubbing through liquid paint to the priming. This was generally done with his fingers

* David's bicentennial exhibition of 1948 at the Paris Orangerie, the Louvre, and Versailles.

or a very broad brush, and the effect is to produce light and transparency from within. With this in mind and taking account of his artistic personality there are a number of pictures hitherto attributed to David which should now be excluded. Though in considering the various problem pictures it is always necessary to remember that David trained over 400 pupils, that hardly any of his major works were executed without assistance, that copies of many of them were made in his studio and that some of his pupils had considerable ability.

Douglas Cooper. "Jacques-Louis David: A Bi-Centenary Exhibition." *Burlington Magazine*, October 1948, p. 277 ff.

The Oath of the Horatii
Le Serment des Horaces

1784 oil on canvas 130" x 168" Paris, Louvre

According to the Roman historian Livy, the three Horatii brothers fought against the three Curatii brothers to settle a war between Rome and the town of Alba. Two of the Horatii perished, but the surviving brother killed the three wounded Curatii, thus achieving victory for Rome. Upon his return he found his sister mourning one of the Curatii to whom she was betrothed, and he killed her in turn. David chose for his painting an episode not mentioned by Livy. The aged Horatius hands three swords to his sons, who take the solemn oath to give their lives for their country, while the women lament over the anticipated fate of the three young heroes, models of Roman patriotism and stoic virtue.

In 1785 David unveiled his canvas of *The Oath of the Horatii,* a picture that was to shake the world, as Picasso's *Guernica* affected his contemporaries in the twentieth century.

For all of its impressiveness *The Oath of the Horatii* was in reality a continuation of the homely naturalism of Greuze accoutred in fashionable Roman dress. This essentially sentimental bombastic drama was different only from Greuze's homely scenes of domestic crises in being raised to a heroic level. The combination of naturalism and classical format was bound to appeal to the taste of the middle class, just as the patriotic theme, hinting of revolutionary change, could not have come at a more opportune moment. . . .

There is no question that the first inspiration for *The Oath of the Horatii* came from Corneille's play, which was being presented in Paris in 1784. David, as a matter of fact, remarked, "If I owe my subject to Corneille, I owe my picture to Poussin."* This indebtedness to the great classicist of the seventeenth century is evident not only in this but in many other canvases by David. Poussin's *Death of Germanicus* seems to have influenced the general arrange-

* L. Hautecœur, *Louis David.* (Paris, 1954).

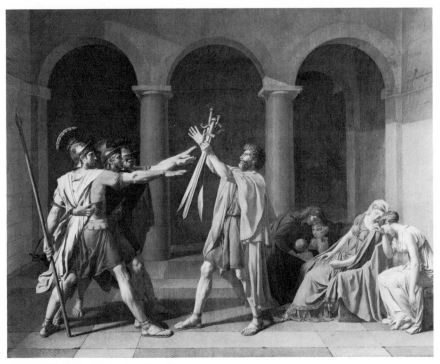

The Oath of the Horatii.　*David*

ment of the figures against the closed background, and the individual forms, both of the heroes themselves and of the mourning women at the right, are modifications of his figures. Again the main compositional element of a triangle culminating in the apex of the raised swords is a favorite of David's predecessor. . . .

David's *Oath of the Horatii*, upon its unveiling, was the manifesto of the new school based on the fervent study of the antique. It fulfilled the hopes of some twenty years of theorizing in subject, expression, and style. This moral tragedy met the highest requirements of the history painter in its dramatic combination of figures expressing greatness of soul, love of country, and filial love. It satisfied the current admiration of Roman virtue in this victory in the struggle of duty and passion. It was at once philosophical, tragic, and antique. . . . If the figures in this composition, as in others by the artist, do not suggest the frozen coldness of marble, it is because David invariably worked from the living model and had a sense for the enlivening touch of the brush.

<div style="text-align:right">

Benjamin Rowland.　*The Classical Tradition in Western Art.*

Cambridge, Mass., 1963, p. 298 ff.

</div>

The Death of Marat
Marat assassiné

1793 oil on canvas 63¾″ x 49¼″ Brussels, Musées Royaux

The *divine* Marat, with one arm hanging over the edge of the bathtub, limply holding his last pen, and his breast stabbed by the *sacrilegious* wound, has just breathed his last. On the green desk before him his other hand still grips the perfidious letter: "Citizen, my extreme misery suffices to give me the right to your benevolence." The water in the bathtub is red with blood, the paper is bloodstained; on the ground lies a large kitchen knife steeped in blood; on a wretched wooden box, which represents the writing desk of the indefatigable journalist, we read: "À Marat, David." All these details are historic and real, like a novel by Balzac. The drama is there, vivid in all its dismal horror, and by a singular *tour de force*, which makes this painting David's masterpiece and one of the great treasures of modern art, there is nothing trivial or ignoble about it. Most astonishing about this extraordinary poem is the fact that it was painted with extreme speed, and, if we consider the beauty of the drawing, it is quite overwhelming. This painting is the bread of the strong and the triumph of the spirit; as cruel as nature, it has the flavor of the ideal. What has become of that ugliness which holy Death has so swiftly wiped out with the tip of his wing? Marat can henceforth challenge Apollo; Death has kissed him with his loving lips, and he is at rest in the calm of his metamorphosis. There is something at once tender and poignant about this work. In the chill air of that room, over those cold walls, about that frigid and funereal bathtub hovers a soul. May we have your permission, you politicians of all parties, and even you, determined liberals of 1845, to give way to our emotions before David's masterpiece? This painting was a gift to a bereaved country, but our tears are not dangerous.

> Charles Baudelaire. "Le Musée classique du Bazar Bonne-Nouvelle (1846)." *Curiosités esthétiques.* Paris, 1892, p. 201 ff.

In the history of taste, the importance of this work is enormous. It has nothing to do with Neo-Classicism, and leaps outright over all the romanticism to come. By virtue of the energy and the lack of prejudice of the representation, it is a realistic work, an anticipation of Courbet. Never again will David have this force of prophecy. His *Marat* is perhaps the only picture that gives us, in some way, the form of one aspect of the French Revolution, and in this way it suggests to us what would have been David's taste, and the taste of the Revolution, if Napoleon and Romanticism had not obliged them to deviate from their path.

> Lionello Venturi. *Modern Painters.*
> New York, 1947, p. 70.

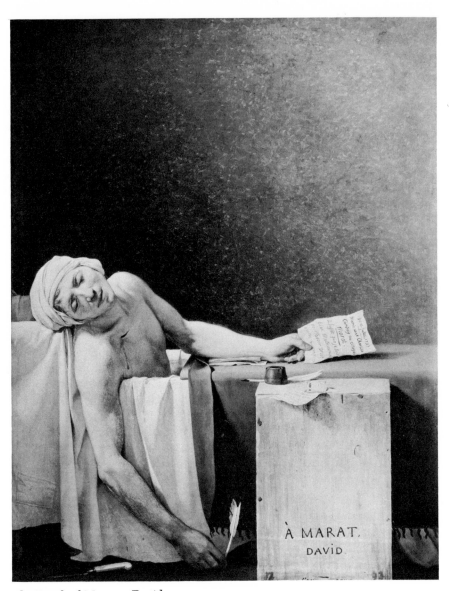

The Death of Marat. *David*

Portrait of Madame Récamier

1800 oil on canvas 68″ x 96″ Paris, Louvre

Never was David's art so supple, so humanised, as in this picture, where he was directly under the spell of a warm and living personality—never was

278

Portrait of Madame Récamier (detail).
David

his hand so light, his method so nearly that of a painter. His science is subordinated to the rendering of life, his draughtsmanship employed to convey an adequate impression of the slenderly graceful figure, but there is none of the hard finish and rather brutal solidity of his ordinary handling—everything is indicated in thin and almost transparent rubbings, apparently at a single sitting. Perhaps the portrait was never finished; if so we must be thankful that accident, or perhaps his own realisation that he had already done better than his best, prevented his ruining it, as he must infallibly have done had he attempted to carry it further.

But if the picture is a capital instance of the influence of life upon art it is no less an instance of the influence of art upon life. The theories of David had profoundly influenced the world about him, and the austerity of these bare walls, the slender forms of the furniture, the classical tripod with its lamp; the simple white robe, bare feet and arms, and coiffure imitated from the antique—these things are the tribute of the age to a powerful artistic personality.

Kenyon Cox. *Painters and Sculptors.* 2nd series.
New York, 1907, p. 59 ff.

PIERRE-PAUL PRUDHON

Prudhon (sometimes spelled Prud'hon) was born in 1758 at Cluny, in Burgundy. At the age of sixteen the monks of the ancient monastery of Cluny, who had undertaken his education, sent him to Dijon to study painting with Devosge. In 1780, Prudhon reached Paris. After winning the Rome Prize in 1784, he proceeded to

Italy, where he was profoundly influenced by the works of Leonardo da Vinci and Correggio. He returned to Paris in 1787. Prudhon became an enthusiastic partisan of the French Revolution; later he was favored by Napoleon and the Empress Josephine, whose portrait he painted in 1805 (Louvre). He designed furniture and interior decorations for Napoleon's second wife, Marie Louise. After the fall of the empire, Prudhon maintained his position and in 1816 became a member of the Institute. An ill-fated love affair with his pupil Constance Mayer, who committed suicide in his studio, was the cause of his depression and ultimate death in 1823.

Many of the merits of antiquity are discernible in Prudhon, and even in his slightest sketches we can see that he was profoundly inspired by the beauties of that age. We would not go so far as to say he equalled the ancients in every respect, but he alone among the moderns rediscovered the secret, known only to them, of greatness, beauty, truth, and above all simplicity. However, we must also admit that his charm sometimes degenerated into affectation and that, despite the ingenuity of their conception, the coquettishness of his touch often deprived his figures of their seriousness. Sometimes, carried away by his search for expression and oblivious of his model, he failed with respect to proportion, but generally he was well able to protect himself from his shortcomings. . . .

His colors are seductive rather than true to life, but it would be hard to imagine others more appropriate for his work. Besides, the feeling of harmony is so complete that we do not ask for more than we see. Prudhon did some very fine portraits, but all of them are idealized; his choice of background and the manner in which they are illuminated transform them into poems, like his paintings. We will cite just one example which embodies the qualities of all the others: it is the portrait of the Empress Josephine. Here Prudhon fused perfect resemblance with a feeling for the greatness of his subject, which he expressed in the pose and expression as well as in the accessories. The Empress is sitting in a grove at Malmaison and her melancholy expression seems a presentiment of her future misfortune. Her head, arms, and robe are exquisite but the canvas seems a little too large, especially the upper part which should have been reduced somewhat. Apart from this defect and perhaps a little harshness in the rendering of the shawl and some less important areas, this portrait is one of his masterpieces.

Prudhon's true genius lies in allegory; this is his empire and his true domain. In this sphere he brings together the full force of his merits. The defects of his style are less manifest and even seem to become qualities. Since he normally prefers those allegories which represent graceful images, the charm of his execution makes us forget

the incorrectness of the drawing and the monotony of the coloring.
This misty tone, this semitwilight with which he envelops his figures,
takes hold of our imagination and leads us effortlessly into the world
of the painter's own invention.

Eugène Delacroix. "Prudhon (1846)." *Œuvres littéraires.*
2 vols. Paris, 1923, II, 125 ff.

When the inspiration of Watteau ceased to influence French
painting, when the eighteenth century with its modes and manners,
its tastes and ideas, was relegated to the past, when the great renewal
of the nation's mind and heart called for a new art replacing its former
ideals, two men appeared in France who, with opposing talents, con-
trasting temperaments, and differing fates, attempted to restore art to
the teachings of antiquity as recalled or plagiarized by the men and
events of their own day.

The first rediscovered the spirit of the antique through Winckel-
mann and its graphic qualities through anatomical life studies. He
painted the *Horatii* and *Brutus,* and thought he could reconstitute
ancient Rome from the shape of a chair or the design of a sword. . . .
This man, spoiled by the idolatry of an admiring public, immortal
in his own lifetime, was proclaimed . . . the restorer of antiquity. He
was David.

Standing aside in the shadow was another painter, whom David
contemptuously called "the Boucher of his age." Yet he carried
Greece and her gods in his heart. He did not resuscitate the beauties
of ancient art from every fragment or remnant; he found its beauties
in his soul; they radiated from his hands. Intuition was his science.
Without the use of a model he animated his creations with the move-
ment and glow of life. . . . The spirit of antiquity comes to life through
his art for the last time. But the name of this painter became popular
only in posterity—his name was Prudhon. . . .

Complete and systematic abstention from all chromes and yel-
lows, which Prudhon judged unnecessary in rendering the color of
our skin and which, according to his observations, darkened quickly,
kept his palette and its range of flesh tones too uniformly dark. Other
prejudices and discoveries which he hoped would insure the fresh-
ness and conservation of his paintings deceived the master. He dis-
dained oil and substituted for its usage a *pommade* that he prepared
himself. . . . But far from preserving the bloom and freshness of Prud-
hon's painting, this *pommade* . . . broke down the substance of certain
colors; it volatilized the bitumens and caused a process of decomposi-
tion in the paintings, which were probably also varnished too soon,
all of which can serve as a warning of the danger of such innovations

in technique. Obsessed with the initial preparation of the canvas, Prudhon often painted on surfaces covered over with a red-brown tint on which he rubbed very lightly a purplish umber for the shadows of the face, and which, given the purity of the tone and the sparing use of the brush, lent a superb and almost automatic modeling to eyelid, pupil, nostril, lips, and at the base of the neck. A brownish-red underpainting on a primed canvas was used for the master's last and most beautiful portraits—those female portraits which seem to me to place Prudhon, if not actually foremost among French painters, at least above the French tradition when it comes to portrait painting. . . .

Prudhon's greatness rests in his portraits. It is in the painting of *Justice and Divine Vengeance Pursuing Crime.* It is perhaps above all in those sketches illumined by his hand's first ardor, in those hastily painted cartoons, in the little sun-spattered canvases struck with rays of light—rough sketches which were the cradle and the classroom of the most brilliant colorists of the contemporary French school.

Edmond and Jules de Goncourt. "Prudhon (1861)."
L'Art du XVIII^e siècle. 3 vols.
Paris, 1909–10, III, 345, 400 ff.

Prudhon belongs, by the years of his production and by the character of his art, to both the eighteenth and the nineteenth centuries. . . . In his dainty sentiment and gentle moralizings, Prudhon is thoroughly . . . of the epoch of Louis XVI. . . . He belongs to the Romantics by a deep personal feeling which underlies his graciousness —a passionate and unsatisfied yearning for the noble and the beautiful—and by the fact that he is a painter in love with light and air and the pearly gleam of flesh emerging from ambient shadow. He went to Rome a poor and ill-educated youth to study Raphael. . . . He remained to become a fanatic admirer of Leonardo and to make a deep study of Correggio. . . . Like every one else of his time he studied the antique also. . . . Of eighteenth-century gayety, of romantic feeling, of Greek sense of form and arrangement, of Correggiesque light and shade—out of these various elements by the strange alchemy of personality is combined that perfectly unified and homogeneous thing, the art of Prudhon. . . .

He is so steeped in chiaroscuro that he sees everything in masses of light and shadow, and draws by such masses and by the soft modelling of surfaces more consistently than almost any one. He was fond of drawing upon blue or gray paper and of building up his figure by the gradations of light, laid on with white chalk, almost more than by the shadows. . . .

Prudhon's coloring is entirely personal. He had a dislike and distrust of yellow and banished it almost entirely from his palette, so that all his tones, subtly and delicately varied, are based upon violet, and this coloring, together with the chastity of the forms themselves, gives a cold and moonlit purity to the most passionate of his dreams.

<div align="right">Kenyon Cox. *Concerning Painting.*
New York, 1917, p. 198 ff.</div>

Prudhon is a poet and expresses himself poetically; he chooses, combines and, above all, suppresses. He envelops, he veils; and herein lies the best of his art and the secret of his charm. You know, of course, that I do not mean draperies or linens. The nude is the only object truly worthy of art and the most magnificent garment wherewith beauty might cover itself. The veil that poetic geniuses throw over their figures consists of light. . . . David, who in spite of his great creative talent was not at all a poet in the modern sense of the word, knew himself well and said of himself that he was a prose artist. The painter of the *Horatii* and of *Brutus* is a fine translator of Livy; neither Virgil nor Lucretius inspired him. Thus he does not use chiaroscuro except where it is indispensable. He fears it, and restricts it to the absolutely essential, making us see everything in an even light, on a day without rays of light or deep shadows. His entire school neither veils nor dissembles. Moonlight, as depicted by Girodet, casts a blue tint on Endymion's body without ever softening its contours.

The poetic genius of Prudhon, on the other hand, seeks in chiaroscuro the charms of illusion, of sweet mysteries and delightful disorders. Whether consciously or instinctively, but probably with that blend of thought and feeling which makes for great artists, Prudhon overemphasizes the shadows and highlights and fills his atmosphere with an enchanting mistiness. At the end of his life, however, he carried these struggles between light and shade to excess.

<div align="right">Anatole France in *Pierre Paul Prud'hon:*
72 reproductions . . . accompagnées d'une vie du peintre
par Anatole France. Paris, 1923, no paging.</div>

Justice and Divine Vengeance Pursuing Crime

1808 oil on canvas 96″ x 115″ Paris, Louvre

Summary of the painting intended for the Great Hall of the Criminal Court in the Palace of Justice: Divine Justice Pursues Crime Relentlessly; Crime Can Never Escape It.

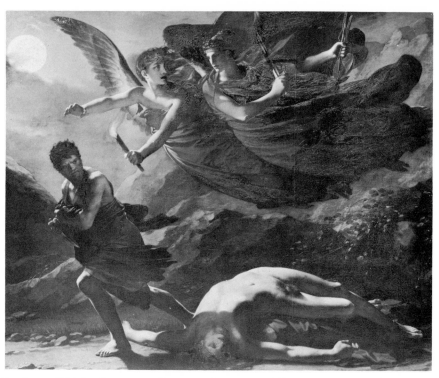

Justice and Divine Vengeance Pursuing Crime. *Prudhon*

In a wild and lonely spot the greedy criminal, covered by the veil of night, strangles his victim, seizes his gold, and looks once more to see whether a spark of life in the victim might not lead to the discovery of the crime. The fool! He does not see that Nemesis, the terrible handmaiden of Justice, pursues him like a vulture hurling itself on its prey, will soon catch up with him, and hand him over to her merciless companion. Such is the subject of the picture. . . .

The cost of the picture, eight feet high and ten feet wide, shall be 15,000 francs, payable in three installments of 5,000 francs each. The first installment shall be due upon presentation of the design, the second upon completion of the outline, and the third upon termination of the painting in its entirety.

I shall finish the painting within ten months from the date on which the prefect's contract, which irrevocably commissions the work, is received. All my efforts shall be directed toward complying with the expectations of the Councilor of State, Prefect of the Seine, in order to execute the work with a forcefulness worthy of the locale it will occupy.

<div style="text-align:right">

P.-P. Prudhon. Letter to the Prefect of the Seine, 1804.

Quoted in Edmond and Jules de Goncourt.

L'Art du XVIIIᵉ siècle, III, 396 ff.

</div>

This painting . . . is of an originality of style, coloring, and effect that places it among the most significant works of our school. It is the fruit of an imaginative genius whose artistic impulse is carried through from the first glimmer of thought to the last stroke of the brush. . . .

This painting, as sublime as it is ingenious and expressive, is not the artist's first attempt in the allegorical style—a style so difficult to handle well and so often accused of coldness. M. Prudhon has understood how to animate his subject with a lively action and powerful emotion.

One must see the painting in order to form a correct idea of the beauty of the figures, of the bold and vigorous coloring and especially of its magical effect and elegant execution, which are reminiscent of the chiaroscuro and the delicate brush stroke of Correggio.

> C. P. Landon. *Annales du musée et de l'école moderne*
> *des beaux-arts. Salon de 1808.* Paris, 1808, p. 52.

ANNE-LOUIS GIRODET DE ROUCY

Born in 1767 at Montargis, Girodet (also known as Girodet-Trioson) was orphaned at an early age and raised by a guardian, Dr. Trioson. He entered David's studio in 1785 and won the Rome Prize at the age of twenty-two. In Rome he painted *Endymion Asleep* (1792; Louvre), inspired by the sculptor Canova and by Correggio. His *Deluge* (Louvre), first exhibited in the Salon in 1806, was later awarded the decennial prize, winning over David's *Rape of the Sabines*. His *Entombment of Atala* (1808; Louvre) won him the Legion of Honor. Girodet was an intellectual and aesthete as well as a painter. When in 1812 he inherited a large fortune, he gave up painting and devoted himself entirely to writing. Among other works he composed a long didactic poem, *The Painter*. He was also a collector of paintings by the old masters. He died a recluse in Paris in 1824.

> In . . . *Atala at the Tomb* (which I think his best, and which would make a fine bas-relief*) the outline of the countenance of Atala is really noble, with a beautiful expression of calm resignation; and the only fault to be found with it is, that, supported as the head is in the arms of the Priest, it has too much the look of a bust after the antique, that we see carried about the streets by the Italian plaster-cast-makers. Otherwise, it is a classical and felicitous stroke of French genius. They do well to paint Sleep, Death, Night, or to approach as near as they can to the verge of *still-life*, and leaden-eyed obscurity! But what, I believe, is regarded as the master-piece of this artist, and what I have

* French pictures, to be thoroughly and unexceptionably good, ought to be *translated* back again into sculpture, from which they are originally taken. (—W.H.)

no objection to consider as the triumph of French sublimity and pathos, is his picture of the *Deluge*. The national talent has here broken loose from the trammels of refinement and pedantry, and soars unconstrained to its native regions of extravagance and bombast. . . . There is none of the keeping or unity that so remarkably characterizes Poussin's fine picture of the same subject, nor the sense of sullen, gradually coming fate. The waters do not rise slowly and heavily to the tops of the highest peaks, but dash tumultuously and violently down rocks and precipices. This is not the truth of the history, but it accords with the genius of the composition. I should think the painter might have received some hints from M. Chateaubriand for the conduct of it. It is in his frothy, fantastic, rhodomontade way—"It out-herods Herod!"

> William Hazlitt. "Notes of a Journey Through France and Italy. (1826)." *Complete Works,* vol. X, London, 1932, p. 131 ff.

Girodet's work, even though not approaching Gérard's in quantitative output or influence, is in many ways more interesting. . . .

Girodet was entirely conscious both of his subjectivism and of his departure from the usual Davidian ideals and norms. *Ce qui m'a surtout fait plaisir,* he once wrote to his adoptive father, de Trioson, *c'est qu'il n'est qu'une voix pour dire que je ne ressemble en rien à David.**

There was a spirit of contradiction in Girodet, a sort of rebellious self-consciousness which kept him from any pure imitation of David. On the other hand he was too vacillating a character, too little sure of himself, to be able to pursue his own direction; nor was he one-sided enough to fall into the anti-Davidian circle of those rebellious hypersensitives called *les primitifs.* However, he was wholeheartedly opposed to the academic, surpassing even David in his hatred of the Academy. . . .

Girodet demonstrated a similar talent in many pictures that display a sort of sharpened and refined mannerism. In contrast to David he always insisted on being imaginatively intellectual. *Girodet est trop savant pour nous,*† David said of him; and to him (as Girodet himself informs us) he said: *L'esprit, M. Girodet, est l'ennemi du génie, l'esprit vous jouera quelque mauvais tour, il vous égarera.*‡

* "What pleases me above all is the unanimous opinion that I do not resemble David at all."

† "Girodet is too learned for us."

‡ "Intelligence, M. Girodet, is the enemy of genius. Your intelligence will play a bad trick on you and it will lead you astray."

L'esprit led him to very intricate themes, often with strongly romantic overtones.

Walter Friedlaender. *David to Delacroix.* Cambridge, Mass., 1952, p. 41 ff.

Entombment of Atala
[Atala at the Tomb]
Atala mise au tombeau

1808 oil on canvas 83″ x 105″ Paris, Louvre

Toward evening, we carried her precious remains to the opening of the grotto which faced to the north. The hermit had wrapped her in a piece of European linen woven by his mother; it was the only possession he had from his native country. . . . Atala was laid on a carpet of mountain mimosa. Her feet, her head, her shoulders, and a part of her bosom were uncovered. You could see a wilted magnolia blossom she wore in her hair, the very one I had placed on the bed of the virgin to make her bear children. . . . Her lips, like pink buds gathered two mornings ago, seemed to languish and smile. One

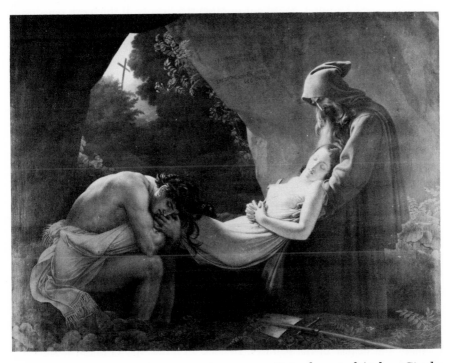

Entombment of Atala. *Girodet*

could distinguish some blue veins on her very white cheeks. Her beautiful eyes were closed, her modest feet were joined together, and her alabaster hands pressed a crucifix of ebony to her heart. The scapular of her vow encircled her neck. She seemed transfigured by the angel of melancholy and by the twin sleep of innocence and death. I have never seen anything more heavenly. Whosoever had not known that this young maiden had once enjoyed the light of day would have taken her for a statue of virginity asleep.*

F. R. Chateaubriand. *Atala* (1801). Paris, 1930, p. 113 ff.

There are only three figures in this funeral scene: Chactas, whose features and attitude betray his despair and grief; the compassionate aged Father Aubry, lost in deep thought; and the ill-fated Atala, whose lifeless body is still, even in death, a model of beauty and purity. . . .

Add to this picturesque expression of the artist's burning genius and lively sensibility, his precision of drawing reminiscent of the masterpieces of antiquity, a fresh coloring, a studied effect, and a brush stroke at once generous, fluent, and delicate, and you will then have perceived the excellence of this painting. No other work in the exhibition will give you cause to forget it.

Atala at the Tomb has, therefore, received universal acclaim; for we must not count as criticisms some trifling, if not childish, observations, which, even were they well-founded, could not impugn the beauty of the work nor detract from the artist's reputation.†

C. P. Landon. *Annales du musée et de l'école moderne des beaux-arts. Salon de 1808.* Paris, 1808, p. 18 ff.

Whatever certain elderly practical jokers may think of it, Girodet's *Atala* is as drama far superior to a mass of unmentionable modern insipidities.

Charles Baudelaire. "L'Exposition Universelle, 1855." *Curiosités esthétiques,* Paris, 1892, p. 225.

* These passages were the inspiration for Girodet's picture.
† The criticisms can be reduced to the following observations: "A greenish reflection is diffused over the figure of Chactas. . . ."

"The painter should not have hidden the feet of Chactas and of the hermit since this makes them appear disproportionately short. . . ."

Finally, the last reproach, and the one on which most stress is laid: "Atala seems not dead but, rather, asleep." Would these critics perhaps have liked to see her features disfigured by the poison which cut short her days? The great painters, especially the Greek sculptors, our masters in every imitative genre, have always proscribed too lifelike a representation of violent passions, which could debase the nobility and beauty of the features. Besides, to refute this criticism it suffices to recall the words of M. Chateaubriand [see above]. (—C.P.L.)

Atala, the daughter of a Spaniard and an Indian mother, lives in her maternal tribe in the midst of the North American forest. She saves Chactas, a young Natchez Indian, who had been taken prisoner and condemned to death at the stake. She flees with him, loving and being loved. But her mother, who had christened her, had chained her to a vow of virginity. She would nonetheless have yielded to the passion which enmeshed her as well as her lover, had it not been for a thunderbolt intervening at that moment, and for the arrival of a venerable missionary, Father Aubry. When he is about to unite her with Chactas, she takes poison to keep her vow. . . .

In Girodet's *Atala* we look in vain for the impassioned lyricism and pathos of Chateaubriand's *Atala,* nor do we find a feeling for the grandiose nature of early America. . . . Girodet has also failed to include some picturesque and touching details . . . such as the magnolia blossom "placed once on the bed of the virgin" and the scapular of her vow. As to the execution, nobody can ignore the dryness of the brush stroke and the poverty of the color. Throughout, we note the concern with minute details, everything is spelled out. On the other hand, the painting has truly great beauties if we accept the classicist tradition. . . . The scene is expressive in its simplicity. . . . The artist has even conveyed something imperceptible, the majestic silence of suffering. We are left with an impression of purity, dignity, and an almost pious sadness, whereas Chateaubriand has lavished upon his novel an almost sensuous passion and an almost pagan glorification of the beauty of woman.

> Henry Lemonnier. "L'Atala de Chateaubriand et l'Atala de Girodet." *Gazette des Beaux-Arts,* May 1914, p. 363 ff.

FRANÇOIS GÉRARD

Son of a French father and an Italian mother, Gérard was born in Rome in 1770. At the age of twelve he was sent to Paris, where he studied sculpture with Augustin Pajou and entered David's studio in 1786. In 1789, Gérard competed unsuccessfully for the highly coveted Rome Prize, which that year was won by Girodet. In 1791 he assisted David in the execution of his *Le Peletier de Saint-Fargeau,* completed in 1793, but later destroyed. Although Gérard was appointed to the Revolutionary Tribunal, he participated little in its terroristic activities. Working in continuous rivalry with Girodet, he painted his *Belisarius* (Hermitage, Leningrad) in 1795 and his *Cupid and Psyche* (Louvre) in 1797. He illustrated editions of Virgil, Longus, and Racine for the printer Didot, and was a highly successful portrait painter. Napoleon, Madame Récamier, Madame de Staël, and members of the Viennese Congress of 1815 were among his sitters. Paralyzed during the last years of his life, Gérard died in Paris in 1837, having become Baron of the Empire, Officer of the Legion of Honor, member of the Institute, and *peintre du roi* to Louis XVIII.

When Gérard paints a portrait it is like Voltaire turning out a madrigal—and we know how well it comes off! If there is perfection in any of man's creations we should perhaps look for it in works of a subordinate genre, into which the great artists have poured all the superiority of their talents. Even the lion trifles at times, but his strength is revealed as much in his games as in his fights. Thus the new portrait by Gérard [*The Duchess of Orléans with the Young Duke of Chartres*] has a perfect resemblance, natural flesh tones, an elegant pose and tasteful decor. . . .

Kératry. *Annuaire de l'école française de peinture . . . le Salon de 1819.* Paris, 1820, p. 138.

Baron Gérard was in the arts exactly what he was in his salon, the Amphitryon eager to please everyone. It is this courting eclecticism which destroyed him. David, Guérin, and Girodet have stood fast, the immovable and invulnerable remains of the great tradition, but Gérard has left nothing behind him but the reputation of a charming and very witty man. Nevertheless, it was he who announced the arrival of Eugène Delacroix with these words: "A painter has been born to us! He is a man who runs across rooftops."

Charles Baudelaire. "Le Musée classique du Bazar Bonne-Nouvelle (1846)." *Curiosités esthétiques,* Paris, 1892, p. 204.

The artist who remained closest to David was François-Pascal Gérard. Judged by the standard of David's grandiose pathos, Gérard's art represents a softening towards the delicate and the intellectual. In his portraits as well as in his historical pictures he was what one might call a courtly Classicist. Like his teacher, who placed his art at the disposal first of the Revolution and then of Napoleon, Gérard came unscathed through a political upheaval—in his case the transition from the rule of Napoleon to that of Louis XVIII. In the gallery of fame founded by the latter at Versailles, there are two colossal paintings by Gérard, *Henry IV in Paris* and *Austerlitz.* In these historical pictures the grandiose style of monumental mural painting is as unsuccessful as it is in the ceilings in the Panthéon (after 1830). Gérard's temperament found its purest fulfilment in a series of notable portraits. That of Mme Récamier in the Louvre (1802) is by no means inferior to David's, but the tendency of Gérard's gentler, more feminine talent towards the intimate and the pleasing is clearly visible. Quite as masterly and exemplary as specimens of Classicist portraiture are the *Family of Reichsgraf Moriz Christian Fries,* the Viennese patron of the arts

(1800), and that of the painter *Jean-Baptiste Isabey and His Little Daughter* (1795; Louvre).

Fritz Novotny. *Painting and Sculpture in Europe, 1780–1880*. Baltimore, 1960, p. 11 ff.

Cupid and Psyche
[Psyche Receiving the First Kiss of Love]

Salon of 1798 oil on canvas 70″ x 52″ Paris, Louvre

Even though *Cupid and Psyche* was appreciated at the Salon of 1797 [*i.e.*, 1798] the painting was also subject to much criticism. The conception of the figure of Cupid was found to be too far-fetched, too metaphysical, and the graceful expression of the two figures appeared to have degenerated into affectation. Other critics, considering the technical aspect of the painting, thought that in his desire to simplify and purify the forms, the painter, in many instances, had rendered them vaguely and imperfectly. . . . However, in spite of all these reproaches, which are far from unfounded, *Cupid and Psyche* has remained a most remarkable work of its period and one of Gérard's best paintings.

E. J. Delécluze. *Louis David, son école et son temps.*
Paris, 1855, p. 276.

Cupid and Psyche. *Gérard*

291

These two figures responded to the prevailing ideal of the purest delineation of contours and the most delicate sentiment, down to the pale flesh tones which were the supreme condition of beauty. Observers of manners reported that the ladies powdered their faces white in order to look like Psyche.*

> Jules Renouvier. *Histoire de l'art pendant la Révolution.* 2 vols. Paris, 1863, II, 90.

Gérard's best-known work is his *Cupid and Psyche.* . . . The figures . . . are placed in a receding landscape and are partly silhouetted against the sky, an arrangement directly opposed to the classical tradition because it makes impossible a composition in layers of space. David's *Paris and Helen* of ten years before, if somewhat affected, is nevertheless physically solid. By comparison this group of figures is effeminate and precious. Cupid, naked and winged, kisses most tenderly on the brow a foolish, staring Psyche. Here the *volupté décente* familiar in Vien's Athenian women and in Greuze still plays a part. While the figures of David may suggest marble, or occasionally wax, these smooth, soft groups of Gérard remind us of the *biscuit* which for a time was in such favor for salon statuettes.

> Walter Friedlaender. *David to Delacroix.* Cambridge, Mass., 1952, p. 39.

Corinna on Cape Miseno

1819–20 oil on canvas 100½″ x 109″ Lyon, Musée

Although Gérard is the greatest living painter in France today, he does not belong to the French school but rather rises above it. He possesses a rare spiritual gift that enables him to follow the higher dictates of art while at the same time satisfying the requirements of the taste of his time. The great popularity of his works all over Europe need not cause him to fear for the permanence of his fame. . . .

When I visited Paris again in the autumn of 1820, he was just putting the last touches to an enchanting painting which I will attempt to describe here as graphically as possible. He allowed me the pleasure of studying it repeatedly before it left his studio.

First of all I note the particularly fortunate choice of subject. . . . Painters have often been advised to join forces with poets, but if such a painting is to

* "Red makeup is no longer used. To be pale is far more interesting. This is called a face *à la Psyche,* after a very pretty painting by Gérard. The ladies, therefore, use only white makeup and leave the red to the—gentlemen." (August Kotzebue, *Erinnerungen an Paris im Jahre 1804,* Carlsruhe, 1804.)

Corinna on Cape Miseno. *Gérard*

be comprehensible the writer must be very well-known to all, which among the ancients can only be said of Homer and Virgil. The more recent literature has no truly picturesque writers, and to have recourse to foreign works—for a French artist to paint subjects out of Dante or Tasso for instance—is a doubtful undertaking. . . .*

Gérard has had the mature judgment to choose a rare exception. *Corinna,* a novel that is universally read and has become the favorite guidebook of all travelers to Italy, is indeed a picturesque subject, especially in its delineation of the heroine, who combines truly distinctive features with an idealized bearing. In the entire book there is probably no passage more suitable to be rendered pictorially than the one chosen, which shows Corinna on Cape Miseno pouring forth the inspiration of the moment in a solemn hymn.

She is surrounded by the wonders of nature and the remains of antiquity,

* Ingres had exhibited his *Roger Liberating Angelica* (after Ariosto) in 1819 and Delacroix his *Dante and Virgil* in 1822.

by the magic of the present moment and the memories of time immemorial, all of which she extols in her song. She is sitting on mossy stones, which a trace of former shape allows us to recognize as ancient ruins. Behind the elevated foreground we glimpse the Bay of Naples bordered by the mountains of Sorrento and the smoking Mount Vesuvius. The action is entirely comprehensible even without previous knowledge of the book. We see an enraptured girl raising her voice in praise of the great drama unfolding before her, and amazed listeners gathering around. Yet the artist has remained faithful to the story and has incorporated all the details indicated by the author. The figure of Corinna is full of stately grace, . . . her coloring is warm rather than delicate. The bold verve of her stance, the flow of her garments, everything, from the parted curls falling over her forehead to the very soles of her feet, is imbued with spirituality: her entire appearance is one of unselfconscious transport. . . .

Her garment is yellowish white, her shawl red with gold borders, and the ribbon in her black hair as well as her belt are yellow with golden highlights. These warm colors aid in further accentuating the main figure in contrast to the dark background. She emanates, as it were, a cheerful light of ecstasy, whereas the waning day, the sky laden with storm clouds, the smoking crater and the agitated sea appear as ominous portents of a dark and stormy future.

In her facial traits, particularly in the upturned eyes, we cannot fail to discern a hint of personal resemblance [to Madame de Staël]. . . .

In describing the painting I have the same difficulty I encounter when looking at it; I can hardly tear myself away from the main figure. For Corinna is indeed the whole picture; the other figures are just background; they exist only for the sake of contrast, and are thus duly subordinate. . . .

The choice of late afternoon light for the entire composition is excellent, and it is beautifully executed. The lower half of Corinna and of the figures in the central plane are placed in shadow, so that the light is limited to the main portion of the painting where it is most effective.

<div style="text-align:right">

A. W. von Schlegel. "Corinne auf dem Vorgebirge Miseno nach dem Roman der Frau von Staël (1821)." *Sämmtliche Werke*, vol. IX. Leipzig, 1846, p. 360 ff.

</div>

A volcano, an enraptured girl, a man whose features are ravaged with passion, a red scarf billowing in the wind—what more would be necessary to paint a romantic picture? Yet Gérard did not succeed. He was too strongly entrenched in the Davidian tradition. . . . He remained an authentic representative of Empire art in the Salon of 1822, where, not far from *Corinna at Cape Miseno*, [Delacroix's] *Dante and Virgil* could already be seen. . . .

Today we can no longer share the enthusiasm which Gérard's painting, inspired by Mme. de Staël's novel, aroused at its first appearance. The painting is meager, the brushwork too smooth and uniform. . . . We look in vain for some kind of rhythmic flow in the unfolding of this frieze. . . . Excessive

literary research, especially in the exalted air of Corinna and the affected pose of Oswald, has taken the place of a concern with structure and composition. Only in 1822 could anyone have said with M. Thiers: "I find in the picture above all the same profound melancholy which has charmed me in the novel."* ...

On the other hand, this canvas is of real historic interest. *Corinna on Cape Miseno* reflects the passion which Mme. Récamier instilled in Prince August of Prussia and the friendship which had united the Prince with Mme. de Staël. [The present picture was commissioned by the Prince in memory of Mme. de Staël after her death in 1817.]

> Madeleine Vincent. *La Peinture des XIX^e et XX^e siècles [au Musée de Lyon]*. Lyon, 1956, p. 13 ff.

ANTOINE JEAN GROS

Gros was born in Paris in 1771. In 1785 he entered David's studio and in 1787 the Royal Academy of Painting. In 1792 he competed for the Rome Prize, but failed to win. When the Academy was dissolved in 1793, Gros went to Italy where he was introduced to Bonaparte by his wife Josephine and painted *Napoleon Crossing the Bridge at Arcola* (1796; Versailles). Napoleon named him to a commission charged with selecting looted art works for the Louvre. In 1799, Gros escaped the beleaguered city of Genoa and returned to France. With his enormous canvases *The Plague-Stricken at Jaffa* (1804; Louvre), *The Battle of Aboukir* (1806; Versailles), and *Napoleon at Eylau* (1808; Louvre), Gros, together with David, became the chief painter of the Napoleonic legend. After the Battle of Waterloo and David's flight into exile, Gros took over David's studio. From 1814 to 1824 he decorated the dome of the Pantheon, for which he received a barony from Charles X. Although Gros influenced and encouraged Géricault and Delacroix, the romantic tide swept him away. His late classicist work evoked adverse criticism, and his own sense of failure drove him to suicide. He drowned himself in the Seine in 1835.

Madame Bonaparte received me in a very straightforward manner and of her own accord began telling me that she knew of my wish to go to Milan ... to paint some of her husband's victories. She offered me a place in her carriage. ...

The day after we arrived here she presented me to her illustrious husband, who was quite distant and stern but who nevertheless gave me a welcome that was worthier of the arts than of me.

"This is the young artist I told you about," she said. "Ah! I am delighted to see him. You are David's pupil?" he asked. And then, after several words about his talent, he said: "David has requested this

* Adolphe Thiers, *Salon de 1822*, (Paris, 1822).

drawing [of the victory at Lodi] . . . which he intends to paint; but I have several other fine subjects that I will tell you about." . . . "But I am closer to you at the moment," I said, cutting short a conversation I did not feel equal to, since we were speaking of the famous David, "and I have a very important subject to portray, or at least, that is my ardent desire." "What is it?" he asked. "Your portrait," I replied. He nodded his head slightly and modestly. I was invited to dinner. Today I have gathered together all the materials I could in order to begin work as soon as possible. . . .

I have just begun the general's portrait; but what little time he gives me couldn't even be called a proper sitting. I have no time to choose my colors, and must resign myself to painting only the characteristics of his physiognomy, and completing the portrait afterwards as best I can. But I am being encouraged and am satisfied with the little bit already on the canvas. I am quite impatient to see the head almost finished.

<div style="text-align: right">

A. J. Gros. Letter to his mother, 1796. Quoted in
J. B. Delestre. *Gros; sa vie et ses ouvrages.*
Paris, 1867, p. 33 ff.

</div>

M. Gros is an eminently original painter whose talent lies in his remarkable accuracy; he is not so concerned as his rivals with the nobility of style, but aims rather at observing and recapturing nature. Besides, he knows her better; his backgrounds are true, his planes recede convincingly, his figures merge well with the surrounding air; his outlines are neither abrupt nor harsh. The contours of the human frame or dress stand out in a completely different manner from the contours of the marble statues. . . . There is, if I may use the expression, more affinity between the air and the human frame than between the air and the marble; a human figure, alone in the middle of space, does not appear so isolated nor so glaring against the background as a statue. This difference becomes obvious when we compare the *Pyrrhus and Andromache* of M. Guérin with M. Gros's paintings, for example the *Surrender of Madrid.* I admire the *Andromache* very much but cannot help finding, in the way the painter has detached his figures from the background, something which recalls statuary. He has, if I may risk the remark, separated them too much from the air they breathe. In M. Gros's paintings I seem to see living, animated creatures whose contours are modified by the surrounding air which is their element and which penetrates through their pores. This quality adds a new verisimilitude to the expressions and attitudes . . . whereas

M. Guérin has perhaps left a trace of rigidity and immobility in his figures. This defect doubtless originates from the study of sculpture.

François Guizot. "De l'état des beaux-arts en France et du Salon de 1810 (1810)." *Études sur les beaux-arts en général.* Paris, 1860, p. 89 ff.

How can we define M. Gros? Is he a classicist, a romanticist, a Florentine perhaps, or a Raphaelite, or possibly a Venetian? What is his painting like? Is it pretentious? Is it a system, or a compilation? It is Bonaparte and the plague-stricken . . . it is a painting of living nature, terrible, majestic, superb. M. Gros met his hero once and carried away with him the image of his stern profile, which he later conveyed on canvas, dipping his brush in the ardent colors of a venomous sky; he paints as Homer sang.

In saying that no other work of the French school surpasses these three magnificent canvases, we are not afraid of being accused of prejudice; this painter, along with Voltaire and Goethe, can boast of witnessing, while still alive, the judgment of posterity. . . .

The Battle of Aboukir represents the pride and courage of a great conqueror; the foot of his horse resting on the bodies of the vanquished, but still erect in the saddle as on the day of parade, Murat surveys with glittering eyes the retreat of the army he has beaten, and looks on at the last efforts of the pasha. What pitiful agony! In a frenzy the pasha seizes the turban of a fleeing soldier while his young son with touching dignity offers the hilt of his sabre to the French hero.

Let us now turn to the painting of [The Plague-Stricken at] Jaffa. Consider this vast and imposing composition: look at Eylau; what infinite sadness is in the Emperor's expression! What telling gesture! If you are an artist and can appreciate the comments of one, observe closely the wounded men covered with sores, mud, and snow, the cossacks with their bloodstained bandages, the cowering figures of those stricken with the plague dragging themselves to the walls and writhing on the ground in a desperate attempt to find some shade . . . then think of Géricault. Is not this painting the source of his inspiration for the *Medusa?*

Alfred de Musset. "Exposition au profit des blessés dans la Galerie du Luxembourg (1831)." *Œuvres complètes,* vol. VIII, Paris, 1909, p. 250 ff.

Gros raised contemporary subjects to the stature of the ideal. He was able to paint the costumes, manners, and passions of his time without falling into pettiness or triviality, the usual dangers inherent

in such subjects. Habit and prejudice were against him. When he appeared, it was an established principle that only the forms and themes of antiquity were capable of eliciting interest from the point of view of composition and execution. . . .

Gros has seen his heroes as defined by his own enthusiasm. The grandeur of their action alone elevates them sufficiently; of his figures he made demigods. The school from which he emerged taught him a rigorous sense of proportion and a purified appreciation of design. Yet, unfortunately, those aspects of his technique which are subject to criticism also stem from this source. But he owed to no one but himself the forceful and original qualities which put him at the head of our school of painting. . . .

Time has caused his technique, which appeared bold and brilliant when his painting [*Napoleon at Jaffa*] was new, to lose its splendor. The same is true of almost all paintings executed under the influence of the Davidian tradition. The lightly rubbed shadows and the sober impasto of the highlights, which lend the painting a becoming transparency at the moment of its completion, unfortunately take on a kind of yellowing, a noticeable attenuation of the colors, after a number of years. As a result, there is something empty and *hollow* about these works, in contrast to Flemish and Venetian paintings, which are technically superior. These troublesome influences make us regret that a man like Gros was neither a pupil of Rubens nor of Van Dyck. Nobler and as abundantly rich in subject matter as the former, more animated and more inventive than the latter, no one would have disputed his place close to those leaders of Flemish painting.

Eugène Delacroix. "Gros (1848)." *Œuvres littéraires*, vol. II, Paris, 1923, p. 163 ff.

While 18th-century painters such as Chardin, Watteau and Fragonard had attached little importance to the political events of Europe, their Romantic counterparts, from David to Courbet and Daumier, reacted with the sensitivity of seismographs to the undercurrents disturbing both society and individuals. The Romantic painter was deeply rooted in his own age; everything happening round him awoke in him an echo, a sympathetic resonance. . . . It was the painters, even more than the poets, who contributed to the formation of the Napoleonic myth with its strange but impressive brilliance.

Widely different artists shared in this hero-worship, this idolatry of the great man, but the most remarkable of them, the only one who can really be called a genius, was Baron Gros. Gros' distinction lies not only in his ability to portray battle scenes with such documentary

accuracy that a historian might well go to them for information as to the uniforms of the various European armies, for instance, but also in his evocation of the spirit stimulating the military ardour of these armies and above all the very skilful way in which he makes the pathetic-mythical element harmonize with the visual (almost tactile and olfactory) realism. In all of his pictures where Napoleon is the hero, *The Plague-Hospital at Jaffa* (1804; Louvre, Paris), *Napoleon Crossing the Bridge at Arcola* (1796), *The Battle of Eylau* (1808; Louvre), he appears as a superhuman figure, a commander of men and almost of the elements; when he touches the wounds of the plague-sufferers he appears not merely to be making a heroic gesture, courageously defying the disease, but actually to be healing the sick man who sees him as a miracle-worker—as Gros probably did himself. . . .

But most of all he was interested in translating reality into myth —and indeed the spirit of the Napoleonic campaigns could only be reproduced at this level. Delacroix hit the nail on the head when he said that Gros succeeded in "raising a modern subject to the stature of the ideal," a description which might well be applied to Delacroix himself. . . .

Compared with Gros, the other painters inspired by the campaigns appear mere chroniclers, almost anecdotists. Anne-Louis Girodet de Roucy-Trioson used the Egyptian campaign as a subject for his *Revolt at Cairo* (c. 1810; Versailles), but this hardly bears comparison with *The Plague-Hospital at Jaffa.* Where Gros' picture is filled with the sinister smell of poverty, the charnel-house and infected death-beds, Girodet's is merely picturesque in an anecdotal way; Gros' power, so great that one can almost smell the wet skins, the sweating horse, the trampled snow and the bricks warmed by the sun, is completely missing in Girodet.

Marcel Brion. *Romantic Art.*
New York, 1960, p. 129 ff.

The Plague-Stricken at Jaffa
Les Pestiférés de Jaffa

1804 oil on canvas 209½ " x 283½ " Paris, Louvre

Gros did not fear treating the horrible, which filled the artists of antiquity with dismay. A strange subject indeed, in an age of mythology and selected history,—a hospital filled with sick, dying, and dead! The artist has solved his problem in triumphant fashion. There exists a first sketch of this painting

The Plague-Stricken at Jaffa. *Gros*

which Gros made under the direction of Denon, and in which he is absolutely faithful to the prosaic truth. It was merely a memorandum, and the painter, giving himself up to his genius, turned it into an epic. He threw down the walls of the room in which the historical fact occurred, and showed through the open tracery of the Moorish arcades the Eastern silhouette of Jaffa. The scene, thus broadened, enabled him to make plain to the eye the moral grandeur of the subject. In the centre of the composition the general-in-chief, Bonaparte, touches, with the security of the hero who trusts in his star, the plague spots of a half-naked sailor who has raised himself on the approach of the general. Berthier, Bessières, Commissary Daure, and Desgenettes, the chief surgeon, follow Bonaparte, terrified at his sublime imprudence. An officer suffering from ophthalmia, his eyes covered with a bandage, feels his way towards the radiant figure. In the corner are patients attended by Turks. Masclet, a young French surgeon who fell a victim to his devotion, supports on his knees a sick man. Dead bodies lie here and there on the floor, and convalescent plague patients take bread brought them by Arabs. Certainly the tragic horror is in no wise diminished, and yet there is a certain beauty in that heaping up of expiring or already dead bodies. The artist has exhibited the ugliness of it, but he has not sought it, and he idealises it either in a touching or a dramatic manner. His painting is like the description of the plague in Virgil, and still preserves the noble colours of the epic. When it was first exhibited it produced a tre-

mendous sensation, and the public covered the frame of the great composition with palm branches and wreaths.

<div style="text-align: right">

Théophile Gautier. "The Louvre. (1867)."
Works, vol. IX. Cambridge, 1906, p. 23 ff.

</div>

The Battle of Aboukir

1806 oil on canvas 227½″ x 381″ Versailles, Musée

M. Gros's fine picture has hardly been less maligned by several censors than the picture by M. Girodet.* M. Gros is a human being and consequently we can find imperfections in his work as in all human creations. But without wanting to set ourselves up as a judge between him and his critics we shall limit ourselves to expressing in some detail an opinion on his work, which does honor to him as well as to the French school.

The hope raised by the painter of *The Plague-Stricken at Jaffa* has been realized by the painter of *The Battle of Aboukir*. This huge canvas can compete in its general arrangement with Le Brun's famous *Battles of Alexander*, which were more praised in their own time than today. As for its drawing and facial expressions we dare affirm that a comparison between Le Brun and

The Battle of Aboukir. *Gros*

* Girodet, speaking of himself in the third person, refers to his painting *The Deluge* (Louvre), shown in the same Salon of 1806.

M. Gros will turn out fully to the advantage of the latter. Le Brun's drawing is generally indistinct, rounded, and heavy; though not without grandeur, it is nothing but an *envelope of beautiful form,* if I may express it in these terms. M. Gros's drawing is always lifelike and, moreover, it is noble, masterly, and full of vitality. . . . As for the action of the individual figures and entire groups, the difference between Le Brun and M. Gros is also apparent, and to the advantage of M. Gros. Le Brun's battle scenes are filled with purely *academic* figures. He uses poses and attitudes for which he has a *predilection.* Those of M. Gros conform much more readily to nature. . . .

With respect to color M. Gros seems to stand midway between Rubens and Paolo Veronese; posterity may find him equal to these two illustrious masters. . . .

> A.-L. Girodet-Trioson. "Combat d'Aboukir par M. Gros; la critique des critiques du Salon de 1806." *Œuvres posthumes.* 2 vols. Paris, 1829, II, 484 ff.

JEAN AUGUSTE DOMINIQUE INGRES

Born at Montauban in 1780, Ingres was encouraged by his father to pursue an artistic career. At the age of eleven he was sent to the Academy of Toulouse and then, in 1797, to David's studio. While studying in Paris, the young Ingres earned his living as a violinist. In 1799 he entered the École des Beaux-Arts and two years later won the Rome Prize, but did not go to Rome immediately. He began painting portraits, such as those of the Rivière family (Louvre) and a self-portrait (Chantilly, Musée Condé). When he finally reached Italy in 1806, he remained fourteen years in Rome, and four additional years in Florence. Though at first unsuccessful with the paintings he sent to the Salon from Italy (for example, the *Great Odalisque*), his *Vow of Louis XIII* (1824), commissioned for the Montauban cathedral, established him as official painter and won him a membership in the Institute. He opened a studio in Paris, which was soon crowded with students. His classicism made him the irreconcilable opponent of Delacroix and romanticism. In 1834 Ingres returned to Rome to succeed Horace Vernet as director of the French Academy. Back in Paris in 1841, more honors were heaped upon him. He was named Grand Officer of the Legion of Honor on the occasion of the Universal Exhibition of 1855, and Senator in 1862. Ingres remained active until his death in Paris in 1867, at the age of eighty-seven.

> M. Ingres represents an essential element of poetry. He is in search of style, accuracy, polish, and beauty. It is true that beauty, as he seems to understand it, is circumscribed by a narrow combination of forms, an abstraction made from all other living and infinitely varied qualities of nature. This system is, in our opinion, . . . radically vi-

cious. But M. Ingres brings to his conviction so much violence and tenacity that his paintings always retain character. . . .

David sought, through art, social significance, morality, and instruction from the lessons of history. But as a painter he remained inferior to the theorist. M. Ingres wants beauty for its own sake, without anxiety about social questions, without concern for man's passions or the world's destiny. He aims at plastic perfection. But his execution does not really match his artistic intention.

Basically, M. Ingres is the most romantic artist of the nineteenth century, if romanticism is the exclusive love of form, the absolute indifference toward all the mysteries of life, skepticism in philosophy and politics, and the egotistical detachment from all common sentiments of solidarity. The doctrine of art for art's sake is, in effect, a kind of materialistic Brahmanism, which absorbs its practitioners in the monomania of external and perishable form, rather than in the contemplation of things eternal. It is remarkable that romanticism, though its good influence on style cannot be denied, has not produced a single artist of social conviction. . . .

M. Ingres is contrary to the national tradition, especially to the recent doctrines of David. . . . David's Brutus, Socrates, and Leonidas have been succeeded by Odalisques. The artist no longer has an opinion. He exalts only his imagination. Isolated from the rest of the people, he scorns the events of our common existence from the height of his conceit.

<div style="text-align:right">Théophile Thoré. "Salon de 1846." Salons de T. Thoré.
Paris, 1870, p. 239 ff.</div>

We lack the space, if not the words, to give fitting praise to [Ingres'] *Stratonice* [1840; Chantilly, Musée Condé], which would have amazed Poussin, to his *Great Odalisque* [Louvre], which would have anguished Raphael, to his *Little Odalisque* [1839; Fogg Art Museum], that delicious, strange work of fantasy which has no precedent among the old masters, and to the portraits of M. Bertin [Louvre], M. Molé [1834], and Mme. d'Haussonville [1845; Frick Collection, New York] —real portraits, in other words, ideal reconstructions of individuals. . . . However, we think it useful to set right certain peculiar prejudices which are current on the score of M. Ingres. . . . It is understood and recognized that M. Ingres' painting is *gray*. Open your eyes, you nation of fools, and tell us if you ever saw such dazzling, eye-catching painting, or even a greater quest for color?. . . It is also agreed that M. Ingres is a great but clumsy draftsman, who is ignorant of aerial per-

spective and whose painting is as flat as a Chinese mosaic.* To this we have nothing to say except to compare his *Stratonice*, in which an enormous complexity of color and light effects does not preclude harmony, with *Thamar*, in which M. H. Vernet has solved an incredible problem—how to produce a painting which is at once infinitely gaudy and infinitely obscure and indistinct! . . . One of the things which in our opinion particularly distinguishes M. Ingres' talent is his love of women. His libertinism is serious and full of conviction. M. Ingres is never so successful nor so powerful as when his genius finds itself in the grips of a charming young beauty. The muscles, the folds of the flesh, the shadows of the dimples, the hilly undulations of the skin— nothing is omitted. If the Island of Cythera were to commission a picture from M. Ingres, it would assuredly not be smiling and frolicsome like Watteau's, but robust and nourishing like antique love.

> Charles Baudelaire. "Le Musée classique du Bazar Bonne-Nouvelle (1846)." *Curiosités esthétiques.*
> Paris, 1892, p. 205 ff.

I saw Ingres' exhibition at the *Exposition universelle* . . . it is the complete expression of an incomplete intelligence; effort and pretension are everywhere; there is no spark of naturalness in it.†

> Eugène Delacroix. *Journal.* 3 vols. Paris, 1932, II, 327.
> Entry for May 15, 1855.

M. Ingres is a robust old man of seventy-five, squat and small in stature and with a commonplace outward appearance, which is quite at odds with the affected elegance of his works and his Olympian propensities. One would at first glance take him for a retired businessman, or, rather, a Spanish priest in civil dress. . . .

The usual appearance of the great master is one of studied majesty, of being buttoned up to the chin: he is seated squarely in his armchair, grave and unmoving, like an Egyptian god sculptured in granite. The whole effect is contrived to convey the distant and icy grandeur of officialdom. . . .

At the Salon of 1827 the principal work by M. Ingres was *The Apotheosis of Homer* [Louvre]; that of M. Eugène Delacroix *The*

* Victor Hugo said of the *Great Odalisque* that it was "painted in the manner of the Chinese, without shadow or relief." (*Conservateur littéraire,* vol. I, part 2, Paris, 1819.)

† After another visit to the exhibition Delacroix modified the severity of this judgment: "The group of Ingres' works seemed better to me than it did the first time, and I am grateful to him for the many fine qualities he reveals." (Entry of June 1, 1855.)

Death of Sardanapalus. . . . It was the decisive moment. Which of these would carry the day and capture official sanction?

The dispute was over hardly more than a question of form. To paint for the sake of painting . . . art for art's sake: this was the entire content of a dialectic which rings with the logomachies of liberalism. In any case it must be agreed that the colorists, along with the new generation of writers, in insisting upon the freedom to record their own impressions by whatever means they preferred, naturally produced work that was valid and noteworthy, in defiance of all the existing rules. . . .

What truth was M. Ingres defending with such invincible tenacity and incredible energy? He denied that there need be a social commitment on the part of the artist, and went to great lengths to restore the painterly methods of his master, David. Whereas David had put form to the service of the concept, M. Ingres did away with the concept altogether and thus established the cult of form. He pursued, through the use of straight and curved lines, the plastic Absolute itself—that ultimate principle underlying all things. After having created his new Adam and Eve, however, he was incapable even of realizing that he had forgotten to give them a soul. . . .

But I have gone on at too great a length. Ten lines would suffice to record the history of this famous artist who sacrificed emotions and human qualities for the sake of dexterity and the calligraphy of art, and who thereby drastically reduced the scope of painting. Since he is not afraid, however, of striving for the Ideal—from the depths of his bourgeois studio peopled with plaster divinities—nor of mocking the France of Poussin, Le Sueur, Claude Lorrain, and Le Brun, forcing admiration upon himself as an omnipotent genius—I owed him nothing less than the truth. It has only been ten years now since, thanks to his subtle maneuvering, the appearance of one of his paintings was hailed as an event. That time is now passed; M. Ingres is dead to the world and the autopsy has begun. The fanatics who would prepare his apotheosis will only make him miss his burial; for France will not fail to react against the pretensions of a phony master who would, without any title to it, force the door to immortality. M. Ingres has nothing in common with us. He is simply a Chinese painter lost in the ruins of nineteenth-century Athens.

<div style="text-align:right">

Théophile Silvestre. *Histoire des artistes vivants.*
Paris, 1856, p. 3 ff.

</div>

The *Great Odalisque* . . . was the first picture which drew attention to the master, who was yet unknown in his own country. The effect it produced might have discouraged a man of less sturdy con-

victions. No one appreciated the exquisite perfection of his drawing, his admirable and subtle modeling, and his superb taste which combined choicest nature with the purest traditions of antiquity. The *Great Odalisque* was called Gothic, and the painter was accused of wanting to go back to the beginnings of art. The so-called barbarians, whom Ingres supposedly imitated, according to the critics of 1817,* were none other than Andrea Mantegna, Leonardo da Vinci, Perugino, Raphael—artists who, as everyone knows, have long since been left behind by "progress." . . .

In spite of some bizarre details, I admire Ingres' whole personality, his life totally and unreservedly dedicated to art, his persistent search for the beautiful, from which nothing can distract him. Men active in religious, political, or philosophical causes will undoubtedly say that Ingres does not serve any ideal. That, precisely, is his superiority. Art is the end, not a means for him, and there has never been a higher end. . . .

There is still another quality which could be added to those Ingres possesses. He has preserved the secret, now lost, of rendering feminine beauty in all its purity. Look at the *Iliad* and the *Odyssey*,† *Angelica*,‡ the *Great Odalisque*, the portrait of Madame de Vauçay . . . the *Muse of Cherubini* [1842; Louvre], *Venus Anadyomene* [1848; Musée Condé, Chantilly], *Stratonice*, the figure of Victory in *The Apotheosis of Napoleon* [1853; Musée Carnavalet, Paris], and finally, *La Source* [1856; Louvre], pure Parian marble roseate with life, an inimitable masterpiece, a marvel of grace and of bloom, a flower of a Grecian Spring blossoming under the artist's brush at an age when the palette would fall from the most vigorous hands.

<div align="right">

Théophile Gautier. "Ingres." *L'Artiste,*
April 5, 1857, p. 4.

</div>

It has been said that M. Ingres was a Greek of the age of Pericles gone astray in the nineteenth century. This notion seems to me more ingenious than correct. A man who was so opposed to things unreal and such an avowed lover of Nature in whatever form, could only very

* Gautier errs in the date; he means the critics of the Salon of 1819, where the *Great Odalisque* was first exhibited.

† The *Iliad* and the *Odyssey* are represented as two figures in *The Apotheosis of Homer*.

‡ There are several paintings by Ingres of this subject, which is taken from Ariosto's *Orlando Furioso*—in the Louvre, the Fogg Art Museum, and elsewhere. Ingres first intended this painting to represent the mythical Andromeda.

occasionally be considered a Greek, since he possessed such a marvelous instinct for assimilation. . . .

Today . . . M. Ingres has become for many people the epitome of classical purity. This is indeed true if the term *classical* is applied to the artists of the fifteenth and sixteenth centuries, but false if restricted to the school of David alone, whose principles M. Ingres repudiated all his life. This is further evidenced by the fact that M. Ingres' first admirers were the Géricaults, Delacroixs, in other words, the new school which wanted to throw off the yoke of the Institute, and which welcomed a master in M. Ingres. . . .

Later on, when the cause was won, there occurred a rupture which subsequently degenerated into a dispute between the *draftsmen* and the *colorists;* and it is to the colorists that the name of *romanticists* was given. . . .

I would not say that M. Ingres was a romantic, but I do assert that he was never classical in the sense that the term is understood. . . .

The resurrection of the Middle Ages has always been attributed to the romanticists. But before they were born, M. Ingres had not only used subject matter from that period, but, in order to do so, had gone so far as to borrow from primitive art a certain quality of naïve rigidity . . . which lends to his detailed and scientifically exact paintings that certain *local color* so in favor with the new school.

I will go even further: Sixty years ago M. Ingres was admiring Japanese painting, which the new school believes it has discovered for itself. The proof of this is in the portrait of Madame Rivière, and in the *Odalisque Pourtalès* [*Great Odalisque*] about which the critics noted: "This work resembles the colored drawings which sometimes decorate Arabian or Indian manuscripts." . . .

Ingres' name was found to contain the anagram "en gris" [in gray]. Since then M. Ingres supposedly appropriated gray; gray was his preferred color, and he even initiated his pupils with gray. This is amusing, witty, but nothing more. . . .

I will further note that M. Ingres often achieved a certain charm in the use of color . . . and I cite as examples of this the *Sistine Chapel* and the *Odalisque* [the *Bather of Valpinçon;* Louvre].

I firmly believe that in bringing art back to a more honest and straightforward treatment of nature, M. Ingres reversed the trend of the school of David and in so doing originated realism, which is engulfing us today.

<div align="right">E. E. Amaury-Duval. <i>L'Atelier d'Ingres.</i>
Paris, 1878, p. 277 ff.</div>

Disciple of David and continuing in his footsteps, Ingres com-

bined the study of antiquity with that of Raphael and the early Renaissance painters. From this eclecticism he created a tradition which has resulted in remarkable achievements. No one except [John] Flaxman has probed as deeply into the spirit of Greek antiquity and of ancient Roman painting. With his marvelous sense of beauty, Ingres produced admirable paintings. But his pictures, such as *Oedipus Interrogating the Sphinx* [1808; Louvre], the *Odalisque in the Harem* [Fogg Art Museum], or *Andromeda* [i.e. *Angelica*] *on the Rock* [Louvre], consist solely of unrelated details, isolated heads or figures. He succeeded little in the representation of groups and in paintings with numerous figures. He lacked imagination and spontaneity. His large compositions . . . are almost always laborious, confused, and frigid. When he dealt with a subject he saw it in terms of a multitude of other works of art. He always worked having engravings after antiquity, Raphael, or Poussin under his eyes. . . .

Lacking passion, his paintings reveal an expert archaeologist and a consummate draftsman. . . . One might say that his best paintings are his portraits, above all his male portraits, such as that of M. Bertin. . . .

To me his pencil drawings are even stronger than his portraits in oil. They are masterpieces of elegance, refinement, and verisimilitude. . . .

Will his reputation as an artist . . . increase with the passing of time? I do not believe so.

As a painter and composer, M. Ingres' fame is already greatly diminished. There remains his reputation as a draftsman. In this respect he will occupy a top position. . . . In the absence of human greatness, his work preaches a love of form, conscientious execution, and discrimination in representing reality.

In short, he was not a great painter, but a great professor.

> Auguste Barbier. *Souvenirs personnels.*
> Paris, 1883, p. 272 ff.

By the beginning of the nineteenth century art had ceased to be the language it once was in every country steeped in the memory of great traditions. It had become a kind of Volapük, or artificial language, formed from a medley of different recipes. . . . This Volapük is still spoken, is still a law unto itself. Though convenient for mediocre spirits it must . . . have caused great torment to men of genius, especially to Delacroix, who was always in conflict with the established School and his own temperament. Parallel with Delacroix, the willful and obstinate Ingres, also feeling the incoherence of such a language,

tried simply to reconstruct a beautiful and logical language for his own use, turning his eyes to Greece and to Nature.

Since, with Ingres, drawing consisted of line, the change was less noticeable. No one around him understood him, not even his disciple Flandrin. . . .

Ingres died and was probably buried too hastily, for he is very much alive today, no longer as an official painter but as someone entirely outside the tradition. He could never be one of the majority.

Thank God there were also Corot, Daumier, Courbet, Manet, Degas, Puvis de Chavannes, and a few others.

After the historic events of 1870 and the coming of the spirit of journalism, painting became the "miscellaneous" column, the pun, the literary page. With photography came speed, ease, and accuracy of drawing. And once again Ingres was found to be among us.

<div style="text-align: right">

Paul Gauguin. "Racontars d'un rapin (1902)."

In Jean de Rotonchamp. *Paul Gauguin.*

Paris, 1925, p. 239 ff.

</div>

Ingres took pains to leave no trace of touch. "Touch," he wrote, "is an abuse of execution. . . . Touch, no matter how skillful, should never be apparent; else it destroys the illusion and deadens everything. Instead of the object represented, it shows the method pursued; it betrays the hand instead of the thought."

It is to this sobriety of execution that is due the constant, methodical, undisturbed perfection of his paintings—their almost glazed surface. . . . We may go close up to them and examine them . . . nothing of the texture alters; no brushwork at all becomes visible upon the even firmness, the satin finish of the color. All is cold and smooth as porcelain.

<div style="text-align: right">

Octave Uzanne. "The Paintings of Jean Auguste Dominique Ingres." *Magazine of Fine Arts,*

I, 1905, p. 276 ff.

</div>

Ingres . . . ranks in achievement with the great masters of all time. For we have come now to the modern who was not the sketcher, but the painter of pictures. At the age of twenty-five he had painted the portrait of *Madame Rivière* [1805; Louvre], which is one of the great paintings of the world. . . .

What is the secret of a great painting? A great painting happens when a master of the craft is talking to you about something that interests him. In the case of Ingres the thing that interests him is sometimes divinely lovely in itself and sometimes it is fustian. But the quality of art is that it transmutes whatever it touches to favour and to

prettiness. . . . In what does the painting by Ingres differ from a plate of colour photography? Firstly in this, that all dross, external to what has interested the painter, has been fired out. Then that each line and each volume has been, subtly and unconsciously, extended here and contracted there, as the narrator is swayed by his passion, his rhetoric. . . . Nature having the range of all colours, plus the range from light to shade, can set this double range against the painter's single range of colours in a uniform light. So the great painters of the world have in their traditional cunning hit upon the plan of attenuating, as they cannot but do, the light and shade of their pictures, and paying us back by drenching each tone with as much of the wine of colour as it will hold without contradicting the light and shade.

The light in the [*Great*] *Odalisque* is a light that never was on land or sea, but a kind of sublimated illumination, where nothing is dark and nothing glitters, but all is saturated with colour to the n^{th} degree.

W. R. Sickert. "French Art of the Nineteenth Century." *Burlington Magazine*, June 1922, p. 266 ff.

Great Odalisque

1814* oil on canvas 36″ x 64″ Paris, Louvre

At the time of his early studies M. Ingres was a most promising artist who above all demonstrated much technical ability. But he has moved backwards since then and has made such sad use of his gifts that in his present works we can see nothing but the desire to be original at all costs.

An odalisque, her hair elegantly coiffed, has been tempted by the heat of the day to shed her clothing and rests in a semirecumbent position on a pile of cushions. She holds a fan of peacock feathers in her hand. A pipe leans against a toilet stand at her feet.

Her pose does not lack elegance; the forms, incorrect though they are, show fluid and rather graceful outlines. If at first sight there is little to attract the spectator, there is at least nothing that shocks. The picture even has a certain charm. But after a moment's attention we realize that this figure has neither bone, nor muscle, nor blood, nor life, nor relief—in other words there is nothing which constitutes the imitation of nature. The flesh painting is cold and monotonous. The parts of the picture which should be more shaded receive as much light as the most conspicuous areas. There is, properly speaking, no real highlight; the light is flat and spread evenly all over the picture, without artistry or discretion. It is evident that the painter has knowingly trans-

* Painted in Rome, first exhibited at the Paris Salon of 1819.

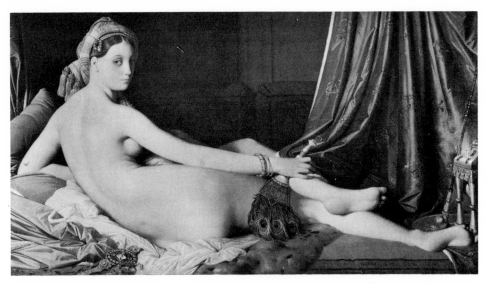

Great Odalisque. *Ingres*

gressed, that he wanted to do badly on purpose, or that he hoped to revive the pure and primitive style of the ancient painters; yet he insisted on taking as his model some fragments of a later period and of a degenerated execution, and these have led him completely astray.

C. P. Landon. *Annales du musée et de l'école moderne des beaux-arts. Salon de 1819.* Paris, 1819, p. 28 ff.

Neither bone, nor muscle—this was, indeed, what Ingres wanted. He had a marked indifference for things anatomical. . . .

Such was his ideal when he painted his *Great Odalisque*: line alone was essential for him, but he was not concerned with the exact, truthful representation of a contour. He re-created the actual forms according to his imagination and artistic sensibility. Granted, then, that Ingres' delineation showed "neither bone nor muscle," yet there was an extraordinary animation in his arabesque. This assumed a deep significance for Ingres and was equally if not more adept in characterizing his model than all the chromatic magnificence of Eugène Delacroix.

He imagined an oriental interior, and thus was one of the first, if not the first artist to introduce the Orient into a work of this type. The idea was original, but it must be emphasized that [with Ingres] it was no more than a decorative device: a turban, or an inlaid footstool—these are some of the accessories with which the painter attempted to create an atmosphere.

Jean Alazard. *Ingres et l'Ingrisme.* Paris, 1950, p. 112 ff.

311

The Vow of Louis XIII

1824 oil on canvas 165¾" x 103⅛" Montauban, Cathedral

It seems to me that this work is rather harshly painted and, furthermore, a composite of the styles of the old Italian masters. The Madonna is beautiful, certainly, but her beauty is of an *earthly* kind which seems to exclude the existence of the divine. This defect is even more apparent in the figure of the Infant Jesus which, though beautifully drawn, is the very antithesis of divine. However, this failing stems *not from lack of technique* but from a want of feeling. A subject such as this demands a certain kind of spiritual grace and celestial physiognomy which are entirely absent from the figures here portrayed. . . .

We have successfully mastered the mechanical arts, lithography, and diorama, but our hearts are cold, and *passion* of any kind is nowhere to be found, least of all in painting. Not a single work in this exhibition could compete with the fiery intensity of an opera by Rossini.

However, I must end this digression—which would have scandalized the intellectual painters—and return to M. Ingres, who is indeed one of the great draftsmen of the French school and also a man of intelligence. Nevertheless, I am surprised M. Ingres has failed to see that the charm of a religious painting lies in its spiritual quality, particularly when the action itself is basically unmoving. The angels drawing aside the great veil on either side of the picture are painted in a very dry manner, so are their garments, and the little cloud on which the Virgin is resting seems made of marble. The colors further the general impression of crudity.

The pose and gesture of Louis XIII are quite striking but there is nothing to indicate that he is the leader of a great empire imploring the aid of the divine Creator for all his countless subjects. The little Spanish moustache which is practically all one can see of the face of the principal figure produces a rather poor effect. These are some of the many criticisms which have been directed against this work by M. Ingres, and yet I still consider *The Vow of Louis XIII* to be one of the best religious paintings in the exhibition. It improves a great deal on further acquaintance, and I think it will gain even more when it is hung in a church where one will be constrained to look at it for perhaps an hour at a time. I find a depth of knowledge and thought in this work which establishes M. Ingres as a man sincerely dedicated to painting and one who exercises his art with integrity. . . . If the painter had been endowed with the spiritual fervor necessary for imparting a soul and some expression to the Madonna's face, this painting would undoubtedly have attracted the attention of the public.

<div align="right">

Stendhal. "Salon de 1824."
Mélanges d'art et de littérature.
Paris, 1867, p. 116.

</div>

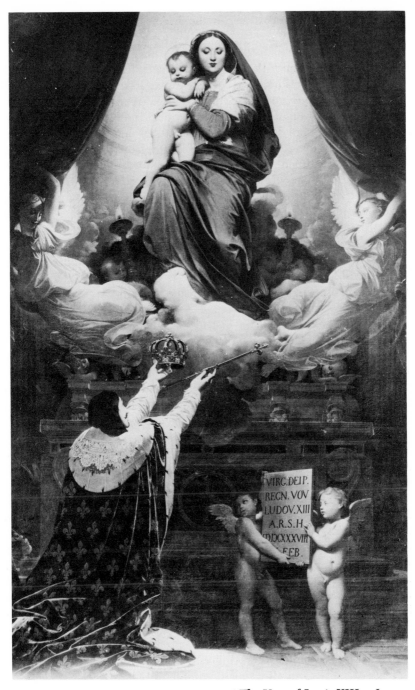

The Vow of Louis XIII.　*Ingres*

Portrait of Louis-François Bertin the Elder

1832 oil on canvas 45¾" x 37⅜" Paris, Louvre

For the past month the crowd of promenaders, fired by the admiration of the more serious critics, have been swarming to see the *Portrait of M. Bertin the Elder*. Without understanding, or even remotely suspecting, the innumerable questions of historical and critical interest which this important work has raised, they have, nevertheless, fallen under its spell. As best they can, they study the details of the head, portrayed with such marvellous perception and, with an almost childish pleasure, they examine the tactile qualities of the materials and the conspicuousness of the armchair; the simplicity and strength of the pose enraptures them and they never weary of contemplating with fascinated absorption the eyes and lips, so expressive and speaking. . . .

The success of this portrait is a foregone conclusion. . . .

But does this mean, however, that we must absolve the different parts of the composition from every standpoint? Is there nothing to find fault with, nothing to censure in the line, draftsmanship, color, or expression of the various components?

These questions might at first glance seem in bad taste . . . but they assume a special importance in this instance, for we are dealing with the work of a master, the head of a school which today is flourishing and esteemed, and because they concern M. Ingres. For twenty years he has pursued the same single and unshakable course; his doctrines and works have changed only in the smallest degree. His teaching, as revealed both by his pronouncements and by his brush, has had but one aim. The *Great Odalisque, The Apotheosis of Homer,* and the *Virgil* [1819; Musées Royaux, Brussels] have all demonstrated the singleness of his intention, and the portrait here under discussion reveals, when compared with the preceding works, not the slightest deviation in the painter's purpose. . . .

But, in all seriousness, I must add that the innovation attempted by M. Ingres seems to me contrary to the laws of sane logic. He has produced many admirable works, and will assuredly produce many more, but he has the whole of history working against him . . . which forbids a return to the past. He is wrong to take up the style of painting current at the time of Raphael's death because the last word of man's genius was not said by the Roman school. . . . He is wrong to forget, deliberately, the two past centuries. . . . Paolo Veronese, Rubens, and Rembrandt discovered and demonstrated resources unknown to Raphael.

This is why the serious admiration I profess for the portrait of M. Bertin does not alter my opinion of M. Ingres. It is a masterpiece of verisimilitude, I will agree. . . . Yes, but after Velasquez and Van Dyck is it permissible to disregard the warm and vigorous tone of the living model? I must answer no, decisively.

Portrait of Louis-François Bertin
the Elder. *Ingres*

Even the finest works by M. Ingres will always lack that one ingredient which ensures popularity, namely, progress. They will be valued as learned but will only rarely meet with approval since they do not belong to their age; the success which we now concede to M. Ingres does not preclude the realization of this prophecy.

> Gustave Planche. "Salon de 1833." *Études sur l'école française.* 2 vols. Paris, 1855, I, 206 ff.

Nobody paints better portraits than he. To the external likeness of the sitter he adds the resemblance of character; beneath the physical portrait he paints the moral one. Is this magnificent pose of M. Bertin not the revelation of an entire era, as he rests his fine and muscular hands on his hefty knees, like a middle-class Caesar, with the authority of his intelligence, his wealth, and his just self-confidence? . . . Such as he is, here is the honest bourgeois during the reign of Louis Philippe.

> Théophile Gautier. *Les Beaux-arts en Europe, 1855.* 1st series. Paris, 1857, p. 163.

HORACE VERNET

The battle painter Émile-Jean-Horace Vernet, a grandson of Claude-Joseph Vernet, was born in Paris in 1789. He was trained by his father Carle Vernet and his maternal grandfather Moreau le Jeune, and later studied under Vincent. He exhibited at the Salon from 1812 and was Director of the French Academy in Rome

from 1828 to 1835. An academic but very popular painter, he produced his battle-pieces heedless of the controversy between classicists and romanticists. He died in 1863.

I have seen two or three thousand painted battle scenes—I have seen two or three real ones, and this is sufficient for me to proclaim a masterpiece, that of M. Horace Vernet. There is more truth and naturalness in the way he paints even the sky than in twenty other landscapes sanctioned by the admiration of the connoisseurs.

Stendhal. "Salon de 1824." *Mélanges d'art et de littérature.* Paris, 1867, p. 13.

The public considers Horace Vernet the greatest painter of France, and I do not wish to contradict this opinion. He is, at any rate, the most nationalistic of French painters, and he surpasses them all by virtue of his prolific know-how, his demoniacal extravagance, and the ever blossoming self-rejuvenation of his creativity. He is a born painter . . . and his works seem to be the result of necessity. No style, but nature. Productivity which borders on the ridiculous. A caricature has represented Vernet on horseback, brush in hand, painting while galloping alongside a huge canvas. As soon as he arrives at the end of this canvas, the picture is already completed. What quantities of colossal battle-pieces has he not recently furnished for Versailles? Indeed, no German ruler, with the exception of Austria and Prussia, possesses as many soldiers as Horace Vernet has put on canvas. . . . On Judgment Day Horace Vernet will certainly appear in the Valley of Jehoshaphat with several hundred thousand foot soldiers and cavalrymen. No matter how stern the assembled judges will be . . . I do not believe that Horace Vernet will be condemned to roast in the eternal fire for the lack of propriety with which he depicted *Juda and Thamar.** I don't think so because, in the first place, the picture is so well painted that this would be reason enough to acquit him. Secondly, Horace Vernet is a genius, and a genius is allowed to do things which are forbidden to ordinary sinners. And, lastly, whoever marches at the head of several hundred thousand soldiers will likewise be forgiven much, even if he does not happen to be a genius.

Heinrich Heine. "Lutezia (1843)." *Sämtliche Werke,* vol. V, Philadelphia, 1855, 396 ff.

M. Horace Vernet is a soldier who produces paintings. I hate an art improvised to the roll of drums, I hate canvases tossed off in a

* Probably the painting in the Wallace Collection, London.

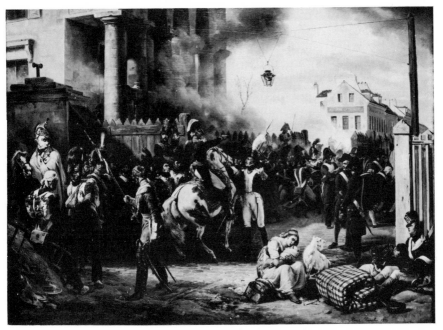

The Gate of Clichy: Defense of Paris. *Horace Vernet*

hurry, I hate paintings manufactured to the sound of pistol shots, just as I hate the army, the police force, and everything else that drags its noisy arms into a peaceful place. His immense popularity . . . this *vox populi, vox Dei* is for me like an oppression.

I hate this man because his pictures have nothing at all to do with painting, but are, rather, a kind of brisk and frequent masturbation in paint, an irritation of the French epidermis. . . .

I hate him because he was born with a silver spoon in his mouth, and because for him art is a simple and easy matter. . . .

To define M. Horace Vernet as clearly as possible—he is the absolute antithesis of an artist; he substitutes *chic* for drawing, cacophony for color, and disconnected episodes for unity; he paints Meissonniers as big as the entire world.

Furthermore, in order to fulfill his official mission, M. Horace Vernet is endowed with two eminent qualities—of one he has too little, of the other too much: he lacks all passion and has a memory like an almanac. Who knows better than he how many buttons there are on each uniform, . . . or where on a soldier's gear the copper of his arms deposits its verdigris? Therefore, what a vast public he has and what joys he provides for them! In fact, he has as many publics as there are different trades to manufacture uniforms, shakos, sabres,

muskets, and cannons! Imagine all these corporations united by their common love of glory, looking at a Horace Vernet! What a spectacle!

When one day I reproached some Germans for liking [the dramatist Eugène] Scribe and Horace Vernet, they answered: "We have a profound admiration for Horace Vernet as the artist who most fully represents his century." Well put, indeed!

<div align="right">

Charles Baudelaire. "Salon de 1846."
Curiosités esthétiques. Paris, 1892, p. 159 ff.

</div>

Horace Vernet's glory is the result of his having dared, first and foremost, to paint a modern battle, not just an episode of a fight . . . but a real collision of two armies, with their lines deployed or concentrating, the artillery charging, the batteries thundering, the staffs and the ambulances on some vast plain, the natural chessboard of great strategic combinations. He understood that the modern hero is that collective Achilles which is called a regiment.

Instead of mourning the ugliness of our costumes . . . Horace Vernet quietly accepted the man dressed in modern garb. . . . No one better than he reproduced the military *chic* of a particular time. . . .

In order to paint battles one must be able to paint horses. . . . The horse is, next to man, the most difficult creature to depict correctly. . . . He actually was bold enough to represent modern horses, their breed, gait, and characteristics. They certainly have not the poetic beauty of the steeds painted by Gros, nor the vigor of those . . . [by] Géricault, . . . but they are irreproachable from the horseman's point of view. . . .

To all these qualities, which are indispensable to a battle painter, he added a keen feeling for the topography of a landscape. . . . And as a man does thoroughly well only what he likes, he adored war; in him the artist was partly a soldier.

<div align="right">

Théophile Gautier. "Horace Vernet (1863)."
Portraits of the Day. Works, vol. VI,
Cambridge, 1906, p. 271 ff.

</div>

THÉODORE GÉRICAULT

Géricault was born at Rouen in 1791. At the age of seventeen he entered the studio of Carle Vernet, whom he left two years later to study with Guérin. His first exhibit at the Salon of 1812, *Officer on Horseback Charging* (Louvre), won him a gold medal. Two years later he exhibited *The Wounded Cuirassier* (Louvre). An unhappy

love affair with the wife of one of his best friends affected him deeply. He never revealed her identity, not even to his son, Hippolyte-Georges, who was born of this relationship in 1818. In 1816, Géricault went to Italy, where he produced numerous drawings and oil sketches for *The Race of the Riderless Horses*. After his return to Paris in 1818 he painted his best-known work, *The Raft of the Medusa;* Delacroix, whom he had met in Guérin's studio, posed for one of the figures. From 1820 to 1822, Géricault was in England, where he exhibited the *Medusa* and painted and lithographed street scenes, racing pictures, and studies of horses. His friendship with the Parisian psychiatrist Dr. Georget and his interest in extreme or abnormal situations resulted in ten unusual portraits of the insane, of which five are extant. Géricault died in Paris in 1824 of a spine injury incurred after a riding accident.

In general he [Géricault] started to paint as soon as it was light enough, working without interruption until nightfall. He was often forced to paint in this manner in order to finish that very day an important piece begun in the morning. This time limit was even more obligatory for him than for anyone else, since he used the fastest drying thick oil paint obtainable and therefore would not have been able to carry over to the next day his work of the previous evening. . . .

He worked without uttering a word. He smiled at me softly with an expression of light reproach and assured me that even the noise of a mouse was sufficient to prevent him from painting.

His completely new method of painting was no less surprising to me than his extreme diligence. He painted directly on the white canvas without any sketch or underpainting, except for a well-placed outline. The solidity of his work did not suffer from this procedure. I also observed the intensity of attention with which he posed the model before he touched the canvas. He appeared to proceed very slowly, when actually he was painting very rapidly. He would place each brush stroke one after the other and was only rarely obliged to do something over again.* He moved neither his body nor his arm. He appeared perfectly calm. Only a slight touch of color in his face indicated the preoccupation of his mind. Seeing thus his calm outward appearance, one was all the more surprised by the verve and energy of his execution. What plasticity, especially when a part was still only in its preparatory stage! It resembled a fragment of sculpture in the rough. One would think that Géricault used very wide brushes for this monumental type of painting. However, this was not so. They were small, comparable to those used by other artists I have known.

* Gros said to his pupils: "Get set, let go!" In other words, keep the brushwork in all its freshness. This was also Géricault's method: He put in the shadow, half-tint and highlight, and the picture was finished. (—C.C.)

The spectator can easily convince himself by looking at some of the figures in his paintings which were done entirely with hatchings.*

A. A. Montfort (1818–19). Quoted in Charles Clément.
Géricault. Paris, 1879, p. 138 ff.

I should like to see removed from the Louvre that picture of the *Medusa* and those two big *Dragoons,* its acolytes. I should like to have one of them placed in some corner of the Navy Department, and the other two in the War Department; then they will no longer corrupt the taste of the public, which should be accustomed solely to the Beautiful. And we should be spared, once and for all, subjects such as executions, autos-da-fé, and the like. Is that the mission of painting, of sane and moral painting? Is that what we should admire? Is it in such horrors that we should find pleasure? I do not object to the effects of pity or fear, but I want them represented as they were by Aeschylus, Sophocles, or Euripides. I resent the *Medusa* and those other pictures of the dissecting room: they show us man only as a cadaver and reproduce only the ugly and the hideous. No! I object to them! Art should always be beautiful and should teach us nothing but the Beautiful!

J. A. D. Ingres (undated). *Écrits sur l'art.*
Paris, 1947, p. 53 ff.

The *Officer of Light Cavalry,* exhibited in 1812 under the title of *Equestrian Portrait of M. Dieudonné Serving in the Guards of the Empire,* was painted in twelve days with the dash, fury, and audacity of genius. At the sight of this strange painting, so violent, so full of motion, so proud, so splendid in drawing and colour, David, terrified, cried, "Where does that come from? I do not know the touch." It came from a new idea, from a seething brain which the old forms could not satisfy and which burst the old moulds. Géricault was then twenty, and his teachers kindly advised him to give up painting, for which he was not born. They sought contour and motionless purity; he strove after life, passion, and colour. He worshipped Rubens, then pro-

* A note by [Géricault's pupil] M. Jamar permits me to indicate the colors Géricault used and how . . . he arranged them on the palette: vermilion, white, Naples yellow, yellow ocher, Italian earth, *ochre de Brie,* raw Sienna, brown-red, burnt Sienna, ordinary lake, Prussian blue, peach black, ivory black, Cassel earth, and bitumen. He worked very neatly, keeping his colors separated on the palette. After a day's work the palette looked as if it was hardly used. (—C.C.)

scribed; all the violent, all the fiery painters, Michael Angelo, Rembrandt; he was a Romanticist long before Romanticism.

<div align="center">Théophile Gautier. "The Louvre (1867)." Works,
vol. IX. Cambridge, 1906, p. 35.</div>

Géricault, unlike Ingres, was an innovator. His system (if we may speak of a system when referring to the fine arts and to a painter as spontaneous as Géricault) is the perfect fusion of tradition and progress. He loved, understood, and accepted all styles: from antiquity and the Renaissance to the severe line of the Greeks and the Florentines, as well as the colors of the Venetians and the chiaroscuro of the Flemish. He encompassed all, seeing, understanding, and absorbing everything. He was not an eclectic, but an artist possessed of absolute sincerity, whose hand and eye had been strengthened by long hours of study. He turned away from the arid and meaningless decorative painting of the Empire; it was not a deliberate rejection, but simply the natural result of his feeling for the picturesque. In a highly individual way he presents a new point of view. By dint of applying himself to the study of reality and by familiarizing himself with the works of the masters he acquired a precise and profound fund of knowledge which enabled him to treat of modern subjects; he marked everything he touched with his powerful originality. . . .

Géricault's premature death was a great and irreparable loss to the French school. If he had completed the normal span of life and confirmed by repeated successes the promises implicit in his beginnings, a new era would perhaps have opened up for French art. His influence, which was without doubt enormous, still lasts today. He had a profound effect on the genre and landscape painters of his time, and the extent of his influence on Delacroix, Decamps, and the sculptor Barye is even more pronounced and obvious.

<div align="center">Charles Clément. Géricault (1867).
Paris, 1879, pp. 9 ff., 207.</div>

Gracefulness was not his domain; he introduced vigor, if not brutality, into everything he touched. When he copied Prudhon's *Justice and Divine Vengeance,* he modified its character, intensified the light, and made the drapery more striking. When he had Delacroix pose for a study of a head, he did not render the aristocratic delicacy of his model. He avoided drawing women and hardly ever distinguished between the concept of force and that of beauty. A massive, heavy female nude in the Rouen Museum demonstrates these tendencies, from which coquetry and frivolity were totally absent.

On the other hand, his passion for reality led him to examine

closely all the imperfections and physical deformations which plague the human body, whether they were caused by privation as in *The Raft of the Medusa,* by torture as in the *Inquisition* and *Slave Trade,* by madness as in the portraits of deranged persons, or by violent death as in the heads of executed criminals. Géricault studied them all and depicted them with what appears to be a feeling of gratification. An enumeration alone of the subjects he grappled with shows how fertile was the domain that he opened up to artists who, with the exception of Gros later on, had been hampered by academic prohibitions and concern for an unreal purity.

Léon Rosenthal. *Géricault.* Paris, 1905, p. 140 ff.

The influence of England on the art of Géricault cannot be gauged from the famous little racing picture in the Salle des États. To appraise it you must study the pictures of horses in their stalls or at exercise which he produced during or just after his stay. Géricault had ever cherished an intense, and, as it turned out, unfortunate, passion for horses: it was as a result of a third riding accident within a few years that he died in January 1824. From Constable he learned to observe them; and Constable it was who helped him to a technique wherewith to express his acute, one may almost say gloating, observations. This technique, however, was so modified by the intelligent admirer of Rubens and the Renaissance that his little studies often thrill one with a fat and glossy *matière* which seems to anticipate Courbet. Also, in England he picked up a taste for oddities and characteristics in human beings. This new passion reveals itself most happily in a series of lithographs of street-scenes and queer types executed and published in England—at that time the home of this comparatively unknown process; and to less advantage in the studies of idiots, in oil, done after his return to Paris.

Clive Bell. *Landmarks in Nineteenth-Century Painting.* New York, 1927, p. 51.

Géricault brought to the worn-out forms of French painting a renewed passion and warmth, and a wealth of solid painterly qualities. His vehement character and his restless, exuberant temperament made him the first of the romantic painters. But he went beyond them and even looked forward to realism in his modern attitudes and his impassioned study of actual life. Like all great poets, he remained close to reality; he imbibed it, he became drunk with it. David's forms had been restricted to the surface of bodies stripped by the gray studio light and frozen into noble gestures; they had been thinly painted in an impersonal, flat style. In contrast, Géricault's drawing is twisted

and curved, his forms are heavy and modeled by broad planes of light and shadow. They appear as if simplified by the intense beam of an artificial light, as we see it later in the work of Daumier.

<div style="text-align: right">

Henri Focillon. *La Peinture au XIX^e siècle.*
Paris, 1927, p. 191 ff.

</div>

When the pictures [of the insane] have been discussed by modern writers, they have been regarded only as additional evidences of Géricault's preoccupation with violence, and are usually associated with his studies of cadavers from the charnel houses and decapitated heads from the prisons, or as a final statement of his increasingly realistic view of the world around him. No notice has been taken of the historical novelty of portraying insane people with such fidelity and sympathetic restraint.

Heretofore, madness, however accurately reported by painters, had most frequently been interpreted in terms of demonic possession, or occasionally witchcraft. In much rarer instances the insane have been represented as phenomena of the every-day world without religious or fantastic associations. In such cases the insane are depicted

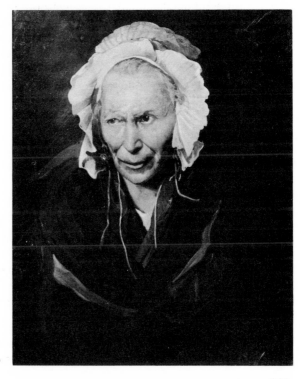

The Madwoman.
Géricault

in behaviour which deviates widely from the norm, and their possessive excitements or patent eccentricities are exposed with the unmindful intrusiveness of a modern photographer.

But Géricault, in his paintings of Georget's patients, interprets insanity not in terms of behaviour, but as a state of mind, which, though disordered and clinically classifiable, emphasizes rather than obliterates individuality. The patients are painted as normal portraits, the genre most appropriate to the study of human personality. Géricault, respectful of the sensibilities of his sitters, tactfully represents them in no specific environment, such as a hospital room, which might betray their segregation from normal society, and in no particular action which might dramatize their disease and so isolate them from the experience of the average spectator. The sitters, conscious of the artist, anxious to appear at their best, by their pose, their choice of clothes and their manner of wearing them, impose on the painter their idea of themselves. Hidden in the "likeness," in the colour of the skin, the eyes, the veins, are the pathological "emblems" of their malady which are only for the psychiatrist to read. To the layman their abnormal state of mind can only be deduced from their physical bearing and the disquietude of their faces. This establishment of the insane as understandable individuals was not accomplished exclusively through the insight of the painter, but was as closely dependent upon the conceptions of his time as were the victims of demonic possession portrayed so frequently in the religious art of earlier periods.

Margaret Miller. "Géricault's Paintings of the Insane."
Journal of the Warburg and Courtauld Institutes,
IV, 1941, p. 151 ff.

The Raft of the Medusa
Le Radeau de la Méduse

1818–19 oil on canvas 193″ x 282″ Paris, Louvre

In 1816 the frigate *La Méduse* was shipwrecked near the West African coast. One hundred forty-nine persons were put on a raft towed by lifeboats. In a storm the raft broke loose and was left drifting on the high seas. After twelve days of starvation, madness, and murder only fifteen of the 149 survived (Géricault painted nineteen survivors) and were picked up by rescue vessels. Two of the survivors, Corréard and Savigny, published an account of their ordeal, which became a *cause célèbre* embraced by the liberals.

. . . It cannot be denied that the painting of this terrible disaster is capable of arousing our compassion; but . . . we may feel surprised that the artist, in

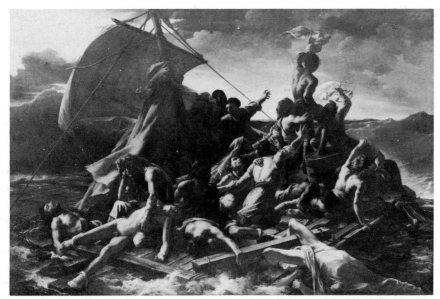

The Raft of the Medusa. *Géricault*

preserving its memory on canvas, should have used this immense frame and these colossal dimensions. Such grandiose proportions are normally reserved for celebrating events of a more general interest, such as a national festival, a great victory, the coronation of a sovereign. . . .

Let us also add that an artist is usually not indifferent to the fate of his work, but what public building, what royal palace or collector's gallery would be willing to house this painting? . . .

The action [in the painting] is weak and ill-planned; where is the central point? Which is the principal figure and what is the artist trying to convey? We see bodies half submerged in water, the dead and the dying, men yielding to despair, and others clinging to a feeble ray of hope. These are the elements which the artist, despite his widely recognized talent, has been unable to arrange satisfactorily.

The execution also leaves a great deal to be desired. The light, drawn from the background of the painting, is gray and monotonous; it barely touches the objects and leaves everything else black and opaque. The drawing is not without warmth and vigor, but it is far from being correct. Yet the painting has at least the merit of originality and, furthermore, there is a certain vitality in the brush stroke which promises well for the painter's future, and once he has learned to control his brush and turn it in a more fitting direction he will profit considerably.

C. P. Landon. *Annales du musée et de l'école moderne des beaux-arts. Salon de 1819.* Paris, 1819, p. 66.

Géricault got in touch not only with the two authors but with other survivors. Like a modern reporter, he wanted to know just how it all had happened. He had a model of the raft built, studied the expressions of persons *in extremis* and the look of newly dead corpses, which he procured from the neighboring hospital and the morgue; his atelier began to look like a slaughterhouse. He made physiognomical studies, some of them, notably, of Negroes,—three of the survivors were of dark races,—he listened to the desperate and watched the deranged wherever he could find them. To a friend whose face was transformed because he was suffering from jaundice, the artist exclaimed, "How beautiful you are!" and hastened to fetch his paint-box in order to incorporate this observation into his material. He made a short trip to Le Havre to look at the action of waves. The innumerable sketches in pencil and pen, life-size portrait studies of the participants, monumentally painted death's-heads, arms, and legs, which have come down to us, show what new territory his grandiose artistic vision opened up for representation.

The distribution of so many figures and compositional elements over the colossal surface seems to have offered the greatest difficulties. No painter of the 19th century was at ease in constructing large compositions. Géricault remembered the old masters, perhaps Michelangelo more than all the rest, and settled, after much vacillation, on the scene with the rescue ship in sight and on double diagonals as a scaffold of form, but at the last moment he discovered a "hole" in the lower right. Shortly before the opening of the exhibition he changed his scheme, and inserted a new figure. . . .

It may be doubted whether the *Medusa* is among his best performances. Despite great beauty in details, it does not give either the clearest or the strongest presentation of what the artist sought. It lays itself open to criticism at too many points, and although it is the only subject-picture that reached completion, it is in a profound sense more of a fragment than many of the studies and smaller paintings. The fact that it was for a century almost the unique vehicle of the artist's fame, is one of the chief causes of the misunderstandings which have clustered about Géricault's art.

<div style="text-align: right">

Klaus Berger. *Géricault and His Work.*
Lawrence, Kansas, 1955, pp. 18, 51.

</div>

The Raft of the Medusa is a truly impressive picture. The freedom with which gesture is used to translate the grief, the resignation, the despair and the hope of the huddled figures; the light and shade which seems to represent so many mental states, recalls the technical device of Caravaggio, though animated by a new and personal spirit. It was a complete break from Classicism, an emotional art in terms of the nineteenth century.

<div style="text-align: right">

William Gaunt. *Bandits in a Landscape.*
London, 1937, p. 150.

</div>

CAMILLE COROT

Camille Corot, born in Paris in 1796, pursued a business career until the age of twenty-six when his father at last gave him an allowance to study painting. His teachers were the classicist landscape painters Michallon and J. V. Bertin. From 1825 to 1828 Corot was in Italy, where he developed his strongly constructed early landscape style. From 1827 on Corot exhibited at the Salon fairly regularly, but attracted little notice until 1838, when the Duke of Orléans bought two paintings. Other government purchases and independent commissions followed. With the exception of his three visits to Italy (1825–28, 1834, and 1843) and brief trips to Switzerland, Holland, and England, Corot spent his life in France searching the countryside for subjects. He painted frequently at the family property in Ville d'Avray, near Paris, and in the forest of Fontainebleau, where he associated himself with the Barbizon artists. During the 1850's Corot began to paint his silvery, feathery landscapes which became immensely popular and led to innumerable imitations and forgeries. Still later Corot turned to figure paintings, which were first exhibited at the Salon of 1869, but little known in his lifetime. Although Corot became wealthy in his later years, he remained a man of great simplicity and charity. He supported Millet's widow and bought a house for Daumier when the latter became blind and destitute. Corot, who never married, died in Paris in 1875, universally beloved and respected.

At the head of the modern school of landscape painting stands M. Corot. If M. Théodore Rousseau were to exhibit, his supremacy would be in doubt. M. Théodore Rousseau combines a naïveté and originality, which are at least equal to M. Corot, with a greater charm and a greater certainty of execution. It is, in fact, naïveté and originality which constitute the merit of M. Corot. This artist evidently loves nature with sincerity and knows how to look at her with as much intelligence as love. The qualities by which he excels are so strong—for they are qualities of heart and soul—that M. Corot's influence is now apparent in almost all the works of the young landscapists. . . . From the depth of his modesty M. Corot has acted upon a host of other artists. Some have applied themselves to selecting from nature the motifs, the views, and the colors of which he is fond—others have even tried to imitate his clumsiness. Speaking of M. Corot's alleged clumsiness—it seems that there is a slight misconception to clear up. All those half-baked critics, after having conscientiously admired and loyally praised a picture by Corot, usually end up by saying that it fails in its execution, and they agree that M. Corot decidedly does not know how to paint. Fine fellows! who first of all are ignorant of the fact that a work of genius—or, if you will, a work of the soul—in which everything is well seen, well observed, well understood, and

well imagined, will always, when it is sufficiently executed, be very well executed. There is a great difference between a work that is *complete* and one that is *finished* . . . from which follows that M. Corot paints like the great masters. . . .

Another proof of M. Corot's powers, if only in the sphere of technique, is that he knows how to be a colorist with a limited tonal range and that he is always harmonious even when using rather raw and rather vivid colors. His composition is always superb.

Charles Baudelaire. "Salon de 1845."
Curiosités esthétiques. Paris, 1892, p. 53 ff.

Corot is a true artist. One must see a painter in his own studio in order to have an idea of his merits. I saw there, and appreciated quite differently, pictures I had seen at the Salon, which had then impressed me but slightly. His large *Baptism of Christ* [Church of St. Denis du Saint-Sacrement] is full of simple beauty. His *trees* are superb. I spoke to him about the tree I have to do in my *Orpheus*. He said I should let myself go a little and do whatever comes to me naturally; that is what he generally does. He does not admit that one can attain beauty by infinite efforts. . . . Corot ponders long over a subject: his ideas come to him and he adds to them while working; that is the right way to do things.

Eugène Delacroix. *Journal.* 3 vols.
Paris, 1932, I, 206 ff. Entry for March 14, 1847.

Corot is simple, good, and utterly lacking in . . . jealousy, false-hood, and rudeness. . . . He is never disagreeable or envious, even of his most direct rivals. "Théodore Rousseau," he says "is more revolutionary than I," and in the presence of some paintings by a famous master [Delacroix] he added: "He is an eagle and I am but a lark, chirping my little songs in the gray clouds."

Théophile Silvestre. *Histoire des artistes vivants.*
Paris, 1856, p. 98.

His landscapes all resemble one another, yet no one would think of reproaching him for it. We like those Elysian woods and meadows, those twilight skies, those ideal vales through which the painter—nay, the poet—wanders, treading lightly on the dewy grass, gazing at the rosy dawn. A light, silvery veil seems to drift across the canvas, like a white morning haze settling over the fields. Everything is indistinct, everything undulates, floating in the misty light. The trees are nothing

but gray masses; we cannot distinguish a single leaf, but we feel the fresh breeze of life.

> Théophile Gautier. "Salon de 1857, XVIII."
> *L'Artiste,* II, October 25, 1857, p. 114.

I have no idea where this excellent man, whose manner is so quietly emotional, finds his landscapes; I myself haven't met with them anywhere. They are infinitely charming, however, such as they are. There is something in his particular manner of conceiving and rendering nature that is reminiscent of Bernardin de Saint-Pierre.* It is vague and indecisive. The notion of the natural individuality of each tree, plant, and rock is scarcely apparent; but what is definitely acknowledgeable in the work, and which is equal to the simplicity of the themes, is his keen understanding of ordinary things—the wet grass, lush shadows, and purified light.

His limpid landscapes seem swept along in a mystic dance to the harmonies of an invisible instrument. They must not be disturbed, these nymphs and cupids that run wild in regions as primeval and virgin as Eden, and as humid and dense. They are simply there, standing or supine, inwardly following the chorus of aerial melodies. A mere breath has set them upon the grass. A breath can bear them away again on the whirlwind of a whispered dance, to the rhythm of sweet ecstasies born of sounds, light, and perfume combined!

> Jules Castagnary. "Salon de 1857." *Salons, 1857–1870.*
> 3 vols. Paris, 1892, I, 25 ff.

If Corot would consent to kill once and for all the nymphs with whom he populates his woods and replace them with peasant women, I would like him beyond measure.

I know that for his airy foliage, for his moist and smiling dawns he needs diaphanous creatures, dreams clothed in mists. Yet I am sometimes tempted to demand a more human, more vigorous side of the master's character. This year he has exhibited studies painted, no doubt, in the studio. I much prefer a rough sketch done by him out in the fields, face to face with powerful reality.

> Émile Zola. "Mon Salon (1866)."
> *Mes haines.* Paris, 1880, p. 319.

Everybody knows that M. Corot, whose paintings appear unfinished, is on the contrary extremely subtle and accomplished. . . . If, for the expression of his dreams, he intentionally leaves vague jumbles

* French writer (1737–1814), author of the idyllic novel *Paul et Virginie.*

almost obliterated in semiobscurity, he immediately places next to them a detail superbly firm and well observed. This proves clearly that the artist knows much; his dream is supported by a seen reality. . . . One asks oneself why M. Corot, who knows so well how to be a realist, always dares with great temerity to paint putti and nymphs. . . . The old masters have proved that the artist, once he has established his own idiom, once he has taken from nature the necessary means of expression, is free, legitimately free, to borrow his subjects from history, from the poets, from his own imagination, from the thousand sources of his fantasy. That makes the superior artist: face to face with nature he is a painter, but in his studio he is a poet and thinker.

> Odilon Redon (1868). Quoted in *Odilon Redon, Gustave Moreau, Rodolphe Bresdin* (New York, Museum of Modern Art). New York, 1961, p. 46.

Papa Corot used to say to us: I have only a little flute, but I try to strike the right note.

> Camille Pissarro. Letter to his son Lucien, February 23, 1894. *Letters . . .* New York, 1943, p. 235.

Corot venerates the Masters. But he seems to think that their "knack" is theirs alone—feeling, perhaps, that another man's ways would be more of a hindrance than a help. He is not of those whose endless spirit of rivalry extends even to their predecessors, and who yearns to absorb all the greatness of the past, to be in themselves all the other Great—*and* themselves. . . .

He believes in "Nature" and "work," in all good faith.

In May 1864, he writes to Mlle Berthe Morisot: "Work hard and steadily; don't think too much about papa Corot; nature is a still better adviser."

What could be simpler? The spirit of simplicity was in him. . . . Nature: for Delacroix a *dictionary;* for Corot, the *model.*

This difference, for the two painters, in the functions of *what is seen,* is worth thinking over. . . . Nature, then, was for Corot a model —but from several points of view.

First, it stood for the utmost precision with respect to light. When he comes to painting views veiled in haze, mist-capped trees, the evanescent forms still imply their clouded precision. Structure is there behind the veil: not absent, but at one remove.

He is, besides, one of those painters who studied the lie of the land most closely. Rocks, sand, folds of terrain, the molded lift of a road across the country, the continuous accidental sweep presented by natural formations, are for him objects of the first importance. For

him a tree is a growing thing, and can only live where it is; each tree
has its appointed site. And the tree which he shows as so firmly rooted
is not simply an essential type; it is individualized, with a history of
its own, unlike any other's. It is, for Corot, a personality.

<div align="right">

Paul Valéry. "About Corot (1932)."
Degas, Manet, Morisot. New York, 1960, p. 137 ff.

</div>

Corot is usually mentioned in connection with the painters of
Barbizon. . . . Anyone satisfied with this classification cannot possibly
understand the real significance of Corot. In looking at his pictures
we see before us a large portion of the history of French painting.
Looking backward we find paths leading to Chardin, Poussin, and
Claude Lorrain; beyond that to Rembrandt, Vermeer, Correggio, and
Giorgione—to mention only a few of the relationships. Corot's work
had an effect on his contemporaries: *viz.* Millet. The young Manet,
the young Monet, the young Renoir, the young Cézanne were more or
less strongly influenced by him. Sisley owes part of his formation to
him. The beauty of Corot's landscapes is mirrored in the pictures of
Utrillo's youth. The most beautiful landscapes of Derain are unthink-
able without Corot's early landscapes of the Campagna. . . . In Corot's
work there is no trace of the impetuous externalization characteristic
of so many other French painters of the nineteenth century—David,
Gros, Géricault, Delacroix, Courbet, Manet, and even Renoir.

The entire nineteenth century saw in Corot only . . . the great
landscapist. Only since the beginning of our own century has Corot,
the figure painter, who was rarely mentioned earlier, been recognized
as the greater artist.

In his figure paintings Corot shows a classic and timeless great-
ness. Whereas his landscapes fit into the nineteenth-century tradition,
the figure paintings defy any attempt at classification. They are monu-
mental in their own special way. . . . They form ties across the
centuries with those of Leonardo, Raphael, Titian, and Vermeer.
Occasionally we see strangely luminous colors, the source of which
will remain a secret: a rich lemon yellow, blood red, a magnificent
warm blue, a saturated green. These colors are no longer applied in
strokes, but laid on in colored planes next to one another or on top
of each other. These figure paintings are of an incredible boldness, as
if painted under the dictate of a demon. They contain the secret of
mature old age, and yet they display an almost childlike insouciance.
Some works of his latest period recall Rembrandt.

<div align="right">

Gotthard Jedlicka. *Französische Malerei.*
Zurich, 1938, p. 45 ff.

</div>

"The two most important subjects for disciplined study are, in my opinion, drawing and values," [said Corot]. He does not mention color.

It is astonishing that Corot, in according color a subordinate role, was nevertheless a colorist as varied as he was subtle.

François Fosca. *Corot.* Brussels, 1958, p. 129.

It is worth summarizing the story of Corot and his imitators in order to make clear what extraordinary difficulties have had to be overcome by scholars like Bazin in the process of finding out what Corot actually painted, and thus arriving at a dependable overall estimate. The story may also help us to understand how a painter who was eagerly sought by almost every American collector of the late nineteenth century could so drop out of sight in the twentieth that a retrospective exhibition staged by the Museum of Modern Art in 1930 came as a revelation. . . . Alfred Robaut, Corot's great friend who devoted thirty years to compiling a catalogue of his authentic work, lists twelve major "copyists, pasticheurs, and plagiarists"; seven pupil-copyists who worked "without thought of personal gain"; eighteen artists working from nature in Corot's general manner (that is, in his "feathery" style); and forty-five artists to whom he, Robaut, had lent Corot studies so that they could make copies. He also noted that Corot often touched up the work of friends or pupils painting in his company, and that he even made his own variations of their work, perhaps to instruct them. Moreau-Nélaton, who completed Robaut's catalogue and published it in 1905, added more disturbing information in a personal study, *Corot raconté par lui-même* (1924). We learn that Corot often signed, out of sheer pity, the work of poor imitators. Bazin lists more sources of confusion: authentic works exist with false signatures provided by dealers even when a true signature existed hidden under the frame! The "Vente Corot" stamp, affixed for the posthumous sale to works in his studio not already signed, is not a guarantee of authenticity because Corot owned many works by his friends, pupils, and imitators. Such works also went into the possession of Corot's family; thus even the most gilt-edged pedigree cannot be accepted as ultimate proof. As to outright forgeries, consider the following information: in 1888 a Brussels imitator shipped two hundred and thirty-five "Corot" landscapes to Paris; and a certain Dr. Jousseaume, more avid than he was astute, collected no less than 2414 paintings, sketches, and autographs, every one of them by the same forger! This obviously surpasses the famous quip of some decades ago, that of two thousand works by Corot, three thousand were in America.

S. Lane Faison in *J. B. C. Corot . . . an Exhibition*
(Art Institute of Chicago). Chicago, 1960, p. 8 ff.

View of Rome: The Bridge and the Castle of St. Angelo with the Cupola of St. Peter's

1826–27 oil on canvas 8⅝" x 15"
San Francisco, California Palace of the Legion of Honor

The work is typical of Corot's early period; the drawing is precise and defined, and the brush-stroke is a firm, decisive one—both qualities which were greatly modified in his later periods, as is seen readily by comparison of the *View of Rome* with the canvas *Banks of the Somme at Pecquigny* dated 1860 [also in the Museum collection]. . . .

Influenced as he was by the emphasis on construction and composition in the works of many of the artists whom he admired (Claude le Lorrain and Nicolas Poussin were among them), and yet with his natural tendency to paint with photographic realism, Corot's works frequently show evidence of the divergent forces which guided him. . . .

Corot's well-known palette, largely responsible for the grace and charm of his work, was a part of his painting at even this early period in his career— muted yet lucid, subtle yet with a fine-drawn vigor, it strikes the fundamental key-note for the greater body of his work. True, in this as well as in his other early paintings, Corot was less limited in his choice of colors than he later was, when he emphasized tone value, interpreted principally in tinted greys, at the expense of clearly conceived form and definitive drawing. But the familiar softness and delicacy is here, and the sky, especially, is painted with the attention to tonal values which became the primary characteristic of the artist's later work. . . . In the latter part of the nineteenth century, Corot's

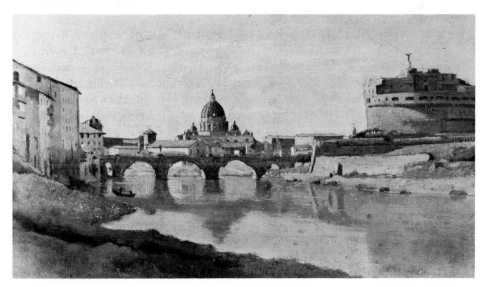

View of Rome. *Corot*

concept of tonal values, resulting from what has been called his "photographic vision," was tremendously admired; his method was accepted as the proper method of painting and was taught widely in art schools. The inevitable outcome in France of this teaching was a flood of countless grey paintings—an unassailable proof of Corot's ultimate popularity and the esteem in which his work was held.

> G. D. Davisson. "An Early Landscape by Corot."
> *Bulletin, California Palace of the Legion of Honor,*
> February 1946, p. 87 ff.

Souvenir of Mortefontaine

1864 oil on canvas 25⅝" x 35" Paris, Louvre

A delicious landscape by Corot. . . . The morning haze caresses a lake. Large trees trace lace designs on the silvery atmosphere. Three young girls at the water's edge play with the branches of a graceful ash tree. Corot is incomparable in evoking poetic images with the simplest means. There is barely anything, but the impression is here, and it is conveyed from the artist to the spectator.

> Théophile Thoré. "Salon de 1864." *Salons de W. Bürger,*
> *1861 à 1868.* 2 vols. Paris, 1870, II, 75 ff.

If I had to select two landscapes which would be most representative of Corot's work, my choices would be *The Cathedral of Chartres* [1830; Louvre] and the *Souvenir of Mortefontaine.* The latter painting is like a crossroads in the painter's career, wherein his entire past is crystallized. At this late hour in his lifetime, the form has arisen straight up out of his soul, like a decantation of thirty years of life. The old man is searching for the byroads of his youth; but they are now obscured by the evening's mist. There is actually in Corot's earlier work a foretaste of and a sequence leading up to Mortefontaine. The embryo of this natural-looking composition—where a mass of airy foliage at the right is set against a slender, bared tree trunk on the left—is already contained in the study of *The Lake of Nemi,* from the 1843 trip. The very characteristic tree on the left, composed of a trunk with a single branch growing up alongside from its base, is a memory from his youth; Corot sketched this tree with its branches curving upward like wisps of smoke in the woods of the Città Castellana in 1826 [Louvre]—a tree which has awaited its time in the painter's portfolio for more than thirty years. And lastly, haven't the hazy,

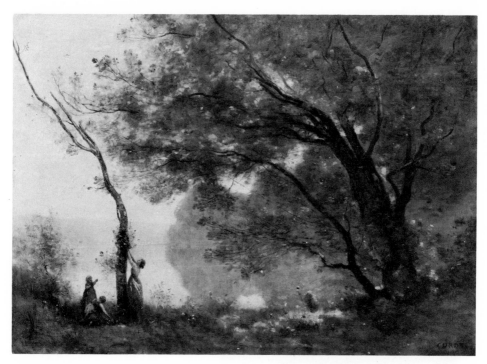

Souvenir of Mortefontaine. *Corot*

bluish forms on the opposite bank, seen through the fog, appeared some time before in the aforementioned *Lake of Nemi* and *The Study at Riva* from the 1834 trip? There is nothing, down to the suggested figure of the woman, that cannot be found in a former composition such as *The Reaping of the Laurel,* painted about ten years earlier.

Corot's art of that period is a remembrance of things past. The memories of forms his brush created long ago come crowding back upon his consciousness and possess his imagination. Thus his work results in cycles of paintings that are variations on a remembered theme. We have considered the cycle of Mortefontaine. There is also the cycle of the *Ronde des nymphes,* originating from an old study of the Palatine; the cycle of the Ariccia; the cycle of Castelgandolfo, and that of the *Coup de vent.* The cycles often intermingle. The art of the aging Corot is fraught with reverberating echoes and reminiscences.

Germain Bazin. *Corot.* Paris, 1951, p. 47 ff.

We must admit that some of his poeticizing pictures are extremely beautiful. *Souvenir de Mortefontaine* (1864) is a masterpiece, which rises out of popular painting as the lyrics of Burns or Heine rise out of popular songs.

From all his great range of delicate visual experiences Corot came to be satisfied with one—shimmery light reflected from water, and passing through the delicate leaves of birches and willows. He concentrated on it because he loved it, and he thereby proved once more his extreme simplicity of character. For he had revealed one of the eternally popular effects of nature, one which is still quoted by simple people as a standard of visual beauty.

Kenneth Clark. *Landscape into Art* (1949). Boston, 1961, p. 83.

The Interrupted Reading

ca. 1865–70 oil on canvas 36½″ x 25¾″ Art Institute of Chicago

For the most part I have represented humble girls, humble women. I had met them in the street, in their Italian garb or servant's clothes. Or else they might have come to my studio, asking if I needed a model. I never sent them away. I saw the beauty of life in them. This beauty is in every living creature, it is in everything that breathes, as it is in everything imbued with life. It has given me as much pleasure to paint these women as to paint my landscapes. On their skin I have seen the poem of the hours unfold—as beautiful, as en-

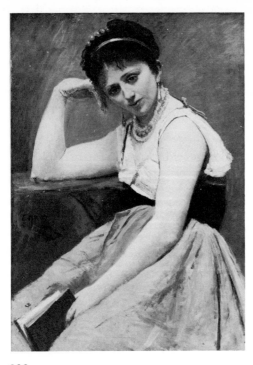

The Interrupted Reading. *Corot*

chanting as we see it on the earth, the water, the hills, and the trees. The mysteries of the woods were in their hair, the mystery of the sky and still pools in their eyes. Spring and autumn seemed to pass before me when they smiled happily or sadly. And their simple words would make me see the dance of the nymphs.

> Camille Corot (undated). Quoted in Étienne Moreau-Nélaton. *Corot raconté par lui-même.* 2 vols. Paris, 1924, I, 24 ff.

When [the painter] Gérôme asked Degas whether he really thought that Corot could draw a tree well, Degas replied: "I shall surprise you, but he draws a figure even better."

> Edgar Degas (undated). Quoted in P. A. Lemoisne. *Degas et son œuvre.* 4 vols. Paris, 1946–49, I, 144.

The Interrupted Reading . . . is perhaps the masterpiece among Corot's figures, something that corresponds in his work in figures to *The Bridge at Mantes* [1868–70; Louvre] among his landscapes. The composition recalls Corot's neo-classical origins, the theme is romantic, the aim is realistic, the execution comes close to impressionism. And all this is spontaneously fused, in such a way that it is difficult to distinguish what is ingenuous from what is consciously created. The colours murmur as though muted: greyish yellow in the skirt, reddish grey in the carpet, white-grey-pink in the flesh, white-grey in the smock, black in the hair and bodice, grey-brown in the background. The "finish" of the face is typical, all transparent glazes, nuances, delicate gradations: a refinement of skill that coincides with the candor of expression, a curb that becomes the free play of creation. From the subordination of the colours to the greys in the transitions, is born the grace that is typical of Corot.

> Lionello Venturi. *Modern Painters.* New York, 1947, p. 160.

EUGÈNE DELACROIX

Ferdinand-Victor-Eugène Delacroix, France's foremost romantic painter, was born at Charenton-Saint-Maurice near Paris in 1798, the son of a high government official. In 1816 he entered the studio of Guérin, where he met Géricault. His debut at the Salon of 1822 with *Dante and Virgil Crossing the Styx* (Louvre) was a success, but his entries at the Salons of 1824, *The Massacre of Chios,* and of 1827, *The Death of Sardanapalus* (both in the Louvre), were adversely criticized.

In 1832 Delacroix visited Morocco, a trip which had a lasting influence on him, enriching his subject matter and palette. In 1831 he was awarded the Legion of Honor for his *Liberty Leading the People* (Louvre). He thus came into official favor and received commissions for large-scale decorations over his inveterate

opponent Ingres. He decorated the Town Hall of Rouen (1840) and in Paris the Library of the Chamber of Deputies (1847), the ceiling of the Galerie d'Apollon in the Louvre (1849), the Hôtel de Ville (destroyed in 1870), and finally St. Sulpice (1857–60). In 1857 he was elected to the Institute after a thirty-year struggle for admission. Delacroix never married. His *Journal*, which he kept from 1822 to 1824 and from 1847 until his death in 1863, is one of the great literary documents of art. A perceptive critic, Delacroix's writings included the essay *On the Beautiful*, and discussions of the work of Poussin, Gros, and Prudhon. Delacroix was associated with most of the leading personalities of his age, but he was only casually acquainted with Baudelaire, the most profound interpreter of his art.

In my opinion no picture reveals more clearly the future great artist than M. Delacroix's *Dante and Virgil in Hell* [*Dante and Virgil Crossing the Styx*]. The artist has not only the poetic imagination common to both painter and writer, but also that specific artistic imagination which might be called "graphic" imagination. He tosses his figures on the canvas, grouping them and bending them at will with the boldness of a Michelangelo and the abundance of a Rubens. . . . I do not believe I am mistaken in saying—M. Delacroix has been blessed with genius.

Adolphe Thiers. *Salon de 1822.* Paris, 1822, p. 55 ff.

Delacroix is a painter of undeniable talent. Yet . . . he causes Parisian art lovers and connoisseurs a great deal of trouble, for neither can they deny his merits nor are they able to applaud his somewhat wild manner of painting. Delacroix seems to be at home [in Faust's world*] and in his true element, creating a wondrous realm between heaven and earth, the possible and the impossible, utter brutality and utter tenderness—and whatever other contrasts the bold play of fantasy may evoke.

Johann Wolfgang von Goethe. "Faust, tragédie de Mr. de Goethe, traduite en français. . . , ornée de XVII dessins par Mr. Delacroix (1828; review)." *Sämtliche Werke,* vol. XIX, Berlin, n.d., p. 767 ff.

M. Delacroix has produced a number of rude, barbarous pictures; but there is the stamp of genius on all of them,—the great poetical *intention*, which is worth all your execution.

W. M. Thackeray. "On the French School of Painting."
The Paris Sketchbook of Mr. M. A. Titmarsh (1840).
Works, vol. XXII, New York, 1911, p. 55.

* Goethe refers to Delacroix's seventeen lithographs for a French edition of *Faust*, translated by A. Stapfer, published in 1828.

Delacroix is decidedly the most original painter of ancient and of modern times. . . . None of M. Delacroix's friends, not even the most enthusiastic among them, has dared to state this as simply, as bluntly, and as boldly as we do. . . . M. Delacroix will always remain a somewhat controversial figure, just enough as is necessary to add sparkle to his glory. . . .

We know of only two other men in Paris who draw as well as M. Delacroix, one in an analogous, the other in a contrary manner. The former is M. Daumier, the caricaturist, the latter M. Ingres, the great painter. . . . Daumier draws perhaps even better than Delacroix, if you prefer wholesome, robust qualities to the strange and astonishing faculties of a great genius sick with genius. M. Ingres, who is so enamored of detail, draws better perhaps than either of them, if you prefer painstaking subtleties to overall harmony, or the character of a fragment to a whole composition, but.
. .
let us love them, all three.

> Charles Baudelaire. "Salon de 1845."
> *Curiosités esthétiques.* Paris, 1892, p. 5 ff.

Romanticism and color are leading me straight to Eugène Delacroix. I do not know whether he is proud of his "romantic" quality, but his place is here. . . .

For Eugène Delacroix, Nature is a vast dictionary whose leaves he turns and consults with a sure and penetrating eye; and his art, which emerges principally from memory, speaks above all to our memory. . . .

Eugène Delacroix is universal: he has painted genre scenes full of intimacy and history paintings full of grandeur. He is perhaps the only artist in our unbelieving age who has conceived religious paintings which are neither cold and empty like competition works, nor pedantic, mystical, or neo-Christian. . . .

I shall note one last quality in Delacroix, . . . the quality which makes him the true painter of the nineteenth century. It is the unique and persistent melancholy in which his work is steeped and which is expressed in his choice of subjects, in the expression and gestures of his figures, and in his choice of color. Delacroix converses with Dante and Shakespeare, two other great portrayers of human suffering. He knows them thoroughly and interprets them freely. . . . Heir to the great tradition—in other words, to breadth, nobility, and splendor in composition—worthy successor of the old masters, he even surpasses them in the masterful delineation of anguish, passion, and gesture.

> Charles Baudelaire. "Salon de 1846." *Ibid.*, p. 95 ff.

Even when seen from a distance too great for the spectator to analyze or comprehend the subject, a picture by Delacroix will already have produced a rich, joyful, or melancholy impression on our mind....

This singular phenomenon results from his special powers as a colorist, from the perfect concord of his tones, and from the harmony (preestablished in the artist's mind) between color and subject matter.... These admirable color chords often evoke dreams of harmony and melody, and the impression we carry away from his pictures is often an almost musical one. A poet* has expressed these subtle sensations in some verses, the sincerity of which may excuse their peculiarity:

Delacroix, lake of blood in the evergreen shade
Of a wood of fir trees, under a brooding sky,
Haunted by evil angels, where strange fanfares fade
And pass, as in Weber, a muffled sigh.†

Lake of blood: the color red—*haunted by evil angels*: supernaturalism—*an evergreen wood*: green, complement of red—*a brooding sky*: the turbulent and stormy backgrounds of his paintings—*the fanfares and Weber*: ideas of romantic music aroused by his color harmonies....

Another very great, most remarkable quality of M. Delacroix's genius, one which is making him the painter beloved by poets, is that he is essentially literary. His paintings have ranged, and ranged successfully, over the entire field of literature. He has been at home with and has interpreted Ariosto, Byron, Dante, [Sir] Walter Scott, and Shakespeare, and he has revealed ideas of a loftier, more subtle, and more profound order than those of most modern painters. And—please take note—he has succeeded, not by means of exaggerated expression, minutiae, or technical tricks, but, rather, by means of a total effect, the profound, full, and complete accord between color, subject, draftsmanship, and dramatic gesture....

What will Delacroix mean to posterity? . . . Like us, posterity will say that he united within himself the most amazing faculties.

* Baudelaire himself in "Les Phares" (Beacons), *Les Fleurs du mal* VI, which was published only in 1857. This passage, to the end of the paragraph, was not in the text as printed in 1855.

† *Delacroix, lac de sang hanté des mauvais anges,*
 Ombragé par un bois de sapins toujours vert,
 Où, sous un ciel chagrin, des fanfares étranges
 Passent, comme un soupir étouffé de Weber.

Like Rembrandt, he had a sense of intimacy and of profound magic; like Rubens and Le Brun, a feeling for combination and decoration; like Veronese, an enchanting sense of color. . . . But he also had a quality *sui generis,* indefinable, yet itself defining the melancholy and burning passions of his age—something entirely new, which has made him the unique artist that he is, without precursors, without precedent, and probably without successor, a link in the chain of history . . . so precious that it could not be replaced; yet if we were to suppress it—should such a thing be at all possible—we would destroy an entire universe of ideas and feelings which would leave a gap too large to be filled.

> Charles Baudelaire. "Exposition Universelle
> de 1855." *Ibid.,* p. 241 ff.

How can we define Delacroix? . . . What then is that mysterious quality that Delacroix, to the glory of his age, has conveyed better than anyone else? It is the invisible, the impalpable, the dream, the nerve, the *soul.* And he has conveyed this . . . with no other means than line and color. . . . He has done it with the perfection of a consummate painter, with the accuracy of a subtle writer, with the eloquence of an impassioned musician. . . .

Delacroix is the most *suggestive* of all painters, the painter whose works . . . set our minds thinking. . . .

Delacroix was passionately in love with passion and coldly determined to seek the means with which to express it in the most visual terms. Let us observe in passing that it is in this dual nature that we find the signs which characterize the staunchest geniuses. . . .

Eugène Delacroix was a strange mixture of scepticism, politeness, dandyism, burning will power, craftiness, despotism, and, finally, the special kind of tempered warmth which always accompanies genius.

> Charles Baudelaire. "L'Œuvre et la vie d'Eugène
> Delacroix (1863)." *L'Art romantique.*
> Paris, 1925, p. 4 ff.

No one has felt the tormented personality of Hamlet as strongly as Delacroix. No one has enveloped in a more poetic light or placed in a more truthful pose this hero of suffering, of indignation, of doubt, and of irony. . . . If you would think about this, you could draw just conclusions about the discrepancy that certain disappointed enthusiasts have been able to notice . . . between Delacroix the creator and Delacroix the storyteller; between the impetuous colorist and the

341

subtle critic; between the admirer of Rubens and the adorer of Raphael. . . .

You will agree that Delacroix is a universal artist. He enjoys and understands music in such a superior way that he would probably have been a great musician, had he not chosen to be a great painter, and he is no lesser critic of literature. Few minds are as richly endowed and as keen as his. If his arms and eyes ever became tired, he could still dictate, in very beautiful language, pages which are missing in the history of art and which will remain archives, as it were, for all the artists of the future to consult.

> George Sand. Letter to Théophile Silvestre,
> January 5, 1853. *Correspondance,*
> vol. III, Paris, 1882, p. 360.

M. Delacroix's influence on French artists has been twofold: fortunate for the strong, and disastrous for the weak. To the former he has demonstrated the existence of elective affinities between colors, which can be used to great advantage. To the latter he has given the understanding that it is unnecessary to know how to draw or paint in order to produce some results. The true victim of M. Delacroix is M. Théodore Chassériau. . . .

The noise surrounding M. Eugène Delacroix . . . will eventually die down. When posterity with its impartial scales weighs the good and bad qualities of this all too incomplete artist, M. Delacroix will fall into oblivion, or at least into the realm of indifference, and he will find his place beside Solimena, Luca Giordano, and Tiepolo.

> Maxime Du Camp. *Les Beaux-arts à l'Exposition
> Universelle de 1855.* Paris, 1855, p. 118.

Delacroix is consumed by his thirst for immortality, yet he maintains an air of scepticism. "What will they think of me when I am dead?" he sometimes asks. He takes infinite pains to prevent the alteration of his paintings, . . . conducts all sorts of experiments with respect to the quality of colors and canvases, and trembles at the thought of a picture being destroyed, making replicas of his subjects with rugged determination. . . .

Ferdinand-Victor-Eugène Delacroix [was a] painter of noble lineage, who carried a sun in his head and storms in his heart; who for forty years played upon the keyboard of human passions, and whose brush—grandiose, terrible, or tender—passed from saints to warriors, from warriors to lovers, from lovers to tigers, and from tigers to flowers.

> Théophile Silvestre. *Les Artistes français,
> études d'après nature.* Paris, 1878, pp. 22, 75.

The genius of Delacroix is neither disputed, nor must it be proven; it is felt instinctively. Whoever demands exact proportions of heads, mathematical delineation of arms and legs, and a rigid adherence to the rules of perspective, must detest Delacroix.

But whoever takes delight in the harmony of tone, truthfulness of movement, or the originality of a pose—in short, in the creation of a subject alive with animation, sparkling with color, and profound in feeling—will be a fanatic admirer of Delacroix.

Delacroix was born to paint. Take away his colors, palette, brushes, or canvases, and he will paint on the wall, on the floor, or on the ceiling, with the first piece of wood he could find, with plaster, with charcoal, with saliva, or even with ashes. He would paint, or else he would die. . . .

If Ingres and Delacroix had lived three hundred years before Apelles, Ingres might perhaps have invented drawing, but Delacroix would have certainly invented painting.

His strange, magical, supernatural brush produces an effect unknown to the artists who preceded him. It makes the viewer dizzy with color. . . .

There is something of the brilliant cashmeres of India in the color of Delacroix. The Indian fabric is less regular and the design less articulated than in the French "cashmere." But if you put the two side by side, the latter will be eclipsed by the former.

If photography could ever reproduce color . . . it would obliterate many paintings of popular, successful modern artists . . . but it would pass by Delacroix's genius without harming him. For Delacroix does not copy nature, he transforms it. He does not merely reproduce nature, but he lets it pass through the crucible of his genius and casts it in the mold of his personality.

Alexandre Dumas (père). *L'Art et les artistes contemporains au Salon de 1859.* Paris, 1859, p. 9 ff.

Delacroix, whom I first met sometime after 1830, was then an elegant and frail young man. . . . His pale olive skin, his rich black hair . . . his tawny eyes with their feline expression . . . his thick eyebrows . . . and thin lips formed a physiognomy of wild, strange, exotic, almost alarming beauty. His nervous, expressive, changeable face sparkled with wit, genius, and passion. People found that he resembled Lord Byron.

Nobody was more seductive than he, if he would take the trouble. He was springy, velvety soft and cajoling like one of those tigers whose supple and formidable grace he rendered so well. People said in the salons, "Too bad that such a charming man paints in such an atrocious manner."

Though his manner of speaking was cool, Delacroix felt the feverish pulse of his epoch more vividly than anyone else. He possessed its restless, tumultuous, lyrical, disturbed, and paroxysmal character.

Théophile Gautier. ["Eugène Delacroix; 1864."]
Histoire du romantisme. Paris, 1874, p. 202 ff.

An unextinguishable thirst for emotion, passion, and color dominates Delacroix's paintings and makes up his personality. Of delicate nature, high-strung, and a conscientious worker, he hardly ever left his studio. Driven by a need for energy and movement, he exaggerated in his paintings the qualities he could not find to the same degree in the classical works. I do not want to establish myself here as a judge of the two schools. The classical virtues and poses bore me; yet the superficial, often affected energy [of the romanticists] does not delight me either. But who does not perceive that Delacroix, whose romanticism consists in the manifestation of his *personal impressions,* and who defined painting as the art of producing an *illusion* for the spectator, . . . reduced the reform of art of which he was the standard bearer to a simple difference in the *means* of execution . . . ?

Aside from the *expression of the pathetic,* energy of movement, the *inner violence* of his figures, *effects of light,* and extravagance of description, which characterizes the painters as well as the writers of the romantic school, . . . Delacroix did nothing different from what was done before him and is still being done today by the classicist painters. He accommodates himself to all subjects: ancient history, mythology, Biblical and religious themes, legends and novels, and scenes from contemporary life; anything suits him, the only difference being that he treats these subjects according to his *personal impression. . . .*

We must ask ourselves whether this man, who looks beyond the centuries, who frequents the invisible and inhabits the supernatural world, who places before himself the heroes of Shakespeare, was capable of observing and comprehending what was happening around him . . . ?

It is true that Delacroix has been concerned only with his *personal impression.* But what illusion does he convey to the spectator who does not share his point of view?

P.-J. Proudhon. *Du principe de l'art et de sa
destination sociale.* Paris, 1865, p. 125 ff.

Delacroix painted half a dozen masterpieces and hundreds of horrors. His place will remain at the left of M. Ingres. . . .

> Edmond About. *Causeries.* 1st series.
> Paris, 1865, p. 6.

Delacroix had adopted the practice of spending some time each day making sketches of engravings, trying with a few strokes to capture the most salient features. It was an idea he borrowed from Rubens, having read somewhere that it was owing to this daily exercise that Rubens had acquired such dexterity . . . and certainly Delacroix's own sketches are a remarkable achievement.

"The artist must be able to represent what he sees effortlessly," he used to tell me; "his hand must acquire lightness and speed, which can only be achieved by exercises such as this. Paganini's amazing virtuosity on the violin was the result of his practicing nothing but scales for an hour each day. Drawing is for us a similar discipline."

Delacroix used to prepare his palette with enormous care. . . . Before starting to paint he would set out a great variety of colors, selecting and opposing them with infinite art. This facilitated the speed of the execution. He could not work for long hours at a stretch; his poor health had obliged him to devise a way of painting which would permit him to interrupt his work and resume it without difficulty later on. When he had obtained the effect desired in his preliminary sketch he would complete the painting with the help of hatchings and glazing. . . . He composed his paintings with the utmost facility, but he first would leaf through his portfolios, which contained hundreds of engravings from different schools; this stimulated his imagination. He would finally pick out those figures and entire groups most suited to his present subject, which he would then, without the least scruple, so transform that his "piracies" were rendered quite unrecognizable.

> Gustave Bordes-Lassalle (after 1863) in Eugène Delacroix.
> *Lettres* . . . 2 vols. Paris, 1880, II, xvii ff.

. . . He was not another Titian, nor another Tintoretto; he was not even a modern Rubens. But he was of the same artistic strain as these great painters; for him, to do a thing at all meant to do it grandly. He had an imagination which urged and inflamed him, and never allowed him to rest in the common and the conventional. He was a great colourist and a great composer: in this latter respect he always reminded me of Tintoretto. He saw his subject as a whole; not as the portrait of a group of selected and isolated objects, but as an incident in the continuity of things and the passage of human life.

345

. . . What it is the imagination finds in him I do not pretend always to settle; but the burden of his message to it is almost constantly grave. He intimates that life is a perplexing rather than an amusing business; and it is very possible that in so doing he is unfaithful to his duty as a painter—the *raison d'être* of these gentry being, constructively, the beautifying of existence. . . . But there is plenty of beauty in Delacroix— . . . His vision of earthly harmonies leaves nothing to be desired; only his feeling about it, as he goes, is that of a man who not only sees, but reflects as well as sees. It is this reflective element in Delacroix which has always been one of the sources of his interest, and I am not ashamed to say that I like him in part for his moral tone.

<div align="right">Henry James. "The Letters of Delacroix (1880)."

The Painter's Eye. Cambridge, Mass., 1956, p. 184 ff.</div>

Let us appeal to the authority of Delacroix's great and glorious talent, since the principles of color, line, and composition . . . ,which are summarized in the outline below, were already proclaimed by this great painter. . . .

The aim of Neo-Impressionist technique is to obtain . . . a maximum of color and light. Is not this purpose clearly stated in Eugène Delacroix's well-phrased outcry:

Gray is the enemy of all painting![*]

In order to obtain that burst of luminosity and brilliant color the Neo-Impressionists use nothing but pure colors, which approximate the colors of the prism as much as matter can approximate light. Does this not follow the example of him who wrote:

Banish all earth colors! . . .

Since all flat tones seem dead and dull to them, they strive to make every least bit of their canvases glisten by creating an optical mixture of juxtaposed and graduated strokes of color.

Delacroix had clearly formulated this principle and the advantages of this method:

It is good if the brush strokes do not blend materially. They blend naturally at a certain distance required by the harmonic law that has combined them. The colors thus attain greater vigor and brilliance.[†]

[*] The italicized sentences are quotations from Delacroix's *Journals*: 1852, undated; Jan. 13, 1857; Sept. 1846; Nov. 3, 1850; Sept. 7, 1856; Jan. 13, 1857; 1852, undated.
[†] This paragraph, and the famous "Nature is but a dictionary" below, are not by Delacroix, but are quoted from Baudelaire's *Life and Work of Eugène Delacroix*.

And further on:

Constable has said that the superiority of the green he uses for his meadows derives from the fact that it is composed of a multitude of different greens. . . . What he said of the green of the meadows can be applied to all other tones.

This last sentence proves clearly that the breakdown of colors into graduated strokes, this so very important aspect of division, was already anticipated by the great painter. . . .

Those yellow and orange-hued areas of light and the blue and violet shadows, which have elicited so much laughter, were quite specifically prescribed by Delacroix in the following passages:

. . . chrome tones on the side of the light and blue shadows. . . .

Dull orange in the light areas, the most vivid violets for the shaded areas, and golden reflections in the shadows that face toward the ground. . . .

The edge of every shadow contains some violet.

. . . If he knows the laws of harmony, the artist must never fear to go beyond their bounds. Delacroix spurs him on to use color in excess, indeed he even commands him to do so:

. . . It is absolutely essential that the half-tint in a picture, that is to say all the tones, generally speaking, should be exaggerated. Rubens exaggerated, and so did Titian. Veronese sometimes appears gray, because he searches too hard for the truth. . . .

If the Neo-Impressionists strive to express the splendors of light and color nature has to offer . . . they also think that the artist should select and arrange these elements, and that a painting conceived as a linear and chromatic composition will be superior to whatever chance might provide in a direct copy from nature.

In defense of this theory they cite the following lines by Delacroix:

Nature is but a dictionary. In it we look for the meaning of words . . . [and] we extract from it the elements that compose a sentence or a narrative. But no one has ever thought of a dictionary as a composition in the poetic sense of the word. . . .

For half a century Delacroix strove to obtain greater brilliance and more light, thereby showing the colorists who were to follow in his footsteps both the path to pursue and the goal to achieve.

Paul Signac. *D'Eugène Delacroix au néo-impressionnisme* (1899). Paris, 1911, p. 6 ff.

In his *Journal* he is rarely revealing . . . for full as it is of personal details it does not admit the reader into confidence. . . . This aloofness . . . prevents him . . . from giving any illuminating comment on

347

the extremely interesting men and women with whom he came into contact. Balzac, Hugo, Stendhal, George Sand, Chopin—the whole of his fervid and brilliant world was less real to him than that impersonal world of art where, unobserved, he could hang on the words of Racine and the flutes of Mozart. . . .

The avoidance of the scene about him makes Delacroix as solitary in the history of art as he wished to be in Père-Lachaise. He had no personal disciples. . . . He gave some unfortunate impetus to the painting of historical and literary themes . . . but the passion of his art could not be transmitted. . . .

<div align="right">

William Gaunt. *Bandits in a Landscape.*
London, 1937, p. 174 ff.

</div>

No other figure in the history of nineteenth-century French painting exerted an influence comparable to that of Delacroix. Without him it is impossible to imagine the remainder of the century. Concrete proof of his influence lies in the copies made after Delacroix by so many of his most gifted younger compatriots. Manet twice copied *Dante et Virgile aux Enfers* [*Dante and Virgil Crossing the Styx*]. . . . Cézanne, according to Lionello Venturi, made six copies, and Renoir made a careful study of the *Noce juive dans le Maroc* [*Jewish Wedding in Morocco*; 1841; Louvre], and used pictures by Delacroix in the backgrounds of his portraits of M. and Mme. Chocquet. . . . Degas . . . was an ardent collector of the paintings and drawings of Delacroix, and Van Gogh used the romantic artist as an inspiration on a number of occasions.

<div align="right">

H. P. McIlhenny. "David to Toulouse-Lautrec at the
Metropolitan Museum." *Art Bulletin,*
June 1941, p. 170 ff.

</div>

. . . We shall never know whether Delacroix recognized himself fully in the portrait Baudelaire has made of his personality and his art. We see only what everyone else has seen—the man of the world . . . the dandy, the upper-class bourgeois, the highly civilized Parisian.

Let us not be deceived. Delacroix, the leader of romanticism, was an eminently reactionary man. . . . His tastes in art and literature were decidely academic. He was a humanist, true to the principles of humanism. In the rapture of his youth and his genius as a painter . . . he had illustrated Shakespeare and Goethe, but he preferred the classical humanists. His tastes were those of a cultured bourgeois and traditionalist. . . .

A misanthropic and sickly little man goes on his daily walk from his studio on the Place Furstenberg . . . to the Chapel of St. Sulpice.

There he finds his angels. The little man is at the summit of bliss. In his work he partakes of the mystical joys which he discloses in his journals in ecstatic words. Who, after all, has spoken better about painting? Who has expressed himself better about *silence* and the *silent arts?* . . .

Testimony has come down to us about the meetings between Delacroix and Chopin, one of the few persons whom Delacroix really loved. . . . But what did they talk about when they went for a ride together? About technique. . . . The idol of romantic music and his accomplice Delacroix, idol of romantic painting, . . . discussed, when they were together, . . . the mathematics of their art. About inspiration and passion, of which each had his share, they had nothing to confide to one another.

Jean Cassou. *Delacroix.* Paris, 1947, (no paging).

The Massacre of Chios
Scènes des massacres de Scio

1824 oil on canvas 166⅛″ x 138½″ Paris, Louvre

There is a *Massacre of Chios* by M. Delacroix, who does with color what M. Guiraud and M. de Vigny do with poetry—they exaggerate the melancholy and the somber. But the public is so bored with academic painting and copies of statues in paint . . . that they stop before the livid, half-finished corpses which M. Delacroix offers to the spectator. . . .

I have tried, but I could not admire M. Delacroix and his *Massacre of Chios*. It always seems to me that this picture was originally meant to represent the plague and that the painter, after reading the newspapers, transformed it into a massacre of Chios. In the large corpse occupying the center of the composition I can see only a miserable, plague-stricken man who singlehandedly attempts to eradicate the bubonic plague. . . . Another episode young art students never fail to put in their pictures is a child demanding milk from the breast of his already dead mother. This can be found in the right-hand corner of M. Delacroix's picture. A massacre imperiously demands a hangman and a victim. It requires . . . a fanatic Turk . . . who immolates Greek women of angelic beauty. . . .

M. Delacroix . . . has a feeling for color. This is much in our *graphic* century. He seems to me a follower of Tintoretto; his figures have movement.

The *Journal des debats* of the day before yesterday claims that *The Massacre of Chios* is of Shakespearean poetry. It seems to me that this painting is mediocre more for its irrationality than for its insignificance, like so many of the classical paintings I could enumerate. . . .

M. Delacroix still has that tremendous superiority over all the painters

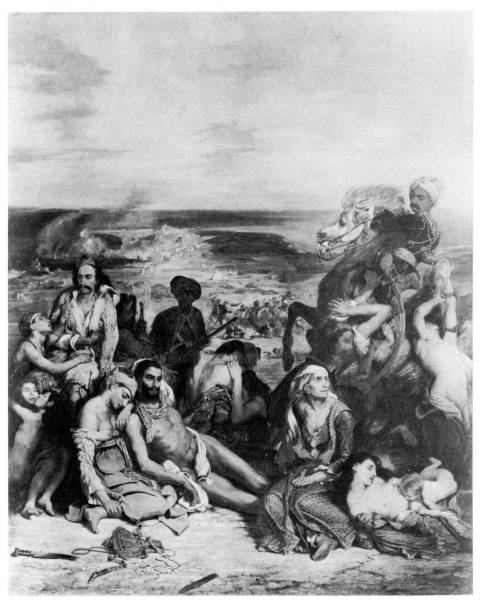

The Massacre of Chios. *Delacroix*

of large pictures which adorn the great salons, so that at least the public has become quite well aware of his work.

Stendhal. "Salon de 1824." *Mélanges d'art et de littérature.*
Paris, 1867, p. 179 ff.

The Massacre of Chios became the signal for a violent dispute between the romanticists and the school of David. This time the Baron Gros left the young innovator to his fate and returned to the classicist fold, exclaiming: "This is the massacre of painting!"[*] Henceforth the two camps were irreconcilable. "This man runs across rooftops," said the Baron Gérard. On the other hand, the painter of *The Massacre of Chios* had all impetuous youth on his side. . . . "I do not know M. Delacroix," M. Jal wrote, "but should I meet him, I shall embrace him . . . and cry with joy and gratitude. . . . He has done a great service to the enemies of tyranny, for he has shown tyranny in all its terror!"

<div align="right">

Charles Blanc. *Les Artistes de mon temps.*
Paris, 1876, p. 33 ff.

</div>

This work has remained a creation of superb richness. . . . *The Massacre of Chios* is the prelude, as it were, to that "frightful hymn composed in honor of destiny and irreparable suffering" (Baudelaire). Here the *molochisme* denounced by Baudelaire makes its first appearance. . . .

Sprung from the Revolution and the wars of the Empire, romanticism carried within itself an almost Neronian taste for cruelty. More massacres were committed on the stage and in exhibitions between 1824 and 1849 than ever before. . . .

[*The Massacre of Chios*] is a *symphonie pathétique* in which coppery tones, sanious reds, and putrid greens predominate. Beneath a soft blue sky and floating roseate clouds, with fires burning in the distance, two opposing pyramids of human flesh, separated by a diagonally extending shadow, seem to clutch and let go of one another convulsively. . . .

Eugène Delacroix had found the expression that his generation had impatiently awaited. It was Delacroix who spelled out this modern poem of feverish enthusiasm that Gros had glimpsed and at which Géricault, in his brief life, had hinted. Whether he wanted it or not, . . . Delacroix became the painter *par excellence* of the revolutionary generation.

<div align="right">

Raymond Escholier. *Eug. Delacroix.* Paris, 1963, p. 19.

</div>

Liberty Leading the People
[The July Revolution]
Le 28 juillet (La Liberté guidant le peuple)

1830 oil on canvas 102⅜" x 128" Paris, Louvre

I now come to Delacroix, who has contributed a picture before which I always see a crowd. . . . The sacredness of the subject does not permit a harsh

[*] In 1822 Gros had called Delacroix's *Dante and Virgil* "Rubens chastized."

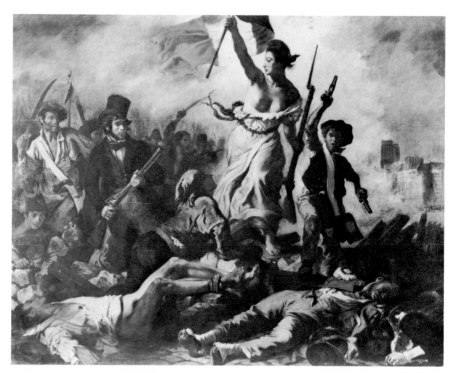

Liberty Leading the People. *Delacroix*

criticism of the coloring, which might turn out adversely. But despite a few
artistic defects this picture radiates greatness of thought. . . . It represents a
group of people during the July revolution; from its center rises boldly a
young woman—almost like an allegorical figure—a red Phrygian cap on her
head, a gun in one hand, and a tricolor flag in the other. She strides over
corpses, calling men to battle—nude to the hips, a beautiful impetuous figure,
her face seen in bold profile, an air of insolent suffering in her features—
altogether a strange mixture of Phryne, fishwife, and goddess of Liberty. It is
not clearly shown that the artist meant to depict the latter; the figure seems to
represent the savage power of the people casting off an intolerable burden. . . .

There is no other picture in the Salon in which the color is as dull as in
The July Revolution by Delacroix. But just this absence of varnish and sheen
combined with the powder-smoke and dust which covers the figures like a
gray cobweb, those sun-dried tones which seem to be thirsting for a drop of
water, give the picture a veracity, a substance, an originality, in which we
sense the true physiognomy of the July days.

Among the spectators were many who had been participants in or wit-
nesses of the Revolution, and these could not praise the picture enough. . . .

"Daddy," asked a little Carlist girl, "who is that dirty woman with the red cap?" "Well, indeed," sneered the noble papa with a sweetish, squashed smile . . . "she has nothing in common with the purity of lilies. She is the goddess of Liberty." "But, Daddy, she does not even wear a chemise!" "A true goddess of freedom, my dear child, seldom has a chemise and is therefore very angry at all people who wear clean linen. . . ."
 . . . But I forget that I am only the reporter of an exhibition. . . .
 Heinrich Heine. "Französische Maler: Gemäldeausstellung
 in Paris 1831. (1834)." *Sämtliche Werke*, vol. III,
 Philadelphia, 1855, p. 23 ff.

Paganini

1831 oil on cardboard 17¼″ x 11½″ Washington, D.C., The Phillips Collection

It is impossible for most Englishmen to share the full enthusiasm which Delacroix has always aroused in French artists. We are put off by the theatrical quality of his vision, and for myself I can rarely understand why his color is so much admired. However, I can come to terms with so profound and dramatic an interpretation of character as the little *Paganini* discovers. It is indeed a marvellously intense and imaginative conception, and though the abandon-

Paganini. *Delacroix*

ment of the romantic attitude to life seems strangely distant and unfamiliar to us now, one cannot refuse to it an imaginative sympathy, when it makes so eloquent and so passionate an appeal as it does here.

> Roger Fry. "Modern Paintings in a Collection of Ancient Art."
> *Burlington Magazine*, December 1920, p. 309.

The sketch of Paganini was probably painted shortly after the Genoese virtuoso's first recital in Paris on 9th March 1831, which Delacroix attended. . . . Paganini was yet at the height of his powers as a violinist. Delacroix makes him seem like a soul which has met a body by accident. . . . By means of expressive distortion and suppression of sharp detail, he stresses his spiritual force, his deep concentration, his assurance and vitality as a musician, rather than the physical accidents of his debilitated frame. More than that, he conveys—almost miraculously, considering the economy of means employed—a sense of the satanic power that many felt in Paganini who heard him play. . . .

> Lee Johnson. *Delacroix.* New York, 1963, p. 49 ff.

Algerian Women in Their Harem

1834 oil on canvas 70⅞" x 90⅛" Paris, Louvre

If I were rich, it would give me pleasure to send you a picture, an *Algerian Interior* painted by Delacroix, which seems excellent to me. . . .

> Honoré de Balzac. Letter to Madame Hanska, April 28, 1834.
> *Lettres à l'étrangère.* 2 vols. Paris, 1899–1906, I, 155.

We are all in this Delacroix. When I mention the joy of color for color's sake, that is what I mean. . . . Those pale roses, the thick cushions, that slipper, all that limpidity . . . it somehow hits you in the eye. . . . It is the first time that volume has been rendered since the great masters. And in Delacroix . . . there is a feverishness that the old masters lacked. . . . Delacroix may be a romantic, he has perhaps absorbed too much of Shakespeare and Dante, read too much of Goethe. His remains the finest palette in France and nobody in our country has possessed at once such calm and pathos, such shimmering color. We all paint in him.

> Paul Cézanne (undated). Quoted in Joachim Gasquet.
> *Cézanne.* Paris, 1926, p. 179 ff.

Three women—odalisques—are seated in crouched or semireclining positions on rugs, occupied in doing nothing. . . . A Negress, whose profile is barely discernible, is standing with her back to us. She has just served the women and is leaving. The interior is extremely rich. The walls are ornamented with blue and yellow tiles in small patterns, composing an overall tonality in a soft,

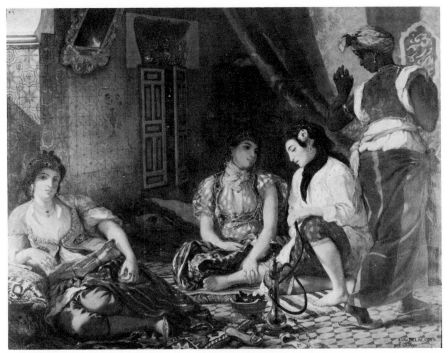

Algerian Women in Their Harem. *Delacroix*

fresh, indefinable green. In the wall is a small aperture painted in a bright red. The pavement is composed of small violet and green flagstones forming a mosaic. An indirect ray of light illumines the scene.

All the sumptuousness of the Orient furnishes the foreground of this rich interior: narghilehs, Turkish slippers, straw mats, cushions, rugs, and various other small objects, in the greatest possible profusion of forms and colors. In this single painting Delacroix has brought to bear all the resources of his art—an art he developed to the point of magic. Principally, just as there is no dominant figure here, there is no dominant color. The painter, intending to give an idea of oriental life, has represented the women of the harem as an array of lovely objects, like beautiful jewels in a case. . . .

To enhance and harmonize his colors, he used both the contrast of complementary colors and the concordance of similar colors (in other words, the repetition of a bright tone by the same blended tone). He made use of the action and interaction of whites and blacks, which serve in turn as a foil, accent, or relief for the eye. He also used color modulation and what is called optical mixture.

For example, the orange bodice of the woman lying on the divan allows us a glimpse of its blue satin lining; the dark violet silk skirt has gold stripes.

The Negress is wearing a deep blue bolero with sky-blue stripes and an orange kerchief—three tones that support each other and give each other value, to the point where the last, made even more brilliant by the Negress' brown skin, had to be cut with the background colors so as not to stand out too sharply. These contrasts, as we see, are made by the juxtaposition of complementary and similar colors. Since contrast must be tempered in order not to destroy it, . . . Delacroix knows how to set his tones against each other in the subtlest manner. Thus the woman with a rose in her hair seated near the Negress is wearing short green trousers strewn with yellow dots, while the color of her silk chemise is modified by an imperceptible scattering of small green flowers. The tones are set down, not in isolation, but in a series; they are interlaced and made to interpenetrate, to interact, to mitigate, and to sustain each other.*

<div align="right">

Charles Blanc. *Les Artistes de mon temps.*
Paris, 1876, p. 68 ff.

</div>

CONSTANTIN GUYS

Born in 1805 at Flushing, the Netherlands, of a French family, Guys became a soldier at the age of eighteen and fought with Lord Byron in the Greek War of Independence. He returned to France in 1827, entered the French Dragoons, and subsequently traveled throughout Europe and the Orient. As war correspondent for the *Illustrated London News* he participated in the Crimean War (1853–56). From 1860 until his death in 1892 he resided in Paris. Guys began to draw only at the age of forty-two. He preferred obscurity and was known only to a small circle of friends which included Baudelaire, Gavarni, Daumier, and the photographer Nadar. His work consists wholly of pen-and-ink drawings and watercolors. He was the chronicler of life during the Second Empire, and his favorite subjects were women and horses.

Today I want to talk about an extraordinary man, whose originality is so commanding, so absolute, that it is entirely self-sufficient and does not even seek approval. Not one of his drawings is signed, if by signature we mean the few letters, so easy to counterfeit, which spell a name. . . . Yet all his works are signed with his brilliant *mind;* and the connoisseurs who have seen and appreciated them will readily recognize them from the descriptions I am about to give.

An impassioned lover of crowds and incognitos, M. C. G. carries

* This analysis appears almost verbatim in Odilon Redon's *À soi-même* (Paris, 1922), p. 170 f.

his originality to the point of shyness. . . . Recently . . . when he learned that I proposed to write an appreciation of his character and talent he begged me with the utmost insistence to suppress his name and to speak of his works as if they were by an anonymous artist. I shall humbly abide by his unusual request. The reader and I will pretend that M. G. does not exist. . . .

The crowd is his element. . . . His passion and his profession are *to become one with the crowd.* For the perfect *flâneur,* for the impassioned observer, it is an immense pleasure to find himself in the midst of the multitude, the tides of movement, the fugitive and the infinite. . . .

He marvels at the eternal beauty and the astonishing harmony of life in the capitals. . . . He contemplates the great cityscapes, the landscapes of stone caressed by the fog or buffeted by the sun. He delights in fine carriages and proud horses . . . the sinuous gait of women, the beautiful, happy and well-dressed children—in other words, he delights in universal life. . . .

M. G. draws from memory and not from the model, except in those cases (the Crimean War, for example) when he may urgently need to take immediate hasty notes, and to fix the principal lines of a

Two Women and Two Soldiers. *Guys*

subject. As a matter of fact, all true draftsmen draw according to the images imprinted on their minds, and not from nature. . . .

M. G. begins [to draw] with a few slight indications in pencil which only mark the position the objects are to occupy in the picture space. The principal planes are then indicated by tinted washes, indistinct and lightly colored masses at first, but taken up again later and successively charged with more intense color. At the last moment the contour of the objects is finally outlined in ink. Unless one has seen them one can hardly imagine the surprising effects that can be obtained by this simple, almost elementary method, which has the incomparable advantage that at any stage in its execution each drawing will look sufficiently "finished." You may call it a "study," but you will have to admit that it is a perfect study. . . .

I am convinced that in a few years M. G.'s drawings will become precious archives of civilized life. His works will be sought after by collectors as much as those of Dubucourt, Moreau, Saint-Aubin, Carle Vernet, Lami, Devéria, and Gavarni, and all those other exquisite artists who, though having depicted nothing but the familiar and the charming, are in their own way no less serious historians. . . . Less clever than they, M. G. retains a unique quality which is all his own. He has deliberately fulfilled a function which other artists have scorned. . . . He has sought after the transitory, fleeting beauty of present-day life, the characteristics of what the reader has kindly permitted me to call *modernity*. Often bizarre, violent, and extravagant, yet always poetic, M. G. has contrived to distill in his drawings the sometimes bitter, sometimes heady bouquet of the wine of life.

<div style="text-align:right">

Charles Baudelaire. "Le Peintre de la vie moderne (1863)." *L'Art romantique.* Paris, 1925, pp. 55 ff., 109 ff.

</div>

HONORÉ DAUMIER

Honoré Daumier, the son of a glazier, was born in 1808 in Marseilles. The family moved to Paris when Honoré was very young. He became apprentice in turn to a bailiff, a notary, and a bookseller. In his spare time he copied works in the Louvre, attracting the attention of Alexandre Lenoir, the founder of the Musée des Monuments Français, who persuaded Daumier's parents to let their son become an artist. Daumier studied lithography under Ramelet and in 1830 became cartoonist of the newly founded journal *La Caricature*. In 1832 he served six months in prison for having represented King Louis Philippe as "Gargantua swallowing bags of gold extorted from the people." In 1835 *La Caricature* was suppressed, and Daumier joined the staff of *Charivari*. For this and other papers he executed some

4,000 lithographs of highly effective and bitter social and political satire. What little time he had left after his hectic daily tasks was spent painting; Daumier also did some sculptures. About 1860 his eyesight began to fail, and ten years later he became totally blind. He would have become destitute if his friend Corot had not purchased a house for him at Valmondois-sur-Seine, where Daumier died in 1879.

I now want to speak about one of the most important men not only in caricature but in the whole of modern art. He is a man who every morning keeps the Parisian population amused, a man who provides for the daily needs of public hilarity and furnishes its nourishment. The bourgeois, the businessman, the youngster, and the housewife laugh and go on their way, often—how ungrateful!—without even noticing his name. Until now only his fellow artists have understood the serious qualities of his work and have recognized that it is really an appropriate subject for study. You will have guessed that I am referring to Daumier. . . .

Daumier has carried his art very far; he has transformed it into a serious art; he is a *great* caricaturist. To appreciate him properly it is necessary to analyze him from both the artistic and the moral point of view. As an artist, Daumier is distinguished by his conviction. He draws like the great masters. His drawing is abundant, facile—it is a coherent improvisation; yet it never descends to the chic. He has a wonderful, almost superhuman memory which for him takes the place of a model. All his figures stand firmly on their feet, and their movement is always true. His gift for observation is so sure that you will not find a single head among his figures which does not match its supporting body.

As to his moral qualities, Daumier has affinities with Molière. Like him, he goes straight to the point. The central idea stands out in immediate relief. We look, and we understand. The captions written at the bottom of his drawings do not amount to much and can generally be dispensed with. His humor is, so to speak, involuntary. The artist does not look for ideas—he just lets them slip out. His caricature has a formidable amplitude, but is quite without bile or rancor. In all his work there is a foundation of honesty and good-naturedness. . . .

One more thing. What completes Daumier's remarkable character, and what makes him an exceptional artist who belongs to the illustrious family of the masters, is the fact that his drawing is inherently *colored*. His lithographs and wood-engravings arouse ideas of color. His pencil contains more than just the black suitable for delineating contours. He evokes color as he does thought, and this is the

359

sign of a superior quality in art, one that all intelligent artists are clearly able to discern in his works.

Charles Baudelaire. "Quelques caricaturistes français (1857)." *Curiosités esthétiques.* Paris, 1892, p. 397 ff.

This great draftsman will leave behind a kind of satirical fresco of the bourgeoisie during the first half of the nineteenth century. His work forms a procession of the persons in power: magistrates, industrialists, inventors, men and women. By the same token it is a representation of the comic saga of Paris and the Parisians engaged in business and pleasure. . . .

It may be useful to give an analytic picture of his creations. [But] one volume will hardly be sufficient to catalogue the four thousand compositions by the master. . . .

Three important classes are absent from this human comedy: the clergy, the army, and the nobility. But, after all, Daumier is the satirical "first painter" of constitutional government, condemned to paint only the bourgeois.

Daumier certainly does not wield the pencil for the sake of pleasing the so-called *poetic* minds. This is one of the reasons why the man behind his art has been ignored for a long time. Over the years few of the hypocrisies and vices have escaped this penetrating satirist. As a result, all the wounded vanities have united and formed a vast conspiracy to keep silent about him. Only time will reverse this situation. It is not without cause that Daumier has aroused the anger of an epoch marked with the terrifying initials H.D., which have bitten deeply into the flesh. . . .

A print by Daumier is on the same artistic level as some of the boldest conceptions of modern art. For his passion, only Delacroix could have competed with the *caricaturist*. It is this epithet which has so far prevented Daumier from being recognized as a great artist.

He has the productiveness of all exceptionally endowed men. The public pretends not to notice the fertile temperament which is hiding beneath that unrestrained laughter.

Champfleury. *Histoire de la caricature moderne* (1865). Paris, 1885, p. 180 ff.

To the writer . . . he remains considerably less interesting than Gavarni; and for a particular reason, which it is difficult to express otherwise than by saying that he is too simple. Simplicity was not Gavarni's fault, and indeed to a large degree it was Daumier's merit. The single grossly ridiculous or almost hauntingly characteristic thing which his figures represent is largely the reason why they still rep-

resent life and an unlucky reality years after the names attached to them have parted with a vivifying power. Such vagueness has overtaken them, for the most part, and to such a thin reverberation have they shrunk, the persons and the affairs which were then so intensely sketchable. Daumier handled them with a want of ceremony which would have been brutal were it not for the element of science in his work, making them immense and unmistakable in their drollery, or at least in their grotesqueness; for the term drollery suggests gaiety, and Daumier is anything but gay. . . .

Daumier's figures are almost always either foolish, fatuous politicians or frightened, mystified bourgeois; yet they help him to give us a strong sense of the nature of man. They are sometimes so serious that they are almost tragic; the look of the particular pretension, combined with inanity, is carried almost to madness. . . . We feel that Daumier reproduces admirably the particular life that he sees, because it is the very medium in which he moves. He has no wide horizon; the absolute bourgeois hems him in, and he is a bourgeois himself, without poetic ironies, to whom a big cracked mirror has been given.

Henry James. "Honoré Daumier (1893)."
The Painter's Eye. Cambridge, Mass., 1956, p. 229 ff.

Among the few who have grasped the problem of Don Quixote in its deepest sense we must include Daumier, who identified himself with that "knight of the sorrowful countenance." . . . He saw in Don Quixote the cruel tragedy of his own life, spent vainly in fighting for the highest ideals, and he came back to this subject time and time again. . . . The shattering impact of virtually all of Daumier's treatments of the Don Quixote theme can be explained in terms of his deep personal involvement with the subject. It also throws light on the manner in which Daumier formally and spiritually solves the relationship among the three protagonists of the tragicomedy, Don Quixote, Rosinante, and Sancho Panza. . . . As conceived by Daumier, Don Quixote emerges skeletonlike, an idea divorced from the reality of things, an idea of the ideal but utterly grotesque. Thus he is depicted forever straining erratically forward and upward, forever striding into the future, almost always in the lead of Sancho Panza, who represents the reality of things. Forever ready to fight, never weakening in his resolve, . . . he is constantly defeated anew, only to arise and resume his stubborn march. Thus he appears altogether grotesque, as does all purely idealistic striving. Don Quixote's noble steed Rosinante, symbolic of the tenacious will that spurs him on to ever new goals and defeats, . . . resembles his master in every feature. They

Don Quixote and Sancho Panza. *Daumier*

are fused, as it were, into a single being, the personification of a disembodied idealism. In contrast to them the third figure—Sancho Panza with his large paunch—represents ordinary common sense, proving over and over again that all these desperate efforts are sheer and dangerous folly when measured by worldly wisdom. . . .

Daumier's strongest treatments of the subject include the representation of Don Quixote and Sancho Panza riding side by side in a mountainous landscape, Don Quixote riding alone, the paintings with the dead mule in the foreground, and above all the large charcoal drawing showing Don Quixote turning somersaults before Sancho Panza. Here the idealism that would rid the whole world of injustice debases itself to play the fool for a fat belly, for the mean and calculating common sense that would never reach for the stars but only grab the biggest morsel. . . .

But the most powerful among all the Don Quixote paintings and also one of the latest, in which Daumier formulates his philosophy of life in artistic terms, is the scene depicting Sancho Panza seated on his saddle beneath a tree, while Don Quixote appears far off on the horizon, a wraithlike figure resembling an emaciated scarecrow. Sancho Panza, personification of the belly, dominates the foreground in monumental size, as if to prove symbolically that the belly is the only persevering historical truth. . . . Daumier has here given climactic

expression to all the tragedy inherent in the Don Quixote theme. Yet even here Daumier's idealism is matched by his tremendous spirit of defiance—undaunted by the spirit of defeat and despair, the idea, even though it be in the guise of a scarecrow, marches ever on into the future.

Eduard Fuchs. *Der Maler Daumier.*
Munich, 1927, p. 37 ff.

Daumier's genius is essentially dramatic; and, in nearly all of his caricatures, he is singularly original. It has been said of him that his style is grand and elemental, his matter trivial; his effect is the angry assault of that drawing on this matter, the tilt of the lance against the windmill: in a word, a Cervantes who paints. Turn over his drawings and you will see, in their fantastic and poignant beauty, all that Paris contains of living monstrosities; all that is sinister, cruel, comic, abominable. It is not the Paris of Balzac, it is the Paris of Daumier.

Arthur Symons. *From Toulouse-Lautrec to Rodin.*
London, 1929, p. 136.

Since Daumier did not actually begin painting until rather late, and because the greater part of his work was concurrent with the development of realism under Courbet and Millet, he has often erroneously been called a realist. If his subject matter can be judged realist, his manner of interpretation is not so in the least. There is nothing in him of the scrupulous, the exacting observer; he is a romanticist—one who renders realist themes in a romanticist way. Daumier was forty-two years old in 1850, at a time when the realist movement was in full bloom and propagating—when Courbet was exhibiting *The Burial at Ornans* and *The Stone Breakers;* Millet *The Winnower* and *The Sower.* Daumier's formation had been completed. Everything we know about him assures us that he was not the sort of reflective soul who goes on from one stage to the next, like Degas, for example. He remained exactly the same at the age of sixty-two in 1870 as he was in 1830 at the age of twenty-two. He was a born romanticist, whose romanticism increased with age. . . .

Daumier's romanticism—which I define as the need to surmount immediate, humdrum reality and to transform it by exaggeration—appears very distinctly when one examines the spirit in which he handled familiar scenes: the inside of a third-class railway car, for example, or an open-air market, or a butcher cutting meat. One must not look for the meticulousness of Henry Monnier or [François] Bonvin. Daumier has contributed nothing, or next to nothing, for the

363

historian of manners and the appreciators of Abraham Bosse, Wenceslaus Hollar, or [Pietro] Longhi. Daumier disdained all picturesque and accurate detail, and saw in his subjects simply a pretext for studying human shapes in a certain light, setting them down so that they took on a certain significance. . . . When he conceives a waiting room at the station, he evokes for us an indeterminable vestibule in hell—one of the cycles of Dante's *Inferno*—rather than the familiar setting with its weary and benumbed travelers.

Because these realist themes have been transformed by a romanticist vision, Daumier's paintings and drawings of everyday life are really very close to Baudelaire's *Tableaux parisiens* [in *Les Fleurs du mal*]. When looking at *The Gossips* from the former Bureau collection [present location unknown]—when standing face to face with these three old, shrilling magpies illumined by their candles, whose voices, hoarsened by cassis and vespétro, we can almost hear—we recall *Les Petites Vieilles:* "Debris of mankind, ripe for eternity."

François Fosca. *Daumier.* Paris, 1933, p. 75 ff.

The Uprising
L'Émeute

ca. 1860 oil on canvas 24½" x 44½" Washington, D.C., The Phillips Collection

The Uprising is one of those works which express most poignantly the nineteenth century and its universal poetry . . . bursting forth from the strange electrical shock of revolution. Here is a visionary painted by a visionary. In a Paris street with a backdrop of tall, sad, and pallid buildings silhouetted against the sky, a man in shirt sleeves thrusts himself forward accompanied by a group of insurgents. He lets out either a cry or a song, repeated by the crowd. His open mouth magnifies the outcry. His raised arm accentuates its rhythm and pulse. His long face and refined traits are stamped with an innate nobility, and his soft hair reveals the type of aristocratic craftsman in the workshops on the outskirts of Paris, who would work painstakingly on precious materials with delicate instruments. His eyes are open, but he does not see. His look is turned inward. He is possessed by a vision to which he rallies the crowd. A magnetic attraction carries away the bystanders. To the left is a man with coarse features, long, thin nose and lowered head, a Parisian country fellow with a surly expression. To the right stands a hollow-cheeked citizen with a tall silk hat worn at the edges. Near him two profiles somehow converge toward the man in shirt sleeves, the leader in the magnetic center. What a novel of life is revealed to us through what we see and feel: nocturnal readings by eccentric philosophers, snuffed-out candles stuck into bottles, club meetings, ominous exaltations, gay cabaret scenes where drinkers sing of love, glory, and proletarian virtues. . . . [The heroes of Hugo's *Les Misérables*],

The Uprising. *Daumier*

although invisible, are spiritually present in this undulating crowd, which masses behind the outstretched arms of its leader. We feel here all the moving passions of the times—peopled by the eternal insurgent, the wandering mind haunted by the future, the anonymous fighter of battles without name. . . .

Daumier's brush stroke has the characteristics of an inspired sketch. . . . The graphic underpainting is sometimes visible, like the supporting pen strokes in a watercolor of broadly executed washes. This underpainting, which supports the plastic form throughout, is produced by a homogenous but not compact impasto. The light falls strongly on the shoulders of the man in the white shirt, seeming at the same time to emanate from him. This light leaves the secondary figures . . . , who join wholeheartedly in the leader's chant, in a fleeting shadow with openings filled here and there with a few flickers and accents. This painterly language, laconic and awe-inspiring, is not the rhetoric of the French Revolution which, in contrast, had expressed itself in linear patterns. Daumier's abbreviated style speaks a warm, more human language. It is filled with an intimate knowledge of the aspiration of the masses.

How astonishing is this vision of Daumier, the painter of *The Uprising*. . . .
Henri Focillon. "Deux visionnaires: Balzac et Daumier (1943)."
De Callot à Lautrec. Paris, 1957, p. 105 ff.

365

The Third-Class Carriage

ca. 1862 oil on canvas 25¾" x 35½" New York, Metropolitan Museum of Art

The Third-Class Carriage is a kind of icon of Daumier's faith. He was the bitter opponent of all who exploit the common man: tyrants, politicians, profiteers, and sophistical lawyers. The people who ride third-class carriages do not excite his sarcasm. . . .

The Walters Art Gallery, Baltimore, owns a series of three water-colour studies of railway travel, one of which was the sketch for the painting in the Metropolitan Museum. The other two are generally called *The First-Class Carriage* and *The Second-Class Carriage*. Although these titles are acceptable, they do not convey the whole meaning of Daumier's interpretation. As the first and second class compartments are nearly identical, any distinction in the social condition of the occupants was arrived at by other means. Weather is the chief protagonist in these scenes. Without its aid Daumier might have found it difficult to establish two social levels. The elegance of the first-class travellers is enhanced by the clement season. Winter forces the second-class passengers into a shivering huddle. . . . In *The Third-Class Carriage*, however, the weather is not a positive factor. The effect produced by the picture comes from within the characters themselves. Although Daumier has dispensed with

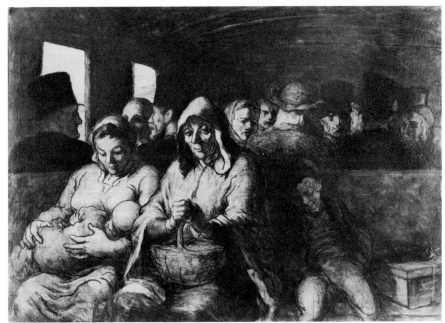

The Third-Class Carriage. *Daumier*

external aids, the social overtone is more powerfully established here than in either of the upper-class scenes. . . .

As the painting appears to be unfinished, one might argue that some of the eliminated details were to have been added later on. It would not be easy to prove such a contention. For the most part, Daumier's oils were painted for no one but Daumier. Few were exhibited in his lifetime. The usual demands of the Salon as to surface polish did not appeal to him. Most of his oils retain the quality of a sketch. Some were "finished" later by another hand. Daumier himself was constantly laying on oil glazes, as thin and transparent as water-colour, re-establishing the original contour lines, and laying on more glazes. It is hard to say when, if ever, the process was actually "finished."

In the oil painting, colour becomes a more positive means of emphasis than in the study. . . . A wider gamut is reached. A strong blue-green forces out the lower half of the old woman. This colour recurs elsewhere, but in reduced and paler variation: on the shoulder of the infant, the back of the large man behind the boy, and the cap of the man at the extreme right. As the colours are otherwise warm earth tones, low reds and oranges, the effect of the complementary area of blue-green is all the more striking.

When *The Third-Class Carriage* was lent to the Philadelphia Museum of Art for inclusion in an exhibition of Daumier's work, a series of infra-red and panchromatic enlargements was made as part of an exhaustive study of Daumier's technique. Modern understanding of his methods dates from the publication of the catalogue to that exhibition (1937).

S. L. Faison. *Honoré Daumier's Third-Class Railway Carriage.*
London, 1947, p. 3 ff.

VIRGILE NARCISSE DIAZ DE LA PEÑA

Diaz, the son of Spanish immigrants, was born in 1808 at Bordeaux. He was orphaned early, and as a boy lost a leg as the result of a snakebite. Like Renoir, he started his career as a china painter. Later, under the influence of Delacroix and the writings of Théophile Gautier, he painted romantic themes—gypsies, Oriental women, and nymphs. His love of nature attracted him to the forest of Fontaine-bleau, where he met Théodore Rousseau in 1837. He painted his first Fontainebleau subject at that time. Considered one of the Barbizon painters, he exhibited at the Salon from 1831 to 1859. His kaleidoscopic technique greatly influenced Monti-celli; in the 1860's the young Renoir, Monet, Sisley, and Pissarro temporarily fell under his spell. Diaz died in Menton in 1876.

Diaz is one of the greatest fanatics of light and color. His mono-mania makes him see everywhere flecks of sunlight and the jewelled sparkle of precious stones. For him, nature is always brilliantly

367

illuminated and vibrant with pleasure. Winter and gray weather are unknown to him. He cannot imagine that the earth is round and its poles frozen, for he has never left the tropics. Thus the inhabitants of his landscapes gladly dispense with their clothing, and if they sometimes permit themselves to be lightly veiled it is in a luxuriant fantasy of color. . . . To tell the truth, the figures in Diaz's paintings are nothing but ornaments and accessories. They have been created to complement the poetry of his landscapes and, if need be, could be replaced by a rosebush or the glow of a sunbeam.

What, then, is the meaning of Diaz's painting? It means that the countryside always gladdens man's heart, that the woods always offer magnificent spectacles, that it feels good to lie down in the grass and watch the sparkling daylight through the foliage, and that we are wrong not to refresh ourselves more often on the bosom of nature. . . . By the way, what is the meaning of a beautiful sunset?

A walk in the forest of Fontainebleau for the purpose of self-improvement is worth more than all the sermons of the Abbé Ravignan.*

There are at the Salon nine sermons by Diaz, or, if you wish, the same lecture in nine images. The *Forest Interior* is resplendent with light. In a glade, opening beneath the trees, transparent shadows and brilliant sunshine play on moss-covered ground. First class. The *Bas-Bréau* . . . tall and beautiful trees surrounding a wild pond from which a perfectly healthy herd of cows drinks. In the *Causerie* there is a bouquet of women in the midst of the countryside. . . . There is the same exuberance and the same magic everywhere. Diaz is drunk with the sun.

> Théophile Thoré. "Salon de 1847." *Salons de T. Thoré.*
> Paris, 1870, p. 461 ff.

M. Diaz is a curious example of a fortune easily achieved by a unique faculty. The time is not yet long past when we were truly infatuated by him. His bright color, which was scintillating rather than rich, brought to mind the motley gaiety of oriental fabrics. Our eyes were so honestly beguiled by him that we readily forgot to look for contour and modeling. When he, in truly prodigal fashion, had used up this unique faculty with which nature had prodigally endowed him, he felt a more difficult ambition stirring within him. These first impulses manifested themselves in the form of pictures of larger dimensions than those in which we had generally taken so much pleasure. But his ambition turned out to be his ruin. Everyone

* Xavier Delacroix de Ravignan (1795–1858), Jesuit preacher and colorful orator.

noticed this period, during which his mind was tormented with jealousy of Correggio and Prudhon. It seemed that his eye, accustomed as it was to noting down the scintillations of a microcosm, could no longer perceive vivid colors on a large scale. His sparkling palette turned to plaster and chalk; perhaps, in his ambition to achieve careful modeling, he lost sight of the qualities that had hitherto constituted his glory. It is difficult to determine the causes which have so rapidly diminished M. Diaz's lively personality. But we may be allowed to suppose that these praiseworthy ambitions have come to him too late. Certain changes are impossible after a certain age. . . . It is really most unpleasant to have to say such things about a man of the recognized stature of M. Diaz. But I am only an echo; everyone has already said, either aloud or in a whisper, either with malice or with sorrow, what I am writing today.

Charles Baudelaire. "Salon de 1859." *Curiosités esthétiques*. Paris, 1892, p. 306 ff.

THÉODORE ROUSSEAU

Pierre-Étienne-Théodore Rousseau was born in Paris in 1812. He studied under Rémond and Lethière, but soon left the studios to sketch outdoors. His first paintings were accepted at the Salon when he was only nineteen. He exhibited regularly from 1831 to 1836, but was rejected from 1837 to 1847, which caused him to be nicknamed *le grand refusé*. He became a controversial figure in landscape painting, and was maligned for associating himself with republicans such as Daumier, Dupré, the critic Thoré-Bürger, and others. Beginning in 1837 Rousseau spent long periods of time at Barbizon, a village in the forest of Fontainebleau. He soon settled there permanently for the summer, painting in Paris during the winter. Barbizon became the meeting ground of the so-called Barbizon artists, a group of landscape painters whose aim was the direct and simple representation of landscape and peasant life, sketched or painted outdoors. Rousseau became their guiding spirit. The year 1849 marked Rousseau's return to the Salon and the beginning of his close friendship with Millet. In 1867 Rousseau finally won official recognition and received a special medal in the Universal Exhibition. He died the same year at the age of fifty-five.

There is one man who more than all of these [landscape painters] and even more than the most celebrated absentees [from the Salon] seems to fulfill the conditions of beauty in landscape painting. He is a man little known by the crowd, a man whom earlier setbacks and quiet harassment have kept from exhibiting at the Salon. It seems to me high time that M. Rousseau—you may have guessed that it is he to whom I am referring—presents himself once again to the public.

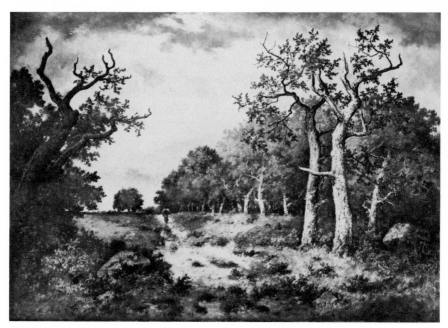

The Edge of a Forest. *Diaz*

It is as difficult to interpret M. Rousseau's gifts as it is to interpret those of Delacroix with whom he has something in common. M. Rousseau is a landscape painter of the North. His painting breathes a deep sigh of melancholy. He prefers nature in her *bluish* moments, the twilight hours, the strange and moisture-laden sunsets, the deep shadows animated by breezes, the rich play of light and dark. His color is magnificent without being brilliant. His skies are incomparable for their fleecy softness. If we recall certain landscapes by Rubens or Rembrandt, add a few reminiscences of English painting, and assume a profound and serious love of nature as the underlying principle, then we can perhaps form an idea of the magic of M. Rousseau's paintings. Like Delacroix he suffuses them with his soul. He is a naturalist ceaselessly carried toward the ideal.

> Charles Baudelaire. "Salon de 1846." *Curiosités*
> *esthétiques.* Paris, 1892, p. 181.

M. Th[éodore] Rousseau—a painter of the minor aspects of nature—finds that God is a skillful arranger. He does not attempt to invent more severe outlines, nor does he seek to ennoble the density of shrubs and foliage. He pursues his studies in all naïveté, in all sincerity, and he is not . . . ashamed to sketch the first tree he en-

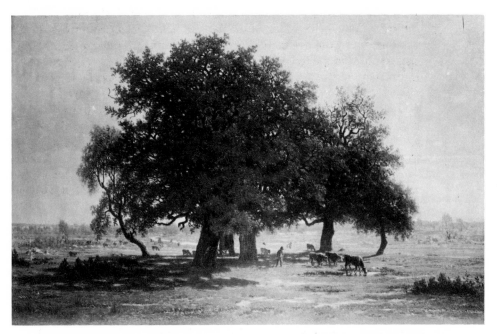

Oaks. *Théodore Rousseau*

counters. . . . He is very little preoccupied with style, but, on the other hand, he is very much preoccupied with truth. He is daring, but not all his boldness arouses our sympathy. Yet he has carried further than anyone the study of the most delicate modifications of daylight, and the representation of the most subtle play of light in foliage, during the morning hour, at noon, and in the evening, or before and after the rain.

<div align="right">

Edmond and Jules de Goncourt. "Le Salon de 1852."
Études d'art. Paris, 1893, p. 28.

</div>

Leaving the Salon I wanted to return to the Musée du Luxembourg to see Rousseau's landscape there. Do you remember that mightily twisted tree forming a dark silhouette against the somber red sunset? There are cows in the pasture. The painting is profound and anguished. It may not be an exact representation of nature, but trees, cows, and skies are interpreted by a vigorous mind which has communicated to us, as in a foreign language, the feelings aroused in him by the countryside.

And now I am asking myself how M. Théodore Rousseau could have arrived at the laboriousness in which he takes pleasure these days. Look at his landscapes at the Salon: each leaf and each pebble

are counted; the pictures seem to be painted with little sticks and the colors glued bit by bit to the canvas. The interpretation has no largesse. Everything is forcibly small. The artist's temperament disappears behind the tedious minutiae. The painter's eye does not grasp the horizon in its vastness, nor is his hand able to render the impression received and seen through his temperament. That is why I feel nothing is alive in this painting. When I ask M. Rousseau to capture with his brush (as he did in the past) a piece of the countryside, he amuses himself by turning the country into crumbs and presenting it to me dissolved in dust.

Émile Zola. "Mon Salon (1866)." *Mes haines.*
Paris, 1880, p. 315.

By his date and his rank in the history of French painting Rousseau occupies an intermediary position; he belongs to the period of transition between the Dutch painters and those of the future. His work is derived from the Dutch painters, but he separates himself from them. . . . He has discovered in nature a thousand things which have hitherto remained unnoticed. The repertory of his impressions is immense. All the seasons; every hour of day, of evening and dawn; all the inclemencies of weather, from the hoarfrost to the dog days; all altitudes from shore to hilltop, from the moors to Mont Blanc; villages, meadows, brushwood, forests, the naked earth and the vegetation that covers it—there is nothing that has not tempted him, stopped him, won him over, persuaded him to paint it. The Dutch painters seem to have revolved only about themselves when we compare them with the ardent course pursued by this seeker of new impressions. . . . From this point of view he is absolutely original, and by that very fact [Rousseau] is the product of his age. Once plunged into the study of the relative, the accidental and the true, there is no stopping. . . . He was not the only contributor to the creation of a school which may well be called the *school of sensations,* but he was certainly the greatest. . . .

The things that Jean-Jacques Rousseau, Bernardin de Saint-Pierre, Chateaubriand, and Sénancour, our first landscape masters in literature, observed with an all-encompassing glance and expressed in summary form seemed nothing more than a very incomplete abridgment, a very limited *aperçu,* when literature became purely descriptive. In the same way painting, analytical and imitative . . . found in foreign styles nothing but confinement and limitation. The eye became continually more curious, more fastidious. Sensibility became more nervous, drawing probed more deeply, observation multiplied. Nature, studied more closely, was teeming with details,

incidents, effects, and nuances. . . . A new language was needed to express this multitude of new sensations, and it was Rousseau who almost singlehandedly invented the vocabulary in use today.* In his drawings, his sketches, and his finished pictures we are able to perceive the attempts, the efforts, the happy or unsuccessful devices, the excellent neologisms or risky phrases with which this profound seeker of formulas was to enrich the ancient language and grammar of painting.

Eugène Fromentin. *Les Maîtres d'autrefois* (1876).
Paris, 1906, p. 276 ff.

Each of the Barbizon artists had his particular qualities, but there are a number of characteristics which they shared and from which Impressionism was born. It is here that one finds the cohesiveness of the Barbizon school. Plein-air painting and the direct impression of nature are perhaps the most important. Rousseau's special easel for working out-of-doors, his and Daubigny's lean-tos, and Daubigny's studio-boat were devices to facilitate plein-air painting. . . .

In the 1830's, the Barbizon artists were still much aware of the architecture of trees and their autonomous existence in illusionary space, but shortly after the mid-century, memory knowledge of touchable, solid masses yielded to the optical, so purged of non-visual experience that the dabs of pigment began to float free of imaginary substance. . . . By the early sixties they were all painting in a variety of small strokes whose colors, no longer blended one with another, took on new life. Earth colors, the customary matrix for brighter hues, began to wane when that matrix was no longer used, and a lighter palette was the result. . . .

Barbizon naturalism was the chief manifestation in painting of a European-wide phenomenon of the mid-century, observable in literature and all the arts. . . .

There are two poles of naturalism in Barbizon art, each conveniently represented by the two great friendships among the group. Corot and Daubigny were both painters of the countryside, Rousseau and Millet, of nature. The countryside is nature seen by a suburban stroller, which is why Corot and Daubigny were closer to Impressionism than the other two. They did not often paint forest interiors, but meadows, the environs of villages, harbors and beaches. A sense

* Fromentin, who completed his *Maîtres d'autrefois* in 1875 in Brussels, was apparently unaware of the pictorial discoveries of the Impressionists and their first exhibition in Paris in 1874.

of enjoyment, a poignant enjoyment, pervades their pictures—limpid calm, gentle breaths of air, subtle harmonies of attenuated color. For all these reasons they are closer to us than Rousseau and Millet, whose different ardor we find difficult to comprehend. . . .

Rousseau made an inventory of her riches with all the passionate exactitude of Darwin or Ruskin; he was an accomplished geologist, meteorologist and botanist. His paintings were built on a structure of hard lines, almost like engravings, because he had to have the certainty that he had penetrated to the vitals of nature. He surrounded himself with the protective embrace of writhing foliage. Most of his paintings are from the inside of the forest looking out toward the light, the opposite of Corot and Daubigny who were outside, looking in. He said that in the marsh he found the primeval ooze from which life sprang, and in the tree, the whole of past history. And always he had the convictions of a moralizer. "Do you understand now," he wrote, "that everything my intelligence reproves is in direct relation to everything my heart aspires to, and that the sight of human disdain and baseness is to me as powerful a vehicle of action in the exercise of my art as the depths of serene contemplation that I have been able to put in myself since childhood?"

<div style="text-align: right">R. L. Herbert. *Barbizon Revisited.*
New York, 1962, p. 62 ff.</div>

JEAN-FRANÇOIS MILLET

A son of Norman peasants, Millet was born at Grouchy, near Cherbourg, in 1814. He was sent to Cherbourg at the age of eighteen to study with a local painter, Langlois. In 1837 friends subsidized a trip to Paris, where Millet entered the studio of Paul Delaroche. Early in his career he painted portraits and did pastels in the manner of Boucher. Under the influence of Daumier he exhibited a peasant subject in the Salon of 1848, *The Winnower* (destroyed). In 1849 the outbreak of a cholera epidemic in Paris induced Millet to move to the village of Barbizon in the forest of Fontainebleau, where he made friends with Rousseau and the Barbizon group. It was here that he painted his most famous works: *The Sower* (1850; Boston Museum of Fine Arts), *The Gleaners* (1857; Louvre), *The Angelus* (1859; Louvre) and *The Man with the Hoe* (1863). Between 1865 and 1869 he produced over one hundred pastels, considered by many to be his finest works. After many years of struggle for recognition he was awarded a medal at the Universal Exhibition of 1867 and the following year received the Legion of Honor. Millet died at Barbizon in 1875.

To tell the truth, the peasant subjects suit my temperament best; for I must confess, even if you think me a socialist, that the human

side of art is what touches me most, and if I could only do what I like,—or, at least, attempt it,—I should do nothing that was not an impression from nature, either in landscape or figures. The gay side of life never shows itself to me. I don't know where it is. I have never seen it. The gayest thing I know is the calm, the silence, which is so sweet, either in the forest or in the cultivated land. . . .

Sometimes, in places where the land is sterile, you see figures hoeing and digging. From time to time one raises himself and straightens his back, . . . wiping his forehead with the back of his hand. "Thou shalt eat thy bread in the sweat of thy brow." Is this the gay, jovial work some people would have us believe in? But nevertheless, to me it is true humanity and great poetry.

> J.-F. Millet. Letter to Sensier, February 1, 1851.
> Quoted in Alfred Sensier. *Jean-François Millet:*
> *Peasant and Painter.* Boston, 1881, p. 93.

When Millet entered the Salon he produced the same effect Courbet had produced six or seven years earlier: a howl of indignation from some and a hurrah of admiration from others.

We like this kind of entrance into the world of art, because we know that men of mediocre talent are not greeted by such an outcry. . . .

We recognize three distinctive qualities in Millet: individuality, originality, and unusualness. . . .

Is his work beautiful or is it ugly? Is it good or is it bad?

It is certainly new.

Its novelty, whether understood or not, must be of interest to those who have already attained success, and must disturb the young artists who are still trying to feel their way. . . .

Millet has been reproached for painting peasants who resemble beasts rather than men, and for selecting types depicting idiocy. . . .

Now, can we not meet this reproach with the excuse that Millet wished to portray peasants, not thinkers? . . .

However, I personally would like to consider the question further and suggest another answer:

Millet himself inhabits the fields which he has constantly before his eyes and which he depicts with such verisimilitude. Look closely and you will see in his peasants not the unhealthy stupidity which his superficial critics and biased detractors see, but an air of calmness and strength, a look of resigned suffering habitual with those men who are not fully aware of their suffering or the reason for it.

The subjects, you will say, are generally sad, desolate, and pitiful, but who knows whether the artist, who tells a story with his brush

just as we do with the pen, is not himself sad and miserable at seeing men working without hope of ever attaining tranquillity, rest, or happiness?

Whatever may be the case it is certain that the painting [*The Cowgirl;* Bourg-en-Bresse, Musée de l'Ain] exhibited this year is a serious piece of work and the proof is that it has been bought by [the painter Constant] Troyon directly from Millet's studio. . . .

Its simplicity is Biblical. . . .

I do not know if Millet is a great painter or if this is a great painting, but I do know that it is a bad neighbor, since it makes everything around it seem insignificant.

> Alexandre Dumas (père). *L'Art et les artistes
> contemporains au Salon de 1859.* Paris, 1859, p. 27 ff.

M. Millet is most particularly in search of style. . . . But "style" has been his ruin. His peasants are pedants who have too high an opinion of themselves. They display a kind of somber and fatal brutishness which makes me want to hate them. Whether they reap or sow, tend their cows or shear their animals, they always look as if they are saying "We are the poor and disinherited of this earth, yet it is we who render it fertile! We are accomplishing a mission, we are exercising the function of priests!" Instead of simply extracting the natural poetry from his subject, M. Millet wants to add something to it at all cost. In their monotonous ugliness, all those little pariahs have a philosophical, melancholic, and Raphaelesque pretentiousness. This unfortunate element in M. Millet's art spoils the fine visual qualities which at first attract us to him.

> Charles Baudelaire. "Salon de 1859."
> *Curiosités esthétiques.* Paris, 1892, p. 327.

Millet was both painter and thinker; this felicitous combination of two faculties, seemingly contradictory and rarely united in one man, is the key to his great originality. Properly speaking, I understand the term "painter" to mean one who paints in the manner of the Spanish, Dutch, and some contemporary French artists; all those, in fact, who are in direct communion with nature and can bring her to life for others by means of their palette and colors. . . .

Since the poet in Millet was never absorbed by the painter, he preserved his vision. He sought and found in the *plein air* a completely new world. He imbued the clouds with moral significance. The inanimate nature of the countryside—even his trees—participated in the life of man. There is a very fine drawing by Millet which illustrates his ideal perfectly. It shows two children near a little

hillock; one child is knitting and the other is gazing into the luminous sky at some unseen phenomenon, perhaps the flight of a bird. This scene opens up a whole new page of poetry.

If we now make the observation that throughout his entire life Millet portrayed the French peasant, that is to say the Frenchman caught up in the monotonous toil of agricultural life, we cannot but consider him a profound thinker who passed his life in reflection. There is much in the study of his work to provide matter for serious thought.

> Odilon Redon. *À soi-même.* Paris, 1922, p. 389 ff.
> Entry dated 1878.

I went to the Millet exhibition yesterday. . . . A dense crowd.— There I ran into Hyacinthe Pozier, . . . he was all in tears, we thought someone in his family had died.—Not at all, it was *The Angelus*, Millet's painting, which had provoked his emotion. This canvas, one of the painter's poorest, a canvas for which in these times 500,000 francs were refused, has just this moral effect on the vulgarians who crowd around it: they trample one another before it! This is literally true— and makes one take a sad view of humanity; idiotic sentimentality which recalls the effect Greuze had in the eighteenth century: *The Bible-Reading, The Broken Jar.* These people see only the trivial side in art. They do not realize that certain of Millet's drawings are a hundred times better than his paintings which are now dated.

> Camille Pissarro. Letter to his son Lucien, May 16, 1887.
> *Letters . . .* New York, 1943, p. 110.

Millet gave the synthesis of the peasant.

> Vincent van Gogh. Letter to Theo (no. 519). 1888.
> *The Complete Letters . . .* Greenwich, Conn., 1958, vol. III, p. 4.

The paintings [by Millet] which have been most ardently extolled since his death are, it must be admitted, harsh and mean, outdated and dull. Take *The Man with the Hoe* or *The Angelus* or *The Gleaners*. What do we find in them? Monotonous and russet-toned figures, resigned to their mud-caked boots, and immobile under an implacable sky against a dim and airless landscape. These oil paintings savor of toil and the sweat of Millet's big arms. None of the old masters of landscape painting—and Millet paints in their tradition— has used his brush with such frankness; there is no one whose paintings have, with the passing of years, become so sour and flimsy. As an oil painter he is, in fact, mediocre and hopelessly inadequate.

Happily, however, Millet's *œuvre* is not confined to these canvases.

A very real artist emerges from the least praised of his works, his black crayon drawings heightened with pastel.

Here the artist's temperament is most clearly defined in the views of dawn rising from the still-sleeping, empty countryside from which the human figure has been banished or, at most, is just discernible on the horizon.

<div align="right">J.-K. Huysmans. *Certains.* Paris, 1889, p. 191.</div>

Of the noblest of all so-called "schools," Millet is perhaps the most popular member. His popularity is in great part, certainly, due to his literary side, to the sentiment which pervades, which drenches, one may say, all his later work—his . . . true subject, the French peasant. A literary, and a very powerful literary side, Millet undoubtedly has; and instead of being a weakness in him it is a power. . . .

It is idle to deny this potency, for his portrayal of the French peasant in his varied aspects has probably been as efficient a characterization as that of George Sand herself. But, if a moral instead of an æsthetic effect had been Millet's chief intention, we may be sure that it would have been made far less incisively than it has been. Compare, for example, his peasant pictures with those of the almost purely literary painter Jules Breton, . . . whose work is, . . . by contrast with Millet's, noticeably external and superficial even on the literary side. When Millet ceased to deal in the Correggio manner with Correggiesque subjects, and devoted himself to the material that was really native to him, to his own peasant genius, . . . he did so because he could treat this material *pictorially* with more freedom and less artificiality, with more zest and enthusiasm, with a deeper sympathy and a more intimate knowledge of its artistic characteristics, its pictorial potentialities. He is, I think, as a painter, a shade too much preoccupied with this material, he is a little too philosophical in regard to it, his pathetic struggle for existence exaggerated his sentimental affiliations with it somewhat, he made it too exclusively his subject, perhaps. . . . With his artistic gifts he might have been more fortunate, had his range been broader. But in the main it is his pictorial handling of this material, with which he was in such acute sympathy, that distinguishes his work, and that will preserve its fame long after its humanitarian and sentimental appeal has ceased to be as potent as it now is.[*] . . .

His great distinction, in fine, is artistic.

<div align="right">W. C. Brownell. *French Art.* New York, 1901, p. 48 ff.</div>

[*] In the twentieth century Millet's reputation declined. The rise of Cubism and abstract art, the emphasis on form over subject matter, led to a reluctance to accept

The prevailing view of Millet is derived from the myth elaborated in the nineteenth century. Millet was presented to the public as a painter of sentimental peasant subjects, . . . a peasant who simply painted the life he was born to, and a pious man entirely devoted to the Bible, a sort of nineteenth-century Fra Angelico. . . . The myth is typically nineteenth-century, for it concerns his person and his historical role rather than his art. . . .

Millet came to Paris in 1837. By the time he left for Barbizon in 1849, he had long ceased to be a peasant. He was a sophisticated intellectual endowed with a profound culture. He immersed himself in a rural environment out of nostalgia for the pre-industrial past. Like many progressive thinkers of his generation he detested the city and regarded with horror the rapid spread of industrial change. He found in nature a renewal of self, a release from the city. . . .

The formulation of an art involving an escape from modern industrial life was not easy. Millet-myth was a peasant who quite simply painted his fellow rustics, but what is more absurd than to think a real peasant would want to paint scenes from his daily life? No, the real Millet was an intellectual formed in Paris who saw peasant life through historical eyes. At first a portraitist and painter of lovely nudes and *scènes galantes* quite Rococo in flavour, he broached rural subjects about 1845, well before going to Barbizon: paintings of a bucolic and arcadian spirit, inspired by Diaz and the eighteenth century, or of fishermen, country washerwomen and rural folk inspired by Michelangelo and Poussin. The latter subjects became more important . . . from his first years at Barbizon. At the same time he was strongly impressed by Chardin, the Lowlands artists of the seventeenth century, the Le Nain, Bruegel, and Gothic sculpture. Poussin and Michelangelo remained very important for him, and the creative amalgam of the two traditions is the basis of his fully mature style. Nothing is more exciting than to see in Millet this hesitant evolution, the elaboration of a personal vision. . . .

An historical reassessment of Millet's role in the evolution of modern art will not be difficult when we remember the profound impact he had upon the rest of the century, even if we choose to ignore the whole generation of artists who marched in his footsteps: Breton, Israëls, Mauve, Bastien-Lepage, Roll, Lhermitte, and think only of

art "with a message." See, for example, Albert C. Barnes, *The Art of Painting* (Merion, Pa., 1925), p. 231 f.: "Millet's paintings are scarcely entitled to serious consideration as landscapes, because he uses nature as a setting for a human story which is, in essence, sentimental. . . . This is done well enough as illustration, but is of little plastic interest. . . ."

the most progressive artists. Pissarro and Van Gogh were formed by Millet and also drank at his moralistic well. Degas was much taken by Millet's drawings and owned several. The young Seurat found his first subjects in Millet and looked closely at his drawing in developing his own style of shadowy black and white. Gauguin in Brittany recalled Millet and later, in the Pacific islands, was to continue the Barbizon master's devotion to the primitive and animal-like being. . . .

An historical analysis will aid the necessary re-evaluation of Millet's merits, but the only solid foundation will be built upon the study of his painting and drawing. This is very difficult because so little of his work is published. His drawings probably provide the soundest basis for a new look because in them the subject is less in evidence and will not invoke our dislike for art with a message. They are above all his finest work, full of a unique vigour and beauty.

R. L. Herbert. "Millet Revisited." *Burlington Magazine,*
July 1962, p. 294 ff.

The Gleaners
Les Glaneuses

1857 oil on canvas 32⅞″ x 43¾″ Paris, Louvre

Do you remember *The Sower* by M. Millet? A poor, wretchedly dressed devil with a sorry-looking felt cap on his head, who, silhouetted in black against a pale sky, scatters grain into the fresh, open furrows with a gesture that is both noble and prophetic. . . . The artist had not flattered his subject; the colors were dull and the effect melancholy. This somber canvas nevertheless made a remarkably powerful impression. The sublimity of so vast and sweeping a movement across the barren landscape only waiting for the seed to become fertile once again, struck a chord in even the most indifferent of souls. It was as though this symbolic and yet flesh-and-blood hand was scattering grain over all the earth, as in the parable from the Gospel. . . .

The Gleaners, on exhibit in the present Salon, where a public customarily seduced by the flashy and eyesore variety of painting is failing to take proper notice of it, combines in just the right proportion the elements of style and truth.

Along furrows strewn with stubble whose bristling short stalks would wound a more delicate foot like thorns, three gleaners advance in single file, bent to the ground, and gather in their sunburned hands the rare ear of grain fallen from the sheaf. . . . Poor women, they are not beautiful, and the rude labor of the fields has sullied their looks since childhood. . . . Knotted kerchiefs bind their heads; their bodies, divested of any trace of femininity,

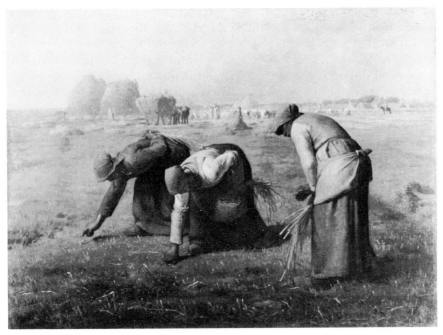

The Gleaners. *Millet*

are wrapped in plain, heavy cloth of a neutral color. La Bruyère's familiar and terrible lines on the peasants* are as sad as they are true. The painter, however, sees what the philosopher has failed to notice. He has lent to a bundle of rags on a bent back something of the style of Michelangelo's Parcae and Sibyls....

M. Millet's gleaners, then—ugly and old, ragged and dirt-covered as they are—engender a notion of beauty not evoked by the vision of a nymph or bather smothered in lilies and roses, to use the classic formula. The result seems odd, but it proves the power of art.

A sky pale with heat, yellowish earth, three tattered figures, and a horizon beyond, where loaded grain wagons are roughly sketched in the dust-laden rays of the sun—such is M. Millet's painting. Of elements so simple and means so sparing and restrained, the artist has produced one of the most serious works in the Salon.

Théophile Gautier. "Salon de 1857, XV." *L'Artiste*, II, September 20, 1857, p. 33.

* "We see certain wild beasts, male and female, scattered across the country, black, livid, burnt by the sun, chained to the soil they dig and turn over with invincible stubbornness. Their voices are almost articulate, and when they get up on their feet they reveal human features; indeed, they are human beings." From *Les Caractères* (1688–94).

The Gleaners . . . presents the very poorest of the peasants who are fated to bend their backs to gather with clubbed fingers the wisps of overlooked grain. That they seem so entirely wedded to the soil results from the perfect harmony of Millet's fatalistic view of man with the images which he created by a careful disposition of lines, colors and shapes. . . . Millet has weighted the figures ponderously downward, the busy harvest scene is literally above them, and the high horizon line which the taller woman's cap just touches emphasizes their earth-bound role suggesting that the sky is a barrier which presses down upon them, and not a source of release.

The humility of primeval labor is shown, too, in the creation of primitive archetypes rather than individuals . . . by suppressing the gleaners' features. . . .

It was, paradoxically, the urban-industrial revolution in the nineteenth century which prompted a return to the images of the pre-industrial, ageless labors of man. For all their differences, both Degas and Van Gogh were to share these concerns later, and even Gauguin was to find in the fisherman of the South Seas that humble being, untainted by the modern city, who is given such memorable form in Millet's *Gleaners*.

<div align="right">

R. L. Herbert in *Terre des hommes: Man and His World*.
Montreal, 1967, p. 86.

</div>

The Man with the Hoe

1859–62 oil on canvas 32″ x 39½″
San Francisco, Collection of Mrs. Henry Potter Russell

In the middle of the great heat of a summer day a peasant clears the land of thistles and weeds. Leaning on his hoe he stops in his hard work to catch his breath and rest for an instant. He is bareheaded, in shirt sleeves, and dressed in blue cloth trousers. His hat and jacket are on the right in the middle of a field. In the distance we see a woman burning grass and a laborer whose cart is drawn by two white horses. . . . Capital picture of Millet's *œuvre*.

<div align="right">

Louis Soullié. *Peintures, aquarelles, pastels, dessins
de Jean-François Millet.* Paris, 1900, p. 48.

</div>

Imagine a monster without brow, dim-eyed and with an idiotic grin, planted in the middle of a field like a scarecrow. No trace of intelligence humanizes this brute at rest. Has he just been working, or murdering? Does he dig the land or hollow out the grave? . . . Even the most vigorous execution would make such a figure barely tolerable. Indeed, M. Millet's brush becomes visibly duller and weaker. From year to year his color turns muddier and

his drawing becomes more disjointed. . . . The terrains, flesh tones and rags are all of the same smudgy and flabby substance. . . .

M. Millet seems to glorify idiocy . . . a strange way of honoring people for a painter dedicated to plebeian things. . . . As if the country folk are not graced with their own beauty and elegance! As if work in the fields has to smite the laborer with the stupidity of his ox!

> Paul de Saint-Victor (1863). Quoted in É. Moreau-Nélaton.
> *Millet raconté par lui-même.* 3 vols. Paris, 1921, II, 134 ff.

Bowed by the weight of centuries he leans
Upon his hoe and gazes on the ground,
The emptiness of ages in his face,
And on his back the burden of the world.
Who made him dead to rapture and despair,
A thing that grieves not and that never hopes,
Stolid and stunned, a brother to the ox?
Who loosened and let down this brutal jaw?
Whose was the hand that slanted back this brow?
Whose breath blew out the light within this brain?
. . . .
O masters, lords and rulers in all lands,
How will the Future reckon with this man?
. . . .

> Edwin Markham. "The Man with the Hoe* (1899)."
> *The Poems of Edwin Markham.* New York, 1950, p. 30 ff.

I was about ten years old when I saw the Man with the Hoe by Millet and that was a natural thing and a completely foreign thing because the fields were french fields and the hoe was a french hoe and yet it was really the fields hoes and men and all three together.

> Gertrude Stein. "An American in France."
> *What Are Masterpieces?* Los Angeles, 1940, p. 68.

* "As I looked at Millet's *The Man with the Hoe*, I realized that I was looking on no mere man of the field; but was looking on a plundered peasant, typifying the millions left over as the debris from the thousand wars of the masters and from their long industrial oppressions, extending over the ages. This Hoe-man might be a stooped consumptive toiler in a New York City sweat-shop; a man with a pick, spending nearly all his days underground in a West Virginia coal mine; a man with a labor-broken body carrying a hod in a London street; a boatman with strained arms and aching back rowing for hours against the heavy current of the Volga." (—E.M.)

383

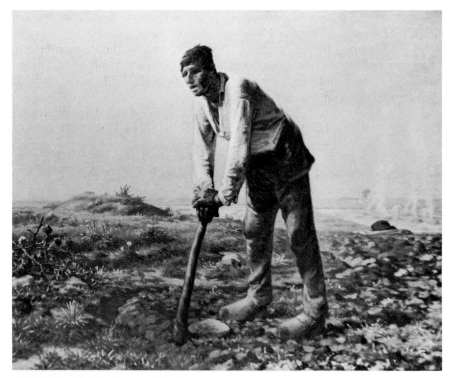

The Man with the Hoe. *Millet*

CHARLES FRANÇOIS DAUBIGNY

Daubigny was born in 1817 in Paris. He visited Italy in 1835 and on his return worked on the restoration of paintings in the Louvre. In 1838 he joined the studio of Paul Delaroche briefly and exhibited at the Salon for the first time. He continued to show regularly, and was awarded several medals. He was also active as an etcher and published woodcut illustrations for books and magazines. To facilitate his *plein-air* painting Daubigny built a houseboat, the *Botin*, in 1857, which he used both as a house and studio. Cruising the Seine and Oise he painted the river landscapes for which he is best known today; they foreshadow Impressionism. Although he was friendly with the Barbizon painters, especially Corot, and is often considered one of the group, he never actually lived in Barbizon. He died in 1878.

The entire aesthetic of Daubigny can be found in one word, sincerity. He knows that the landscape painter is nothing without nature, that he cannot exist when he removes himself from it. But he copies it with his soul and not with the cold precision of a daguerreotype camera; hence the eloquent faithfulness of his brush. The model

is before his eyes, but it is in his heart that he finds the exquisite feeling with which he imbues his work, and the undefinable emotion that shimmers on his canvas.

Daubigny's great boldness is his simplicity; his novelty is the renunciation of all the trite and easy methods of achieving an effect. It is also the substitution of relative tone values for the conventional pictorial planes which usually guide the spectator's eye to a focus. In this way, the light is obtained from an artifice of contrasts. Daubigny is original because he proceeds directly from nature and his work shows no influence of foreign masters. He was one of the first who dared to paint gay, bright, and wholesome pictures, instead of aiming at tragic feelings in a period that put elegies in style. We have enough morose landscape painters, thank goodness, and Daubigny is well justified in proving that poetry is not necessarily gloomy, sickly, or tormented. If his work is sometimes melancholic it is the gentle and penetrating melancholy of the reveries of Corot or Chintreuil. . . .

The fault attributed to Daubigny is that his work is apt to remain sketchy. But I am not the one to understand this reproach, for in front of a picture I never ask myself whether it is a sketch or a painting, but simply whether it is good or bad. Daubigny's brush, if I understand his work correctly, stops with his inspiration. Once he has seized the impression he wants to render, he is unable to pursue his work with interest and cling to details lest his work loses the first bloom. . . . But aside from a finish down to the last leaf or blade of grass, which he is right to reject, there are qualities of execution essential to all good painting: strength of drawing, accentuation of planes, and a simple, tightly organized study of form. Daubigny is rarely lacking in these qualities.

Frédéric Henriet. "Daubigny." *L'Artiste*, I,
June 14, 1857, p. 197.

M. Daubigny's landscapes have a grace and a freshness which fascinate us immediately. They quickly convey to the spectator's mind the original feeling in which they are steeped. But it seems that M. Daubigny has obtained this quality only at the expense of finish and perfection of the details. Many a picture of his, though sparkling and charming, lacks solidity. It has the grace, but also the softness and inconsistency of an improvisation. Above all, however, we must do justice to M. Daubigny by saying that his works are generally poetic and that I prefer them with all their faults to many others more perfect in their execution, but wanting in the quality which distinguishes him.

Charles Baudelaire. "Salon de 1859."
Curiosités esthétiques. Paris, 1892, p. 326 ff.

The summer exhibition of paintings, drawings, and etchings by Charles François Daubigny at the Gallery of Modern Art was one of the most interesting shows to be seen in New York for some time. . . .

What was shown was a fair sampling, and it left one with the feeling that Daubigny is an artist who is hardly known at all—with the exception of Herbert's catalogue,* no serious work has been done on him since the books of Dorbec and Moreau-Nélaton in 1925—and who, because of the variety of his styles and the bewildering problems of chronology, will be very hard to study. Dorbec's characterization of his particular contribution as *"plus marqué dans la diversité de ses nuances que du Corot†"* seems to put it mildly. Corot was eclectic, but he had the advantage of eclecticism: from disparate elements he could create a synthesis. Daubigny appears not so much eclectic as representative: one finds in him a bit of everything, as one finds him giving to some artists while he takes from others, and all this in no particular sequence. . . .

Nevertheless, Daubigny's originality was primarily not in his style—although stylistic sources for, as well as borrowings from, his contemporaries are to be found throughout his work—but as a discov-

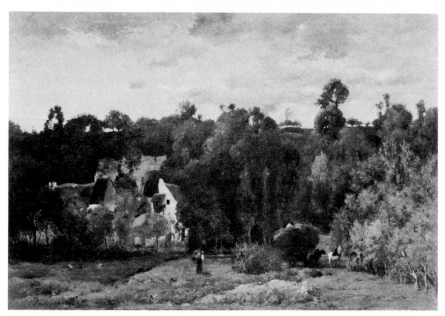

Landscape near Pontoise. *Daubigny*

* R. L. Herbert: *Barbizon Revisited* (New York, 1962).
† "more markedly diverse in his nuances than Corot"

eror of motifs. The riverbank scene, as it came to dominate French landscape paintings for the next three decades, seems to have been largely his creation. The magnificent *Landscape Near Pontoise* (Bremen) had a numerous progeny of landscapes at Pontoise and Auvers by Pissarro, Cézanne, Van Gogh, and Gauguin. Everyone knows that Monet's floating studio was inspired by Daubigny's but it now appears that Manet's famous picture of Monet in his boat derives from a Daubigny etching.

Jerrold Lanes. "Daubigny Revisited." *Burlington Magazine,* October 1964, p. 457 ff.

GUSTAVE COURBET

Courbet, a farmer's son from Ornans in Franche-Comté, was born in 1819. Ignoring his father's wish that he become a lawyer he went to Paris in 1840 to become a painter. He studied briefly under Steuben and Hesse, but was essentially self-taught. Courbet made his debut at the Salon of 1844 with *Courbet with a Black Dog* (Paris, Petit Palais). In 1849 he was awarded a medal for his *After Dinner at Ornans* (Lille, Musée). However, *The Burial at Ornans* created a scandal at the Salon of 1851. *The Burial* and *The Atelier* were rejected at the Universal Exhibition of 1855, whereupon Courbet rented a space near the exhibition grounds, put up a tent, and displayed the rejected canvases together with thirty-eight other works, calling it the "Pavilion of Realism." It was the first one-man show in history. He charged an admission fee and issued a "Realist Manifesto" which, together with the "Letter to Prospective Students" (1861), articulated his realist credo.

In 1863 his anticlerical painting *Return from the Conference,* depicting drunken priests, was rejected by the official Salon and by the Salon des Refusés. It was finally bought by a Catholic and destroyed. During the Universal Exhibition of 1867 Courbet held another one-man show outside the World's Fair. By that time Courbet had turned socialist under the influence of Proudhon (who had died in 1865); although the public began to accept his work he refused the official honors offered him by Napoleon III. In 1871, after the fall of Napoleon III, Courbet became a Deputy of the Paris Commune. Implicated in the destruction of the commemorative column in the Place Vendôme, he was sentenced to six months in prison and the payment of a large fine. Unable to raise this sum, Courbet fled to La-Tour-de-Peilz in Switzerland, where he died in exile in 1877.

I cannot teach my art, neither can I teach the art of any other school, for I deny that art can be taught.* . . . Art is altogether indi-

* In 1861 a group of art students, rebelling against the academic instruction at the École des Beaux-Arts, set up a school of their own, proclaimed themselves disciples

vidual, it is . . . nothing but the talent resulting from the artist's own inspiration and the study of the artistic tradition. . . .

The art of painting itself can consist only of the representation of objects that are visible and tangible to the artist. Any epoch can be depicted only by its own artists, that is to say, by the artists who have lived in it. I contend that the artists of one century are totally incompetent to depict the objects of a preceding or future century—in other words, to paint either the past or the future. . . .

I also hold that painting is an essentially *concrete* art, and can consist only of the representation of *real* and *existing* things. It is a completely physical language which instead of words is composed of all visible objects. An *abstract*, invisible, nonexistent object is outside the domain of painting.

Imagination in art consists of knowing how to find the most complete expression of an existing object, but never in imagining or creating the object itself. . . .

Beauty is in nature and is encountered in reality under the most diverse forms. . . .

Beauty, like truth, is relative to the time in which we live and to the individual capable of conceiving it. The expression of beauty is in direct ratio to the power of perception acquired by the artist. . . .

Gustave Courbet (1861). Quoted in Charles Léger.
Courbet. Paris, 1929, p. 86.

Here is a man who for seven years has made more of an uproar in the city than twenty celebrities and their noisy coteries. To some he is the robust yet vivacious personification of a new art, another Caravaggio who fights imagination for the sake of reality. . . . Others take him for a sort of ragpicker of art, picking up the truth from the mud of the streets and tossing into the waste-basket the last tatters of the romantic school of 1830 and the wigs of the Academy. The fanatics have with one *coup* placed him above all the artists of our day, and he himself resolutely swears that within a short time he will have erased every modern work of art from the memory of our century.

Society people, critics, artists, and vaudeville writers turn up their noses at him, avoid his company, pull him to pieces, and make a clown of him. . . . Like his illustrious friend and compatriot Proudhon . . . Courbet has become the *bête noire* of the Parisian public. . . .

of Courbet, and invited him to direct the school. Courbet replied with an open letter, from which the above excerpts are taken.

It seems to me . . . that he deserves "neither this excess of honor, nor this indignity." Though he is not a revolutionary genius, neither is he simply one of those sly and bragging hillbillies from the Franche-Comté. . . . We must recognize in him a forceful, original, and extraordinary painter, who, by virtue of his temperament, by his opposition to the past and the trivialities of its tastes, throws himself headlong into ridicule and thereby compromises those solid qualities which no one can seriously deny him. . . .

Courbet is really of gentle nature . . . the only violent thing about him is his self-esteem. . . . The soul of Narcissus has taken possession of him in its last incarnation. . . . He always paints himself in his pictures with voluptuousness, and he praises his own work to the skies. Nobody could pay him one-tenth of the compliments he pays himself from morning to night. . . . Courbet would be quite likable if his intellectual training were in keeping with his claim of knowing and judging everything. . . . To give more color to an opinion he held he once reported to me in all earnestness a conversation he had in England with Hogarth—dead since 1764. . . .

Théophile Silvestre. *Histoire des artistes vivants.*
Paris, 1856, p. 241 ff.

In the opinion of everyone Courbet is the apostle of ugliness. He is the Antichrist of physical and moral beauty. For the past six or seven years he has carried out his propaganda, and his zeal has not diminished. He has told himself: I shall surpass in ugliness the ugliest things ever seen. Then he begins his search and finds something still uglier than common ugliness: the combination of ugliness and stupidity.

Charles Perrier. "Du réalisme." *L'Artiste,*
October 14, 1855, p. 86.

He is no seeker, no composer, no interpreter. He paints pictures as one polishes shoes.

Maxime Du Camp. "Salon de 1857." Quoted in Charles Léger.
Courbet selon les caricatures et les images. Paris, 1920, p. 37.

At about three o'clock Courbet said, "I have to work." We went upstairs. . . . He lit his pipe, sat down before his easel . . . and, grasping his palette and palette knife, he began to paint, talking, laughing, and smoking all the time. From time to time he got up and moved back a step or two, in order to see the effect of his work. He painted with admirable precision. I followed the movements of his arm. His hands were long, elegant, and of rare beauty. . . . For

the first time I saw how he used the palette knife and what marvelous effects he obtained with it. . . . His hand was skillful and so sure that in the end he accomplished much, even though he painted only for a few hours in the afternoon.

> J. A. Castagnary (undated). Quoted in *Courbet raconté par lui-même et par ses amis.* 2 vols. Paris, 1948–50, I, 155.

He painted on heavy gray paper [*sic*], prepared with oil and mounted on a stretcher three times the size of those used for ordinary canvas. . . . The paintbox he used was also of unheard of dimensions. It contained enormous receptacles filled with the most common paints sold by the kilo: white, yellow ochre, vermilion, black. . . . This is how he combined his colors after having carefully studied his model. He prepared three basic hues for the light, half-tint, and shadow. Then he arranged his colors in the shape of a fan on the top of his palette. This done, he painted with the brush, the palette knife, a rag, even his thumb, whatever served him at the moment.

> A.-L. Schanne.* *Souvenirs de Schaunard.* Paris, 1886, p. 286.

Courbet is a sceptic in art . . . and that is really a pity, for he has very fine and powerful qualities. His technique is vigorous, his color solid, and his depth is often surprising. He has a grasp of the external appearance of things. . . . But he does not go beyond that, because he does not believe in painting. . . . Courbet is a valiant craftsman-painter who, lacking an understanding of the aesthetics of his art, unprofitably wastes splendid and rare qualities. As a genre painter he may formerly have believed that painting should have a social meaning; but at present he no longer believes such things. As a landscape painter he sees nature only through a tavern window. . . . It is as a portraitist that he seems to me at his best.

> J. A. Castagnary. "Salon de 1857." *Salons, 1857–1870.*
> 2 vols. Paris, 1892, I, 26 ff.

This remarkable artist, who stands out from all the others around us, uses extraordinary means in the service of his personal aesthetic. He is a painter in the strictest sense of the word, *pictor, pittore*—he sees clearly and renders accurately. His is a craft marvelously rich and supple, to the point of varying it with each object he represents; in a single stroke his brush captures both form and movement. Nothing

* Alexandre-Louis Schanne was the prototype of Schaunard, the musician in Henri Murger's novel *Scènes de la vie de bohème* (1847–49), hence the title of his volume of recollections.

in the visual world is a stranger to him: figures, landscapes, animals, seascapes, portraits, flowers, and fruit—Courbet handles them all with the same superior command. He is above all subject to things themselves, and drawing his impression thus from Nature he can be as diverse as she. For his wide range and great strength I would readily compare him to Velasquez, the great Spanish naturalistic artist. With a slight difference, however: Velasquez belonged to the court while Courbet is the Velasquez of the people.

Courbet's avowed aim is to paint what he sees. One of his favorite axioms, in fact, is that anything not recorded by the retina is outside the domain of painting.

J. A. Castagnary. "Salon de 1863." *Ibid.*, p. 148 ff.

Because realism owes its name to Courbet; because it is he who by his talent and boldness expresses the present trend most forcefully, because in the last analysis it is his picture, *The Return from the Conference,* that inspired this study, I shall give particular consideration to this artist. . . .

Although I recognize in Courbet the characteristics of an initiator, I cannot accept his claim to having opened up horizons heretofore completely unknown in art. In the first place, genius never appears in isolation; there are always precedents, traditions, accumulated ideas. . . . Genius does not occur in a solitary individual consciousness; it is a collective thought grown in the course of time. Secondly, the entire French school, perhaps unknowingly, moves in the same direction as Courbet. It is through the landscape and animal painters that painting is returning to nature and things democratic. It suffices to cite the best-known names: Rousseau, Fromentin, Daubigny, Corot, Barye, Rosa Bonheur, Marilhat, Millet, Brion. . . .

Courbet has invented neither realism, nor idealism, just as he did not invent nature. What he has done has been done before him. . . . The truth is . . . that Courbet, in his realism, is one of the most powerful idealizers there is, a painter with the most vivid imagination. I just mention his *Fighting Stags,* where the animals certainly did not pose for him. . . . Courbet's idealism is most profound; however, he is careful not to invent anything. He sees the mind through the body, its forms are a language for him, and its traits a sign. . . .

This is Courbet's realism: the representation of the outside to show us the inside. But this representation is neither a simple portrait, a photograph, nor a Venus of Praxiteles. It is composed of features collected and combined from the observation of reality. In this way, it is a pure idealization. In the *Bather,* ideal feminine beauty is implied. . . . What the artist wanted to show us is the bourgeois mind. . . .

To sum up, Courbet, a critical, analytical, synthetical, and humanitarian painter, is an expression of his time. His work coincides with Auguste Comte's *Philosophie positive,* Vacherot's *Métaphysique positive,* my own *Droit humain,* and *Justice immanente.* It coincides with the right to work and the right of the worker, announcing the end of capitalism and the sovereignty of the producers; the phrenology of Gall and Spurzheim, the physiognomy of Lavater. Courbet was extremely fortunate to have lived in Ornans. Had he been born or had he grown up in an academic environment, he would not be the same. Liberty has taught him direction. . . .

Let us give credit to Courbet for being the first among the painters to imitate Molière and transfer the high comedy of the theater to the canvas. He has seriously undertaken to warn us, to castigate us, to better us, by painting us just as we are. Rather than to amuse us with mythology, rather than to flatter us with tinsel highlights, he has had the courage to portray our image, not as nature intended us, but as we have been formed by our passions and vices.

P.-J. Proudhon. *Du principe de l'art
et de sa destination sociale.* Paris, 1865, p. 281 ff.

The younger generation—I am speaking of the young men of twenty or twenty-five—hardly knows Courbet, for his recent paintings are greatly inferior to his earlier works. I had the good fortune to see in his studio, during one of his absences, some of his earlier paintings. I was amazed, and could not find the slightest cause for laughter in these grave and powerful canvases of which the public has made monsters. I expected to see caricatures, the work of a grotesque and silly imagination, but I stood before compact and bold paintings of utmost finish and sincerity. The characters were lifelike without being vulgar; the flesh painting was firm and supple, powerfully alive. The backgrounds were suffused with atmosphere, lending the figures an astonishing vigor. The color, in a rather low key, had an almost tender harmony, while precise values and a broad technique established the relative planes so that each detail stood out in strange relief. Closing my eyes I see again those strong, solidly built canvases, all of one piece, true as life and beautiful as truth. Courbet is the only painter in our time. He belongs to the family of flesh painters and has for his brothers, whether he likes it or not, Veronese, Rembrandt, and Titian.

Proudhon has seen the pictures of which I speak, but he sees them differently; he ignores all aspects of craftsmanship and sees them strictly as pure thought. A canvas, for him, is a subject. Paint it red or green, it makes no difference. . . . He insists that the painting

must mean something, but of its form he says nothing. . . . He does not see that Courbet exists as an artist in his own right, not just because of the subjects he has chosen. . . . The object or the person on the canvas is a mere pretext. It is in the new way, the superior or better way in which this object or person is represented, that genius exists.

Émile Zola. "Proudhon et Courbet (1866)." *Mes haines.* Paris, 1880, p. 35 ff.

Nothing, nothing, and again nothing in this Courbet exhibition. Just about two seascapes. . . . The figure of the *Woman with a Parrot* [Metropolitan Museum of Art, New York] is as remote from a true nude as any academic nude of the eighteenth century. And then the ugly—always the ugly, and, above all, *bourgeois ugliness;* ugliness without its grandiose character, without the beauty of ugliness.

Edmond and Jules de Goncourt. *Journal.* 9 vols. Paris, 1935–36, III, 124. Entry for September 18, 1867.

Courbet was a born painter of the great tradition, who had the most remarkable gifts. He had the full command of his medium. His technique was masterly without being unduly contrived, marvelously suited to render the quality of surfaces, the density of volumes, and the fullness and continuity of everything he saw. No one could paint as he did the textures of flesh, fabrics, furs, and rocks; the glowing, vigorous, yet soft bodies of women, or the strength and firmness of his native landscape—in other words, everything that is heavy and solid. In his largest compositions a magnificent uniformity of execution links all the parts together from one end of the canvas to the other; it is therefore untrue to say that Courbet was merely a painter of details. There are some wonderful details, but they are always part of an overall plan. They are never striking just for their virtuosity or their adept execution, which can become tiresome in merely clever painters. The universe of Courbet is above all a homogeneous one, and his works should be considered as a unified group.

From large brush strokes loaded with a thick yet softly blended impasto, to the use, or rather abuse, of the palette knife, the flat impressions of which resemble the smooth, hard, veined surface of agate, Courbet's handling of the medium is strong and generous. He avoided large amounts of oil or the transparent brilliance of glazes. He was an austere colorist rather than an ostentatious one; his range of colors was derived from the tonality of his time, consisting largely of nuances of white and black, animated by warm tones. Unfortunately many of his works, especially his early ones, have darkened with time. This is

393

the fate which threatens canvases that have too heavy an impasto. But we can still feel the impact of the open air . . . in his southern landscapes such as *The Meeting* [1864; Montpellier]. We find in Courbet's paintings not only richness and a fine, deep tonality, but also delicate grays, pearly flesh tones, and the exquisite brilliance of verdant foliage lit by a transparent color. Courbet's strongest quality is his powerful objectivity of execution. . . . What did he lack to be considered an artist of the first magnitude. . . ? A certain sense of mystery . . . and finally some tenderness.

Henri Focillon. *La Peinture au XIX^e et XX^e siècles.*
Paris, 1928, p. 12 ff.

It is important to remember that Courbet made his appearance on the artistic scene at a moment when the struggle between the classical emulators of Ingres and the romantic admirers of Delacroix was nearing its end. Now that both the aging giants were loaded down with official honors and tokens of public esteem, the quarrel was simmering down . . . when the third aesthetic revolution of the century broke out in 1855 under the auspices of Realism. . . .

Courbet took up his position outside both of the two rival schools, the romantic school of Delacroix and the classical school of Ingres, and their influence and splendor were diminished by the power of his genius and of his concepts. Courbet approved of all the naturalistic precepts, and applied them effectively. On the other hand, following in Delacroix's steps, he thought that an artist should record the events of his age, but he went much further than the leader of the romantics and extended this idea to the whole of his work. He was, moreover, in all artistic and social respects a *contemporary* painter.

Thus, exactly in the middle of the century, Courbet's influence led to the eruption of many new concepts of art. . . . This great "Realist" movement was also to prepare the way for painters with an entirely new outlook. It is true that Courbet continued to use a technique inherited from illustrious predecessors, but even so his works contained elements of what was to come. . . . The younger painters had taken Corot and Courbet as their masters. Courbet's pictures taught them the technique of achieving an effect by means of massed colors (as in the figures in *Funeral at Ornans*) and the potency of dazzling light (as in *The Meeting*). It was on this latter picture that the style of the painter Frédéric Bazille, a close friend of Monet, was based. Fantin-Latour, who was also a friend of the Impressionists, attended Courbet's school in 1861. Jongkind and Boudin were admirers of his. Boudin introduced Monet to Courbet. . . .

In his first experiments Renoir imitated Courbet. . . . Cézanne

wavered for a long time between Courbet and Delacroix, "willing to accept no others," as Zola tells us.

<div align="right">

Marcel Zahar. *Gustave Courbet.*
New York, 1950, pp. 11, 16.

</div>

The Burial at Ornans
L'Enterrement à Ornans

1849–50 oil on canvas 123⅝" x 236" Paris, Louvre

I have listened to the comments of the crowd in front of *The Burial at Ornans*, I have had the courage to read the stupidities printed about this painting, and I have written this article. . . .

M. Courbet's subject is a burial in a small town, such as might have taken place in Franche-Comté, and he has portrayed fifty lifesize people on their way to the cemetery. That is the picture.

Some have found it too large and have advised the painter to go to M. Meissonier's flyspeck school. Others have complained that the citizens of Ornans are wanting in grace and elegance and resemble the caricatures of Daumier.

A few cold-hearted romantics have declaimed against its ugliness, like simple ignoramuses.

Some have wished that Courbet were a simple savage, studying painting while tending the cows. Still others assert that the painter is a leader of socialist gangs. . . .

Oh misery! . . .

The critics roasted Balzac on the grill so many times that they ended up by burning him. . . ; they used to say that he liked only to portray villains, and that he took pleasure in describing only the most vicious types of people. . . .

M. Courbet can say to his judges, just as this great master, whom we have now lost,* could have said to those who wielded their pens against him: I grant you that my beadles are not beautiful like Antinous, I am even convinced that Winckelmann would not discourse on my paintings because of the lowliness of some of the personages depicted; but beauty is not a common thing in France. You, my critics, who pretend to understand beauty, go and look at yourselves in a mirror and then dare to state in print that your features conform to the *Caractères des nobles passions* by the illustrious M. Le Brun. . . .

It is not hard to understand why *The Burial* created such a scandal, since

* Balzac died in 1850.

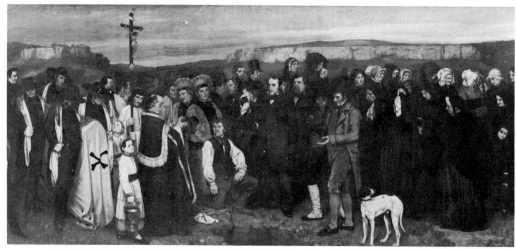

The Burial at Ornans. *Courbet*

works of a sentimental narrative character, academic paintings, and a faked vigorousness of feeling surrounded Courbet's virile, powerful, and sincere masterpiece.

As, on entering the exhibition, one looks at *The Burial* from afar, it seems to be framed by a doorway. Its simplicity, like that of the primitive wooden images carved with a clumsy knife, takes everyone by surprise. . . . The effect is identical because the execution in both cases is equally straightforward. The trained artist has here achieved the same emphasis as the primitive. Like a painting by one of the great masters, *The Burial* makes an immediate impression. The simplicity of the black costumes is reminiscent of the red-robed magistrates painted by Largillière. Courbet has depicted the modern bourgeois in all his ridiculousness, ugliness, and beauty.

Part of the scandal which M. Courbet's *Burial at Ornans* has aroused can be attributed to its uncompromising individuality, which, being both powerful and vigorous, overwhelms the neighboring paintings. Critics are enthusiastic about the slightly mannered head of a man smoking, which is a portrait of the painter. The hand of genius is certainly in *The Burial at Ornans;* the much-admired portrait of the *Man with the Pipe* [Musée Fabre, Montpellier], has at least ten counterparts in *The Burial*, all of them ten times better painted. I would not wish to give advice to the painter—let him go where his brush leads him. In this time of mediocrities he has produced a masterpiece; may his studies enable him to forget the sufferings to which the nobodies have subjected him.

<div align="right">

Champfleury. "Courbet: L'Enterrement d'Ornans (1851)."
Grandes figures d'hier et d'aujourd'hui. Paris, 1861, p. 231 ff.

</div>

The Atelier

1854–55 oil on canvas 141″ x 228″ Paris, Louvre

The full title is "The Painter's Studio, a Real Allegory Defining a Phase of Seven Years of my Life as an Artist." Courbet himself has explained the meaning of this painting:

The left side represents the common people, the wealthy, the poor, the exploiters and the exploited, "those who thrive on death": The rabbi and the priest (organized religion); the veteran of 1793 (neglected old age); the hunter with his dogs, the farmer, the laborer, the cloth merchant (exploitation); the professional mourner, the prostitute, the Irishwoman nursing a baby (poverty); the nude lay figure (academic painting); the skull on a newspaper (the decadence of the press—Proudhon had called newspapers the cemeteries of ideas); the plumed hat, guitar, and dagger (romantic poetry).

The center shows true realist art: Courbet himself at his easel, painting a landscape of his native Franche-Comté; a nude model (reality); a little shepherd (homage to future generations).

On the right are "those who thrive on life," actual portraits of Courbet's friends: Promayet (music), Proudhon (philosophy), Buchon, Champfleury [seated], and Baudelaire [reading] (literature); Bruyas and the couple in the foreground (patrons of realist art); and a couple in the background (free love).

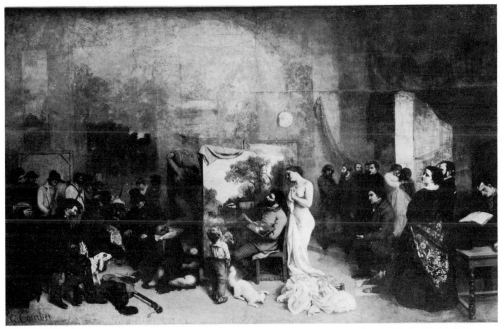

The Atelier. *Courbet*

397

He [Courbet] is seated in the center before an easel, and although he is painting a landscape, a nude woman with a rather commonplace figure seems to be posing for him. . . . Ugliness and vulgarity characterize most of the figures. Traces of talent appear only here and there, as if to bring into sharp relief the defects of his work and the studied artificiality of his degraded personality.

> Guy de Fère (1855). Quoted in René Huyghe.
> *Courbet: L'Atelier du peintre, allégorie réelle,*
> *1855.* Paris, 1944, p. 24.

I went to see Courbet's exhibition; he has reduced the admission to ten *sous*. I stayed there alone for almost an hour and discovered that the painting they have rejected is a masterpiece. I simply could not tear myself away from the sight of it. He has made enormous progress, and yet this has made me admire his *Burial*. . . .In the later work [*The Atelier*] the planes are well understood, there is atmosphere, and some parts are remarkably well executed: the haunches, thighs, and bosom of the model, the woman with a shawl in the foreground. . . . They have rejected one of the most singular paintings of our time, but Courbet is not the sort of fellow to be discouraged by such a trifle.*

> Eugène Delacroix. *Journal.* Paris, 1932, II, 363 ff.
> Entry for August 3, 1855.

L'Atelier is a great picture. It is great in spite of its stupidities and its commonplaces, its stock figures and anecdotic gestures; but it would be a mistake to call it a masterpiece. It falls short of that. . . .

This superb piece of painting . . . has not been so organized as to compose a plastic unity. To keep it together a literary interpretation is needed. We cannot help wondering, as we look at it, what precisely it is all about; and until we know we have a vague sense of discomfort. Also we cannot help feeling that this vast and richly painted canvas might, without serious loss, be divided into at least three distinct pictures. This is not how one feels before a completely sucessful design. . . .

The composition of this picture is thoroughly traditional: its modernity— which is by no means conspicuous—must be sought in the painting. It belongs emphatically to its age—1855, the moment before the coming of impressionism. The nude in the centre, with her light clothes flung beside her in a heap, the white cat, and the picture on the easel, form a luminous centre around which the remaining figures are grouped; but it would have needed

* Delacroix misjudges Courbet's personality here. After the negative vote of the jury of the Exposition Universelle, Courbet wrote to Bruyas: "I am almost frantic. Terrible things have happened to me. They have just rejected *The Burial* and my latest picture, *The Atelier*. . . ."

a greater artist than Courbet even to have concentrated and brought to perfect coherence so many complex forms and open spaces. If, however, the design lacks concentration, the painting and drawing of many of its parts are of the highest beauty. The nude in the centre, the crouching, ragged woman on the artist's left, and the *femme du monde* with her miraculously painted shawl, each, in itself, is a masterpiece. The portrait of Baudelaire will not disappoint amateurs of painting with a taste for literature, while those for whom the literary and historical interest of a picture is of more consequence than the aesthetic significance will find plenty to amuse themselves with in the portraits of Proudhon, Bruyas, Cuénot, Buchon, Promayet, Champfleury, and the artist himself.

> Clive Bell. "L'Atelier de Courbet."
> *Burlington Magazine*, January 1920, p. 3.

Today Courbet's *Atelier* is a classic. We no longer attack it, nor does it astonish us. . . . But then the picture waivers between its two poles, reality and allegory, and does not choose between them. It is a visual paradox just as the title is a verbal paradox.

> René Huyghe. *Courbet: L'Atelier du peintre* . . .
> Paris, 1944, p. 3.

The Covert of the Roe Deer
La Remise des chevreuils

1866 oil on canvas 68⅞″ x 81½″ Paris, Louvre

It is the embankment of a brook amid rocks and large trees. All is light. This past winter I rented a few deer and painted a covert. In the middle is a small doe, seated and receiving as in a parlor. Next to it is its male. . . . It is ravishing, and they are polished like diamonds. . . .

> Gustave Courbet. Letter to Urbain Cuénot, April 6, 1866.
> Quoted in *Courbet raconté par lui-même et par ses amis*.
> Geneva, 1948–50, I, 215.

Who would have thought that the great success of the Salon of 1866 . . . would be Courbet's! Well, my dear friend, your business is done, accomplished—ended. Your brave days are over. Here you are, accepted, bemedaled, decorated, glorified, and embalmed. . . . Everyone is attracted by this fresh, clear, luminous landscape—though the sky is not visible—a mysterious and tranquil retreat between mother-of-pearl rocks glazed by the shimmering brook, with elegant shrubs, whose branches and foliage draw

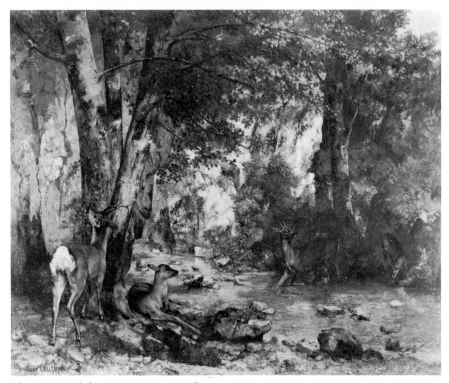

The Covert of the Roe Deer. *Courbet*

light arabesques on the rocky background. . . . Instead of placing nude women and goddesses under the subdued light of the birch trees, Courbet, contemptuous of poetry and all, has sheltered a troop of deer. They are, indeed, less rare in the woods of the Jura than naiads or dryads. But, sure enough, the idealists in painting criticize Courbet for not having risen to the proper style by putting there some Diana surprised by Actaeon.

Yet, such as it is, this purely sylvan landscape pleases the fanatics of good painting, the lovers of the real countryside, the society women, the fat bourgeois as well as the naïve crowd.

I am not the one to explain this unexpected shift in public opinion. Courbet has certainly remained the same. He has always had this profound and poetic feeling for nature, this sensitive brushwork, this opulent palette, this sure touch that seems to lift color and form from objects and transfer them to the canvas.

<div style="text-align:right">

Théophile Thoré. "Salon de 1866." *Salons de W. Bürger.* 2 vols. Paris, 1870, II, 276 ff.

</div>

... A famous, but very superficial picture ... a victory for technique. ...
The color is lightened and loses its tonal value, and the finish is excessive. ...
Lionello Venturi. *Modern Painters.*
New York, 1947, p. 218.

The Covert ... is the most beautiful of Courbet's landscape-and-animal
compositions. At the left an antlered buck munches the tender spring leaves
of a vine growing at the base of a huge tree; a doe lies beside him at the edge
of a rippling mountain stream, the rivulet of the Puits Noir, and another buck
stands in the shallow water under the arching trees. The colours are lighter
and fresher than in most of Courbet's landscapes; the background, painted
in the Franche-Comté, is in fact almost faultless, but the animals, added in
Paris some months later, stand out a little too sharply from their surroundings
and betray the fact that their models were carcasses hired from a game
butcher, not living denizens of the forest.
Gerstle Mack. *Gustave Courbet.* New York, 1951, p. 206.

THÉODORE CHASSÉRIAU

A colorful personality and a precocious artist of French-Creole descent, Chassériau was born in 1819 at Samana in the Dominican Republic. He came to Paris early, entering the studio of Ingres at the age of twelve, and studying with him until 1834, when Ingres left for Rome to become Director of the French Academy. At the age of sixteen Chassériau won a medal at the Salon of 1836 for his *The Malediction of Cain.* By the age of twenty he had developed a personal style with *Susanna and the Elders* and *Venus Anadyomene,* both shown at the Salon of 1839, and now in the Louvre. After visiting Italy and Ingres in 1840–41 he became alienated from classicism and leaned more and more toward romanticism and Delacroix. In 1846 he visited Algeria and thereafter adopted Oriental subjects. His masterpiece was the fresco decoration of the stairway in the Paris Cour de Comptes (1848) which was almost completely destroyed by fire in 1871; some remnants were salvaged later and transferred to the Louvre. Chassériau was a close friend of Théophile Gautier, who was the first to champion his work. He died in Paris in 1856 at the age of thirty-seven.

M. Chassériau's talent is characterized above all by refinement
and simplicity. Without abandoning reality he aspires towards ideal
beauty. ... At an age when most artists find it difficult to avoid exag-
geration, this young painter has been able to remain unaffected,
serious, in good taste, without onesidedly favoring either drawing or
color, and equally removed from too labored or too detailed an
execution. His *Venus Anadyomene* ... is mythology understood and

rendered with that dreamlike and passionate grace which the Greek artists so often lack.

> Théophile Gautier (1839). Quoted in Léonce Bénédite.
> *Théodore Chassériau.* 2 vols. Paris, 1931, I, 96.

With a profound feeling of sorrow I entered this studio . . . which the artist, alas, no longer inhabits. . . . In silence, my heart heavy with memories, I wandered about this room where I had sat so many times, a cigar in my mouth, watching a figure emerge from Théodore's brush; from time to time he would turn to me with a witty thought, a sparkling remark, an original expression. For his conversation was charming; he mingled the language of the most sophisticated high society with the bold and picturesque vernacular of the artist. . . .

Here I found again one of my favorite paintings, *Susanna and the Elders.* . . . Nowhere was the painter as successful in representing his ideal of exotic beauty, for which he had such a penetrating sensitivity. Other artists have undoubtedly been purer, more complete and more explicit, but none has stirred me as deeply as Théodore Chassériau. His heads always have a morbid and strange expression, a nostalgic languor, an anguished voluptuousness, a sad smile, a mysterious gaze turned toward infinity. It seems as if we had already seen these faces in our dreams, in distant countries, long ago, and in the midst of strange cities with a vegetation never seen before. They are like captured savages led into our civilization, clothed in their brightly colored garments, bespangled with their primitive jewels, crouching like gazelles recaptured in their poses of wild grace.

> Théophile Gautier. "Atelier de feu Théodore
> Chassériau." *L'Artiste,* March 15, 1857, p. 209.

Chassériau came into the world with the capacity for fertilisation from the East, which may compare in importance with Manet's assimilation of Spanish influences. His contact with Delacroix was a result, not a cause; it deepened and beautified his Orientalism. . . .

The Toilette of Esther [1841; Louvre] seems to me the gem of the easel pictures. Earlier than the others, it has not, as yet, the full, free poetry of the *Daphne* [1846; Louvre]; it is a further evolution of the *Venus,* which it recalls in the gesture of the hands, uplifted to the hair. . . . This time the figure is seated, facing the spectator. The exquisite plane of the naked torso occupies the center of the picture; slaves on either side present the jewels with which Esther is to appear before the king. The dreamy, far-away expression of the sweet figure is of exquisite beauty. Here the East blossoms in a fashion quite unlike that of Delacroix's orgies of color; we seem to catch a glimpse

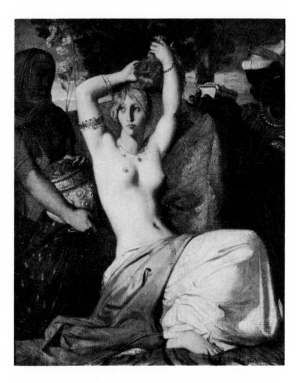

The Toilette of Esther.
Chassériau

of the soul of exotic beauty, whereof Delacroix saw the outward splendor. We are reminded of a much later artist, of Gauguin, in his rare moments of calm and happiness.

This is perhaps the secret of Chassériau's monumental art, the natural calm which only the East possesses. The intention of the monumental painter is also clearly apparent. The whole picture lies in the action of the arms. The black slave holds her casket with the typical gesture of the ancients. A delicious play of line, never contradicting itself, and expanding in vigorous breadth at the base, runs from her head over the hands and arms of Esther and the bust of the other slightly higher figure. The bodies of the two flanking figures are cut off almost schematically by the frame—a masterly touch. I am inclined to rate this little picture even higher than the gorgeous *Tepidarium* [1853] in the Louvre, the beautiful monument he raised to the master of the *Bain turc* [*The Turkish Bath*, by Ingres], in which we may admire both what the pupil took from his teacher and what he added. In spite of its beauty this remains a brilliant school picture. The new elements that went beyond Ingres lie in the *Esther*.

Julius Meier-Graefe. *Modern Art.* 2 vols.
London, 1908, II, 44 ff.

403

Chassériau occupies a peculiar position in the history of French art. The tendency of his own generation was all in the direction of realism. He was born the same year as Courbet, two years before Flaubert and Baudelaire, and at the end of the same decade that saw the birth of Troyon, Théodore Rousseau, Dupré, Millet and Daubigny. If he had lived he would have found himself in conflict with movements far different from his own art. One can imagine few points of contact between himself and the painter of *The Funeral at Ornans*. Nevertheless he foreshadows in many ways the tendencies that were to succeed the realism of the mid-century. His exoticism, his peculiarly personal conception of form, his relative brilliancy of color and the freshness and directness of his handling are all a foretaste of later developments. His sensuousness is akin to that of Renoir, and the *Two Sisters* [1843; Louvre] is an ancestor of some of Manet's portraits. But it is doubtful whether these were direct influences. His work was fragmentary and scattered. On only two artists, both personal friends, is it possible to say that he had a direct influence: Puvis [de Chavannes] and Gustave Moreau. His relation to later art, therefore, was that of a precursor, not a leader.

Chassériau has always suffered the fate of those who do not fit into easy classifications. But as his affinities with the modern spirit have become more evident he has begun to regain his rightful place. To us today, although he does not seem to stand beside the greatest innovators like Ingres, Géricault and Delacroix, he nevertheless appears as one of the rarest and most interesting figures in French art of the last century.

<div style="text-align: right">

Lloyd Goodrich. "Théodore Chassériau."
The Arts. (New York), 1928, p. 95 ff.

</div>

GUSTAVE MOREAU

Solitary, wealthy, and an intellectual, Moreau spent most of his life in Paris, where he was born in 1826. He was trained by Picot, but when he failed to win the Rome Prize he associated himself with Chassériau and Delacroix. A *Pietà* was accepted for the Salon of 1852 and after four years in Italy he exhibited his *Oedipus and the Sphinx* (Metropolitan Museum of Art, New York) in the Salon of 1864. Thereafter Moreau showed his works infrequently. He became known to the public chiefly through Huysmans' novel *Against the Grain*. He was elected to the Institute in 1888 and was appointed Professor at the École des Beaux-Arts in 1892; Matisse, Rouault, and Marquet were among his pupils. Before his death in 1898 Moreau willed his house and its entire contents to the State. It is now a national museum containing about 1,000 paintings and more than 7,000 drawings.

I am the bridge over which some of you will pass.

Gustave Moreau (undated).
Quoted by Georges Rouault in
"Lettres de Georges Rouault à André Suarès."
L'Art et les Artistes, 1926, p. 242.

An anguished, often delicate mind, nurtured by ancient poetry and symbolism, the greatest lover of myths that ever was, Moreau spends his life interrogating the sphinx. Together they have succeeded in instilling a strange system of painting in the groups of young people nursed with the bottle of official, traditional art; it is a system of painting bordered in the south by Algeria, in the east by mythology, in the west by ancient history, and in the north by archaeology. True painting is clouded by a period of criticism, by trivia, and pastiches.

Louis Duranty. *La Nouvelle Peinture* (1876).
Paris, 1946, p. 23 ff.

His moving impulse does not come from the heart; he loves the sumptuousness of material goods which he stuffs everywhere. Of every human being he makes a piece of jewelry covered with jewelry.

Paul Gauguin (ca. 1890–91). Quoted in
J. Loize. "Un Inédit de Gauguin."
Nouvelles Littéraires, May 7, 1953.

Remote from life, remote from actuality, he remained ever engrossed in his dream, and his noble art served him to retain his apparently multifarious, but, in reality, little-changing dream pictures. His museum, too, is a world by itself, which has no more in common with the objective outer world than have dreams with reality. . . .

Moreau was a denizen of the shadow world. . . . Its landscapes are curiously jagged rocks seemingly formed of coral; chalky plains with reflections of a glimmering moon; mountain peaks made of cumulus clouds; lakes and seas opalescent like oil or saturated with indigo. The animals that inhabit this hypnotizing paradise are unicorns with silvery furs, stupefying dragons too coiled to inspire fear, milk-white flying horses, seven-headed hydras standing erect on the tips of their tails, Stymphalian birds with women's faces, sphinxes, chimeras, and phoenixes. . . .

Moreau's transcendental images necessarily reveal themselves to our senses in colors and forms other than those familiar to us from experience. An eerie light fills his pictures with the shimmering radiance of mother-of-pearl. . . . Buildings are of gold and precious stones; there is a twinkle of rubies, sapphires, and emeralds every-

where. Moreau's amazing art elicits from his palette effects that go far beyond the technique of oil painting. . . . They seem like paintings on glass with sunlit, jewel-like fragments of color or Byzantine mosaics of lapis lazuli, jasper, and carnelian. . . .

The first impression received from the Moreau Museum is that of having entered an enchanted castle. . . . As we tarry longer and our eyes grow accustomed to the ripple of pearls and precious stones, of enamel and gold, we are astonished at the strange, weird stiffness and stillness of all these splendid creatures. . . .

Moreau formed his views on Baudelaire's rules. In the rooms of his museum we fancy we are looking at a series of book illustrations for *Les Fleurs du mal:*

I hate the movement which displaces the lines,
And never do I weep and never smile.

This would . . . most fittingly convey in words the main feature of Moreau's art. This *silence d'éternité* is the characteristic of Moreau's art. Here nothing moves . . . Moreau reverses Pygmalion's miracle. His brush takes the life out of every human being he paints, and turns it into a statue.

<div align="right">Max Nordau. Von Kunst und Künstlern.
Leipzig, 1905, p. 136 ff.</div>

Gustave Moreau is haunted by the image of Salome, and he paints her a hundred times, always a rigid flower of evil, always in the midst of sumptuous glooms or barbaric splendours: a mosque, a cathedral, a Hindu temple, an architecture of dreams. She is not a woman, but a gesture, a symbol of delirium; a fixed dream transforms itself into cruel and troubling hallucinations of colour; strange vaults arch over her, dim and glimmering, pierced by shafts of light, starting into blood-red splendours, through which she moves robed in flowers or jewels, with a hieratic lasciviousness. . . .

Moreau is the mathematician of the fantastic, a calculating visionary. In his portrait of himself one sees a sickly dreamer, hesitating before his own dreams. His effects are combined mentally, as by a voluptuary who is without passion. His painting is sexless and yearning, and renders the legends of sex with a kind of impotent allurement. Leda and the swan recur as a motive, but in the rendering of that intense motive there is no more than decorative toying, within landscapes crackling with ineffectual fire. Sometimes colour is sought,

sometimes line; never the kernel and passion of the story. And it is the same with Helen, Bathsheba, Messalina, Eve and the Serpent, and the eternal Salome; always the same strengthless perversity, fumbling in vain about the skirts of evil, of beauty, and of mystery. What he tries to suggest he has not realised; what he realises he has not seen; his emotion is never fundamental, but cerebral; and it is only when he shuts it wholly within his colour, and forces his colour for once to obey his emotion (as in a little *Magdalen on Calvary*, with the three crosses black against hills corroded out of sunsets), that he is able to produce a single imaginative effect, that he is able to please the eye by more than some square or corner of jewelled surface into which life comes surreptitiously.

<div style="text-align:right">

Arthur Symons. "Gustave Moreau (1905)." *Studies in Seven Arts.* London, 1910, p. 76 ff.

</div>

If Moreau were seen only in his "literary" works, the Salon pictures with their ambitious allegorical intentions, he would rest in art history as a disconcertingly uneven painter whose dreams were more bizarre than profound. But . . . it is in the lesser-known and often unfinished paintings that Moreau the painterly painter, the uniquely experimental dreamer must be sought and understood. . . .

Moreau's lifetime was given to the struggle to elevate himself to an almost unapproachable ideal. Born in the Romantic period, his restless mind confronted the problems raised by the new esthetic and, in a sense, carried them to their logical conclusions far in advance of his contemporaries. His inexplicable "abstractions" are as much a reflection of the questions posed by the Romantic generation as are his theatrical presentations of myth and legend. His technical experiments, "discovered" by abstract expressionist artists who find his textures, hectic linear interlaces and strange concordances of color so close to their own, grew as much from Romantic theory milled in his peculiar imagination as did the few large, obsessively detailed "finished" paintings publicly exhibited. . . .

Moreau has been seen so variously by critics and connoisseurs that he emerges an invincible figure of paradox. . . . He stands in the history of art a symbolic figure, bristling with significant arrows pointing far backward and forward in time, East and West in space.

<div style="text-align:right">

Dore Ashton. "Gustave Moreau." In *Odilon Redon, Gustave Moreau, Rodolphe Bresdin* (New York, Museum of Modern Art). New York, 1961, p. 109 ff.

</div>

<div style="text-align:right">

407

</div>

Salomé Dancing Before Herod

1876 oil on canvas 56¾" x 40¾" The New York Cultural Center

Amid the heady odor of the perfumes, in the hot, stifling atmosphere of the great basilica, Salomé, the left arm extended in a gesture of command, the right bent, holding up beside the face a great lotus blossom, glides slowly forward on the points of her toes, to the accompaniment of a guitar whose strings a woman strikes, sitting crouched on the floor.

Her face wore a thoughtful, solemn, almost reverent expression as she began the wanton dance that was to rouse the dormant passions of the old Herod; her bosoms quiver and, touched lightly by her swaying necklets, their rosy points stand pouting; on the moist skin of her body glitter clustered diamonds; from bracelets, belts, rings, dart sparks of fire; over her robe of triumph, bestrewn with pearls, broidered with silver, studded with gold, a corselet of chased goldsmith's work, each mesh of which is a precious stone, seems ablaze with coiling fiery serpents, crawling and creeping over the pink flesh like gleaming insects with dazzling wings of brilliant colors, scarlet with bands of yellow like the dawn, with patterned diapering like the blue of steel, with stripes of peacock green. . . .

In the work of Gustave Moreau . . . Des Esseintes saw realized at last the

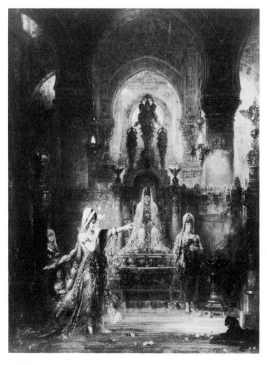

Salomé Dancing Before Herod.
Moreau

Salomé, weird and superhuman, he had dreamed of. No longer was she merely the dancing-girl who extorts a cry of lust and concupiscence from an old man by the lascivious contortions of her body; . . . she was now revealed in a sense as the symbolic incarnation of world-old vice, the goddess of immortal hysteria, the curse of beauty supreme above all other beauties by the cataleptic spasm that stirs her flesh and steels her muscles—a monstrous Beast of the Apocalypse, indifferent, irresponsible, insensible, poisoning, like Helen of Troy of the old classic fables, all who come near her, all who see her, all who touch her.

> J.-K. Huysmans. *Against the Grain* (1884).
> New York, 1956, p. 57 ff.

PIERRE PUVIS DE CHAVANNES

Puvis de Chavannes, born in Lyons in 1824, originally planned an engineering career, but turned painter after a trip to Italy. He studied briefly with Henry Scheffer, the brother of Ary Scheffer, and Thomas Couture, but was more strongly influenced by Delacroix and Chassériau. At the age of thirty he met Princess Marie Cantacuzène, who was then the friend of Chassériau; Puvis married her in 1897, the year before his death, after a friendship of over forty years. She was the model and central figure in a series of murals, the *Life of Ste. Geneviève* (1874–78, 1898; Paris, Pantheon), his principal work. Puvis, who painted on canvas in flat, pale oil colors and simplified drawing in order to create the effect of frescoes, decorated the Sorbonne and the Hôtel de Ville in Paris, and executed murals in Amiens, Marseilles, Poitiers, Rouen, and the Boston Public Library (1893–95). He died in 1898.

> You tell me that the artist rearranges objects according to his dreams; I should rather say he establishes an order according to his dreams. For I am convinced that the most orderly conception is also the most beautiful. I love order, because I passionately love clarity.
>
> Puvis de Chavannes (undated). Quoted in Maurice Denis.
> "Les Arts à Rome ou la méthode classique (1898)."
> *Théories, 1890–1910.* Paris, 1920, p. 46.

> Although M. de Chavannes has previously exhibited a very promising *Return from the Hunt,* his real debut, so to speak, is taking place this year. With one stroke he has emerged from the shadow. . . .
>
> M. P. de Chavannes is not looking for, as we say, small potatoes. His mind dwells in the most august spheres of art, and his ambition even surpasses his talent. The mere sight of his two great compositions, *Bellum* and *Concordia,* is intriguing. Are they cartoons, tapestries, or, rather, frescoes removed from some unknown Fontainebleau

by a secret process? What medium did he use? Was it tempera, wax, or oil?° We cannot be sure, so strange are the hues, so different from the usual color schemes. They are shades which are either neutral or intentionally dulled as in the mural paintings which adorn buildings without crass reality, producing the general idea of the objects, rather than depicting them outright.

M. Puvis de Chavannes—we must insist—is no painter of pictures. He needs, not an easel, but a scaffold and large wall spaces to cover. This is his dream, and he has proved that he could realize it. In an era of prose and realism he is naturally heroic; he is epic and monumental by a strange recurrence of genius. It seems that he has not taken notice of contemporary painting, but issues directly from the school of Primaticcio or Rosso.

Théophile Gautier. *Abécédario du Salon de 1861.* Paris, 1861, p. 102 ff.

I take issue with M. Puvis de Chavannes on his conception. This is not my fault, for M. Puvis de Chavannes presents himself as a thinker. He does not want to achieve his effects by means of color; his muddy grisailles are of a melancholy and repulsive aspect. He wants to achieve but little through drawing. He demands nothing of nature or the living model: his personages are imaginary, without character, without race, and without individuality. His landscapes are without time, climate, or light. Can this truly be called painting? Someone has mentioned frescoes. Fortunately, the golden and luminous frescoes have nothing in common with the gray and dirty tones of these canvases, which resemble washed-out tapestries. M. Puvis de Chavannes has dedicated himself to a gigantic task without much utility. What little painting there is on his canvases harms their effect. If he really wants to attempt fresco painting, and if he knows how to draw, he should limit himself to the cartoons.

J. A. Castagnary. "Salon de 1863." *Salons.* 2 vols. Paris, 1892, I, 130.

Here is a really original temperament which was formed outside of all academic influence. He [Puvis de Chavannes] is the only artist who can succeed in decorative painting, in the vast frescoes which the crude lighting of our public buildings require. With the downfall of the classical principles in our time the question of mural painting has become critical. . . . But it seems to me that Puvis de

° A wax medium was used. *War* and *Peace,* painted in 1861, are now both in the Musée de Picardie, Amiens.

Chavannes has found a way out of this impasse. He knows how to be interesting and vivid by simplifying the lines and by painting in uniform tones. . . . But, to tell the truth, Puvis de Chavannes is only a precursor, as far as I am concerned. It is imperative that large-scale painting treat contemporary subjects. I do not know who will be the painter of genius capable of extracting art from our civilization . . . but it is indisputable that art should depend neither on the drapery nor on the nudes of antiquity.

> Émile Zola. "Une Exposition de tableaux à Paris [Salon de 1875]." *Salons.* Geneva, 1959, p. 155.

M. Puvis de Chavannes is the only painter today who has the feeling for large-scale decorations. His originality and strength lie in the simplification of drawing, the unity of color, in those large works which decorate monumental structures without obliterating or crushing the architecture. We have to commend him specially for having remained true to nature while at the same time simplifying its representation. His sobriety does not exclude truth; on the contrary, there is, indeed, an almost hieratic convention of drawing and color, but we sense humanity beneath the symbol.

> Émile Zola. "Le Naturalisme au Salon (1880)." *Ibid.*, p. 251.

Let us not ask of Puvis what he has deliberately put aside—I mean photographic exactitude and specific chronological correctness. He envisages painting as a great decorative scheme, hence the subdued tones, which harmonize perfectly with the architectural lines of the buildings, but shock in an easel painting. Puvis is the master of the fresco; the murals at Marseilles, Poitiers, and Amiens are irrefutable proof of this. His work, hermetic and symbolic, intelligible only to those who think, is executed throughout in a superbly simplified style, taking up the tradition of the great primitives, Buffalmacco, Benozzo Gozzoli, and Gaddo Gaddi; it will be one of the glories of this century.

The *Young Girls at the Seashore* and *Women at Their Toilette* are profoundly charming. We like *The Poor Fisherman* less. The head of *The Prodigal Son* expresses a tremendous and painful sadness, a frightful, all-embracing melancholy for which Odilon Redon, this great, still ignored artist, has found the formula in his illustrations of Poe.

> Félix Fénéon. "Exposition nationale des Beaux-Arts (1883)." *Œuvres.* Paris, 1948, p. 92.

No drawing, no color, or, rather, detestable drawing and hardly any color—these are the things that can always be said of the paintings of Puvis de Chavannes. Nevertheless, there is something in these canvases which arouses respect, if not admiration, in the most rebellious among us, something which makes us place them far above others that are more skillfully executed. What is it? Some call it genius. M. de Chavannes can neither paint nor draw, but he has genius, and that is sufficient to put him far ahead of the most learned and skillful painters who are merely talented. . . . The truth is that not only do we not *admire* M. de Chavannes' drawing and color schemes, but, on the contrary, we *pardon* them. What we admire in him . . . are his intention and his composition. In those particulars, and only in those particulars, is he superior to his colleagues. He employs his art to express emotions by a harmonious arrangement of lines. In contrast to the majority of painters who paint in prose, he tries to paint in poetry. . . . In the paintings of Puvis de Chavannes we admire something other than their actual content. . . . They represent for us, I believe, a reaction against the excesses in the opposite direction, of which we are beginning to get tired. In painting as in literature the moment had already arrived several years ago when we had had enough, or too much, of the so-called realism, enough, or too much, of the so-called truth. . . . We have been thirsting for dreams, emotion, and poetry. Saturated with too bright and too crude a light, we have been longing for the mist. It was then that we passionately attached ourselves to the poetic art of M. de Chavannes. We have loved his poetry in spite of his grave deficiencies, his faulty drawing, and his lack of color. . . . We have attached ourselves to him like the sick to a new cure. . . .

<div style="text-align:right">

Téodor de Wyzewa. "Une Exposition de Puvis de Chavannes (1894)." *Peintres de jadis et d'aujourd'hui.* Paris, 1910, p. 364 ff.

</div>

Puvis is above all things a decorator, and . . . his work cannot be properly judged except in place. It does not show to good advantage in an exhibition, where it is necessarily placed in contrast with works done on radically different principles. I have often felt disappointed with a canvas by him when I saw it in the Salon; but I have seldom seen one of his decorations in the surroundings for which it was intended without being struck with its fitness and the perfection with which it served its purpose. His *Poor Fisherman,* hung as an easel-picture among other easel-pictures in the Luxembourg, seems almost ludicrous. It was said of Millet's peasants that they were too poor to afford folds in their garments; here the poverty seems

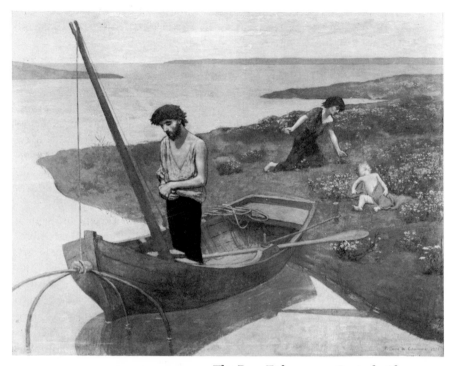

The Poor Fisherman. *Puvis de Chavannes*

even more abject, and drawing and color seem equally beyond its resources. Transfer the contest to his own ground, however, and see how Puvis in his turn triumphs over those who, in a gallery, utterly crush him by their greater strength and brilliancy of technic. Go to the Panthéon and look at the mural pictures executed there by many of the foremost of French painters, and I think you will feel that there is just one of them that looks like a true decoration, exactly fitted for the place it occupies and the architecture that surrounds it, and that that one is Puvis de Chavannes'. . . .

At first sight the drawing may seem simple and almost childish, and one may think it easy to do the like; but there is the knowledge of a lifetime in these grand lines, and they are simple only as a Greek statue is simple. . . .

A classicist of the classicists, a primitive of the primitives, a modern of the moderns, Puvis de Chavannes is, above all, an individual and original artist, and to copy his methods would be to learn ill the lesson he teaches. His style is indissolubly bound up with his message; his manner is the only one fit to express what he alone has to say. It would be but an ill-fitting, second-hand garment for another.

413

But let us learn from him that imitation is not art, that the whole is greater than the parts, and that art in service is the freest art and the noblest.

Kenyon Cox. "Puvis de Chavannes."
Century Magazine, LI, 1896, p. 558 ff.

Nothing could be farther from literary ideas than his simple types of meaning. They were all rebuilt from an inner consciousness and appreciation of what is purely plastic, and an intention as general as the very words which we use to designate general ideas. In a certain sense, therefore, his allegories and representations of ideas are nearer to the representation of these ideas than the allegorical figures of most painters. . . .

The very manner in which he has avoided the enclosing of a definition has probably had a great deal to do with his gradual appreciation by intelligences living outside of the practice of plastic art. The literary mind, the poet, the writer has found in Puvis de Chavannes a stimulus or an excuse for other methods of feeling. Because the writer and the literate began to like him, the artists living in technique alone, and their coadjutors, objected to him as painting literature. But it was not so—no writing, no verse, no phrase could claim to be the origin of the life of his figures. They were parallel to literary expressions which remain entirely outside the meaning of plastic art.

John La Farge. "Puvis de Chavannes."
Scribner's Magazine, XXVIII, 1900, p. 672 ff.

Puvis explains his idea, yes, but he does not paint it. He is a Greek, whereas I am a savage, a wolf in the woods without a collar*. Puvis calls a picture *Purity*†. In explanation, he paints a young virgin with a lily in her hand—an obvious symbol; hence it is understood. Gauguin, under the title *Purity*, would paint a landscape with limpid waters, unspoiled by civilized man, perhaps with a single figure.

Without going into details here, there is a world between Puvis and me. Puvis as a painter is literate, but not a man of letters, while I myself am not literate, but perhaps a man of letters.

Paul Gauguin. Letter to Charles Morice, July 1901.
Lettres de Gauguin à sa femme et à ses amis. Paris, 1946, p. 300.

* Gauguin refers to the lean wolf in La Fontaine's fable, who would rather starve and be free than be well-fed and in chains.
† The painting is actually *Hope* (1872; Louvre), which Gauguin himself included in the background of his *Still Life with "Hope",* painted 1901.

Puvis de Chavannes—what bad literature!
> Paul Cézanne (undated). Quoted in Joachim Gasquet.
> *Cézanne.* Paris, 1926, p. 76.

No one but Puvis knows how to place each figure correctly in a composition. Try to move one of them just a hairline, a point, and you will see that it is impossible.
> Edgar Degas (undated). Quoted in P. A. Lemoisne.
> *Degas et son œuvre.* 4 vols. Paris, 1946–49, I, 144.

At the time when Monet's school was dissolving everything solid in colour and light, and every half-defined detail gave its devotees a nervous shock, Puvis went on calmly setting his broad dark contours against the atmosphere, giving his faded brownish gray to the earth, and getting his flesh-tints by making the tone of his ground a shade or two higher. Save for the exquisite blue of his skies, there is often no pure colour at all upon his palette. He contented himself with a wise manipulation of tones within the same colour, and employed the colour of the moderns only where he could use it. . . . Roger Marx records a saying of his to the effect that the true function of painting is to animate walls. . . . He was the only artist in this age of artistic plethora, who was quite clear as to the true tasks of painting, and who knew how to master them. To this end, he invented a free, half classic, half modern legend, very far removed from the instruction which sometimes compelled the earlier painters to exchange their palettes for archæological text-books.
> Julius Meier-Graefe. *Modern Art.* 2 vols.
> London, 1908, II, 51.

Used as we are to later extremes, Puvis' simplifications seem very mild to us today, yet they are of greater importance than their limited formal influence upon the painters [Maurice Denis, Aman-Jean, and Gauguin] just mentioned. Almost alone among the painters of the middle of the nineteenth century Puvis foreshadowed a major development of the twentieth: the simplification and reduction of the means of the artist. It is true that other painters and groups such as the Nazarenes and the Pre-Raphaelites talked a great deal of a return to simpler and "purer" methods. But they compensated for a reduction in spatial extension, chiaroscuro, and modelling by an elaboration of linear pattern, an emphasis on the fine quality of the line itself, a detailed rendering of the material setting, and a story-telling multiplication of the figures. In their own way they were part of and contributed to the minute, realistic vision characteristic of the middle of the cen-

415

tury. But Puvis subtracted without adding, indeed without intensifying the elements he did retain. His was really a restriction of the means employed, and however short the distance he travelled, his direction was the direction of later art. That this was often felt without being understood does not detract from its importance. . . .

In . . . [the easel] paintings allegory is not alone reduced to its simplest form, it is depicted as a rendering of mood, and is given something of a vague, indefinite, and suggestive character which allows the spectator the luxury of personal reverie and association. The two most famous instances of this are *The Prodigal Son* (1879) and *The Poor Fisherman* (1881), which might be termed combinations of allegorical and expressionist painting. . . .

For a realization of the problem with which Puvis was dealing we need go no farther afield than a contrast of certain of his works with others. A large composition like the hemicycle of the Sorbonne [*An Allegory of Letters, Science, and the Arts;* 1887–89] necessitating many figures related within the design rather than to the spectator, each figure with a specific allegorical denotation, has little force of comprehensive meaning, while its mood of passive quiet differs little from other murals with other subjects. . . . The picture is charming but difficult to decipher; it has neither the assured public existence of an allegory invented within an accepted, still strong tradition, nor the private, reflective, and inward character of Puvis' smaller paintings. It was, however, precisely the combination of the two, the joining of allegory with mood, of conventional description with reflection and expression, that Puvis attempted. But the two could be united on the scale of mural decoration only by the attenuation and pallor characteristic of Puvis' art. . . . Thus in conclusion we may say that though in one sense there is truth in the suggestion that whereas certain of his contemporaries "renouvellent la tradition, Puvis la termine, et par là, il est à la limite même où la tradition devient convention,"* there were other aspects of his art which were part of, and above all gave inspiration to the beginnings of a new tradition†. To those qualities, and to the legend created around them, Puvis owed the reputation with which he so happily ended his career.

Robert Goldwater. "Puvis de Chavannes: Some Reasons for a Reputation." *Art Bulletin,* March 1946, p. 33 ff.

* renew the tradition, Puvis ends it, and is thereby at the very border line where tradition becomes convention.

† L. Werth. *Puvis de Chavannes.* (Paris, 1925), p. 57.

ADOLPHE MONTICELLI

Monticelli, who was of Italian descent, was born at Marseilles in 1824. He was mainly influenced by the local artists Émile Loubon, Paul Guigou, and Gustave Ricard. In the mid-forties he moved to Paris, where he came under the influence of Diaz. During the siege of Paris in 1870 he returned to Marseilles on foot. An eccentric given to dissipation, he lived and painted in great poverty in the South until his death in 1886.

He gave the rein to his extraordinary faculty of improvisation, producing a picture a day, and selling his work for whatever it would bring. And year by year the paint grew thicker and less significant, the harmonic instinct more eccentric and uncertain, the intellectual quality more childish and obscure. It was said . . . that his rare and admirable temperament was wrecked in absinth. . . . For some time before the end they were but few who knew if he were alive; his "painted music," his clangours of bronze and gold and scarlet, his triumphs of unrepresentative effect, had profited him so little.

With Monticelli the be-all and end-all of painting was colour. A craftsman of singular accomplishment, to tint and tone he yet subordinated drawing, character, observation—three-fourths of art. . . .

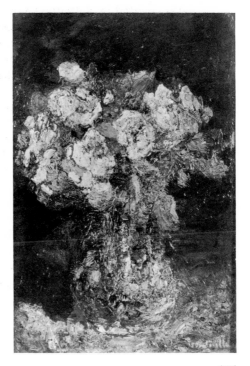

Bouquet of Roses. *Monticelli*

True it is that he has a magic—there is no other word for it—of his own: that there are moments when his work is infallibly decorative as a Persian crock or a Japanese brocade; that there are others when there is audible in these volleys of paint, these orchestral explosions of colour, a strain of human poetry, a note of mystery and romance, some hint of an appeal to the mind. As a rule, however, his art is purely sensuous. His fairy meadows and enchanted gardens are so to speak "that sweet word Mesopotamia" in two dimensions; their parallel in literature is the verse that one reads for the sound's sake only—in which there is rhythm, colour, music, everything but meaning. If this be painting, then is Monticelli's the greatest of the century. If it be not—if painting be something more than dabbling exquisitely with material—then, it has to be admitted, these fantasies material-ised, these glimpses of the romance of colour, are only the beginnings of pictures—the caprices of a man of genius gone wrong.

W. E. Henley in *Memorial Catalogue of the French and Dutch Loan Collection* (Edinburgh, International Exhibition, 1886).
Edinburgh, 1888, p. 61.

His first period was his most graceful; ivory-toned languorous dames, garbed in Second Empire style, languidly stroll in charming parks escorted by fluttering Cupids or stately cavaliers. The "decorative impulse" is here at its topmost. In his second period we get the Decameron series, the episodes from Faust, the Don Quixote—recall, if you can, that glorious tableau with its Spanish group and the long, grave don and merry, rotund squire entering on the scene, a fantastic sky behind them.

Painted music! The ruins, fountains, statues, and mellow herb-age abound in this middle period. The third is less known. Extrava-gance began to rule; scarlet fanfares are sounded; amethysts and em-eralds sparkle; yet there is more thematic variety. Voluptuous, per-fumed, and semi-tragic notes were uttered by this dainty poet of the carnival of life. The canvas glowed with more reverberating and in-fernal lights, but lyric ever. Technique, fabulous and feverish, ex-pended itself on flowers that were explosions of colours, on seductive marines, on landscapes of a rhythmic, haunting beauty—the Italian temperament had become unleashed. Fire, gold, and purple flickered and echoed in Monticelli's canvases. . . . He discarded the brush, and standing before his canvas he squeezed his tubes upon it, literally modelling his paint with his thumb until it almost assumed the relief of sculpture.

James Huneker. *Promenades of an Impressionist.*
New York, 1910, p. 47 ff.

He discarded romanticism in order to achieve his own transcendental realism in his portraits, still lifes, flower-pieces, and landscapes. But his realism is not as complex as that of the Impressionists, it is far more one-sided; more violent, less detached, less serene, because it is agitated even when it tries to be gay. It tends more towards Expressionism than Impressionism. And here it may be well to mention that the artist who most admired Monticelli was Van Gogh. . . . Van Gogh once wrote of a sunset: "It couldn't have been more Monticelli with the sun pouring its yellow rays over the bushes in an absolute golden rain." He set to work quickly "to prove that we are following Monticelli's example here." Van Gogh knew whereof he spoke. To the purity of Monticelli's color, which he assimilated, Van Gogh was able to contribute the moral conscience which was his greatness. Endowed with less perception than Van Gogh but possessing an ingenuous kindliness and love of nature, Monticelli was able to create for himself a purity of color which was not only a model but a thing of perfection.
Lionello Venturi. "A New Appraisal of Monticelli."
Burlington Magazine, February 1938, p. 75.

Exciting as it is now to rediscover Monticelli as a great painter of flowers, fruits, landscapes and portraits, distinguished by a terrifically intense and transcendent realism, we must never forget that most of his paintings are fantasies out of Watteau—that dreamer whose wistful reveries about palace gardens the young Monticelli loved at first sight. He was also in debt to the earlier Provençal romantic, Fragonard, and to the great Venetians he always claimed as his ancestors. . . .

The Abstract-Expressionists of the 1950's could claim the impetuous and ambiguous rhapsodies of Monticelli during the last period as prophetic of their own subconscious improvisations. They should also read what Henley added to his praise of Monticelli's magic. He called it "dabbling exquisitely with raw material." He warned that "glimpses into the romance of color can be only the beginning of pictures," that "undue development of a special faculty can be fatal to the general growth." Monticelli was an impassioned virtuoso who is said to have loved music madly and to have rushed away from concerts to paint by candlelight, scarcely seeing what his brush and palette knife were doing to the panel. . . . In the heavily pigmented panels of his last years, when madness and death were approaching, the uncontrolled automatism of his color was a kind of rage, as in Dylan Thomas' poem against the dying of the light. Then it was that he claimed that he painted for thirty years later. Seventy

years later the Abstract-Expressionists of today can acknowledge his claim that he was a pioneer.

Duncan Phillips. "A Niche for Monticelli."
Art News, December 1954, p. 65 ff.

EUGÈNE BOUDIN

Boudin, born in 1824 at Honfleur in Normandy, was a cabin boy on his father's ship until the age of eleven, when the family moved to Le Havre. In Le Havre he became a painter's apprentice and a clerk in a shop for artists' materials. At the age of twenty he opened his own shop, which was frequented by Millet and Isabey. In 1846 Boudin went to Paris to study painting with Isabey. After three years he returned to Le Havre, where he made friends with Jongkind and Courbet and became Monet's first teacher. At his debut in the Salon of 1859 his work was noticed by Baudelaire. During the 1860's his work began to sell, but at low prices. In 1874 he exhibited with the Impressionists at their first group show, and Paul Durand-Ruel became his dealer. His success was soon assured. Boudin, who never lost his love for the sea, specialized in seascapes and beach scenes. He died in Paris in 1898.

Boudin is a painter who has a feeling for the moist expanse of water and the vibrant patches of color made by a woman's dress against a gray sky. . . . *The Departure for the "Pardon"* deviates somewhat from the painter's usual manner. . . . I prefer his *Jetty of Le Havre*. In this picture I find again the artist's exquisite originality, the silver-gray, wide-open skies and those small figures which he delineates with so much subtlety and wit. There is an exceptional accuracy of observation in these "notes," and in the poses of the figures grouped at the edge of this immensity. It is charming and has the ring of truth. Together with Manet, Jongkind, and Claude Monet Boudin is most certainly one of the leading marine painters of our time.

Émile Zola. "Mon Salon (1868)."
Salons. Geneva, 1959, p. 138.

He is an admirable seascape painter. He has known how to render, with unfailing mastery, the gray waters of the Channel, the stormy skies, the heavy clouds, the effects of sunlight feebly piercing the prevailing gray. His numerous pictures painted at the port of Le Havre are profoundly expressive. . . . Boudin is a learned colorist of gray tones. His impressionism consists in the exclusion of useless details, his comprehension of reflections, his feeling for values, the boldness of his composition and his faculty of directly perceiving

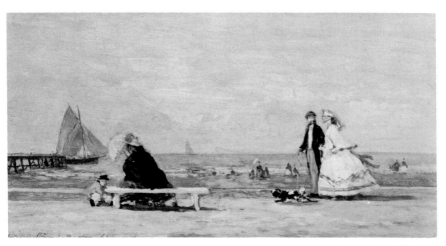

Beach at Trouville. *Boudin*

nature and the transparency of atmosphere; he reminds sometimes of Constable and of Corot. Boudin's production has been enormous, and nothing that he has done is indifferent. . . . He may be considered an isolated artist, on the borderline between classicism and impressionism; and this is unquestionably the cause for the comparative obscurity of his fame.

<div style="text-align: right">

Camille Mauclair. *The French Impressionists.*
London, 1911, p. 161 ff.

</div>

Boudin's series of Trouville and Deauville, painted between 1864 and 1869, in which he demonstrated the measure of his rapid, precise, and picturesque vision, were pleasant enough; we may consider these works, to use his own words, "if not great art, at least a fairly frank interpretation of our present-day world." But they still contained a narrative element of which he had to free himself in order to attain a broader and more permanent expression. . . .

Many of his large later canvases, however, make us too conscious of the painstaking, detailed work done in the studio. . . . They radiate coldness as they become more finished, and we return more eagerly to his sketches, to those studies in which we sense the quality of life. . . . But in the series of his best period the large canvases have all the virtues of sketches and all the qualities produced by a longer gestation. He states this in one of his notebooks: "Show extreme stubbornness to preserve the first impression, which is the best." In his [late] marines of Trouville (1880–85) where he is in full command of his craft and of a brightened palette, he abandons himself

completely to the charm of the subjects he has set out to paint. His sureness and lightness of touch are a marvel. He knows the art of characterizing, in a few brush strokes, the rigging of a ship, the finely graduated sparkle of a sail. Only Jongkind is his rival in the art of evoking the movement of ships or their inaction in port.

G. Jean-Aubry. *Eugène Boudin.* Paris, 1922, p. 153 ff.

CAMILLE PISSARRO

Pissarro was born in 1830 at St. Thomas in the West Indies. His father was a Frenchman of Portuguese-Jewish descent, his mother a Creole. He was educated in Paris, but had to return to St. Thomas to work in his father's shop. In 1852 he followed the Danish painter Melbye to Venezuela and finally persuaded his parents to allow him to become an artist. Pissarro reached Paris again in 1855. His first painting was accepted by the Salon of 1859, but in 1863 his work was hung in the Salon des Refusés, a special exhibition of works rejected that year, ordered by Napoleon III. During the Franco-Prussian War of 1870 Pissarro fled to London. His house in Louveciennes was occupied by the Germans, who destroyed most of his paintings. In London Pissarro was introduced by Daubigny to Paul Durand-Ruel, the art dealer who was to become the Impressionists' staunchest promoter.

After the war Pissarro settled at Pontoise; Cézanne joined him there in 1872. It was Pissarro who converted Cézanne to painting outdoors. In 1874 Pissarro was instrumental in organizing the first Impressionist group show which took place in the gallery of the photographer Nadar in Paris. Pissarro was the only Impressionist who participated in all eight shows. In 1880 he introduced Gauguin and in 1886 Seurat and Paul Signac to the group. About 1884 Pissarro adopted Seurat's pointillism and optical mixture; after Seurat's death in 1891 he broke with the Neo-Impressionists and resumed the Impressionist technique. Increasing eye trouble forced him to give up painting outdoors, but from his windows in Paris and Rouen he was still able to paint some of his most successful street scenes. He died almost blind at Eragny in 1903. Pissarro worked in oil, gouache, and pastel and was also a printmaker. His letters to his son Lucien are an important document of Impressionism.

M. Pissarro is an unknown artist, whom surely no one will mention. I make it my duty to shake his hand vigorously, before leaving [the Salon]. Thank you, Sir; your landscape [*Banks of the Marne in Winter,* now in the Art Institute of Chicago] has refreshed me for half an hour during my journey through the great desert of the Salon. I know that you have been admitted with great difficulty, and I pay you my sincere compliments. Anyway, you must have known that nobody likes your work and that the public finds your picture too barren

and too dark. But why the deuce do you have the signal clumsiness to paint solidly and to study nature freely?

Look here: You chose a winter scene. There is a plain, short, tree-lined road, a hilltop in the background, and bare fields up to the horizon. No treat whatsoever for the eyes, only austere and serious painting, utmost concern for truth and precision, and a harsh, strong will. You are a great fool, Sir—you are an artist to my liking.

<div align="right">

Émile Zola. "Mon Salon (1866)."
Mes haines. Paris, 1880, p. 320.

</div>

Camille Pissarro has been exhibiting for nine years now: nine years during which he has shown to critic and public alike the forceful and convincing works that neither has deigned to notice. . . . It is simply that he has none of the facile skills of his colleagues. . . .

In the midst of their overly decorous canvases the paintings of Camille Pissarro appear desolately barren. . . . The artist's sole concern is truth and his own conscience. He takes up his station before a segment of nature and sets himself the task of interpreting the horizons in all their austere breadth, not attempting to put in the least embellishment of his own invention. He is neither poet nor philosopher, but simply naturalist—a creator of skies and lands. Dream, if you will; this is what he has seen.

His originality is profoundly human, . . . rooted in the very temperament of the painter. Never have paintings seemed to me of a more masterful scope. You hear in them the deep voices of the earth and sense the powerful life of the trees. . . . Such a reality is more heightened than the dream. . . . One need only glance upon such works to understand that there is a man in them—a personality that is upright and vigorous and incapable of falsehood—who fashions art into a pure and eternal truth. . . .

Camille Pissarro is one of the three or four painters of our time. . . . And his valley and hillside are of a heroic simplicity.

<div align="right">

Émile Zola. "Mon Salon (1868)."
Salons. Geneva, 1959, p. 126 ff.

</div>

I keep on thinking that [the representation of] simple, rustic nature, including animals, suits your talent best. You do not have the decorative sense of Sisley, nor the incredible eye of Monet, but you have something that both of them lack: an intimate and profound feeling for nature and a forceful technique; as a result a fine painting of yours is something solidly set down on canvas.

<div align="right">

Théodore Duret. Letter to C. Pissarro (1873).
Quoted in L.-R. Pissarro and L. Venturi.
Camille Pissarro. 2 vols. Paris, 1939, I, 26.

</div>

This is a frightening spectacle of human vanity gone astray to the point of madness. Try to make M. Pissarro understand that trees are not violet, that the sky does not have the color of fresh butter, and that nowhere do we perceive things the way he paints them. Nowhere can the mind accept such aberrations.

Albert Wolff (1876). Quoted in P. A. Lemoisne. *Degas et son œuvre.* 4 vols. Paris, 1946–49, I, 238.

After groping around for a long while, occasionally producing a painting like last year's *Summer Landscape,* Pissarro has suddenly put his mistakes behind him and shaken off his bonds, and is exhibiting two landscapes that are the work of a great painter. The first, *Setting Sun in a Cabbage Field,* proves him to be a powerful colorist who has finally grasped and minimized the terrible dilemma of the open spaces and the great outdoors. It is the new formula, long sought after and now fully realized: the true countryside has at last emerged from that assortment of paint tubes, and the result is an abiding calm in a nature saturated with air—a serene plenitude filtering down with the sunlight, an enveloping peace emanating from this vibrant spot whose dazzling colors are muted under a vast firmament of innocent clouds.

The second, *The Cabbage Path in March,* is a hallelujah of reviving nature whose sap is bubbling, a pastoral exuberance that flings out violent colors and sounds loud fanfares of brilliant greens upheld by the blue-green tone of the cabbages, the whole shimmering in particles of sunlight and a quivering of air—hitherto unattempted in painting.

Close up *The Cabbage Path* is a patchwork quilt of curious, crude dabbings, a hodgepodge of all sorts of tones suffusing the canvas with lilac, Naples yellow, madder-red, and green; at a distance it is air in motion, the limitless sky, Nature panting, water volatilizing, sunlight diffusing, and the earth simmering and smoking.

In sum, we can now classify M. Pissarro among our most innovative and remarkable painters. If he can keep so very perceptive, quick, and discriminating an eye, we shall certainly have in him the most original landscape artist of our day.

In addition to his landscapes of the Seine and Oise, M. Pissarro is showing a whole series of peasant men and women; and here again we are shown a new aspect of the painter's self. As I stated earlier, I believe, at one time the human figures in his work seemed to have a biblical appearance; this is no longer the case. M. Pissarro has entirely divorced himself from the memory of Millet. He paints his rustics as he sees them—simply, and without phony grandeur.

His delightful little red-stockinged girls, his old, kerchiefed women, his shepherdesses and laundresses, his peasant women eating, or cutting grass, are truly little masterpieces.

> J.-K. Huysmans. "L'Exposition des Indépendants en 1881" and "Appendice (1882)." *L'Art moderne* (1883). Paris, 1908, pp. 258 ff, 290.

... Millions and millions of working days are being spent on the production of ... incomprehensible works in painting, in music, and in drama. ...

Here is an extract from the diary of an amateur of art,* written when visiting the Paris exhibitions in 1894:—

"I was to-day at three exhibitions: the Symbolists', the Impressionists', and the Neo-Impressionists'. ... The first exhibition, that of Camille Pissarro, was comparatively the most comprehensible, though the pictures were out of drawing, had no content, and the colourings were most improbable. The drawing was so indefinite that you were sometimes unable to make out which way an arm or a head was turned. The subject was generally, '*effets*'—*Effet de brouillard, Effet du soir, Soleil couchant.* There were some pictures with figures but without subjects.

"In the colouring, bright blue and bright green predominated. And each picture had its special colour with which the whole picture was, as it were, splashed. For instance in *A Girl guarding Geese* the special colour is *vert de gris*, and dots of it were splashed about everywhere: on the face, the hair, the hands, and the clothes. ... Pissarro has a water-colour all done in dots. In the foreground is a cow entirely painted with various-coloured dots. The general colour cannot be distinguished, however much one stands back from, or draws near to, the picture."

> Leo Tolstoy. *What Is Art?* (1898). London, 1930, p. 170 ff.

If we examine Pissarro's art as a whole, disregarding a certain unevenness, we find not only a strong, unflagging artistic will, but also an essentially intuitive art of true distinction. However far away the haystack may be on the hilltop, Pissarro will take the trouble to go there, walk around it and examine it.—He took from everyone, you say.—Why not? Everyone took from him, too, but denied him. He was one of my masters, and I do not deny it.

> Paul Gauguin. "Racontars d'un rapin (1902)." In Jean de Rotonchamp. *Paul Gauguin.* Paris, 1925, p. 237.

* Tolstoy's eldest daughter, Tatiana.

We can distinguish the successive phases of Pissarro's production and analyze the different influences he experienced—Corot, Cézanne, Seurat, or perhaps recently, [the painter Maximilien] Luce —but the one thing that always remains constant is his love for the moist color of our seasons. Whether he paints the harbors of Rouen at noon or the Avenue de l'Opéra in midsummer, and especially if the subject (our damp meadows, the snow, our fogs) provides him with a pretext, it seems that he purposely refuses to translate the brilliance of sunlight into yellow and orange as prescribed by the color theories he professes to follow. Thus sunlight appears as a chalky, milky whiteness among violet shadows, the meadows are verdant between blue-tinged copses. . . . It is out of love for our landscapes that he became an Impressionist. . . .

The free, flexible technique of Impressionism had allowed Monet, Sisley, Renoir, and Berthe Morisot to exalt the beauty of pure color, to create radiant harmonies in brightness, resembling nature at her most festive. As for Pissarro, his search was for the grays, and he obtained them through the most skillful color combinations. He divided in order to neutralize. . . . But when he painted the Norman marketplaces, the peasants bent by work of the soil, or the apple pickers, his gouaches in particular show fresh, harmonious, occasionally acid tones in which the greens, blues, and his favorite violets still predominate. Far from expressing the life and soul of the peasant, as did Millet—whose romanticism, incidentally, idealized them to an exaggerated degree—he rather observed them with the curiosity of a Gauguin avidly searching for the exotic. He liked the cotton fabrics, the kerchiefs, the aprons, the colors of cheap cloth; with these he brightened up the heavyset silhouettes of the farm girls. . . .

Neither a lyricist nor a vulgarian, he set out to construct solidly, by means of masses and values, those rural figures and places whose opaque yet delicately varied greens render the bounty of the Seine Valley.

<div style="text-align: right">

Maurice Denis. "Camille Pissarro (1903)."
Théories, 1890–1910. Paris, 1920, p. 140 ff.

</div>

There was nothing sensational about his gentle painter-like art. It did not make good copy. Nor was he concerned that it should. To reminders that this one had had a medal, and that the other was making money, his invariable answer was: *"Il n'y a que la peinture qui compte."* [Only the painting counts.] This sentence would be his complete epitaph. . . .

It was after the war that he settled in Pontoise, for, perhaps, the most characteristic decade of his artistic life. To this period belongs

his association with Cézanne, an association fruitful to both painters, of immense mutual influence and inspiration. It is one of the entertaining ironies of fashion that Cézanne, ninety per cent of whose work consists of monstrous and tragic failures, should have been deified by speculation in Paris, Berlin and New York while Pissarro's brilliant and sane efficiency awaits full justice. . . .

Pissarro's importance has not yet been properly understood. . . . To study the work of Pissarro is to see that the best traditions were being quietly carried on by a man essentially painter and poet. For the dark-and-light chiaroscuro of the past was substituted a new prismatic chiaroscuro. An intensified observation of colour was called in, which enabled the painter to get the effect of light and shade without rendering the shadow so dark as to be undecorative.

What the Impressionists have taught cannot be ignored again. . . .

W. R. Sickert. Preface to a
Catalogue of Pictures by Camille Pissarro.
London, Stafford Gallery, 1911, no paging.

In its essence Pissarro's style remained personal from 1867 up until his death. He never deviated in any way from his belief in objective reality. What he saw was solid, well set forth, like good prose; but it so happened that Pissarro had the imagination to escape from this prose and attain pure poetry. After he had given what was best in him to Monet, Cézanne, and Seurat, he seemed to realize that they had transcended him, once they had come into their own. Always enthusiastic, always modest—perhaps too modest—he made it his duty to follow them. Yet he painted neither Monets nor Cézannes; having assimilated their poetry, he enriched his own language. It was then that he created his most complex, happiest, and most perfect works. He was not as fortunate with respect to Seurat, because too great a difference in temperament and age lay between them. He realized this too late. . . .

On the other hand we must not forget that Pissarro's first preoccupation in his work was to find the harmony in the painting as a whole. Fortunately, everything he expressed always went beyond his technical findings. In Le Havre, at the end of his life, he defined his method of work: "I see only patches. The first thing that I try to establish, when I begin a painting, is harmony. Between such and such a sky, terrain, and water, there is necessarily a relationship. It can only be a relationship of accords, and this is the greatest difficulty in painting. The material side of painting (the lines) interests me less and less. . . . The big problem to solve is how to relate everything,

427

even the smallest details of the picture, to the harmony of the whole, that is to say, to the unity. . . ."

Pissarro was certainly not the only [Impressionist] who discovered poetry in lowly reality. . . . In the humble motif—cabbages or cottages—elegant design is avoided and form follows the dictates of his [social] ideal, creating the perfect homogeneity of the Impressionist manner. It was no doubt Pissarro who went furthest in this common tendency.

> Lionello Venturi in L.-R. Pissarro and L. Venturi. *Camille Pissarro*. 2 vols. Paris, 1939, I, 68 ff.

On his own admission Pissarro understood little of the ins and outs of politics, and at heart was more interested in the possible bearing that anarchist theory might have on the art of painting. He made plans for outlining the anarchist conception of the role that artists could play and the manner in which they could combine in an anarchist society—"indicating how artists could work with absolute freedom, once rid of the terrible constraints of Messrs. capitalist collector-speculators, and dealers, etc."*

In the ideal world of the future, the people will learn to love the countryside which with the abolition of property will be the inheritance of all, and hence they will appreciate art based on the study of nature; and the artists who support the revolution will achieve a new freedom by working in the service of the people. In this new world cheaper and humbler objects of art will be needed; and Pissarro begins experimenting in the early Nineties in gouache, watercolour, fan-painting, and engravings.† "There are hundreds of ideas in your other engravings," he writes, "which belong to you, anarchist and lover of nature, to the Lucien who reserves the great ideal for a better time when men, having achieved another mode of life, will understand the beautiful differently." (8.7.1891). Pissarro describes his own philosophy as absolutely social, anti-authoritarian, and anti-mystical, and envisages the new social art in terms of perception and hard work. He believes that nature makes the deepest impact on those closest to the soil, the peasants, and if the peasant is also endowed with creative gifts, he alone can see and interpret nature in a new way, unclouded by romantic or mystical yearnings.

> Benedict Nicolson. "The Anarchism of Camille Pissarro." *The Arts* (London), no. 2, 1946, p. 50 ff.

* Letter to his son Lucien, May 5, 1891.
† He had his own press at Eragny from 1890 onwards on which he printed etchings. As early as 1877 he used white frames for his oil paintings in place of the rich, gilded frame; and he was using banded frames long before Seurat. (—B.N.)

The Red Roofs

1877 oil on canvas 21″ x 25¼″ Paris, Louvre (Jeu de Paume)

The subject of houses seen through trees was used by Pissarro from 1868 onwards. The clean construction of the houses is broken up by bare branches forming a kind of diaphanous tracery. Through this poetic screen, we see the solid mass of grouped buildings, their roofs bright and gay beneath the winter sun. The dominating hillside of the Hermitage is close at their elbow. Its crest is outlined against a narrow band of blue sky. This winter effect is achieved by a magnificent clarity of design, which is the difference between a picture by Pissarro and one by Monet on the same subject.

Neither human being nor animal draws the eye away from the principal subject. Before 1870 Pissarro had been inclined to work in fluid colours and half-impasto in the manner of Corot. In the Pontoise period, he was more ready to use a mass of stipple worked over with a thicker brush. This technique he owed, doubtless, to the continued influence of Cézanne who left him at the beginning of 1874. In 1954, at an exhibition at the Musée de l'Orangerie devoted to the painters of Auvers-sur-Oise, I placed next to one another pictures done in this manner by Cézanne and Pissarro. They were so much alike that one could easily make a mistake as to which was which.

Germain Bazin. *French Impressionists in the Louvre.* New York, 1958, p. 176.

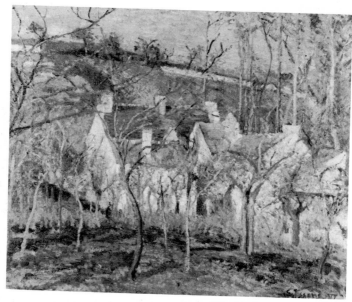

The Red Roofs. *Pissarro*

The Avenue de l'Opéra and Place du Théâtre Français

1898 oil on canvas 29″ x 36¼″ Reims, Musée des Beaux-Arts

Toward the close of Camille Pissarro's career the artist's style acquired new wealth, lyrical broadness, a more sensitive, explicit touch, and grandeur of outlook. All this was wisely expended on motifs not only fresh, but of uncommon and inimitable interest: The Paris of half a century ago. . . .

Although he did not begin his unforgettable impressions of Paris until 1897, that city never ceased to exert an influence on Camille Pissarro. . . .

From above the street and through the recess of his window [facing Boulevard Montmartre] Pissarro could look out upon the most complex motif Impressionism ever knew. . . . There was uninterrupted movement: jutting façades and fragmentary rhythms. . . . Contrasting with his usual admirable calmness, the sixteen "Boulevards," as he termed the work of this winter and spring of 1897, were acute sensory portraits of the effervescent life culled from the thoroughfare. . . .

A beautifully cut and lightly brushed version of the Rue Saint-Honoré [in the Musée des Beaux-Arts, Reims] leads into this felicitous year of 1898.

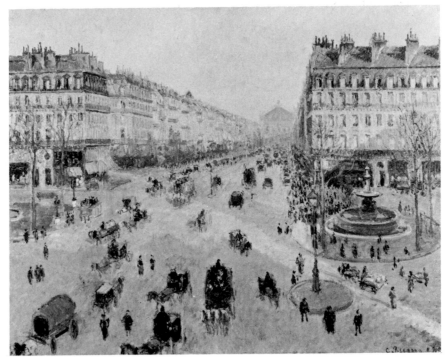

The Avenue de l'Opéra and Place du Théâtre Français. *Pissarro*

If Pissarro ever proved himself the peer of his early source of inspiration, Corot, he did so in a canvas of the *Avenue de l'Opéra*, the happiest of six paintings based on that particular subject [painted from a room at the Hôtel du Louvre]. He never reached beyond the definition of the lucid exuberance of this perfect thing. The blond harmony was as brilliant as correct (Venturi): nothing impaired the stunning beauty of its unities, the ripeness of indication, the sense of well-being. Such equilibrium stands as an end result of the stable philosophy behind his entire career....

Commenting on his latest efforts after they were placed on exhibition at Durand-Ruel's [in 1898], Pissarro brought out their eminent clarity by a comparison that may seem odd to us of today: "My 'Avenues' are so clear that they would not suffer beside the paintings of Puvis."[*]

Ralph T. Coe. "Camille Pissarro in Paris."
Gazette des Beaux-Arts, February 1954, p. 93 ff.

ÉDOUARD MANET

Manet was a native Parisian, born in 1832 of an upper middle-class family. His parents wanted him to become a lawyer, but he refused, and was finally allowed to enter the studio of Thomas Couture, where he remained from 1850 to 1856. In the fifties he met the young Dutch pianist Suzanne Leenhoff, who became his wife in 1863.

Manet made his debut at the Salon of 1861 and received an honorable mention. In 1863 his *Déjeuner sur l'herbe* (together with two other canvases) was rejected and hung in the *Salon des Refusés* (Salon of the Rejected Artists). It caused a storm of indignation which was eclipsed only by the scandal created by the *Olympia*, shown in the official Salon of 1865. The same year Manet visited Spain and studied the works of Velazquez and Goya, but most paintings of his Spanish period predate this trip.

When Manet's work was not admitted to the Paris Universal Exhibition of 1867, he followed Courbet's example and opened his own exhibition of fifty works near that of Courbet. After 1870 Manet adopted the brighter Impressionist palette and abandoned the use of black. Although he was friendly with Renoir, Monet, Sisley, Pissarro, and Degas, and met with them in the Cafés Guerbois and Nouvelle Athènes, he did not take part in the Impressionist exhibitions, but continued to send his pictures to the official Salon, where his entries were again rejected in 1876 and 1877. However, in 1881 Manet was at last awarded a medal. By that time he was crippled with locomotor ataxy, which allowed him to paint only small-scale works, chiefly flower pieces and still lifes, and some pastels. In 1883 a leg had to be amputated; gangrene set in, causing his death at the age of fifty-one.

[*] Letter to his son Lucien, May 29, 1898.

He spoke a harsh but elegant language which infuriated the public. I do not claim that his language was entirely new and that it contained no Spanish idioms. . . . But it is easy to realize that an artist was born to us. He spoke a language which he had made his own and which henceforth belonged to him alone. . . . When he sensed that he was getting nowhere by copying the old masters, by painting nature seen through temperaments other than his own, he realized one day that it was up to him to see nature as it is, without looking for it in the works and opinions of others. As soon as this idea occurred to him he took anything—a person or an object—put it against his studio wall, and began to represent it on canvas in accordance with his own visual capacity and comprehension. . . .

Édouard Manet ordinarily starts with a hue lighter than the actual color in nature. His paintings are bright, luminous, and pale throughout. A full white light falls softly on the objects. Nothing appears forced. Figures and landscapes are bathed in a sort of gay limpidity which permeates the entire canvas. . . . The artist . . . perceives his subject in broad areas of related tones. . . . His whole artistic personality is inherent in the way his eye functions: he sees in terms of brightness and mass. . . .

Our first impression of a canvas by Édouard Manet is that it is somewhat harsh. We are not accustomed to seeing such simple and direct translations of reality. Then, as I have said, they are surprisingly elegant in their stiffness. The eye at first perceives only broad areas of color; soon the objects become more defined and fall into place. . . . After a few seconds the total effect becomes apparent in all its strength. . . . Coming close to the canvas we note that the technique is delicate rather than rough. The artist uses only the brush and employs it very carefully. The colors are not piled on top of one another; there is only a single layer of paint. . . .

In short, if I were asked what is Édouard Manet's new language, I would answer: His language is one of simplicity and precision. The new quality he brings to art is the luminosity which fills his canvas with light. . . .

The artist does not seek absolute beauty; he paints neither history, nor the soul; so-called composition is nonexistent for him; he does not set himself the task of representing such and such a thought, or such and such an historical act. For this reason he should be judged neither as a moralist nor as a man of letters, but as a painter. He treats figure paintings as the academic painter treats still lifes. In other words, he arranges the figures before him seemingly at random and is then only concerned with setting them down on canvas just as he sees them, in the lively contrasts they form with each other. Demand

nothing more of him than a literally correct translation. He neither sings nor philosophizes. He paints, and that is all.

Émile Zola. "Édouard Manet* (1867)."
Mes haines. Paris, 1880, p. 336 ff.

After all, M. Manet has talent, and very much so. . . . Among the young painters I do not find many colorists equal to the painter of *The Fifer* and *The Tragic Actor.* He is a Velazquez of the boulevards or, say, a Parisian Spaniard, but if he lacks the striking originality that M. Émile Zola in all sincerity sees in him, he at least deserves the attention of the public, and of the critics who create the public.

Jules Claretie. "Courrier de Paris." *Indépendance Belge,*
June 15, 1867, no paging.

At the Salon my first concern was to go to the gallery "M."† There I found Manet. . . . I've never seen so expressive a face. . . . As usual his paintings made me think of wild, even unripe, fruit. They are far from unpleasant. In *The Balcony*‡ I'm odd, rather than ugly. It seems that the epithet of *femme fatale* is making the rounds among the visitors.

Berthe Morisot. Letter to her sister Edma, May 2, 1869.
Correspondance avec sa famille et ses amis. Paris, 1950, p. 26.

There is a man named Manet, whose pictures are for the most part mere scrawls, and who seems to be one of the lights of the French school. Courbet, the head of it, is not much better.

Dante Gabriel Rossetti. Letter to his mother, November 12,
1864: *Letters.* 4 vols. Oxford, 1965-67, II, 527.

He was greater than we thought.

Degas at Manet's funeral (1883).
Quoted in J.-É. Blanche. *Manet.* New York, 1925, p. 61.

When at some future date—still a long way off—professors of aesthetics will lecture on Manet, they will say that as far as color is concerned (for color was his principal objective) this so-called "naturalist" painter spent the first part of his life pursuing a cult of syste-

* The original title of this essay was "Une Nouvelle Manière en peinture." ("A New Way of Painting.")

† At that time the paintings exhibited in the Salon were hung in alphabetical order.

‡ Berthe Morisot posed for the seated figure with the fan. This picture, painted in 1868, is now in the Louvre.

matic exaggeration. . . . In *Le Déjeuner sur l'herbe* he employs a crude style filled with brusque and sharp contrasts; he does not believe in making colors harmonize with the pervading atmosphere.

The savagery of his manner frightened away many respectable people, even those who had been converted to the cult of clear tones. . . .

The Fifer [1866; Louvre] . . . representing a young musician somewhat incorrectly drawn, is painted in lively colors among which the red of his trousers stands out boldly, and is set against a monochromatic gray background. No ground, no air, no perspective. . . . The idea that . . . bodies are surrounded by air does not occur to Manet. He remains faithful . . . to the good old makers of playing cards. *The Fifer,* an amusing specimen of primitive illustration, is like a Jack of Diamonds stuck on a door. . . .

[In *Boating* (1874), now in the Metropolitan Museum, New York] he forgot all about Argenteuil and geography and turned the Seine into a delightfully blue Mediterranean Sea. The harmonious contrast between two colors [the orange flesh tints against the blue background] is interesting. . . . It proves conclusively that Manet is anything but a "realist." He attempts to relate tones rather than to express the actual resemblance of the things around him; when the "truth" bothers him, it is suppressed. . . .

What is the significance of Manet's art? . . . If the representation of human life . . . counts for anything in art, then Manet's work . . . has very little to tell us. . . . The actors whom he places on the stage . . . pose motionless; don't ask them to show feeling or to express opinions. They share the calm of a still-life group. . . . Their sole interest lies in the technical problems they raise. . . . With Manet, everything is subservient to the problem of color and light. That was his chief preoccupation and will remain the most interesting aspect of his work. . . .

However, he did serve a purpose. . . . He reduced the "cooks" of Bologna° to silence. In his happiest moments he had a real understanding of light. . . . We see in him only a beginning. Manet is like a false dawn, still surrounded by night.

Paul Mantz. "Les Œuvres de Manet." *Le Temps,*
January 16, 1884, no paging.

° Mantz apparently refers to the painters of the School of Bologna, the Carracci, Domenichino, Guercino, etc., whose dark color schemes were imitated by the academic painters of the nineteenth century and were ironically referred to as "brown sauce."

People talk about Manet's originality; that is just what I can't see. What he has got, and what you can't take away from him, is a magnificent execution. A piece of still life by Manet is the most wonderful thing in the world; vividness of color, breadth, simplicity, and directness of touch—marvellous!

George Moore. *Confessions of a Young Man* (1888). New York, 1907, p. 73.

Degas' eye was a photographic lens; it was his brain that later corrected the proof. Degas retouched his work very much as some writers rewrite the first draft, making corrections in the proofs, and imparting by deliberate reflexion, a noble and difficult style to commonplace phrases enunciated without thought.

With Manet, on the other hand, whether he covered a scrap of paper with a few dashes of his brush, with Indian ink, or with a few strokes of pen or pastel; whether he suggested by rubbing an effect of light on a fruit, a rose or a face, or whether he laboured for half a century, the sketch or the finished work proved to be a strange, personal creation.

Manet liked to be looked at as he bent over his easel, turned to his model, then to the reflection of him or her in his hand mirror held upside down. He would have painted quite readily in the Place de la Concorde, with a crowd around him, just as among his friends in his studio, although at times he was impatient and scraped or rubbed out his work. But he would quickly get over that, and smile at the girl posing for him or exchange chaff with a newspaper writer. Degas, on the contrary, double bolted his door, hid his work, unfinished or in course of execution, in presses, intending to take it up again later, in order to change the harmony or to accentuate the form. His work was always in a state of becoming. Worry gripped him, for he was at one and the same time proud and modest. When alone, with his work before him, he would curse and swear, trembling with passionate love for his art and contempt for the female creature.

Manet—but why carry the contrast farther, although I do consider it obligatory, just as one cannot talk of Delacroix without speaking of Ingres. The one helps us to understand the other.

J.-É. Blanche. *Manet.* New York, 1925, p. 59.

Manet was the first painter who made an immediate translation of his sensations into visual terms, thus liberating his instinct. He was also the first to act through his reflexes alone, and thus was able to simplify the artist's craft. In order to achieve this he had to ignore everything that was taught in the academies and be guided only by

435

what came from within himself. Here is an example of his simpli-
fication of technique: Instead of executing rather time-consuming
underpainting in order to obtain transparent tones, Manet applied
color in only one layer. By correct and precise relationships he was
able to produce the equivalent of this transparency. Manet was as
direct as possible. He abandoned the old subjects which would have
impeded the simplicity of his process, and painted only themes which
affected his senses directly. His basically romantic nature inclined
him towards Spanish subjects. Thus . . . he painted *The Dead Torea-
dor* [1864; National Gallery of Art, Washington, D.C.].

The *Olympia* belongs to a transitional period in the art of Manet.
Although this famous painting contains indications of the future in
certain respects, it remains very close to the traditional painting of
the old masters. It may well be for this reason that it is not one of
Manet's best paintings.

A great painter is one who finds personal and durable symbols
in order to express visually the world as he sees it. Manet has found
his own.

<div align="right">Henri Matisse. "Manet (1932)." Quoted in M. Florisoone.

Manet. Monaco, 1947, p. 122.</div>

Manet . . . deliberately took painting out of the dark Barbizon
studio, established it firmly in the open air, and dared to make oppo-
sitions of vivid, saturated colors. But—and this is where he differs
not only from a painter like Seurat, but also from a Pissarro or a Monet
—he neither analyzes nor breaks up his light, but paints in broad
planes that stand out in their contrast. To intensify the light he spreads
it in sheets within the contours of his forms, simplifying details to the
extreme. This is the technique of *The Fifer*, from which all shadows
are banished. . . .

This palette of Manet's . . . has the refinement of a coquette and
the cunning of a butterfly. There is something irresistibly attractive
about its exquisite cleanness. It is impossible to convey in words its
radiant intensity, its yellowed poppy-reds, its acid foliage beneath
which there suddenly appears the brilliance of a scarlet geranium. . . .

In his earth pigments, too, Manet is no less enchanting, with his
warm grays and mouse-colored or greenish shadows. . . .

Manet knew how to obtain from black, the famous black that was
to disappear temporarily from the palette of the Impressionists, an
infinite number of varieties. . . .

A master of the psychology of color, who was able to transfix
movement at the instant of its aerial mutation, Manet was not a
painter of impressions, but of composed instants. In his art, he had an

intuition of time according to its emotional importance, which made him greater than most of the Impressionists who followed him, for whom time only existed outside man in the luminous, spaced procession of hours on things. This fact, despite his evident unevenness and the small number of works in which his essential qualities are fully present, explains Manet's extraordinary importance for his century.

Pierre Courthion. *Édouard Manet.* New York, 1961, p. 9 ff.

Le Déjeuner sur l'herbe
[The Picnic]

1863 oil on canvas 84″ x 106″ Paris, Louvre (Jeu de Paume)

The artist who, after Whistler, arouses the most discussion is M. Manet. He, too, is a true painter. . . . His three paintings* seem rather like a deliberate provocation to the public, which is dazzled by the too brilliant color. . . . M. Manet loves Spain, and Goya seems to be his favorite master. . . .

The Bath is very risqué. A nude woman is quietly sitting on the grass in the company of two fully dressed men. Further back we see a bather in a small lake, and in the distance, hills. The scene takes place beneath large trees forming a bower. Unfortunately, the nude does not have a good figure, and one cannot imagine anything uglier than the man stretched out beside her, who has not even thought of removing, out of doors, his horrible padded cap. It is the contrast between a creature so inappropriate to a pastoral scene and this undraped bather that shocks us. I cannot guess what could have made an intelligent and distinguished artist choose such an absurd composition, which might have been justified had the figures been elegant and charming. But there are qualities of color and light in the landscape, and even truly convincing areas of modeling in the woman's body.

Théophile Thoré. "Salon de 1863." *Salons de W. Bürger, 1861 à 1868.* 2 vols. Paris, 1870, I, 424.

There has been a great deal of excitement about this young man. Let us be serious. *The Bath*, the *Majo*, and *L'Espada* are good sketches, I admit. There is a certain animation in the color, a certain freedom in the brushwork, and no vulgarity. But then, what? Is this drawing? Is this painting? M. Manet thinks he is firm and powerful, but he is only harsh. Strange thing, he is as soft as he is harsh. The reason: everything in his work is uncertain and is left

* *Le Déjeuner sur l'herbe* (originally called *The Bath*) was exhibited together with the *Young Man in the Costume of a Majo* and *Mlle. V. in the Costume of an Espada*, now both in the Metropolitan Museum of Art, New York.

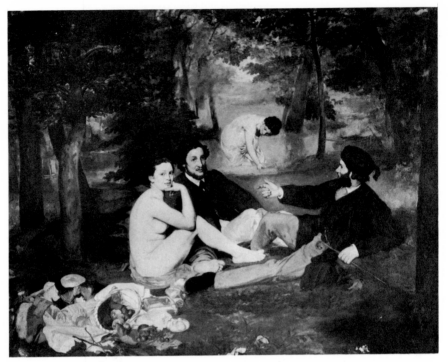

Le Déjeuner sur l'herbe. *Manet*

to chance. Not one detail is delineated in precise and strongly defined form. I see garments without sensing the human frame beneath. . . . I see fingers without bones and heads without skulls. I see moustaches represented by two black cloth strips plastered on the cheeks. What else do I see? The artist's lack of conviction and sincerity.

<div style="text-align:right">

Jules Antoine Castagnary. "Le Salon des Refusés (1863)."
Salons, 1857–1870. 2 vols. Paris, 1892, I, 173.

</div>

Le Déjeuner sur l'herbe is Édouard Manet's largest painting, in which he has realized the dream of every painter: to set life-size figures in a landscape. . . . There is some foliage, a few tree trunks, and in the background a river in which a woman in a chemise is bathing. In the foreground two young men are seated facing a second woman, who has just emerged from the water and is drying her nude body in the open air. This nude has scandalized the public, which has failed to notice anything else in the picture. Good Lord! How indecent! A woman without a stitch of clothing on, between two fully dressed men! Such a thing has never been seen before! Yet this belief is a gross error: in the Louvre there are more than fifty paintings in which both clothed and nude figures occur. But no one goes to the Louvre to be shocked. Furthermore,

the public has been very careful not to judge *Le Déjeuner sur l'herbe* as a real work of art. It has only noticed some people lunching outdoors after a swim; it has believed that the artist was deliberately obscene and provocative in the choice of his subject, whereas he had merely sought to obtain vivid contrasts and bold masses.

Painters, especially Édouard Manet, who is an analytical painter, do not share this preoccupation with subject matter which worries the public above everything. For the artist the subject is only a pretext, whereas for the public there is nothing but the subject. Thus, the nude woman in *Le Déjeuner sur l'herbe* is there assuredly only to provide the painter with an opportunity to paint a bit of flesh. What should be noticed in the painting is not just the picnic, but the landscape as a whole with its forcefulness and subtlety, the broadly painted, solid foreground, the light and delicate background, the firm flesh modeled in large patches of light, the supple, strong fabrics, and especially the delightful silhouette of the bather in the background, a charming patch of white among the green leaves; in fact you must look at the whole of this vast, air-filled composition, this fragment of nature rendered with just the right simplicity, this admirable canvas, onto which the artist has poured his special and unique talents.

Émile Zola. "Édouard Manet (1867)." *Mes haines*, p. 355 ff.

He ignored the traditional chiaroscuro, the universally respected convention of a fixed opposition of light and shade, and substituted for it an opposition of different tones. According to the teaching of the studios and the practice of painters, in order to fix the perspectives, to obtain modelling in the masses and to give their just value to certain parts of the picture, it was necessary to use certain combinations of light and shade. Above all it was held that a number of bright tones ought not to be put side by side without gradation, and that the transition from the bright passages to those less bright ought to be graduated in such a way that the shades should soften the abruptness of the contrast, and blend the whole together. . . .

This technique of a constant opposition of shade and make-believe light had led to the production of works which were really all shadow, from which all true light had disappeared. . . . The public had grown accustomed to this lifeless kind of painting. . . .

In the *Déjeuner sur l'herbe* it was suddenly confronted with a different method of painting. Properly speaking, there was no shadow in the picture. . . . The entire surface was, so to speak, painted brightly; colour penetrated everywhere. Those parts which other painters would have filled with shadow were painted in tones less bright but always coloured, and of the right value. Thus it came about that the *Déjeuner sur l'herbe* seemed simply like an enormous blotch of colour. The effect was as of an extravaganza. It shocked the eye. . . . The word *bariolage* had been used by Paul Mantz, one of the

439

most authoritative critics of the day, who had written about Manet's works in the *Gazette des Beaux Arts*. . . . In this article he condemned them as "pictures whose patchwork of red, blue, yellow and black, was not colour at all, but merely a caricature of colour." This judgment exactly expressed the feeling of the public when it gazed on Manet's painting in the Salon des Refusés. It saw in it nothing but a debauch of colour.

If the *Déjeuner sur l'herbe* gave offence by reason of its coloration and handling, it raised, if possible, a still greater storm of indignation because of its choice of subject, and the way in which the figures were treated.

> Théodore Duret. *Manet and the French Impressionists* (1902).
> Philadelphia, 1910, p. 24 ff.

Olympia

1863* oil on canvas 51″ x 74¾″ Paris, Louvre (Jeu de Paume)

Nothing so cynical has ever been seen as this *Olympia*, a sort of female gorilla. . . . Truly, young girls and women about to become mothers would do well, if they are wise, to run away from this spectacle.

> Amédée Canteloube (*Grand Journal*, May 21, 1865). Quoted in
> A. Tabarant. *Manet et ses œuvres*. Paris, 1947, pp. 107–8.

The grotesque aspect of this exhibit is caused first by an almost infantile ignorance of the fundamentals of drawing and secondly by an attitude of inconceivable vulgarity. . . . He [Manet] manages to provoke almost scandalous laughter which causes the visitors of the Salon to crowd around this *ludicrous* creature called *Olympia*. The baroque construction of this "lofty" young girl with her toad-shaped hand produces hilariousness and hysterical laughter among some. In this particular case the comedy results from the artist's loudly advertised intention of producing a noble work, a claim utterly foiled by the impotence of the execution.

> Ernest Chesneau (*Constitutionnel*, May 16, 1865).
> Quoted in *ibid.* p. 107.

We now come reluctantly to M. Manet's strange pictures. It is delicate to speak about them, yet we cannot pass them over in silence. . . . In the eyes of many it would suffice to move on and laugh. This is a mistake. M. Manet's work is not a trifling matter. He has followers, admirers, even fanatics, and his influence extends further than one would think. Manet has the honor of

* The *Olympia* was first exhibited in the Salon in 1865.

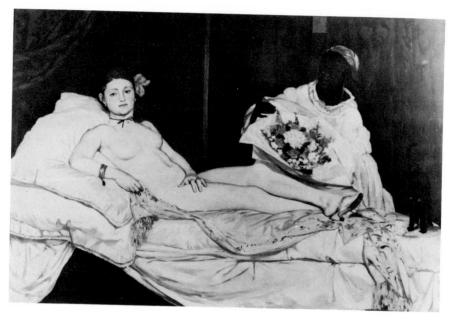

Olympia. *Manet*

being a dangerous man, but the danger is now past. *Olympia* cannot be explained from any point of view, not even by taking her for what she is, a puny model stretched out on a sheet. The flesh tones are dirty, the modeling is non-existent. Shadows are indicated by larger or smaller strokes of shoe polish. What can be said of the Negress bringing a bunch of flowers, or of the black cat, which leaves its muddy footprints on the bed? We could excuse ugliness, if it were true, carefully observed, or relieved by some splendid color effect. The ugliest woman still has bones, muscles, skin, and some sort of color. Here is nothing—we regret to say—but the desire to attract attention at all costs.

Théophile Gautier (*Moniteur universel,* June 24, 1865).

Quoted in *ibid.* p. 108.

In 1865 Manet . . . exhibited a *Christ Scourged* [1865; Art Institute of Chicago], and his masterpiece, *Olympia.* I said masterpiece, and I shall not retract the word; I maintain that this canvas is truly the painter's flesh and blood. It will endure as the characteristic expression of his talent, as the high mark of his power. The personality of Manet can be read in it, and when I analyzed the artist's temperament I had before me only this canvas, which sums up all the others. Here we have, as the humorists say, an Épinal print. Olympia, recumbent on the white sheets, is a large pale spot on the black background. Emerging from this dark background is seen the head of a Negress carrying a bouquet, and that famous cat which has amused the public

so much. At first sight you distinguish only two tones in the painting, two strongly contrasting tones. The details have dissappeared. Look at the head of the young girl. The lips are two thin pink lines, the eyes are reduced to a few black strokes. Now look closely at the bouquet, if you please. Some patches of pink, blue, and green. Everything is simplified, and if you wish to reconstruct reality you must move back a step or two. Then a curious thing happens. Each object falls into its proper plane. Olympia's head stands out from the background in amazing relief, the bouquet becomes marvelously fresh and brilliant. Accuracy of vision and straightforward handling have performed this miracle.

The painter worked as nature does, in simple masses and large areas of light, and his work has the slightly crude and austere appearance of nature itself. But there is also a personal quality; art exists only by virtue of fanatic enthusiasm and partiality. This tendency is found in just that elegant dryness, those violent transitions which I have pointed out. This is the personal accent, the particular flavor of his work. Nothing is more exquisitely refined than the pale tones of the different whites of the linen on which Olympia rests. In the juxtaposition of these whites an immense difficulty has been overcome. The color of the child's body itself is charmingly pale. She is a girl of sixteen, a model, no doubt, whom Édouard Manet has quietly copied just as she was. Yet everyone cried out that this nude was indecent.

. . . *Cher maître*, proclaim out loud that you are not what they think and that a picture for you is simply an excuse for an exercise in analysis. You needed a nude, and you chose Olympia, the first comer; you needed some clear and luminous patches of color, so you added a bouquet of flowers; you needed some dark patches, so you placed in a corner a Negress and a cat. What is the meaning of all this? You hardly know it, and neither do I. I only know that you have succeeded admirably in doing a painter's job, a great painter's job: you have forcefully rendered in your own particular idiom the truths of light and shade, and the realities of objects and persons.

<div align="right">Émile Zola. "Édouard Manet (1867)." Mes haines.
Paris, 1880, p. 357 ff.</div>

We must always have the *Olympia* before our eyes. It is a new stage of painting. Our Renaissance dates from it.

<div align="right">Paul Cézanne (undated). Quoted in Joachim Gasquet.
Cézanne. Paris, 1926, p. 75.</div>

In the name of a group of subscribers* I have the honor of offering to the

* In 1889 Claude Monet singlehandedly and on his own initiative began raising nearly 20,000 francs to purchase the *Olympia* from Manet's widow and offer it to the State. The subscribers included most of France's notable artists, writers, and

nation the *Olympia* by Édouard Manet. . . .

The discussions aroused by Manet's paintings, the hostilities to which they have been subjected, have now died down. But even if the war against him were still going on, we should be no less convinced of the importance of Manet's work and his ultimate triumph. It is sufficient to recall what has happened to artists such as Delacroix, Corot, Courbet, and Millet—to name but a few of those once derided and rejected but now famous—their isolation at the beginning of their careers and their undisputed posthumous glory. Most persons interested in French painting will admit that the role of Édouard Manet was useful and decisive. He not only played an important individual part, but he was, above all, the representative of a great and fruitful evolution.

It seems incredible to us that his work should not have its place in our national collections. . . . Furthermore, we view with alarm . . . the competition of the American market and the departure—so easy to foresee—of so many of our great and glorious works of art for another continent. We therefore wish to retain here one of Édouard Manet's most characteristic canvases, the one where he appears at the height of his victorious struggle, as the master of his vision and of his art.

It is the *Olympia* which we entrust to your hands. . . . It is our desire to see it placed in the Louvre in due course, among the works of the French school. If regulations do not permit its immediate entrance and if, in spite of the precedent of Courbet, the objection is made that less than ten years have elapsed since Manet's death, we consider the Luxembourg* indicated to receive the *Olympia* until the time for a transfer comes. . . .

<div align="right">

Claude Monet. Letter to the Minister of Education,
February 7, 1890. Quoted in Gustave Geffroy.
Claude Monet. 2 vols. Paris, 1924, I, 232.

</div>

In the afternoon Philip thought he would go to the Luxembourg to see the pictures, and walking through the garden he saw Fanny Price sitting in her accustomed seat. . . .

"Where are you going?"

"I wanted to have a look at the Manet, I've heard so much about it."

collectors. An exception was Zola, although in 1866 he stated prophetically that "Manet's place is marked in the Louvre."

* Until the opening of the Paris Musée d'Art Moderne in 1947 the works of contemporary or living French artists purchased by the government were housed in the Musée du Luxembourg. They could later be transferred to the Louvre or to provincial museums. *Olympia* was accepted for the Luxembourg in November, 1890. It entered the Louvre in 1907 only after Monet had urged his friend Georges Clemenceau, then the Prime Minister of France, to intervene. It is still part of the Louvre collection, but hangs in the Jeu de Paume.

"Would you like me to come with you? I know the Luxembourg rather well. I could show you one or two good things." . . .

They walked towards the gallery. Caillebotte's collection had lately been placed on view, and the student for the first time had the opportunity to examine at his ease the works of the Impressionists. Till then it had been possible to see them only at Durand-Ruel's shop in the Rue Lafitte . . . , or at his private house. . . . Miss Price led Philip straight up to Manet's *Olympia*. He looked at it in astonished silence.

"Do you like it?" asked Miss Price.

"I don't know," he answered helplessly.

"You can take it from me that it's the best thing in the gallery except perhaps Whistler's portrait of his mother." . . .

He [Philip] had altered a good deal himself, and regarding with scorn all his old opinions of art, life, and letters, had no patience with anyone who still held them. He was scarcely conscious of the fact that he wanted to show off beyond Hayward, but when he took him around the galleries he poured out to him all the revolutionary opinions which he himself had so recently adopted. He took him to Manet's *Olympia* and said dramatically:

"I would give all the old masters except Velasquez, Rembrandt, and Vermeer for that one picture."

"Who was Vermeer?" asked Hayward.

"Oh, my dear fellow, don't you know Vermeer? . . . He's the one old master who painted like a modern."

He dragged Hayward out of the Luxembourg and hurried him off to the Louvre. . . .

At last, in a small room, Philip stopped before *The Lacemaker* of Vermeer van Delft.

"There, that's the best picture in the Louvre. It's exactly like a Manet."

W. Somerset Maugham. *Of Human Bondage.*
New York, 1915, p. 178 ff.

In the *Olympia* the technical and conceptual experiments of the earlier years finally found a coherent and complete expression. The restricted color range of the *Bullfight* [1864; Frick Collection, New York], the full frontal lighting of the *Dead Christ* [1964; Metropolitan Museum of Art, New York], the contemporary subject devoid of any moralizing or romantic idealization which he had sought but never achieved in the Spanish themes and which had been compromised in the *Déjeuner sur l'herbe* by the ambiguous treatment of the theme, all this was now realized in terms of simplified color and design and with a new assurance in technique. Manet's technical innovation lay in the suppression of almost all the intermediate values between the highest light and the deepest shade. Only along the edges of the forms, along the contours, was there a pronounced and then very abrupt change in value. Today we read

these outlined shapes as three-dimensional form without difficulty; in 1865, to eyes so long accustomed to more complex and gradual transitions from light to dark, *Olympia* looked like an arrangement of flat patterns lacking the depth and three-dimensionality needed in such elaborate compositions. This aspect called forth the remark attributed to Courbet that *Olympia* resembled the Queen of Spades just out of the tub.*It is easy to understand how pale and two-dimensional she must have seemed to the creator of the *Bathers*.

G. H. Hamilton. *Manet and His Critics*. New Haven, 1954, p. 69.

The Laundress
Le Linge

1874 oil on canvas 57⅛" x 45¼" Merion, Pa., Barnes Foundation

After the rejection of the *Portrait of Desboutin* (1875; now in the São Paulo Museu de Arte) and *The Laundress* by the jury of the Salon of 1876, Manet invited the press to his studio for a private viewing of the two canvases. Visitors wrote sarcastic comments, such as "M. Manet is right, one should wash one's dirty linens at home," on sheets of notepaper left for their use. Albert Wolff wrote in the *Figaro* of April 17, 1876, ". . . For us who like M. Manet very much, the sight of *The Laundress* is a moment of sadness."

The natural light of day penetrating into and influencing all things, although itself invisible, reigns also on this typical picture called "The Linen," which we will study next, it being a complete and final repertory of all current ideas and the means of their execution.

Some fresh but even-coloured foliage—that of a town garden—holds imprisoned a flood of summer morning air. Here a young woman, dressed in blue, washes some linen, several pieces of which are already drying; a child coming out from the flowers looks at its mother—that is all the subject. This picture is life-size, though this scale is somewhat lower in the middle distance, the painter wisely recognizing the artificial requirements forced upon him by the arbitrarily fixed point of view imposed on the spectator. It is deluged with air. Everywhere the luminous and transparent atmosphere struggles with the figures, the dresses, and the foliage, and seems to take to itself some of their substance and solidity; whilst their contours, consumed by the hidden sun and wasted by space, tremble, melt, and evaporate into the surrounding at-

* "This is flat; it is not modeled. It looks like the queen of spades from a set of playing cards, rising from her bath." This remark was first reported by Albert Wolff in *Figaro*, May 1, 1883.

The Laundress. *Manet*

mosphere, which plunders reality from the figures, yet seems to do so in order to preserve their truthful aspect. Air reigns supreme and real, as if it held an enchanted life conferred by the witchery of art; a life neither personal nor sentient, but itself subjected to the phenomena thus called up by science and shown to our astonished eyes, with its perpetual metamorphosis and its invisible action rendered visible. And how? By this fusion or by this struggle ever continued between surface and space, between colour and air. Open air:—that is the beginning and end of the question we are now studying. Æsthetically it is answered by the simple fact that there in open air alone can the flesh tints of a model keep their true qualities, being nearly equally lighted on all sides. On the other hand if one paints in the real or artificial half-light in use in the schools, it is this feature or that feature on which the light strikes and forces into undue relief, affording an easy means for a painter to dispose a face to suit his own fancy and return to bygone styles.

The search after truth, peculiar to modern artists, which enables them to see nature and reproduce her, such as she appears to just and pure eyes, must lead them to adopt air almost exclusively as their medium, or at all events to habituate themselves to work in it freely and without restraint. . . . As no artist has on his palette a transparent and neutral colour answering to open air, the desired effect can only be obtained by lightness or heaviness of touch,

or by the regulation of tone. Now Manet and his school use simple colour, fresh, or lightly laid on, and their results appear to have been attained at the first stroke, that the ever-present light blends with and vivifies all things. As to the details of the picture, nothing should be absoluely fixed in order that we may feel that the bright gleam which lights the picture, or the diaphanous shadow which veils it, are only seen in passing, and just when the spectator beholds the represented subject, which, being composed of a harmony of reflected and ever-changing lights, cannot be supposed always to look the same, but palpitates with movement, light, and life.

Stéphane Mallarmé. "The Impressionists and Édouard Manet." *Art Monthly Review*, vol. I, no. 9, September 30, 1876, p. 119.

A Bar at the Folies-Bergère

1882 oil on canvas 37½ x 51″ London, Courtauld Institute of Art

Before us stands a tall girl in a blue, low-necked dress. Her waist is cut by a counter on which champagne bottles, liquor flasks, oranges, flowers, and glasses have been assembled. A large mirror extends behind her, showing in its reflection the back of the girl and a gentleman seen full-face, talking with

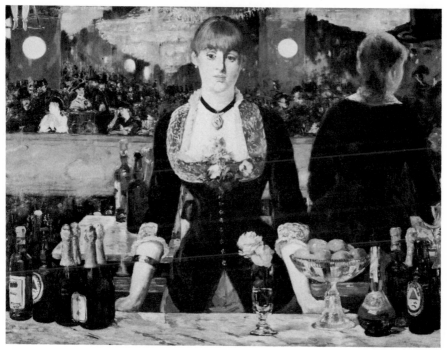

A Bar at the Folies-Bergère. *Manet*

her. Farther down, or, rather, beside the two people whose perspective is relatively correct, we see the entire dress circle of the *Folies* and, in a corner, up high, the green boots of the acrobat on the trapeze.

The subject is very modern and M. Manet's idea of thus putting the barmaid in her milieu is ingenious; but what is the meaning of this lighting? Is it gas or electric light? Why, no! It is a vague outdoor light, bathed in pale daylight! Therefore, everything falls apart—the *Folies-Bergère* exist and can exist only in the evening. Treated in this adulterated fashion they are absurd. It is really deplorable to see a man of M. Manet's gifts take to such subterfuge and paint, after all, as conventionally as all the others.

I regret it all the more because in spite of his chalky color the *Bar* is full of good qualities. The figure is well-placed, and the crowd is stirring with movement. All considered, the *Bar* is certainly the most modern and most interesting picture in the entire Salon.

J.-K. Huysmans. "Appendice (1882)." *L'Art moderne* (1883). Paris, 1908, p. 295.

. . . A brilliant piece of fireworks, with colors and harmonies scattered all over the canvas, in which the clever use of a mirror revealed hitherto unsuspected spatial values. It is the work of the greatest virtuoso of his time, who was also one of the greatest creators of all times.

Wilhelm Uhde. *The Impressionists.* Vienna, 1937, p. 17.

HILAIRE-GERMAIN-EDGAR DEGAS

Edgar Degas, a native Parisian, was born of a wealthy family in 1834. He studied painting at the École des Beaux-Arts under Louis Lamothe, a pupil of Ingres whom Degas knew and greatly admired. Degas' earliest paintings were academic, but in the course of the 1860's he began to develop an individual style in some keenly observed and delineated portraits, including the *Woman with Chrysanthemums* (1865; Metropolitan Museum of Art, New York).

During 1872–73 he visited relatives in New Orleans. His *Cotton Market of New Orleans* (1873; Pau Museum) is characteristic of this period. By 1870 Degas ceased to exhibit in the Salon. As one of the principal organizers of the *Société Anonyme des Artistes Peintres, Sculpteurs, Graveurs, etc.,* the "Impressionists," he participated in all but the seventh of their eight group shows. The eighth exhibition of 1886, in which he showed his *Series of Nude Women Bathing, Washing, Drying, Wiping Themselves, or Having Their Hair Combed,* was also his last, except for a one-man show at Durand-Ruel's in 1893 and a few entries in the Paris *Exposition Universelle* of 1900.

Horses were Degas' favorite subjects up to about 1873; then dancers on and off stage became his most frequent theme. He gradually came to prefer working in

pastel, experimenting with combinations of various painting and graphic media. He also took up sculpture; his statuettes of dancers and horses were modeled in wax, but are now generally cast in bronze. Degas also wrote a number of sonnets. Eye trouble and fear of blindness afflicted him all his life and run like a leitmotif through his letters and recorded sayings. During the last ten years of his life Degas, who never married, was nearly blind and became more and more of a recluse. He died in Paris in 1917.

Yesterday I spent the day in the studio of an odd painter named Degas. After many experiments, trials, and feelers put out in all directions he has become infatuated with modernity and has chosen to represent laundry girls and ballerinas. I cannot say that this is a bad choice, for in [my novel] *Manette Salomon* I sang the praises of both these occupations as offering the most suitable models for the modern artist. Pink flesh amid the white of linen or the milky froth of gauze is the most charming pretext for light and delicate color schemes. . . .

We see the greenroom of the *Opéra* with dancers coming down a little staircase, their legs fantastically silhouetted against the light from a window, a bright red patch of a tartan in the midst of all those billowing fluffy white clouds, with the vulgar figure of an absurd ballet master to serve as foil. And here before us, caught on the spot, we have the graceful, sinuous movements and gestures of these little monkey-girls.

The painter shows us his pictures, illustrating his explanations now and then with some dance movement, imitating an arabesque in the dancer's own style—and it's really funny to see him bending his arms—mixing the aesthetics of the dance with those of the painter. . . .

A strange fellow, this Degas—sickly, a bundle of nerves, with such weak eyes that he is afraid of going blind, yet for these very reasons extremely sensitive to the character of things. He is more skillful in capturing the essence of modern life than anyone I know. . . . But will he manage to bring anything to completion? I wonder. He strikes me as having a very restless mind.

<div style="text-align:right">

Edmond and Jules de Goncourt. *Journal.* 9 vols. Paris, 1935–36, V, 88. Entry for February 13, 1874.

</div>

Try to make M. Degas listen to reason. Tell him that there are in art such qualities as drawing, color, execution, and artistic intention. He will laugh in your face and treat you as a reactionary. . . . All these vulgar things are being shown to the public without regard to any

unfortunate consequences they may entail. Yesterday a young man coming out of the exhibition was arrested for biting passers-by.

Albert Wolff (1876). Quoted in P. A. Lemoisne.
Degas et son œuvre. 4 vols. Paris, 1946–49, I, 238.

How can I talk intelligently about this essentially Parisian artist [Degas] whose work reveals as much literary and philosophical talent as it displays artistry of line and knowledge of color?

He is able to state better and more quickly in one brush stroke all that can be said to characterize him, because his works are always brilliant, refined, and sincere. He is not trying to make us believe that he is naïve, which he is not. On the contrary, his prodigious knowledge shines everywhere. With his ingenuity, so attractive and so exceptional, he groups his figures in the most unexpected and amusing fashion, yet they are always true to life, even normal. Indeed, M. Degas detests more than anything else romantic exaltation, the substitution of dreams for life—in short, the grand gesture. He is an observer, he never exaggerates. Effect is always obtained by natural means, without flourish. This makes him the most reliable historian of the scenes he traces for us. If you have seen his pastels of the girls of the corps de ballet, you need no longer go to the *Opéra*. . . .

Georges Rivière. "L'Impressionniste no. 1 (April 6, 1877)."
Quoted in *ibid.* I, 240.

Particularly striking is the impressionistic quality of his drawing. Fleeting gestures, barely indicated or simulated movements, unconscious or quickly passing facial expressions, unusual distortions, a precarious balance, strange poses—these are the things he seeks and expresses. Thus it is natural that he would study again and again, and would draw again and again, ballerinas, ballets, the greenroom, and backstage scenes as well as stage effects. When it comes to animals he would choose horses and especially race horses, for similar reasons. . . .

It is his special trademark to depict the unusual movement never shown before. . . . He is the painter of nerves and muscles, but even more of nerves than of muscles. All his works are distinguished by his perfect artistic judgment and the wise awareness of his capacities. He is the least disputed of his group. Many of those who are up in arms against Monet, Pissarro, Sisley, Cassatt, Morisot, Caillebotte, Renoir, Cézanne, and Guillaumin, will acept and defend him.

Émile Verhaeren. "L'Impressionnisme (1885)."
Sensations. Paris, 1927, p. 180.

I cannot accept a man who shuts himself up all his life to draw a ballet girl as ranking coequal in dignity with Flaubert, Daudet, and Goncourt.

Émile Zola (1886). Quoted in George Moore.
Impressions and Opinions. New York, 1891, p. 299.

M. Degas, who in his superb pictures of ballerinas has implacably rendered the degradation of the mercenary female, her mind dulled by mechanical exercises and monotonous choreographic figures, has this time brought to his studies of nudes a deliberate cruelty and a patient hatred.

It seems as if, exasperated by the sordidness of his environment, he wants to retaliate and fling into the face of his century the grossest outrage, to demolish its most consistently enshrined idol—woman—and to debase her by representing her naked in her bath in the humiliating positions of her private toilet.

And in order to better rebuke her, he selects a woman who is fat, potbellied, and short, burying all grace of outline under tubular rolls of skin. . . .

But beyond this particular accent of contempt and hatred we must recognize in these works the unforgettable truthfulness of his types, recaptured with an intrinsically rich style of drawing, with lucid, controlled passion, with an icy fever. We must note the glowing yet muted color, the mysterious yet opulent tone; it is the supreme beauty of flesh turning bluish or pink under the water, lit by closed, muslin-draped windows in dark rooms where the dim daylight from a courtyard reveals cretonne-covered walls, washbasins and bathtubs, bottles, combs, brushes, and rose-colored copper kettles.

This is no longer the smooth and slippery skin of eternally nude goddesses, of flesh painting whose inexorable formula is best expressed by a picture in the Louvre where one of the Three Graces is seen with her buttocks of pink, oily muslin lit from the inside with a night light; this is real, living, unclothed flesh responding to the ablutions. . . .

Shocked by this frankness, yet gripped by the life emanating from these pastels, some of the people who visited this exhibition exclaimed: "This is obscene!"

But work was never less obscene, never as free from tricks or questionable overtones, never so entirely, so decidedly chaste. Indeed, these pastels glorify the contempt of the flesh as no other artist has dared to do since the Middle Ages.

J.-K. Huysmans. *Certains.* Paris, 1889, p. 23 ff.

To pass through the world unobserved by those who cannot understand him—that is, by the crowd—and to create all the while an art so astonishingly new and so personal that it will defy imitator, competitor, or rival, seems to be his ambition, if so gross a term can be used without falsifying the conception of his character. For Degas seems without desire of present or future notoriety. . . .

He often says his only desire is to have eyesight to work ten hours a day. . . . He is merely satisfied . . . to pursue the art he has so laboriously invented. To this end he has for many years consistently refused to exhibit in the Salon; now he declines altogether to show his pictures publicly.

In old times, after a long day spent in his studio, he would come to the Nouvelle Athènes late in the evening, about ten o'clock. There he was sure of meeting Manet, Pissarro, and Duranty, and with books and cigarettes the time passed in agreeable æstheticisms: Pissarro dreamy and vague; Manet loud, declamatory, and eager for medals and decorations; Degas sharp, deep, more profound, scornfully sarcastic. . . . Latterly Degas has abandoned café life. . . . He goes to the opera or the circus to draw and find new motives for pictures. Speaking to a landscape-painter at the Cirque Fernando, he said, *"À vous il faut la vie naturelle, à moi la vie factice."* [You need the natural life, I the artificial.] . . . Degas is not deficient in verbal wit. Mr. Whistler has in this line some reputation, but . . . when Degas is present Mr. Whistler's conversation is distinguished by "brilliant flashes of silence." . . .

If led to speak on the marvellous personality of his art, Degas will say, "It is strange, for I assure you no art was ever less spontaneous than mine. What I do is the result of reflection and study of the great masters; of inspiration, spontaneity, temperament—temperament is the word—I know nothing."

<div style="text-align:right">George Moore. Impressions and Opinions.
New York, 1891, p. 306 ff.</div>

In terms of academic concepts Degas knows neither how to draw nor how to paint. He represents on his canvas ballerinas, milliners, and jockeys; in other words the most trivial subjects rather than profound philosophical thoughts. . . .

Degas' drawing is stunning, always hitting the nail on the head and often approaching caricature—he is akin to Daumier. He avoids the so-called beautiful line, in other words, calligraphy.

His color is like his drawing: simple and proud, of aristocratic distinction. His palette is the simplest imaginable. Sometimes a picture is painted in the finest nuances from black to white, relieved only by the bow of a dancer's dress or her pink satin slipper. Whistler, too,

paints harmonies in black and white, but with him we feel the intention, the preconceived idea.... With Degas, it all comes naturally....

At first Degas' pictures give the impression of a snapshot. He composes a picture so that it no longer looks composed.... Take, for instance, *The Pedicure* [1873; Louvre]: the scene as well as the pose is as explicit as possible.... The arrangement of the two figures is as casual, as unstudied as if it had been haphazardly photographed.... But if we look closely we discover beneath the apparent snapshot the highest artistry of composition. Every detail ... is necessary for the characterization of the action and for the pictorial effect. The anecdotal element is fully expressed in terms of form and color. Without losing any part of its poignancy the trivial motif has been transformed into a work of art which recalls Velasquez. It is a feast for the eye. *La mise en toile*, as it is called in academic parlance, has the decorative effect of a print by Utamaro.

We can recognize a Degas from far away by the original angle from which he chooses his field of vision. He boldly shows us here only the head, there only the hind legs of a racehorse. Or suddenly he cuts across the stage with a double bass, and he does it with such assurance, just at the right point, that we feel it must be so and could not be otherwise. He sometimes places the horizon all the way on the upper edge of the painting to be able to show the feet of a ballet girl, disregarding the sacred rule of the golden section*. At other times he shows his models in the most impossible positions: climbing into the tub, dressing and undressing, or drying themselves. Untiringly he makes studies from nature, until he has found the characteristic pose....

Degas never can or will be popular. He shuns the approval of the masses; he works for the few connoisseurs, hateful of the trivial taste of the crowd, proud and lonely, jealous not of success, but of his art.

Max Liebermann. "Degas." *Pan*, vol. IV, no. 3, 1898, p. 193 ff.

One of the earliest known pictures by Degas is a cotton shop. Why describe it? Look at it, look at it carefully, and do not come to tell us "No one could paint cotton better." The cotton is not the point, nor even the cotton brokers. He himself knew this so well that he passed on—to other works....

Raised in elegant surroundings, he dared to admire the milliners' shops of the Rue de la Paix, the pretty laces, those famous touches of

* The golden section or golden mean defines as harmonic proportion a relationship of parts in which the size of the smaller part is to the larger part as the larger part is to the whole.

our Parisian women which make you buy an extravagant hat. And then he sees them again at the races. . . .

In the evening, to rest from the day's work, he goes to the *Opéra*. There, Degas told himself, everything is make-believe: the light, the scenery, the hairdos of the dancers, their waists, their smiles. Nothing is real but the effects they create, their bodies, their bones, and their movement: arabesques of all sorts. What strength, suppleness, and grace! . . .

Degas' ballerinas are not women. They are machines moving with graceful lines and incredible balance, arranged with all the pretty artificiality of a hat from the Rue de la Paix. . . .

There is no pattern in any of these things, only the vibrant line, line, and line again. His style is his own. Why does he sign his works? No one needs it less than he.

Recently he has done a good many nudes. The critics, as a rule, see only the woman. Degas sees the woman, too . . . but he is no more concerned with women than he used to be concerned with dancers. . . .

With what is he concerned? Drawing was at its lowest ebb; it had to be restored. Looking at these nudes, I exclaim, "Drawing has come back again!"

As a man and painter he sets an example. Degas is one of those rare masters who could have had anything he wanted, yet he scorned decorations, honors, fortune, without bitterness, without jealousy.

Paul Gauguin. *Avant et après* (1903). Paris, 1923, p. 116.

He [Degas] seized upon the horse, the crowd, the world of the racecourse, with its special colors and lines and its special elegance. He showed how the legs of the jockeys become part of their horses; he revealed the mechanism of the riders intent only on their motion; he depicted the improvised and unpremeditated jostling of the horse at the start . . . and all things that go on simultaneously in the elegant carriages of the spectators. . . .

All these things he drew to perfection. There is not a movement which an eye, trained as his was to observe such motion, failed to detect and to seize, and he was able to differentiate between the finest shades in nature. . . .

This penetrating insight into a special sphere exercises its effect even upon the layman who has nothing to do with the turf, because this thoroughbred elegance is irresistible. . . .

Degas did not paint his sporting pictures in the open. He made drawings of horses and figures, noted the colors, and invented the landscape to suit them. . . . He was never a landscape painter. Degas did not hide the weakness of his sporting pictures from himself. He con-

sidered his landscape responsible for his weakness, and . . . as time went on he gave increasing preference to subjects which he could see and paint within four walls. While his contemporaries swarmed to the banks of the Seine, Degas retreated to his studio and made his models pose for him before a solid wall.

> Julius Meier-Graefe. *Degas.*
> London, 1923, p. 33 ff.

For Degas a painting was the result of a limitless number of sketches—and of a whole *series of operations.* I am convinced that he felt a work could never be called *finished,* and that he could not conceive how an artist could look at one of his pictures after a time and not feel the need to retouch it. He would sometimes get possession of a canvas that had long been hanging in a friend's home, and take it back to his den, whence it would rarely re-emerge. It reached a point where those who knew what he was like would hide anything of his that they possessed. . . .

Degas always felt himself to be a solitary, and so he was, in all the senses of solitude; *solitary* in character, *solitary* in his natural and exceptional distinction, in his uprightness, his rigorous pride, his inflexible principles and judgments; *solitary* above all in his art, that is, in what he expected of himself.

> Paul Valéry. "Degas, Dance, Drawing (1935)."
> *Degas, Manet, Morisot.* New York, 1960, p. 50.

Among painters, that remarkable man [Degas] most nearly sums up the artist type which conditions in nineteenth-century France had tended to produce. He was the creative aristocrat as Baudelaire had conceived the part. He had an immense contempt for the mass of the people. A crusted Tory, he was the enemy of popular enthusiasms and the supporter of ruling cliques. In the famous Dreyfus case[*], his attitude was what would now be known as "fascist." As the son of a wealthy banker he had no need to sell his work or to take trouble to interest others in it and this was fortunate, for he professed a strong disbelief in work supposed to help or to be for the benefit of humanity. So far was he from thinking that his own art might come under this head that the idea of a public exhibition was distasteful to him. In a characteristic phrase he said *"Laissez-moi donc tranquille. Est-ce que c'est*

[*] The French army officer Alfred Dreyfus, a Jew, was wrongly accused and convicted of espionage in 1894, pardoned in 1899, and rehabilitated in 1906 after a fierce struggle between liberals and reactionaries, which split France into two unreconcilable camps and aroused world opinion.

fait pour être vu, la peinture? dites!" Don't bother me! Is painting meant to be looked at?

Painting, he asserted, was private life. . . .

As art was for Degas the one thing that existed, religion, morality and other serious concerns had no meaning for him and he was at some pains to dissociate art itself from any taint of idealism. ("Art is a vice. One doesn't marry it legitimately, one rapes it"—"Art is dishonest and cruel.") His strictly aesthetic devotion caused him to worship in the theatres and dance halls where the shifting lights and colours, the varied postures of the dancers inspired him not with profound thoughts but with the delight of vision. So, when he was asked what honour the state could bestow on him, he answered, "You wish to decorate me— that is, please me. Well then, give me a free pass for life to the *Opéra.*"

William Gaunt. *The Aesthetic Adventure.*
New York, 1945, p. 72.

Today it seems as if Degas has said the last word on ballet and it is difficult to conceive how any succeeding painter may get a fresh angle upon it. Not only this, he has also accomplished the rare feat of delighting equally the devotees of the pictorial as well as of the Terpsichorean arts. Professionals of both are wholly satisfied because he has thoroughly understood the one while expressing it in terms of the other. He has shown his respect for the classical ballet by his absolute faithfulness to its laws and conventions, and by so doing has refuted the theory of incompatibility between factual accuracy and artistic expression. His effects have been obtained without his feeling the need for distortion—or artistic license, as it may be called. . . .

Through the *Répétitions sur la Scène* Degas has shown himself a forerunner of a method of modern cinema direction. After the "shot" of the *pas de deux* rehearsal from the distance of the box, he approached to take a "close-up" of the dancers appearing in all their finery before the footlights in an almost identical position; then, and this time moving still nearer, he took another "close-up" as the dance progressed.* Both of these pictures were painted within a year or so of the famous *L'Étoile* [Louvre] and the *Danseuse sur la Pointe*. . . .

Then followed the series of *Danseuses sur la Scène*† which were

* *Le Pas de deux sur la scène* [Two Dancers on the Stage] (oil), in the Courtauld Institute, London, and the pastel on monotype of the same title in the Fogg Art Museum.
† The present owners of some of these paintings and pastels are unknown, but there are examples in the Louvre, the Art Institute of Chicago, and the Boston Museum of Fine Arts.

painted within the next ten years; the many variations on *L'Étoile* theme; the charming *Danseuse saluant* pictures; and the group of *Danseuses aux Cheveux Longs*. In them the dancer no longer shares honours with audience or orchestra, but is given the whole of the canvas for her own display. She is on the stage and this is her moment, the *raison d'être* for the countless hours of patient, laborious training. . . . And so the Muses meet, the dancer's transient moment being translated by the painter into terms of an eternity. . . .

Perhaps it is only a professional who can fully appreciate the depth of Degas' understanding of the fundamental characteristics which mark the classical ballet dancer. There is a particular air, a way of carriage, a certain kind of seriousness which stamps her all over and makes her recognisable even in out-door clothes, It is precisely this that he has realised, whereas other painters of ballet, like Carrière-Belleuse, Henri Meyer, Paul Destez and Renouard, apart from artistic considerations, have hopelessly failed.

Lillian Browse. *Degas Dancers*. London, 1949, p. 46.

. . . The majority of finished pictures painted by Degas before 1880 were executed in oil paint. At first Degas used a thin and rather dry oil paint which he applied very precisely; but around 1880 his technique changed. Then his handling of the medium became more free, he began to cultivate a rich *matière*, and he used brighter, more daring colours. This change corresponded with his discovery of the astonishing effects he could obtain with pastel, and with the growing importance it assumed for him after 1875. From 1880 on he used oil paint less and less—perhaps because, with failing eyesight, he found it a more tricky medium to control—and in the few pictures where it was used his method of handling it was greatly influenced by his new experiences with pastel. . . .

Between 1875 and 1880 Degas used pastel in a conventional manner, but gradually his technique became more complex. As with oil paint, he was not content to accept a limited application of the medium, so it was not long before he began experimenting with methods of varying the texture and *matière*. Thus he worked with pastel over monotype, and used it in combination with other media such as gouache, watercolour, or *peinture à l'essence*. At the same time he began to exploit a contrast in values between areas of dry, powdery pastel normally applied, and other areas of the picture in which the pastel had been turned into a paste by adding hot water or steaming it, after which it was worked with a brush. After 1880, Degas' use of pastel became still more individual and daring. Before that date he delighted in the subtle nuances of colour, the elegant gradations of light

and shade, which were easier to obtain with pastel than with oil paint, and on the whole his colours were pretty. After 1880, however, he used brighter and sharper colours and evolved a loose technique of working with pastel in a series of emphatic "hatchings." Previously Degas had worked with carefully blended colours, and had applied pastel smoothly and more or less uniformly. After 1880, he tended to produce a broken surface texture, to emphasize contrasts of light and shade, and to create atmosphere and a sense of depth by juxtaposing strokes of contrasting or related tones running in several directions. Simultaneously with this marked innovation in technique, pastel became the principal medium used by Degas, although he never gave up experimenting with it. Degas seems to have found that pastel allowed him more freedom for self-expression than oil paint. Certainly his use of it was more original, and latterly he evolved a completely new technique which enabled him to obtain effects which had hitherto only been obtained with oil paint. The technique in question was based on the practice of glazing with oil paint. Degas first of all made a pastel, or pastel and charcoal, drawing with heavy outlines and in rather strong colours. This he fixed in the normal way; but then, defying the practice of earlier generations, he continued working in pastel over this base, imposing one layer of colour upon another, each in turn being fixed, until at the end, when he had achieved his desired effect, his sheet was covered with quite a heavy impasto. However, whereas a glaze of oil paint can be applied evenly and thinly, Degas could not do this with pastel, which is a dry medium and not translucent. So, in order that the underlying colours could show through, he was obliged to apply the subsequent layers of colour irregularly, and this accounts also for the rugosity of the surface texture of many of his late works.

Douglas Cooper. *Pastels by Edgar Degas.*
New York, 1953, p. 12 ff.

Dancer on the Stage
Danseuse sur la scène. L'Étoile

ca. 1876 pastel 23" x 17" Paris, Louvre

He is never tender, yet there is veiled sympathy in the ballet-girl series. Behind the scenes, in the waiting rooms, at rehearsal, going home with the hawk-eyed mother, his girls are all painfully real. No "glamour of the footlights," generally the prosaic side of their life. He has, however, painted the glorification of the danseuse, of that lady grandiloquently described as *prima donna assoluta*. What magic he evokes as he pictures her floating down stage! The pastel . . . *L'Étoile* is the reincarnation of the precise moment when the

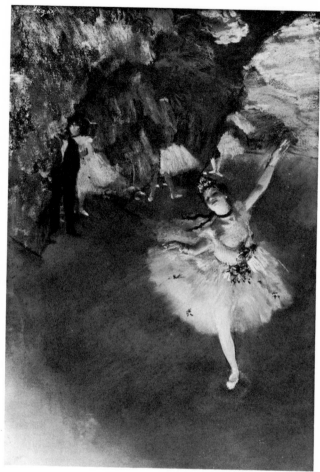

Dancer on the Stage. *Degas*

aerial creature on one foot lifts graceful arms and is transfigured in the glow of the lights, while about her beats—you are sure—the noisy, insistent music. It is in the pinning down of such climaxes of movement that Degas stirs our admiration. He draws movement. He can paint rhythms. His canvases are ever in modulation. His sense of tactile values is profound. His is true atmospheric colour.

. . . The rhythmic articulations, the volume, contours, and bounding supple line of Degas are the despair of artists. Like the Japanese, he indulges in abridgments, deformations, falsifications. . . . His vast production is dominated by his nervous, resilient vital line and by supremacy in the handling of values.

<div style="text-align:right">

J. G. Huneker. *Promenades of an Impressionist.*

New York, 1910, p. 76.

</div>

Absinthe

1876 oil on canvas 36¼ " x 26¾ " Paris, Louvre (Jeu de Paume)

This picture, which was probably first shown at the second Impressionist exhibition of 1876 under the title *Dans un café*, represents Degas' friend, the engraver Marcellin Desboutin, and the actress Ellen Andrée at the café *La Nouvelle Athènes*, the haunt of the Parisian avant-garde of the 1870's. The painting was acquired by the English collector Henry Hill and exhibited in Brighton in 1876 as *A Sketch at a French Café*. In 1892 it was sold to Arthur Kay of Glasgow who lent it to the Grafton Gallery in London for its Inaugural Exhibition of 1893. It was by this time entitled *L'Absinthe,* and it caused an outrage among the Victorian puritans against French "immorality."

The row which flared up when Degas' painting, *L'Absinthe*, was shown at the Grafton Gallery in 1893 set alight the columns of the English press for more than a month. . . . The controversy was not merely a storm in a wineglass, an isolated outburst that was quickly forgotten. The issues it raised had important repercussions on English painting and English art criticism.

That a painting by Degas should have sparked off the controversy is in one sense ironical. His work was welcomed, and indeed praised, by the English critics, one of whom, Frederick Wedmore, called him in 1883 "the master of the Impressionist School, the man of genius, the inspirer of the whole party." . . .

When D. S. MacColl devoted his weekly article in the *Spectator* to the exhibition [at the Grafton Gallery] his words were far from a cry in the wilderness. He found *L'Absinthe* "the inexhaustible picture, the one that draws you back, and back again. It sets a standard. . . . The subject, if you like, was repulsive as you would have seen it, *before Degas made it his*. If it appears so still, you may make up your mind that the confusion and affliction from which you suffer are incurable." . . .

Not until 9 March, a fortnight after his article, and three weeks after the opening of the exhibition, did the . . . journalist J. A. Spender respond in the *Westminster Gazette* . . . [and he] concludes: "If you have been taught to think that dignity of subject and the endeavour to portray a thing of beauty are of the essence of art, you will never be induced to consider *L'Absinthe* a work of art. . . ."

Letters quickly followed. . . . The first into the fray was Sir William Blake Richmond, the Grand late Victorian Knight [who wrote] . . . "Now *L'Absinthe* is a literary performance. It is not a painting at all. It is a novelette—a treatise against drink. Everything valuable about it could have been done, and has been done, by Zola. . . ." Walter Crane, an "Arts and Crafts" man and therefore concerned with the sobriety and morality of the ordinary citizen . . . thought the painting "a study of human degradation, male and female." Sickert, on the other hand, observed that "much too much has been made of 'drink'

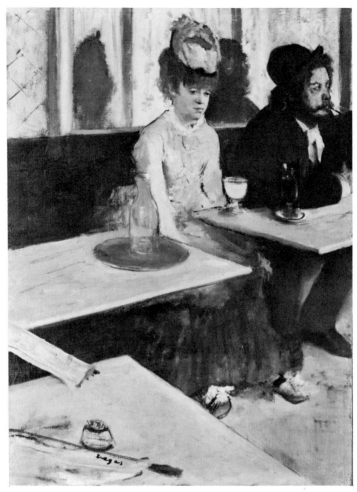

Absinthe. *Degas*

and 'lessons' " . . . and that the title ought simply to read *Un Homme et une femme assis dans un café* [a man and a woman sitting in a café]. . . .

The fundamental issue was the artist's freedom in his choice of subject. . . .

One immediate result of the controversy was that Moore published *Modern Painting* . . . and a manifesto of the "New Art Criticism": Manet, Whistler, Degas, Monet, Sickert and Steer were his heroes. . . . The coming generation of English art critics—Roger Fry, Frank Rutter, Charles Mariott— owed much to the efforts of MacColl, Moore and R. A. M. Stephenson.

Ronald Pickvance. *"L'Absinthe* in England."
Apollo, May 1963, p. 395 ff.

... The picture is merely a work of art, and has nothing to do with drink or sociology. . . . The subject-matter out of which the artist extracted his composition was a man and woman seated in a café furnished with marble tables. The first difficulty the artist had to overcome was the symmetry of the lines of the tables. Not only are they exceedingly ugly from all ordinary points of view, but they cut the figures in two. . . . But the ingenuity with which Degas selects his point of view is without parallel in the whole history of art. . . . One line of tables runs up the picture from left to right, another line of tables, indicated by three parts of one table, strikes right across the foreground. The triangle thus formed is filled by the woman's dress, which is darker than the floor and lighter than the leather bench on which both figures are seated. Looking still more closely into the composition, we find that it is made of several perspectives—the dark perspective of the bench, the light perspective of the partition behind, on which the light falls, and the rapid perspective of the marble table in the foreground. The man is high up on the right-hand corner, the woman is in the middle of the picture. . . . The empty space on the left, so characteristic of Degas' compositions, admirably balances the composition, and it is only relieved by the stone match-box, and the newspaper thrown across the opening between the tables. . . . A beautiful dissonant rhythm, always symphonic; . . . an exasperated vehemence and a continual desire of novelty penetrated and informed by a severely classical spirit—that is my reading of this composition. . . .

To complete my study of this picture we should have to examine that smooth, clean, supple painting of such delicate and yet such a compact tissue; we should have to study that simple expressive modelling; we should have to consider the resources of that palette, reduced almost to a monochrome and yet so full of colour.

George Moore. "The New Art Criticism."
Modern Painting. New York, 1893, p. 232 ff.

Portrait of Duranty

1879 gouache and pastel on canvas 39¾" x 39½"
Glasgow, Art Gallery & Museum

... An artist ought to paint his sitter at home, in the street, in an appropriate setting. . . . M. Duranty is there all right, amidst his books and engravings, seated at his desk. . . . I see his slender, nervous hands, his sharp, mocking eye, his alert, searching expression, the wry air, the short, dry laugh. . . . All this is brought before my eyes in this canvas, which so well expresses the character of that inquiring analyst. And then, what a radical departure from

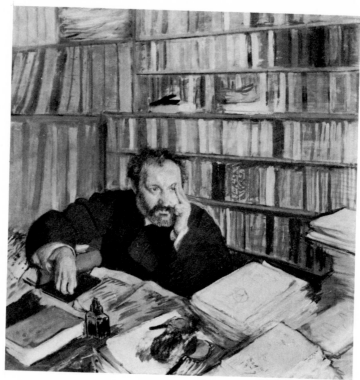

Portrait of Duranty. *Degas*

all accepted procedures of modeling. . . ! What a new application of the optical mixture used by Delacroix, that is to say, of the color which is not on the palette but is brought about by the combination of two other tones on the canvas. Here . . . are patches of bright pink on the forehead, of green in the beard, of blue on the velvet collar; some of the fingers are painted in yellow fringed with violet. Seen from close by, it is a crisscross of colors . . . ; stand back a few feet, and all blends harmoniously. . . .

No painter since Delacroix, whom he has studied at great length and who is his true master, has understood the accord and discord of colors as does M. Degas; no other painter today draws as amply and as precisely; no one else's color schemes blend so delicately.

> J.-K. Huysmans. "L'Exposition des Indépendants en 1880."
> *L'Art moderne* (1883). Paris, 1908, p. 132.

. . . By surrounding Duranty with books in the cases behind him and on the table before him, Degas built up an effective sense of space, as he had in

the portraits of Martelli, Pagans, and Cézanne. But, as always, the man himself triumphs over the setting. . . .

J. S. Boggs. *Portraits by Degas.*
Los Angeles, 1962, p. 57.

As a general principle Duranty believed that the portrait should always show the man or woman in the clothes, surroundings and activities peculiar to them in ordinary life. . . . To what extent Duranty's theory was modelled on Degas' practice and vice versa it is now impossible to say, but that they had come to share more or less identical views about portraiture is certain. . . .

With the exception of a bottle of ink and two magnifying glasses, the picture comprises nothing but Duranty and books, all that is not Duranty is books and all that is not books is Duranty. . . .

The portrait shows Duranty as a man immersed in but by no means stifled by his surroundings. Books provide his natural element and he breathes freely among them. With two fingers pressed to his temple and his right hand gently tapping a book by way of emphasis, he is probably expounding an idea which has just occurred to him, perhaps about the art of portrait painting and in particular perhaps the portrait then in progress which, unlike his own literary projects, he lived to see completed, but not exhibited.

William Wells. "Degas's Portrait of Duranty."
Scottish Art Review, vol. X, no. 1, 1965, p. 18 ff.

The Tub

1886 pastel on cardboard 23⅝″ x 32⅜″ Paris, Louvre

Probably from Japanese art was derived this daring perspective with its tilted point of view and the shelf of toilet articles which runs in a flattened vertical to contrast with the curves in the figure and the round tin bathtub. Over his bed Degas hung a scene of women in a bathhouse by the Japanese master of color prints, Kiyonaga, and it may well be from such a source that he conceived his first idea. But always the realist, Degas has made something extremely solid as well as lovely in surface from the figure of the woman. The rhythm of the body's contour is most delicately apprehended and the way the light falls is skillfully observed to model the full, rounded forms, which, incidentally, are echoed in the pitchers on the shelf. Supple, masterly, sketchy here, more finished there, is Degas' use of pastel. Never before or since has an artist found such a range in this medium. . . .

These women, whom he studied so assiduously in the intimate confines of their boudoirs, do not exist as individuals. He seldom personified them; their faces are often hidden by the poses he caught them in; usually there is only a line of cheek, an ear, a slight indication of profile. The artist concentrated

464

instead on the supple or tensed bodies and rendered, by his powerful drawing, the play of muscles beneath their light-struck flesh. There is something curiously chaste about his reaction; his nudes are never voluptuous and they lack the healthy animalism of Rubens or the radiant sensuality of Renoir. They are first and foremost studies of the human form and only secondarily women.

D. C. Rich. *Edgar-Hilaire-Germain Degas.*
New York, 1951, pp. 110–12.

Of all impossible things in this world to treat artistically, the ballet-girl seemed the most impossible, but Degas accomplished that feat.... The philosophy of this art is in Degas' own words. *"La danseuse n'est qu'un prétexte pour le dessin."* [The dancer is only a pretext for the drawing.] ...

But perhaps the most astonishing of all Degas' innovations are his studies of the nude. The nude has become well-nigh incapable of artistic treatment.... But ... with cynicism Degas has again rendered the nude an artistic possibility. Three coarse women, middle-aged and deformed by toil, are perhaps the most wonderful. One sponges herself in a tin bath; another passes a rough night-dress over her lumpy shoulders.... A woman who has stepped out of a bath examines her arm. Degas says, *"La bête humaine qui s'occupe d'elle-même; une chatte qui se lèche."* [The human animal occupied with itself; a cat licking herself.] ... "The nude has always been represented in poses which

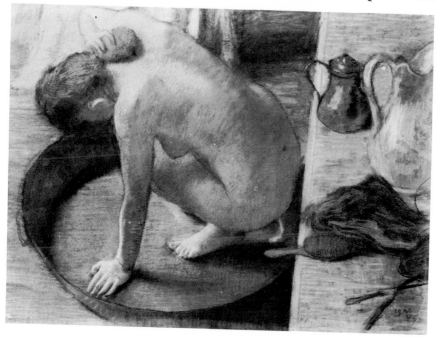

The Tub. *Degas*

presuppose an audience, but these women of mine are honest, simple folk, unconcerned by any other interests than those involved in their physical condition. Here is another; she is washing her feet. It is as if you looked through a key-hole."

George Moore. *Impressions and Opinions.*
New York, 1891, p. 314 ff.

HENRI FANTIN-LATOUR

Ignace-Henri-Jean-Théodore Fantin-Latour, the son of a minor portrait painter and a Russian mother, was born in 1836, a native of Grenoble. He received his early training from his father and studied at the École des Beaux-Arts. From 1861 on he exhibited regularly at the Salon, but in 1863 his *Parade de la Féerie* (*Display of Enchantment*, Montreal Museum of Fine Arts) was rejected and hung in the Salon des Refusés. The death of Delacroix inspired the first of Fantin's celebrated three group portraits (all in the Jeu de Paume), *Homage to Delacroix*, containing portraits of Fantin himself, Manet, Whistler, Delacroix, Bracquemond, Duranty, Legros, Champfleury, and Baudelaire. It was followed in 1869 by the *Studio of Batignolles*, portraying Renoir, Manet, Bazille, Monet, Zola, and Z. Astruc, and in 1871 by *Un Coin de table* [*A Corner of the Table*], showing Verlaine and Rimbaud.

The music of Richard Wagner's *Tannhäuser*, performed in Paris in 1862, turned Fantin into an impassioned Wagnerian who visited Bayreuth for the opening of the first music festival of 1876. He devoted paintings, etchings, and lithographs to allegorical subjects derived from Wagner and other composers. His long friendship with Whistler resulted in early contacts with English collectors, especially Mr. and Mrs. Edwin Edwards, who started the vogue for Fantin's flower-pieces in England. Fantin died in 1904 at Buré in Normandy.

As the result of painstaking and careful researches this artist has attempted to render music through painting. But he forgets that no color whatsoever can transform the altogether inward world of music, which is completely outside actual nature. Not having succeeded in these attempts, he in turn has poured out his heart in lithography and has created light, soft sketches based on the musical poems of Wagner. But when he draws his inspiration from the scores of Brahms, Schumann, and Berlioz there is always present that vague Germanic sentimentalism, which in itself is nothing new in our midst, but which should be expressed with less emphasis. . . . This artist, by whom we have seen exquisite flower still lifes, is unable to compose a painting. Even if one changes the position of a figure or of an object, his picture is none the worse for it. He organizes only the color schemes, the pinks, blues, greens, yellows, etc.

Odilon Redon. *À soi-même.* Paris, 1922,
p. 148. Entry for 1882.

Everyone who has ever entered the Luxembourg will remember the picture which represents Manet painting in his studio, with Zola and a group of friends standing around him. How good it is, how trustworthy, how searching in its study of all these types of the artist; but, at the same time, how chilling to the eyes. It is not a thing caught just thus, but a collection of people painted one by one, and set there very intelligibly before us. Fantin never saw the visible world as it was, even in these early portraits after nature, or in the early studies of still-life. He loves flowers, but individual flowers plucked and put in glasses, . . . definite objects, . . . which he makes into a beautiful thing, all by itself; carefully chosen faces, mostly those of one kind or another of artist, each very carefully individualised, as in that *Coin de Table*, which has preserved for us the face of the young Rimbaud. It is not a way of seeing reality, but a way of picking certain choice things, a flower, a fruit, a face, out of reality, and reproducing just that, just as it is. Finally, and as a natural consequence of this selection . . . he can find nothing any longer in reality that contents him, and he takes refuge in dreams, among wild lights and supernatural gleams, among phantoms of poets and musicians, Wagner, Berlioz, Byron, Schumann; himself most like Schumann, a cloudy dreamer, to whom Astarte comes on a cadence that is like moonlight. He has always sought rarity, and now he seeks ecstasy, which he would fain transpose from other arts into his own art; he would find short cuts to ecstasy, being a little tired of all there is to pore over and copy in the single flower, the single face. The lithographs snatch a filled cup too hastily and part of the music is spilled.

Arthur Symons. "Fantin-Latour and Whistler (1905)." *Studies on Modern Painters.* New York, 1925, p. 30.

In his representation of the rose Fantin was unequalled. He knew more intimately than anyone this flower, so difficult in its design, shape, and color, in its roundness and curls. . . . He preserved all the nobility of the rose which has been vulgarized by so many bad watercolorists in paintings on screens and fans. In Fantin's paintings the rose is bathed in light and air. With the point of his scraper he reaches down to the "absorbent" canvas itself, beneath the layers of paint, to produce those blank spaces which are the interstices by which the painting breathes. His method is just the opposite of Courbet's, whose palette knife molds the paint and sinks it forcefully into the canvas, thus creating that magnificent polished and glazed onyx or marble-like surface.

In his flower paintings Fantin's drawing is sometimes beautiful and ample; it is always sure and incisive. He bestows a physiognomy

467

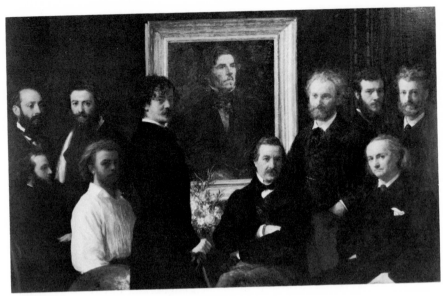

Homage to Delacroix. *Fantin-Latour*

on the flower he copies. It is an individuality, not one of a type. He dissects, analyzes, and reconstructs the flower and is not satisfied to convey just an impression by means of lively, cleverly juxtaposed patches....

How analytical and reasoned is this art, yet still so fresh, and so French! These canvases seem to be painted by a grandchild of Chardin. It is in the rose that the good French citizen Fantin-Latour has expressed himself most fully. There is no trace of austerity or German heaviness, but only the logic and fine clarity of the eighteenth-century language.

<div style="text-align: right">

J.-É. Blanche. *Propos de peintre.*
Paris, 1919, p. 46 ff.

</div>

His fame today—apart from that of the flower still-lifes so favored by private collectors (there is only one in the Louvre)—rests chiefly on the fact that he portrayed some of the most influential artistic figures of the second half of the nineteenth century, thus providing us with what is, at times, exceedingly rare pictorial documentation.... Whether through luck or instinct, he picked the future immortals....

How did Fantin, as timid personally as he was in his work, come to be associated with the most revolutionary artists of his time? Or, to put it more generally, what brought about this paradoxical conjunc-

ion of a conservative and the *avant-garde*? The answer is quite simple.

He frequented the Café de Bade and the Café Guerbois, where Manet presided over the discussions of *la jeune peinture*. No more was needed. Excitement hid the underlying differences. . . .

They were far from sharing the same ideas, nor even necessarily sympathetic to one another. The sulking stiffness of the figures is due not only to the fact that they did not pose together, but also to their having just patched up things after a particularly violent quarrel. Melodramas seethed under the seeming tranquillity of *Homage to Delacroix,* the *Studio at Batignolles* and *The Corner of the Table.* Between sittings, Duranty and Manet fought a duel, with Zola acting as witness. Albert Mérat refused to come when he heard that Rimbaud and Verlaine were going to be present. . . .

Still, Fantin painted them. . . . He projects upon them his own reticence and indifference, and thereby he unexpectedly restores them to their true solitude. Silent, inward-looking, unexpressive, imprisoned within their individual fates, they co-exist but do not communicate. Fantin confronts us with the inviolable secret of their privacy; Baudelaire, veiled in lassitude; Duranty, a downright enigma; Manet, his restless anxiety hidden behind a fragile smile. . . . Verlaine, wooden, simian, false, an Asiatic Socrates turned satyr; Rimbaud, . . . a living paradox. . . .

He domesticated his wild visitors. He tidied them up, made them sit straight, did his utmost to make them look like respectable Protestant clergymen. . . . Their identity mattered so little that he was able to replace Mérat by a hydrangea in *The Corner of the Table.* . . . This depersonalization also shows the superficiality of Fantin's ties with the *avant-garde.*

Analysis of his manner in the portraits merely confirms this conclusion. He has little in common with Manet and the Impressionists. Sober to the point of indigence, discreet to the point of dullness, honest to the point of clumsiness, his canvases scarcely partake of the *peinture claire* which his models—Whistler, Manet, Renoir, Monet—were then evolving. He was right when, speaking of the *Studio,* he noted, "its aspect is simple and severe, nowhere in it can be seen a trace of effrontery." . . . Fantin differed basically from his Impressionist friends on the point which constituted their most original contribution: the supremacy of the painter's vision over his perceptions, his emancipation from the subject's tyranny. In this light, Fantin appears as an arch-conservative. . . . He did not break with the advance-guard, for he never really had been a part of it: he simply drifted away.

<div align="right">

Pierre Schneider. "Fantin-Latour."
Art News Annual, XXIV, 1955, p. 58 ff.

</div>

PAUL CÉZANNE

Born in 1839 at Aix-en-Provence, Cézanne was the son of a wealthy banker. He received a classical education at the Collège Bourbon, where he formed a close friendship with Émile Zola. Urged by Zola, Cézanne went to Paris in 1861 to study painting. At the Académie Suisse he met Pissarro, who introduced him to Monet and Renoir. Cézanne's work was hung in the Salon des Refusés of 1863 and continued to be rejected by the official Salon. During the Franco-Prussian War of 1870 Cézanne hid at the Estaque near Marseilles, which was later to become the subject of some of his greatest landscape paintings.

In 1872 Pissarro invited Cézanne to Pontoise and converted him to outdoor painting. He participated in the Impressionist group shows of 1874 and 1877, but did not exhibit thereafter until 1890, when he entered three paintings in an exhibition of *Les Vingt* in Brussels. Ambroise Vollard gave him his first one-man show in 1895. About 1869 Cézanne had met Hortense Fiquet, by whom he had a son, Paul, but whom he married only in 1886, when his father's death made him financially independent. In that year Cézanne broke with Zola over the publication of Zola's novel *L'Œuvre,* whose hero, Claude Lantier, seemed to Cézanne a travesty of his own personality.

During the last years of his life Cézanne lived and painted in great isolation in and near Aix, but his importance was becoming more and more recognized in the art world, and young painters, among them Émile Bernard and Maurice Denis, made pilgrimages to see him. Caught in a storm while painting outdoors in October 1906, Cézanne collapsed and died a week later.

M. Monet and M. Cézanne, happy to show off, have exhibited thirty and fourteen paintings respectively. One must have seen them in order to imagine what they are like. They provoke laughter and are altogether lamentable. They display the utmost ignorance of drawing, composition, and color. When children play with paper and colors they do better.

Roger Ballu. "L'Exposition des peintres impressionnistes."
Chronique des Arts de la Curiosité, April 14, 1877.

A revealing colorist, who contributed more to the Impressionist movement than the late Manet, an artist with a sick retina, who in the exasperation of his vision discovered the preambles of a new art—this is how we may briefly characterize the almost forgotten painter, M. Cézanne.

He has not exhibited any more since 1877, when he showed, on the rue Le Peletier [at Durand-Ruel's], sixteen canvases, whose perfect artistic integrity amused the public for a long time.

J.-K. Huysmans. *Certains.* Paris, 1889, p. 41 ff.

At Vollard's there is a very complete exhibition of Cézanne's works. Still lifes of astonishing perfection, and some unfinished works, really extraordinary for their fierceness and character. I don't imagine they will be understood.

. . . I also thought of Cézanne's show in which there were exquisite things, still lifes of irreproachable perfection, others *much worked on* and yet unfinished, of even greater beauty, landscapes, nudes and heads that are unfinished but yet grandiose, and so *painted*, so supple. . . . Why? Sensation is there! . . .

Curiously enough, while I was admiring this strange, disconcerting aspect of Cézanne, familiar to me for many years, Renoir arrived. But my enthusiasm was nothing compared to Renoir's. Degas himself is seduced by the charm of this refined savage, Monet, all of us. . . . Are we mistaken? I don't think so.

> Camille Pissarro. Letters to his son Lucien, November 13
> and 21, 1895. *Letters* . . . New York, 1943, pp. 274, 276.

You can be assured that color in painting enters into a musical phase. Cézanne, to name an old [master], seems like a pupil of César Franck. He constantly plays on the great organ; in other words, he is polyphonic.

> Paul Gauguin. "Racontars d'un rapin (1902)." In Jean de
> Rotonchamp. *Paul Gauguin*. Paris, 1925, p. 239.

His landscapes are crude and hazy, weak in colour, and many admirers of Impressionism find them entirely uninteresting. His figure compositions have been called "clumsy and brutal." Probably his best work is to be found in his studies of still-life, yet even in this direction one cannot help noting that his draughtsmanship is defective. It is probable that the incorrect drawing of Cézanne is responsible for a reproach often directed against Impressionists as a body—a general charge of carelessness in one of the first essentials of artistic technique. Apart from this defect, Cézanne's paintings of still-life have a brilliancy of colour not to be found in his landscapes. . . .

Personally he unites a curiously shy nature with a temperament half-savage, half-cynical.

> Wynford Dewhurst. *Impressionist Painting*.
> London, 1904, p. 16.

By his nature Cézanne is attracted to ugliness. If he paints a house it is bound to be warped and threaten to collapse. If he portrays a human being the features are distorted, as if paralyzed on one side,

and the expression is deeply depressed or moronic. . . . Here is a female portrait: a withered, wrinkled face, dirty clothes looking as if dragged through the gutter. Is she a streetwalker who was pushed into the paddy wagon during a mass roundup and just dismissed after a night in the police station? Indeed not! She is an honorable lady of the best society! . . . It is inconceivable to me how anyone could voluntarily submit to being painted by him. . . . But he does not treat himself better than his other victims: his self-portraits would be grossly insulting, if another had painted them. . . . According to Heine "a woman's body is a poem." Heine would not dare to maintain this statement if he were to see Cézanne's *Three Nude Women before the Bath*. Such nudities are really immoral and cry out, not for a discreet figleaf, but for a ninefold shroud of cloth and fur.

> Max Nordau. *Von Kunst und Künstlern.*
> Leipzig, 1905, p. 107 ff.

Fourth [after Manet, Renoir, and Degas] comes Cézanne and here again is great mind, a perfect concentration, and great control. Cézanne's essential problem is mass and he has succeeded in rendering mass with a vital intensity that is unparalleled in the whole history of painting. No matter what his subject is—the figure, landscape, still life—there is always this remorseless intensity, this endless unending gripping of the form, the unceasing effort to force it to reveal its absolute self-existing quality of mass. There can scarcely be such a thing as a completed Cézanne. Every canvas is a battlefield and victory an unattainable ideal. Cézanne rarely does more than one thing at a time and when he turns to composition he brings to bear the same intensity, keying his composition up till it sings like a harp string. His color also, though as harsh as his forms, is almost as vibrant. In brief, his is the most robust, the most intense, and in a fine sense the most ideal of the four.

> Leo Stein. Letter to Mabel Weeks, ca. 1905. Quoted in
> *Journey into the Self.* New York, 1950, p. 16.

This is how Cézanne's palette was composed as I saw it at Aix:
Yellow: brilliant yellow, Naples yellow, chrome yellow, yellow ocher, raw Sienna.
Red: Vermilion, red ocher, burnt Sienna, madder lake, carmine lake, burnt lake.
Green: Veronese green, viridian, green earth.
Blue: cobalt blue, ultramarine, Prussian blue.
Peach black.
It is evident that the composition of colors is derived from the

color circle, and in the most elaborate way. Thus, from silver white, forming the uppermost part, down to the base, black, it passes through perfect gradations of hues from the blues to the greens and from the lakes to the yellows. Such a palette has the advantage of not forcing the mixture of colors and of producing well-defined relief: it permits the separation of light and dark, in other words, strong contrasts. This palette differs from that of the Impressionists, which stops with blue; it thereby renders black powerless and also prevents warm shadows. . . .

Cézanne's palette is the true painter's palette; that of Rubens or Delacroix could not have been much different. . . .

Émile Bernard. "Souvenir sur Paul Cézanne (1907)."
Sur Paul Cézanne. Paris, 1925, p. 59 ff.

(It is conceivable that someone might write a monograph about blue; from the thick waxy blue of the Pompeian frescos to Chardin and further to Cézanne: what a life story!) For Cézanne's very peculiar blue has this parentage, comes from the blue of the eighteenth century that Chardin divested of its pretentiousness and that now, with Cézanne, no longer carries with it any secondary significance. Chardin was, on the whole, the intermediary; even his fruits are no longer thinking of dinner, they lie about on the kitchen table and care nothing for being nicely eaten. With Cézanne, they cease entirely to be edible, they become such very real things, so simply indestructible in their obstinate existing. When one sees Chardin's portraits of himself, one thinks he must have been an old eccentric. How much so and in what a sad way Cézanne was, I shall tell you tomorrow perhaps. I know a few things about his last years when he was old and shabby and every day on the way to his studio had children after him throwing stones at him as at a bad dog. But within, deep within, he was most beautiful, and now and then would furiously shout something quite magnificent at one of his rare visitors.

Rainer Maria Rilke. Letter to Clara Rilke, October 8,
1907. *Letters, 1892–1910.* New York, 1945, p. 175.

Cézanne was fated, as his passion was immense, to be immensely neglected, immensely misunderstood, and now, I think, immensely overrated. Two causes, I suspect, have been at work in the reputation his work now enjoys. I mean two causes, after all acknowledgement has been made of a certain greatness in his talent. The moral weight of his single-hearted and unceasing effort, of his sublime love for his art, has made itself felt. In some mysterious way, indeed, this gigantic sincerity impresses and holds even those who have not the slightest

knowledge of what were his qualities, of what he was driving at, of what he achieved, or of where he failed. . . .

"*Ah, Mademoiselle, je n'arrive jamais à faire quelque chose de complet*" [I shall never completely finish anything], Cézanne said to someone I know. . . . Canvas after canvas was begun, worked on eternally, redrawn, worked on again, and abandoned anywhere, while the fury-driven painter pursued the perfection he had in his mind on new versions of the same problem. . . .

History must needs describe Cézanne as *un grand raté*, an incomplete giant. But nothing can prevent his masterpieces from taking rank. . . .

> W. R. Sickert. "The Post-Impressionists (1911)."
> *A Free House!* London, 1947, p. 102 ff.

People have tried to make Cézanne into a sort of genius *manqué*: they say that he knew admirable things but that he stuttered instead of singing out. The truth is that he was in bad company. Cézanne is one of the greatest of those who orient history, and it is inappropriate to compare him to Van Gogh or Gauguin. He recalls Rembrandt. Like the author of the *Pilgrims of Emmaus*, disregarding idle chatter, he plumbed reality with a stubborn eye and, if he did not himself reach those regions where profound realism merges insensibly into luminous spirituality, at least he dedicated himself to whoever really wants to attain a simple, yet prodigious method.

He teaches us how to dominate universal dynamism. He reveals to us the modifications that supposedly inanimate objects impose on one another. From him we learn that to change a body's coloration is to corrupt its structure. He prophesies that the study of primordial volumes will open up unheard-of horizons. His work, an homogeneous block, stirs under our glance; it contracts, withdraws, melts, or illuminates itself, and proves beyond all doubt that painting is not—or is no longer—the art of imitating an object by means of lines and colors, but the art of giving to our instinct a plastic consciousness.

He who understands Cézanne, is close to Cubism.

> Albert Gleizes and Jean Metzinger. "Cubism (1912)."
> In R. L. Herbert, ed. *Modern Artists on Art*.
> Englewood Cliffs, N.J., 1964, p. 4.

He was an industrious man and covered many canvases. Light interested him, but he cared most for color. His style was rough to the point of brutality. Sometimes the object is clearly and handsomely realized in his work. More often it is lost in an obscurity of coarse, unlovely pigment. He is one of those types who convey the impression

that they are feeling their way toward something large and beautiful, but never have fully mastered a sound technical method. Looking at Cézanne quietly and disinterestedly, one would recognize in him a rather crotchety man of talent, many of whose pictures should have been discarded as crude attempts. About none of them, good or bad, is there really any esoteric mystery. The mystery lies in the fuss that has been made over them, as over the tablets of a new evangel. Cézanne was simply an offshoot of the Impressionist School that we know, who never quite learned his trade, and accordingly, in his dealings with landscape, still life, and the figure, was not unaccustomed to paint nonsense. Nothing here to explain the Post-Impressionist furore.

Royal Cortissoz. "The Post-Impressionist Illusion." *Art and Common Sense.* New York, 1913, p. 130.

What the future will owe to Cézanne we cannot guess: what contemporary art owes to him it would be hard to compute. Without him the artists of genius and talent who to-day delight us with the significance and originality of their work might have remained port-bound for ever, ill-discerning their objective, wanting chart, rudder, and compass. Cézanne is the Christopher Columbus of a new continent of form. . . .

He travelled towards reality along the traditional road of European painting. It was in what he saw that he discovered a sublime architecture haunted by that Universal which informs every Particular. He pushed further and further towards a complete revelation of the significance of form, but he needed something concrete as a point of departure. . . . Few great artists have depended more on the model. . . . His own pictures were for Cézanne nothing but rungs in a ladder at the top of which would be complete expression. The whole of his later life he was climbing towards an ideal. For him every picture was a means, a step, a stick, a hold, a stepping-stone—something he was ready to discard as soon as it had served his purpose. He had no use for his own pictures. To him they were experiments. He tossed them into bushes, or left them in the open fields. . . .

Cézanne is a type of the perfect artist; he is the perfect antithesis of the professional picture-maker, or poem-maker, or music-maker. He created forms because only by so doing could he accomplish the end of his existence—the expression of a sense of the significance of form. . . . His life was a constant effort to create forms that would express what he felt in the moment of inspiration. The notion of uninspired art, of a formula for making pictures, would have appeared to him preposterous. The real business of his life was not to make pictures,

but to work out his own salvation. Fortunately for us he could only do this by painting.

<div align="right">

Clive Bell. "The Debt to Cézanne." *Art* (1914).

London, 1949, p. 199 ff.

</div>

Cézanne wanted something that was neither optical nor mechanical nor intellectual. . . .

He wanted to touch the world of substance once more with the intuitive touch, to be aware of it with the intuitive awareness, and to express it in intuitive terms. . . .

Where Cézanne did sometimes escape the cliché altogether and really give a complete intuitive interpretation of actual objects is in some of the still-life compositions. . . . Here Cézanne did what he wanted to do: . . . he gave us a triumphant and rich intuitive vision of a few apples and kitchen pots. For once his intuitive consciousness triumphed and broke into utterance. And here he is inimitable. . . .

But when it came to anything beyond the apple, to landscape, to people, and above all to nude women, the cliché had triumphed over him. The cliché had triumphed over him, and he was bitter, misanthropic. . . . But Cézanne did get as far as the apple. . . . After a fight tooth-and-nail for forty years, he did succeed in knowing an apple, fully; and, not quite so fully, a jug or two. That was all he achieved.

<div align="right">

D. H. Lawrence. *The Paintings of D. H. Lawrence.*

London, 1929, no paging.

</div>

During Gertrude Stein's last two years at the Medical School, Johns Hopkins, Baltimore, 1900–1903, her brother was living in Florence. There he heard of a painter named Cézanne and saw paintings by him owned by Charles Loeser. When he and his sister made their home in Paris the following year they went to Vollard's the only picture dealer who had Cézannes for sale, to look at them. . . .

They asked to see Cézannes. . . . As they found out afterward Cézanne was the great romance of Vollard's life. The name Cézanne was to him a magic word. He had first learned about Cézanne from Pissarro the painter. Pissarro indeed was the man from whom all the early Cézanne lovers heard about Cézanne. Cézanne at that time was living gloomy and embittered at Aix-en-Provence. . . .

There were Cézannes to be seen at Vollard's. Later on Gertrude Stein wrote a poem called Vollard and Cézanne and Henry McBride printed it in the New York Sun. This was the first fugitive piece of Gertrude Stein's to be so printed. . . .

They said what they wanted was one of those marvellously yellow sunny Aix landscapes of which Loeser had several examples. Once

more Vollard went off and this time he came back with a wonderful small green landscape. It was lovely, it covered all the canvas, it did not cost much and they bought it. Later on Vollard explained to every one that he had been visited by two crazy americans and they laughed and he had been much annoyed but gradually he found out that when they laughed most they usually bought something so of course he waited for them to laugh. . . .

Before the winter was over, . . . Gertrude Stein and her brother decided to . . . buy a big Cézanne. . . . They told Vollard that they wanted to buy a Cézanne portrait. In those days practically no big Cézanne portraits had been sold. Vollard owned almost all of them. He was enormously pleased with this decision. . . . There were about eight to choose from and the decision was difficult. . . . Finally they narrowed the choice down to two, a portrait of a man and a portrait of a woman, but this time they could not afford to buy twos and finally they chose the portrait of the woman.*

Vollard said of course ordinarily a portrait of a woman always is more expensive than a portrait of a man but, said he looking at the picture very carefully, I suppose with Cézanne it does not make any difference. They put it in a cab and they went home with it. It was this picture that Alfy Maurer used to explain was finished and that you could tell that it was finished because it had a frame.

It was an important purchase because in looking and looking at this picture Gertrude Stein wrote Three Lives.

> Gertrude Stein. *The Autobiography of Alice B. Toklas.*
> New York, 1933, p. 35 ff.

In Cézanne's work, great importance may be attached to the brushing, the handling of the pigment. In the early work, his fury and frustration, his aspiration and failure, are clearly felt in the character of the brush strokes. At first, the romantic or dramatic subjects were painted in black and white rather than in color. The paint is thick, the brush marks sweeping but clumsy. Little wonder that he found no audience for such undigested pomposity and bombast. Then, under the influence of Impressionist color, he began taming down, and produced palette-knife pictures like *La Maison du Pendu* [*The House of the Hanged Man,* 1873; Louvre]. . . . Color and light had now become important to him. Luminous color, he built up with layers of slightly variegated color. Later, under the direct influence of Pissarro, he be-

* It was *The Woman with a Fan,* one of the many portraits of Cézanne's wife Hortense Fiquet, now in the Emil G. Bührle Collection of the Kunsthaus, Zurich.

gan to use small brush marks and to break up his color, somewhat in the manner of typical Impressionists. . . .

The first characteristically Cézannean paintings were those executed in uniform, rectangularly shaped strokes that often fell in diagonally parallel directions throughout the picture. The brush strokes of this period reveal, automatically, that a system and point of view has been discovered. For the first time Cézanne has a formula under his control; he has discovered his "little sensation," the color gradations. . . .

Through the influence of his own work in the more fluid medium of water color the handling becomes more and more free. Finally, he attains a freedom of execution that is one of the marvels of modern painting. . . . The surfaces vary from light washes, thinned with turpentine, to paint that piles up to a dangerous thickness from endless repainting. That Cézanne could have repainted certain pictures more than a hundred times without ever losing the freshness of a quick sketch is one of the mysteries of art. Perhaps no other artist has ever succeeded in doing quite the same thing. There should be no hesitation about admiring these surface qualities in Cézanne. The extraordinary richness of his color depends specifically on his method of applying the color. The juxtaposition of variously colored little planes produced an effect of transparency, depth, and fullness, comparable to or even richer than the effects achieved by Renaissance painters, who depended on glazes and scumbling over forms built up with white.

Erle Loran. *Cézanne's Composition*. Berkeley, 1943, p. 30.

Cézanne's accomplishment has a unique importance for our thinking about art. His work is a living proof that a painter can achieve a profound expression by giving form to his perceptions of the world around him without recourse to a guiding religion or myth or any explicit social aims. If there is an ideology in his work, it is hidden within unconscious attitudes. . . . In Cézanne's painting, the purely human and personal, fragmentary and limited as they seem beside the grandeur of the old content, are a sufficient matter for the noblest qualities of art. We see through his work that the secular culture of the nineteenth century, without cathedrals and without the grace of the old anonymous craftsmanship, was no less capable of providing a ground for great art than the authoritative cultures of the past. And this was possible, in spite of the artist's solitude, because the conception of a personal art rested upon a more general ideal of individual liberty in the social body and drew from the latter its ultimate confidence that an art of personal expression has a universal sense.

Meyer Schapiro. *Cézanne* (1952). New York, 1965, p. 30.

The Bay of Marseilles Seen from the Estaque

ca. 1883–85 oil on canvas 29" x 39½" New York, Metropolitan Museum of Art

I must tell you that your letter surprised me at Estaque on the sea shore. . . . It is like a playing-card,—red roofs over the blue sea. . . . Up to the present I have done nothing.—But motifs could be found which require 3 or 4 months' work, for the vegetation does not change here. The olive and pine trees are the ones which always preserve their foliage. The sun is so terrific here that it seems to me as if the objects were silhouetted not only in black and white, but in blue, red, brown and violet. I may be mistaken, but this seems to me to be the opposite of modelling.

> Paul Cézanne. Letter to Camille Pissarro, July 2, 1876.
> *Letters.* London, 1941, p. 102.

Cézanne had for some time been enchanted by the motif of *The Bay of Marseilles Seen from L'Estaque,* and he painted it several times. . . . In reality, the mountains seen from L'Estaque are many miles farther away and hence can be seen but vaguely. To indicate their structure, Cézanne brought them forward. But he preserved the space relationship between nearness and distance, choosing to change the foreground and make it more distant than in reality. That is, he abstracted both foreground and background from their real positions, and he excluded from the space of the picture the place where he was

The Bay of Marseilles Seen from the Estaque. *Cézanne*

standing and hence every subjective reference. He treats the surface of the sea in similar fashion, seeing it from a considerable elevation (today we would say from the air), in order that it may appear to rise and give the impression of great volume. And it is the mass of the water which makes the distance of the background convincing, even though the mountains have a thickness of volume that in reality is theirs only when they are seen at close range. Cézanne thus organized an objective relationship between the village, the sea, and the mountain, objective not with respect to nature but with respect to the picture, to art. In nature "near" and "far" are the material terms of a finite world. Cézanne's work is thus coherent, self-sufficient, belonging to no particular world; it is a world in itself, which belongs to the infinite and to the universal and has the solemnity of things that live eternally.

Lionello Venturi. *Impressionists and Symbolists.*
New York, 1950, p. 132 ff.

This imaginary world is of incomparable splendor. The foreground is yellow, brick red, and green. The sea is of an intense blue with white highlights and brown shadows. Marseilles and Notre Dame de la Garde are white and light blue, the coast ranges from yellowish to dark blue with red reflections in the mountain of the background, and the sky is blue green shot through with brown. The entire color harmony is extremely intense, but at the same time restful, solidly founded in the composition itself. According to M. Larguier* Cézanne said, "There is neither light nor dark painting, there are only tone relations. When they are realized correctly, harmony is established automatically. The more numerous and varied they are, the more pleasing they are to the eye." . . . Cézanne no longer needs short straight brush strokes to construct his pictorial order; he already paints by means of touches and accents and is able to vary his effects infinitely. It is this variety which enlivens the stability of his form.

Lionello Venturi. *Cézanne, son art, son œuvre.*
2 vols. Paris, 1936, I, 54.

Card Players

1890–92 oil on canvas 38″ x 51″ Paris, Pellerin Collection

Here he [Cézanne] seems to have carried the elimination of all but the essentials to the furthest point attainable. The simplicity of disposition is such as might even have made Giotto hesitate to adopt it. For not only is everything seen in strict parallelism to the picture plane, not only are the figures seen in

* Léo Larguier. *Le Dimanche avec Cézanne.* (Paris, 1925.)

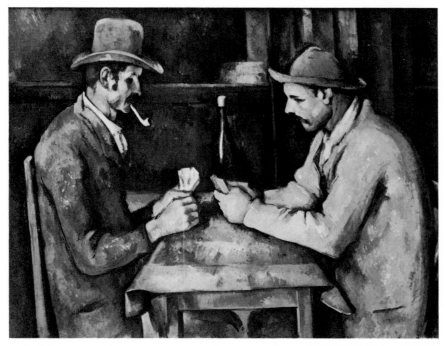

Card Players. *Cézanne*

almost as strict a profile as in an Egyptian relief, but they are symmetrically disposed about the central axis. And this again is, as it were wilfully, emphasized by the bottle on the table. It is true that having once accepted this Cézanne employs every ruse to render it less crushing. The axis is very slightly displaced and the balance redressed by the slight inclination of the chair back and the gestures of the two men are slightly, but sufficiently varied. But it is above all by the constant variation of the movements of planes within the main volumes, the changing relief of the contours, the complexity of the colour, in which Cézanne's bluish, purplish and greenish greys are played against oranges and coppery reds, and finally by the delightful freedom of the handwriting that he avoids all suggestion of rigidity and monotony. The feeling of life is no less intense than that of eternal stillness and repose. . . .

These figures have indeed the gravity, the reserve and the weighty solemnity of some monument of antiquity. This little café becomes for us, in Cézanne's transmutation, an epic scene in which gestures and events take on a Homeric ease and amplitude.

If, by reason of the helplessness of language, one is forced to search for poetical analogies even to adumbrate at all the emotional effect of this design it is none the less evident that this results from a purely plastic expression. There is here no appeal to any poetical associations of ideas or sentiments. It

481

is a triumph of that pictorial probity which it is the glory of modern art in France to have asserted—its refusal of the assistance which romantic interpretations offer. And the reward of this difficult attempt is seen here, for Cézanne's purely plastic expression reaches to depths of the imaginative life to which consciously poetical painting has scarcely ever attained.

Roger Fry. *Cézanne.* New York, 1927, p. 72.

Still Life with Apples

ca. 1890–1900 oil on canvas 27″ x 36½″ New York, Museum of Modern Art

Suppose . . . we put together . . . three still lifes, one by Manet, one by Gauguin, and one by Cézanne. We shall distinguish at once the objectivity of Manet: He imitates nature "as seen through his temperament,"* he translates an *artistic* sensation. Gauguin is more subjective. His is a decorative, even hieratic interpretation of nature. Before the Cézanne we think only of painting; neither the object represented nor the artist's personality claim our attention. We cannot decide so quickly whether it is an imitation or an interpretation of nature. We feel that this art is closer to Chardin than to Manet or Gauguin. And if at first sight we say: this is a picture, and a classical picture, the word begins to take on a very precise meaning, namely, that an equilibrium, a harmony, between the objective and the subjective has been achieved.

Maurice Denis. "Cézanne (1907)." *Burlington Magazine,* January 1910, p. 208 ff.

Nearly all Cézanne's still lifes are finished pictures; the proportion of still life studies to finished still lifes is infinitesimal. Such is not the case with landscape and figure paintings. This fact alone might have served as a warning to critics that Cézanne did not treat his still lifes as mere "guinea pigs." On the contrary, calm and collected in front of this subject, which he found more easily assimilable than others because he could organize it before painting it, Cézanne more often "realized" his picture, down to the last stroke of the brush. It has been very plausibly suggested by Paul Jamot that if Cézanne seldom painted flowers, this was because they wither so rapidly. . . . The more his "meditations brush in hand" slowed down his execution, the fewer flower pieces he painted, and the fewer of these he finished.

By embodying his complex researches in his still lifes, of which an unusually high proportion are masterpieces, Cézanne gave this theme an impor-

* It was Zola who had defined art as "a fragment of nature seen through a temperament."

tance which had never attached to it before in the whole history of painting. From Caravaggio and Zurbarán to Goya and Manet the great masters no longer ignored it; in Chardin it even found a specialist who . . . established himself as a master. . . . With Cézanne, however, still life ceased to be a side line in the career of a great artist; it vied with landscape painting and took precedence of portraiture.

Charles Sterling. *Still Life Painting from Antiquity to the Present Time.* New York, 1959, p. 103 ff.

We may sum up the subject of Cézanne's still-life painting by saying that the best of it is built upon an architectonic conception of volume-and-space units which is made particularly dynamic by the interaction of pattern, picturesquely distributed objects, and color of appealing sensuous quality, structural solidity and multifarious compositional activities. Each of these is organically adapted to the main purpose of the design: a space-and-volume composition in which all the units are constructed and distributed to bring about Cézanne's characteristic effect of power and force. In his most successful work, the pattern in the modeling, or rather the composition, of the units, is adapted to the composition of the whole picture: the pattern in the different areas or masses, similar as far as shapes are concerned but different in quality of color, yields a varied series of cognate forms that reënforce one another and constitute a rich unified totality.

A. C. Barnes and Violette De Mazia. *The Art of Cézanne.* New York, 1939, p. 73.

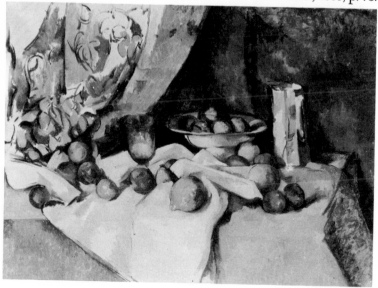

Still Life with Apples. *Cézanne*

Women Bathers
Les Grandes Baigneuses

1898–1905 oil on canvas 82″ x 98″ Philadelphia Museum of Art

As you know I have often made drawings of male and female bathers, which I had wanted to execute on a large scale and from nature, but the lack of models has compelled me to limit myself to rough sketches. Obstacles piled up before me: how to find an appropriate setting for my painting, a setting which would not differ too much from the one I had imagined; how to find men and women willing to undress and remain motionless in the poses I had decided upon. Lastly, there was the problem of carrying about a large canvas, and the thousand difficulties of good and bad weather, of a suitable spot in which to work, and of the supplies needed for the execution of such a large painting. So I was forced to postpone my project of doing Poussin over entirely from nature, instead of constructing piecemeal from notes, drawings, and fragmented studies; in other words, of painting a living Poussin out of

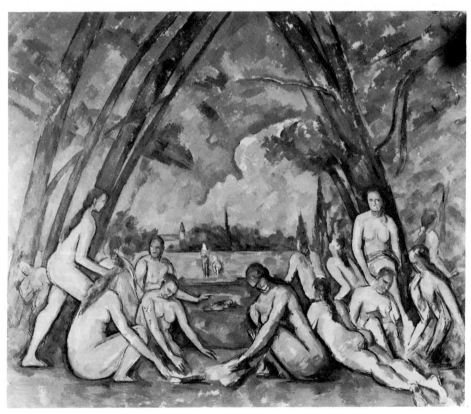

Women Bathers. *Cézanne*

484

doors, with color and light, rather than one of those works thought up in the studio, where everything has the brown color of fading daylight and lacks the reflections from the sky and the sun.

> Paul Cézanne (ca. 1904). Quoted in Émile Bernard.
> *Sur Paul Cézanne.* Paris, 1925, p. 122.

In the ordinary acceptance of the word it was left unfinished. The canvas is uncovered in some places: in the flesh of the bathers, in the clouds, and elsewhere. But no doubt what Cézanne wanted to say was fully and completely realized. . . .

The motif is clear: the main group of the bathers has a horizontal direction, which is underlined by the foreground, the river and the shore behind it. From this horizontal base some lines of trees rise and converge, to form a pyramid. Two bathers in particular and the poses of the others accompany the direction of the trees. Thus all the images concur in forming the geometrical shape of a pyramid. . . .

He painted this great composition in the last years of his life, when he combined, towards a superior synthesis, all the experiences of his creativity; the romantic magic realism of his early period, the sensibility to light and colors of his impressionistic years, the intellectual organization which gave a structural order to his color masses and transformed painting into an ideal architecture. All these experiences were present to the mind of Cézanne when he painted the *Great Bathers* [*Women Bathers*]. His aim was to paint an ideal architecture, but he could not renounce his lively sensibility to colors and tones, nor the romantic mood of the early days. Hence a unity of form and color, an anxious participation in the life of the images, a romantic pathos. . . . The work is a painting, but in looking at it one recalls the whole façade of a cathedral.

> Fiske Kimball and Lionello Venturi. *Great Paintings in America.* New York, 1948, p. 198.

ODILON REDON

Redon, the son of a French farmer and a Creole from New Orleans, was born in Bordeaux in 1840. He developed an early interest in botany, which was strengthened by his close friendship with the botanist Clavaud. At the age of twenty Redon went to Paris to study painting with Gérôme, etching with Rodolphe Bresdin, and lithography with Fantin-Latour. All of Redon's early work consists of drawings and prints in black and white. His first album of lithographs, *Dans le rêve (In the Dream),* appeared in 1879 and was followed by other series dedicated to Poe, Baudelaire, Flaubert, and Goya, and the *Temptation of St. Anthony.* In 1894 Redon had his first important one-man show at Durand-Ruel's.

About 1900 Redon turned to color and began painting in oil and pastel; most of his flower pieces date from this late period. Redon died in 1916 in Paris. He wrote reviews of the Salon of 1868 for a Bordeaux paper, *La Gironde*. His revealing journal, *À soi-même (To Oneself)* was published posthumously by his widow in 1922. Redon became first known in the United States through the famous "Armory Show" of 1913, for which the art historian Walter Pach brought a large number of Redon's works to New York.

My originality consists in bringing to life, in a human way, improbable beings and making them live according to the laws of probability, but putting—as far as possible—the logic of the visible at the service of the invisible.

Odilon Redon. *À soi-même.*
Paris, 1922, p. 29. Entry for 1909.

But . . . Des Esseintes was more particularly attracted by the other pictures that decorated the room. These were signed Odilon Redon.

In their light frames of unpainted pear-wood, with a gold beading, they contained productions of an inconceivable eccentricity—a head in a Merovingian style, placed upon a cup; a bearded man, . . . touching with the tip of his finger a colossal cannonball; a horrible spider, with a human face lodged in the middle of its body. Then there were crayons that went further yet in the horrors of a nightmare dream. Here it was an enormous die that winked a mournful eye; there, a series of landscapes—barren, parched, burnt-up plains, riven by earthquakes, rising in volcanic heights wreathed with wild clouds under a livid, stagnant sky. . . . These drawings passed all bounds, transgressing in a thousand ways the established laws of pictorial art, utterly fantastic and revolutionary, the work of a mad and morbid genius. . . .

Overcome by an indefinable sense of distress before these designs —the same distress he had formerly experienced at the sight of certain *Proverbs* of Goya's which they resembled, as also after reading some of Edgar Allan Poe's stories, whose mirages of hallucination and effects of terror Odilon Redon seemed to have transferred into a sister art, he would rub his eyes and gaze at a radiant figure that, amid these frenzied designs, rose calm and serene, a figure of *Melancholia*, seated before a round sun's disk, on rocks, in an attitude of depression and despondency.

J.-K. Huysmans. *Against the Grain* (1884).
New York, 1956, p. 67 ff.

Odilon Redon is a creator of nightmares. His sense for pure beauty is but slight, or rather for normal beauty; for he begets upon horror and mystery a new and strange kind of beauty, which astonishes, which terrifies, but which is yet, in his finest work, beauty all the same. Often the work is not beautiful at all: it can be hideous, never ineffective. He is a genuine visionary: he paints what he sees, and he sees through a window which looks out upon a night without stars. . . . He paints the soul and its dreams, especially its bad dreams. He has dedicated some of his albums to Flaubert, to Poe, to Baudelaire; but their work is to him scarcely so much as a starting-point. His imagination seizes on a word, a chance phrase, and transforms it into a picture which goes far beyond and away from the author's intention—as in the design which has for legend the casual words of Poe: *"L'œil, comme un ballon bizarre, se dirige vers l'infini."* We see an actual eye and an actual balloon: the thing is grotesque.

The sensation produced by the work of Odilon Redon is, above all, a sensation of infinitude, of a world beyond the visible. Every picture is a little corner of space, where no eye has ever pierced. Vision succeeds vision, dizzily. A cunning arrangement of lines gives one the sense of something without beginning or end: spiral coils, or floating tresses, which seem to reach out, winding or unwinding for ever. And as all this has to be done by black and white, Redon has come to express more by mere shadow than one could have conceived possible. One gazes into a mass of blackness, out of which something gradually disengages itself, with the slowness of a nightmare pressing closer and closer. And, with all that, a charm, a sentiment of grace, which twines roses in the hair of the vision of Death. The design, *La Mort,** is certainly his masterpiece. The background is dark; the huge coils which terminate the body are darker than the background, and plunge heavily into space, doubling hugely upon themselves, coils of living smoke: yet the effect of the picture is one of light—a terror which becomes beautiful as it passes into irony.

<div align="right">

Arthur Symons. "A French Blake."
Art Review, July 1890, p. 206 ff.

</div>

Already in his early works . . . Odilon Redon combined a certain keen austerity with the sad wisdom of one who has arrived at the summit of his career, weary of having understood and imagined all. And now he shows bouquets of flowers, portraits, and other compositions of an astonishing freshness, brilliance, and youthfulness. For several

* Lithograph, 1889; no. 3 of the series *À Gustave Flaubert.*

years he has been in the process of transformation and development. Without regrets, driven by a mysterious force, he has turned his back on the sumptuous harmonies of black and white in which he had excelled, and has indulged in the pleasures of rendering the splendors of multihued flowers, the happy delights of color.

By what miracle do those poppies, those wild flowers so full of sap, exert the same fascination as did the nocturnes and romantic lithographs of his youth? Suffice it to note that his craftsmanship— simple yet subtle—remains the same, and that there is the same resolve of an invariable and very healthy conception of the work of art.

> Maurice Denis. "Odilon Redon (1903)."
> *Théories, 1890–1910.* Paris, 1920, p. 136.

Very cultivated, musically gifted, easily accessible, and kindly . . . he was the ideal of the Symbolist generation; he was our Mallarmé. Before Cézanne's influence made itself felt through Gauguin and Émile Bernard, it was Redon whose series of lithographs and superb charcoal drawings determined, in a spiritual sense, the evolution of art around 1890. He is at the source of all aesthetic innovations and renovations and of all the revolutions of taste we have witnessed since then. . . . The lesson of Redon is his incapacity to paint anything that does not represent a state of the soul, that does not express a profound emotion or translate an inner vision.

> Maurice Denis in "Hommage à Odilon Redon."
> *La Vie,* November 30, 1912.

Your butterflies and your bouquets of flowers exchange their luminous pollen and shimmering dust, and it is always the same miracle of a *dream awake,* offered by the least literary yet most poetic of geniuses.

> Jean Cocteau. Letter to O. Redon, 1913.
> In Ari Redon, ed. *Lettres . . . à Odilon Redon.*
> Paris, 1960, p. 256.

Essentially he was the worshipper of the lip of flower, of dust upon the moth wing, of the throat of young girl, or brow of young boy, of the sudden flight of bird, the soft going of light clouds in a windless sky. These were the gentle stimulants to his most virile expression. . . . He knew the loveliness in a profile, he saw always the evanescences of light upon light and purposeless things. The action or incident in his pictures was never more than the touch of some fair hand gently and exquisitely brushing some swinging flower. . . .

Beyond these excessively frail renderings of his, whether in oil

or in pastel, I do not know him, but I am thinking always in the presence of them that he listened very attentively and with more than a common ear to the great masters in music, absorbing at every chance all that was in them for him. . . . Most of all it is Redon who has rendered with exceptional elegance and extreme artistry, the fragment.

Marsden Hartley. "Odilon Redon (ca. 1916)."
Adventures in the Arts. New York, 1921, p. 126 ff.

For Redon, the source of mystery lay in every-day life. This cannot be too highly stressed, and we must therefore keep in mind, as he did, the shell, the golden or sky-blue butterfly and the bunch of delphiniums or poppies. His points of departure were familiar objects or those landscapes he painted in his youth under the influence of Chintreuil and Corot. "My signature is a cloud," he liked to say. . . .

Although Redon, like Poe, believed that truth lay "in dreams" (that is the title he gave to his first series of engravings in 1879) and, like Baudelaire, that "singularity is the spice of beauty," his imagination at its best has nothing morbid or monstrous about it. What is the importance of all those moving eyes, the faces emerging from eggcups, the human-headed grubs, the serpent-like haloes or the women-flowers that were the source of his reputation during the height of the Symbolist movement? They now represent the most dated aspect of his work. . . .

Had Redon limited himself to these themes he would have incurred the same criticism as Blake, Boecklin and Gustave Moreau, those timid ambassadors of the Marvelous. But he soon abandoned this feverishly extravagant manner. . . .

I have lived with one of Redon's *Bouquets* for thirty-five years. Its charm is still fresh. In a triple-necked jar of dark green earthenware, forty anemones (and they seem like a thousand) in shades of purple, violet, mauve, blue, lemon-yellow and plain or pink-veined white, carry on a silent colloquy. There is no suggestion of strangeness in their petals or the stamens. They seem to have just been brought in from the garden. . . . But there is no legend or myth attached to this radiant bouquet; the flowers have not been transformed into jewels, insects or human faces. Nevertheless, a man of prophetic vision, plunged in contemplation of common existence, has focussed our eyes on the invisible. Dispensing with philters and incantations, he initiates us into miracles he does not pretend to explain.

Claude Roger-Marx. "Odilon Redon: Painter and
Mystic." *The Selective Eye*, II, 1956, p. 149 ff.

If his drawing is sometimes weak, he was one of the most aston-

ishing colorists that ever lived: a colorist in black and white ("blacks as royal as the purple"), in his prints and drawings, and when he worked with pastels, watercolors, tempera or oils. He was perhaps the first really free colorist.

He gave color its independence before Gauguin did, and released it from stylized naturalism. He demonstrated the endless possibilities of lyrical chromatics; he invented *color as metamorphosis*. In a word, contrary to the accepted idea that Redon is passable as a draftsman or post-Romantic illustrator, but an artist without pictorial genius, it is exactly in the pictorial that he is a major creator. It is here that, along with the late Monet, he announces a new period. The young artists of 1956—not those of day-before-yesterday—who admire Redon do not make mistakes.

André Masson. "Redon: Mystique with a Method."
Art News, January 1957, p. 41 ff.

Orpheus

Pastel 27 ⅜" x 22 ¼" Cleveland Museum of Art

The pastel *Orpheus* . . . formed part of the collection of the late John Quinn. It was not one of the memorable group of Redons hung in the Armory Exhibition of 1913 in New York, which first made him known in America. The

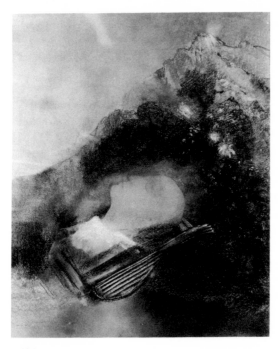

Orpheus. *Redon*

Orpheus was not painted till later* and in a sense is a still clearer statement of the artist's purpose. Redon always prized it as one of his finest works.

No reproduction can give any sense of its quality, for color is an essential element in the effect. It is simply the bust of Orpheus supported by his lyre. Poetry and music unite to evoke a world of hypnotic imaginings. It is as if it were the emanation of the spirit of poet and painter, a world of mountains and flowers, of mysterious depths and rising mists. The purples of the background dissolve and re-dissolve into the orange and greens of the flowers; and the unique color harmony is carried to completion in the turquoise of the lyre and the blues of the columnar base of the bust itself. In its power of concentration the *Orpheus* represents at its fullest the ample spirit of the painter.

<div style="text-align:right">

W. M. Milliken. *"Orpheus, by Odilon Redon." Bulletin of the Cleveland Museum of Art,* June 1926, p. 141.

</div>

JEAN FRÉDÉRIC BAZILLE

Bazille was born at Montpellier in 1841. He went to Paris in 1862 and enrolled in the studio of the Swiss painter Gleyre, where he met Monet, Renoir, and Sisley, who soon became his friends. Supported by an allowance from home, he was frequently able to come to the aid of the impecunious Renoir and Monet. Bazille exhibited for the first time at the Salon of 1866. He enlisted at the outbreak of the Franco-Prussian War, and was killed in action at Beaune-la-Rolande in 1870 at the age of twenty-nine. His work provides the link between Courbet, whose paintings he saw at Montpellier, and the Impressionists, whom he foreshadows.

Bazille's premature death prevented his participation in Impressionism's most characteristic period, that of the years between 1874 and 1880. His artistic development, however, involved him in the origins of the movement.

Bazille was an Impressionist in terms of his desire to paint out of doors, in his interest in representing contemporary life, and in the clear tonality of his palette....

From a purely formal point of view, the painter from the Languedoc was less of an innovator than Monet. Even before 1870 the painter of *Women in the Garden* was permitting himself audacities which Bazille always refused.

Because his temperament and inclination took him in another direction, Bazille never entirely adopted the new technique of the Im-

* According to Klaus Berger, *Odilon Redon,* New York, 1965, it was painted "after 1903."

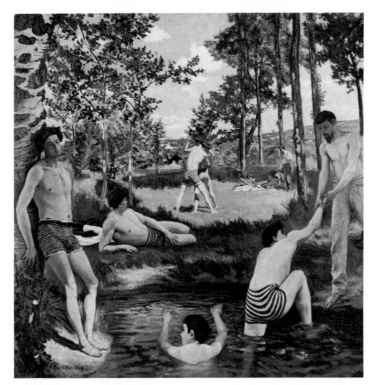

Summer Scene. *Bazille*

pressionists. . . . He was a Latin, a son of the South, of the country where men have always been concerned with form. The southern light does not lend itself to the interpretation of landscape as Monet, Sisley, or Pissarro painted it; the shapes are distinct rather than blended together, with planes and contours sharply defined. . . .

Northern painters such as Monet, Sisley, or Pissarro suggest rather than define the presence of the object, whereas we find form, construction, and profile of primary importance to Cézanne and Guigou, painters of the South. Like them, Bazille would have certainly upheld this position. . . . What separates the static art of Bazille from the dynamic work of Monet is not entirely explained by geography and climate. . . .

The naturalism of Monet and the pure Impressionists is based on that which is visually most immediate and mobile. Conversely, Bazille's art aims at what is constructed, immobile, and lasting. In a large composition such as *Summer Scene* [1869; Fogg Art Museum], the painter of the Languedoc wants to create a symphony in which

trees, clouds, and people are the themes, and to discipline these themes according to a coherent order. . . .

Finally, Bazille remains the painter of his milieu. . . . He always preferred to paint his family and friends. . . . Dedicated to nature and reality, Bazille painted them as he saw them, in the ordinary events of his daily life. His drawings, sketches, and paintings parallel his life and closely mirror it. His profound originality was to "live his painting and paint his life."

<div align="right">

François Daulte. *Frédéric Bazille et son temps.*
Geneva, 1952, p. 153 ff.

</div>

ALFRED SISLEY

Sisley's parents were English, but he was a native of Paris, born in 1839. At the age of seventeen he was sent to England to learn English and enter a commercial career. He returned to Paris, however, and enrolled in the studio of the academic painter Gleyre, where he met Renoir, Bazille, and Monet. In 1863 his work was hung in the Salon des Refusés, but it was accepted for the Salon of 1866. Sisley exhibited with the Impressionists in 1874, 1876, 1877, and 1882. He was in England during the Franco-Prussian War and again in 1874, when he painted the English countryside, including Hampton Court. His best work was done between 1872 and 1876; it includes several snow scenes and representations of the flooding of the Seine at Port-Marly. Sisley was never as successful as Monet or Pissarro, with whom he is usually compared. He died of cancer of the throat in 1899.

Together with M. Pissarro and M. Monet, M. Sisley was one of the first artists who went directly to nature, who dared to consult her, and who attempted to render faithfully the sensations he experienced before her. With a temperament less erratic and less nervous, with eyes less frenzied than those of his two confreres, M. Sisley is evidently less determined, less personal than M. Pissarro and M. Monet. He is a painter of real value, but has here and there retained influences from other masters. Certain reminiscences of Daubigny are apparent in this year's exhibition, and Sisley's autumn leaves even remind me of [Ludovic] Piette. But in spite of everything his work has resolve and vigor. It has also a pretty, melancholy smile and often even the great charm of tranquillity.

<div align="right">

J.-K. Huysmans. "Appendice (1882)."
L'Art moderne. Paris, 1908, p. 291.

</div>

Here is a painter who has found his region. It is the edge of the forest of Fontainebleau, the little towns nestled along the banks of the Seine and the Loing, like Moret or Saint-Mammès. He [Sisley] has

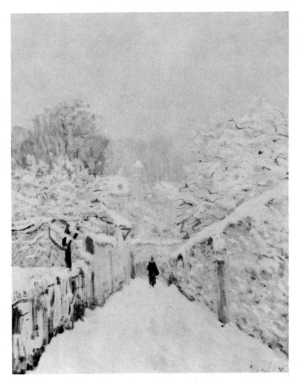

Snow at Louveciennes.
Sisley

made a few journeys here and there, has gone to Asnières and traveled up the Thames, but he always returns to this damp and verdant bit of earth where his talent is at ease, where the people and things are familiar to him. He has chosen his countryside and remains faithful to it, enamored of the placid river and the serene outline of the little towns.

Thus he adds his chapter to the history of our soil, our waterways, and our sky. He has left his mark on the gallery of landscapes that our age will leave to posterity. . . .

He is not the discoverer of luminous harmonies, or of the subtle interplay of light and color; at times his canvases make us think of the application of a formula. But we consistently find in his works an honest, sincere personality; they reveal his joy in being a simple, rustic painter, his aptitude for portraying nature in somewhat slight yet delicately outlined and graduated scenes. He has also sought to render the diffusion of light and orchestration of tones. He has looked for a landscape that would appeal to his inclination and his vision and, having found it, he has pursued incessantly the object of his love and his study. He loves the banks of the river, the edges of the forest, the

494

town and villages glimpsed through trees, old buildings hidden under foliage, the sun of winter mornings, and the afternoons of summer. He could express most delicately the effects of foliage upon stone, the flowing of a river, the vegetation of a hillside exposed to the sun. . . . The charm of his painting remains.

<div align="right">

Gustave Geffroy. *La Vie artistique.*
3rd series. Paris, 1894, p. 282.

</div>

If we look at Sisley's landscapes as a whole, the most striking thing is the passionate, almost exclusive, love of nature revealed in his work. Unlike Degas or Manet, Sisley was never tempted to paint the human face. The few figures, to be found in his interiors, are not really portraits. They are, rather, people caught in a moment of thought or activity in their natural surroundings. Nor was Sisley a painter of the still-life. In the whole of his work there are only three or four pictures of fruit or flowers. To these may be added a few rather dark compositions, mostly of fish (pike caught in the Loing, with shining scales) or dead game on a kitchen table. But despite these exceptions, Sisley was essentially a painter of landscape. He depicted the little villages strung along the banks of the Seine above and below Paris, and although he sometimes emerged from his retreat at Louveciennes (and later, his house at Moret) to paint the mists of London, a regatta at Hampton Court, or the cliffs at Langland, he always returned in the end to his chosen corner of France. These villages on the banks of the Seine and the Loing meant far more to Sisley than the undeniable attractions of Paris, or even his friendship with Monet, Renoir, and Bazille. The people and places were all familiar, and Sisley remained always faithful to them.

<div align="right">

François Daulte. *Sisley Landscapes.*
New York, 1962, p. 6.

</div>

CLAUDE MONET

A native Parisian born in 1840, Monet spent his childhood in Le Havre where his father owned a grocery. At the age of fifteen Monet was locally famous for his caricatures, which attracted the attention of Eugène Boudin. Boudin became Monet's first teacher and awakened his interest in landscape painting. In 1859 Monet went to Paris to study painting at the Académie Suisse where he met Pissarro, and at the studio of Gleyre where he made friends with Renoir, Sisley, and Bazille. Two seascapes were accepted for the Salon of 1865, and his *Camille* (Kunsthalle, Bremen) was noticed by Zola in the Salon of 1866.

During the Franco-Prussian War of 1870 Monet fled to England. Together with Pissarro and Degas he was one of the principal organizers of the Société Anonyme des Artistes Peintres, Sculpteurs, Graveurs, etc., which held its first exhibition in 1874 at the gallery of the photographer Nadar in Paris. His *Impression: Sunrise** caused the group to be dubbed "Impressionists." Monet exhibited in all but the last of the eight Impressionist group shows. In the 1880's his work, promoted by the dealer Paul Durand-Ruel, began to sell and Monet was able to purchase a house in Giverny where he lived until his death in 1926.

In 1890 Monet began work on a series of paintings representing the same subject under varying conditions of light—the *Poplars* (exhibited 1892). This was followed by other series—*Haystacks* (1891), *Cathedral of Rouen* (1892–95), the *Thames* (1899–1904), and *Venice* (1908). His numerous paintings and studies of *Water Lilies* were painted after 1890 in his garden, which he had designed and grown expressly to observe and paint the reflections of light on water. These studies culminated in the huge semi-abstract canvases in the Paris Orangerie (1914–18). In 1923 Monet was operated on for double cataracts; some critics claim that his late style was the result of impaired vision rather than artistic intent. Monet was married twice; his first wife, Camille, died in 1879 and his second wife, Mme. Hoschedé, whom he married in 1892, died in 1911.

> As to the colors I use, is it so interesting to talk about it? I don't think so, provided that one can paint better and brighter with an entirely different palette. . . .
>
> In short, I use silver white, cadmium yellow, vermilion, dark madder, cobalt blue, emerald green, and that is all. . . .
> > Claude Monet. Letter to Paul Durand-Ruel, June 3, 1905.
> > Quoted in Lionello Venturi. *Les Archives de l'impressionnisme.* 2 vols. Paris, 1939, I, 404.

> I admit that the canvas before which I paused the longest was M. Monet's *Camille.* This painting is forceful and alive. I was wandering through those cold and empty galleries, weary of finding no fresh talent, when I noticed this young woman with her long, trailing gown. . . .
>
> I do not know M. Monet, nor do I believe I have paid attention to his paintings before. It seems to me, nevertheless, that I am one of his

* According to J. Rewald (*History of Impressionism*, rev. ed., New York, 1961, p. 339), *Impression: Sunrise*, painted in 1872 and exhibited in 1874, is not the painting now exhibited under that title in the Musée Marmottan, Paris, as has been generally assumed. The Musée Marmottan painting should be called *Impression: Fog;* it was also painted in 1872, but not exhibited until 1879. The painting shown in 1874 represents a similar subject. It is now in a private collection.

old friends. This is because his picture tells me a whole story of vitality and truth.

Why, yes!—here is a temperament, here is a man in a crowd of eunuchs. Look at the neighboring canvases, how paltry they seem next to this window opened on nature. Here is an artist who is more than a realist; here is a sensitive and strong interpreter who can render every detail without becoming harsh.

<div style="text-align: right">

Émile Zola. "Mon Salon (1866)."
Mes haines. Paris, 1880, p. 301 ff.

</div>

We have in Monet a marine painter of the first rank. He interprets the genre in his own personal way, however, and here again I find a profound involvement with the realities present. This year only one of his paintings—*Boat Putting out from the Pier at Le Havre*—has been accepted.

What struck me most about this work was the utterly free and even crude quality of the brush strokes. There is an unsavoriness to the water, a ruthlessness in the way the horizon stretches itself out; you feel that the high sea must be somewhere near.

Monet is one of the very few painters who understand how to paint water, without the usual simplistic transparency or deceptive reflections. His water is alive, and deep, and very convincing. It laps against the small boats in little greenish wavelets, interspersed with glimmers of white; it stretches away in gray-green marshes ruffled by the sudden passage of air; it elongates the masts by shattering their reflections upon its surface; and here and there pallid and lifeless hues becomes suddenly alight with intense translucence.

The other painting, refused by the jury, which represents the pier at Le Havre, is perhaps even more characteristic. I have seen very original works by Claude Monet which are most certainly of his very flesh and blood. Last year a figure painting [*Women in the Garden;* Louvre]—women in light-colored dresses—was refused. Nothing could be more bizarre in effect. An artist must be singularly at one with his own time in order to risk a comparable feat: the sharp contrast of sunlight and shadow upon fabrics.

What is distinctive about his talent is an astonishing ease of execution, a very versatile intelligence, and an alert, quick comprehension of any subject whatsoever. I am not the least bit anxious on his behalf. He will win over the crowd when he is ready.

<div style="text-align: right">

Émile Zola. "Mon Salon (1868)."
Salons. Geneva, 1959, p. 131 ff.

</div>

M. Manet is among those who claim that in painting one may—

and one must—content oneself with one's impression. Of these *Impressionnalistes* [*sic*] we have seen a recent exhibition at Nadar's on the Boulevard des Capucines. It was simply disconcerting. M. Monet—a more intransigent Manet—M. Pissarro, Mlle. Morisot, etc. seemed to have declared war on beauty. The *impression* of some of these landscapists has turned to fog and soot.

> Jules Claretie. "Salon de 1874." *L'Art et les artistes français contemporains.* Paris, 1876, p. 260.

The prodigious animation of a public road, the antlike movement of the crowd on the sidewalk and of carriages in the street, the stirring of trees in the dust and light of the boulevard, the intangible, the transitory, the instantaneousness of movement have never been perceived and rendered in their wonderful fluidity, as in this extraordinary, this marvellous study, which M. Manet [*sic*] has recorded under the title *Boulevard des Capucines* [1873, Collection Mrs. Marshall Field, New York].

. . . Evidently this is not the last word in art, not even in this type of art. This sketch must be transformed into a finished work. But what a clarion call for those who have ears subtle enough to listen, and how it carries far into the future!

> Ernest Chesneau (*Paris-Journal*, May 7, 1874).
> Quoted in J. Lethève. *Impressionnistes et symbolistes devant la presse.* Paris, 1959, p. 70.

Like the old master Frenhofer in Balzac's *Unknown Masterpiece*, the Impressionists see and admire in their works what they believe to have put there. . . .

[M. Manet's] *Le Bon Bock,* the *Woman with Cat* [*Olympia*], *Boating* and, lastly, *The Laundress,* which I'm told has just had the honor of being rejected by the Salon, . . . are the masterpieces from which they draw their inspiration as well as the record which guides them in . . . developing their personal impressions. . . .

Here is M. Monet, the similarity of whose name has tossed him into the ranks of the *Impressionnalistes* [*sic*], after the fashion of his almost namesake.

M. Monet knows very well that trees are never bright chrome yellow as in his *Small Branch* [of the Seine] *at Argenteuil.* He is convinced that the *Road at Épinay: Effect of Snow,* has never had the aspect of a white, blue, and green woolen tapestry. . . . Yet this has not prevented him from rendering his alleged impression. . . . The public has looked, it has laughed, and asked for his name. It has now been informed that the gentleman who has had the amazing idea of

producing knitted landscapes is called Monet, and M. Monet is about to become as famous as M. Manet.

> Albert d'Arnoux-Bertall (1876). Quoted in Gustave
> Geffroy. *Claude Monet.* 2 vols. Paris, 1924, I, 70.

Claude Monet is the artist who has brought to landscape painting more imagination and originality than any other artist since Corot. If painters were classed according to the degree of novelty and unforeseen effects in their work, Monet should unhesitatingly be placed among the masters. . . . We claim that as a landscape painter M. Monet will in the future be placed beside Rousseau, Corot, and Courbet. . . .

> Théodore Duret. "Claude Monet (1880)."
> *Critique d'avant-garde.* Paris, 1885, p. 94.

The Impressionist sees and depicts nature as it really is, that is to say, solely in color vibrations. He does not concern himself with either drawing or light, with modeling, or perspective, or chiaroscuro—these are childish classifications. In reality all these effects resolve into color vibrations, and should therefore be produced on canvas solely by color vibrations.

In this small and crowded exhibition at Gurlitt's* the formula is above all noticeable in the work of Monet . . . and Pissarro . . . where everything is achieved by a thousand tiny strokes dancing in all directions like straws of color—in a concurrence vital for the impression of the whole. Rather than an isolated melody, this whole is a symphony; this symphony in turn is vibrant and variegated life itself, just as the "forest murmurs" in Wagner's music blend in this same vital relationship to become the great voice of the forest, and just as the Unconscious, the law of the world, is the great melodic voice resulting from the symphony of the collective consciousness of races and individuals. This is the principle behind the *plein air* Impressionist school. It takes the eye of the master to best discern and render perceptible these most sensitive gradations, these fragmentations, and to do so on a simple, flat canvas. This principle has also been applied, not systematically but in spirit, by some of our poets and novelists.

> Jules Laforgue. "L'Impressionnisme (1883)." *Œuvres*
> *complètes; mélanges posthumes.* Paris, 1923, p. 137 ff.

Inasmuch as the eye of the Impressionists is particularly sensitive, it is logical that all their efforts should be concentrated on translating the most evanescent, the most fleeting, and most subtle aspects of

* In Berlin, where Laforgue was then living.

nature. They must feel themselves called to this manner of interpretation. It has become their faith, their very raison d'être.

Consequently, when we look at the work of Monet we find him intent on the study of water, sky, and air: water, in its infinite variety, . . . the sky, with its thousand softened and changeable hues, . . . and, finally, the air, which modifies all things and marks all with its eternal mutations. . . .

The majority of Monet's landscapes are seascapes, where water, sky, and air are depicted and combined, influencing, attracting, and interpenetrating one another. . . . The color is radiant, all is splendor, for it is the hour of midday and of sunshine that the painter is necessarily seeking and has, indeed, sought above all.

<div style="text-align: right">Émile Verhaeren. "L'Impressionnisme (1885)."

Sensations. Paris, 1927, p. 178.</div>

Last year . . . [at Étretat] I often followed Claude Monet in his search of impressions. To tell the truth he was no longer a painter but a hunter. He used to walk along followed by children who carried five or six of his canvases. Each of these canvases represented the same motif at different times of the day and with different effects. He took them up in turn and put them down according to the changes in the sky. And before his subject the painter lay in wait for the sun and shadows, capturing in a few brush strokes the falling ray or the passing cloud. Scorning falseness and convention, he put them rapidly on his canvas.

It was in this way that I saw him snatch a glittering shower of light on the white cliff and render it as a stream of yellow tones, which depicted amazingly the surprising and fleeting effect of this elusive and dazzling brilliance.

At another time he captured, at the height of its intensity, a rainstorm beating down on the sea, tossing it on his canvas; and, indeed, it was the rain itself he had thus painted.

<div style="text-align: right">Guy de Maupassant. "La Vie d'un paysagiste (1886)."

Études, chroniques et correspondance. Paris, 1938, p. 167 ff.</div>

M. Claude Monet's talent is distinguished by its grandiose yet learned simplicity, by its implacable harmony. He has expressed everything, even the imperceptible, even the inexpressible—in other words, the motion of inert and invisible things—as though it were the path of meteors. Nothing has been left to the accidents of inspiration, no matter how fortunate, or to the whim of the brush stroke, no matter how spirited. All is combined and brought into harmony with the laws of atmosphere and with the regular and precise movement of the

phenomena of earth and sky. It is for this reason that M. Monet creates the complete illusion of life. The flush of life runs through the sonorities of his backgrounds, it blossoms fragrantly in his sheafs of flowers, it shimmers on sunlit surfaces, it veils the mysterious softening of the mists, it is saddened by the bleak bareness of the rocks modeled like faces wrinkled with age. He recaptures the great dramas of nature and expresses them with supreme poignancy.

> Octave Mirbeau (1889). Quoted in J. Lethève.
> *Impressionnistes et symbolistes devant la presse.*
> Paris, 1959, p. 130.

. . . It is nature fixed at the very moment of perception as we experience it in a first, all-embracing glance. The mechanism seems photographic, but in this lightning-like swiftness the mind has collaborated with eye and hand and the "snapshot" becomes a personal work of utmost originality. It is neither a sketch, nor an outline, nor a study, but a very complete and very beautiful poem. Furthermore, it is certain that not all of Monet's canvases were painted with the same rapidity as the series of the *Haystacks, Poplars* or *Cathedrals**. There exist less feverish Monets, almost restful ones, and these give a more complete idea of his genius. . . .

Monet is not what we would call a colorist. He paints nature gray when it is gray. Is there actual color in his paintings? Not more than in the objects themselves. There are brilliant or delicate tints, flame or fog. Who can name the color of a river flowing under a blue sky, on yellow soil, between the green blades of grass? An analytical painter would give his picture a general color, a dominant tone. Such a stream as painted by Monet would be the river itself, the undefinable, mysterious river. . . . Taking the word Impressionist in its narrowest sense, Monet is the only true Impressionist because he alone has been able to reconcile theory and practice. He alone has been able to represent in painting the colored impression received by the eye. Impressionism is Monet himself, Monet in the isolation of his glorious and thaumaturgic genius.

> Rémy de Gourmont. "L'Œil de Monet (1905)." *Promenades philosophiques:* 1st series. Paris, 1913, p. 226.

Actually Monet's technique made him particularly dependent on the nature of his subjects; and they were limited. Only sun on water and sun on snow could give full play to the prismatic vision and the

* Gourmont was apparently unaware of Monet's long preparation, repeated efforts, and slow execution.

501

sparkling touch. In such pictures Monet has remained without an equal. But in order to prove his point he chose for the subjects of his experiments, cathedrals and haystacks. No doubt he did so intentionally in order to show that the most articulate works of man, and the most formless, were pictorially of equal importance to the painter of light. But the choice, especially that of cathedrals, was disastrous, because grey Gothic façades do not sparkle. In an attempt to make them vehicles of light Monet painted them now pink, now mauve, now orange; and it is evident that even he, with his marvellous capacity for seeing the complementary colours of a shadow, did not really believe that cathedrals looked like melting ice-creams. . . .

The arbitrary colour of the cathedrals is much less beautiful than the truly perceived colour of the Argenteuil pictures. . . . If decadence in all the arts manifests itself by the means becoming the end, then the last works of Monet may be cited as text-book examples.

Impressionism is a short and limited episode in the history of art, and has long ago ceased to bear any relation to the creative spirit of the time. We may therefore survey, with some detachment, the gains and losses of the movement.

There was the gain of the light key. . . . Then Impressionism gave us something which has always been one of the great attainments of art: it enlarged our range of vision. . . . The Impressionists . . . taught us to see the colour in shadows. . . . Impressionism achieved something more than a technical advance. It expressed a real and valuable ethical position. As the Count of Nieuwerkerke* correctly observed, it was the painting of democrats. Impressionism is the perfect expression of democratic humanism, of the good life. . . . What pleasures could be simpler or more eternal than those portrayed in Renoir's *Déjeuner des Canotiers;* what images of an earthly paradise more persuasive than the white sails in Monet's estuaries, or the roses in Renoir's garden? . . . The men who painted them were miserably poor. . . . Yet their painting is full of a complete confidence in nature and in human nature.

<div align="right">Kenneth Clark. *Landscape into Art* (1949).
Boston, 1961, p. 94 ff.</div>

Recently a new generation of historians, critics and, above all, artists . . . have looked at Monet with fresh eyes, and during the last five or six years have focused attention on him in such a way that he has begun to regain some of the artistic stature which he seemed to

* A. E. Nieuwerkerke (1811–92) was a French sculptor who, as the powerful director of the French national museums and chief government official supervising the arts from 1849–70, pursued a conservative artistic policy.

have lost. This time, however, Monet is presented to us as a begetter of the abstract movement in painting on the basis of the broad brushwork and polyphonic use of colour which occur in his late works, notably in his last (post-1912) *Water-Lilies* series. . . .

We need not be surprised, therefore, to find the last works of Monet described as "abstract impressionism," a label which serves the convenient purpose of immediately linking them with that tendency in contemporary painting for which the term "abstract expressionism" has already been coined. It seems to be established that *tachiste* and "abstract expressionist" painters on both sides of the Atlantic—Bazaine, Manessier, Singier, Riopelle, Sam Francis, Jackson Pollock and Mark Tobey for example—have consciously derived inspiration for their own work through studying paintings by Monet. He was undeniably great, and it was not fortuitous that his painting made itself felt as a profound influence during his lifetime. Among those most deeply affected have been Manet, Cézanne, Renoir, Pissarro, Gauguin, Seurat, van Gogh, Signac, Luce, Cross, Sargent, Vuillard, Bonnard, Matisse and Derain in their early years, Marquet, Braque, and in the immediate past Nicolas de Staël. The record is impressive. Nevertheless I would not claim for Monet the primacy which undoubtedly belongs to Cézanne, nor in the last resort would I set him above Degas and Renoir. But I do believe that the true greatness of Monet still remains to be discovered and that, in the perspective of history, his importance will continue to increase. . . .

To the end of his life Monet remained an Impressionist, but there was nothing narrow or banal about his vision. For Monet was constantly in search of new and different types of impression to challenge both his powers of perception and his capacity as a painter. . . . Mr. [Alfred] Barr's comment that Monet "was an artist as well as an eye" is singularly pertinent. . . .

Monet's work, it seems to me, can be very roughly divided into five progressive but inter-related phases: the years of apprenticeship from 1857 to 1864; an early phase from 1865 to 1871, during which Monet evolved the idiom of Impressionism; a pure Impressionist phase from 1872 to 1877; an exploratory post-Impressionist phase from 1878 to 1891, during which he broadened his vision and elaborated his Impressionist technique; and finally a late, imaginative phase of Impressionism from 1892 onwards, during which Monet became increasingly a visionary, until after 1912 he found all the inspiration which he required in the private world of his own water-garden.

Douglas Cooper in *An Exhibition of Painting: Monet*
(Royal Scottish Academy, Edinburgh).
Edinburgh, 1957, p. 6 ff.

Haystacks: End of Summer
Meules: fin d'été

1891 oil on canvas 25⅝" x 39⅜" Bâle, Private Collection

> You have dazzled me recently with those *Haystacks,* Monet, so much!—
> that I catch myself looking at the fields through the recollection of your paint-
> ings; or, rather, they impose themselves on me in this manner.
> Stéphane Mallarmé. Letter to Monet, July 9, 1890. Quoted in
> Gustave Geffroy. *Claude Monet.* 2 vols. Paris, 1924, II, 186.

Two haystacks in a field, seen at different times of the day and in the changing seasons of the year 1890–91. On this subject we have fifteen paintings, each different from the other. Since the painter is M. Monet, we have here a panegyric demonstration of the first Impressionist program, which has as its aim to capture and immobilize, by means of a direct sketch from nature, some transitory, unique moment in a nature that is whirling in a constant round of change. Actually nature is not so mobile, she only stumbles from one state to the next, and perhaps we would prefer painters less ready to serve her every whim, who would coordinate her disparate aspects so as to render her more stable and endow her with permanence. Two ordinary haystacks . . . and here comes M. Monet to invest them with his discerning vision, and imbue them with his multihued offerings. When have colors ever united in a more brilliant burst to produce a more harmonious clamor? The evening sun

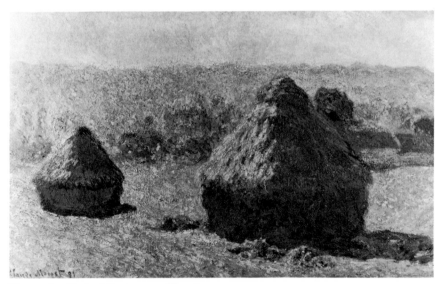

Haystacks: End of Summer. *Monet*

above all transfigures the haystacks; in summer they are enveloped in a halo of purple sparks; in winter their phosphorescent shadows stream onto the ground while they glisten, coated in bluish gloss by a sudden frost, against a roseate sky that turns to gold.

> Félix Fénéon. "Œuvres récentes de Claude Monet (ca. 1891)."
> *Œuvres*. Paris, 1948, p. 188.

It was around that time, that two events took place, both of which were to influence me strongly in my future life. The first was the exhibition of French Impressionists that was held in Moscow [in 1895], one of the pictures being "The Stack of Hay" by Claude Monet. The second was the production of Wagner's "Lohengrin" at the Grand Theatre.

Up to this time I was familiar with the realistic school of painting, and—at that—chiefly with the work of the Russian painters. . . .

And then suddenly, for the first time in my life, I found myself looking at a real painting. It seemed to me, that, without a catalogue in my hand, it would have been impossible to recognize what the painting was meant to represent. This irked me, and I kept thinking that no artist has the right to paint in such a manner. But at the same time, and to my surprise and confusion, I discovered that it captivated and troubled me, imprinting itself indelibly on my mind and memory down to its smallest detail. . . .

What did become clear to me, was the previously unimagined, unrevealed and all-surpassing power of the palette. Painting showed itself to me in all its fantasy and enchantment. And deep inside of me, there was born the first faint doubt as to the importance of an "object" as the necessary element in a painting.

> Wassily Kandinsky. "Text Artista: Autobiography of Wassily
> Kandinsky, 1918." *In Memory of Wassily Kandinsky*
> (Solomon R. Guggenheim Foundation). New York, 1945, p. 53 ff.

The Cathedral of Rouen: Gray Weather

1894 oil on canvas 39⅜″ x 25½″ Paris, Louvre (Jeu de Paume)

Monet's exhibition opened yesterday, he is showing twenty *Cathedrals of Rouen!*—forty canvases in all. This will be the *great attraction*. It will run till the end of the month. . . .

If only you could get there before Monet's show closes; his *Cathedrals* will be scattered everywhere, and these particularly ought to be seen in a group. They have been attacked by the young painters and even by Monet's admirers. I am carried away by their extraordinary deftness. Cézanne, whom I met yes-

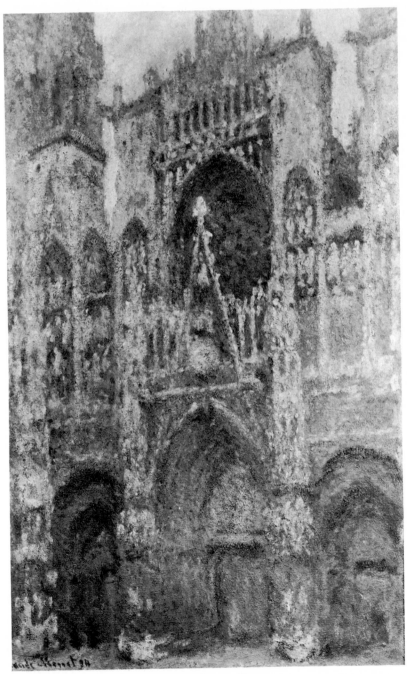

The Cathedral of Rouen: Gray Weather. *Monet*

terday at Durand-Ruel's, is in complete agreement with my view that this is the work of a well-balanced, but impulsive artist who pursues the intangible nuances of effects that are realized by no other painter. . . .

. . . The *Cathedrals* are being much talked of, and highly praised, too, by Degas, Renoir, myself and others. I would have so liked you to see the whole series in a group, for I find in it the superb unity which I have been seeking for a long time. . . .

> Camille Pissarro. Letters to his son Lucien, May 11, May 26, and June 1, 1895. *Letters* . . . New York, 1943, pp. 268, 269, 270.

Never before, and certainly scarcely even then, except in Cézanne's late landscapes, had the secret processes of artistic feeling been so exhaustively and exactly realized in the physical materials of painting. The consequence is that the twenty moments represented by the twenty views of Rouen are less views of the cathedral (one alone would have been sufficient for that), less even twenty moments in the going and coming of the light (which is an insignificant situation), than twenty episodes in Monet's private, perceptual life. They are twenty episodes in the history of his consciousness, and in thus substituting "the laws of subjective experience for those of objective experience" he revealed a new psychic rather than physical reality.

That is why we can describe these paintings as the climax of Impressionism, its climax, destruction, and transformation. . . . Monet erected a new kind of painting which reveals the nature of perception rather than the nature of the thing perceived.

For much too long we have repeated the trite remark about Monet which has been attributed to more than one of his friends: "Monet is only an eye, but *bon dieu,* what an eye!" It is time that we thought of him as a mind in the special sense in which mind has come to be understood in the twentieth century. . . . The *Cathedrals* must be thought of as the revelation of a physiologically complicated and psychologically continuous experience which can only be known by the spectator when he sees (or imaginatively reviews) the series as a whole. . . . For Monet, the prime Impressionist, the expansion of experience within and through time was conceivable only in terms of the addition of separate items to form a whole. Now that he had discovered how to communicate those values of continuous consciousness he would rarely again be content with the single picture. After the *Cathedrals* came the London series of Waterloo Bridge, Charing Cross Bridge, and the Houses of Parliament, and the countless canvases of water-lilies, culminating in those astonishing and long-neglected water-gardens in the Orangerie in Paris where the view extends laterally in either direction around each of the two rooms. The experience

507

which had begun to unfold in the earlier series came in the end to embrace all visible space.

> G. H. Hamilton. *Claude Monet's Paintings of
> Rouen Cathedral.* London, 1960, p. 26 ff.

Water Lilies
Les Nymphéas: études d'eau, reflets verts

oil on canvas 6'6" x 14' Paris, Musée de l'Orangerie

The great *Water Lilies* of the "Musée Claude Monet" comprise ten compositions (nineteen panels) selected by Monet himself together with Georges Clemenceau from the many large studies of the subject he painted between 1914 and 1918 in Giverny. The panels, which Monet donated to the French government in 1922, were specially installed in the order and with the titles designated by the artist. Set in two oval rooms, they were placed on public view only after Monet's death, in 1927.

> ... Those landscapes of water and reflections have become an obsession. They are beyond my strength, old as I am, and yet, I want to succeed in rendering what I experience. I destroy ... I begin again ... and I hope that something will come of all this effort.
>
> Claude Monet. Letter to Gustave Geffroy, August 11, 1908.
> Quoted in Gustave Geffroy. *Claude Monet*, II, 143.

> He [Monet] took us down the paths of his garden to a newly built studio. ... There we were confronted by a strange artistic spectacle: a dozen canvases placed one after the other in a circle on the ground, all about six feet wide by four feet high: a panorama of water and water lilies, of light and sky. In this infinity, the water and the sky had neither beginning nor end. It was as though we were present at one of the first hours of the birth of the world. It was mysterious, poetic, deliciously unreal.
>
> René Gimpel. *Diary of an Art Dealer.* New York,
> 1966, p. 59 ff. Entry of August 19, 1918.

> The idea of the *Water Lilies* obsessed Monet for years. ...
> It was after having long observed the flowers, criticized them, confronted them in a thousand ways in his water garden, that Monet resolved definitely to embark on the adventure of these pictures and began by having his big studio built (1916). ...
> Numerous canvases on which the first *Water Lilies* are painted inaugurated the series which was to find its fullest expression in the outburst of the

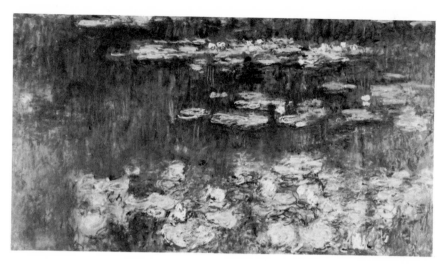

Water Lilies (detail). *Monet*

Tuileries. . . . Some of them were very beautiful and full of character but were unfortunately destroyed in the treacherous uncertainty of the first moments. . . .

In the mirror of his pond, in the heavy flagstones of the lily pads edged with clouds, a burst of petals rises at the mercy of the creeping mist. . . . Monet used to come there to sharpen his most acute sensations. For hours he would stay there without moving, voiceless in his armchair, searching with his glance, seeking to read in their reflections the hidden nature of things. . . . The water drank in the light and transposed it, sublimated it to its quintessence before returning it to the sensitive retina surprised by unknown reactions.

Rightly speaking, it is therein that lies the miracle of the *Water Lilies*, which shows us the order of things as other than we had observed it so far. New relations, new light. Ever-changing aspects of a universe which does not know itself and yet expresses itself in our sensations. . . . That is what Monet discovered as he looked at the sky in the water of his garden. And that is what he intends to reveal to us in our turn.

Thus Monet painted action, the action of the universe struggling with itself, to produce itself and continue itself through series of momentary views caught on the reflecting surfaces of his lily pond.

<div style="text-align: right">

Georges Clemenceau. *Claude Monet: The Water Lilies*. New York, 1930, p. 36 ff.

</div>

The Orangerie of the Tuileries is the Sistine Chapel of Impressionism, . . . one of the summits of French art.

<div style="text-align: right">

André Masson. "Monet le fondateur." *Verve*, vol. VII, nos. 27–28, 1952, p. 68.

</div>

Venturi, writing in 1939, called Monet the "victim and grave-digger of Impressionism." At that time Monet still appeared to have nothing more to say to the avant-garde. But only a few years later, several Americans who were to become the most advanced of advanced painters were enthusiastically re-discovering him. They had not even seen, outside reproductions, those huge close-ups which are the last *Water Lilies;* but they were already learning from Monet, as well as from Matisse, that a lot of sheerly physical space was needed for the development of a strong pictorial idea that did not involve an illusion of more than shallow depth. Monet's broad, slapped-on daubs of paint and his scribbles were telling them, further, that paint on canvas had to be able to breathe; and that when it did breathe, it exhaled color first and foremost—color in fields and areas, rather than in shapes; and that this color had to be *solicited* from the surface as well as applied to it. It was under the tutelage of Monet's later art that these same young Americans began to reject sculptural drawing—"drawing-drawing"—as finicking and petty, and turn instead to "area" drawing, "antidrawing" drawing.

It used to be said that Monet had outlived himself, that by the time of his death in 1926 he was an anachronism. Now, however, those great summations which are the last *Water Lilies* begin to belong to our age in a way that Cézanne's own attempts at summations (in his two large *Bathers*) no longer do. The twenty-five years' difference in dates of execution between the *Bathers* and the *Water Lilies* of the Orangerie turns out not to be meaningless after all, and the twenty years by which Monet outlived Cézanne not to have been in vain.

<div style="text-align: right">

Clement Greenberg. "The Later Monet (1959)."
Art and Culture. Boston, 1961, p. 44 ff.

</div>

PIERRE AUGUSTE RENOIR

Renoir, the son of a tailor, was born in 1841 in Limoges. At the age of thirteen he became a china painter; he also painted fans and window shades. By 1862 he had saved enough money to enter the studio of Gleyre in Paris, where he made friends with his fellow students Monet, Sisley, and Bazille. In 1864 the Salon accepted a painting, *La Esmeralda,* which Renoir later destroyed. Prior to 1868 Courbet was his major influence. Joining Monet at La Grenouillère, he began painting outdoors, and his palette lightened. During the Franco-Prussian War (1870–71) Renoir served in the army. He resumed painting after the war, partici-pating in the first Impressionist exhibition of 1874. One of his entries was *The Loge* (Courtauld Institute, London).

Always interested in the figure, Renoir became a successful portrait painter in the late 1870's. This assured him a comfortable income and enabled him to travel to North Africa, Italy, Germany, Holland, and Spain. Although he exhibited in

several of the Impressionist group shows, he also showed at the Salon. Durand-Ruel gave him two one-man shows, in 1883 and 1892. About 1881–82 Renoir's form became more solid, and he entered his "arid" period. After 1900 he painted mostly nudes in warm reds and pinks. In 1906 he settled in Cagnes on the Riviera with his family and with Gabrielle, his maid and favorite model. Although disabled with arthritis and able to paint only with the brush strapped to his hand, he continued working until his death in 1919; his *oeuvre* is enormous. Toward the end of his life he also created sculptures by dictating to an assistant, who worked in clay according to his instructions.

> I arrange my subject as I want it, then go ahead and paint it, like a child. I want a red to be sonorous, to sound, like a bell; if it doesn't turn out that way, I put more reds and other colors till I get it. I am no cleverer than that. I have no rules and no methods; anyone can look over my materials or watch how I paint—he will see that I have no secrets. I look at a nude, there are myriads of tiny tints. I must find the ones that will make the flesh on my canvas live and quiver. Nowadays they want to explain everything. But if they could explain a picture it wouldn't be art. Shall I tell you what I think are the two qualities of art? It must be indescribable and inimitable.
>
> P. A. Renoir. Quoted in Walter Pach.
> "Pierre Auguste Renoir." *Scribner's Magazine,*
> May 1912, p. 610 ff.

> These so-called artists call themselves members of the intransigent set, or Impressionists. They grab a canvas, colors, and brushes, slap on some paint haphazardly and sign their names underneath. . . .
> Try to explain to M. Renoir that a woman's body is not a mass of flesh in a state of decomposition, on which the green and purplish spots denote a complete state of cadaveric putrefaction. . . .
> Albert Wolff (1876). Quoted in P. A. Lemoisne.
> *Degas et son œuvre.* 4 vols. Paris, 1946–49, I, 238.

> The painter who is attracting the most vehement notice after Monet is a figure painter: Renoir. All the refinements and unflagging enthusiasm that the former applies to capturing the subtlest tones of nature in broad daylight . . . Renoir employs in the rendering of flesh tints. Here, too, is an utterly new vision, a quite unexpected interpretation of reality to solicit our imagination. Nothing is fresher, more alive and pulsating with blood and sexuality, than these bodies and faces as he portrays them. Where have they come from, those light and vibrating tones that caress arms, neck, and shoulders, and give a sensation of soft flesh and porousness? The backgrounds are suf-

fusions of air and light; they are vague because they must not distract us.

Renoir's preferred subjects are women, and specifically young girls. His brush is superb at capturing their blushing ingenuousness and chastity—the blossom becoming a flower. His art is most certainly of French lineage. He is descended from the magnificent eighteenth century, when Watteau, Fragonard, Greuze, Madame Vigée-Lebrun, [Angelica] Kauffmann, and Drouais were producing works of marvelous inventiveness. The resonant and high-pitched quality of his color, however, is more reminiscent of that great genius, Eugène Delacroix. . . .

<div align="right">Émile Verhaeren. "L'Impressionnisme (1885)."

Sensations. Paris, 1927, p. 179 ff.</div>

The innate qualities of M. Renoir's art are, unfortunately, easier to appreciate than to define in words. It seems to me that they embody in one remarkable sentiment all that is intangible, capricious, and feminine in nature. Unconsciously, M. Renoir endows everything he sees with a particular expression, at once naïve and sophisticated, tranquil and moving. His prototype of a young girl definitely remains unmodified: we find the same delightful little being everywhere, in all varieties of dress and attitude, like a kitten . . . who half opens on the world its strange little eyes, malicious but full of tenderness. It is not only the contour of the body and the cast of the features that create this expression; we see it also in the semifantastic scenes which serve as background to the figures. We find it even in the simple and powerful actual landscapes M. Renoir likes to paint from time to time. . . . M. Renoir reveals himself most fully to us in his flower paintings, the finest ever painted. They are marvellously alive, bursting with color, and always compelling in their wholly feminine mixture of gentle languor and disquieting whimsy.

M. Renoir is, therefore, a painter of our time: . . . it is exactly this troubled and intangible sensual melancholy which he imparts to everything he paints. But M. Renoir is also a classical painter. . . . He is concerned with formal perfection, and hates exaggeration. More and more he is veering towards an art of discreet and simple harmony, thus returning to the spirit of the old French masters, the only one amongst us to do so. And thereby, surpassing Impressionism, surpassing all the restless and sickly painting of his time, he rejoins that admirable master in whose company posterity will certainly place him—the poet [Watteau] of the *Leçon d'amour* and the *Embarkation for Cythera.*

<div align="right">Téodor de Wyzewa. "Renoir (1890)." *Peintres de*

jadis et d'aujourd'hui. Paris, 1910, p. 375 ff.</div>

I went to see Renoir. He had on his easel a red crayon and chalk drawing of a young woman nursing her baby, charming in its grace and subtlety. As I was admiring it, he showed me a series of drawings done from the same model and in similar poses. He is a draftsman of the first rank. All these preliminary studies would astonish the public which obviously imagines that the Impressionists work tremendously fast. I do not think one could go further in the rendering of form in a drawing. I am charmed by his *Bathers* quite as much as by those of Ingres. He tells me that the nude is absolutely indispensable as an art form.

I have also been struck by two views of Venice and Algiers. Both canvases show a strong feeling for the Orient. In short, [Renoir] is an artist *de race*, a subtle, brilliant draftsman and yet a colorist with a most exquisite, almost morbidly acute, sense of color.

> Berthe Morisot. "Journal." *Correspondance*
> *avec sa famille et ses amis.* Paris, 1950, p. 128.
> Entry for January 11, 1886.

In an exhibition on the Boulevard des Italiens I see a strange head. I don't know why something happened inside of me, and why I should hear strange melodies in front of a painting. The head of a doctor, very pale, whose eyes do not stare at you, do not see, but listen.

In the catalogue I read, *Wagner,*[*] by Renoir.

This needs no commentary.

> Paul Gauguin. *Avant et après* (1903).
> Paris, 1923, p. 191.

The handling of the large-sized portrait groups seems often unnecessarily coarse and repellent. Many find it hard to appreciate his landscapes, considering them to be thin, of a greasy woolly texture, unatmospheric and lacking many of the qualities one looks for in such representations of nature. The work of Auguste Renoir will always remain a battlefield for the critics.

> Wynford Dewhurst. *Impressionist Painting.*
> London, 1904, p. 52.

When the subject is simple he begins his canvas by tracing some very sketchy outlines with the brush, generally in a brownish-red, in order to note the proportions of the pictorial elements. "The volumes," he says, with a somewhat mocking air. Immediately thereafter he

[*] Renoir's portrait of the composer Richard Wagner was painted in 1882 and is in the Paris Opéra.

rapidly rubs the canvas with pure colors diluted with turpentine, as if he were painting a watercolor, and we see something vague and iridescent emerge, the colors running into one another. It delights us even before we have understood the meaning of the image.

At the second session, when the turpentine has evaporated somewhat, he returns to this preparatory work, proceeding in much the same fashion but with a mixture of oil and turpentine and a little more coloring matter.

He lightens the areas that are to be bright by putting pure white straight on the canvas. He strengthens the shadows and halftones in the same manner, directly on the canvas. He hardly ever mixes the colors on the palette, which is covered only with small, comma-shaped dabs of almost pure color mixed with oil.

Gradually he states the forms more precisely, yet always blending them. "It has to set," he says. A few more touches . . . and we see the soft, rounded forms of the first stage rise from the colored mist. A jewel-like luster glistens on them, and they are wrapped in golden transparent shadows.

He has found reds and blues never seen before. He has put accents of pink silver on cool greens—the bittersweet charm of spring. The pure whites he has dared for some time now to use as highlights appear as if they themselves are colored, so cleverly are they surrounded by color.

Before undertaking a complicated composition, he does not make what can properly be called studies. Once he has found his subject, he executes a few small pictures in the spirit of the subject. It may be a single figure, or several figures. These studies are for him a sort of training for the definitive work. When the composition is completely fixed in his mind, he draws it in sanguine and then transfers it to the canvas. . . . In the course of his work he cannot change his brush. Once chosen and attached to his paralyzed fingers it speeds from the canvas to the turpentine pot for cleaning and returns to the palette for a little color which it carries to the canvas. When he becomes tired someone has to remove the brush from his hands. . . .

<div style="text-align:right">Albert André. *Renoir.* Paris, 1918, p. 22 ff.</div>

By subjecting himself to the influence of the Impressionists Renoir showed that he was neither spiritually profound nor intellectually strong; being only a *painter* he inevitably underwent the same influences as almost all the Impressionists. . . . When this period was over, Renoir found his way. He returned to large figure paintings, the portrait and the nude. But the solidity of his early years, the profound pictorial sense of his first works, was gone. The Impressionist period left an indelible mark on all his subsequent paintings. He neglects

drawing; violet and orange are his predominant colors. He later eliminates, or, rather, reduces the use of these two colors so characteristic of Impressionism, and uses more reds and ochres. In this period he treats the figure in an exaggerated manner which often lends his pictures a fascinating psychological and caricature-like aspect.

The Luncheon of the Boating Party [is a work] full of melancholy and deep *ennui*. . . . The boredom of a Sunday afternoon, of a trip to the country, of the minor daily tragedies, are fixed in the gestures and expressions of his obscure characters. This aspect of boredom and melancholy is devoid of certain metaphysical implications, of a subtle, inexplicable feeling which always accompanies a true work of art. . . .

The type of woman whom Renoir left us [is] the petit bourgeois, the housewife, the mother, the maid, or the young girl; she may be at the piano, in the backyard, or in the garden, but always in a somewhat stifling setting. These women, when indoors, always seem to be in low-ceilinged rooms. When outdoors, they work in the still, sultry heat of a summer evening, or in one of those heavy, oppressive late spring afternoons like that in which Flaubert makes the unhappy husband of Madame Bovary die, with the solemn pathos of a Greek tragedy.

<div align="right">Giorgio de Chirico. "Augusto Renoir."

Il Convegno, I, 1920, p. 43 ff.</div>

Why is it that we do not find his nudes shocking? First of all, because they are healthy; secondly, because they are "painting." Renoir's lyricism and plastic sense have transformed them. They are not idealized (thank heaven!) but they have become form and color. . . . Such is the magic of art that they no longer exist except as pink light relieved by pearl-gray, mauve, and green, sustained by harmonious volumes and balanced masses. Signs, symbols, and images of Renoir's optimistic frame of mind, they retain the joy of the spirit and the delectation in nature, as it was called in the time of Poussin. Nothing remains of base, animalistic passion.

The type of humanity he has created—the healthy, splendid bodies, the beautiful structures of robust flesh and blood, steeped in a feeling of classic serenity—is free from all perversity. *Sana, sancta.* The expression of innocent animalism [in these figures] places them in the same category as flowers or magnificent fruit. Not even antiquity rendered better the freedom of instinct, or portrayed it in a manner at once more sensual and more chaste. If Renoir could be reproached for anything, it is that he had no notion of original sin. Yet there is melancholy in these faces—the melancholy of the antique.

<div align="right">Maurice Denis. "La Mort de Renoir (1920)."

Nouvelles théories sur l'art moderne, 1914–1921.

Paris, 1922, p. 108.</div>

It was in the house of Stéphane Mallarmé that I encountered Renoir for the first time. He was seated on a small sofa on which Whistler and Redon had often sat. . . . Renoir was neither silent like Redon nor a conversationalist like Whistler. His features and body were thin and he appeared extremely nervous, his face twitching and intelligent, refined and with watchful eyes. . . . With a somber mien and simple movements Renoir had just sketched a little portrait of Mallarmé. . . .

I met him again at Berthe Morisot's . . . in a strange milieu of rare distinction . . . Eugène Manet, nervous and hard pressed, Berthe Morisot of a lofty and cool courteousness, of a distant elegance beneath her white hair, her glance sharp and sad, and little Julie, a silent but wild child. . . . Friends of the house sometimes met for dinner. Degas gave the cue to Mallarmé. Téodor de Wyzewa contributed his Slav subtleties. Renoir partook of his meal with provincial, rustic gestures, his hands already deformed.

. . . These encounters with Renoir . . . left in my memory the living image of a great artist, and constitute for me, as it were, the frontispiece to his work.

<div style="text-align: right">

Henri de Régnier. *Renoir, peintre du nu.*
Paris, 1923, p. 9 ff.

</div>

The miracle is not that Renoir was able to paint until the last minute of his life, in spite of all his illnesses, but that he could realize, in so great a number, works of such high quality that we have to go back to the period of 1874–79 to find an equivalent. *The Judgment of Paris* (1908), . . . two or three *Seated Nudes* of 1912, two or three compositions of *Bathers* of 1916 or thereabouts (among them the *Bathing Group* of the Barnes Foundation) are masterpieces which impress as much by the Dionysiac exaltation of color as by the rhythmic suppleness of forms and the prodigious harmony of Renoir's vision in surface and depth.

In 1916 Dédée became Renoir's model; Renoir was fascinated by her. His art was rejuvenated again by her bright youthfulness, by her skin which reflected the light so well. I have counted over one hundred paintings and sketches (heads, nudes, and portraits) done by Renoir with Dédée as model, all dating from the last four years of his life. Many of them rank among his masterpieces. Red with an infinite variation of shades predominates.

. . . The nudes, especially, are powerfully assertive, even in the rapidly executed sketches. They are hymns to light and color, to youth and life. With the exception, perhaps, of Titian and Cézanne, no

painter but Renoir has in his old age shown such enthusiasm for a life that is constantly renewing itself.

<div align="right">Lionello Venturi. *Les Archives de l'impressionnisme.*
2 vols. Paris, 1939, I, 108.</div>

There are no *periods* in his work, in the usual sense of the word; there is only a slow maturation. If we observe a progressive tightening in his draftsmanship—between 1881 and 1890 it reminds us of Ingres —followed by a period in which it loosens and becomes less sharp, it is because he has reached an age where he, like all the great technicians, has freed himself of all effort and can enjoy the pleasures that come with experience, guided by instinct alone. . . .

The genius of Renoir makes us marvel, as did that of Ingres, for he also turned to the past and was unaware that the implacable present caused his hand to deviate, compelling him to graft onto the classical line the most astonishing deformations. Onto the traditional "roundedness" and upon the sacrosanct modeling Renoir paradoxically grafted the strongest colors possible, which negate this modeling. He alone was able to bring off this miracle of reconciling the most famous opposites in painting, without apparent effort and as if aided by a superhuman grace.

. . . While Cézanne . . . achieved space by means of a series of vertical planes set up in depth, like the steps of an imaginary staircase, Renoir suggests it by a series of dancing globes, revolving in the manner of melting stars, from the foreground to infinity. In the late paintings these rotundities, these balls with fiery, cometlike tresses, inexorably attract everything into their variegated orbit—grass, human shapes, garments, clouds, even water and foliage. The sphere . . . is the common denominator to which the Master of Cagnes reduces all forms, even the smallest. It is thereby that he achieves his unity and his undulating rhythm. . . .

Renoir rejects from his work all the "M. Bertins"[*] he could have portrayed and all the devotees of facts—realists who exist under the hypnotic spell of material things. He portrays only artists such as Bazille, Monet, Sisley, or Wagner, depicts only subtle minds like that of [the collector Victor] Chocquet. By painting principally women and children, those symbols of sensitivity, Renoir opposes the all-consuming ardor of an age committed to a terrible power complex with all the innocence and all the potential for happiness still remaining in the world.

<div align="right">André Lhote. *Renoir: peintures.* Paris, 1947, p. 4 ff.</div>

[*] This refers to Ingres' portrait of M. Bertin, who represents the epitome of a fat, smug philistine.

The Luncheon of the Boating Party
Le Déjeuner des canotiers à Bougival

1881 oil on canvas 51" x 68" Washington, D.C., Phillips Collection

The Luncheon of the Boating Party marks the culmination point of Renoir as a painter of modern life, and his farewell to Impressionism. . . . The subject . . . is similar to that of the *Moulin de la Galette* [1876; Louvre]. It is a happy assembly of men and women, of the young and casual *bohème*. . . . The luncheon is drawing to a close in a pleasant disorder. The men, having just finished handling the oars, have retained their straw hats and jerseys, the insignia of their activities. Others, having arrived from Paris, are sporting a more urban attire; even a top hat can be seen. Some of them are still seated, others are rising to chat with one another or with the young women. Words are being exchanged across the table or among small groups attracted to each other. A beautiful young girl, with red lips and smiling eyes, wearing a little striped sailor hat on her fluffy hair, is turning toward a young man who leans over her shoulder. Her neighbor, a sportsman with bare arms, remains silent and indifferent, his gaze vague. Further down, a somewhat older man with a sarcastic profile is amused by the shocked expression of the girl he has addressed, who stops her ears because she does not want to listen. Three of the ladies do not seem concerned about their beaux. One, in the foreground, is alone with her little dog whom she has placed on the table before her, telling him that he is far prettier and more interesting than those nasty men. The other girl at the end of the table is busy with her glass, taking a last sip. A third girl rests her elbows on the banister of the terrace, . . . turning her back on the beautiful scenery visible beneath the scalloped edge of the awning, and on the water glistening between the branches.

Thanks to the jolly fellow behind her, who is leaning against the table and questioning her with voice and gesture, she is showing her pretty face resting in the hollow of her hand, her face fresh as a piece of fruit. Though she is smiling there remains in her eyes, shadowed by her straw hat, a trace of mystery and musing.

Only a great artist would have the intuition to place a figure evoking a stream of mysterious impressions somewhat apart, in the rear of a picture of a simple, almost trivial reality. . . . The figure of this young woman with her elbows on the balustrade had been a favorite subject of Renoir's studies.

<div style="text-align:right">Paul Jamot. "Renoir." Gazette des Beaux-Arts,
December 1923, p. 321 ff.</div>

Every inch of the canvas is alive and worth framing for itself, yet an integral part also of the complex pattern in which we note an interesting use of inverted perspective. In spite of all the people, the landscape, the sparkling, sumptuous "still life," there is no division of interest and no crowding nor con-

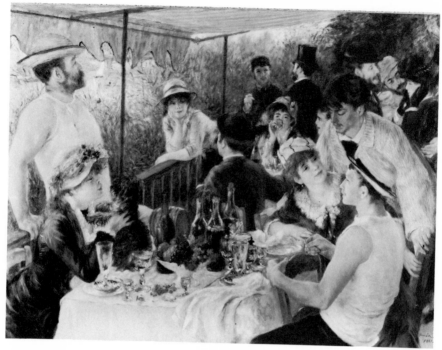

The Luncheon of the Boating Party. *Renoir*

fusion. We feel to the manner of Titian and Rubens is added the Impressionist's art of expressing the passing moment in the softness of a woman's glance, the flapping of the striped awning in a fitful breeze, the unity and vivacity of the caressing enveloping light.

Duncan Phillips. *A Collection in the Making.*
Washington, D.C., 1926, p. 34.

The Bathers
Les Grandes Baigneuses

1884–87 oil on canvas 45½" x 66" Philadelphia Museum of Art

In his conversations with the art dealer Ambroise Vollard* Renoir remarked that by 1883 he had "wrung Impressionism dry" and had reached the point where he felt that he could neither paint nor draw. He entered a new phase, his "arid" period *(période aigre)* in which he aimed at classic form while retaining the lumi-

* A. Vollard: *Renoir, an Intimate Record* (New York, 1925).

519

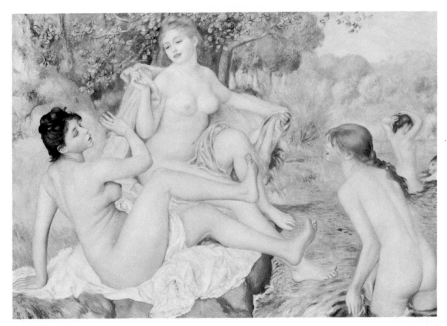

The Bathers. *Renoir*

nosity of the Impressionist palette. After three years of experimentation he painted *The Bathers*, which he himself considered a masterpiece. When it was exhibited at Georges Petit's Exposition Internationale in 1887 Camille Pissarro wrote to his son Lucien, in a letter of May 4, 1887, that Renoir, now emphasizing line without regard for color, had isolated his figures and had thus become "unintelligible."

The general movement and some of the poses were inspired by a relief on Girardon's *Fountain of the Nymphs* at Versailles, and throughout the many studies for the finished picture this sculptural conception persists. It is most marked in a large drawing, a cartoon worthy of the Renaissance, where the sense of relief and the flow of line are so perfectly satisfying that I cannot conceive why Renoir should have altered them; yet in the finished picture every interval is worked out afresh. The execution is equally deliberate, and although the tonality recalls Boucher, the use of paint has none of his decorative ease. In certain lights it almost seems as if the painstaking enamel of the surface has killed the first sensation of delight; but a passing cloud or an unexpected reflection will soften those dry transitions so that the whole picture flatters the eye like a Gobelin tapestry.

The *Grandes Baigneuses* occupied Renoir from 1885 to 1887, and whether we consider it a masterpiece or a prodigious exercise of will, it liberated him from his anxieties. In the next twenty years his nudes still show to the perceptive eye evidence of labor and calculation, but it is artfully concealed.

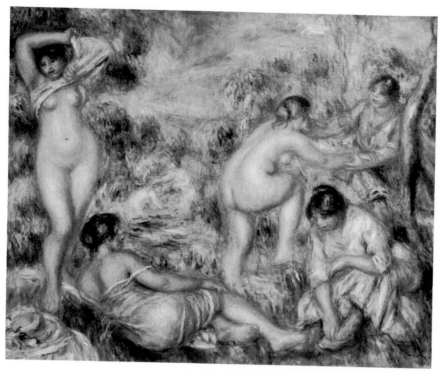

Bathing Group. *Renoir*

These charming creatures sit by the banks of streams, dry themselves, or splash each other with an appearance of perfect naturalness and spontaneity. They are somewhat plumper than the classical norm and have an air of Arcadian health. Unlike the models of Rubens, their skin never has the creases and puckers of a body that is normally clothed, but fits them closely, like an animal's coat. In the unselfconscious acceptance of their nudity they are perhaps more Greek than any nudes painted since the Renaissance, and come closest to attaining the antique balance between truth and the ideal.

Kenneth Clark. *The Nude: A Study in Ideal Form.*
New York, 1956, p. 169 ff.

Bathing Group

1916 oil on canvas 28¾" x 36½" Merion, Pa., Barnes Foundation

Most of the characteristics of Renoir's late work attain their highest point of development in *Bathing Group* of 1916. This picture though painted three years before his death represents the apotheosis of his art, the culmination of his steady growth in profundity of imaginative insight, in resources and in

technical skill. The design is a fusion of two late types . . . : one in which all the objects are generalized and have an equal compositional status in the form as a whole; the other in which the components are primarily individual units in an organization of volumes in space.

Color attains to the highest levels of sensuous quality and active movement: every object is constructed of deep, rich, luscious, voluptuous color, and the richly variegated organization is resplendent with shimmering color-chords, and has the exuberance, the glamour of a glorified bouquet, studded with sparkling jewels. A delicate many-toned rose-red dominates the ensemble and its areas interlock with large areas of green and blue to form a three-colored general pattern which is interspersed with areas of iridescent light and color. . . .

The high esthetic value of the picture springs from the fact that color is in supreme command everywhere: line, space and light have no independent identity except as aspects of color; hence, the indissoluble oneness of all the individual plastic units in a single, highly decorative and expressive form. An important factor in this unification is the all-pervasive luminous and richly colorful suffusion which radiates from the ubiquitous iridescent units. . . .

Correspondingly, drawing, modeling, color, technique, light, space and composition, all contribute to and are affected by the many-phased plastic activities of the suffusion. This coördination and fusion of all plastic factors reach a high degree of intricacy, individuality and perfection in the compositional organization of *Bathing Group*. Any one of the individual units may be selected as a focal point and corresponding units will be found elsewhere in the picture to balance it and establish equilibrium. Moreover, these subsidiary groupings flow into one another in a continuous movement that embraces every plastic factor in the entire composition. The unity thus established is between a wealth of plastic relationships greater than in any of Renoir's previous paintings, and the technical skill in execution represents the climax of his powers.

<div align="right">A. C. Barnes and Violette De Mazia. *The Art of Renoir*.
New York, 1935, p. 144 ff.</div>

BERTHE MORISOT

Berthe Morisot, a great-grandniece of Fragonard, was born in 1841 at Bourges. Together with her sister Edma she studied painting with G. A. Chocarne and J. B. Guichard. Corot, whom she first visited in 1860, encouraged and influenced her, suggesting that she study with his follower Oudinot. In 1868 Berthe Morisot met Manet, who invited her to paint in his studio. She often posed for him, and appears in his *Balcony*. In 1874 she married Manet's younger brother Eugène. From 1864 to 1873 she sent her pictures to the Salon, but from 1874 to 1886 she exhibited with the Impressionists in all but one (1879) of their eight group shows. Her first

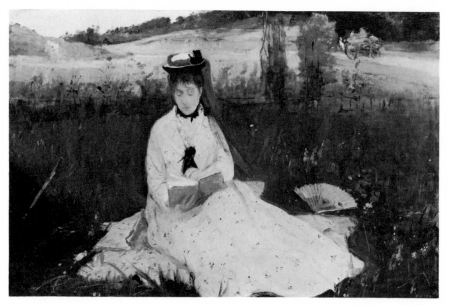

Madame Pontillon, Sister of the Artist. *Morisot*

one-man show was in 1892; she died in 1895. In 1896 Durand-Ruel gave her a retrospective for which Stéphane Mallarmé, with whom she had maintained a long and distinguished friendship, wrote the preface to the catalogue. Morisot's favorite subjects were figure paintings and intimate family portraits, especially of her daughter Julie and her niece Jeannie Gobillard (who later married the symbolist poet Paul Valéry), as well as landscapes and flowerpieces.

Mlle. Morisot is always the same: rapid sketches, delicate, even charming in tone, but alas!—there is no solidity, no full-bodied complete work. She always serves fluffy beaten egg whites on vanilla cream at her dinner parties of painting.

J.-K. Huysmans. "Appendice (1882)." *L'Art moderne.*
Paris, 1908, p. 288.

Mlle. Berthe Morisot is all elegance: bold, clear, and nimble technique, and feminine charm without affectation. In spite of a tendency toward improvisation her values are rigorously accurate. Those young girls sitting on the grass, at their toilet, or combing their hair (all paintings) are exquisite works; her rapid drawings and swiftly delineated watercolors are a joy.

Félix Fénéon. *Les Impressionnistes en 1886.*
Paris, 1886, p. 17.

523

The world is for her an elegant spectacle in which ugliness or bitterness have no part. A harmony of bright tones, of light and mobile forms, is the sole theme of her paintings, pastels, and drawings. The figures seem but shadows, yet are so graceful and so intimate in expression that no one would think of regretting the absence of contour and life. Furthermore, it is only the physical and material side of life that is missing from Mme. Morisot's figures. For there is hardly one of them which does not fully reveal its soul, and this soul is charming, at once naïve and sophisticated, smiling and melancholy, the soul of a little princess in the suburbs of Paris. Mme. Morisot is today the foremost among the musical painters. Her works suggest an infinitely varied range of feminine feelings, and no one knows better than she how to express a figure in terms of an appropriate ensemble of lines and colors.

Téodor de Wyzewa. "Mme. Berthe Morizot [*sic*] (1891)." *Peintres de jadis et d'aujourd'hui.* Paris, 1910, p. 218.

All these bright, iridescent paintings, here, precise, impulsive, can await that propitious future when, even before their worth has been determined, the Name that heads their catalogue will be pronounced for its own sake, for the extraordinary charm of its bearer, and evoke a person of exquisite breeding, in her life and her exceptional personal elegance. Paris knew her little, though she was so much part of it, both by lineage and by deliberate graceful intent, except for exhibitions like this one or other public shows, usually of Monet and Renoir, where Degas might be somewhere around, perhaps in front of a Whistler or a Puvis de Chavannes, among the visitors to the great salon of an evening. Daytime, on the other hand, would find her in her beautifully kept studio, its Empire paneling framing canvases by Édouard Manet. When, in turn, the lady herself painted there, with fury and nonchalance, for years, keeping up the monotony, yet radiating a profusion of fresh ideas, it must be said—always—that except for the intimate receptions where, the materials of art having been put aside, art itself was far away, yet omnipresent in conversation that matched the decor, ennobled by the participants. . . .

To remember the enchantress apart from her magic art is to obey an immediate wish in accordance with a thought she herself cherished: to be perceived by others as she felt herself to be; and we can say that she never lacked admiration or solitude. Furthermore—we must look at these walls—to recognize that, while current praise would see in her a typically feminine talent—she was indeed also a master. Her work, now completed, is worthy, in the estimation of some of the great revolutionary artists who considered her a comrade-in-arms, to rank

beside that produced by any one of them, and is intimately, exquisitely
linked with the history of painting during an epoch of this century.*

<div align="right">

Stéphane Mallarmé. "Berthe Morisot (1896)."
Divagations. Paris, 1935, p. 129 ff.

</div>

Those who know and love the charm of her work are fully aware
of the sober qualities of her life—a life of retired elegance—simple,
single-minded, inwardly and passionately devoted to her work. They
know that the true begetters of her taste and vision were the luminous
painters whose art died out before David: that her friends and constant
associates were Mallarmé, Degas, Renoir, Claude Monet, and very few
others; that her noble and unrelenting aim was the highest and most
refined art, of the kind which, by means of countless studies, produced
and then pitilessly destroyed, consumes itself to attain the final, mirac-
ulous effect of instantaneous creation out of the void.

As for her personal character, it is well known that it was rare and
reserved; distinction was of her essence; she could be unaffectedly and
dangerously silent, and create without knowing it a baffling distance
between herself and all who approached her, unless they were among
the first artists of her time. . . .

But the peculiarity of Berthe Morisot . . . was to live her painting
and to paint her life, as if the interchange between seeing and render-
ing, between the light and her creative will, were to her a natural
function, a necessary part of her daily life. She would take up the
brush, leave it aside, take it up again, in the same way as a thought
will come to us, vanish, and return. It is this which gives her works the
very particular charm of a close and almost indissoluble relationship
between the artist's ideals and the intimate details of her life. Her
sketches and paintings keep closely in step with her development as
a girl, wife, and mother. I am tempted to say that her work as a whole
is like the diary of a woman who uses color and line as her means of
expresssion.

<div align="right">

Paul Valéry. "Tante Berthe (1926)," and "Berthe
Morisot (1941)." *Degas, Manet, Morisot.*
New York, 1960, pp. 123, 119.

</div>

Berthe Morisot was an artist *de race*. Everyone who ever knew
her or wrote about her work eventually turns to the descriptive adjec-
tive "charming." As an artist, as a friend, as a woman she was exactly

* This translation attempts to reproduce Mallarmé's condensed and complex style.

that. . . . Berthe Morisot's charm was entirely French of her epoch in quality and character. It was based on personal distinction, wit, cultivated intelligence, femininity and grace. . . .

. . . It was [in the Louvre] while she was copying a detail from the Marie de Medici series by Rubens, that she met Édouard Manet. . . . The deep and lasting friendship which followed was certainly to the advantage of both. Her painting became freer in technique and more daring. He came to a better realization of the subtle challenge of painting *en plein air*. Until then Manet had painted almost entirely indoors. The real ambition of both was the same, to place fully realized, casual human beings in the vibrant atmosphere of nature.

Inevitably Berthe Morisot became a member of the Impressionist circle. . . .

Berthe Morisot's long, extraordinary friendship with the poet Mallarmé was partly based on their mutual, intense dislike of anything vulgar in art and life. There was also in her an instinctive perception of and sympathy with the symbolist ideas as they were spoken or written by the poet.

<div style="text-align: right">

Elizabeth Mongan. *Berthe Morisot: Drawings, Pastels, Water Colors, Paintings.* New York, 1960, p. 11 ff.

</div>

HENRI ROUSSEAU

Rousseau was called *Le Douanier* because he was a customs inspector at a Parisian tollgate. Born at Laval in 1844 he claimed to have fought in the Mexican War of 1862, but only the record of his army service exists. During the Franco-Prussian War of 1870 he was a sergeant. Rousseau, who was self-taught, began to paint about 1880. In 1886 Paul Signac invited him to participate in the Salon des Indépendants, founded in 1884, where he showed *Carnival Evening* (Philadelphia Museum of Art). He continued to exhibit with the Independents and at the Salon d'Automne (founded in 1903) until his death in 1910.

Rousseau was "discovered" by Apollinaire and by Alfred Jarry, the author of *Ubu Roi;* although supported by the literary avant-garde, his work was ridiculed and found few buyers. In 1908 Picasso, who had just bought one of his early portraits, *Mademoiselle M.,* gave a banquet in his honor, which was later described by several guests, among them Gertrude Stein, Fernande Olivier, and the art historian Maurice Raynal. Rousseau maintained an art school, where he taught painting, diction, and music. He gave musical *soirées,* playing the violin or clarinet, and wrote three plays. He was married and widowed twice. Toward the end of his life he became implicated in a fraud connected with the Bank of France, but his sentence was remanded. The German art dealer Wilhelm Uhde, who met Rousseau in 1907, became his first biographer (1911) and his first dealer, followed by Ambroise Vollard and Josef Brummer, whose portrait Rousseau painted in 1909.

He [Rousseau] seems to have been one of those harmless amateurs who continue sending perfectly hopeless pictures before the juries of exhibitions without ever getting them exhibited. . . . His work is perfectly innocent and entirely inept, and his pictures resemble the productions, on a larger scale than usual, of a child of seven.

> Kenyon Cox. "The 'Modern' Spirit in Art."
> *Harper's Weekly,* March 15, 1913, p. 165.

The *Douanier* painted with the purity, the charm, and the candidness of a primitive. He also played [the violin]. . . . The art of music nurtured the art of painting, and if Ingres' violin has by now become proverbial, we can say that without the violin of the *Douanier* we would not have had any of those strange decorations that are the only element contributed by American exoticism to the plastic arts in France. . . .

I have posed* a number of times for the *Douanier,* and he began by measuring my nose, my mouth, my ears, my forehead, my hands, my entire body. He then transposed these measurements with great care to his canvas, reducing them to the dimensions of his frame. During that time, in order to divert me from the tedious task of posing, Rousseau would sing songs from his childhood to me. . . .

His only shortcomings were due to an occasional excess of feeling, to a somewhat folksy naïveté from which he was unable to free himself, and which contrasted a little too strongly with his artistic endeavors and with the position he had been able to achieve in contemporary art.

The *Douanier* saw his paintings through to the end, which is a very rare thing nowadays. In his work we find no trace of mannerism, no particular way of doing things, no system. Hence the variety of his work. He mistrusted neither his imagination nor his hand. Hence the felicity and the richness we find in his highly decorative compositions. Having served in the Mexican campaign, he retained a very precise visual and poetic image of tropical flora and fauna.

Thus it happened that this old Breton living in the Paris suburbs is without doubt the strangest, most daring, and most charming painter of exotic subjects. The *Snake Charmer* [1907; Louvre] shows this abundantly. But Rousseau was more than a decorator, more than a creator of images, he was an artist. . . . His love of order is notice-

* Two versions of the portrait *The Poet and his Muse* (1909) are in the Museum of Modern Western Art, Moscow, and the Kunstmuseum, Basel.

able not only in his paintings; it is even more apparent in his drawings, all neatly arranged like Persian miniatures. . . .

I have often seen Rousseau at work, and I know what care he lavished on every detail, as well as his gift for retaining the original and definitive conception of his painting until its completion. He never left anything to chance, above all nothing essential.

> Guillaume Apollinaire. *Il y a* (1914).
> Paris, 1925, p. 171 ff.

His black areas are lightless spaces which act on the eye like prismatic colors in uneven relationships. These blacks sparkle and appear alive among the thousands of greens grouped to form trees, underbrush, and forests. Rousseau does not copy the external appearance of a tree; he creates an internal and rhythmic entity, the true, solemn, and essential expression of a tree and its leaves in relation to the forest. The way he multiplies these contrasts by building up a marvellously rich scale of green tones bears witness to his quasi-scientific knowledge of his craft.

In a Rousseau landscape there is nothing superfluous. There is no element that is not in its place, and which does not contribute to the world he re-creates. . . .

Rousseau is ancient in expression, and yet he is also very modern. He must be studied in relation to the other painters of our time, the destroyers and the rebuilders. . . . He presented himself so naturally and was so lacking in reserve that he seemed like a phenomenon, even as an isolated case, whereas he actually was a truly popular synthesis.

> Robert Delaunay. "Henri Rousseau le Douanier."
> *L'Amour de l'Art*, November 1920, p. 228 ff.

Rousseau represents the perfection of a certain order of thinking. The first of the *Douanier's* work that I had the opportunity of acquiring has haunted me with its great power. I was walking along the Rue des Martyrs. A merchant of bric-a-brac was disposing of piles of canvases outside his shop. A portrait head stuck out, the face of a woman with a harsh look of French astuteness, decisiveness, and clarity. The canvas was huge. I asked the price. 100 cents (*sous*), said the merchant, you can paint over it again. . . .

It is one of the most truthful psychological French portraits.

> Pablo Picasso (undated). Quoted in Florent Fels.
> *Propos d'artistes*. Paris, 1925, p. 144.

Rousseau's art is not a true folk art issuing from a collective consciousness. It is the work of a man of the people, but marked with the deeply personal imprint which reveals a soul. He is not, as some would have it, the towering artist. However, we are fortunate to have, in an epoch thirsting for poetry, the works of the *Douanier* in addition to the researches of our great painters—works filled with enchantment and rising in their midst like the clear waters of a fountain.

Christian Zervos. *Rousseau.* Paris, 1927, p. 72 ff.

In many respects his art is abstract and even Surrealist. His Surrealism is the sort that springs from a healthy poetic vision or dream. It is transcendent, radiant, full of love and joy. It is a flower from the Garden of Eden. It is the extreme opposite of the abysmal and negative. I imagine that Rousseau tapped the same spiritual wells that William Blake did when he wrote his *Songs of Innocence,* and *Songs of Experience.* And is not Rousseau's poem *Yadwigha* much like Blake's poem *Tiger, Tiger, Burning Bright* or Edgar Allan Poe's *The Raven?*

Max Weber. "Rousseau As I Knew Him."
Art News, February 15, 1942, p. 35.

One or two misconceptions about this great artist are not yet dispelled. He is sometimes called an amateur, or a "Sunday painter." It is implied that his painting was a hobby. Nothing could be farther from the truth. Rousseau always described himself as *artiste-peintre,* which means a professional painter. It was his ambition to become an academician, to rival the perfect "finish" of Bouguereau or Courtois, to be accepted (as he might have said) in the best circles. When he saw the Cézanne memorial exhibition in 1907 he was distressed. "I could have finished these paintings for him," he said.

Rousseau does not belong to "the modern movement," though he has no doubt had an influence on painters who do—even on Picasso and Braque. There has been much talk of his *naïveté,* but the word is misleading if it implies anything childish or incompetent. Rousseau was not even spontaneous: he was a hard worker, a meticulous craftsman. "I have been told that my work is not of this century," he wrote in a letter to the art critic, André Dupont, in 1910. "As you will understand, I cannot now change my manner which I have acquired as the result of obstinate toil. . . ." I would rather call Rousseau a *natural* painter. His nearest affinities are with folk-art—with the glass-paintings, illustrated chap-books, painted pottery which

529

represent the natural expression of untaught people throughout Europe. . . .

Certainly he was not a naturalistic painter, intent on reproducing the exact image recorded by his visual perception of the outer world. He made a deliberate study of nature, but so does Picasso or Henry Moore, or any genuine artist. . . . It has been said that the tropical jungles and exotic landscapes which Rousseau painted were not reminiscences of the four years he spent in Mexico as a regimental musician, but that he made accurate studies of the vegetation in the Jardin des Plantes in Paris. But a Chicago professor, who has studied photographs of several pictures, reports that "the plants are conventionalized and most of them are difficult to identify." . . .

Rousseau may not be a great artist, in the sense in which we recognize Raphael or Rembrandt or Picasso as great artists. . . . But he is greatly significant in that he measures very exactly the dividedness of our civilization, our schismatic culture. A true culture is indivisible. Art, in a true culture, emerges like spring water on every hillside. Rousseau was an oasis in our desert.

<div align="right">Herbert Read. "Henri Rousseau (ca. 1944)."

A Coat of Many Colours. New York, 1956, p. 100 ff.</div>

Rousseau's sense of form was as highly developed as his sense of fantasy. His work is craftsmanlike as well as creative, his drawing clean and sure. . . .

His composition is a triumph of space perception, delicately plotted and sensitively balanced. . . .

His sense of color values was no less notable. The blues, violets and pinks are both subtle and beautiful, the greens and blacks simply incomparable. Certain of his pictures are done almost entirely in a gamut of greens, and his bold use of black astonished Gauguin and has left lesser painters gasping. "Matisse's pinks and light greens," I noted in *Picasso et la Tradition Française,* "are artful and tasteful, Manet's brown is brilliantly effective, but Rousseau's black grips the very soul." . . . Rousseau had no theory of color, but fully understood its possibilities and became an absolute master of its effects. The gloomy gray-greens in his view of the Paris fortifications accent precisely the cheerless remoteness of the spot. The pinks, grays and light greens of his *Snake Charmer,* on the other hand, are so seductive that one can almost hear the notes of the snake charmer's flute.

Yet colors, like patterns and forms, were but a means to an end. Translating them to their simplest and most significant terms, Rousseau used them to express what his heart impelled him to say. He studied literal detail, often making drawings in the Jardin des Plantes,

or going out in autumn to gather leaves and grasses for examination at home. . . . He was a conscious stylist, interpreting color, form and pattern in his own way.

<div align="right">

Wilhelm Uhde. *Five Primitive Masters.*
New York, 1949, p. 36 ff.

</div>

Rousseau's great compositions are distinguished by movement caught at a particularly striking moment, in a story that develops in his mind, of which the picture is to a certain extent the symbol. The dramatic element of his pictorial vision has been considered more often than not as the full theme of the subject treated. This is true to the extent that we are not able to recreate the fiction from which it derives. Hence comes the need on Rousseau's part to animate his pictures with the aid of verses, sentences destined both to complete the comprehension of the picture and to bring to life figures from those plays for the theatre that at certain periods of his life had, as we know, preoccupied him enormously.

Rousseau had been led to treat the implication of the themes of space and time from an unexpected angle in order to render visible the development of the narrative that, *sous-jacent*, is to be found in his important paintings. Seeking to create the illusion of depth or the distance between the different objects, Rousseau had recourse at times to methods of perspective that though incorporated in his special vision are nonetheless unusual, especially if we compare them with the conventional usage of these principles codified during the Renaissance. Hence comes the assertion that has been repeated so often that Rousseau had no idea of perspective. . . .

Perspective as Rousseau conceived it . . . proceeds from his mechanical vision of duration. Seemingly it is constituted by a series of movements in a process of transformation. The static quality of his pictures is simply the consequence of the splitting up of movement into individual elements, veritable slices of time bound together by a sort of arithmetical operation.

In Rousseau's canvases, spectacular scenes taken from life at the precise moment of an incident, take on more importance than the object. (This incident could as well have to do with a succession of details as with a line of thought.) This calls to our mind his *Bataille* that hangs in the Louvre, as well as *La Profanation de l'Hostie* by Uccello with its snapshot scenes that express strange moments full of emotion in a dramatic sequence. . . .

Rousseau treated his landscapes in somewhat the same way as he did his portraits. They were often adorned with emblems: planes, wires, metal bridges, etc., that materialize his outlook on the progress

<div align="right">531</div>

of ideas that to him was so important. But they never lack animals or men, without which nature does not make sense to him. They should mostly be considered as *souvenir* landscapes, and if we do not grasp their sentimental motives, it is nevertheless these that gave the necessary impetus that set working his imaginative mechanism.

<div align="right">

Tristan Tzara. *Henri Rousseau: The Role of Time and Space in His Work.* New York, 1951, no paging.

</div>

As an artist, Rousseau followed no steady evolution of style, nor even a series of outwardly melodramatic reversals like Picasso's. At his first Salon des Indépendants in 1886, the year following his retirement at forty-one, Rousseau hung *Un Soir de carnaval* [*Carnival Evening*], one of his masterpieces. Painted large (almost four by three feet) and in limpid color, this canvas shows him already in command of his mature style. The brushwork and detail are immaculate, and he combines in an astonishingly simple composition areas of pure color with areas of an intricate fretwork in silhouette. Twelve years later Rousseau painted an equally successful picture, *La Bohémienne endormie* [*The Sleeping Gypsy*]. It restricts treatment of detail to the lion's mane and the robe of the gypsy and allows areas of subtle color to glow in the same mysterious moonlight that filled *Un Soir de carnaval.* A gradual simplification of manner appears to have taken place. After a similar interval came the final masterpiece, *Le Rêve* [*The Dream*], almost his largest picture. Rousseau returned to the exploitation of detail and unrolled a veritable tapestry of exotic foliage with a few spaces of solid color; again, moonlight and mystery. In none of these compositions did he explore linear perspective; we feel space as accumulation. In *Le Rêve* he accumulated detail to create the physical presence of the jungle; in *La Bohémienne endormie* he accumulated plain (and plane) color to imply depth; in *Un Soir de carnaval,* the best of the three and the earliest, he employed both methods. What can one tell of his "evolution" from these high points in his career? Only that he reached the fullness of his style very early and sustained it to the last.

<div align="right">

Roger Shattuck. *The Banquet Years.* Garden City, N.Y., 1961, p. 85.

</div>

Rousseau's career as a painter coincides with the Post-Impressionist reaction. But whereas Signac and Seurat, though opposed to the evanescent forms of the Impressionists, codified the latters' fragmentation of visual reality . . . , Rousseau from the outset went back to realistic means of expression, as though its freshness had never been exhausted. Thus, in his own way, he took part in the reaction

against Impressionism; moreover . . . he came close to the Cubist experiments, just as in his own way he plumbed the sources of exoticism. . . . Gauguin's flight to Tahiti, dramatizing the conflict between Western man and his environment, was not as painterly a solution as Rousseau's, though Rousseau never traveled farther than the Jardin des Plantes. He escaped into painting, his eyes wide open to the attractiveness of things, and made of art a coveted goal, his own Tahiti. . . . At the same time he had direct descendants—the latter-day naive or primitive painters. Rousseau's vision, both as a whole and in detail, persists in these artists. . . . However, it seems that each of the best-known naive painters has inherited but a part of Rousseau's patrimony: Vivin, the love of detail; Bombois, the powerful clarity of forms; Bauchant, the candid intellectual aspirations; and Séraphine, the visionary gifts of that man who was so fond of faraway, tropical landscapes.

> Dora Vallier. *Henri Rousseau.* New York, 1964, p. 145.

The Sleeping Gypsy
La Bohémienne endormie

1897 oil on canvas 51" x 70" New York, Museum of Modern Art

A wandering Negress, playing the mandolin, with her jar beside her (vase containing drinking water), sleeps deeply, worn out by fatigue. A lion wanders by, detects her and doesn't devour her. There's an effect of moonlight, very poetic. The scene takes place in a completely arid desert. The Gypsy is dressed in Oriental fashion.[*]

> Henri Rousseau. Letter to the Mayor of Laval, July 10, 1898.
> Quoted in D. C. Rich. *Henri Rousseau.* New York, 1946, p. 31.

The Quinn sale includes a phenomenon, a unique piece, the hub of the wheel, the center of centers, the place where speed itself stops dead, the core of storms, the sleep of sleeps, the silence of silences; it is *The Sleeping Gypsy* by Henri Rousseau. This painting is not a painting. No, I take that back. This picture, which surpasses the art of painting, which soars above it and compromises it, remains a painting nevertheless. . . .

We are in the desert. The gypsy lying in the middle distance is carried far away by the dream, or rather, the dream brings her from far away, even

[*] With this description Rousseau offered the painting to his native town for 1,800–2,000 francs. The mayor brought it to the attention of the director of the local museum, who apparently did not respond to the offer. The painting disappeared for some time; it was later purchased by the American collector John Quinn.

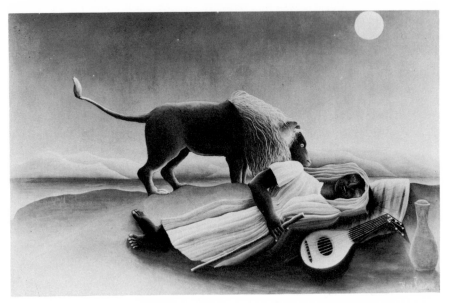

The Sleeping Gypsy. *Henri Rousseau*

as the mirage brings the river from the far background, just as the lion behind her scents her without being able to reach her.

Indeed, it may be that this lion and this river are the sleeping girl's dream. . . . The light of the moon and the polestars whitens the lion's vitreous mane and his tail, which he holds up into the sky, facing the moon. The gypsy sleeps with her eyes not quite closed, her lips slightly parted. Her head rests on her left arm, which is bent back under her body. A stick is in her right hand.

How can I describe this immobile yet flowing form, this river of oblivion? I am thinking of Egypt keeping her eyes open in death's darkness as divers do in the ocean depths.

The disks of the white moon and the dark face are repeated in the body and hole of a mandolin lying in the sand next to the flowing form. Its strings flow in the same direction as the burnoose and the stick. . . .

Out of where does such a thing appear? From the moon. . . . We happen on this scene in the desert as if by deceit; we might say that it all came about through a negligence of heaven. It is the product of so many accidents of chance that we might compare it to a deck of cards that, being shuffled and thrown into the air, falls back into its box in perfect order.

Furthermore, it is probably not without meaning that the painter, who never forgot a detail, did not leave any imprint in the sand around the sleeping feet. The gypsy did not come there, she just is there. She is not in any human

534

place. She inhabits mirrors. She can rise, cut herself in two, speak like the talking torso of the side show. She is the secret soul of lyricism, an act of faith, a proof of love.

> Jean Cocteau in John Quinn. *Catalogue des tableaux modernes . . . vente . . . à Paris, Hôtel Drouot, 28 octobre 1926,* no paging.

The Dream

1910 oil on canvas 80″ x 118½″ New York, Museum of Modern Art

> Yadwigha lay sleeping fair
> And heard in a lovely dream
> The snake charmer's pensive air
> Played on his flute, by the stream.
>
> The silvery moonlight glistens
> O'er flowers and verdant trees,
> The savage serpent listens
> To the gay-sounding melodies.
>
> Henri Rousseau. "Le Rêve (1910)." Quoted in French by Wilhelm
> Uhde. *Five Primitive Masters.* New York, 1949, p. 32.*

His last great effort is a creative résumé of his entire career. In *The Dream* he mingled the moonlight of *Carnival Evening* and *The Sleeping Gypsy* with the nude of *An Unpleasant Surprise* [1901; Barnes Foundation, Merion, Pa.] and set the figure of Yadwigha on a red sofa in the midst of a jungle. This mixture of incongruous elements surprised even his friends and caused a sensation in the Independents. To a critic, André Dupont, who wrote for an explanation, Rousseau replied: "The sleeping woman on the sofa dreams that she is transported into the forest, hearing the music of the snake charmer. This explains why the sofa is in the picture." But though the motif was thus cleared up for the literal, Rousseau was so much the artist that to André Salmon he confided: "The sofa is there only because of its glowing, red color."

* *Yadwigha dans un beau rêve*
 S'étant endormie doucement
 Entendait les sons d'une musette
 Dont jouait un charmeur bien pensant.
 Pendant que la lune reflète
 Sur les fleurs, les arbres verdoyants,
 Les fauves serpents prêtent l'oreille
 Aux airs gais de l'instrument.

The Dream is a summation of all those qualities which make Rousseau inimitable. Its organization of spaces and complex tones (an artist counted over fifty variations of green alone) is equaled by its sentiment. The plane of reality (the figure on the sofa) is inventively joined to the plane of the dream (the jungle). In it appears, in heightened form, every symbol of the last ten years of Rousseau's life, redesigned and related with a free intensity. The nude figure surrounded by enormous lilies is one of Rousseau's most perfect realizations, while the leopards peering from the jungle leaves are full of his expressive mystery.

<div style="text-align:right">D. C. Rich. *Henri Rousseau.* New York, 1946, p. 69 ff.</div>

It is a veritable dream-world, out of no garden, zoo or cinema studio, but straight from the fearsome and beautiful shadows of childhood fantasy. Palm groves glisten in the moonlight along a broad river. Lions peer from tall canebrakes; gay-colored birds perch motionless amid preternaturally large leaves; apes swing from treetop to treetop. In the night the scream of a black man struck down by a panther is heard, or the flute of a black woman luring snakes from their holes. The story goes that while painting these jungle scenes, Rousseau was sometimes so fevered by his conception that he would break off work and throw open a window for air. His huge landscape called *The Dream* is a climactic blend of the charms, horrors, dangers and delights of his

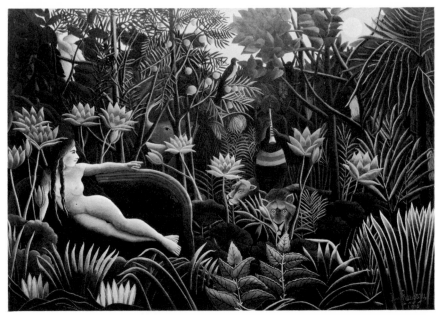

The Dream. *Henri Rousseau*

imagination—with Yadwigha lying calmly in the midst of it all on a red sofa. The secret of the picture's power is not the striking color contrast (red sofa *vs.* jungle green), but the extraordinary evocation of a mysterious and incredible world.

Wilhelm Uhde. *Five Primitive Masters.*
New York, 1949, p. 32.

PAUL GAUGUIN

Born in 1848 in Paris, Gauguin spent his earliest childhood in Peru, his mother's native country, before his family moved to Orléans in 1855. At the age of seventeen he joined the merchant marine. In 1871, following the Franco-Prussian War, he entered a Parisian brokerage firm and took up painting in his leisure time. Pissarro encouraged his efforts and introduced him to the other Impressionists, whose works he began to collect. Gauguin exhibited a still life in the Salon of 1876, but from 1879 to 1886 he showed with the Impressionists. In 1883 Gauguin, married for ten years and the father of five children, decided to give up his job and become a painter. Eventually he separated from his wife, who returned to her native Copenhagen.

Between 1886 and 1890 Gauguin lived intermittently in the small artists' colony of Pont-Aven and Le Poldu in Brittany, where the "Synthetist" (i.e., symbolist) movement was born. In 1887 Gauguin visited Panama and Martinique. Ill with malaria he returned home and at the insistence of Vincent van Gogh came to Arles in October 1888. Barely two months later the tragedy of van Gogh's breakdown drove Gauguin away. In Paris Gauguin organized a group show of "Impressionists and Synthetists" at the Café Volpini to coincide with the 1889 Universal Exhibition. Hoping to raise money he sold his paintings at the Hôtel Drouot in 1891 (Octave Mirbeau wrote the preface to the catalogue) and sailed for Tahiti. Lack of money forced his repatriation in 1893. Urged by Degas, Durand-Ruel gave him a one-man show in 1893, but it was financially unsuccessful. In 1895 Gauguin again put up his paintings for auction, inviting August Strindberg to write an introduction to the catalogue. Strindberg declined in a letter published by Gauguin with his own answer in lieu of a preface. Gauguin returned to Tahiti the same year. Ill health and poverty drove him to an abortive suicide attempt during the winter of 1897–98. Disillusionment with his life in Tahiti and trouble with the colonial authorities for championing the causes of the natives induced Gauguin in 1901 to move to the island of La Dominique in the Marquesas. He died there in 1903 in the village of Atuana.

Gauguin worked chiefly in oil, but also made woodcuts and ceramics, and did some wood carving. Gauguin's writings, in an aphoristic staccato prose, are among the most remarkable literary documents left by an artist. His first book, *Noa Noa* (1897), was edited for publication by his friend and biographer Charles Morice; the original unedited text became available in English only in 1961. *Avant et après* (1903) was published in a condensed English translation as *The Intimate Journals of Paul Gauguin* (1936).

Gauguin interests me very much as a man—very much. . . . Here we are without the slightest doubt in the presence of a virgin creature with savage instincts. With Gauguin blood and sex prevail over ambition. . . .

Vincent van Gogh. Letter to Émile Bernard, October 1888.
Complete Letters. Greenwich, Conn., 1958, III, 518.

I have just learned that M. Paul Gauguin is about to leave for Tahiti. It is his intention to build his cabin there, to live alone for several years, and to begin all over again working on the things that haunt him. I am intrigued and moved by the case of a man fleeing civilization in voluntary pursuit of oblivion and silence, in order to become more aware of himself, to better listen to the inner voices which have been drowned in the noise of our passions and disputes. Paul Gauguin is a very exceptional and most disturbing artist, who rarely appears in public and whom, consequently, the public knows very little. . . .

In spite of his apparent intellectual ruggedness, Gauguin has a restless temperament; he is tormented by the infinite. Never satisfied with his accomplishments he moves on, always searching for the beyond. Confusing things agitate his mind. Vague yet powerful aspirations are leading him toward more abstract paths, more tightly closed forms of expression. His thoughts are turning toward the lands of light and mystery he has once traveled. It seems to him that he will find there, asleep and inviolate, the elements of a new art conforming to his dream. . . . His art is strangely cerebral and passionate, uneven still, but poignant and superb in its very unevenness. A sorrowful work, . . . it sometimes rises to the height of the mystical act of faith; sometimes it obliterates itself and grimaces in the gloom of doubt. It always emanates the bitter and violent aroma of the poisons of the flesh. There is a dazzling and savory mixture of barbaric splendor, Catholic liturgy, Hindu reverie, Gothic imagery, and obscure and subtle symbolism; there are harsh realities and distraught flights into poetry, through which M. Gauguin creates an altogether new and personal art—the art of a painter and poet, of an apostle and demon, an art which instills anguish.

Octave Mirbeau. "Gauguin (1891)." *Des artistes:*
1st series, 1885–1896. Paris, 1922, p. 119 ff.

The Impressionists of the group of the XX . . . have invited to their pointillist saturnalia a bungler worthy of them: M. Gauguin. This clown—for I cannot imagine that he takes himself seriously— . . . has undertaken to sculpt erotic-enigmatic scenes *à la* Seurat! ! These

bas-reliefs, *Be in Love and You Will Be Happy,* and *Be Mysterious,* surpass all limits of insanity.

> Achille Chainaye, called Champal. "Le Carnaval d'un ci-devant." *L'Art Moderne,* February 15, 1891, p. 56.

I do not criticize Gauguin for having painted a rose background nor do I object to the two struggling fighters and the Breton peasants in the foreground,* what I dislike is that he copied these elements from the Japanese, the Byzantine painters and others. I criticize him for not applying his synthesis to our modern philosophy which is absolutely social, anti-authoritarian and anti-mystical.—There is where the problem becomes serious. This is a step backwards; Gauguin is not a seer, he is a schemer who has sensed that the bourgeoisie are moving to the right. . . . The symbolists also take this line! What do you think? They must be fought like the pest!

Gauguin's present show [at Durand-Ruel's] is the admiration of all the men of letters. They are, it appears, completely enthusiastic. The collectors are baffled and perplexed. Various painters, I am told, all find this exotic art too reminiscent of the Kanakians. Only Degas admires, Monet and Renoir find all this simply bad. I saw Gauguin; he told me his theories about art and assured me that the young would find salvation by replenishing themselves at remote and savage sources. I told him that this art did not belong to him, that he was a civilized man and hence it was his function to show us harmonious things. We parted, each unconvinced. Gauguin is certainly not without talent, but how difficult it is for him to find his own way! He is always poaching on someone's ground; now he is pillaging the savages of Oceania.

> Camille Pissarro. Letters to his son Lucien, April 20, 1891, and November 23, 1893. *Letters . . .* New York, 1943, pp. 164, 221.

Remarks in explanation of my Tahitian art, because it is reputedly incomprehensible:

As I wanted to suggest a luxuriant and wild nature and a tropical sun setting ablaze everything around it, I needed to give my figures a setting in harmony with it.

It is indeed the life outdoors and yet intimate, in the thickets, near the shaded brooks; it is those whispering women in an immense

* Pissarro refers to Gauguin's painting *Jacob's Struggle with the Angel,* now in the National Gallery of Scotland, Edinburgh.

palace decorated by Nature herself with all the abundance that Tahiti holds.

Hence all those brilliant colors, that glowing though filtered and silent air.

—But all that does not exist!

—Yes, it does exist, as the equivalent of this grandeur and depth, of this mystery of Tahiti, when it is to be expressed on a canvas of one square meter.

She is very subtle and very knowing in her naïveté, the Tahitian Eve.

The enigma hidden at the bottom of her childlike eyes remains incommunicable. . . . It is Eve after the fall, still able to walk naked without shame, and keeping her animal beauty as on the first day. . . .

> Paul Gauguin (ca. 1893). Quoted in Jean de Rotonchamp.
> *Paul Gauguin.* Paris, 1925, pp. 139–40.

You have your heart set on having me write the preface to your catalogue, in remembrance of the winter of 1894–95 when we were both living behind the Institute. . . .

I would have liked to give you this souvenir to take along with you to that island of Oceania where you are seeking a setting in harmony with your strong personality, and an expanse of space, but . . . I cannot, or, more brutally . . . I do not want to do so.

On the other hand I owe you an explanation for my refusal, which is not due to complacency or laziness. . . .

I cannot grasp your art and I cannot like it. Your art, which has become exclusively Tahitian, has no hold over me. But I know that this confession will neither surprise nor hurt you, for you seem to thrive on the hatred of others. . . .

It was toward Puvis de Chavannes that my thoughts turned yesterday evening when, to the tropical sounds of the mandolin and the guitar, I saw on the walls of your studio that medley of sun-filled pictures which pursued me last night in my dreams. I saw trees unknown to botanists, animals whose existence Cuvier would never have suspected, and men whom only you could have created. I saw a sea flowing out of a volcano, a heaven which no God could inhabit.

"Sir," I said in my dream, "you have created a new heaven and a new earth. But I do not enjoy myself in your creation. It is too bright with sunshine for me who delights in the play of light and shade. And in your paradise there dwells an Eve who is not my ideal —for I, too, have an ideal of woman!"

This morning I went to the Luxembourg to look at Chavannes, who kept coming to my mind. . . .

No, Gauguin is not made of the stuff of Chavannes, any more than of Manet or Bastien-Lepage.

What is he, then? He is Gauguin, the savage who hates the burden of our civilization, a sort of Titan who, jealous of the Creator, makes his own little world in his spare time, a child who takes toys apart in order to build others from the pieces, one who denies and defies, who prefers to see the sky red rather than blue like the rest of us. . . .

> August Strindberg. Letter to Gauguin, February 1, 1895.
> Quoted in P. Gauguin. *Avant et après* (1903). Paris, 1923,
> p. 22 ff.

Above all I love in him [Gauguin] the sumptuous and princely ceramist; in this medium he has created new forms. I can compare them to flowers in a primeval region where each blossom will be the prototype for a species, leaving to other artists after him the task of achieving varieties by association. As a sculptor in wood he was a refined savage, grandiose or delicate, and above all free of any tradition. As a painter, he was a willful searcher, very conscious of his potentials; he attained that powerful originality, the repercussions of which we can trace in the work of others. All that he touched clearly bears his imprint, and proclaims him a master. And, indeed, he was a master in the most vigorous sense of the word.

> Odilon Redon in "Quelques opinions sur Paul Gauguin."
> *Mercure de France*, November 1903, p. 428 ff.

It is time that we recognize the value of Gauguin's work and the important role he has played in the history of modern art. He has been the most influential of the French painters since Manet. What Manet meant to the generation of 1870, Gauguin meant to the generation of 1890. Cézanne, who, after all, initiated Gauguin, became influential only after Gauguin, though as an artist he was more complete, more uncommon, albeit more inaccessible. The exhibition at the Café Volpini in 1889, where for the first time the Synthetists and the entire school of Pont-Aven were grouped around Gauguin, . . . inaugurated an epoch. This showing . . . marked the beginning of the reaction against Impressionism. The symbolist crisis, which erupted a little later, facilitated the spreading of Gauguin's ideas to the point where all the applied arts, decorative painting, accessories, and the poster down to the caricature, were revitalized. . . . No movement was more purely traditionalist. Far from denying the masters of the past, he [Gauguin] responded to the lessons of the most brilliant periods in art—the Egyptian, Greek, and Gothic. . . . A new art arose, orig-

541

inating from the calvaries of Brittany, Maori idols, and Épinal prints, in other words from the most naïve, the most childlike, the simplest expressions that mankind ever has produced. . . . This is the living tradition.

> Maurice Denis. "De Gauguin, de Whistler
> et de l'excès de théories (1905)."
> *Théories, 1890–1910.* Paris, 1920, p. 199 ff.

If Cézanne is a builder, Gauguin is a decorator, but a decorator tainted with insanity. His arrangements of line are sometimes noble and graceful, but the things he represents are often hideous. His color is sometimes beautiful, but it is always unnecessarily false and often unpleasantly morbid. "The Spirit of Evil" haunts more of his pictures than the one so named.

> Kenyon Cox. "The 'Modern' Spirit in Art."
> *Harper's Weekly,* March 15, 1913, p. 165 ff.

The rather numerous colors used by Gauguin in his definitive style consisted of the following: Blues—ultramarine, Prussian blue, cobalt. Yellows—light chrome yellow, cadmium citron, deep cadmium citron, yellow ocher, *ocre ru.* Reds—light vermilion, madder, carmine lake. Greens—veronese green, emerald green, green earth. If we add to this list silver-white, we have the full composition of Gauguin's palette, which completely excluded browns, bitumens, and blacks.

Gauguin had a predilection for ultramarine, chrome yellow and Veronese green, in other words, for the richest hues in each series. In spite of what he himself had said, he cared little about the greater or lesser stability of certain colors and never made any serious effort to avoid ill-considered mixtures of incompatible chemical elements. Rather than covering his paintings with varnish, of which he had a horror, he applied, once the paintings were dry, a coat of white wax dissolved in petroleum. He always painted on absorbent, coarsely woven canvases, which he prepared himself. He had to acknowledge that his underpaintings often lacked solidity. When in Tahiti he devoted all his attention to this serious defect, attributing it to the poor quality of the white lead sold there, which came from America. He thought it was prepared with tallow. Once it had been applied and was dry, this underpainting began to crack, having an insufficient binder. This, then, caused cracks in the painting itself. To remedy the situation, Gauguin added linseed oil, but this forced him to work with an oily paint base, which was contrary to his intention.

> Jean de Rotonchamp. *Paul Gauguin.* Paris, 1925, p. 257.

It is the fashion of the moment to speak of Gauguin as if he were a mere decorator; a maker of agreeable colour patterns without much substance or significance. . . . But the best of his works . . . do very much more than combine formidable colour with striking and audacious design. They have real substance. The figures are admirably modelled in very low relief, and the paintings have a "complex" underlying their outward pattern. They seem haunted by some spell of savage magic and mystery, an indwelling spirit, which in this age of the sceptic and the materialist is naturally suspect. . . . Nor is his colour so simple as it seems. If we take the trouble to examine it closely we shall find that under its apparent crude force there are unexpected subtleties of gradation, the outcome of a deliberate refining process based on Gauguin's early Impressionist training. What looks like a vivid patch of pure yellow, for example, will prove to be modified toward one extremity by little touches of blue or green—at the other the modification may be red or orange. These interweavings, this ever-changing texture, give Gauguin's best works a subtlety which, added to his undeniable vitality and breadth, make him one of the men we should do well to consider seriously, whatever we may be told to his discredit.

<div align="right">Charles Holmes. *Old Masters and Modern Art . . .*
London, 1927, p. 137.</div>

All symbolism is at a remove from the immediate present—that is its function: to enable us to discourse without the associations and distractions of sensation. This does not mean that a symbolic painter is trying to evade "life" or "reality." He is like a mathematician or a logician who can deal more effectively with life or reality by means of signs. But the visual signs of painting and sculpture are more like the characters of a fable. The story of the Good Samaritan, or of the man who went forth to sow seed—such fables are strictly comparable to Gauguin's pictures, and when we read them we do not think of real men with distinctive features, but of typical men with conventional features. To load it with detail would detract from the universality of the fable. In the same way, Gauguin does not need to create an illusion of particular presence, or even of a particular time and place: his discourse is universal and must be expressed in symbolic signs, which are never aspects of reality.

It is for this reason that Gauguin, for all his exoticism, is a popular artist—an artist easily accessible to the man in the street. There have been other exotic artists in our time, most of them influenced in some degree by Gauguin—Emil Nolde, Paula Modersohn-Becker, Max Pechstein. But though there are good, even great artists among

<div align="right">543</div>

them, they have not the same appeal as Gauguin because they lacked the same bold grasp of universal themes.

Nevertheless Gauguin, too, has his limitations. We have only to compare him with a universal artist like Rembrandt to see how limited was the range of his intelligence. Gauguin was capable of creating universal symbols, but selectively, discreetly. Rembrandt was himself a universal spirit. . . .

But these comparisons reveal another distinction. A self-portrait by van Gogh, like a self-portrait by Rembrandt, is a self-analysis, a revelation of the innermost self. A self-portrait by Gauguin is a *persona*, a mask—that is to say, again a symbol. The symbol may represent what is universal in the man, of evil and of good; but it does not reveal the particularities that are neither good nor evil, that are uncharacterized, but that nevertheless are a segment of the living reality . . .

Gauguin's work is symbolic, and he himself is a myth. He rejected the values of bourgeois society and of a machine civilization. His gesture had its sordid side, but retrospectively it seems to have been appropriate, coming at a time when the world was preparing for annihilating wars. It was not a useful example: we cannot all go and live on South Sea islands, and, as I have said before in this connection, modern man carries his civilization like a pack on his back, and cannot cast it off. But he can nevertheless protest against the burden, and state the real values of life.

So Gauguin did, in paintings that are symbols of eternal truths, images of great beauty and serenity. He is not a painter's painter, and his influence is not to be found in the schools and academies, but in hearts weary of the burden of modernity and enticed for a moment of contemplation into an Earthly Paradise.

<div style="text-align: right">

Herbert Read.　"Gauguin: Return to Symbolism."
Art News Annual, XXV, 1956, p. 125 ff.

</div>

The structure of Gauguin's pictures is essentially flat and decorative; he rarely, if ever, tried to give the illusion of depth or atmosphere. . . . He has given our eyes the feeling of depth by overlapping flat surfaces of color, very much as it is done in the theatre. . . . Sometimes the feeling of depth is achieved by color alone, by a heavy dark shade of green, blue or violet.

Gauguin's arrangement of forms, their balance, their movement, is also quite simple. They are distributed across the surface of the

painting, like a sculptured frieze. We know that he admired and studied the sculpture of Egypt, Persia, and India, and that he took with him to Tahiti photographs of Indian, Javanese, and Roman bas-reliefs. . . . Their influence undoubtedly contributed to the stately monumental character of his style. His use of borrowed motifs, how-ever, is never imitative but always personal. . . .

Gauguin's brush stroke . . . —one might say his handwriting—has this same simplicity and strength. About this aspect of technique he clarified his attitude in his discussions with Van Gogh. Gauguin disliked a broken surface, he was always after something very plain and broad. . . . The nervous brushwork of the Impressionists, and the smooth finished surfaces of the Academicians, were equally alien to the effect he sought.

The areas of color in his pictures are broad and consistent, with little modulation either in their hue or values. The paint itself has a rich cream-like consistency. It is applied in a thick layer without glazes. The heavy texture of the burlap canvas he used often adds roughness and warmth to the total effect. It unifies the picture, bring-ing to mind the plaster surface of fresco. The irregularities of his out-lines, never carefully finished, also add to this effect. . . .

The appeal of Gauguin's pictures has not been limited to his own country. It is universal. Most of his early works have remained in Europe, in France and in Denmark, but his masterpieces, painted in Tahiti, are for the most part in the United States and Russia. . . .

The high esteem in which Gauguin is held rests on his art itself and on his great contribution to all of the artists of the twentieth cen-tury. It is far too early to know whether his pictures will always enjoy the high popularity accorded them at the moment. . . . It is certain, however, that he will have an enduring fame as the personality who has exerted the strongest influence on modern art. With ferocious courage he asserted his own right to "dare anything," thereby secur-ing this right for all who came after him. Bonnard and Vuillard, who first saw Gauguin's paintings in 1889 at the Café Volpini, drew their inspiration from him and their flat decorative design. Picasso's sad figures of the blue period are kin to Gauguin's brooding Tahitians. The Fauves owe him much of their color. . . . German Expressionists, like today's abstractionists, inherited from him their emotional force and their aggressiveness. Indeed nearly every progressive painter of the last half century at some time in his career has been moved by the continuing power of Gauguin.

<div align="right">Theodore Rousseau, Jr. in *Gauguin* [Exhibition] (Art
Institute of Chicago). Chicago, 1959, p. 11 ff.</div>

The Yellow Christ
Le Christ jaune

1889 oil on canvas 36⅛″ x 25⅝″ Buffalo, Albright-Knox Art Gallery

In a landscape that is all yellow, a yellow with the pallor of death, on top of a Breton hill sadly ochred by the end of autumn, a crucifix stands under the open sky, a roughly hewn crucifix, rotting, falling apart, stretching out its warped arms into the air. The Christ—like a Papuan deity hastily carved out of a tree trunk by a local artist—this piteous and savage Christ has been daubed with yellow paint. At the foot of the calvary some peasant women are kneeling. Indifferent, their bodies bearing down heavily on the ground, they have come because it is the custom to go there on the Day of Pardon,° but their eyes and lips are devoid of prayers. They have not a single thought, not a single glance, for the image of Him Who died out of love for them. Already some other peasant women hasten home to their hovels, jumping over hedges and fleeing under red apple trees, glad to have finished their devotions. Christ's head shows the most frightful sorrows, His emaciated flesh appears to mourn the torture of long ago, and He seems to say to Himself as He regards this miserable, uncomprehending humanity at His feet: "Could it be that all My agony has been in vain?"

Such is the work that begins the series of Gauguin's symbolic [i.e. symbolist] canvases.

<div style="text-align:right">

Octave Mirbeau. "Gauguin (1891)." *Des artistes:*
1st series, 1885–1896. Paris, 1922, p. 127.

</div>

The Yellow Christ, which Gauguin composed in the last months of 1889, is among the two or three most important canvases done in Brittany. These works did more than create an image of a province and its people; they were the first examples of a new way of painting, achievements in themselves, and of great portent for the future. The later Tahitian pictures, fine as they are, but continue upon a road that had already been opened. . . .

We cannot, of course, know what inner impulse drove Gauguin away from Impressionism. . . .

By the time of his second trip to Brittany in 1888 Gauguin had evolved a new style, . . . based upon the use of pure color applied in flat areas. This color derived from the object, but it did not attempt to reproduce the object as it was seen. Its purpose was not to represent, but to express. . . .

To define the purposes of the style thus achieved, we may borrow the terms of the painter and writer Maurice Denis. . . . "A picture," he says, "is not an imitation of nature, but the work of the imagination and the sensibility of the artist, who creates, not a copy of the object, . . . but a symbol. To achieve

° The Day of Pardon is a religious festival celebrated in Brittany.

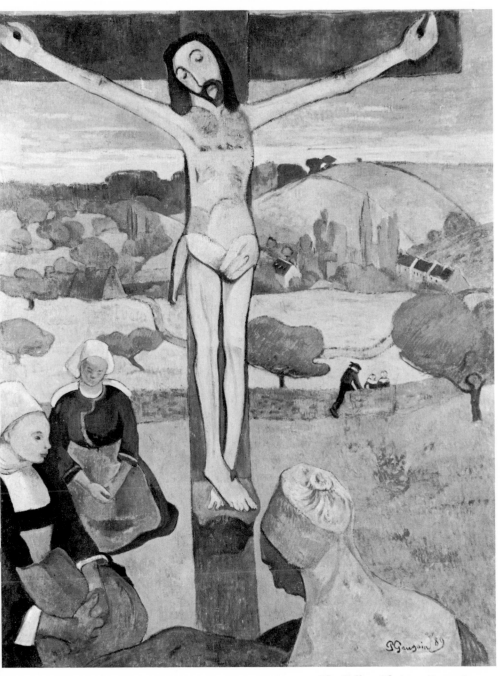

The Yellow Christ. *Gauguin*

this symbol . . . the artist's imagination must stylize nature into a distillation of his feeling, and by emphasis, by omission, by exaggeration if necessary, produce a form that conveys his sentiment. And the artist's sensibility must impose upon the haphazard shapes of nature an arrangement, a composition, a harmony and a structure which make his picture a delight to the eye. From the fusion of these two, the one determined by the *subjective* necessity of emotion, the other by the *objective* necessity of the laws of color and line, results that expressive synthesis which is a work of art. The emotion springs from the canvas itself, a plane surface coated with colors." . . .

Such was Gauguin's purpose in painting *The Yellow Christ.* . . .

Without a doubt his ideas were never so explicitly formulated. . . . Yet it was his intention as he boldly set down the blue of the peasant skirts, the red of the trees, the yellow of the Christ, and as he repeated the rhythmic contours of his shapes. Here is emotion fused with pattern to create a symbol.

Robert Goldwater. "Gauguin's *Yellow Christ.*" *Gallery Notes, Buffalo Fine Arts Academy,* June 1947, p. 3 ff.

Where Do We Come From? What Are We? Where Are We Going?
D'où venons-nous? Que sommes-nous? Où allons-nous?

1897 oil on burlap 55½" x 151⅜" Boston, Museum of Fine Arts

. . . But before I died I wanted to paint a large canvas that I had in mind, and during the entire month I worked day and night in an incredible fever. Well, it is not painted like a Puvis de Chavannes, with studies from nature, preliminary cartoon, and so on. It is all done without a model, straight from the brush, on sackcloth full of knots and wrinkles, so its appearance is terribly rough.

They will say that it is sloppy, unfinished. It is true that one is not the best judge of one's own work, but I believe nevertheless that this canvas not only surpasses all my previous ones, but that I shall never paint a better or even similar picture. . . .

It is a canvas four meters fifty wide by one meter seventy high. The upper two corners are chrome yellow, with an inscription on the left and my signature on the right, like a fresco damaged at the corners and attached to a golden wall. On the right, at the lower end, are a child asleep and three crouching women. Two figures clothed in purple confide their thoughts to one another; an enormous crouching figure, intentionally out of proportion, raises its arms into the air and looks in amazement upon these two who dare to think of their fate. A figure in the center is picking a fruit. Two cats near a child. A white goat. The idol, raising its two arms mysteriously and rhythmically,

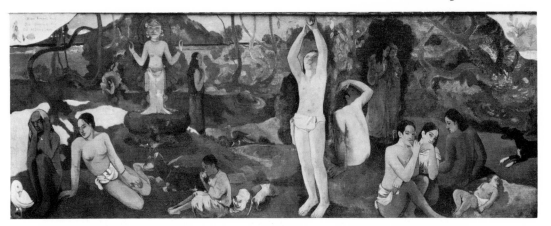

Where Do We Come From? What Are We? Where Are We Going? *Gauguin*

seems to point to the Beyond. The crouching figure appears to be listening to the idol; lastly, an old woman near death seems to accept, to be resigned to, her thoughts, thus ending the story. At her feet, a strange white bird, holding a lizard in its claws, represents the futility of words. All this takes place on a riverbank in the woods. In the background the sea, then the mountains of the neighboring island. In spite of the nuances in tone the appearance of the landscape from one end to the other is all blue and Veronese green. All the nude figures stand out against this in bold orange. If the Beaux-Arts students competing for the Rome Prize were told, "The picture you are to paint shall represent—'Where Do We Come From? What Are We? Where Are We Going?'" what would they paint? I have completed a philosophical work on this theme, comparable to the Gospel. I believe that it is good.

Paul Gauguin. Letter to G.-D. de Monfreid, February 1898.
Lettres de Paul Gauguin à Georges-Daniel de Monfreid.
Paris, 1920, p. 199 ff.

. . . You are right to point out numerous defects, violence, monotony of tone, arbitrary colors, etc. Yes, all these probably exist. . . . Sometimes, however, they are intentional. Are not these repetitions of tone, these monotonous color harmonies (in the musical sense) analogous to oriental chants . . . ? You often go to the Louvre; think of what I have said and look closely at Cimabue. Think also of the musical role color will henceforth play in modern painting. . . .

Here near my cabin, in complete silence, surrounded by the intoxicating fragrance of nature, I dream of violent harmonies. . . . Animal forms rigid as statues, with something indescribably ancient, solemn, and religious in the rhythm of their gesture, in their strange immobility. In eyes that dream, the blurred surface of an unfathomable enigma. . . .

"In the large panel that Gauguin exhibits there is nothing that explains the meaning of the allegory." Yes, there is: my dream is intangible, it requires no allegory. As Mallarmé said: "It is a musical poem, it needs no libretto." . . . The essence of a work of art consists precisely in "that which is not expressed; it is implied in the lines without color and words; it is incorporeal."

I also heard Mallarmé remark, in front of my Tahitian pictures: "It is extraordinary that one can put so much mystery in so much brilliance."

To return to the panel: the idol is there not as a literary explanation but as a statue, yet perhaps it is less of a statue than the animal forms, less animal also, becoming one with all nature in my dream before my cabin. . . .

I paint and dream at the same time with no tangible allegory within reach —due perhaps to a lack of literary education.

Upon awakening, my work finished, I ask myself: "Where do we come from? What are we? Where are we going?" A thought which has no longer anything to do with the canvas. . . . Not a title, but a signature. . . .

I have tried to render my dream in an appropriate setting without recourse to literary means and with all the simplicity my craft permits—a difficult task.

> Paul Gauguin. Letter to André Fontainas, March 1899.
> *Lettres de Gauguin à sa femme et à ses amis.* Paris, 1946, p. 286.

As far as the execution is concerned, this large canvas is not perfect. It was done in one month, without any preparation or preliminary studies. I wanted to die and in this state of despair I painted it in a single spurt. I rushed to finish and sign it and then took an enormous dose of arsenic. Excruciating pain resulted, but not death. Anything that may be lacking in this picture may be compensated by something inexplicable to those who have not suffered in the extreme and know nothing of the state of the artist's mind. . . . Emotion first, understanding afterwards!

In the large painting:

Where are we going? A woman near death; an exotic stupid bird in conclusion.

What are we? Day-to-day existence. The man of instinct wonders what all this means.

Where do we come from? Brook—child—communal life.

The strange bird brings the poem to an end, contrasting the inferior being with the intelligent being in this great whole, which is the question posed in the title.

Behind a tree are two sinister figures wrapped in somber garments, injecting, near the tree of knowledge, their note of sorrow caused by this knowledge, as compared with the simple beings in virgin nature. . . .

Explanations and known symbols would congeal the canvas into a melancholy reality and the question asked would no longer be a poem. . . .

Are the forms rudimentary? Yes, they have to be.

Is the execution too simple? Yes, it is necessarily so.

Many people say that I don't know how to draw, because I don't draw particular forms. When will they understand that execution, drawing, and color (in other words, style) must be in harmony with the poem?

> Paul Gauguin. Letter to Charles Morice, July 1901. *Ibid.*, p. 300.

Whether or not this is the finest of all of Gauguin's paintings, it is certainly among the most beautiful. It is one of those works in which we cannot fail to see the hand of a master. I do not truly know of any other that is more charged with the things of the spirit; the artist hardly needed to tell us that in this astonishing painting he cried out his deepest thought.

Astonishing and at first sight disconcerting, the painting seems complicated and confused. We are tempted to think the forms too numerous and too varied. . . . Then, gradually, under our fascinated eyes the composition becomes coordinated and the masses balanced; the lines follow one another, establishing relationships between the figures, tacit, fatal, unconscious sympathies which perhaps conceal the most precious secret, the greatest gift of life. And truly—Gauguin was not mistaken—life runs through this painting in abundance. . . . And the thought is not obscure. Is it then an answer to those three questions written on the edge of the canvas? No. It is rather the questions themselves. For it is the study of them which makes up human life. . . .

I do not write these few lines as an explanation . . . of this complex work —this marvel of painted literature, which deserves an extensive study. The hope and anguish of a great tormented mind, believing to be called to die and ready to respond, are transformed by this veritable artistic credo into an outpouring of tenderness and reverie in paint, which is extraordinarily personal in its ardent, mystic, and painful purity.

> Charles Morice. *Paul Gauguin* (1919). Paris, 1920, p. 222.

I must in fact confess that I have never even tried to discover in what way it [the painting *Where Do We Come From?* . . .] expresses Gauguin's life. . . . Nor do I imagine that one's pleasure in the picture would anyway be heightened by an elucidation of the symbolism. That indeed was Gauguin's own affair—it led him to this splendid co-ordination of forms, and in that it served all its purpose. It remains like Giorgione's *Tempest,* a magnificent design the origin of which was symbolical, but the effect of which on the spectator is purely and quite satisfyingly pictorial. It is a work which summarises the whole development of Gauguin's art, his learned simplification and amplification of form, his intricate and yet lucid rhythmic design—which is here called upon to hold together a whole panorama—his development of flat, scarcely varied, masses of colour in frank opposition and yet harmonised by a peculiar subtlety of tone and a splendid lacquer-like quality of the surface.

In all of these personal characteristics it would be hard to say whether he had learned more from his native Latin tradition or from Polynesian handicrafts and sculpture, so perfectly are the characteristics of each fused by the fire of Gauguin's imaginative spirit.

> Roger Fry. "On a Composition by Gauguin."
> *Burlington Magazine*, March 1918, p. 85.

EUGÈNE CARRIÈRE

Carrière was born at Gournay in 1849. His youth was spent in Strasbourg, where he worked as a lithographer. In 1868 his family moved to Saint-Quentin, and it was the pastels of Maurice-Quentin de La Tour in the local museum which inspired him to become a painter. The Franco-Prussian War of 1870 broke out after Carrière had entered the École des Beaux-Arts. He served in the army and was taken prisoner by the Germans. Released in 1872, he resumed his studies under the academic painter Cabanel. He exhibited at the Salon from 1879 to 1904. A friend of Cézanne, Redon, Gauguin, and the poets Mallarmé and Verlaine, Carrière founded his own art school, the Académie Carrière. He died in Paris in 1906.

> Carrière is not only the painter of Modern Motherhood; he is also a great portraitist, as can be seen in the portraits of Daudet, Verlaine, Geffroy, [Jean] Dolent, and others. He is a painter whose mind, whenever he paints, is preoccupied with the *intellectuality inherent in the forms* which he represents on his canvas. He seeks, caresses, and constructs these forms like a sculptor who models a clay without body. Thus his figures have an almost sculptural reality, yet he envelops and tones down this reality by means of the color schemes so dear to him, which adhere almost completely to brown-black and white. In the slight *muddiness of his brush strokes,* in the glistening highlights and the seemingly moving shadows, in the almost moonlit accents amid the reddish darkness, the physical features of his sitters' faces seem to reveal something of their soul. Yes, his figures are always transformed poetically, and sometimes even fantastically.
>
> Edmond de Goncourt. Preface to Gustave Geffroy.
> *La Vie artistique:* 1st series. Paris, 1892, p. viii.

> The world of his canvases is a world of tears, of the moanings, partings and eternal regrets of shadowy heads, in which nothing is material but the eyes—eyes like boot-buttons in their insistent and solid detachment from impalpable surroundings. In France, to criticise Carrière would, I am sure, seem almost like a slight on maternity....

Technically, everything has been said about Carrière when one has said, "*C'est de la peinture creuse.*" It is *hollow* painting. . . .

The work of Carrière raises in a very interesting manner another question of immense importance, and that is the degree to which it is possible to eliminate colour from painting, and yet stop short of monochrome. We know that monochrome is a legitimate and satisfactory convention, whether it is drawn or painted monochrome. . . . Now there is a type of painter, over-sensitive, and dimly conscious of not possessing a sense of colour, who jibs at colour, just as certain neurasthenics, who are wanting in a talent for life, jib at life. Both embrace a kind of negative quietism. It is the fashion to call both refined, whereas they are in reality sick. Carrière was of these. His work would have taken a higher rank had he frankly forsworn even the tiny dose of colour to which he still clung. If you look at the picture entitled *The Mother's Kiss*, the hollow evocation in decadent form would have remained at least harmonious and consistent but for the intrusion of the odious pink tone, which invades the province of colour only to utter a blasphemy on the immutable laws of harmony.
W. R. Sickert. "The International Society."
English Review, May 1912, p. 316 ff.

I have seen his [Carrière's] portraits of Verlaine, Daudet, Edmond de Goncourt, Geffroy, of the artist himself and many others. The Verlaine is a veritable evocation. It was painted at one *séance* of several hours, and the poet, it is said, did not sit still or keep silence for a moment. He was hardly conscious that he was being painted. What a head! Not that of the old faun and absinthe-sipping vagabond of the Latin quarter, but the soul that lurked somewhere in Verlaine; the dreamer, not the mystifier, the man crucified to the cross of aspiration by his unhappy temperament. Musician and child, here is the head of one of those pious, irresponsible mendicants who walked dusty roads in the Middle Ages. It needed an unusual painter to interpret an unusual poet.
James Huneker. *Promenades of an Impressionist.*
New York, 1910, p. 73.

Carrière's sensibility and his fine, profound mind have inspired a devotion and passion which his paintings alone, in monochrome and overcharged with extrapictorial intentions, could not achieve. Carrière's moral influence was particularly strong with men of letters. He gave the writers on art a *point of view* and cause for a facile rhetoric. Later Carrière took on the role played too often by an artist who leans more towards ideas and theories than towards painting as such

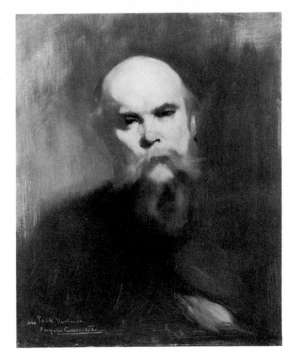

Portrait of Verlaine.
Carrière

—the role of a Diderot. Yet Carrière was above all a painter. He spoke of humanitarian ideas, pity, and justice. His *théâtre populaire,* his workmen with their emaciated faces, his love for the disinherited, touched the socialist dreamers in the midst of the luxury and pleasure with which prewar Paris was infatuated. The melancholic gravity of his monochromes counterbalances the false glitter and finery of the all too pleasing art of the salons.

J.-É. Blanche. *Propos de peintre: De David à Degas.*
Paris, 1919, p. 3.

GEORGES-PIERRE SEURAT

Georges Seurat's brief life was uneventful; its stages were marked by his seven major paintings. He was born in 1859 in Paris. While a student at the École des Beaux-Arts he became interested in the color theories of E. Chevreul, H. von Helmholtz, and O. N. Rood, from which he evolved divisionism or pointillism, also called chromo-luminarism. Between 1881 and 1883 Seurat developed his highly original style of drawing in black and white using conté crayon. His first great painting, *Bathers at Asnières,* was rejected by the Salon of 1884. This led to the

founding of the Salon des Artistes Indépendants by Seurat, Paul Signac, Redon, and Albert Dubois-Pillet, where this painting was shown.

A Sunday Afternoon on the Island of La Grande Jatte, Seurat's second large painting, was exhibited at the eighth and last Impressionist show of 1886 and at the show of the XX *(Les Vingt)* in Brussels in 1887. It was a complete demonstration of Seurat's divisionism and the law of simultaneous contrast, which Seurat later explained in a letter to Maurice Beaubourg, dated July 28, 1890*. The term Neo-Impressionists was coined by Félix Fénéon for Seurat and the other pointillists in 1886. Seurat's next major painting, *Les Poseuses (The Models,* 1886–88; Barnes Foundation, Merion, Pa.) was followed by *The Parade* (1887–88; Metropolitan Museum of Art, New York), *A Young Woman Holding a Powder Puff* (1889–90) a portrait of his mistress Madeleine Knobloch, *Le Chahut (The Cancan,* 1889–90; Rijksmuseum Kröller-Müller, Otterlo), and finally *The Circus* (1890–91; Louvre). Seurat died suddenly in 1891 at the age of thirty-one.

> The city has just ordered that the exhibition of the XX be closed; three visitors have succumbed to smallpox caught in front of a painting done in dots; others have been taken ill. . . .
>
> Anonymous. Quoted in "Documents à conserver à propos des XX." *L'Art Moderne,* March 29, 1891, p. 102.

If I had to characterize him [Seurat] in one word, I would venture to say that he was above all an "organizer," in an artistic sense. Chance, luck, good fortune, mood—he ignored them all. It was not simply that he never began a canvas without knowing what he would do; his preoccupation went even beyond the successful completion of an individual work. His paintings had little significance for him unless they proved such and such a rule, stated some artistic truth, or made a certain inroad upon the unknown. It seems to me that Seurat, if I understand him correctly, had set himself the task of extricating art from the tentative, the vague, the irresolute, and the imprecise. Perhaps he thought that the scientific and positive spirit of his time demanded, in the realm of the imagination, a more clean-cut and solid approach to the conquest of beauty. . . . Frequently he succeeded. And for this reason there appeared each year one important work, perhaps rather more theoretical than just simply beautiful, but imbued with the magnificence of truth searched out and will triumphant! The history of the painter, considered in this light, is among the most strictly exemplary.

His goal, which he had almost achieved by the age of thirty-one, can be summarized as having a two-fold aim. On the one hand Seurat wished to determine, without any recourse to imagination,

* W. I. Homer: *Seurat and the Science of Painting.* Cambridge, 1964, p. 186.

the fundamental principles of color and its sources—the local tone, the source of illumination, the reaction and interaction of objects. On the other hand, he wanted to establish the aesthetic and intellectual expression of lines, whether vertical, horizontal, or curved—in other words, the entire domain of drawing. . . .

If the future had been propitious for him, he would certainly have attempted large-scale decorations in the manner of Puvis de Chavannes, perpetuating this type of work and at the same time renewing and perfecting it.

As we see him, he actually reminds us most frequently and consistently of Ingres. Like Ingres, he had already turned some of his ideas into axioms, he liked to theorize, and he loved doctrines, fixed rules, sure and uncontestable methods; yet he was colder and more austere than the painter of the *Great Odalisque*. His canvases are never sensuous, and his cancan dancers [*Le Chahut*] appear almost sexless.

Although he was reserved, he nevertheless revealed his innermost experiences, leaving the door wide open to all who approached him, provided they were sincere, searching, and well-disposed toward him. He spoke unceasingly about art, stressing not what he had done, but what he was hoping to achieve.

<div style="text-align:right">Émile Verhaeren. "Georges Seurat (1891)."
Sensations. Paris, 1927, p. 202 ff.</div>

Seurat was the first who attempted to substitute a systematic method of work for the more or less fanciful improvisations after nature. He sought to impose order, to create the new doctrine all were awaiting. He deserves credit for attempting to regulate Impressionism. The haste, however, with which he drew technical or aesthetic conclusions from certain theories of Chevreul and Charles Henry, as well as from his own researches, has made of his work—which was, alas, all too soon interrupted—a truncated experience. No matter how admirable this first struggle against artistic license may have been, it is a fact that in spite of the intelligence, perseverance, and talent of Seurat's collaborator, Paul Signac, his work had no profound repercussions, whereas Synthetism and the modes of expression chosen by Gauguin and Van Gogh have had considerable influence on the young painters of France, of Germany, and even of the far corners of Europe.

<div style="text-align:right">Maurice Denis. "De Gauguin et de Van Gogh au classicisme
(1909)." *Theories, 1890–1910.* Paris, 1920, p. 265.</div>

No painter reminds me of Molière as does Seurat, of the Molière of the *Bourgeois gentilhomme,* which is a ballet full of grace, lyricism,

and common sense. And canvases like *The Circus* and *Le Chahut* are also ballets full of grace, lyricism, and good sense.

<div style="text-align: right">

Guillaume Apollinaire. *The Cubist Painters* (1913). New York, 1944, p. 21.

</div>

. . . The dot, the most deliberate and considered of techniques: automatic to the last possible degree.

<div style="text-align: right">

André Masson. "A Crisis of the Imaginary." *Magazine of Art*, January 1946, p. 22.

</div>

[In Seurat] the staticism of the quattrocento and the dynamism of Impressionism form a miraculous harmony.

<div style="text-align: right">

André Lhote. *Écrits sur la peinture.* Brussels, 1946, p. 90.

</div>

With his tiny brush strokes in the form of dots, Seurat could accumulate on a small surface a great variety of colors or tones, each corresponding to one of the elements which contribute to the appearance of the colored object. At a certain distance—which varies according to the size of the dots chosen for the specific work—these tiny particles will fuse optically. And this optical mixture has the advantage of producing a far greater intensity than any mixture of pigments could do.

Seurat's technique has often led to the belief that an execution in dots was an intrinsic part of the artist's system, labeled *pointillism*. Actually these dots are merely the most appropriate means of achieving optical mixture, a by-product rather than an essential feature of what he himself preferred to call *chromo-luminarism*. Some artists among his followers and friends, such as Cross and Signac, experimented with small square strokes (not unlike the stones in mosaics) and obtained similar results, though the optical blending did not always proceed as smoothly. Seurat's pointillist technique was actually regarded by many friends as an unavoidable inconvenience because it tended to be too obvious. Signac even considered to a certain degree as failures all works in which the execution forced itself upon the onlooker's attention instead of guiding him towards a more complete enjoyment of the work itself. It is therefore easy to understand how impatient these painters were with a public that focused its interest on this technical detail without grasping the true character of Seurat's innovations, that is, strict observation of the simultaneous contrast, and optical mixture.

<div style="text-align: right">

John Rewald. "Seurat: The Meaning of the Dots." *Art News*, April 1949, p. 62.

</div>

Admirers of Seurat often regret his method, the little dots. Imagine, Renoir said, Veronese's *Marriage at Cana* done in *petit point*. I cannot imagine it, but neither can I imagine Seurat's pictures painted in broad or blended strokes. Like his choice of tones, Seurat's technique is deeply personal. But the dots are not simply a technique; they are a tangible surface and the ground of important qualities, including his finesse. Too much has been written, and often incorrectly, about the scientific nature of the dots. The question whether they make a picture more or less luminous hardly matters. A painting can be luminous and artistically dull, or low-keyed in color and radiant to the mind. Besides, how to paint brightly is no secret requiring a special knowledge of science. Like van Gogh, Seurat could have used intense colors in big areas for a brighter effect. But without his peculiar means we would not have the marvelous delicacy of tone, the uncountable variations within a narrow range, the vibrancy and soft luster, which make his canvases, and especially his landscapes, a joy to contemplate. Nor would we have his surprising image-world where the continuous form is built up from the discrete, and the solid masses emerge from an endless scattering of fine points—a mystery of the coming-into-being for the eye. The dots in Seurat's paintings have something of the quality of the black grains in his incomparable drawings in conté crayon where the varying density of the grains determines the gradations of tone. This span from the tiny to the large is only one of the many polarities in his art. . . .

Seurat's dots are a refined device which belongs to art as much as to sensation; the visual world is not perceived as a mosaic of colored points, but this artificial micro-pattern serves the painter as a means of ordering, proportioning and nuancing sensation beyond the familiar qualities of the objects that the colors evoke. Here one recalls Rimbaud's avowal in his *Alchemy of the Word:* "I regulated the form and the movement of each consonant," which was to inspire in the poets of Seurat's generation a similar search of the smallest units of poetic effect.

Seurat's dots may be seen as a kind of collage. They create a hollow space within the frame, often a vast depth; but they compel us also to see the picture as a finely structured surface made up of an infinite number of superposed units attached to the canvas. . . .

Seurat's dots, I have intimated, are a means of creating a special kind of order. They are his tangible and ever-present unit of measure. . . .

Seurat's art is an astonishing achievement for so young a painter. At thirty-one—Seurat's age when he died in 1891—Degas and Cézanne had not shown their measure. But Seurat was a complete

artist at twenty-five, when he painted *La Grande Jatte*. What is remarkable, besides the perfection of this enormously complex work, is the historical accomplishment. It resolved a crisis in painting and opened the way to new possibilities. Seurat built upon a dying classic tradition and upon the Impressionists, then caught in an impasse and already doubting themselves. His solution, marked by another temperament and method, is parallel to Cézanne's work of the same time, though probably independent. If one can isolate a single major influence on the art of the important younger painters in Paris in the later 1880's, it is the work of Seurat; van Gogh, Gauguin and Lautrec were all affected by it.

> Meyer Schapiro. "Seurat: Reflections (1958)."
> *Art News Annual*, XXIX, 1964, p. 20 ff.

Bathers at Asnières
Une Baignade, Asnières

1883–84 oil on canvas 71¾" x 144¼" London, Tate Gallery

The subject of *Une Baignade* is an everyday scene on the banks of the Seine in one of the working-class suburbs of Paris. It is a hot summer afternoon; four individuals, one with a dog, are peacefully contemplating the river as it flows past; two others are bathing already; they have prepared themselves by taking off part of their clothing, which lies around in piles on the bank. Sailing-boats are visible; a small party of people is being ferried across to the other bank; one of the boys in the water is calling to an invisible companion. There is hardly a breath of wind; the smoke rises straight from the factory chimneys; the air is heavy with heat and the ardent rays of the invisible sun vibrate through and through the canvas. Except for the boats, nothing is stirring. The motionless figures all face the same way and show no interest in each other; they appear an aimless and chance collection of people, each occupied with his own private relaxation, united only by their common absorption in a pleasurable experience. All this Seurat has recorded with penetrating observation, calm detachment, and a scrupulous attention to nature. Each object is treated with the same degree of exactitude, and all the elements of the picture, human as well as natural, have definite shapes, distinct masses, capable of sustaining their characteristic detail such as bows, boot-tabs or blades of grass. Indeed there is so much in this painting that one would expect the eye to lose itself. Nevertheless it is clear and ordered. But the artist has still managed to preserve so much that is natural and informal about this group on the river-bank that the effect is unquestionably of something seen and experienced by the painter, which has been seized on by his imagination and expressed by his brush with such a sense of immediacy, both physical and emotional, that the spectator is convinced. . . . It is Seurat's

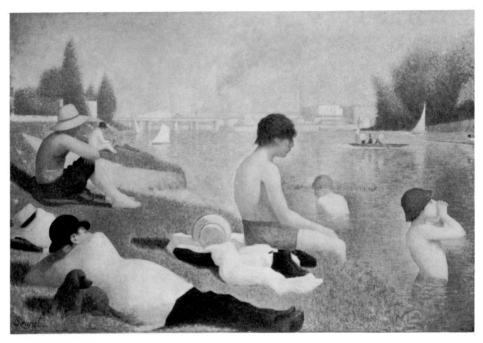

Bathers at Asnières. *Seurat*

triumph to have achieved intellectual and visual verisimilitude by the application of logic and science.

<div align="right">

Douglas Cooper. *Georges Seurat: Une Baignade,*
Asnières. London, 1945, p. 6 ff.

</div>

A Sunday Afternoon on the Island of La Grande Jatte

1884–86 oil on canvas 81¼ ″ x 120¼ ″ Art Institute of Chicago

M. Seurat's idea seems quite clear. The painter wants to show the tedious routine of a Sunday outing—people who, dutifully and without pleasure, go for a stroll in all the places one is supposed to visit on Sundays. The artist has given his figures the automatic gestures of tin soldiers marching on well-marked squares. Nursemaids, clerks, and troopers all walk in the same slow, bored, and even rhythm. The character of the scene is rendered well, but with too great an insistence. Besides being just one glimpse from one point of view, it is exaggeratedly presented. . . . Nevertheless, this transformation of Impressionism is interesting to keep in mind. With it begins the abandonment of pure sensation. Line means idea. In spite of themselves the painters return to the idea, a more fertile source. Once they study line, they are forced to

search for character: they are bound to return to the study of the essence, which they had relinquished for the sake of the object.

A. Paulet (1886). Quoted in Henri Dorra and
John Rewald. *Seurat.* Paris, 1959, p. 160.

If we examine, for example, a few square inches of uniform tone in M. Seurat's *Grande Jatte*, we shall find that all the elements which make up the tone are present on every inch of this surface. Take the lawn in the shadow: most of the brush strokes render the local color of the grass; others, orange-hued and sparsely scattered, express the barely perceptible action of the sun; still others, of blue-red, introduce their complementary green; the touches of cyan blue, brought on by the proximity of a plot of grass in the sun, become more intense toward the line of demarcation, but thin out progressively away from this line. Only two elements are combined to produce this sunlit plot of grass: green and solar orange; all other reactions are canceled by the furious assault of light. Since black is a nonlight, the black dog is colored by the reactions from the grass; its dominant hue is therefore blue-red; but it is also affected by the dark blue activated by the luminosities of the neighboring

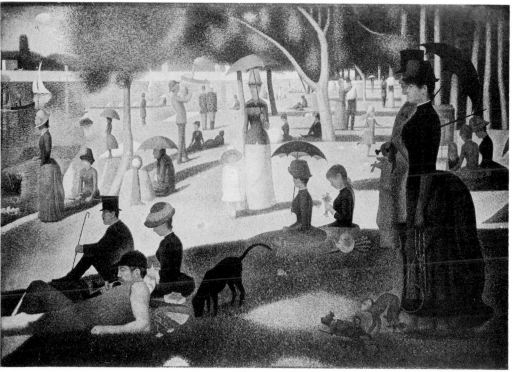

A Sunday Afternoon on the Island of La Grande Jatte. *Seurat*

areas. The monkey on the leash is speckled with yellow, its intrinsic characteristic, and spotted with blue-red and ultramarine. . . .

These colors, isolated on the canvas, recombine on the retina. We have thus a mixture not of colored pigments but of colored light. Need we call to mind that the mixture of pigments and the mixture of light do not necessarily produce the same result, even if the colors are the same? It is generally known that the luminosity of optical mixture is always much greater than that of pigmentary mixture, as the many equations worked out by M. Rood* show. . . . We can therefore understand that the Impressionists, aiming at expressing the utmost luminosities—as Delacroix had done before at times—want to substitute optical mixture for pigmentary mixture.

M. Georges Seurat is the first to present a complete and systematic paradigm of this new way of painting. His immense *Grande Jatte . . .* unfolds like a monotonous and patient tapestry of dots. . . .

The subject: At four o'clock, under a hot midsummer sky, boats are passing the island, which is alive with a group of Sunday visitors scattered amid the trees and enjoying the fresh air. These forty-odd persons are fixed in a hieratic and simplified composition, rigorously drawn and seen either from the back, front, or in profile. Some are seated at right angles, others are in a recumbent position or standing up straight. They are stiffly dressed, like a modernized Puvis [de Chavannes]. The atmosphere is transparent and singularly vibrant; the surface seems to quiver.

<div align="right">

Félix Fénéon. *Les Impressionnistes en 1886.*
Paris, 1886, p. 20 ff.

</div>

La Grande Jatte merits a detailed examination. It is luminous to such a degree that it is almost impossible to take an interest in the other landscapes hanging nearby. It is filled throughout with a purity of atmosphere, a vibrating air. The Seine, the green shadows, the golden grass, and the sky influence, color, and interpenetrate one another, producing a tremendous sensation of life.

M. Seurat has been described as a scholar, an alchemist, etc. However, he utilizes his scientific experiments only for the control of his vision. They give him the additional degree of assuredness. . . . *La Grande Jatte* has been painted with the naïveté and honesty of a primitive. We are reminded of Gothic art. Like the old masters who, at the risk of stiffness, arranged their figures in a hieratic order, M. Seurat synthesizes gestures, poses, gaits. . . .

* The American physicist Ogden N. Rood (1831–1902). His principal work, *Modern Chromatics with Applications to Art and Industry* (1879), deals with the physics of color sensations, explaining the difference between color as pure light and color as the painter's pigment. A French translation of this book greatly influenced the Neo-Impressionists.

The gestures of those strollers, their grouping, their comings and goings, are *essential*. His entire work appears to be the result of numerous occasional observations. It reaches out grandly and gloriously, and that is why the enthusiasts are harnessing themselves like rearing horses.

Émile Verhaeren. "Le Salon des XX à Bruxelles."
La Vie Moderne, February 26, 1887, p. 138.

Among [Seurat's] seven great pictures . . . *La Grande Jatte* is of primary significance. Second in the series, it is the first complete revelation of his mastery. Of all seven it is the most complex in organization, and in it Seurat clearly discovered the various directions along which his art was to develop in the few brief years before his death. Moreover, *La Grande Jatte* is unique among the work of all modern artists for the thoroughness with which each part was studied before finding a place in the finished canvas. At a time when many paintings were done in a day by brushes priding themselves on cleverness, this picture took nearly two years to construct, and we know that about seventy preliminary drawings, painted sketches, and studies went into its careful building.

The value of these documents to the understanding of Seurat is enormous. What other artist of the nineteenth century, with the exception of Ingres, revealed so completely his creative process? . . . To follow the composition of *La Grande Jatte* from the first fragmentary impressions to its final and resolved state is to be admitted, as it were, to the secret chambers of an artist's mind where we observe the raw material of nature being selected and transformed into the quite different material of art. . . . *La Grande Jatte* . . . therefore . . . remains, over and above its interest to the student of Seurat, one of the most complete case studies we possess in the evolution of a pictorial theme.

Today it seems clear that Seurat played a major rôle in rescuing art from the technique and aesthetic of Impressionism, helping to re-establish classical order at a moment when painting was threatened with formlessness and dissolution. . . .

In the 'eighties it was the fashion to see the picture only as a daring and logical experiment in color. According to the earlier critics of Post-Impressionism and Cubism, we must admire it for its form alone. Today, less interested in technique than the nineteenth century, and less fearful of "subject matter" than the Cubists, we can begin to comprehend Seurat's remarkably subtle understanding. For us of today the nurse's back means more than a geometric shape; it is instinct with life. The young girl with the bouquet should not only be considered as an arrangement of tones and colors; she is exquisitely felt as an individual. To one who sits before it for a long time, the whole picture slowly—and always reticently—begins to reveal a tense and concentrated

emotional harmony. Seurat has endowed its strict permanent design with all the delicate insight and lyric power of a career dedicated to art.

D. C. Rich. *Seurat and the Evolution of "La Grande Jatte."* Chicago, 1935, p. 3 ff.

A Young Woman Holding a Powder-Puff
Jeune femme se poudrant

1889–90 oil on canvas 37½″ x 31¼″ London, Courtauld Institute of Art

This is, indeed, one of the strangest pictures I know, so utterly remote is the point of departure from the place to which Seurat carries us. It is as though he had made a bet that he would take the most intractable material possible and yet mould it to his ends. This impossible woman, in the grotesque *déshabille* of the 'eighties, surrounded by every horror of gimcrack finery of the period, might have inspired Daumier to a grim satire, or Guys to an almost lyrical delight in its exuberance, or Degas to a bitter and merciless epigrammatic exposure, or Lautrec to an indulgently ironical scherzo; but Seurat passes over all such implications with an Olympian indifference, he treats

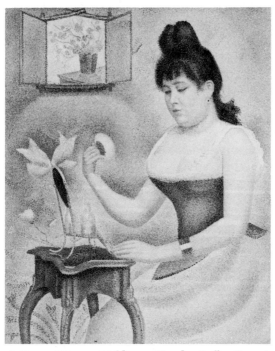

A Young Woman Holding a Powder-Puff. *Seurat*

the subject with religious solemnity and carries it into a region of abstract beauty. No Byzantine mosaic, however solemnly hieratic, could be more remote than this from all suggestion of "La vie Parisienne." The design is affirmed with an almost oppressive decision. We are forbidden to imagine the slightest tremor of change in these impeccable contours. By incessant revision the position of everything has been ascertained down to the minutest fraction. At first it seems to be all surface—contours revealed by spots of pure but elusive colour—and then these almost imperceptible changes of colour build up for us solid volumes bathed in a faint glowing light. There is scarcely any tone contrast, no definite light and shade, and yet in the end these volumes assert themselves with overpowering completeness. For all its decorative flatness, for all its theoretical and abstract colouring, this is intensely real, but for all its reality nothing of the original theme, of the thing seen, remains untransformed, all has been assimilated and remade by the idea. And perhaps this complete transmutation of the theme by the idea is the test of great art. It means that in proportion as a picture attains to this independent reality and inherent significance the element of illustration drops out altogether and becomes irrelevant.

<div align="right">Roger Fry. *Seurat* (1926). London, 1965, p. 16.</div>

HENRI DE TOULOUSE-LAUTREC

Henri-Marie-Raymond de Toulouse-Lautrec Monfa was a descendant of the medieval counts of Toulouse. He was born in 1864 at Albi, and while still a child broke both legs in two accidents, leaving him deformed and stunted. He began to draw at an early age. In 1882 he took up painting seriously, studying first under the animal painter René Princeteau and then under the academic painters Bonnat and Cormon.The work of Degas and the discovery of Japanese prints were his true formative influences, however. In 1885 Lautrec set up his own studio in Montmartre. From 1889 on he exhibited with the Independents and with *Les Vingt* in Brussels. His first posters date from 1891. In 1895 he visited London, where he met Oscar Wilde and Aubrey Beardsley. As a result of a life given to drink and debauchery.Lautrec had to be committed to a sanatorium in 1899. He recovered, resumed drawing and painting, but also returned to the excesses of his earlier life. In 1901 he was taken to his mother's castle at Malromé in southern France, where he died of an attack of paralysis at the age of thirty-six.

It has been a long time since we have encountered an artist as gifted as M. de Toulouse-Lautrec. His forcefulness is probably due to the . . . combination of a penetrating analysis with a keen expression. His cruel, implacable observation resembles that of Huysmans and [Henry] Becque. . . . Although his early work recalls

Forain or Degas, whom he greatly admired, M. de Toulouse-Lautrec soon freed himself of these influences and developed his own individuality. . . . In this present exhibition [at the Goupil Gallery] we note the accuracy of M. de Toulouse-Lautrec's point of view and the fidelity of his angle of vision. . . . His innate gifts as a thinker, satirist, draftsman, and painter have developed continually and have attained an increasingly brilliant command of form and color. . . . His work is a singular revelation of the manners of today—man has been surprised and fixed in his gestures, his variety of attitudes, his views and appearances, his externals, and his inner core. We are thinking not only of the *Moulin Rouge,* with its fierce reality and bitter humor, but also of the artist's sketches, his portraits, . . . his posters, and his lithographs, of his entire *œuvre* with its psychological as well as its visual appeal.

> Roger Marx. "L'Art nouveau. Sur l'exposition d'ouvrages récentes de M. Toulouse-Lautrec (1893)." Quoted in Maurice Joyant. *Henri de Toulouse-Lautrec.* 2 vols. Paris, 1926–27, II, 25.

Lautrec, to be sure, has been wearing a mask, and few people have taken the trouble to lift it. He was acting out a part intentionally and systematically, but people thought he was merely being himself. He depicted his subjects with irony, mockery, even cruelty, and everyone believed that he was revealing his own soul. Because he was injured as a child, and traces of this injury remained, he was treated as if he were a monster. When he fell ill, he was spoken of as dead. . . .

If we consider his work as a whole, we can see that Toulouse-Lautrec has produced not only good things, but also beautiful ones. Even the man in the street realizes that he has infused new life into the poster. . . . Chéret, the originator of this renewal of the sidewalk fresco, applauded Lautrec's first attempts . . . and told me . . . "Lautrec is a master."

In addition to this aspect of his work, Lautrec has produced over five hundred engravings: black-and-white and colored lithographs, book jackets, sheet-music covers, magazine illustrations, drawings published separately, and several hundred pastels and paintings, many of which are very striking in composition, color, and character. . . .

His work is of a very special type. It does not show the beautiful side of human nature; it abounds in misery and bestiality. It shows the streetwalkers, with their lifelike gestures, in their dismal gloom, in their true and unadulterated ugliness. Lautrec's greatest crime is that he has shown the ugliness of ugly things. But he has been pre-

ceded in this by a host of other painters, whose work we now find superb.

In his thirst for truth, in his search as a painter who loves the human animal in its natural state, he had to look for his models where he could find them—in taverns and hovels. Here Lautrec's work becomes complex and painful. This curious, fearless little man descended into the underworld, but he burned his skin. Alcohol, the abominable alcohol, has for a time ravaged the artist, as it is ravaging his models. . . .

<div style="text-align:right">

Arsène Alexandre. "Une Guérison."
Le Figaro, March 30, 1899.

</div>

Lautrec's brushwork was as hasty as his drawing. He liked cardboard for a background, and left as much as possible of the blank surface in his compositions. He would have nothing to do with technical recipes. Seurat interested him, but he would have laughed at the idea of a definite programme. In many of his pictures we find some original little commas, which reveal his pleasure in ornament, but this is not in any degree colour-division. At times he shows an exaggerated negligence, but at his worst he could not be a renegade to his aristocratic taste, and he chose his colours with the same careless confidence with which he scribbled his arabesques. It was only in his last decade that he began to concern himself with technique. Two visits to Spain had revealed Velazquez to him. Here he found the completion of Degas. The result was the series of family portraits, in which the crippled dwarf suddenly revealed himself an inimitable master, whose earnestness, brilliance, and technical accomplishments entitle him to rank among the greatest painters of the nineteenth century. Great things were to be expected of him in those days. There was such a maëstria in these pictures, such a classic repose in form and colour, that we bless the South of France which inspired them, and could curse his beloved Paris, which destroyed him.

It was in vain that they gave him a keeper, of whom he made a brilliant portrait, which he inscribed "Mon gardien quand j'étais fou."[*] His birth was an extravagance, and it was only by means of extravagances that his artistic being was sustained. When it was forced into normal channels, his art was quenched and with it his life.

<div style="text-align:right">

Julius Meier-Graefe. *Modern Art.*
2 vols. London, 1908, I, 285.

</div>

Combined with a chronic pessimism, he [Toulouse-Lautrec] exhibited a divination of character that, if he lived and worked hard,

[*] "My keeper when I was crazy."

might have placed him not far below Degas. He is savant. He has a line that proclaims the master. And unlike Aubrey Beardsley, his affinity to the Japanese never seduced him into the exercise of the decorative abnormal which sometimes distinguished the efforts of the Englishman. We see the Moulin Rouge with its hosts of deadly parasites, La Goulue and her vile retainers. The brutality here is one of contempt, as a blow struck full in the face. Vice has never before been so harshly arraigned. This art makes of Hogarth a pleasing preacher, so drastic is it, so deliberately searching in its insults. And never the faintest exaggeration or burlesque. These brigands and cut-throats, pimps and pickpurses are set before us without bravado, without the genteel glaze of the timid painter, without an attempt to call a prostitute a *cocotte*. Indeed, persons are called by their true names in these hasty sketches of Lautrec's, and so clearly sounded are the names that sometimes you are compelled to close your ears and eyes. His models, with their cavernous glance, their emaciated figures, and vicious expression, are a commentary on atelier life in those days and regions. Toulouse-Lautrec is like a page from Ecclesiastes.

James Huneker. *Promenades of an Impressionist.*
New York, 1910, p. 276.

He painted no landscapes, no still lifes, no religious pictures, no abstract conceptions. All of his subjects, except for a few representations of animals, were people: real people whose lives were an integral part of his own life, whose characters and histories directly affected his own character and his own history. . . . To understand Lautrec, to appreciate his art, we must know the people he knew, the places he visited, and the circumstances that shaped his life.

Lautrec's viewpoint was intensely individual, yet curiously detached. He probed deeply beneath the surface, he exposed vice with brutal frankness; but he condemned neither the victims of depravity nor the conditions that were responsible for it. He was content to record; he had no desire to reform.

As an artist he was a follower of Ingres, Daumier, Degas, and the Japanese rather than of the Impressionists and Cézanne. Drawing was more important to him than brush-work, line more significant than colour. He was a talented, sensitive, distinguished painter, not a strikingly original one. As a draughtsman, however, his right to a place in the front rank can scarcely be questioned. His drawings in pencil, crayon, and ink, his lithographs, coloured and uncoloured, are among the most superb examples of their kind. As a designer of posters he has never been surpassed.

Gerstle Mack. *Toulouse-Lautrec*
(1938). New York, 1949, p. v ff.

He was grotesque. Yvette Guilbert's description of him is horribly vivid:

"A dark, huge head, with a very ruddy complexion, a black beard, a greasy, oily skin, a nose big enough for two faces, and a mouth—a mouth that cut across his face from cheek to cheek, like a great open wound. Flat, thick, flabby, purple lips surrounded this dreadful and obscene chasm. I was aghast, until I looked into Lautrec's eyes. How beautiful they were, how large, how wide, rich in colour, astonishingly brilliant and luminous."

It is important to realize the nature of his deformity because it explains the kind of life he led; and the kind of life he led explains the kind of pictures he painted. . . . For it was his deformity, which deprived him of normal relationships with women, that drove him to the underworld of Paris. Once there, he adopted it as his world, the peculiar theme of his art. The brothels he had visited casually he presently began to live in, so that he might study the inmates with realistic detachment. . . .

Lautrec's talent was modest. He contributed little or nothing to the formal or technical development of modern painting. He seems to have recognized the genius of Van Gogh, and he was a fanatical worshipper of Degas. But he was contemptuous of Impressionists like Monet, and blind to the significance of Cézanne. The importance of his art derives mainly from its subject-matter, and this subject-matter from his life of dissipation. If he had been a better man he would almost certainly have been a less interesting painter. There have been, of course, painters who used the same subject-matter with a sentimental or a pornographic intention. Lautrec is redeemed by his realism; and his realism as we have seen, was probably a result of his deformity.

Prostitutes, comédiennes, clowns; cafés, bars, theatres, racecourses—there is plenty of scope for realism here, but is it the whole of reality? To be fair to Toulouse-Lautrec, we must remember his portraits, which are an important part of his work. But he himself once said: *"Je ne fais pas de portraits. Je peins mes amis les chiens, et mes amis les hommes"*—which is as much as to say that he did not distinguish between his portraits and the rest of his work.

<div style="text-align:right">Herbert Read. "Toulouse-Lautrec." A Coat of Many Colours. New York, 1956, p. 178 ff.</div>

The problem of situating Lautrec as an artist is not easy. . . . From a historical point of view, he was a vital link in the chain of reaction against Impressionism, against *la belle peinture* as such, and against the cosy, smug little bourgeois world which the Impressionists depicted. Yet although Lautrec was very much a *fin-de-*

siècle artist, he was not a reactionary. Stylistically he takes his place along with Seurat, Gauguin, and Van Gogh, and stands in sharp contrast to belated Impressionists such as Bonnard, Vuillard, and the other Nabis. Yet his work as a whole suffers from one consistent weakness: his evasive handling of spatial problems. . . . However, it must be emphasized that Lautrec . . . made one contribution to painting which is unique: his open-minded and outspoken attitude towards sex. Man's sexual activities form the subject of many of Lautrec's greatest pictures and lithographs, yet this was not in itself greatly daring during the 1890's since eroticism was very much in the air. Lautrec's daring was in recording frankly and dispassionately without prettification or *galanterie* what he observed in a bar, in the salon of a *maison close*, or even in the privacy of a bedroom. . . . No less remarkable is his ability to handle sexual themes in such a way that his pictures are never salacious or disgusting, because he never played up the element of grossness or vice, and resisted the temptation to be shocking or sensational. . . .

However, if we wish to situate Lautrec in a true perspective we must take into account the literature of the period, for it is impossible to detach his work from a background formed by the novels of naturalist or realist writers like Flaubert, the brothers Goncourt, Zola, and Maupassant. But we must not stop there, because Lautrec's pictures are also precious historic documents which tell us as much as, if not more than, many a novelist or historian can about the life and moral outlook of his generation.

> Douglas Cooper. *Toulouse-Lautrec.*
> New York, 1956, p. 47.

At the Moulin Rouge

1892 oil on canvas 48⅜" x 55¼" Art Institute of Chicago

Some of Toulouse-Lautrec's friends are seated around a table at the café Moulin Rouge. Édouard Dujardin, editor of the *Revue Indépendante,* with his whiskers and fedora, is talking to the dancer La Macarona. Next to her is the photographer Paul Sescau, seated beside Maurice Guilbert. The identity of the lady seen from the rear is not known. In the foreground is a young girl, "Mlle. Nelly C." In the background, the dancer Louise Weber, known as La Goulue. The lean figure towering over the group is Dr. Tapié de Céleyran, Lautrec's cousin and friend, accompanied by the painter himself.

Lautrec's skill in characterizing these people is like a novelist's. He seizes on the eccentricities of behavior and delights in reporting the particular

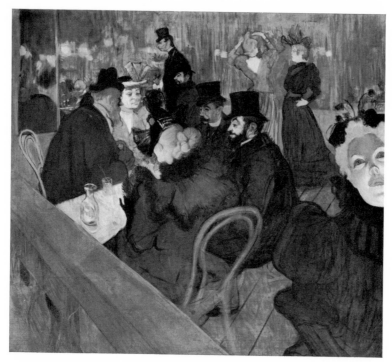

At the Moulin Rouge.　*Toulouse-Lautrec*

detail which sets one human being off from another. . . . From his study of Degas and the Japanese, as well as from unremitting practice, he had developed a remarkably supple and expressive line. That line, quick and agitated, is the basis of his art. . . . Lautrec's ability to do what he pleases with this direct, life-communicating line is further matched with an ability to design patterns. He has a tendency to see things in large outlines and in flat masses of color. Even in the black and white reproduction one can see how the central group, mostly made up of dull browns, blacks and purple, holds the eye because he has surrounded it with plain areas of grayer tone and because he has accented it with spots of light (usually orange or red) which play through the whole design giving it character. From Oriental sources, Lautrec took his fondness for asymmetry, and here by placing the figures slightly to the left, and by running a railing in sharp diagonal across the lower corner he has further fixed attention in an ingenious way.

. . . Through sheer draughtsmanship, Lautrec won himself a place with the great designers of the century, with Millet, with Daumier, and with his own idol, Degas.

D. C. Rich.　"Au Moulin Rouge."　*Bulletin, Art Institute of Chicago,* XXIII, no. 2, 1929, p. 14 ff.

Bibliography

This bibliography does not attempt to be complete. It is, rather, a listing of the works consulted by the editor in selecting and preparing her text. Thus many of the important sources and critical works relating to French painters and paintings, together with less scholarly writings suitable for the general reader, will be found here.

The bibliography is divided into two major groups. The first part contains sources as well as modern publications, general works, collections of essays, including reviews of the "Salons," general exhibition catalogues, and artists' writings. It also includes works of poetry and fiction, of which a sampling has been given in the text. Basic reference tools such as Thieme-Becker's *Allgemeines Lexikon der bildenden Künstler* or *The Encyclopedia of World Art* have been omitted.

The second part of the bibliography lists selected monographs, articles, and exhibition catalogues dealing with a single painter. These are given under the name of each artist, arranged in alphabetical order.

The publication date of the first or original edition of a work quoted in the text has been given in a note whenever possible. Modern reprints have been indicated for older publications only. A starred entry indicates that an excerpt from the work has been especially translated for this book.

GENERAL WORKS

°About, Edmond. *Causeries*. 1st series. Paris, 1865.

Annales du musée et de l'école moderne des beaux-arts. See Landon, C. P.

Antal, Frederick. "Reflections on Classicism and Romanticism." *Burlington Magazine*, April 1935, March 1936, September and December 1940, January 1941.
> Reprinted in his *Classicism and Romanticism*. New York, 1966.

Antonio di Piero Averlino, called Filarete. See Filarete

Apollinaire, Guillaume. *The Cubist Painters: Aesthetic Meditations, 1913*. New York, 1944.

°————. *Il y a*. Paris, 1925.
> Written 1914.

Astruc, Zacharie. *Les 14 stations du Salon, 1859, suivies d'un récit douloureux*. Preface by George Sand. Paris, 1859.

————. *Le Salon intime, exposition au Boulevard des Italiens*. Paris, 1860.

°Bachaumont, Louis de. "Liste des meilleurs peintres, sculpteurs, graveurs et architectes des académies royales de peinture, sculpture et architecture. 1750." In Wille, J. G. *Mémoires et journal*. Vol. II. Paris, 1857.

Baldinucci, Filippo. *Notizie dei professori del disegno*. Vol. IV. Florence, 1728.

°Ballu, Roger. "L'Exposition des peintres impressionnistes." *Chronique des Arts de la Curiosité*, April 14, 1877.

°Balzac, Honoré de. *Lettres à l'étrangère (1833–1844)*. 2 vols. Paris, 1899–1906.

°Barbier, Auguste. *Souvenirs personnels et silhouettes contemporaines*. Paris, 1883.

Barnes, Albert C. *The Art in Painting*. 3rd ed. New York, 1937.

———— and De Mazia, Violette. *The French Primitives and Their Forms*. Merion, Pa., 1931.

Baschet, Robert. *E.-J. Delécluze, témoin de son temps, 1781–1863*. Paris, 1942.

Baudelaire, Charles. *Art in Paris, 1845–1862*. Trans. and ed. Jonathan Mayne. London, 1965.
> With its companion volume, *The Painter of Modern Life* (London, 1964), comprises the most complete English translation of Baudelaire's essays on the visual arts. First published in book form with the titles *Curiosités esthétiques* (Paris, 1868) and *L'Art romantique* (Paris, 1869).

°————. *L'Art romantique*. Ed. Jacques Crépet. Paris, 1925.
> First edition, 1869.

°————. *Curiosités esthétiques*. Paris, 1892.
> First edition 1868.

————. *Curiosités esthétiques, l'art romantique et autres œuvres critiques*. Ed. H. Lemaitre. Paris, 1962.

°————. *Les Fleurs du mal. Œuvres complètes*. Vol. I. Paris, 1886.
> First edition 1857. English translations under the title *The Flowers of of Evil*.

————. *The Mirror of Art.* Trans. and ed. Jonathan Mayne. London, 1955.
 Selected essays.
*————. *Œuvres complètes.* Ed. Y.-G. Le Dantec. Bibliothèque de la Pléiade. Paris, 1954.

————. *The Painter of Modern Life and Other Essays.* Trans. and ed. Jonathan Mayne. London, 1964.

Bazin, Germain. *The Franco-Flemish School, XIV, XV Centuries.* Trans. Lucy Norton. Geneva, 1947.

————. *French Impressionists in the Louvre.* New York, 1958.

————. *Les Primitifs français.* Geneva, 1948.

Béguin, Sylvie. *L'École de Fontainebleau.* Paris, 1960.

Behets, Armand. *Diderot, critique d'art.* Brussels, 1944.

Bell, Clive. *An Account of French Painting.* London, 1932.

————. *Art.* London, 1949.
 First edition 1914.

————. *Landmarks in Nineteenth-Century Painting.* New York, 1927.
 Reprinted Freeport, N.Y., 1967.

————. *Since Cézanne.* London, 1922.

*Bellori, Giovanni Pietro. *Le Vite de' pittori, scultori et architetti moderni.* Rome, 1931.
 First edition 1672.

Beyle, Henri. See Stendhal

*Blanc, Charles. *Les Artistes de mon temps.* Paris, 1876.

————. *Histoire des peintres de toutes les écoles: L'École française.* 3 vols. Paris, 1863–65.

*Blanche, Jacques-Émile. *Propos de peintre: De David à Degas.* Paris, 1919.

Blunt, Sir Anthony. *Art and Architecture in France, 1500 to 1700.* Pelican History of Art. Baltimore, 1954.

*Bouchot, Henri. *L'Exposition des primitifs français: La Peinture en France sous les Valois.* Paris, 1904.

Brantôme, Pierre de Bourdeille. *The Book of the Ladies.* Trans. Katherine Prescott Wormeley. Boston, 1899.
 Original title: *Vies des dames illustres, des dames galantes.* Written after 1584, first published posthumously 1665–66.

*Brion, Marcel. *Lumière de la Renaissance.* Paris, 1948.

————. *Romantic Art.* New York, 1960.

Brownell, William C. *French Art: Classic and Contemporary Painting and Sculpture.* New enlarged ed. New York, 1901.

Bulliet, C. J. *Apples and Madonnas: Emotional Expression in Modern Art.* Chicago, 1927.

Burty, Philippe. *Maîtres et petits maîtres.* Paris, 1877.

Bye, Arthur E. *Pots and Pans: Studies in Still-Life Painting.* Princeton, 1921.

Carrière, Eugène. *Écrits et lettres choisies.* Paris, 1909.

*Castagnary, Jules Antoine. *Salons, 1857–1870.* 2 vols. Paris, 1892.

Bibliography

Cézanne, Paul. *Letters.* Ed. John Rewald. London, 1941.
*Chainaye, Achille, called Champal. "Le Carnaval d'un ci-devant." *L'Art Moderne,*
 February 15, 1891.
Champfleury (Jules Husson, called Fleury). "Du réalisme, lettre à Mme. [George]
 Sand." *L'Artiste,* September 2, 1855, pp. 1–5.
*———. *Histoire de la caricature moderne.* Paris, 1885.
 First edition 1865.
*Champion, Pierre. *La Dame de beauté, Agnès Sorel.* Paris, 1931.
Chantelou, Paul Fréart de. See Fréart de Chantelou, Paul
*Chateaubriand, François-René de. *Atala. René.* Ed. Gilbert Chinard. Paris, 1930.
 First edition of *Atala* 1801.
Châtelet, Albert, and Thuillier, Jacques. *French Painting from Fouquet to Poussin.*
 Geneva, 1963.
———. See also Thuillier, Jacques, and Châtelet, Albert
Chefs-d'œuvre de l'art français, 1937. Palais National des Arts, Paris. 2 vols. Paris,
 1937.
 Exhibition catalogue.
Chefs-d'œuvre de la peinture française dans les Musées de Leningrad et de Moscou
 [Musée du Louvre]. Paris, 1965.
 Exhibition catalogue.
*Chénier, André. "Sur la peinture d'histoire." *Œuvres complètes.* Ed. Gérard Wal-
 ter. Paris, 1958, pp. 284–88.
 First published 1792.
Chennevières, Philippe de. *Essais sur la peinture française.* Paris, 1894.
*Claretie, Jules. *L'Art et les artistes français contemporains.* Paris, 1876.
*———. "Courrier de Paris." *L'Indépendance Belge,* June 15, 1867.
———. *Peintres et sculpteurs contemporains.* 2 vols. Paris, 1882.
Clark, Sir Kenneth. *Landscape into Art.* Boston, 1961.
 First edition London, 1949. Also published under the title *Landscape
 Painting* (New York, 1950).
———. *Looking at Pictures.* New York, 1960.
———. *The Nude: A Study in Ideal Form.* The A. W. Mellon Lectures in the
 Fine Arts. New York, 1956.
Claudel, Paul. *The Eye Listens.* New York, 1950.
*Collé, Charles. *Journal et mémoires.* New ed. by H. Bonhomme. 3 vols. Paris, 1868.
 Covers the years 1748–72. First published posthumously 1805–7.
Commemorative Catalogue of the Exhibition of French Art, 1200–1900 [held in
 1932]. Royal Academy of Arts, London. London, 1933.
Constable, John. *John Constable's Correspondence.* Ed. R. B. Beckett. 5 vols. Lon-
 don and Ipswich, 1962–67.
Cook, Sir Herbert. *A Catalogue of the Paintings at Doughty House, Richmond, and
 Elsewhere in the Collection of Sir Frederick Cook.* 3 vols. London, 1915.
 Vol. III: English, French . . . Schools, by Maurice W. Brockwell.
Cortissoz, Royal. *Art and Common Sense.* New York, 1913.
 Collected essays.
Courthion, Pierre. *Romanticism.* Geneva, 1961.

Cox, Kenyon. *Concerning Painting.* New York, 1917.
————. "The 'Modern' Spirit in Art." *Harper's Weekly,* March 15, 1913.
 Reprinted in *1913 Armory Show, 50th Anniversary Exhibition, 1963.*
 Munson-Williams-Proctor Institute, Utica, N.Y. New York, 1963.
————. *Painters and Sculptors.* 2nd series. New York, 1907.

Degas, Edgar. *Letters.* Ed. Marcel Guérin. Oxford, 1947.
°Delacroix, Eugène. *Journal.* Ed. André Joubin. 3 vols. Paris, 1932.
————. *The Journal of Eugène Delacroix.* Trans. Walter Pach. New York, 1937.
°————. *Lettres de Eugène Delacroix.* Ed. Philippe Burty. 2 vols. Paris, 1880.
°————. *Œuvres littéraires.* 2 vols. Paris, 1923.
————. *On Art Criticism.* New York, 1946.
 First published 1829.
°Delécluze, E. J. *Louis David, son école et son temps.* Paris, 1855.
°Denis, Maurice. *Du symbolisme au classicisme, théories.* Miroirs de l'art. Paris, 1964.
————. *Journal (1884–1943).* 3 vols. Paris, 1957–59.
°————. *Nouvelles théories sur l'art moderne, 1914–1921.* Paris, 1922.
°————. *Théories, 1890–1910.* 4th ed. Paris, 1920.
 Essays first published in book form 1912.
Dewhurst, Wynford. *Impressionist Painting.* London, 1904.
°Dézallier d'Argenville, Antoine Joseph. *Abrégé de la vie des plus fameux peintres* . . . 2nd ed. 4 vols. Paris, 1762.
 First incomplete edition 1745.
Dictionary of Modern Painting. General eds. Carlton Lake and Robert Maillard. New York, 1955.
°Diderot, Denis. *Essais sur la peinture.* Paris, 1795.
 Written 1766, published posthumously.
°————. *Œuvres complètes.* Eds. J. Assézat and Maurice Tourneux. 20 vols. Paris, 1875–77.
 Salons, vols. X–XII.
————. *Œuvres esthétiques.* Ed. Paul Vernière. Paris, 1965.
°————. "Pensées détachées sur la peinture." *Œuvres complètes.* Vol. XII. Paris, 1876.
 Written ca. 1760, first published posthumously 1798.
°————. *Salons.* Eds. Jean Seznec and Jean Adhémar. 4 vols. Oxford, 1957–67.
 Written for the *Correspondance littéraire, philosophique et critique de Frédéric Melchior Grimm* and issued in manuscript copies only. First published posthumously at irregular intervals between 1795 and 1857.
Dilke, Lady E. F. *French Painters of the XVIIIth Century.* London, 1899.
Dimier, Louis. *French Painting in the Sixteenth Century.* London, 1904.
°————. *Histoire de la peinture de portrait en France au XVI^e siècle.* 3 vols. Paris, 1924–26.

°————. *Histoire de la peinture française des origines à la mort de Le Brun.* 3 vols. Paris, 1925–27.

 Also published separately under the titles *Histoire de la peinture française des origines au retour de Vouet, 1300–1627* (Brussels, 1925) and *Histoire de la peinture française du retour de Vouet à la mort de Le Brun, 1627–1690,* 2 vols. (Paris, 1926–27).

°————, ed. *Les Peintres français du XVIIIᵉ siècle.* 2 vols. Paris, 1928–30.

————. "Les Primitifs français." *Gazette des Beaux-Arts,* July and December 1936, November 1937, April, September, and November 1938.

°"Documents à conserver à propos des XX." *L'Art Moderne,* March 29, 1891.

Dorbec, Prosper. *L'Art du paysage en France.* Paris, 1925.

Dostoyevsky, Fyodor. *A Raw Youth.* Trans. Constance Garnett. New York, 1961.

 First Russian edition 1875.

°Du Camp, Maxime. *Les Beaux-arts à l'Exposition Universelle de 1855.* Paris, 1855.

°————. *Salon de 1857.* Paris, n.d.

°Dumas, Alexandre (Dumas père). *L'Art et les artistes contemporains au Salon de 1859.* Paris, 1859.

°Dumont-Wilden, Louis. *Le Portrait en France.* Brussels, 1909.

Dupont, Jacques. *The Seventeenth Century.* Geneva, 1951.

Durand-Gréville, E. "The Sixteenth Century at the Exhibition of French Primitives." *Burlington Magazine* VI, 1904, pp. 143–56.

Durand-Ruel Gallery, New York. *What They Said: Postscript to Art Criticism.* New York, 1949.

°Duranty, Louis. *La Nouvelle Peinture.* New ed. Paris, 1946.

 First edition 1876.

°Duret, Théodore. *Critique d'avant-garde.* Paris, 1885.

————. *Manet and the French Impressionists.* Trans. J. E. Crawford Flitch. Philadelphia, 1910.

 First edition 1902.

————. *Les Peintres français en 1867.* Paris, 1867.

°Eckermann, Johann Peter. *Gespräche mit Goethe in den letzten Jahren seines Lebens.* 2 vols. Berlin, n.d.

 First edition 1836–48.

Einstein, Lewis. "Looking at French Eighteenth-Century Pictures in Washington." *Gazette des Beaux-Arts,* May 1956, pp. 213–50.

Éluard, Paul, ed. *Anthologie des écrits sur l'art.* 3 vols. Paris, 1952–54.

Exposition des primitifs français au Palais du Louvre (Pavillon de Marsan) et à la Bibliothèque Nationale. Catalogue . . . Paris, 1904.

 Exhibition catalogue.

Farington, Joseph. *The Farington Diary.* Ed. James Greig. 8 vols. London, 1923–28.

°Félibien, André. *Entretiens sur les vies et sur les ouvrages des plus excellens peintres anciens et modernes.* 2nd ed. 2 vols. Paris, 1685–88.

 First incomplete edition 1666.

*Fels, Florent. *Propos d'artistes*. Paris, 1925.

*Fénéon, Félix. *Les Impressionnistes en 1886*. Paris, 1886.

*————. *Œuvres*. Paris, 1948.

Filarete. *Filarete's Treatise on Architecture*. Trans. John R. Spencer. 2 vols. New Haven, Conn., 1965.

Florisoone, Michel. "Individualism and Collectivism in French Nineteenth-Century Art." *Burlington Magazine*, June 1938, pp. 270–80.

————. *La Peinture française, le dix-huitième siècle*. Paris, 1948.

Focillon, Henri. *The Art of the West in the Middle Ages*. Ed. Jean Bony. 2 vols. London, 1963.
> Original French edition 1938.

*————. *De Callot à Lautrec: Perspectives de l'art français*. Paris, 1957.
> Selected essays, all previously published.

*————. *La Peinture au XIXᵉ siècle*. Paris, 1927.

*————. *La Peinture au XIXᵉ et XXᵉ siècles*. Paris, 1928.

————. "A Thousand Years of France." *Art News Annual* XXVIII, 1959, pp. 144–69.
> Excerpts in translation.

Fontaine, André. *Les Doctrines d'art en France: Peintres, amateurs, critiques de Poussin à Diderot*. Paris, 1909.

Fosca, François [pseud.]. *The Eighteenth Century*. Geneva, 1952.

Foster, J. J. *French Art from Watteau to Prud'hon*. 3 vols. London, 1905–7.

*Francastel, Pierre. *Histoire de la peinture française: La Peinture de chevalet du XIVᵉ au XXᵉ siècle*. 2 vols. Paris, 1955.

France in the Eighteenth Century. Arts Council of Great Britain. London, 1968.
> An exhibition by Denys Sutton, held at the Royal Academy of Arts, London.

Frankfurter, Alfred. "Museum Evaluations II: Toledo." *Art News*, January 1965, p. 24 ff.

*Fréart de Chantelou, Paul. *Journal du voyage du Cavalier Bernin en France*. Paris, 1885.

Friedenthal, Richard, ed. *Letters of Great Artists*. 2 vols. New York, 1963.

Friedländer, Max J. *Landscape, Portrait, Still Life*. New York, n.d.

Friedlaender, Walter. *David to Delacroix*. Trans. Robert Goldwater. Cambridge, Mass., 1952.
> Originally published 1930 as *Hauptströmungen der französischen Malerei . . . von David bis Delacroix*.

*Fromentin, Eugène. *Les Maîtres d'autrefois*. Paris, 1906.
> First edition 1876. English translations: *The Masters of Past Time* (London, 1948) and *Old Masters of Holland and Belgium* (New York, 1963).

Fry, Roger. "Characteristics of French Art." *French, Flemish, and British Art*. London, 1951.
> First published 1932.

————. "Modern Paintings in a Collection of Ancient Art." *Burlington Magazine* XXXVII, December 1920, pp. 303–09.

————. *Transformations*. Garden City, N.Y., 1956.
>First edition London, 1926.

————. *Vision and Design*. New York, 1947.
>Collected essays first published in book form, London, 1920.

*Gauguin, Paul. *Avant et après*. Paris, 1923.
>Manuscript completed 1903.

————. *Letters to Ambroise Vollard and André Fontainas*. Ed. John Rewald. San Francisco, 1943.

*————. *Lettres de Gauguin à sa femme et à ses amis*. Ed. Maurice Malingue. Paris, 1946.
>English edition, *Letters to His Wife and Friends*, trans. Henry J. Stenning, Cleveland, 1949.

*————. *Lettres de Paul Gauguin à Georges-Daniel de Monfreid*. Paris, 1920.

————. *Noa Noa, Voyage to Tahiti*. Trans. Jonathan Griffin. London, 1961.
>First published, in collaboration with Charles Morice, in the *Revue Blanche*, October 15, 1897 and subsequent issues.

————. *Paul Gauguin's Intimate Journals*. Trans. Van Wyck Brooks. Preface by Emil Gauguin. New York, 1936.
>Reprinted Bloomington, Ind., 1958. Condensed version of his *Avant et après*.

Gaunt, William. *The Aesthetic Adventure*. New York, 1945.
>Reprinted 1967.

————. *Bandits in a Landscape: A Study of Romantic Painting from Caravaggio to Delacroix*. London, 1937.

Gauss, Charles E. *The Aesthetic Theories of French Artists, 1855 to the Present*. Baltimore, 1949.
>Reprinted 1967.

*Gautier, Théophile. *Abécédaire du Salon de 1861*. Paris, 1861.

*————. *Les Beaux-arts en Europe, 1855*. 1st series. Paris, 1857.

*————. *Guide de l'amateur au Musée du Louvre*. Paris, 1882.
>Written 1867; translated as *The Louvre, Works*, vol. IX, Cambridge, 1906.

*————. *Histoire du romantisme*. Paris, 1874.
>Collected essays published posthumously in book form.

————. *The Louvre. Works*. Vol. IX. Cambridge, 1906.

————. *Portraits of the Day. Ibid.* Vol. VI.

*————. "Salon de 1857." *L'Artiste*, 1857, *passim*.

*———— ["Salon de 1865"]. *Moniteur universel*, June 24, 1865.

*Geffroy, Gustave. *La Vie artistique*. 1st–8th series. 8 vols. Paris, 1892–1903.

Gilman, Margaret. *Baudelaire the Critic*. New York, 1943.

Gimpel, René. *Diary of an Art Dealer*. Trans. John Rosenberg. New York, 1966.
>Condensed from the original French edition *Journal d'un collectionneur marchand de tableaux*, published 1963.

*Girodet-Trioson, Anne-Louis. *Œuvres posthumes*. 2 vols. Paris, 1829.

Goethe, Johann Wolfgang von. See Eckermann, J. P.
Gogh, Vincent van. *The Complete Letters of Vincent van Gogh.* 3 vols. Greenwich,
 Conn., 1958.
Goldwater, Robert, and Treves, M., compilers. *Artists on Art, from the XIV to the
 XX Century.* New York, 1945.
*Goncourt, Edmond and Jules de. *L'Art du XVIIIᵉ siècle.* 3 vols. Paris, 1909–10.
 First published 1859–75.
*————. *Études d'art.* Paris, 1893.
————. *French Eighteenth-Century Painters.* Trans. Robin Ironside. London,
 1948.
 Incomplete translation of *L'Art du XVIIIᵉ siècle.*
*————. *Journal: Mémoires de la vie littéraire.* Definitive ed. 9 vols. Paris,
 1935–36.
Gonse, Louis. *Les Chefs-d'œuvre des musées de France: La Peinture.* Paris, 1900.
Gourmont, Rémy de. "Les Goncourt critiques d'art." *Mercure de France,* June 1893,
 pp. 176–78.
*————. *Promenades philosophiques.* 1st series. Paris, 1913.
Grautoff, Otto. See Pevsner, Nikolaus, and Grautoff, Otto
Greenberg, Clement. *Art and Culture: Critical Essays.* Boston, 1961.
*Grimm, Friedrich Melchior. *Correspondance littéraire, philosophique et critique
 de Grimm et de Diderot depuis 1753 jusqu'en 1790.* New ed. 16 vols. Paris,
 1829–31.
 Originally issued in manuscript copies only. First published 1812–13,
 with two supplements, 1814 and 1829.
*Guizot, François. *Études sur les beaux-arts en général.* Paris, 1860.
 First published 1852.

Hamerton, Philip G. *Contemporary French Painters.* London, 1868.
Hamilton, George H. *Painting and Sculpture in Europe, 1880–1940.* Pelican History
 of Art. Baltimore, 1967.
Hartley, Marsden. *Adventure in the Arts.* New York, 1921.
Hauser, Arnold. *The Social History of Art.* 2 vols. London, 1951.
Hautecœur, Louis. *Littérature et peinture en France du XVIIᵉ au XXᵉ siècle.* 2nd
 ed. Paris, 1963.
Hazlitt, William. *Complete Works.* Vols. VIII and X. London, 1930–34.
*Heine, Heinrich. "Französische Maler: Gemäldeausstellung in Paris 1831." *Sämt-
 liche Werke.* Vol. III. Philadelphia, 1855.
 First published in book form 1834.
*————. "Lutezia." *Ibid.* Vol. V.
 First published 1843.
Hendy, Philip. "French Painting in the Sixteenth Century." *Apollo* III, 1926, p. 49 ff.
————. "The Grand Manner in French Painting." *Apollo,* December 1928,
 p. 341 ff.
Henley, W. E. See *Memorial Catalogue . . .*

Herbert, Robert L. *Barbizon Revisited.* Museum of Fine Arts, Boston. New York, 1962.
> Exhibition catalogue.
————, ed. *Modern Artists on Art.* Englewood Cliffs, N.J., 1964.
————. *Neo-Impressionism.* Solomon R. Guggenheim Museum, New York. New York, 1968.
> Exhibition catalogue.
*Hildebrandt, Edmund. *Malerei und Plastik des achzehnten Jahrhunderts in Frankreich.* Handbuch der Kunstwissenschaft. Wildpark-Potsdam, 1924.
Hind, C. Lewis. *The Post-Impressionists.* London, 1911.
Hofmann, Werner. *The Earthly Paradise: Art in the Nineteenth Century.* New York, 1961.
Hogarth, William. *The Analysis of Beauty.* Oxford, 1955.
> First edition 1753.
Holmes, Sir Charles. *Old Masters and Modern Art: The National Gallery, France and England.* London, 1927.
Holt, Elizabeth G., ed. *A Documentary History of Art.* 2nd ed. 2 vols. Garden City, N.Y., 1957–58.
> First edition published under the title *Literary Sources of Art History,* Princeton, 1947.
————, ed. *From the Classicists to the Impressionists: A Documentary History of Art and Architecture in the Nineteenth Century.* Garden City, N.Y., 1966.
> Sequel to the preceding.
Huizinga, J. *The Waning of the Middle Ages.* Garden City, N.Y., 1956.
> First English edition 1924, first Dutch edition 1919.
Huneker, James. *Ivory Apes and Peacocks.* New York, 1915.
————. *Promenades of an Impressionist.* New York, 1910.
Huyghe, René. *Art and the Spirit of Man.* New York, 1962.
————. *Art Treasures of the Louvre, Commentary by Mme. René Huyghe.* New York, 1960.
Huysmans, J.-K. *Against the Grain.* New York, 1956.
> French title: *À rebours.* First edition 1884.
*————. *L'Art moderne.* New ed. Paris, 1908.
> Reviews of the Salons and the exhibitions of the "Independents," first published in book form 1883.
*————. *Certains.* Paris, 1908.
> First edition 1889.

*Ingres, J. A. D. *Écrits sur l'art.* Paris, 1947.
Isarlo, George. *La Peinture en France au XVII^e siècle.* Paris, 1960.
The Italian Heritage: An Exhibition of Works of Art Lent from American Collections. Ed. Irene Gordon. Wildenstein & Co. New York, 1967.

James, Henry. *The Painter's Eye.* Ed. John L. Sweeney. Cambridge, Mass., 1956.

Jamot, Paul. "French Painting." *Burlington Magazine,* December 1931 and January 1932.

*Jedlicka, Gotthard. *Französische Malerei: Ausgewählte Meisterwerke aus fünf Jahrhunderten.* Zurich, 1938.

*Jouin, Henry, ed. *Conférences de l'Académie Royale de Peinture et de Sculpture.* Paris, 1883.

Kandinsky, Wassily. "Text Artista: Autobiography of Wassily Kandinsky, 1918." *In Memory of Wassily Kandinsky, Solomon R. Guggenheim Foundation.* New York, 1945.

Keats, John. *The Letters of John Keats.* Complete rev. ed. by Buxton Forman. London, 1895.

*Kératry. *Annuaire de l'école française de peinture, ou Lettres sur le Salon de 1819.* Paris, 1820.

Kimball, Fiske, and Venturi, Lionello. *Great Paintings in America.* New York, 1948.

Koch, Georg Friedrich. *Die Kunstausstellung, ihre Geschichte von den Anfängen bis zum Ausgang des 18. Jahrhunderts.* Berlin, 1967.

Kultermann, Udo. *Geschichte der Kunstgeschichte.* Vienna, 1966.

*Labande, L.-H. "Notes sur quelques primitifs de Provence." *Gazette des Beaux-Arts,* January 1932 and February 1933.

Laborde, L. E. S. J. *La Renaissance des arts à la cour de France.* 2 vols. Paris, 1850–55.

Laclotte, Michel. *Primitifs français.* Paris, 1966.

*La Font de Saint-Yenne. *Réflexions sur quelques causes de l'état présent de la peinture en France.* n.p., 1747.

La Forge, Anatole de. *La Peinture contemporaine en France.* Paris, 1856.

*Laforgue, Jules. *Œuvres complètes, mélanges posthumes.* Paris, 1923.
> Partial translation in his *Selected Writings,* New York, 1956.

*Landon, C. P. *Annales du musée et de l'école moderne des beaux-arts. Salon[s] de 1808–1822.* 11 vols. Paris, 1808–22.

Lassaigne, Jacques, and Argan, G. C. *The Fifteenth Century.* Geneva, 1955.

Leith, James A. *The Idea of Art as Propaganda in France, 1750–1799.* Toronto, 1965.

Lawrence, D. H. *The Paintings of D. H. Lawrence.* London, 1929.

Lemoisne, P. A. *Gothic Painting in France: Fourteenth and Fifteenth Centuries.* Florence, 1932.

*Lemonnier, Henry. *L'Art français au temps de Richelieu et de Mazarin.* 2nd ed. Paris, 1913.
> First edition 1893.

*Leroy, Alfred. *Évolution de la peinture française des origines à nos jours.* Paris, 1943.

Leroy, Louis. "L'Exposition des impressionnistes." *Charivari,* April 25, 1874.
> Translation in John Rewald, *History of Impressionism,* 1961.

Bibliography

Leslie, C. R. *Memoirs of the Life of John Constable, Composed Chiefly of His Letters.* London, 1845.
>Reprinted London, 1951.

*Lethève, Jacques. *Impressionnistes et symbolistes devant la presse.* Paris, 1959.

Leymarie, Jean. *French Painting: The Nineteenth Century.* Geneva, 1962.

————. *Impressionism.* 2 vols. Lausanne, 1955.

*Lhote, André. *Écrits sur la peinture.* Brussels, 1946.

Lindsay, Jack. *Death of a Hero: French Painting from David to Delacroix.* London, 1961.

Lövgren, Sven. *The Genesis of Modernism: Seurat, Gauguin, van Gogh, and French Symbolism in the 1880's.* Stockholm, 1959.

Loize, J. "Un Inédit de Gauguin." *Nouvelles Littéraires,* May 7, 1953.

Lord, Douglas. "Les Peintres de la réalité en France au XVIIᵉ siècle." *Burlington Magazine,* March 1935, pp. 138–41.
>Article is in English.

*Mâle, Émile. *L'Art religieux après le Concile de Trente.* Paris, 1932.
>Second edition published under the title: *L'Art religieux de la fin du XVIᵉ siècle, du XVIIᵉ siècle et du XVIIIᵉ siècle,* Paris, 1951.

————. *Religious Art from the Twelfth to the Eighteenth Century.* New York, 1949.
>Condensed translation of *L'Art religieux du XIIᵉ au XVIIIᵉ siècle,* 4 vols., Paris, 1931–41, which includes the preceding.

Malraux, André. *The Voices of Silence.* Trans. Stuart Gilbert. Garden City, N.Y., 1953.
>Expanded version of *The Psychology of Art,* 3 vols., New York, 1949–50. French edition, *Les Voix du silence,* published 1951.

*Marcel, Pierre. *La Peinture française au début du dix-huitième siècle, 1690–1721.* Paris, 1906.

Marchand, André. *Les Miroirs profonds.* Paris, 1947.

*Mariette, P. J. *Abécédario.* Eds. P. de Chennevières and A. de Montaiglon. Archives de l'art français. 6 vols. Paris, 1851–60.
>Written about the middle of the eighteenth century.

Markham, Edwin. *The Poems of Edwin Markham.* Ed. Charles L. Wallis. New York, 1950.

Markham, Felix. "Napoleon and His Painters." *Apollo,* September 1964, pp. 187–91.

*Marmontel, Jean-François. "Mémoires." *Œuvres complètes.* Vol. 1. Paris, 1818.
>Written 1792–95.

*Marolles, Abbé Michel de. *Le Livre des peintres et des graveurs.* Ed. Georges Duplessis. Paris, 1872.
>First edition 1673.

Masson, André. "A Crisis of the Imaginary." *Magazine of Art,* January 1946, pp. 22–23.

Mather, Frank Jewett. *Western European Painting of the Renaissance.* New York, 1939.

Mauclair, Camille [pseud.]. *The French Impressionists*. Trans. P. G. Konody. London, 1911.

First French edition 1904.

Maugham, W. Somerset. *Christmas Holiday*. New York, 1939.

——. *Of Human Bondage*. New York, 1915.

°Maupassant, Guy de. "La Vie d'un paysagiste." *Études, chroniques et correspondance*. Paris, 1938, pp. 166–69.

First published 1886.

°Mauricheau-Beaupré, Charles. *L'Art du XVII^e siècle en France*. 2 vols. Paris, 1946–47.

May, Gita. *Diderot et Baudelaire, critiques d'art*. 2nd ed. Geneva, 1967.

McIlhenny, Henry P. "David to Toulouse-Lautrec at the Metropolitan Museum." *Art Bulletin*, June 1941, pp. 170–73.

Meier-Graefe, Julius. *Modern Art*. 2 vols. London, 1908.

Original German edition: *Entwickelungsgeschichte der modernen Kunst*, 3 vols., 1904–5.

Meiss, Millard. *French Painting in the Time of Jean de Berry*. 3 vols. London, 1967–68.

——. "A New French Primitive." *Burlington Magazine*, June 1960, pp. 233–40.

°*Mémoires inédits sur la vie et les ouvrages des membres de l'Académie Royale de Peinture et de Sculpture, publiés d'après les manuscrits conservés à l'École Impériale des Beaux-Arts*. Eds. L. Dussieux et al. 2 vols. Paris, 1854.

Lectures, discussions, records of meetings from the seventeenth and eighteenth centuries. Reprinted 1968.

Memorial Catalogue of the French and Dutch Loan Collection. International Exhibition, Edinburgh, 1886. Edinburgh, 1888.

Text by W. E. Henley.

Mengs, Anton Raphael. *The Works of A. R. Mengs*. 2 vols. London, 1796.

Menz, Henner. *The Dresden Gallery*. New York, 1962.

°Mérimée, Prosper. *Notes d'un voyage dans le Midi de la France*. Paris, 1835.

°Michel, André. *Histoire de l'art depuis les premiers temps chrétiens jusqu'à nos jours*. 8 vols. in 17. Paris, 1905–29.

°Mirbeau, Octave. *Des artistes*. 1st series, 1885–96. Paris, 1922.

——. *Des artistes*. 2nd series . . . 1897–1912. Paris, 1924.

Mirecourt, Eugène de. *Les Contemporains*. Paris, 1856.

Moore, George. *Confessions of a Young Man, 1888*. New York, 1907.

First published 1888. Reprinted New York, 1959.

——. *Impressions and Opinions*. New York, 1891.

——. *Modern Painting*. New York, 1893.

——. *Reminiscences of the Impressionist Painters*. Dublin, 1906.

Morey, Charles R. *Medieval Art*. New York, 1942.

°Morisot, Berthe. *Correspondance avec sa famille et ses amis*. Ed. Denis Rouart. Paris, 1950.

English translation published 1959.

Mortimer, Raymond. "The Desirable Life." *The Arts* (London) no. 1, 1946.

°Musset, Alfred de. "Salon de 1836." *Œuvres complètes*. Vol. VIII: *Mélanges de littérature et de critique*. Paris, 1909.

Myers, Bernard S. *Art and Civilization.* Rev. ed. New York, 1967.
————. *Modern Art in the Making.* 2nd ed. New York, 1959.

New York. Metropolitan Museum of Art. *A Catalogue of French Paintings* [*XV–XX Centuries*], by Charles Sterling . . . 3 vols. Cambridge, Mass., 1955–67.
Niess, Robert J. *Zola, Cézanne, and Manet: A Study of L'Œuvre.* Ann Arbor, Mich., 1968.
Nochlin, Linda, ed. *Impressionism and Post-Impressionism, 1874–1904: Sources and Documents.* Englewood Cliffs, N.J., 1966.
————, ed. *Realism and Tradition in Art, 1848–1900: Sources and Documents.* Englewood Cliffs, N.J., 1966.
°Nordau, Max. *Von Kunst und Künstlern.* Leipzig, 1905.
 Translation, *On Art and Artists,* Philadelphia, n.d.
Nordland, Gerald. "A Return Ticket to Barbizon." *Arts Magazine,* January 1963, pp. 24–28.
Novotny, Fritz. *Die grossen französischen Impressionisten.* Vienna, 1952.
————. *Painting and Sculpture in Europe, 1780–1880.* Pelican History of Art. Baltimore, 1960.

Odilon Redon, Gustave Moreau, Rodolphe Bresdin. Museum of Modern Art, New York. Garden City, N.Y., 1961.
 Exhibition catalogue; text by John Rewald and Dore Ashton.

Pach, Walter. *The Masters of Modern Art.* New York, 1924.
————. *Queer Thing, Painting.* New York, 1938.
Panofsky, Dora and Erwin. *Pandora's Box: The Changing Aspects of a Mythical Symbol.* New York, 1961.
 First edition 1956.
Panofsky, Erwin. *Early Netherlandish Painting.* 2 vols. Cambridge, Mass., 1953.
————. *Meaning in the Visual Arts: Papers in and on Art History.* Garden City, N.Y., 1955.
Paris. Musée National du Louvre. *Peintures: École française, XIVᵉ, XVᵉ, et XVIᵉ siècles, par Charles Sterling et Hélène Adhémar.* Paris, 1965.
————. *Peintures: École française, XIXᵉ siècle, par Charles Sterling et Hélène Adhémar.* 4 vols. Paris, 1958–61.
Pater, Walter. *Imaginary Portraits.* London, 1900.
 First published 1885.
°*Peintres de la réalité en France au XVIIᵉ siècle.* Musée de l'Orangerie, Paris. Paris, 1934.
 Exhibition catalogue; text by Charles Sterling.
°*La Peinture au Musée du Louvre.* Vol. 1: *École française.* Paris, 1929.
 Texts by P. A. Lemoisne, Pierre Marcel, and others.
Percival, Sheila M. "Les Portraits au crayon en France au XVIᵉ siècle." *Gazette des Beaux-Arts,* December 1962, pp. 529–42.

*Perrault, Charles. *Les Hommes illustres qui ont paru en France pendant ce siècle.* 2 vols. Paris, 1696–1700.

*Perrier, Charles. "Du réalisme." *L'Artiste*, October 14, 1855, pp. 85–90.

Pevsner, Nikolaus. *Academies of Art, Past and Present.* Cambridge, Eng., 1940.

*————, and Grautoff, Otto. *Barockmalerei in den romanischen Ländern.* Pt. 2, *Frankreich und Spanien, von Otto Grautoff.* Handbuch der Kunstwissenschaft. Wildpark–Potsdam, 1928.

————. *Pioneers of Modern Design from William Morris to Walter Gropius.* rev. ed. Harmondsworth, England, 1966.

 First published 1936 as *Pioneers of the Modern Movement.*

Phillips, Claude. "Dramatic Portraiture." *Burlington Magazine* VIII, February 1906, pp. 229–315.

Phillips, Duncan. *A Collection in the Making.* Washington, D.C., 1926.

————. *The Enchantment of Art as Part of the Enchantment of Experience Fifteen Years Later.* Washington, D.C., 1927.

Photiades, Vassily. *Eighteenth-Century Painting.* New York, 1964.

Piles, Roger de. *The Art of Painting and the Lives of the Painters, Containing a Compleat Treatise of Painting, Designing, and the Use of Prints, with Reflections on the Works of the Most Celebrated Painters . . . Done from the French.* London, 1706.

 Includes a translation of *Abrégé de la vie des peintres*, Paris, 1699.

————. *Cours de peintres par principes.* Paris, 1708.

————. *The Principles of Painting . . . To Which Is Added: The Balance of Painters.* London, 1743.

 Translation of the preceding.

Pissarro, Camille. *Letters to His Son Lucien.* Ed. John Rewald. New York, 1943.

*Planche, Gustave. *Études sur l'école française.* 2 vols. Paris, 1855.

Poe, Edgar Allan. "The Domain of Arnheim." *Works.* Vol. II. Chicago, 1894?

 First published 1847.

*Poussin, Nicolas. *Lettres de Poussin.* Ed. P. Du Colombier. Paris, 1929.

————. *Lettres de Nicolas Poussin, précédées de la vie du Poussin par Félibien.* Paris, 1945.

Pradel, Pierre. *L'Art au siècle de Louis XIV.* Lausanne, 1949.

Protter, Eric, comp. *Painters on Painting.* New York, 1963.

*Proudhon, P.-J. *Du principe de l'art et de sa destination sociale.* Paris, 1865.

 Published posthumously.

Proust, Marcel. *By Way of Sainte-Beuve (Contre Sainte-Beuve).* Trans. Sylvia Townsend Warner. London, 1958.

 Written between 1894 and 1904; first French edition 1954.

————. *Letters.* Trans. and ed. Mina Curtiss. New York, 1949.

*————. *Les Plaisirs et les jours.* Paris, 1924.

 First edition 1896.

*Quinn, John. *Catalogue des tableaux modernes, aquarelles, gouaches, dessins . . . vente à Paris, Hôtel Drouot, 28 octobre 1926.*

 Preface by Jean Cocteau.

Raynal, Maurice. *History of Modern Painting: From Baudelaire to Bonnard.* Geneva, 1949.
————. *The Nineteenth Century.* Geneva, 1951.
Read, Sir Herbert. *A Coat of Many Colours.* New York, 1956.
 First edition London, 1945. Collected essays.
————. *The Philosophy of Modern Art.* London, 1952.
 Collection of essays.
————. *The Tenth Muse: Essays in Criticism.* New York, 1958.
 First edition London, 1957.
*Réau, Louis. *Histoire de la peinture française au XVIII^e siècle.* 2 vols. Brussels, 1925–26.
*————. *Le Rayonnement de Paris au XVIII^e siècle.* Paris, 1946.
*Redon, Ari, ed. *Lettres de Gauguin, Gide, Huysmans, Jammes, Mallarmé, Verhaeren à Odilon Redon.* Paris, 1960.
*Redon, Odilon. *À soi-même: Journal (1867–1915).* Paris, 1922.
————. "To Myself: Selections." *Portfolio* no. 8, Spring 1964, pp. 100–20.
 Excerpts from *À soi-même* in translation.
*Renouvier, Jules. *Histoire de l'art pendant la Révolution* 2 vols. Paris, 1863.
Rewald, John. *History of Impressionism.* Rev. ed. New York, 1961.
 First edition 1946.
————. *Post-Impressionism from Van Gogh to Gauguin.* New York, 1956.
Rey, Robert. *La Peinture française à la fin du XIX^e siècle: La Renaissance du sentiment classique.* Paris, 1931.
Reynolds, Sir Joshua. *Discourses Delivered to the Students of the Royal Academy.* New York, 1905.
 Discourses held from 1769 to 1790.
Richardson, Edgar P. *The Way of Western Art.* Cambridge, Mass., 1939.
Rilke, Rainer Maria. *Letters, 1892–1910.* Trans. Jane Bannard Greene. New York, 1945.
Ring, Grete. *A Century of French Painting, 1400–1500.* London, 1949.
Robb, David M. *The Harper History of Painting.* New York, 1951.
Rodin, Auguste. *On Art and Artists.* Trans. Paul Gsell. New York, 1957.
 First French edition 1911. Published also under the title, *Art, by Auguste Rodin.*
*Ronsard, Pierre de. *Livre des amours* [*Les Amours*]. *Œuvres complètes, texte de 1578.* Vol. I. Paris, 1923.
 First edition 1552; first edition with the commentary by Marc-Antoine Muret, 1553.
Rosenblum, Robert. *Transformations in Late Eighteenth-Century Art.* Princeton, 1967.
Rossetti, Dante Gabriel. *Letters.* Eds. Oswald Doughty and John Robert Wahl. 4 vols. Oxford, 1965–67.
*Rousseau, Jean-Jacques. *Les Confessions de J.-J. Rousseau.* Paris, 1849.
 First published posthumously 1782. Translation *The Confessions of Jean-Jacques Rousseau* published in several editions.
*————. *Œuvres complètes.* Vol. XV. Paris, 1833.

Rowland, Benjamin. *The Classical Tradition in Western Art.* Cambridge, Mass., 1963.

Roy, Maurice. *Artistes et monuments de la Renaissance en France.* Paris, 1929.

Ruskin, John. *Modern Painters.* 5 vols. London, 1929–35.
> First edition 1843–60.

°Sainte-Beuve, C. A. *Nouveaux lundis.* 13 vols. Paris, 1864–70.

Saisselin, Rémy G. "Some Remarks on French Eighteenth-Century Writings on the Arts." *Journal of Aesthetics and Art Criticism* XXV, no. 2, Winter 1966, pp. 178–95.

°Sand, George [pseud.]. *Correspondance, 1812–1876.* 6 vols. Paris, 1882–84.

Sandrart, Joachim von. *Teutsche Academie der edlen Bau-, Bild-, und Mahlerey-Künste.* 2 vols. Nuremberg, 1675–79.

°Schanne, Alexandre-Louis. *Souvenirs de Schaunard.* Paris, 1886.

Seitz, William C. "The Relevance of Impressionism." *Art News,* January 1969, p. 29 ff.

Le XVIe Siècle européen, peintures et dessins dans les collections publiques françaises. Petit Palais, Paris. Paris, 1965.
> Exhibition catalogue.

Shattuck, Roger. *The Banquet Years: The Arts in France, 1885–1918.* Garden City, N.Y., 1961.
> First edition New York, 1958.

Sickert, W. R. *A Free House! Being the Writings of Walter Richard Sickert.* Ed. Osbert Sitwell. London, 1947.

————. "French Art of the Nineteenth Century." *Burlington Magazine* XL, June 1922, pp. 260–71.

————. "The International Society." *English Review,* May 1912, p. 316 ff.
> Reprinted in his *A Free House!*

°Signac, Paul. *D'Eugène Delacroix au néo-impressionnisme.* Paris, 1911.
> First edition 1899.

————. "Le Néo-impressionnisme, documents." *Gazette des Beaux-Arts,* January 1934, pp. 49–59.
> Included only in the "Miroirs de l'art" edition (Paris, 1964) of the preceding title.

°Silvestre, Théophile. *Les Artistes français, études d'après nature.* Paris, 1878.
> Third revised edition of the title following.

°————. *Histoire des artistes vivants, français et étrangers: Études d'après nature.* Paris, 1856.

Sitwell, Sacheverell. *The Dance of the Quick and the Dead.* London, 1936.

Sloane, Joseph C. *French Painting between the Past and the Present: Artists, Critics, and Traditions from 1848 to 1870.* Princeton, 1951.

Smith, Carleton Sprague. *Barbizon Days: Millet, Corot, Rousseau, Barye.* New York, 1902.

Smith, John. *A Catalogue raisonné of the Works of the Most Eminent Dutch, Flemish, and French Painters . . .* Vol. VIII. London, 1837.

Soby, James Thrall. *Modern Art and the New Past.* Norman, Okla., 1957.

The Splendid Century: French Art, 1600–1715. National Gallery of Art, Washington. Washington, D.C., 1960.
> Exhibition catalogue.

Staley, Edgcumbe. *Watteau and His School.* London, 1902.

Stein, Gertrude. *The Autobiography of Alice B. Toklas.* New York, 1933.

————. *What Are Masterpieces?* Los Angeles, 1940.

Stein, Leo. *Appreciation: Painting, Poetry, and Prose.* New York, 1947.

————. *Journey into the Self.* New York, 1950.

*Stendhal (Henri Beyle). *Histoire de la peinture en Italie.* New ed. Paris, 1892.
> First edition 1816.

*————. *Mélanges d'art et de littérature.* Paris, 1867.

Sterling, Charles. *Great French Painting in the Hermitage.* New York, 1958.

*————. *Les Peintres primitifs.* Paris, 1949.

*————. *La Peinture française: Les Peintres du moyen age.* Paris, 1942.

————. *Still Life Painting from Antiquity to the Present Time.* Rev. ed. New York, 1959.
> First French edition 1950.

————. See also New York. Metropolitan Museum of Art. *A Catalogue of French Paintings . . .*

Stites, R. S. *The Arts and Man.* New York, 1940.

Strömbom, Sixten. *Masterpieces of the Swedish National Museum.* Stockholm, 1951.

Symons, Arthur. *From Toulouse-Lautrec to Rodin, with Some Personal Impressions.* London, 1929.
> Reprinted Freeport, N.Y., 1968.

————. *Studies in Seven Arts.* London, 1910.

————. *Studies on Modern Painters.* New York, 1925.
> Reprinted Freeport, N.Y., 1967.

Sypher, Wylie. *Four Stages of Renaissance Style: Transformations in Art and Literature, 1400–1700.* Garden City, N.Y., 1955.

————. *Rococo to Cubism in Art and Literature.* New York, 1960.

*Taine, Hippolyte. *Carnets de voyage: Notes sur la province, 1863–1865.* Paris, 1897.

Terre des hommes: Man and His World. International Fine Arts Exhibition, Expo 67. Montreal, 1967.
> Exhibition catalogue.

Thackeray, William Makepeace. *The Paris Sketch Book of Mr. M. A. Titmarsh.* Works. Vol. XXII. New York, 1911.
> First published 1840.

*Thiers, Adolphe. *Salon de 1822, ou Collection des articles insérés au "Constitutionnel" sur l'exposition de cette année.* Paris, 1822.

*Thoré, Théophile (W. Bürger, pseud.). *Salons de T. Thoré, 1844, 1845, 1846, 1847, 1848.* Paris, 1870.

*————. *Salons de W. Bürger, 1861 à 1868.* 2 vols. Paris, 1870.

Thuillier, Jacques. *French Painting from Fouquet to Poussin.* See Châtelet, Albert, and Thuillier, Jacques

———, and Châtelet, Albert. *French Painting from Le Nain to Fragonard.* Geneva, 1964.

Tolstoy, Leo. *What Is Art?* Trans. Aylmer Maude. London, 1930.
> First published 1898.

Le Triomphe du maniérisme européen. Rijksmuseum, Amsterdam. n.p., 1955.
> Exhibition catalogue.

Troescher, Georg. *Burgundische Malerei.* 2 vols. Berlin, 1966.

Uhde, Wilhelm. *The Impressionists.* Vienna, 1937?

Valéry, Paul. *Degas, Manet, Morisot.* Trans. David Paul. New York, 1960.
> First published in book form under the title *Pièces sur l'art,* Paris, 1938.

Vasari, Giorgio. *The Lives of the Painters, Sculptors, and Architects . . .* Trans. A. B. Hinds. 4 vols. London, 1927.
> First edition 1550, first complete edition 1568.

*Venturi, Lionello. *Les Archives de l'impressionnisme.* 2 vols. Paris, 1939.
> Reprinted New York, 1968.

———. *Four Steps Toward Modern Art.* New York, 1956.

———. *History of Art Criticism.* Trans. Charles Marriott. New, rev. ed. New York, 1964.
> First edition 1936.

———. *Impressionists and Symbolists.* New York, 1950.

———. *Modern Painters.* New York, 1947.

———. *Painting and Painters.* New York, 1945.

———. *The Sixteenth Century.* Geneva, 1956.

Vergnet-Ruiz, Jean, and Laclotte, Michel. *Great French Paintings from the Regional Museums of France.* New York, 1965.

*Verhaeren, Émile. "Le Salon des Vingt à Bruxelles." *La Vie Moderne,* February 26, 1887, p. 135 ff.

*———. *Sensations.* Paris, 1927.
> Collected essays.

*Vincent, Madeleine. *La Peinture des XIX^e et XX^e siècles.* Catalogue du Musée de Lyon. Vol. VII. Lyon, 1956.

Vollard, Ambroise. *En écoutant Cézanne, Degas, Renoir.* Paris, 1938.

———. *Recollections of a Picture Dealer.* London, 1936.

*Voltaire. "Le Temple du goût." *Œuvres complètes.* Vol. XII. Paris, 1785.
> Written 1731, first published 1733.

*Voss, Hermann. *Die Malerei des Barock in Rom.* Berlin, 1924.

Waern, Cecilia. "Some Notes on French Impressionism." *Atlantic Monthly,* April 1892, pp. 535–41.

Bibliography

Watelet, Claude Henri. *Dictionnaire des arts de peinture, sculpture et gravure.* 5 vols. Paris, 1792.
Webster, Carson. "The Technique of Impressionism: A Reappraisal." *College Art Journal* IV, no. 4, November 1944, pp. 3–22.
Wedmore, Frederick. "The Impressionists." *Fortnightly Review,* January 1883, pp. 75–82.
*Weisbach, Werner. *Französische Malerei des XVII. Jahrhunderts im Rahmen von Kultur und Gesellschaft.* Berlin, 1932.
Whitley, William. *Artists and Their Friends in England, 1700–1799.* 2 vols. London, 1928.
Wilenski, Reginald. *French Painting.* Rev. ed. Boston, 1949.
 First edition 1931.
————. *Modern French Painters.* New York, 1949.
*Wyzewa, Téodor de. *Peintres de jadis et d'aujourd'hui.* Paris, 1910.

*Zola, Émile. *Mes haines.* Paris, 1880.
 Contains also "Mon Salon" (1866) and "Édouard Manet" (1867).
*————. *Salons.* Eds. F. W. J. Hemmings and Robert J. Niess. Geneva, 1959.
Zucker, Paul. *Styles in Painting.* New York, 1963.
 First published 1950.

INDIVIDUAL ARTISTS

AVED, JACQUES

*Wildenstein, Georges. *Le Peintre Aved.* 2 vols. Paris, 1920.

AVIGNON, SCHOOL OF

Adhémar, Hélène, and Adhémar, Jean. "Quelques hypothèses au sujet de la Pietà d'Avignon." *Revue des Arts,* March 1953, pp. 16–19.

Ford, James B., and Vickers, G. Stephen. "The Relation of Nuno Gonçalves to the Pietà from Avignon, with a Consideration of the Iconography of the Pietà in France." *Art Bulletin* XXI, March 1939, pp. 4–43.

BAZILLE, FRÉDÉRIC

Bazille. Wildenstein & Co., Paris. Paris, 1950.
 Exhibition catalogue; text by Gabriel Sarraute.

*Daulte, François. *Frédéric Bazille et son temps.* Geneva, 1952.

BAZILLE, FRÉDÉRIC (continued)

Poullain, G. *Bazille et ses amis.* Paris, 1932.

Scheyer, Ernst. "Jean Frédéric Bazille: The Beginnings of Impressionism." *Art Quarterly* V, no. 2, 1942, pp. 114–34.

BELLANGE, JACQUES DE

Pariset, François-Georges. "Jacques de Bellange, origines artistiques et évolution." *Bulletin de la Société de l'Histoire de l'Art Français* XXXIX, 1953, p. 78 ff.

°————. "Jacques de Bellange." *L'Œil,* September 1962, pp. 42–49.

BLANCHARD, JACQUES

°Sterling, Charles. "Les Peintres Jean et Jacques Blanchard." *Art de France* I, 1961, pp. 77–118.

BOUCHER, FRANÇOIS

Hazlehurst, F. Hamilton. "The Origins of a Boucher Theme." *Gazette des Beaux-Arts,* February 1960, pp. 109–16.

Kahn, Gustave. *Boucher, biographie critique.* Paris, 1905.

Macfall, Haldane. *Boucher: The Man, His Times, and His Significance.* London, 1908.

°Nolhac, Pierre de. *François Boucher, premier peintre du Roi, 1703–1770.* Paris, 1907.

BOUDIN, EUGÈNE

Boudin, aquarelles et pastels: XXXVᵉ exposition du Cabinet des Dessins [du Musée du Louvre]. Paris, 1965.
 Exhibition catalogue.

Cario, Louis. *Eugène Boudin.* Paris, 1928.

°Jean-Aubry, Georges. *Eugène Boudin.* Paris, 1922.
 New edition: *Eugène Boudin, la vie et l'œuvre d'après les lettres et les documents inédits,* Neuchâtel, Switzerland, 1968.

BOURDICHON, JEAN

MacGibbon, David. *Jean Bourdichon: A Court Painter of the Fifteenth Century.* Glasgow, 1933.

°Mâle, Émile. "Jean Bourdichon: Les Heures d'Anne de Bretagne, Bibliothèque Nationale." *Verve* IV, nos. 14–15, 1946, pp. 9–23.

BOURDON, SÉBASTIEN

Ponsonallhe, Charles. *Sébastien Bourdon, sa vie et son œuvre.* Montpellier, 1883.

CALLOT, JACQUES

Bechtel, Edwin de T. *Jacques Callot.* New York, 1955.

Ternois, Daniel. *L'Art de Jacques Callot.* Paris, 1962.

CARON, ANTOINE

°Ehrmann, Jean. *Antoine Caron.* Geneva, 1955.

°Lebel, Gustave. "Notes sur Antoine Caron et son œuvre." *Bulletin de la Société de l'Histoire de l'Art Français,* 1940, pp. 11–34.

————. "Un Tableau d'Antoine Caron." *Bulletin de la Société de l'Histoire de l'Art Français,* 1937, p. 20 ff.

Rosenblum, Robert. "The Paintings of Antoine Caron." *Marsyas* VI, 1950–53, pp. 1–7.

CARRIÈRE, EUGÈNE

Carrière, Jean-René. *De la vie d'Eugène Carrière.* Toulouse, 1966.

Eugène Carrière et le symbolisme, exposition. Musée de l'Orangerie, Paris. Paris, 1950.
Introduction and catalogue by Michel Florisoone.

Morice, Charles. *Eugène Carrière.* Paris, 1906.

Séailles, Gabriel. *Eugène Carrière.* 2nd ed. Paris, 1917.

CÉZANNE, PAUL

Badt, Kurt. *The Art of Cézanne.* Berkeley, Calif., 1965.
First German edition 1956.

Barnes, Albert C., and De Mazia, Violette. *The Art of Cézanne.* New York, 1939.

°Bernard, Émile. *Sur Paul Cézanne.* Paris, 1925.
Collection of previously published essays.

Brion-Guerry, Liliane. *Cézanne et l'expression de l'espace.* Paris, 1966.

Denis, Maurice. "Cézanne." *Burlington Magazine* XVI, 1910, pp. 207–19, 275–80.
Translation by Roger Fry. French version first published in *L'Occident,* September 1907. Reprinted in his *Théories, 1890–1910,* Paris, 1912.

CÉZANNE, PAUL (continued)

——. "L'Influence de Cézanne." *L'Amour de l'Art*, 1920, p. 279 ff.

Dorival, Bernard. *Cézanne*. Trans. H. H. A. Thackthwaite. New York, 1948.

Fry, Roger. *Cézanne: A Study of His Development*. New York, 1927.

*Gasquet, Joachim. *Cézanne*. New ed. Paris, 1926.
　　First edition 1921.

Loran, Erle. *Cézanne's Composition*. Berkeley, Calif., 1943.

Mack, Gerstle. *Paul Cézanne*. New York, 1935.

Novotny, Fritz. *Cézanne und das Ende der wissenschaftlichen Perspektive*. Vienna, 1938.

Raynal, Maurice. *Cézanne: Biographical and Critical Studies*. Geneva, 1954.

Reff, Theodore. "Cézanne's Constructive Stroke." *Art Quarterly*, Autumn 1962, pp. 214–27.

Rewald, John. *Paul Cézanne: A Biography*. New York, 1948.

Rivière, Georges. *Le Maître Paul Cézanne*. Paris, 1923.

Schapiro, Meyer. *Cézanne*. 3rd ed. New York, 1965.
　　First edition 1952.

*Venturi, Lionello. *Cézanne, son art, son œuvre*. 2 vols. Paris, 1936.

Vollard, Ambrose. *Paul Cézanne: His Life and Art*. New York, 1937.
　　French edition published 1914.

CHAMPAIGNE, PHILIPPE DE

Hendy, Philip. "Philippe de Champaigne." *Apollo* V, 1927, p. 166 ff.

Philippe de Champaigne. Musée de l'Orangerie, Paris. Paris, 1952.
　　Exhibition catalogue; text by Bernard Dorival.

CHARDIN, J. B. S.

Dayot, Armand, and Vaillat, Léandre. *L'Œuvre de J.-B.-S. Chardin et de J.-H. Fragonard*. Paris, n.d.

Denvir, Bernard. *Chardin*. New York, 1950.

Klingsor, Tristan [pseud.]. *Chardin*. Paris, 1924.

Proust, Marcel. "Chardin: The Essence of Things." *Art News*, October 1954, p. 38 ff.
　　Translation by Mina Curtiss from his *Contre Sainte-Beuve*, written between 1894 and 1904, first published Paris, 1954.

CHARDIN, J. B. S. (continued)

Rosenberg, Pierre. *Chardin: Biographical and Critical Study.* Geneva, 1963.

°Rothschild, H. J. N. C. de. *Documents sur la vie et l'œuvre de Chardin.* Eds. André Pascal and Roger Gaucheron. Paris, 1931.

Wildenstein, Georges. *Chardin.* Rev. ed. Zurich, 1963.
 First edition Paris, 1933.

CHASSÉRIAU, THÉODORE

°Bénédite, Léonce. *Théodore Chassériau, sa vie et son œuvre.* 2 vols. Paris, 1931.

°Gautier, Théophile. "Atelier de feu Théodore Chassériau." *L'Artiste,* March 15, 1857, p. 209.

Goodrich, Lloyd. "Théodore Chassériau." *The Arts* (New York), 1928, p. 63 ff.

CLAUDE LORRAIN

Courthion, Pierre. *Claude Gellée.* Paris, 1932.

Friedlaender, Walter F. *Claude Lorrain.* Berlin, 1921.

Hetzer, T. *Claude Lorrain.* Frankfurt, 1947.

Röthlisberger, Marcel. *Claude Lorrain: The Paintings.* 2 vols. New Haven, Conn., 1961.

————, and Kitson, M. "Claude Lorrain and the *Liber Veritatis.*" *Burlington Magazine,* January, September/October, and November 1959.

White, John. "The Landscapes of Claude." *Burlington Magazine,* February 1950, pp. 42–49.

CLOUET, JEAN AND FRANÇOIS

°Bouchot, Henri. *Les Clouet et Corneille de Lyon.* Paris, 1892.

Ede, H. S. "Authenticated Information Concerning Jehannet and François Clouet." *Burlington Magazine* XLII, March 1923, pp. 111–28.

Germain, Alphonse. *Les Clouet.* Paris, 1906.

Moreau-Nélaton, Étienne. *Les Clouet et leurs émules.* 3 vols. Paris, 1924.

Popham, Arthur E. "A Portrait by Jehannet Clouet." *Burlington Magazine* XLII, March 1923, pp. 129–30.

COROT, CAMILLE

°Bazin, Germain. *Corot.* 2nd ed. Paris, 1951.

Bernheim de Villers, C. *Corot peintre de figures.* Paris, 1930.

Corot raconté par lui-même et par ses amis. 2 vols. Vésenaz-Genève, 1946.

Davisson, Gay Drake. "An Early Landscape by Corot." *Bulletin, California Palace of the Legion of Honor,* February, 1946, p. 86 ff.

°Fosca, François [pseud.]. *Corot, sa vie et son œuvre.* Brussels, 1958.

Geffroy, Gustave. "Jean-Baptiste [i.e. Camille] Corot." In *Corot and Millet,* edited by Charles Holme. London, 1902.

Gowing, Lawrence. "Corot." *Art News Annual* XXX, 1965, p. 115 ff.

J. B. C. Corot (1796–1875). An Exhibition of His Paintings and Graphic Works. Art Institute of Chicago. Chicago, 1960.
 Exhibition catalogue; text by S. Lane Faison.

Leymarie, Jean. *Corot: Biographical and Critical Study.* Geneva, 1966.

Meynell, Everard. *Corot and His Friends.* London, 1908.

°Moreau-Nélaton, Étienne. *Corot raconté par lui-même.* 2 vols. Paris, 1924.

Robaut, Alfred. *L'Œuvre de Corot: Catalogue raisonné et illustré.* 4 vols. Paris, 1905.

COURBET, GUSTAVE

Aragon, Louis. *L'Exemple de Courbet.* Paris, 1952.

Bell, Clive. "L'Atelier de Courbet." *Burlington Magazine* XXXVI, January 1920, p. 3.

Boas, George, ed. *Courbet and the Naturalistic Movement.* Baltimore, 1938.

°Champfleury (Jules Husson, called Fleury). *Grandes figures d'hier et d'aujourd'hui: Balzac, Gérard de Nerval, Wagner, Courbet.* Paris, 1861.

Chirico, Giorgio de. *Gustave Courbet.* Rome, 1925.

Clark, T. J. "A Bourgeois Dance of Death: Max Buchon on Courbet." *Burlington Magazine,* April and May 1969.

°*Courbet raconté par lui-même et par ses amis.* 2 vols. Geneva, 1948–50.

°Huyghe, René, et al. *Courbet: L'Atelier du peintre, allégorie réelle, 1855.* Paris, 1944.

Ideville, Comte H. d'. *Gustave Courbet, notes et documents sur sa vie et son œuvre.* Paris, 1878.

597

COURBET, GUSTAVE (continued)

°Léger, Charles. *Courbet*. Paris, 1929.

°————. *Courbet selon les caricatures et les images*. Paris, 1920.

Mack, Gerstle. *Gustave Courbet*. New York, 1951.

MacOrlan, Pierre. *Courbet*. Paris, 1951.

Schapiro, Meyer. "Courbet and Popular Imagery: An Essay on Realism and Naïveté." *Journal of the Warburg and Courtauld Institutes* IV, 1940–41, pp. 164–91.

Werner, Alfred. "The Contradiction of Courbet." *Arts Magazine*, March 1960, p. 42 ff.

Zahar, Marcel. *Gustave Courbet*. New York, 1950.

DAUBIGNY, CHARLES FRANÇOIS

°Henriet, Frédéric. "Daubigny." *L'Artiste* I, June 14, 1857.

Lanes, Jerrold. "Daubigny Revisited." *Burlington Magazine*, October 1964, pp. 457–62.

Moreau-Nélaton, Étienne. *Daubigny raconté par lui-même*. Paris, 1925.

DAUMIER, HONORÉ

Adhémar, Jean. *Honoré Daumier*. Paris, 1954.

Alexandre, Arsène. *Honoré Daumier*. Paris, 1888.

Daumier, 1808–1874. Philadelphia Museum of Art. Philadelphia, 1937.
 Exhibition catalogue; introduction by Claude Roger Marx.

Daumier, Paintings and Drawings. Arts Council of Great Britain. London, 1961.
 An exhibition held at the Tate Gallery, London; introduction by Alan Bowness and K. E. Maison.

Daumier raconté par lui-même et par ses amis. Vésenaz-Genève, 1945.

Faison, S. Lane. *Honoré Daumier's Third-Class Railway Carriage*. London, 1947.

°Fosca, François [pseud.]. *Daumier*. Paris, 1933.

°Fuchs, Eduard. *Der Maler Daumier*. Munich, 1927.

Larkin, Oliver W. *Daumier: Man of His Time*. New York, 1966.

Lassaigne, Jacques. *Daumier*. Trans. Eveline Byam Shaw. Paris, 1938.

Maison, K. E. *Honoré Daumier: Catalogue raisonné of the Paintings, Watercolours, and Drawings*. 2 vols. London, 1968.

DAUMIER, HONORÉ (continued)

Marceau, Henri, and Rosen, David. "Daumier: Draftsman-Painter." *Journal of the Walters Art Gallery* III, 1940, pp. 9–41.

Vincent, Howard P. *Daumier and His World*. Evanston, Ill., 1968.

DAVID, JACQUES-LOUIS

Batz, Georges de. "History, Truth, and Art: The Assassination of Marat." *Art Quarterly* VIII, no. 4, March 1945, pp. 248–60.

Cantinelli, Richard. *Jacques-Louis David*. Paris, 1930.

Cooper, Douglas. "Jacques-Louis David: A Bi-Centenary Exhibition." *Burlington Magazine*, October 1948, pp. 276–80.

David: Exposition en l'honneur du deuxième centenaire de sa naissance. Musée de l'Orangerie, Paris. Paris, 1948.
 Exhibition catalogue by Michel Florisoone.

Dowd, David L. *Pageant Master of the Republic: Jacques-Louis David and the French Revolution*. Lincoln, Neb., 1948.
 Reprinted Freeport, N.Y., 1969.

Hautecœur, Louis. *Louis David*. Paris, 1954.

Hazlehurst, F. Hamilton. "Artistic Evolution of David's 'Oath.'" *Art Bulletin*, March 1960, pp. 59–63.

Levey, Michael. "Reason and Passion in Jacques-Louis David." *Apollo*, September 1964, pp. 206–11.

*Maurois, André. *J.-L. David*. Paris, 1948.

Wind, Edgar. "The Sources of David's Horaces." *Journal of the Warburg and Courtauld Institutes* IV, 1940–41, pp. 124–38.

DEGAS, EDGAR

Boggs, Jean Sutherland. *Drawings by Degas: Essay and Catalogue [of the exhibition]*. City Art Museum, Saint Louis. Saint Louis, Mo., 1966.

————. *Portraits by Degas*. Berkeley, Calif., 1962.

Browse, Lillian. *Degas Dancers*. London, 1949.

Cabanne, Pierre. *Edgar Degas*. New York, 1958.

Cooper, Douglas. *Pastels by Edgar Degas*. New York, 1953.

Fosca, François [pseud.]. *Degas*. Geneva, 1954.

DEGAS, EDGAR (continued)

Halévy, Daniel. *My Friend Degas*. Ed. and trans. Mina Curtiss. Middletown, Conn., 1964.
Translation of *Degas parle*, Paris, 1960.

Jamot, Paul. *Degas*. Paris, 1924.

Janis, Eugenia Parry. *Degas Monotypes: Essay, Catalogue, and Checklist [of the exhibition]*. Fogg Art Museum, Harvard University. Cambridge, Mass., 1968.

Lafond, Paul. *Degas*. 2 vols. Paris, 1918–19.

*Lemoisne, P. A. *Degas et son œuvre*. 4 vols. Paris, 1946–49.

*Liebermann, Max. "Degas." *Pan* IV, no. 3, 1898, pp. 193–96.
First published in book form Berlin, 1899.

————. "Degas." *Artist*, 1900, p. 113 ff.
Translation of the preceding title by Adrian Stokes.

Manson, J. B. *The Life and Work of Edgar Degas*. London, 1927.

Meier-Graefe, Julius. *Degas*. Trans. J. Holroyd-Reece. London, 1923.

Pickvance, Ronald. "*L'Absinthe* in England." *Apollo*, May 1963, pp. 395–98.

Rich, Daniel Catton. *Edgar-Hilaire-Germain Degas*. New York, 1951.

"Special Issue Devoted to Degas." *Burlington Magazine*, June 1963.

Valéry, Paul. *Degas, Dance, Drawing*. New York, 1948.
First published in French 1935. Also published, in a different translation, in his *Degas, Manet, Morisot*, New York, 1960.

Vollard, Ambroise. *Degas, an Intimate Portrait*. New York, 1927.
First French edition 1924.

Wells, William. "Degas's Portrait of Duranty." *Scottish Art Review* X, no. 1, 1965, p. 18 ff.

Werner, Alfred. *Degas Pastels*. New York, 1968.

DELACROIX, EUGÈNE

Baudelaire, Charles. *Eugène Delacroix*. Trans. J. M. Bernstein, New York, 1947.

*Cassou, Jean. *Delacroix*. Paris, 1947.

Centenaire d'Eugène Delacroix . . . exposition. Musée du Louvre. Paris, 1963.
Exhibition catalogue.

*Escholier, Raymond. *Eug. Delacroix*. Paris, 1963.
First edition, 3 vols., 1926–29.

DELACROIX, EUGÈNE (continued)

*Goethe, Johann Wolfgang von. "Faust, tragédie de Mr. de Goethe, traduite en français par Mr. Stapfer, ornée de XVII dessins par Mr. Delacroix." Schriften zur Literatur. *Sämtliche Werke*. Vol. XIX. Berlin, n.d., pp. 766–68.
 First published in *Über Kunst und Altertum* VI, no. 2, 1828.

Huyghe, René. *Delacroix*. New York, 1963.

Johnson, Lee. *Delacroix*. New York, 1963.

Lassaigne, Jacques. *Eugène Delacroix*. New York, 1950.

Meier-Graefe, Julius. *Eugène Delacroix: Beiträge zu einer Analyse*. Munich, 1922.

Mémorial de l'exposition Eugène Delacroix. Ed. Maurice Sérullaz. Musée du Louvre. Paris, 1963.

Mras, George P. *Eugène Delacroix's Theory of Art*. Princeton, 1966.

Piron. O. *Eugène Delacroix, sa vie et son œuvre*. Paris, 1865.

Robaut, Alfred, and Chesneau, E. *L'Œuvre complet d'Eugène Delacroix*. Paris, 1885.

Tourneux, Maurice. *Eugène Delacroix devant ses contemporains: Ses écrits, ses biographes, ses critiques*. Paris, 1880.

DIAZ, NARCISSE

Narcisse Diaz de la Peña, 1807–1876. Pavillon des Arts, Paris. Paris, 1968. Exhibition catalogue.

DROUAIS, FRANÇOIS HUBERT

Gabillot, C. "Les Trois Drouais." *Gazette des Beaux-Arts*, September, October, November 1905, February and March 1906.

DUBREUIL, TOUSSAINT

*Béguin, Sylvie. "Toussaint Dubreuil, premier peintre de Henri IV." *Art de France* IV, 1964, pp. 86–107.

DUGHET, GASPARD

Sutton, Denys. "Gaspard Dughet: Some Aspects of His Art." *Gazette des Beaux-Arts*, July–August 1962, pp. 269–312.

*Thuillier, Jacques. "Gaspard Dughet, le 'Guaspre' Poussin." *Art de France* III, pp. 247–49.

Bibliography

FANTIN-LATOUR, HENRI

Fantin-Latour, Victoria. *Catalogue de l'œuvre complet (1849–1904) de Fantin-Latour.* Paris, 1911.

Jullien, Adolphe. *Fantin-Latour, sa vie et ses amitiés.* Paris, 1909.

Schneider, Pierre. "Fantin-Latour." *Art News Annual* XXIV, pp. 54–78.

FONTAINEBLEAU, SCHOOL OF

Wehle, Harry B. "A Painting of the Fontainebleau School [*The Birth of Cupid*]." *Metropolitan Museum of Art Bulletin*, February 1942, pp. 27–30.

FOUQUET, JEAN

Cox, Trenchard. *Jehan Foucquet, Native of Tours.* London, 1931.

Focillon, Henri. "Le Style monumental dans l'art de Jean Fouquet." *Gazette des Beaux-Arts*, January 1936, pp. 17–32.
 Partial translation in *Art Bulletin* XVIII, no. 2, June 1946, p. 131.

Pächt, Otto. "Jean Fouquet: A Study of His Style." *Journal of the Warburg and Courtauld Institutes* IV, 1940–41, pp. 85–102.

Perls, Klaus G. *Jean Fouquet.* London, 1940.

Sterling, Charles. [Review of Klaus G. Perls's and Paul Wescher's books on Jean Fouquet] *Art Bulletin* XXVIII, no. 2, June 1946, pp. 125–31.

Wescher, Paul. *Jean Fouquet and His Time.* New York, 1947.
 Original German edition (Basel) 1945.

FRAGONARD, HONORÉ

*Nolhac, Pierre de. *Fragonard.* 2nd ed. Paris, 1931.
 First edition 1906.

*Portalis, Roger. *Honoré Fragonard, sa vie et son œuvre.* Paris, 1889.

Réau, Louis. "Fragonard." *Connoisseur*, June 1949, pp. 69–74.

*————. *Fragonard, sa vie et son œuvre.* Brussels, 1956.

Thuillier, Jacques. *Fragonard: Biographical and Critical Study.* Geneva, 1967.

Wildenstein, Georges. *The Paintings of Fragonard, Complete Edition.* London, 1960.

Wilhelm, Jacques. "Fragonard as a Painter of Realistic Landscapes." *Art Quarterly* XI, no. 4, 1948, pp. 296–305.

FROMENT, NICOLAS

Harris, Enriqueta. "Mary in the Burning Bush: Nicolas Froment's Triptych at Aix-en-Provence." *Journal of the Warburg Institute* I, April 1938, pp. 281–86.

*Labande, L.-H. "Notes sur quelques primitifs de Provence: Nicolas Froment." *Gazette des Beaux-Arts*, February 1933, pp. 85–103.

GAUGUIN, PAUL

Aurier, G.-A. "Le Symbolisme en peinture—Paul Gauguin." *Œuvres posthumes.* Paris, 1893, pp. 205–19.
First published 1891.

Chirico, Giorgio de. "Paolo Gauguin." *Il Convegno* I, 1920, p. 53 ff.

Dorra, Henri. "Émile Bernard and Paul Gauguin." *Gazette des Beaux-Arts*, April 1955, pp. 227–46, 255–60.

Estienne, Charles. *Gauguin.* Trans. James Emmons. Geneva, 1953.

Fry, Roger. "On a Composition by Gauguin." *Burlington Magazine* XXXII, March 1918, p. 85.

Gauguin. Art Institute of Chicago. Chicago, 1959.
Exhibition catalogue; introduction by Theodore Rousseau, Jr.

Gauguin, Paul. *D'où venons-nous? Que sommes-nous? Où allons-nous?* Marie Harriman Gallery. New York, 1936.

Gauguin, an Exhibition. Tate Gallery, London. London, 1955.
Text by Douglas Cooper.

Goldwater, Robert. "Gauguin's *Yellow Christ.*" *Gallery Notes, Buffalo Fine Arts Academy, Albright Art Gallery* XI, no. 3, June 1947, pp. 3–13.

————. *Paul Gauguin.* New York, 1957.

A Loan Exhibition of Paul Gauguin. Wildenstein & Co., New York. New York, 1946.
Introduction by W. Somerset Maugham.

*Morice, Charles. *Paul Gauguin.* Paris, 1920.
First edition 1919.

*"Quelques opinions sur Paul Gauguin." *Mercure de France,* November 1903, pp. 428–30.

Read, Sir Herbert. "Gauguin: Return to Symbolism." *Art News Annual* XXV, 1956, pp. 122 ff.
First published 1949. Revised version also published in his *The Philosophy of Modern Art,* London, 1952.

GAUGUIN, PAUL (continued)

Rewald, John. *Gauguin.* New York, 1949.
French edition 1938.

Rookmaker, H. R. *Synthetist Art Theories: Genesis and Nature of the Ideas on the Art of Gauguin and His Circle.* Amsterdam, 1959.

*Rotonchamp, Jean de. *Paul Gauguin.* Paris, 1925.
First edition 1906. Contains Gauguin's *Racontars d'un rapin* (1902).

Wildenstein, Georges. *Gauguin I, catalogue.* Paris, 1964.

GÉRARD, FRANÇOIS

Gérard, Henri. *Œuvre du Baron F. Gérard.* 2nd ed. Paris, 1852–57.

Lenormant, Charles. *François Gérard, peintre d'histoire.* Paris, 1848.

*Schlegel, August Wilhelm von. "Corinne auf dem Vorgebirge Miseno, nach dem Roman der Frau von Staël, 1821." *Sämtliche Werke.* Vol. IX. Leipzig, 1846, pp. 360–68.

GÉRICAULT, THÉODORE

Berger, Klaus. *Géricault and His Work.* Trans. Winslow Ames. Lawrence, Kansas, 1955.

*Clément, Charles. *Géricault, étude biographique et critique.* 3rd ed. Paris, 1879.
First edition 1867.

Exposition d'œuvres de Géricault. Hôtel Jean Charpentier, Paris. Paris, 1924.
Exhibition catalogue.

Géricault raconté par lui-même et par ses amis. Vésenaz-Genève, 1947.

Miller, Margaret. "Géricault's Paintings of the Insane." *Journal of the Warburg and Courtauld Institutes* IV, 1941, pp. 151–63.

*Rosenthal, Léon. *Géricault.* Paris, 1905.

GIRODET, ANNE-LOUIS

Adhémar, Jean. "L'Enseignement académique en 1820: Girodet et son atelier." *Bulletin de la Société de l'Histoire de l'Art Français,* 1933, pp. 270–79.

Girodet, 1767–1824, exposition du deuxième centenaire. Musée de Montargis. Paris, 1967.
Exhibition catalogue.

GIRODET, ANNE-LOUIS (continued)

°Lemonnier, Henry. "L'Atala de Chateaubriand et L'Atala de Girodet." *Gazette des Beaux-Arts,* May 1914, pp. 363–71.

Levitine, George. "Girodet-Trioson, an Iconographic Study." Thesis, Harvard University, 1952.

————. "Quelques aspects peu connus de Girodet." *Gazette des Beaux-Arts,* April 1965, pp. 231–46.

GREUZE, JEAN-BAPTISTE

Brookner, Anita. "Jean-Baptiste Greuze." *Burlington Magazine,* May and June 1956.

Mauclair, Camille [pseud.]. *J.-B. Greuze, sa vie, son œuvre, son époque.* Paris, 1905.

————. *Jean-Baptiste Greuze . . . Catalogue raisoné de l'œuvre peint,* suivi de la liste des gravures executées d'après ses ouvrages, par J. Martin et Ch. Masson. Paris, 1906.

GROS, ANTOINE JEAN

Dargenty, G. *Le Baron Gros.* Paris, 1887.

°Delestre, J.-B. *Gros, sa vie et ses ouvrages.* 2nd ed. Paris, 1867.

Gros, ses amis et ses élèves. Petit Palais, Paris. Paris, 1936.
 Exhibition catalogue.

°Musset, Alfred de. "Exposition au profit des blessés dans la Galerie du Luxembourg." *Œuvres complètes.* Vol. VIII. Paris, 1909, pp. 250–58.
 First published 1831.

GUYS, CONSTANTIN

Baudelaire, Charles. *The Painter of Victorian Life: A Study of Constantin Guys.* Trans. P. G. Konody. London, 1930.
 Translation of *Le Peintre de la vie moderne,* first published 1863. Another translation, by J. Mayne, is included in his *Painter of Modern Life,* London, 1964.

Browse, Lillian, ed. *Constantin Guys, Flushing 1805, Paris, 1892.* Introd. Clifford Hall. London, 1945.

INGRES, JEAN AUGUSTE DOMINIQUE

°Alazard, Jean. *Ingres et l'Ingrisme.* Paris, 1950.

°Amaury-Duval, E. E. *L'Atelier d'Ingres, souvenirs.* Paris, 1878.

INGRES, JEAN AUGUSTE DOMINIQUE (continued)

Delaborde, Henri. *Ingres, sa vie, ses travaux, sa doctrine*. Paris, 1870.

*Gautier, Théophile. "Ingres." *L'Artiste*, April 5, 1857.
Translation in *Portraits of the Day, Works*, vol. VI, Cambridge, 1906.

Ingres Centennial Exhibition: Drawings, Watercolors, and Oil Sketches from American Collections. Fogg Art Museum, Harvard University. n. p., 1967.
Catalogue by Agnes Mongan and Hans Naef.

Ingres, Petit Palais, Paris. Paris, 1967.
Exhibition catalogue.

Ingres raconté par lui-même et par ses amis. 2 vols. Geneva, 1947.

King, Edward S. "Ingres as Classicist." *Journal of the Walters Art Gallery*, 1942, pp. 68–113.

Lapauze, Henry. *Ingres, sa vie et son œuvre*. Paris, 1911.

Pach, Walter. *Ingres*. New York, 1939.
Contains excerpts from Ingres' writings in translation.

Perrier, Charles. "Exposition Universelle: Ingres." *L'Artiste*, June 3, 1855.

Picon, Gaëtan. *Ingres: Biographical and Critical Study*. Trans. Stuart Gilbert. Geneva, 1967.

Rosenblum, Robert. *Ingres*. New York, 1967.

Uzanne, Octave. "The Paintings of Jean Auguste Dominique Ingres." *Magazine of Fine Arts* I, 1905, p. 269 ff.

Wildenstein, Georges. *Ingres*. London, 1954.

JOUVENET, JEAN

Jean Jouvenet, 1644–1717. Musée des Beaux-Arts, Rouen. Rouen, 1966.
Exhibition catalogue; text by A. Schnapper.

LA HYRE, LAURENT DE

*Augarde, Thérèse, and Thuillier, Jacques. "La Hyre." *L'Œil*, April 1962, p. 16 ff.

LANCRET, NICOLAS

*Wildenstein, Georges. *Lancret*. Paris, 1924.

LARGILLIÈRE, NICOLAS DE

Exposition N. de Largillierre. Petit Palais, Paris. Paris, 1928.
Exhibition catalogue; foreword by Camille Gronkowski.

LARGILLIÈRE, NICOLAS DE (continued)

°Pascal, Georges. *Largillierre*. Paris, 1928.

LA TOUR, GEORGES DE

Bazin, Germain. "The Art of Georges de la Tour." *Apollo*, November 1936, pp. 286–90.

Bloch, Vitale. *Georges de La Tour of Lorraine*. Amsterdam, 1950.

Furness, S. M. M. *Georges de la Tour of Lorraine*. London, 1949.

Huyghe, René. "Georges de La Tour." *Art News Annual* XXIV, 1955, p. 124 ff.

Jamot, Paul. *Georges de La Tour*. Paris, 1948.

°Pariset, François-Georges. *Georges de La Tour*. Paris, 1948.

Voss, Hermann. "Georges du Mesnil de La Tour." *Art in America*, December 1928, pp. 40–48.

LA TOUR, MAURICE-QUENTIN DE

°Besnard, Albert. *La Tour*. Paris, 1928.

Champfleury (Jules Husson, called Fleury). *La Tour*. Paris, 1887.

°Lapauze, Henry. *Les Pastels de Maurice-Quentin de La Tour au Musée Lécuyer à Saint-Quentin*. Paris, 1919.

°Tourneux, Maurice. *La Tour*. Paris, 1904.

LE BRUN, CHARLES

°*Charles Le Brun, 1619–1690, peintre et dessinateur*. Château de Versailles. Paris, 1963.
> Exhibition catalogue; catalogue of paintings, biography, and bibliography by Jacques Thuillier.

Félibien, André. *The Tent of Darius Explain'd: or, The Queens of Persia at the Feet of Alexander*. Trans. from the French by Collonel [*sic*] Parsons. London, 1703.
> French edition Paris, 1663.

Hartle, Robert W. "Le Brun's *Histoire d'Alexandre* and Racine's *Alexandre le Grand*." *Romanic Review* XVIII, no. 2, April 1957, pp. 90–103.

Jouin, Henry. *Charles Le Brun et les arts sous Louis XIV*. Paris, 1889.

Posner, Donald. "Charles Lebrun's *Triumphs of Alexander*." *Art Bulletin*, September 1959, pp. 237–48.

LE BRUN, CHARLES (continued)

*Stewart, William McCausland. "Charles Le Brun et Jean Racine." *Actes, V^e Congrès International des Langues et Littératures Modernes, 1951.* Florence, 1955.

LE MOYNE, FRANÇOIS

Wilhelm, Jacques. "François Le Moyne and Antoine Watteau." *Art Quarterly* XIV, no. 3, 1951, pp. 216–30.

LE NAIN, ANTOINE, LOUIS, AND MATHIEU

Baker, C. H. Collins. "The Le Nain Brothers." *Apollo,* 1928, p. 66 ff.

Bloch, Vitale. "The Tercentenary of Antoine and Louis Le Nain." *Burlington Magazine,* December 1948, pp. 352–53.

*Champfleury (Jules Husson, called Fleury). *Essai sur la vie et l'œuvre des Lenain, peintres laonnais.* Paris, 1850.

————. *Les Frères Le Nain.* Paris, 1862.

*Fierens, Paul. *Les Le Nain.* Paris, 1933.

Illustrated Catalogue of Pictures by the Brothers Le Nain. Burlington Fine Arts Club, London. London, 1910.
 Exhibition catalogue; text by Robert C. Witt.

*Jamot, Paul. *Les Le Nain.* Paris, 1929.

Montgolfier, Bernard de. "Nouveaux documents sur les frères Le Nain." *Gazette des Beaux-Arts,* November 1958, pp. 267–88.

Thuillier, Jacques. "Le Nain Studies." *Burlington Magazine,* February and March 1958.

*Valabrègue, Antony. *Les Frères Le Nain.* Paris, 1904.

LE SUEUR, EUSTACHE

*Rouchès, Gabriel. *Eustache Le Sueur.* Paris, 1923.

MANET, ÉDOUARD

Blanche, Jacques-Émile. *Manet.* New York, 1925.
 French edition 1924.

Courthion, Pierre. *Édouard Manet.* New York, 1961.

Duret, Theodore. *Manet.* Trans. J. E. Crawford Flitch. New York, 1937.
 First published 1902.

MANET, ÉDOUARD (continued)

Édouard Manet, 1832–1883. Philadelphia Museum of Art. Philadelphia, 1966.
 Exhibition catalogue; text by Anne Coffin Hanson.

°Florisoone, Michel. *Manet*. Monaco, 1947.

Fried, Michael. "Manet's Sources: Aspects of His Art, 1859–1865." *Artforum* VII, no. 7, March 1969, special issue.

Hamilton, George H. *Manet and His Critics*. New Haven, Conn., 1954.

Jamot, Paul; Wildenstein, Georges; and Bataille, M. L. *Manet*. 2 vols. Paris, 1932.

Mallarmé, Stéphane. "The Impressionists and Édouard Manet." *Art Monthly Review* I, no. 9, September 30, 1876, pp. 117–21.

Manet, 1832–1883. Musée de l'Orangerie, Paris. Paris, 1932.
 Exhibition catalogue; preface by Paul Valéry, introduction by Paul Jamot.

Manet raconté par lui-même et par ses amis. 2 vols. Geneva, 1953.

°Mantz, Paul. "Les Œuvres de Manet." *Le Temps*, January 16, 1884.

Reff, Theodore. "The Meaning of Manet's *Olympia*." *Gazette des Beaux-Arts*, February 1964, pp. 111–22.

Portrait of Manet by Himself and His Contemporaries. Eds. Pierre Courthion and Pierre Cailler. London, 1960.
 Translation of *Manet raconté par lui-même et par ses amis*.

°Tabarant, A. *Manet et ses œuvres*. Paris, 1947.

Wolff, Albert. "Calendrier parisien." *Figaro*, April 17, 1876.

——————. "[Manet]." *Figaro*, May 15, 1883.

MASTER OF THE AIX ANNUNCIATION

Liebreich, Aenne. "L'Annonciation d'Aix-en-Provence." *Gazette des Beaux-Arts*, February 1938, pp. 63–76.

MASTER OF MOULINS

Châtelet, Albert. "A Plea for the Master of Moulins." *Burlington Magazine*, December 1962, pp. 517–24.

°Dupont, Jacques. "Jean Prévost, peintre de la cour de Moulins." *Art de France* III, 1963, pp. 75–89.

Hours, Madeleine. "Le Maître de Moulins: Étude radiographique." *Art de France* III, 1963, pp. 62–74.

MASTER OF MOULINS (continued)

°Huillet d'Istria, Madeleine. *Le Maître de Moulins*. Paris, 1961.

MIGNARD, PIERRE

Bray, René. "Les Principes de l'art de Mignard confrontés avec la poésie classique: Le Poème de Molière sur la Gloire du Val-de-Grâce." *Actes, V^e Congrès International des Langues et Littératures Modernes, 1951*. Florence, 1955, pp. 193–99.

Mazière de Monville, Simon Philippe. *La Vie de Mignard*. Amsterdam, 1731.

°Wilhelm, Jacques. "Quelques portraits peints par Pierre Mignard." *Revue du Louvre* XII, no. 4, 1962, pp. 165–74.

MILLET, JEAN-FRANÇOIS

Herbert, Robert L. "Millet Revisited." *Burlington Magazine*, July and August 1962.

°Moreau-Nélaton, Étienne. *Millet raconté par lui-même*. 3 vols. Paris, 1921.

Sensier, Alfred. *Jean-François Millet: Peasant and Painter*. Boston, 1881.

°Soullié, Louis. *Peintures, aquarelles, pastels, dessins de Jean-François Millet, relevés dans les catalogues de ventes de 1849 à 1900*. Paris, 1900.

MONET, CLAUDE

Claude Monet: Seasons and Moments. Museum of Modern Art, New York. Garden City, N.Y., 1960.
 Exhibition catalogue; text by William C. Seitz.

Clemenceau, Georges. *Claude Monet: The Water Lilies*. New York, 1930.
 First French edition 1928.

An Exhibition of Painting: Monet. Royal Scottish Academy, Edinburgh. Edinburgh, 1957.
 Text by Douglas Cooper.

°Geffroy, Gustave. *Claude Monet, sa vie, son œuvre*. 2 vols. Paris, 1924.
 First edition 1922.

Greenberg, Clement. "The Later Monet." *Art News Annual* XXVI, 1957, p. 132 ff.
 Reprinted with revisions in his *Art and Culture*, Boston, 1961.

Gwynn, Stephen L. *Claude Monet and His Garden*. New York, 1935.

Hamilton, George H. *Claude Monet's Paintings of Rouen Cathedral*. London, 1960.

MONET, CLAUDE (continued)

Hoschedé, Jean-Pierre. *Claude Monet, ce mal connu.* 2 vols. Geneva, 1950.

°Masson, André. "Monet le fondateur." *Verve* VII, no. 27/28, 1952, p. 68.

Mauclair, Camille [pseud.]. *Claude Monet.* London, 1924.

Rouart, Denis. *Claude Monet: Historical and Critical Study.* Introd. and Conclusion by Léon Degaud. Trans. James Emmons. Geneva, 1948.

Seitz, William C. *Claude Monet.* New York, 1960.

Wildenstein, Daniel. *Monet: Impressions.* New York, 1967.

MONTICELLI, ADOLPHE

Monticelli et le baroque provençal. Musée de l'Orangerie, Paris. Paris, 1953.
 Exhibition catalogue.

Phillips, Duncan. "A Niche for Monticelli." *Art News,* December 1954, p. 22 ff.

Venturi, Lionello. "A New Appraisal of Monticelli." *Burlington Magazine,* February 1938, pp. 70–75.

Werner, Alfred. "Monticelli: Logical Colorist." *Arts Magazine,* October 1959, pp. 44–47.

MOREAU, GUSTAVE

Holten, Ragnar von. *L'Art fantastique de Gustave Moreau.* Paris, 1960.

°Rouault, Georges. "Lettres de Georges Rouault à André Suarès [sur Gustave Moreau]." *L'Art et les Artistes,* 1926, p. 217 ff.

MORISOT, BERTHE

Bataille, M. L., and Wildenstein, Georges. *Berthe Morisot: Catalogue des peintures, pastels, et aquarelles.* Paris, 1961.

°*Berthe Morisot (Madame Eugène Manet), préface par Stéphane Mallarmé, exposition.* Galerie Durand-Ruel, Paris. Paris, 1896.
 Reprinted in Mallarmé's *Divagations,* Paris, 1935.

Berthe Morisot. Musée Jenisch, Vevey, Switzerland. Paris, 1961.
 Exhibition catalogue. Contains unpublished notes from her journal.

Huisman, Philippe. *Morisot: Enchantment.* New York, 1963.

Mongan, Elizabeth. *Berthe Morisot: Drawings, Pastels, Water Colors, Paintings.* New York, 1960.

NATTIER, JEAN MARC

°Nolhac, Pierre de. *Nattier, peintre de la cour de Louis XV*. Paris, 1910.
First edition 1904.

OUDRY, JEAN-BAPTISTE

Hennique, Nicolette. *Jean-Baptiste Oudry*. Paris, 1926.

Lauts, Jan. *Jean-Baptiste Oudry*. Hamburg, 1967.

PATER, JEAN-BAPTISTE

°Ingersoll-Smouse, Florence. *Pater*. Paris, 1928.

PERRÉAL, JEAN

Dupont, Jacques. "A Portrait of Louis XII Attributed to Jean Perréal."
Burlington Magazine, September 1947, p. 236.

Ring, Grete. "An Attempt to Reconstruct Perréal." *Burlington Magazine*,
September 1950, pp. 255–60.

PERRONNEAU, JEAN-BAPTISTE

MacColl, D. S. "Perronneau." *Burlington Magazine* XLV, 1924, pp. 28–30.

Ratouis de Limay, Paul. "Jean-Baptiste Perronneau, Painter and Pastelist,
1715–1783." *Burlington Magazine* XXXVI, January and February 1920.

°Vaillat, Léandre, and Ratouis de Limay, Paul. *J.-B. Perronneau*. 2nd ed.
Paris, 1923.
First edition 1909.

PISSARRO, CAMILLE

Camille Pissarro: Catalogue de l'exposition . . . Galerie Durand-Ruel, Paris.
Paris, 1904.
Text by Octave Mirbeau, reprinted in his *Des Artistes*, second series,
Paris, 1924.

Coe, Ralph T. "Camille Pissarro in Paris: A Study of His Later Develop-
ment." *Gazette des Beaux-Arts*, February 1954, pp. 93–118.

Lanes, Jerrold. "Current and Forthcoming Exhibitions, New York [Pis-
sarro]." *Burlington Magazine*, May 1965, pp. 275–76.

Loan Exhibition: C. Pissarro. Wildenstein & Co., New York. New York,
1965.
Text by John Rewald.

PISSARRO, CAMILLE (continued)

Nicolson, Benedict. "The Anarchism of Camille Pissarro." *The Arts* (London) no. 2, 1946, pp. 43–51.

*Pissarro, Ludovico-Rodo, and Venturi, Lionello. *Camille Pissarro*. 2 vols. Paris, 1939.

Rewald, John. "Camille Pissarro: His Work and Influence." *Burlington Magazine*, June 1938, pp. 280–91.

————. *Camille Pissarro*. New York, 1963.

Sickert, Walter R. Preface to a Catalogue of Pictures by Camille Pissarro. Stafford Gallery, London. n.p., 1911.
> Exhibition catalogue.

POUSSIN, NICOLAS

Baer, Curtis O. "An Essay on Poussin." *Journal of Aesthetics and Art Criticism* XXI, no. 3, 1963, pp. 251–61.

Bellori, Giovanni Pietro. *Vie de Nicolas Poussin*. Geneva, 1947.
> First published in Italian, 1672.

Blunt, Sir Anthony. *Nicolas Poussin*. 2 vols. The A. W. Mellon Lectures in the Fine Arts. New York, 1967.

————. *The Paintings of Nicolas Poussin, a Critical Catalogue*. London, 1966.

————. "Poussin Studies I: Self-Portraits." *Burlington Magazine*, August 1947, pp. 219–26.

————. "Poussin's Notes on Painting." *Journal of the Warburg Institute* I, April 1938, pp. 344–51.

Borenius, Tancred. "A Great Poussin in the Metropolitan Museum." *Burlington Magazine*, November 1931, pp. 207–08.

*Centre National de la Recherche Scientifique. Colloques Internationaux: *Nicolas Poussin*. Ed. André Chastel. 2 vols. Paris, 1960.
> Includes selected seventeenth-century sources in "Pour un *Corpus Pussinianum*," by Jacques Thuillier, vol. II.

Christoffel, Ulrich. *Poussin und Claude Lorrain*. Munich, 1942.

de Tolnay, Charles. "The Self-Portrait of Poussin in the Louvre Museum." *Gazette des Beaux-Arts*, September 1952, pp. 139–41.

*Exposition Nicolas Poussin. Musée du Louvre. 2nd rev. ed. Paris, 1960.
> Exhibition catalogue; text by Sir Anthony Blunt.

Friedlaender, Walter. *Nicolas Poussin*. Munich, 1914.

POUSSIN, NICOLAS (continued)

——————. *Nicolas Poussin.* New York, 1966.

——————. "Poussin's Old Age." *Gazette des Beaux-Arts,* July/August 1962, pp. 249–64.
 Reprinted with some changes in his *Nicolas Poussin,* New York, 1966.

Gide, André. "The Lesson of Poussin." *The Arts* (London) no. 2, 1946, pp. 59–70.
 First French edition, Paris, 1945.

Grautoff, Otto. *Nicolas Poussin.* 2 vols. Munich, 1914.

*Magne, Émile. *Nicolas Poussin, premier peintre du roi, 1594–1665.* Brussels, 1914.

Mahon, Denis. "Poussiniana: Afterthoughts Arising from the [1960 Poussin] Exhibition." *Gazette des Beaux-Arts,* July/August 1962, pp. 1–138.

Panofsky, Erwin. "*Et in Arcadia ego:* Poussin and the Elegiac Tradition." In his *Meaning in the Visual Arts.* Garden City, N.Y., 1955.
 First published 1936.

Thuillier, Jacques. "Poussin." *Art News Annual* XXX, 1965, p. 38 ff.

PRIMATICCIO, FRANCESCO

Dimier, Louis. *Le Primatice, peintre, sculpteur, et architecte des rois de France.* Paris, 1900.
 Abridged version Paris, 1928.

PRUDHON, PIERRE-PAUL

Alexandre, Arsène. "L'Âme de Prudhon dans sa peinture." *Renaissance de l'Art Français,* May 1922, p. 294 ff.

Brookner, Anita. "Prudhon: Master Decorator of the Empire." *Apollo,* September 1964, pp. 192–98.

Goncourt, Edmond de. *Catalogue raisonné de l'œuvre peint, dessiné et gravé de P.-P. Prudhon.* Paris, 1876.

Grappe, Georges. *Prudhon.* Paris, 1958.

Guiffrey, Jean. "The Prudhon Exhibition." *Burlington Magazine* XLI, July 1922, pp. 27–33.

Pierre-Paul Prudhon. 72 reproductions de Léon Marotte, accompagnées d'une vie du peintre par Anatole France. Paris, 1923.

PUVIS DE CHAVANNES, PIERRE

Cox, Kenyon. "Puvis de Chavannes." *Century Magazine* LI, 1896, pp. 558–69.

Goldwater, Robert. "Puvis de Chavannes: Some Reasons for a Reputation." *Art Bulletin*, March 1946, pp. 33–43.

La Farge, John. "Puvis de Chavannes." *Scribner's Magazine* XXVIII, 1900, pp. 672–84.

Mauclair, Camille [pseud.]. "Puvis de Chavannes and Gustave Moreau." *International Quarterly* XII, 1905, pp. 240–54.

Vachon, Marius. *Puvis de Chavannes.* Paris, 1895.

Werth, Léon. *Puvis de Chavannes.* Paris, 1926.

QUARTON, ENGUERRAND

Sterling, Charles. *Le Couronnement de la Vierge par Enguerrand Quarton.* Paris, 1939.

REDON, ODILON

Bacou, Roseline. *Odilon Redon.* 2 vols. Geneva, 1956.

Berger, Klaus. *Odilon Redon, Fantasy and Colour.* New York, 1965.

*"Hommage à Odilon Redon." *La Vie*, November 30, 1912.

Masson, André. "Redon: Mystique with a Method." *Art News,* January 1957, p. 41 ff.

Mellerio, A. *Odilon Redon, peintre, dessinateur, et graveur.* Paris, 1923. Reprinted New York, 1968.

Milliken, William M. "*Orpheus,* by Odilon Redon." *Bulletin of the Cleveland Museum of Art,* June 1926, pp. 139–41.

Roger-Marx, Claude. "Odilon Redon: Painter and Mystic." *The Selective Eye* II, 1956, pp. 149–57.

Sandström, Sven. *Le Monde imaginaire d'Odilon Redon.* Lund, Sweden, 1955.

Symons, Arthur. "A French Blake." *Art Review,* July 1890, pp. 206–07. Reprinted with revisions in his *From Toulouse-Lautrec to Redon,* London, 1929.

RENOIR, PIERRE AUGUSTE

*André, Albert. *Renoir.* Paris, 1918.

RENOIR, PIERRE AUGUSTE (continued)

Barnes, Albert C., and De Mazia, Violette. *The Art of Renoir.* New York, 1935.

*Chirico, Georgio de. "Augusto Renoir." *Il Convegno* I, 1920, pp. 36–46.

Drucker, Michel. *Renoir.* Paris, 1944.

Fosca, François [pseud.]. *Renoir.* New York, 1924.

Gaunt, William. *Renoir.* London, 1952.

*Jamot, Paul. "Renoir (1841–1919)." *Gazette des Beaux-Arts,* November and December 1923.

*Lhote, André. *Renoir: peintures.* Paris, 1947.

Meier-Graefe, Julius. *Renoir.* Leipzig, 1928.

Mirbeau, Octave. *Renoir.* Paris, 1913.

Pach, Walter. "Pierre Auguste Renoir." *Scribner's Magazine* LI, May 1912, pp. 610–15.
 Reprinted in his *Queer Thing, Painting*, New York, 1938.

————. *Pierre Auguste Renoir.* New York, 1950.

*Regnier, Henri de. *Renoir, peintre du nu.* Paris, 1923.

Renoir, Jean. *Renoir, My Father.* Boston, 1962.

Rivière, Georges. *Renoir et ses amis.* Paris, 1921.

Vollard, Ambroise. *Renoir, an Intimate Record.* Trans. Harold C. Van Doren. New York, 1934.
 First French edition 1919. First English edition 1925.

RIGAUD, HYACINTHE

*Roman, J. "Le 'Livre de raison' d'Hyacinthe Rigaud." *Gazette des Beaux-Arts,* April 1914, pp. 265–76.

ROBERT, HUBERT

Exhibition of Paintings and Drawings by Hubert Robert. Wildenstein & Co., New York. New York, 1935.
 Text by Alfred M. Frankfurter.

Gabillot, C. *Hubert Robert et son temps.* Paris, 1895.

ROUSSEAU, HENRI

Bouret, Jean. *Henri Rousseau.* Greenwich, Conn., 1961.

ROUSSEAU, HENRI (continued)

Carrà, Carlo. "Rousseau le Douanier and the Italian Tradition." *Magazine of Art,* November 1951, pp. 261–67.

Cooper, Douglas. "Henri Rousseau: *Artiste-peintre.*" *Burlington Magazine,* July 1944, pp. 160–65.

*Delaunay, Robert. "Henri Rousseau le Douanier." *L'Amour de l'Art,* November 1920, pp. 228–30.

Rich, Daniel C. *Henri Rousseau.* Museum of Modern Art, New York. New York, 1946.

Tzara, Tristan. *Henri Rousseau: The Role of Time and Space in His Work.* Sidney Janis Gallery, New York. n.p., 1951.
 Exhibition catalogue.

———. "Le Rôle du temps et de l'espace dans l'œuvre du Douanier Rousseau." *Art de France* II, 1962, pp. 322–26.
 Expanded version of the preceding.

Uhde, Wilhelm. *Five Primitive Masters.* Trans. Ralph Thompson. New York, 1949.
 Chapter on Rosseau is essentially the same as original French essay, *Henri Rousseau,* Paris, 1911.

Vallier, Dora. *Henri Rousseau.* New York, 1964.

Weber, Max. "Rousseau as I Knew Him." *Art News,* February 15, 1942, p. 17 ff.

*Zervos, Christian. *Rousseau.* Paris, 1927.

ROUSSEAU, THÉODORE

Dorbec, Prosper. *Théodore Rousseau.* Paris, 1910.

Théodore Rousseau, 1812–1867. Musée du Louvre. Paris, 1968.
 Exhibition catalogue.

SEURAT, GEORGES

Cooper, Douglas. *Georges Seurat: Une Baignade, Asnières.* London, 1945.

*Dorra, Henri, and Rewald, John. *Seurat.* Paris, 1959.

Fry, Roger. *Seurat.* London, 1965.
 First published 1926 in his *Transformations.*

Hauke, C. M. de. *Seurat et son œuvre.* 2 vols. Paris, 1961.

Herbert, Robert L. *Seurat's Drawings.* New York, 1962.

SEURAT, GEORGES (continued)

Homer, William I. *Seurat and the Science of Painting*. Cambridge, Mass., 1964.

Laprade, Jacques de. *Georges Seurat*. Monaco, 1945.

Rewald, John. *Georges Seurat*. New York, 1943.

—————. "Seurat: The Meaning of the Dots." *Art News*, April 1949, p. 24 ff.

Rich, Daniel C. *Seurat and the Evolution of La Grande Jatte*. Chicago, 1935.

Russell, John. *Seurat*. London, 1965.

Salmon, André. "Georges Seurat." *Burlington Magazine* XXXVII, September 1920, pp. 115–22.

Schapiro, Meyer. "Seurat: Reflections." *Art News Annual* XXIX, 1964, p. 20 ff.
 Previously published as "New Light on Seurat," *Art News*, April 1958.

SISLEY, ALFRED

Daulte, François. *Alfred Sisley: Catalogue raisonné de l'œuvre peint*. Lausanne, 1959.

—————. *Sisley Landscapes*. New York, 1962.

°Geffroy, Gustave. *Sisley*. Cahiers d'aujourd'hui, 13/14. Paris, 1923.

Loan Exhibition, Sisley. Wildenstein & Co., New York. New York, 1966.
 Exhibition catalogue; introduction by François Daulte.

TOULOUSE-LAUTREC, HENRI DE

°Alexandre, Arsène. "Une Guérison." *Figaro*, March 30, 1899.

Cooper, Douglas. *Toulouse-Lautrec*. New York, 1956.

Huisman, Philippe, and Dortu, M. G. *Lautrec by Lautrec*. New York, 1964.

°Joyant, Maurice. *Henri de Toulouse-Lautrec*. 2 vols. Paris, 1926–27.

Lassaigne, Jacques. *Toulouse-Lautrec*. Trans. Mary Chamot. London, 1939.

Mack, Gerstle. *Toulouse-Lautrec*. New York, 1949.
 First edition 1938.

Rich, Daniel C. "Au Moulin Rouge." *Bulletin, Art Institute of Chicago* XXIII, no. 2, 1928, pp. 14–15.

VALENTIN

°Thuillier, Jacques. "Un Peintre passionné." *L'Œil*, November 1958, p. 26 ff.

VERNET

Blanc, Charles. *Une Famille d'artistes, les trois Vernet: Joseph, Carle, Horace*. Paris, 1898.

Dayot, A. *Les Vernet*. Paris, 1898.

°Ingersoll-Smouse, Florence. *Joseph Vernet*. 2 vols. Paris, 1926.

VIGÉE-LEBRUN, LOUISE ELISABETH

°Nolhac, Pierre de. *Madame Vigée-Le Brun, peintre de Marie Antoinette*. Paris, 1912.

VIGNON, CLAUDE

°Fischer, Wolfgang. "Claude Vignon." *Nederlands Kunsthistorisch Jaarboek* XIII, 1962, and XIV, 1963.

°Sterling, Charles. "Un Précurseur français de Rembrandt: Claude Vignon." *Gazette des Beaux-Arts*, October 1934, pp. 123–36.

VOUET, SIMON

Crelly, William R. *The Painting of Simon Vouet*. New Haven, Conn., 1962.

WATTEAU, ANTOINE

°Adhémar, Hélène. *Watteau, sa vie, son œuvre*. Paris, 1950.

°Aragon, Louis. *L'Enseigne de Gersaint*. Geneva, 1946.

Barker, Gilbert W. *Antoine Watteau*. London, 1939.

Champion, Pierre. *Notes critiques sur les vies anciennes d'Antoine Watteau*. Paris, 1921.

Dacier, E., and Vuaflart, A. *Jean de Julienne et les graveurs de Watteau au XVIIIᵉ siècle*. 4 vols. Paris, 1922–29.

Levey, Michael. "The Real Theme of Watteau's Embarkation for Cythera." *Burlington Magazine*, May 1961, pp. 180–85.

Mauclair, Camille [pseud.]. *Le Secret de Watteau*. Paris, 1942.

Pilon, E. *Watteau et son école*. Brussels, 1912.

Sitwell, Sacheverell. *Antoine Watteau*. London, 1925.

Copyright
Acknowledgments

The editor and publisher are grateful to the following individuals, periodicals, and publishers for permission to quote from copyrighted material. Every effort has been made to acknowledge properly all copyright owners. If any acknowledgment has been inadvertently omitted, the necessary correction will be made in the next printing.

HARRY N. ABRAMS, INC. for excerpts from *French Impressionists in the Louvre* by Germain Bazin; from *Toulouse-Lautrec* by Douglas Cooper; from *Manet* by Pierre Courthion; from *Art and the Spirit of Man* by René Huyghe; from *Dresden Gallery* by Henner Menz; from *Degas* by D. C. Rich; from *Cézanne* by Meyer Schapiro; from *Henri Rousseau* by Dora Vallier; from *Great French Paintings* by Jean Vergnet-Ruiz and Michel Laclotte.

ALBRIGHT-KNOX ART GALLERY, Buffalo, New York, for excerpt from "Gauguin's *Yellow Christ*" by Robert Goldwater (*Gallery Notes*, 1947).

APOLLO for excerpts from "French Painting in the 16th Century" and "Philippe de Champaigne" by Philip Hendy; "The Art of Georges de la Tour" by Germain Bazin; "*L'Absinthe* in England" by Ronald Pickvance.

EDWARD ARNOLD (PUBLISHERS) LTD. for excerpt from *The Waning of the Middle Ages* by J. Huizinga.

621

Copyright Acknowledgments

ART IN AMERICA for excerpt from "George du Mesnil de La Tour" by H. Voss (Dec. 1928).

THE ART INSTITUTE OF CHICAGO for excerpts from the Introduction to the Catalogue of the Gauguin Exhibition (1959) by Theodore Rousseau, Jr. and to the Catalogue of the Corot Exhibition (1960) by S. Lane Faison; from the article "Au Moulin Rouge" by Daniel C. Rich (*CIA Bulletin*, vol. 23, 1929).

ART NEWS for excerpts from "Rousseau as I Knew Him" by Max Weber (Feb. 15, 1942); "Seurat" by John Rewald (April 1949); "Chardin" by Marcel Proust (Oct. 1954); "A Niche for Monticelli" by Duncan Phillips (Dec. 1954); "Redon" by André Masson (Jan. 1957); "Museum Evaluations II" by Alfred Frankfurter (Jan. 1965); "Fantin-Latour" by Pierre Schneider (*Art News Annual* 1955); "Gauguin" by Sir Herbert Read (*Art News Annual* 1956); "Seurat" by Meyer Schapiro (*Art News Annual* 1964); and "Poussin" by Jacques Thuillier (*Art News Annual* 1965).

THE BARNES FOUNDATION for excerpts from *The French Primitives and Their Forms; The Art of Renoir;* and *The Art of Cézanne,* all by Albert C. Barnes and Violette De Mazia.

BEACON PRESS for excerpt from *Art and Culture* by Clement Greenberg. © 1961 by Clement Greenberg, reprinted by permission of the Beacon Press.

G. BELL & SONS, LTD. for *Old Masters and Modern Art* by Sir Charles Holmes, *National Gallery*, vol. 3.

QUENTIN BELL for excerpts from *Art,* and *Landmarks in Nineteenth-Century Painting* by Clive Bell.

THE BODLEY HEAD, LTD. for excerpts from *Toulouse-Lautrec to Rodin* by Arthur Symons; and *The Autobiography of Alice B. Toklas* by Gertrude Stein. Copyright 1933.

GEORGE BRAZILLER, INC. for excerpt from *Jacques Callot* by Edwin de T. Bechtel, copyright © 1955 by George Braziller, Inc., reprinted by permission of the publisher.

LILLIAN BROWSE for excerpt from *Degas Dancers* (1949).

CALIFORNIA PALACE OF THE LEGION OF HONOR for excerpt from "Early Landscape by Corot" by Gay Drake Davisson (*Bulletin*, Feb. 1946).

CHATTO AND WINDUS LTD. for excerpts from *Art,* and *Landmarks in Nineteenth-Century Painting* by Clive Bell; from *Vision and Design,* and *Characteristics of French Art* by Roger Fry.

622

THE CLARENDON PRESS for excerpt from "Et in Arcadia Ego" by Erwin Panofsky, in *Philosophy and History* (Essays presented to Ernst Cassirer).

THE CLEVELAND MUSEUM OF ART for excerpt from *CMA Bulletin* (June 1926) *"Orpheus,* by Odilon Redon" by William M. Milliken.

CONSTABLE PUBLISHERS, LONDON for excerpt from *Studies in Seven Arts* by Arthur Symons.

COWARD-McCANN, INC. for excerpt by Fiske Kimball and Lionello Venturi from *Great Paintings in America.* Copyright 1948.

CROWN PUBLISHERS for excerpts from *Manet* by Theodore Duret. Copyright © 1937 by Crown Publishers, Inc. Used by permission of Crown Publishers, Inc.; *Journey into the Self* by Leo Stein. Copyright © 1950 by the Estate of Leo D. Stein c/o Joseph Solomon. Used by permission of Crown Publishers, Inc.

MRS. PAMELA DIAMAND for excerpt from *Characteristics of French Art* by Roger Fry.

DODD, MEAD & COMPANY for excerpt from *Manet* by J. É. Blanche.

DOUBLEDAY & COMPANY, INC. for excerpts from *Claude Monet: The Water Lilies* by Georges Clemenceau. Copyright 1930 by Doubleday & Company, Inc. Reprinted by permission of the publisher; from *Christmas Holiday* by W. Somerset Maugham. Copyright 1939 by W. Somerset Maugham. Reprinted by permission of Doubleday & Company, Inc.; from *Of Human Bondage* by W. Somerset Maugham. Copyright 1915 by W. Somerset Maugham. Reprinted by permission of Doubleday & Company, Inc.; from *The Voices of Silence* by André Malraux. Reprinted by permission of Doubleday & Company, Inc.

DOVER PUBLICATIONS, INC. for excerpt from *Styles in Painting* by Paul Zucker. Reprinted through permission of the publisher, Dover Publications, Inc., New York.

FABER AND FABER, LTD. for excerpt from *Jehan Foucquet* by Trenchard Cox.

FARRAR, STRAUS & GIROUX, INC. for excerpt from *Diary of an Art Dealer* by René Gimpel. Copyright 1966.

ROBERT GOLDWATER for excerpt from his article "Puvis de Chavannes" (*Art Bulletin*, March 1946).

HARCOURT, BRACE & WORLD, INC. for excerpt from *Landmarks in Nineteenth-Century Painting* by Clive Bell.

MISS ENRIQUETA HARRIS for excerpt from her article "Mary in the Burning Bush," *Journal of the Warburg Institute* (1937–38).

624

626

STUDIO VISTA LTD. for excerpts from *Bandits in a Landscape* by William Gaunt.

THAMES AND HUDSON INTERNATIONAL LTD. for excerpt from *Romantic Art* by Marcel Brion.

UNIVERSITY OF CALIFORNIA PRESS for excerpt from *Cézanne's Composition* by Erle Loran.

UNIVERSITY OF CHICAGO PRESS for excerpt from *Seurat and the Evolution of "La Grande Jatte"* by Daniel C. Rich.

UNIVERSITY OF LONDON. THE WARBURG INSTITUTE for excerpts from "Mary in the Burning Bush" by Enriqueta Harris; "Géricault's Paintings of the Insane" by Margaret Miller; and "Jean Fouquet" by Otto Pächt.

THE UNIVERSITY OF NEWCASTLE UPON TYNE for excerpt from *Claude Monet's Paintings of Rouen Cathedral* by G. H. Hamilton, published in series of Charlton Lectures on Art.

UNIVERSITY OF OKLAHOMA PRESS for excerpt from *Modern Art and the New Past* by James Thrall Soby. Copyright 1957 by the University of Oklahoma Press.

A. P. WATT & SON for excerpts from *Christmas Holiday*, copyright 1939 by W. Somerset Maugham and *Of Human Bondage*, copyright 1915 by W. Somerset Maugham.

WILLIAM WELLS for excerpt from his article "Degas's Portrait of Duranty," *Scottish Art Review*.

WILDENSTEIN & COMPANY for excerpts from *Exhibition of Paintings and Drawings* by Hubert Robert, text signed by Alfred M. Frankfurter, and *The Italian Heritage*.

YALE UNIVERSITY PRESS for excerpts from *Manet and His Critics* by G. H. Hamilton; *The Painting of Simon Vouet* by William R. Crelly; *Claude Lorrain* by Marcel Röthlisberger; *Filarete's Treatise on Architecture* by John R. Spencer.

Index of Painters
and Paintings

This index lists only painters and paintings discussed under a separate heading

Index of Critics